Architecture
and Interior Design
through the 18th Century
An Integrated History

Buie Harwood

Bridget May

Curt Sherman

Prentice Hall

Upper Saddle River, New Jersey 07458

Library of Congress Cataloging-in-Publication Data

Harwood, Buie.
 Architecture and interior design through the 18th century : an integrated history / Buie Harwood, Bridget May, Curt Sherman.
 p. cm.
 Includes bibliographical references and index.
 ISBN 0-13-758590-X
 1. Interior decoration—History. 2. Interior architecture—History. 3. Decorative arts—History. I. May, Bridget. II. Sherman, Curt. III. Title.

NK1710 .H37 2002
729'.09—dc21

2001054869

Editor-in-Chief: Stephen Helba
Director of Production and Manufacturing: Bruce Johnson
Executive Editor: Vernon R. Anthony
Managing Editor–Editorial: Judy Casillo
Editorial Assistant: Ann Brunner
Marketing Manager: Ryan DeGrote
Managing Editor–Production: Mary Carnis
Production Liaison: Denise Brown
Production Editor/Full-Service Production: Linda Zuk/WordCrafters
Composition: Publishers' Design and Production Services, Inc.
Design Director: Cheryl Asherman
Senior Design Coordinator: Miguel Ortiz
Manufacturing Manager: Cathleen Petersen
Interior Design: Laura Ierardi/LCI Design
Cover Design: Joseph DePinho
Printing and Binding: Courier Westford
Cover Printer: Phoenix Color Corp.
Color Scanning Supervisor: Joe Conti
PrePress Specialists: Mark Handago, Corrin Skidds, Robert Uibelhoer, Ron Walko
Director, Image Resource Center: Melinda Reo
Rights and Permissions Manager: Kay Dellosa
Image Permission Coordinator: Michelina Viscusi
Interior Image Specialist: Beth Boyd-Brenzel
Photo Researcher: Karen Pugliano
Traffic Specialist: Silvana Attanasio
Cover Image Credits: Image 1: Notre Dame. © Copyright Dorling Kindersley. Michael Crockett, Photographer. **Image 2:** Library at Kenwood House. National Trust for Places of Historic Interest or Natural Beauty, National Trust Photo Library, London, England. **Image 3:** Chippendale chair. Buie Harwood. **Image 4:** Moonlight Revelry. Freer Gallery of Art, Smithsonian Institute, Washington, D.C. **Image 5:** Acropolis. © Copyright Dorling Kindersley. Stephen Conlin, Illustrator. **Image 6:** Villa Rotunda. © Copyright Dorling Kindersley. Roger Moss, Photographer.
Credits for Interior Images begin on page 552.

Pearson Education LTD, *London*
Pearson Education Australia PTY, Limited, *Sydney*
Pearson Education Singapore, Pte. Ltd.
Pearson Education North Asia Ltd., *Hong Kong*
Pearson Education Canada, Ltd., *Toronto*
Pearson Educacion de Mexico, S.A. de C.V.
Pearson Education—Japan
Pearson Education Malaysia, Pte. Ltd.

10 9 8 7 6 5 4 3 2 1

ISBN 0-13-758590-X

*This book is dedicated
to our families, mentors, and students.*

Contents

Preface

This book was written primarily to fulfill a need in interior design education and in related design disciplines. We are not aware of another book that allows the reader to compare and contrast architecture, interiors, furniture, and decorative arts through many centuries. We have tried to interweave a design analysis language with that of art and architectural history. Our intent is to provide a flexible, easy-to-use, and well-organized resource for those with a variety of interests. An extensive reference list, glossary, and index are included.

Our primary audience is students in interior design programs. However, this book will also be of use to interior design practitioners, furniture designers, design consultants, design manufacturers, and theater/film set designers, as well as to students and professionals in the related fields of art history, architecture, material culture, museum studies, and history. It may also be of interest to historical/preservation societies, craftspeople, design journalists, and laypeople interested in design.

The development of this book evolved over a number of years through our college teaching experiences. We, and our colleagues, were continually frustrated by the lack of adequate resources to support the desired content, context, and comprehensiveness of design history. All of our shared ideas were realized here as we worked on the scope, organization, and presentation of this material. We hope that this effort fulfills a need for you and future generations who find the study of design history exciting.

ACKNOWLEDGMENTS

This book has been an enormous endeavor and a formidable challenge. We would like to offer our grateful acknowledgment to those who provided valuable assistance though its development. Special thanks to each of you for all of your wonderful contributions!

To our Prentice Hall/Pearson Education support team who had faith in us and made the book happen: Vern Anthony, Judith Casillo, Elizabeth Sugg, Linda Zuk, Denise Brown, and Patsy Fortney.

To our many students who inspired us to undertake this project: those who studied with Buie at Virginia Commonwealth University, the University of Texas at Austin, and North Texas State University; those who studied with Bridget at Marymount University, the University of Georgia at Athens, and Mississippi University for Women; and those who studied with Curt at Winthrop University, San Diego State University, and Washington State University.

To our educational institutions who in various ways supported our efforts: Virginia Commonwealth University, Marymount University, and Winthrop University.

To our friends who offered their expertise, support, resources, interest, and listening ears: Alice Burmeister, Peg De Lamiter, Laura Durfresne, George Fuller, Alan Huston, Dianne Jackman, Philip Moody, Ardis Rewerts, Nancy Templeman, and our family within the Interior Design Educators Council (IDEC).

To our special library resource friends: Carl Vuncannon and his staff at the Bernice Bienenstock Furniture Library in High Point, North Carolina, who opened that resource to us; Suzanne Freeman at the Virginia Museum of Fine Arts in Richmond, who provided a wealth of information; and Ray Bonis in Special Collections, Cabell Library at Virginia Commonwealth University, who provided valuable assistance.

To our individual family members who offered ongoing support, listened to complaints, and provided expertise when needed: Judy Sherman Endeman, Frith Harwood, Robert Harwood, Hope Harwood Liebke, Dottie May, and Henry May.

To those early illustrators and photographers who recorded their environments as well as earlier ones of the 18th, 19th, and 20th centuries. As shown herein, their depictions of architecture, interiors, furnishings, and costumes were of enormous value in providing a resource archive of the past.

And, finally, to our wonderful and talented artist and former interior design student: Chris Good. You did a great job!

Introduction

A people without history is like the wind on the buffalo grass.

Sioux saying

Art is a human activity having for its purpose the transmission to others of the highest and best feelings to which men have risen.

Leo Tolstoi, *What Is Art?*

We shape our buildings, thereafter they shape us.
Winston Churchill, as quoted
in *Time* magazine, 1960

INTEGRATING ARCHITECTURE AND INTERIOR DESIGN

Volume 1 of this book provides a survey of architecture, interiors, furniture, and decorative arts from the earliest cultural precedents through the 18th century. Volume 2 will continue exploring the same material through the 19th, 20th, and 21st centuries. Our intent is to provide a completely integrated and interdisciplinary reference for studying the built environment, interior design, interior architectural features, design details, motifs, furniture, space planning, color, lighting, textiles, interior surface treatments, and decorative accessories. Each period is placed within a cultural, historical, social, and conceptual context, allowing the reader to make connections among all aspects of aesthetic development. Examples depict high-style (expressing characteristics at the forefront of fashion or design: Fig. I-1) and vernacular (expressing characteristics at a local or regional level: Fig. I-2) buildings, interiors, and furnishings reflecting residential, commercial, and institutional projects. Later interpretations may illustrate the application of stylistic influences during later periods, such as the Chinese chair forms interpreted in the Georgian period (Fig. I-3), as well as products currently being manufactured and projects recently completed.

People provide our travelogue through history and our understanding of design. They shape and define our architecture, interiors, furniture, and decorative arts. Their

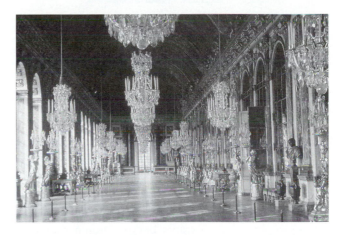

I-1. *Galerie des Glaces* (Hall of Mirrors), Palais de Versailles, near Paris, 1678–1687; begun by Charles Le Brun and completed by Jules Hardouin-Mansart (see Chapter 21, Louis XIV, Fig. 21-22).

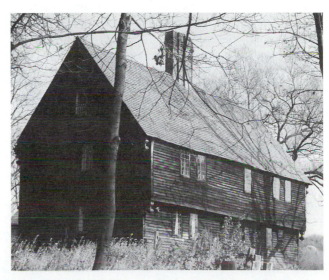

I-2. Parson Capen House, 1683; Topsfield, Massachusetts (see Chapter 16, American Colonial: England, Fig. 16-12).

tastes, ideas, knowledge, activities, and perceptions define the macro and micro environments. The environments discussed herein typically emphasize aesthetic and functional considerations—spaces that have been made by

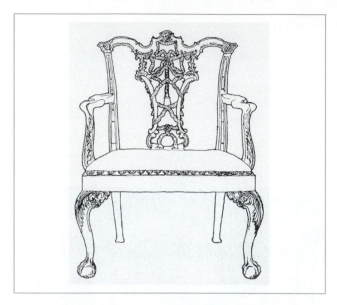

I-3. Armchair, early to mid–eighteenth century; England (see Chapter 24, English Neo-Palladian & Georgian, Fig. 24-51).

people in which to live, work, and play. The study of architecture emphasizes the exterior built environment: buildings within a site, structures that form shelter, forms that articulate a design language—a macro view of space. The study of interior design parallels this concept but focuses on interior environments where people go about their daily activities: areas within the building, rooms and their relationships within a structure, envelopes that display a design vocabulary—a micro view of space. The study of furniture and decorative arts offers a more detailed view of the objects and materials within interiors. This aesthetic and functional language and vocabulary become our road map for understanding design history.

APPROACHES TO DESIGN HISTORY

There are various approaches to the study of design history. Art history uses works of art to study the past and encompasses the arts (painting, sculpture, and architecture) and the decorative arts (furniture, ceramics, metals, etc.). Its formalistic method follows chronology and stylistic development to grasp the meaning of works of art and, by extension, a society or people. Architectural history follows a similar pattern, but with a far greater emphasis on buildings. Its formalistic method addresses buildings primarily through their individual history, function, owners, architects, style, siting, materials, construction, and contextual environment. Material culture looks more specifically at objects as transmitters of the ideas and values of a society or group. Objects made and used by a society may include

tools, furniture, textiles, lighting, and so on, and may be high-style or vernacular.

Interior design historians bring a unique approach to design history by integrating the relationship between architecture and interiors within the context of history and design analysis. To accomplish this, the art history, architectural history, and material culture approaches are merged and examined as they relate to the design considerations of research programming, concept, function, overall aesthetic, principles, and elements, as well as meaning and intent. As interior design educators, we have taken this last approach.

A stylistic approach to design history identifies forms, function, and visual features. This method, which is typically chronological, can be as simple as codifying visual characteristics with little definition of the roles of form and/or function. In a broader view, such as that of art history or material culture, style assumes that groups of people during particular times prefer particular forms and motifs as a reflection of their cultural and social qualities. Therefore, objects, such as architecture, interiors, furnishings, and decorative arts, can embody the values and/or beliefs of a society. In this sense, objects become historical documents or visual records. As primary documents, they can tell us much about an individual or group. Objects survive much longer than written records and often derive from a broader spectrum of society. The most complete picture, however, results from the integration of objects and written records.

Styles evolve from social, cultural, economic, and/or political factors of a given time. Available materials, climate, location, technology, and historical events affect the visual image. Frequently styles originate with political or religious leaders, the wealthy, or other important people; then filter down to the middle class; and gradually become the vernacular or provincial expression. The majority of surviving examples reflect primarily the wealthy and/or nobility in all periods. As such, they represent only a small portion of the material covered in this book. Style dates vary, with change occurring more slowly further back in time and in areas farther from stylistic origins. Consequently, dates provided herein should be considered guidelines since resources deviate in identifying exact dates, and transitions are common as stylistic periods change.

USING DESIGN ANALYSIS

Important competencies of architects and interior designers are reading and understanding existing exterior and interior environments. These competencies are developed through design analysis—a visual language of design evaluation. This process affects aesthetic decisions and functional considerations and is most critical when evaluating

historical structures and interiors. Studying these historical records helps designers to understand the evolution of a building, to build visual literacy, and to assess the appropriate design direction. Understanding historical design can also provide a wealth of design ideas. A designer may enhance the original visual image, reproduce it (copy the original as closely as possible), or adapt it (interpret a new design based on the original).

Design analysis incorporates a specific language based on integrating the principles and elements of design and the architectural and interior components of a building. The principles of design include proportion, scale, balance,

harmony, unity/variety/contrast, rhythm, and emphasis. The elements of design comprise size/space, line, color, light, texture, and shape/form (see Principles and Elements of Design definitions; Fig. I-4). Discussions in this book of architectural components of a building typically include site orientation, floor plan, materials, construction systems, color, facades, windows, doors, roofs, architectural details, and unique features. Interior components generally include the relationship of the interior to the exterior, materials, color, lighting, floors, walls, windows, doors, textiles, ceilings, interior details, special treatments, and unique features. Furnishings and decorative arts address specific

Principles and Elements of Design

Principles of design are the vocabulary used to measure and define design, and they are often described using the elements of design.

■ *Proportion.* The relationship of parts of a design to each other and to the whole, such as between large and small sizes of windows within a house.

■ *Scale.* A contextual relationship comparing dimensional objects, such as the proportional size of a door to all other doors, to human beings, and to the space in which it belongs.

■ *Balance.* A result when forces opposing each other achieve equilibrium. Examples include symmetrical/formal balance developing from a central axis, asymmetrical/informal balance with an irregular axis, and radial balance developing from a central core.

■ *Harmony.* The relationship of parts to each other through similarity and to an overall theme of design, such as the consistency in size and color of architectural trim on a house.

■ *Unity, Variety, Contrast. Unity* is the collection of elements seen as a visually related whole. *Variety* is the tension between opposing elements, such as between straight and curved lines. *Contrast* refers to the means of accenting a composition through light, color, texture, pattern, scale, and/or configuration.

■ *Rhythm.* The relationship of visual elements together in a regular pattern through repetition, alternation, or progression, such as the repetition of lines and shapes in a textile pattern.

■ *Emphasis.* The importance of an item in its space, thereby making other items less important. An example is the focal point created by placing a large oil painting at the end of a narrow hallway.

The elements of design are the tools for working in space.

■ *Space.* The area where things exist and move, as well as a period of time, thereby establishing relationships, such as between man and his environment. Space may be arranged through a linear, nucleus, modular, or grid pattern.

■ *Line.* The connection of two points in space; may be straight or curved, as well as directional (vertical, horizontal, or diagonal).

■ *Color.* Described by hue (the color name), value (its change from light to dark), and intensity (its brightness or chroma). The gradation of color indicates a transition of change from light to dark, such as from pink to rose to burgundy.

■ *Light* Light defines and shapes forms and spaces so man can view them. It typically emits bright spots and shadows that create contrast between light and dark through natural or artificial sources.

■ *Texture.* The visual or tactile quality of natural and manmade objects, such as brick, velvet, or paint.

■ *Shape and Form.* Shape is two-dimensional: squares, circles, and triangles. *Form* is three-dimensional: cubes, spheres, and pyramids.

Reference: Kilmer, Rosemary, and Kilmer, W. Otie. *Designing Interiors.* Ft. Worth and New York: Harcourt, Brace, Jovanovich Publishers and Holt, Rinehart and Winston, Inc. 1992.

I-4. Principles and Elements of Design.

relationships; furniture arrangements; materials; seating; tables; storage; beds; textiles; special decorative arts such as ceramics, metalwork, or mirrors; and unique features. The overall appearance of the exterior and interior derives from the integration of this design analysis language as applied to a three-dimensional form.

Design analysis also addresses ordering systems used to articulate buildings and interiors. The most common ordering systems are spatial definition, proportion, geometry, scale, and visual perception. Spatial definition involves the wall planes enclosing space and the spatial elasticity of the surrounding space, as illustrated in the Reception Hall

at the Alcazar in Seville, Spain. (Fig. I-5). Behavioral design specialists also refer to personal and social space related to the concept of proxemics (the physical distance between people in space). These considerations may define the experience of space as being confined, tight, and restricted, or spacious, expanding, and flexible.

Proportion recognizes dimensions and relationships. The Greeks codified the Golden Section (see Chapter 5, Fig. I-6) clarifying the specific relationship between the whole and its parts. Andrea Palladio (see Chapter 12, Fig. I-7) incorporated a mathematical approach to proportion with rooms in square, circular, and rectangular shapes and heights in a harmonious ratio. In the 20th century, Le Corbusier constructed his "modular" as a measuring tool relating anthropometrics (the proportions of the human body) and mathematics.

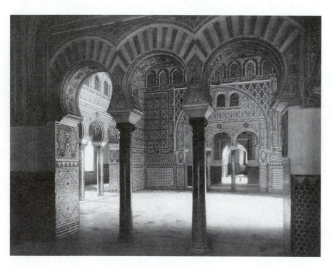

I-5. *Iwan* or Reception Hall, Alcazar, 1364; Seville, Spain (see Chapter 9, Islamic, Fig. 9-21).

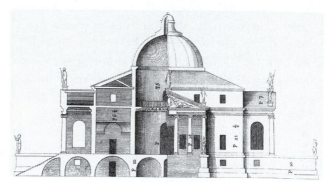

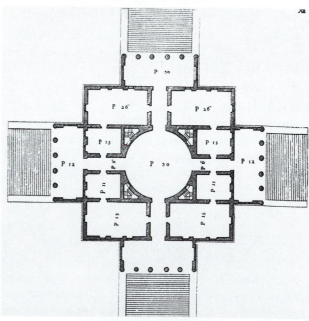

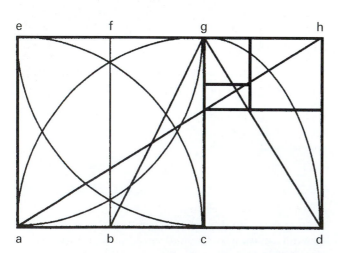

I-6. Golden Section: aceg = square; bf = 1/2 square; bg = bd and determines smaller Golden Mean; adhe = Golden Mean (see Chapter 5, Greece, Fig. 5-2).

I-7. Villa Rotunda (Almerico-Capra), 1565–1569; Vicenza, Italy; by Andrea Palladio and completed after his death (see Chapter 12, Italian Renaissance, Fig. 12-26, 12-27, 12-46).

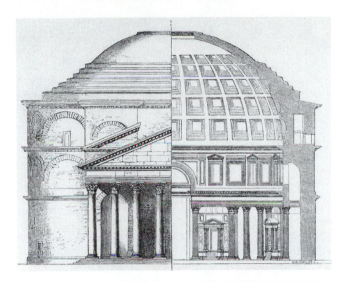

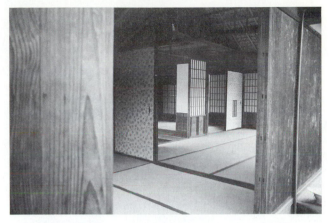

I-9. Rooms of Hearth and Spear, Katsura Detached Palace, early to mid–17th century; Kyoto, Japan; by Kobori Enshu (see Chapter 3, Japan, Fig. 3-24, 3-33, 3-34).

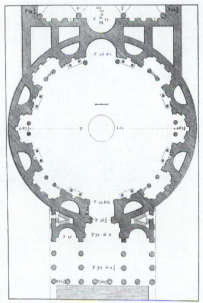

I-8. Pantheon, 118–125 C.E.; Rome, Italy (see Chapter 6, Rome, Fig. 6-18, 6-19, 6-27).

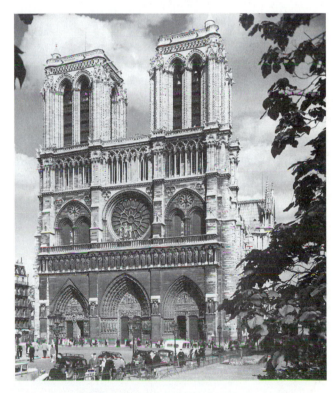

I-10. Cathedral of the Notre Dame, 1163–1250; Paris, France (see Chapter 11, Gothic, Fig. 11-12, 11-41).

Geometry describes three-dimensional forms in terms of standard geometric shapes to include a triangle, square, circle, rectangle, and pentagon integrated with lines. The Roman Pantheon (see Chapter 6, Fig. I-8), for instance, articulates the proportional relationships between an area (cylinder with a sphere) and its perimeter. Often, these shapes have symbolic meaning. The Japanese use the *Ken* (see Chapter 3, Fig. I-9), a mathematical system defined by the placement of rectangular *tatami* mats, to shape and order traditional buildings. Additionally, some contemporary office landscape systems develop from rectangular components grouped to achieve function and flexibility.

Scale refers to the size relationship of one thing to another, such as a building to its site or a piece of furniture to an interior, based on a comparison and human dimensions. As an example, Gothic cathedrals (see Chapter 11, Fig. I-10) are dominant structures within their surrounding sites, have monumental interiors, and display human-scale details. As another example, interiors in large English

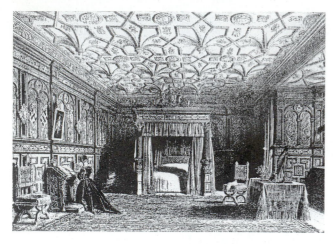

I-11. Bedchamber, Sizergh, 16th century; Westmoreland, England (see Chapter 15, English Renaissance, Fig. 15-44).

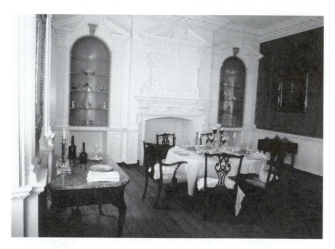

I-12. Dining room, Gunston Hall, 1755–1787; Fairfax County, Virginia; architectural detailing by William Buckland (see Chapter 25, American Georgian, Fig. 25-53).

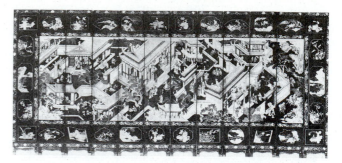

I-13. Coromandel screen, c. 1690; China (see Chapter 2, China, Fig. 2-45).

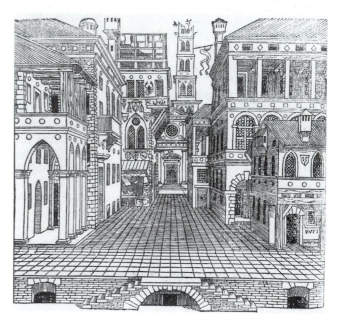

I-14. Stage setting, 1540–1551; by Sebastiano Serlio and published in *D'Architettura* (see Chapter 12, Italian Renaissance, Fig. 12-38).

Renaissance manor houses (Fig. I-11) may be contrasted in scale to those in smaller American Georgian houses (Fig. I-12).

Visual perception pertains to the way one views a space and the person's position within the space. The Chinese concept of perspective (Fig. I-13), rather than being linear as in the West, presents a flat layering of images (the foreground is at the bottom of a picture plane, with the background at the top, and with man small in comparison to the surroundings) to achieve depth. In direct contrast, the Western use of Renaissance perspective (Fig. I-14) relies on a three-dimensional convergence of angled lines to create depth with humans and objects proportionally placed within the framework, as is common in contemporary architectural and interior design presentation drawings.

USING THE BOOK

Within the book, the interrelationship of written narrative and graphic illustrations is considered a guiding principle. This material is totally integrated and equally weighted throughout the book, allowing the reader to make connections between the written and visual content. One can, therefore, read the text or view the images and grasp the basic concepts of the period. A historical vocabulary and design analysis language are interwoven throughout the text.

Basic art movement sections provide a comprehensive introduction to subsequent chapters addressing particular historical styles. These sections feature a time line of important events and inventions and the creation of major

works of art, music, and literature. Maps illustrate special areas discussed in the text. Chapters develop from a consistent footprint composed of headings and subheadings, providing an organized format for the presentation and sequencing of design content. This arrangement supports reviewing the content chronologically (in historical sequence) or topically (through particular topics such as design motifs, exterior facades, interior color and lighting, or particular types of seating). Chapter 1 provides an overview of cultural precedents (Fig. I-15) in many countries to establish a foundation for the subsequent development of the historical styles. Since the book is intended to be a general survey of these periods, supplementary references such as those in the bibliography provide more detailed historical explanations.

The written narrative is descriptive and concise, with a combination of paragraphs and bullet-point lists to aid in the easy retrieval of information. Paragraphs present general information, and bullet-point lists identify distinct design features. Important terms are defined in parentheses within the text and are included in the glossary. Foreign words not common in English usage are italicized and defined. Design characteristics, including specific motifs, are noted within each chapter. The Architecture and Interiors categories are sequenced as one would build a structure, from bottom (foundation or floor) to top (roof or ceiling). The Furnishings and Decorative Arts category provides an overview of the most important furniture, textiles, and decorative accessories. Sidebars provide lists of important buildings and interiors as well as information on important design practitioners to assist in additional study. The Design Spotlight category focuses on individual examples of architecture, interiors, and furniture to illustrate specific characteristics important to a particular period, with graphic illustrations included for reference and identification of characteristics, details, and motifs.

The text synthesizes information from many sources. Primary sources (those created during the period under study), such as treatises and books, are noted where possible so the reader can explore them individually for design ideas. Secondary sources (those describing the period under study) are numerous; the bibliography includes a large selection for further reading. References are grouped alphabetically by general information and by basic movement to facilitate easy use.

The graphic illustrations feature a wide diversity of images, some common to the period and some less known.

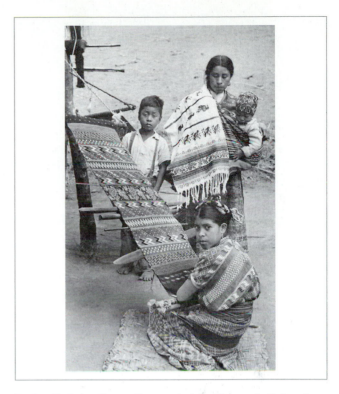

I-15. Backstrap loom; Guatemala (see Chapter 1, Cultural Precedents, Fig. 1-37).

They include new (from more recent sources) and old (from original sources or older publications) images in black and white and color; line drawings; and material from trade catalogs, magazines, books, and journals. Images were selected to convey the best representation of the place or item as it was built or used. Often this results in an illustration from drawings or photographs that may be more contemporary with the date of construction. Our preference has been to show the place or item as it looked when first developed rather than as a ruin. Costume images reinforce the important relationship of clothing and the near environment. Design diagramming (explanatory note; see diagramming examples) highlights major design features and characteristics of a particular style of architecture, interiors, or furniture, allowing the reader to make visual connections among areas of content. Color photographs provide resources for the study of appropriate colors and their application.

First true human beings appear — 2 million B.C.E.
Fire tamed in East Africa — 1.5 million B.C.E.
Boats used to settle Australia — 40,000 B.C.E.
Humans first entered North America — c. 35,000 B.C.E.
First cave art appears — 29,000 B.C.E.
Sewing needle appears — 23,000 B.C.E.
Horses tamed — 18,000 B.C.E.
Bow and arrow appears — 12,000 B.C.E.
Wolves transformed into dogs in
 Palestine — 11,000 B.C.E.
Cereal grains begin to be harvested
 in the Near East — 10,000 B.C.E.
Jericho established in today's Israel — c. 8000 B.C.E.
Peas and lentils domesticated in Iran,
 Syria, and Israel — 8000 B.C.E.
Beans and squash domesticated in South
 America — 7500 B.C.E.
Rice domesticated in China — c. 7000 B.C.E.
Sheep and goats domesticated in Syria — c. 7000 B.C.E.
Ice Age ends — 7000 B.C.E.
Cattle and pigs domesticated in Turkey — c. 6500 B.C.E.
Linen cloth used in Judae — 6500 B.C.E.
Cotton cultivated in Pakistan — 5000 B.C.E.
Copper mining begins in Serbia — 4500 B.C.E.
Flint mines appear in Europe — 4000 B.C.E.
Maize domesticated in Central Mexico — c. 4000 B.C.E.
Irrigation canals dug in Geokysur, Russia — 4000 B.C.E.
Cotton cultivated in Peru — 3500 B.C.E.
Wheel appears in Mesopotamia — 3000 B.C.E.
Plough used in Mideast — 3000 B.C.E.
Papyrus first made by Egyptians — 3000 B.C.E.
Minoan Civilization develops on Aegean
 Islands — c. 2500–1400 B.C.E.
Plumbing appears in Indus Valley — c. 2700 B.C.E.
Soap invented in Babylon — 2000 B.C.E.
Sumerian king Shulgi establishes first
 schools — c. 2000 B.C.E.
Babylonians discover sex of date palms — 2000 B.C.E.
Epic of Gilgamesh composed — c. 2000 B.C.E.
Sewers used in Mahenjo-Daro
 (Pakistan) — c. 2500 B.C.E.
Hammurabi reigns — 1792–1750 B.C.E.
Iron metallurgy develops (Age of Iron) — c. 1200 B.C.E.
Moses leads Hebrews from Egypt — c. 1400 B.C.E.
Old Testament (Tanakh) begins to be
 formalized — c. 1000 B.C.E.
Siddhartha Gautama, better known as
 Buddha, born — 563 B.C.E.
Establishment of caste system in India — c. 300 B.C.E.
Bhagavad Gita, (Hindu text)
 composed — c. 300 B.C.E.–300 C.E.
Classic Maya culture of Central America
 begins — c. 200 C.E.
First Anasazi culture in SW United States
 begins — c. 100 B.C.E.
Teotihuacan becomes dominant city in
 Valley of Mexico — c. 10 B.C.E.
**Division of B.C.E. (Before the Common Era)
 and C.E. (Common Era)**
Chocolate first drunk in Mexico — 100 C.E.
Polynesians settle islands of
 Oceania — c. 400–800 C.E.
Pueblo settlements in SW North
 America — c. 900 C.E.
Mississippi Mound culture develops — 1050–1200 C.E.
Aztecs arrive in central Valley of Mexico — c.1200 C.E.

Dedication Ceremony of a Navaho Hogan

The husband sings:

"May it be delightful, my house;
From my head, may it be delightful;
To my feet, may it be delightful;
Where I lay, may it be delightful;
All above me, may it be delightful;
All around me, may it be delightful."

Flinging a little sacred meal on the fire, he exclaims:

"May it be delightful, my fire," and as he throws a handful up through the smoke-hole he says: "May it be delightful, O sun, my mother's ancestor, for this gift; may it be delightful as I walk around my house."

The woman makes her offering of meal by throwing it upon the fire, saying in a low and gentle voice:

"May it be delightful, my fire;
May it be delightful for my children, may all be well;
May it be delightful with my food and theirs; may all be well;
May all my possessions be made to increase;
All my flocks, may they also increase."

The Craftsman, Vol. VIII, April–September 1905

1. Cultural Precedents

Some of them began to make roofs of leaves, others to dig out caves under the hills; some, imitating the nests and constructions of the swallows made places into which they might go, out of mud and twigs. Finding the other shelters and inventing new things by their power of thought, they built in time better dwellings . . . at the beginning they put up rough spars, interwove them with twigs and finished the walls with mud.

The History of Architecture, VITRUVIUS,
c. 30 B.C.E.

Architecture is a building form developed by people based primarily on functional and aesthetic conditions. Early cultures evolve various interpretations of architecture that serve as precursors or precedents for later developments throughout history. Examples reflect changes in behavior, social structure, environment, climate, materials, construction, technology, and spiritual influences. Materials define the overall character and image. Interiors generally imitate the architectural form with an emphasis on the functional context rather than the decorative display. Furnishings during these early periods are few or nonexistent.

HISTORICAL AND SOCIAL

Human life has existed on earth for approximately 3 million years, but records document only some 7,000 years. The record of the earliest people, those without a written language, exists through the efforts of geologists, anthropologists, and archeologists. They hypothesize how humans lived based on implements, cave drawings, and the remains of prehistoric campsites. Conjectures about early architecture and art develop from the study of this evidence and of present-day tribal groups in areas such as Peru, Africa, and New Guinea. Some people in these countries still live as those from the Stone Age.

Beginning as simple food gatherers, people travel in small bands and gather fruit, tubers, and wild grains. They learn to hunt small animals, birds, and reptiles. Tools are generally rudimentary and shelters are unknown, although they sometimes seek shelter in trees or caves.

About 50,000 years ago, hunters appear who follow wild migrating animal herds, an activity that dominates their life. Because of the herd's importance to survival, hunters

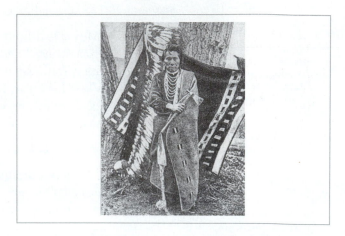

1-1. Native American Indian costume.

view animals as equal or superior to themselves. To assure a prosperous hunt, they ascribe a variety of human attributes to animals and animal attributes to humans, resulting in revered *anthropomorphic* figures with human traits. Cave paintings, such as those found in Lascaux (Fig. 1-2), document their beliefs. Some experts think that the paintings developed to help assure good hunting. Magic plays an important part in a hunter's life, with dwellings, clothes, animals, children, and tasks heavily guarded by magical symbols and actions.

About 8000 B.C.E., there is a shift from hunting for survival to organized food production, which is completed in Europe by about 2000 B.C.E. The earliest farmers in Europe use the slash and burn method of cultivation, which requires them to move frequently as old fields become exhausted. These primitive farming techniques, which hinder a land's ability to regenerate, still exist in areas of the world such as Africa, Brazil, and Indonesia.

Early villages originate along paths of migratory animals, and because of good land and reliable water sources, they thrive and expand. Sufficient food and the influx of goods allow the inhabitants to diversify, with some becoming traders and artisans. With the development of trade, villages also form along and at the crossroads of trading routes. Many of these pivotal villages expanded further to become great cities. Some large settlements extant today, such as Teotihuacan in Mexico or Stonehenge in England, develop as religious centers around deities and their temples. In these centers, a large population may only appear at special times of the year with the majority of the people spending much of their time away from the center in food

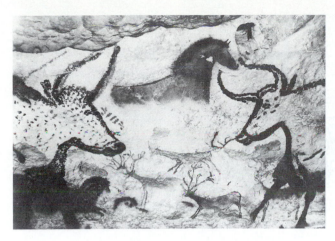

1-2. Hall of Bulls, Paleolithic cave painting, 15,000–10,000 B.C.E.; Lascaux, near Sarlat, France.

gathering or production activities. Other large cities, such as Harappa in the Indus Valley in India, begin as farming villages in fertile areas.

About 5,000 years ago, nomads of the Great Steppes of Europe and Asia begin to herd cattle between the two continents. While on the move, they create objects of wood, fiber, and metal; and leather for saddles, bridles, and tents; and weave coverings both for their own use and for trade (Fig. 1-8). Early tribes live at a subsistence level. While food production is still an overriding concern, as conditions improve and time becomes available, members of the tribe may diversify or specialize in other tasks. Men may be responsible for one set of tasks and women another. The assignment of roles varies by tribe. In some social groups, building a shelter may be a task for women, while in others it may be a task for men. Similar divisions of labor often include such tasks as weaving or ceramics.

CONCEPTS

Art in these early cultures is more than mere decoration. It expresses their belief system, social order, and science. Early concerns for survival, however, are more important than any aesthetic considerations. Although beauty may be thought of differently than in the West, it does exist as a concept, with words of expression, and it is often associated with moral concepts such as goodness. Illiterate people use symbols instead of writing. The repetition of symbols serves as a comfort to them and as a reminder to the gods of their need for protection.

Since tribal groups live in a world controlled by spirits, much of what governs daily activities has a spiritual connotation. The gods, whether they are aspects of nature or in animal or human form, are human conceptions. Consequently, they are thought to enjoy what human beings enjoy: food, drink, jewelry, pretty clothing, music, and

dancing. Animals, the earth, and foods each have spirits to be appeased. Gifts to the spirits often include decorations related to the hunt, housing, or food preparation.

DESIGN CHARACTERISTICS

Nature provides the backdrop and the inspiration for all design considerations in early cultures. The design image is one of simplicity, informality, irregularity, and comfort. Geographic and cultural differences are apparent in architecture, interiors, furnishings, and decorative arts. Built spaces are small and defined by human proportions and available building materials. The arrangement of living environments develops from function and only secondarily from aesthetics. Spiritual influences often impact the overall stylistic impression with individuality denoting differing customs and beliefs.

■ *Motifs.* Many motifs (Fig. 1-3, 1-5), seen as part of an object, reflect the forming process of the object. Geometric motifs often begin as weaves of varying materials or as

1-3. Fan made from palm leaf.

1-4. Temple of Quetzalcoatl, 300–700 C.E.; Teotihuacan, Mexico.

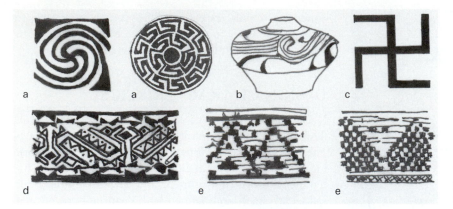

1-5. Design motifs: (a) spiral, (b) spiral/wave, (c) swastika, (d) animal, (e) basket.

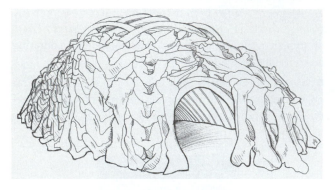

1-6. Mammoth tusk and bone home (reconstruction drawing), c. 16,000–10,000 B.C.E.; Ukraine, Russia.

color changes in basketry. The overall design usually incorporates a variety of symbols, most of which have universal meanings. They include the circle (sun, moon, energy, eternity, magic), spiral (rain, prosperity, fertility), *swastika* (change of seasons, life giving or destroying), animal forms (propitiate the spirit of those killed; Fig. 1-4, 1-5, Color Plate 2), human figures (outstanding ancestors or important tribal members), or body parts (hand prints).

ARCHITECTURE

Humans begin building with an emphasis on materials and construction methods, not on architectural form. Since a structure's appearance is imposed by the nature of the building materials, shelters are rudimentary and the physical form is less important than the relationship of the building to the home or tribal lands. Some living environments develop using permanent materials such as rocks or bricks, while others emphasize movable materials such as tree branches, grasses, and hides. The particular selection evolves from the building site, the physical environment, and functional needs. People, location, climate, culture, and economy usually define the environmental considerations. In some societies, housing and shelter are more important. In others, storing and protecting foodstuffs is more critical. The structural envelopes respond to and are

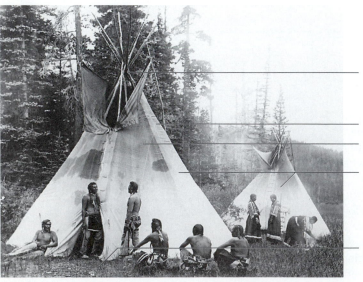

Tree branches for poles and structural support

Animal hides

One central room within

Close proximity for protection and socializing

Outdoor living space

1-7. Native American Plains Indian teepee; North America.

Design Spotlight

Architecture: *Native American Teepee.* The visual icon of the Native American Indians of North America is the teepee (Fig. 1-7). Constructed of branches and animal hides, it is simple and portable, responding to the often nomadic life of Indian tribes. Typically, teepees are grouped together in close proximity for protection and for socializing. The land surrounding each structure serves as an outside living environment and an extension of the multipurpose interior space. Conversation and dining may occur inside or outside, but these activities are often affected by the climatic conditions of hot summers or cold winters. There are usually no furnishings since the Indians commonly sit on the earthen floor. Storage containers are important and include baskets and pottery jars.

shaped by these behavioral factors. With the advent of farming, a more settled way of life, and the growth of cities, houses become less temporary.

Public and Private Buildings

■ *Types.* Building forms derive from construction methods and available materials (Fig. 1-6, 1-9). Early tribes use naturally formed shelters such as windbreaks (the growth or fall of trees or shrubs that break the force of wind), rock cairns (heaps of stones or earth and stones piled up as a memorial or landmark), and caves (underground chambers in rocks). Dugouts (dwellings partially underground or dug in the ground and roofed with sod) develop in a similar manner (Fig. 1-10). Igloos (an Eskimo or Inuit dome-shaped house made of snow blocks; Fig. 1-29) are common in the far northern hemisphere. In many parts of the world mud-clay or adobe bricks are common building materials. Large dwellings housing extended families or entire villages are common in some areas (Fig. 1-22) .

Roof overhangs are important to people who want to be close to the land. Windbreaks, huts made from natural grasses or branches (Fig. 1-9), and those grouped in a circle

Important Buildings and Interiors

■ **Central Mexico:** Teotihuacan, 100 B.C.E.–1525 C.E. (Color Plate 1)

■ **Cuzco, Peru:** Machu Picchu, 15th–16th centuries C.E.

■ **Indus Valley, Pakistan:** Mohenjo-Daro, 2700–1500 B.C.E..

■ **Mesa Verde National Park, Colorado:** Mesa Verde, 750 C.E.

■ **Sarlat, France:** Lascaux Caves, c. 15,000–10,000 B.C.E..

■ **Wiltshire, England:** Stonehenge, 2600–1400 B.C.E..

■ **Yucatan, Mexico:**
—Chichen Itza, 9th–13th century C.E.
—Uxmal, 250–900 C.E.

■ **Zimbabwe, Africa:** Great Zimbabwe, c.1000–1500 C.E.

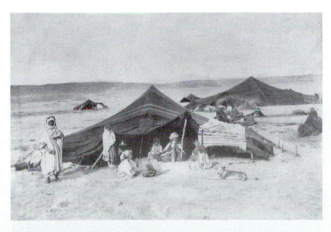

1-8. Camp of a Bedouin; Sahara Desert, North Africa.

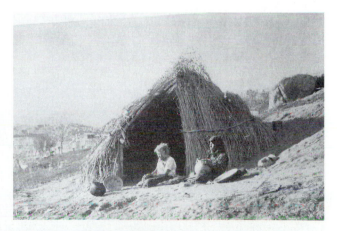

1-9. Native American Cahuilla *kish* (house); California.

are the most popular housing form, but are not suitable for all climates. In some societies, storing and protecting food-stuffs is more important than housing people.

■ *Relationships.* Buildings connect to the land through siting, construction, and materials (Fig. 1-9, 1-10, 1-11, 1-12, 1-21, 1-22). They may be grouped to face outward toward the land or inward toward a protected area or courtyard. The exterior environment becomes an extension of the structure and the interior space. Sun orientation is important since door openings provide the main source of illumination. Site orientation is often of greater importance, however, with entries most often facing the east or rising sun. This concept is evident in cultures all over the world.

■ *Floor Plans.* Early floor plans respond to the natural environment, which imposes considerations for floors, walls, roofs, and openings. Early examples are often round or irregular in shape based on building materials and construction methods. Many plans begin small with one central room and then gradually expand as needed (Fig. 1-21, 1-22). Often this expansion results in a community of

small structures with each area having a specific function: male and female quarters, food preparation areas, storage areas, or places for animals (Fig. 1-27). The rectangular plan first develops in forested countries with the width of

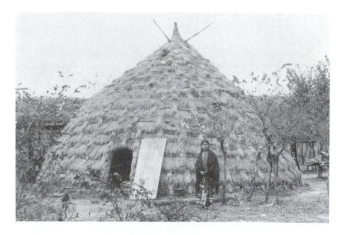

1-12. Native American hut; Neola, Oklahoma.

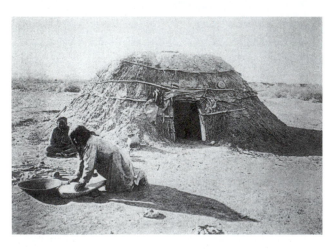

1-10. Native American *kan*; Southwest United States.

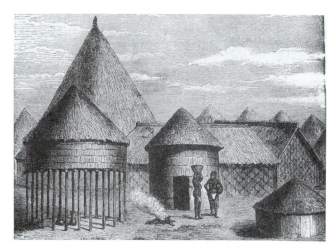

1-13. Bongo houses and granary; Africa.

1-11. Zulu hut showing framework; South Africa. (Courtesy of the American Museum of Natural History)

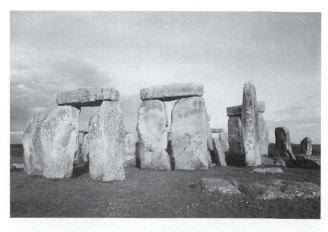

1-14. Stonehenge, c. 2600–1400 B.C.E.; Wiltshire, England.

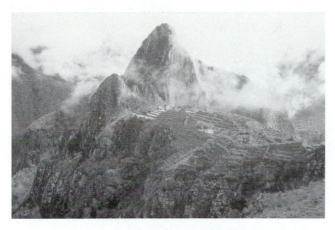

1-15. Machu Picchu, 15th–16th centuries; Peru.

1-17. Native American house; Yuma, Arizona.

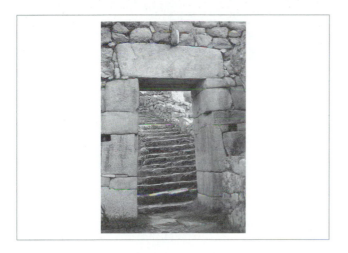

1-16. Doorway, Machu Picchu.

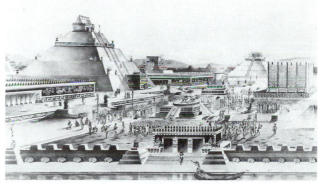

1-18. Temple at Teotihuacan (reconstruction drawing), 100 B.C.E.–1525 C.E.; Central Mexico. (Courtesy of the American Museum of Natural History) (Color Plate 1)

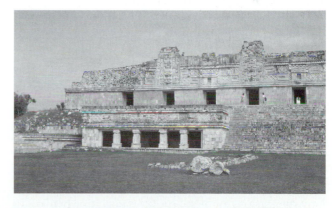

1-19. Nunnery, Uxmal, 250–900 C.E.; Yucatan, Mexico.

a rectangular plan being dependent on the availability of logs or branches that can span an open area (Fig. 1-17). This plan evolves in size and height to provide shelter for growing families, livestock, and defense. In some climates, spatial divisions provide for a separation of men and women, animals, storage, or cooking. In New Guinea, wood houses may be as long as 200 feet and as wide as 40 feet. In other locations, materials may change, but the rectangular plan remains. In the United States, adobe pueblo dwellings of the Southwest develop as multistoried units and take the form of early apartment houses (Fig. 1-22).

■ *Materials.* The most common building material is local vegetation including large leaves, palm fronds, and grasses. Nomadic people of the far north build homes of mammoth bones and tusks while others use snow blocks for igloos (Fig. 1-6, 1-29). Early tribes construct homes from the inside, often stacking stones or vegetation in a circular fashion around the builder. Sun-dried bricks appear extensively in countries with little timber. In time, the discovery of firing bricks in a kiln leads to a more permanent building solution. In Africa, daga plaster made of clay and sand completes the structure, as illustrated in the Great Enclosure at Great Zimbabwe (Fig. 1-23).

■ *Interweaving Construction.* Many early structures take advantage of the flexing nature of grasses and fronds and

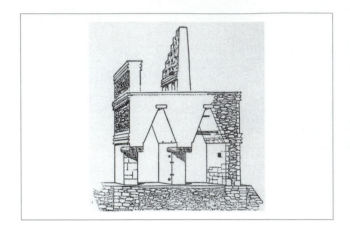

1-20. Section showing corbel arch construction; typical Mayan building; Mexico.

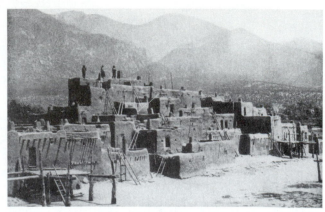

1-22. Native American pueblo houses, c. 1200 C.E.; Taos, New Mexico.

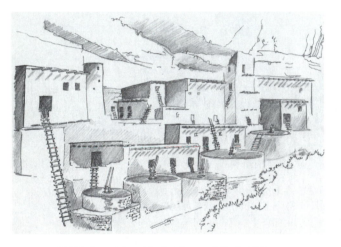

1-21. Cliff Palace, Mesa Verde National Park, 750 C.E.; Colorado.

1-23. Great Enclosure at Great Zimbabwe, c. 1000–1500 C.E.; Zimbabwe, Africa.

are circular (Fig. 1-10, 1-11). Vegetation lends itself to an interweaving of smaller vines, twigs, or strips for coverage. Often a combination of vegetable material for structure and animal hides for enclosure evolves. Nomadic tribes, such as the Plains Indians in the Americas, use animal hides over long branches for their teepees (Fig. 1-7). The long poles of the teepees also provide a traverse to help move possessions as the tribe follows migrating herds.

■ *Post and Beam Construction.* The most common form of building construction is post and beam. Two vertical members such as individual posts, columns, piers, or walls are joined at the top with beams (Fig. 1-14, 1-16). The posts may be groups of branches, logs, or walls of earth or stone. Beams are normally long branches or logs covered with smaller branches which in turn are covered with other foliage or earth. Masonry is less common due to the

limited tensile strength of the materials and the lack of tools for shaping stone. Rock formations (Fig. 1-14, 1-15) may also serve as posts or beams, such as the loglike basalt boulders of Stonehenge in England and of Machu Picchu in Peru.

■ *Vaulted Construction.* Vaulting appears in early structures, but common forms include corbel vaults (Fig. 1-20) and the keystone arch or vault. Corbel vaults develop as large masonry slabs that are piled on top of one another, gradually overlapping the ones below. The enclosed space is limited in size by the material available. The keystone arch or vault features small blocks at the base that gradually lean toward the center or keystone block. Scaffolding keeps the blocks from falling until the keystone is in place. Early scaffolding of wood limits heights. Later, in the Middle Ages, builders develop more flexible concepts allowing higher vaults.

■ *Color.* Natural construction materials provide color. Accents and decoration come from earth or plant materials, animal by-products, or carbon.

■ *Facades.* Exterior facades are simple, plain, and often unadorned except for the entryway. Openings from the exterior to the interior serve as doorways that may be open or closed (Fig. 1-17). In some instances, the entry to a dwelling has spiritual connotations and its compass orientation, location, or appearance may be carefully regulated (Fig. 1-18, 1-19, 1-23, 1-24). Generally, there are few window openings.

■ *Roofs.* Roofs (Fig. 1-13, 1-17, 1-18, 1-22, 1-23) may be flat, curved, slanted, or pitched at an angle. Variations depend on the building materials, construction methods, climate, and customs.

■ *Later Interpretations.* Forms and shapes of early buildings evolve over hundreds of years and gradually become more sophisticated in appearance, style, construction, and character. Later interpretations derive from the visual icons of a variety of cultures to become stage sets for 19th- and 20th-century environs such as parks, hotels (Fig. 1-25), museums, and restaurants. The most noteworthy renditions of these concepts are theme restaurants or recreational areas such as Disney theme parks.

INTERIORS

Interiors are simple and basic in early civilizations with almost all activities occurring in a common space. Each culture reflects peculiarities in room types and designations. Items of daily use often feature symbols with spiritual meaning to appease the spirits or invoke their protection and power.

Public and Private Buildings

■ *Types.* For the most part, buildings start with one multi-purpose room that is the center of social activity (Fig. 1-26, 1-27, 1-28, 1-29). Cooking, dining, conversation, sleeping, and storage all take place here. As functional needs expand, building forms become more sophisticated with separate areas designated for more important activities or attendant structures assigned for specific uses. Public areas are usually separated from private ones, and often there are individual areas for men and women. Domestic interiors are often thought of as female spaces while the public outdoor spaces are dominated by men. The organization of these spaces often reflect the social order, with separate spaces for males and females, married couples, or families. Typically, other spaces are for cooking, sleeping, storage, and entry. This simple pattern develops over time to become the basic footprint of a large house, castle, or governing center (Fig. 1-27).

■ *Lighting.* Most people plan their lives around the period between dawn and dusk. Fires for cooking and heat provide light; animal fat is also burned for light.

1-24. Kwakiutl village plank-built house (reconstruction model); Northwest Coast, North America.

1-25. Later Interpretation: Hotel Loretto, 1975; Santa Fe, New Mexico; by Harold Stewart.

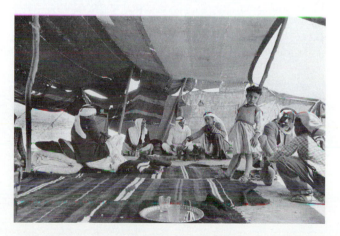

1-26. Interior of Middle Eastern Bedouin tent.

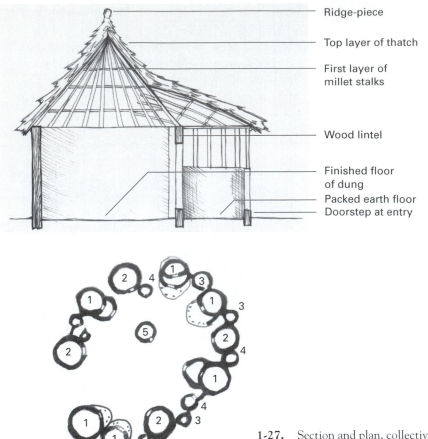

Ridge-piece

Top layer of thatch

First layer of
millet stalks

Wood lintel

Finished floor
of dung
Packed earth floor
Doorstep at entry

1-27. Section and plan, collective dwelling; Ivory Coast, Africa; 1. Women,
2. Men, 3. Granaries, 4. Livestock, 5. Cult objects.

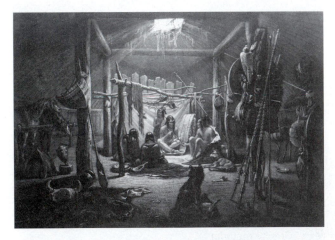

1-28. Native American Mandan earthlodge, 1833.

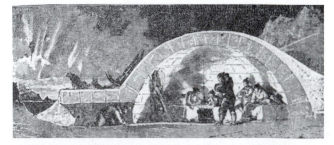

1-29. Eskimo or Inuit igloo (snow); Arctic region, Canada.

■ *Floors.* Floors are most often packed earth (Fig. 1-27, 1-28). In hot climates, raised floors of bamboo or timbers allow cool air to pass below the living space or raise the living space above the water line. Nomadic hunting tribes may cover their floors with hides or woven rugs (Fig. 1-26).

■ *Walls.* Wall are generally an expression of the construction materials (Fig. 1-30).

■ *Windows.* Windows appear infrequently; woven mats or hides cover openings.

■ *Doors.* Doors are openings left in the structure; woven mats or hides cover openings.

■ *Ceilings.* Ceilings reflect a direct expression of the structural system. The space below the roof structure often houses storage. Food items are often stored high to keep them from marauding animals.

■ *Later Interpretations.* "Primitive structures" provide design inspiration for theme parks, zoos, restaurants, and hotels.

1-30. Courtyard, Teotihuacan, 100 B.C.E.–1525 C.E.; Central Mexico.

FURNISHINGS AND DECORATIVE ARTS

Approximately 1.5 million years ago, early people in Africa make tools—symmetrical hand axes beautifully worked on both sides to produce sharp and regular cutting edges. Furnishings are simple but limited. Many utilitarian objects have a subtle and sophisticated sense of form and appear contemporary because of their simplicity. The emphasis is on portability, function, and the economical use of material. Belongings grow to include clothing, jewelry, pottery, metal tools, and woven fabric. Specialization in crafts becomes more common in communities.

Public and Private Buildings

■ *Types.* Almost all furniture forms are variations of two simple forms, the platform and the box (Fig. 1-31, 1-32). The platform evolves into a table, stool, chair, or bed. The box becomes a chest, cupboard, or wardrobe.

■ *Materials.* Common materials (Fig. 1-31, 1-32, 1-33, 1-34) for furniture include stone, mud, wood, grasses, bone or ivory, and to a lesser extent, metals. Animal hides and textiles play an important role. Wood is the most common material because of its availability and ease of working. The large variety of furniture forms did not develop until furniture pieces were fitted together out of parts instead of

Design Spotlight

Furniture: *Seating Platform, Machu Picchu.* Located on a high plateau, this stone seating platform (Fig. 1-31) reflects its natural environment and resembles a draped sofa. Developed during the Inca civilization, it represents the concept of comfort evident in ancient cultures. The platform is simple, unadorned, and massive.

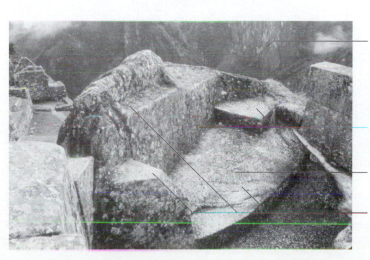

Located on high plateau with view of mountains and clouds provides spiritual experience

Strong relationship of natural and built environment

Granite material cut to human scale

Multi-level seating and resting areas

1-31. Seating platform, Machu Picchu, 15th–16th centuries C.E.; Cuzco, Peru.

being carved from larger trunks. Early furniture pieces develop from small branches tied together with vines or leather thongs. Wood joinery is evident in Mesopotamia, Egypt, and China by 3000 B.C.E.. Paint, carving, and ornament decorate furniture pieces.

■ *Seating.* People sit in different ways, not because of anatomical differences, but because of different cultural habits. In Native American cultures, people sit on the floor with their knees bent and feet on the floor (Fig. 1-28). In Peru, stone blocks at Machu Picchu form a platform or chair for seating (Fig. 1-31). In some middle Eastern and Asian cultures, people sit quite comfortably with their legs in a horizontal or kneeling position under them. Their lower eye level, which is about 30″ inches when seated, affects the design of their tables and stools. These objects have feet instead of legs. In the West, the normal eye level for someone seated is between 42″ and 48″.

The recognition of the tribal position of political or spiritual leaders can occur in several ways. Typically the chief sits above the rest of the tribe, if only on a higher rock or a seating platform. In many parts of the world, this

ultimately becomes a stool (Fig. 1-33, 1-34); often the stool includes totemic figures. By sitting on a raised platform the chief is symbolically supported in his decisions by the spirits of the tribe's ancestors. In the absence of the chieftain, the stool itself may be the focus of veneration and may be covered with woven mats or hides. In certain African tribes, the chief may wear an amulet in the form of a stool to signify his importance. In Northwest America, a small

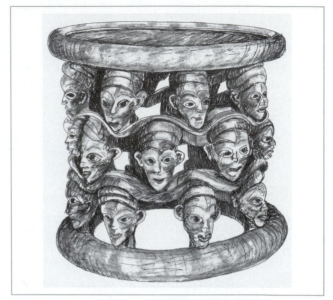

1-34. Stool, c.1900 C.E.; Africa.

1-32. Mayan diviner seated on a platform and gazing into a mirror, 600–900 C.E.; Mexico.

1-35. Headrest, 19th–20th century; Africa.

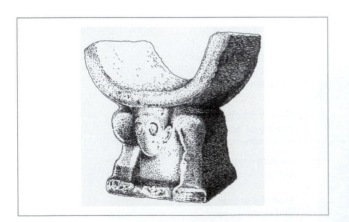

1-33. Pre-Columbian ceremonial stool (stone).

1-36. Bark cloths; Mubuti, Congo, Africa.

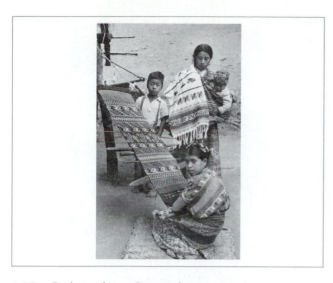

1-37. Backstrap loom; Guatemala.

1-38. Tapestry, Inca style, 11th–14th century; Peru.

1-39. Kuba cloths; Zaire, Africa.

screen of patterned wood frames the chieftain from behind to define his role. When most tribal members have stools to sit on, the chief's stool gains a back. When most chairs have backs, the chief's chair develops into a throne with a higher back.

■ *Storage*. Branches and crevices in early dwellings offer places to store objects. Because much living is at a subsistence level, the need for storage containers is small. The first containers are made from the hides, skins, or intestines

1-40. Kente cloth, Akan Culture; Ghana, Africa.

1-41. Gourd bowl, spoon, and woven covers, Niger or Nigeria, Africa.

of animals or fish hunted for food or from gourds (Fig. 1-41). Nets help catch fish and possibly contribute to the development of basketry for containers (Fig. 1-42).

■ *Beds*. Sleeping or sitting on mats of woven materials or animal hides serve in most instances for comfort. Raised shelves of earth, rocks, or timber are often built into dwellings. Sometimes the tribal chief uses this raised area to help define his status. It may also serve as protection from climatic conditions. In hot or humid climates, head or neck rests allow cooler air to circulate around the sleeper's head and to protect elaborate hairstyles (Fig. 1-35).

■ *Textiles*. Plaited natural grasses create mats (Fig. 1-36) and enclose housing. This concept adapts to textiles when small backstrap looms (Fig. 1-37) that weave narrow strips first appear. The smaller woven pieces of cloth are stitched

1-42. Native American Indian basket; North America.

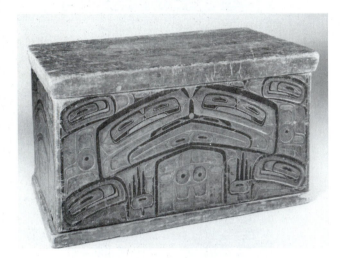

1-43. Storage box, Heiltsuk, c. 1850; Northwest coast, North America.

1-44. Ceremonial box, Ifugao, 20th century; Philippines.

1-45. Native American Jimez pottery; North America.

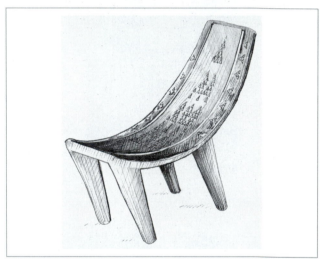

1-46. Later Interpretation: Chair, c.1923; France; by Pierre Legrain; Art Deco.

together to form larger pieces (Fig. 1-38, 1-40). Other textile techniques include appliqué, embroidery, cut-pile raffia, and leather embossing (Fig. 1-37, 1-39, Color Plate 2).

■ *Decorative Arts.* Storage containers (Fig. 1-43, 1-44) are the best expression of the decorative arts. These might be made of hides or gourds or carved from wood (Fig. 1-41, 1-43, 1-44). Many experts feel that woven baskets preceded the development of clay vessels (Fig. 1-45). Clay is used to line baskets to help contain liquids. Many early pots reflect decorative patterns created by the interweaving or plaiting found in basketry (Fig. 1-42).

■ *Later Interpretations.* An interest in the simplicity and natural materials of early civilizations develops in France beginning in the 1920s (Fig. 1-46) and in many parts of the world beginning in the 1960s with the concern for the environment. Many objects created by native craftspeople appear as decorative accessories or art objects in today's design market and in both domestic and commercial environments. The development of the stool with its higher back as used by chieftains can today be seen in thrones or the high-backed chairs of judges, politicians, and executives.

B. Oriental

China and Japan, the two major Oriental or Near Eastern cultures, both have long histories. Each culture develops separately, yet they periodically share concepts, with China most often influencing Japan. Their arts and architecture grow out of their religious philosophies—primarily Taoism, Confucianism, and Buddhism in China and Buddhism and Shinto in Japan. In both countries, the arts reflect a greater awareness and integration with nature than in the West. Orientation, hierarchy, placement, and structural emphasis are important. Man is generally seen in relation to nature, and buildings are carefully sited within garden settings. In China, *yin* and *yang*, the laws of the five elements, and *feng shui* guide planning and placement on both the inside and the outside of structures. In Japan, concepts of aesthetic beauty, simplicity, and *shibui* define the relationship of the exterior and interior spaces.

Both countries share common attributes related to the importance of the total environment. Harmony, unity, and careful proportional relationships articulate overall design concepts. Contrasts arising from religion and philosophy—asymmetry and symmetry, empty space and finiteness, dark and light—are significant. Respect for materials and structural honesty are constant themes. Chinese buildings emphasize strong axial relationships and hierarchy based on status. Interiors illustrate structural, applied, and painted decoration. Furnishings are symmetrical with elegant proportions and simple contours. Forms emphasize natural woods. Japanese buildings feature modularity in facade and plan, movable partitions supporting spatial flexibility, and natural materials. Rooms have few furnishings to allow for versatility in function. Shared motifs include lions, the phoenix, the lotus, bamboo, and geometric forms such as the diaper and fret.

The art, architecture, and designs of China and Japan have long influenced the West beginning as far back as classical Rome, diminishing in the Middle Ages, and increasing throughout the 17th, 18th, and 19th centuries. The terms *Chinoiserie* and *Japonisme* develop in Europe to describe the Oriental influences evident through trade activity. In the late 20th century, cultural and artistic exchanges between the East and West continue.

2. CHINA

Emphasis on the 12th–18th Centuries

The reality of the building consisted not in the four walls and the roof, but in the space within.

—Lao Tzu

China is one of the world's oldest civilizations. Forms and motifs develop early and repeat often due to the culture's respect for age and tradition. From early times, Taoism, Confucianism, and Buddhism form Chinese thought and subsequently affect its art and architecture. Separately and together, these three philosophies reflect a cultural vision that is very different from that of the West. Characteristics such as careful orientation, order, symmetry or asymmetry, and hierarchy evolve from the cultural vision. While significant in themselves, Chinese art, architecture, and culture nevertheless influence various European historical periods beginning with ancient Rome. Trade activity between Asia and Europe, and later with America, during the 17th to 19th centuries provides new and different influences affecting European and American art, architecture, interiors, furnishings, and decoration. During the late 20th century, travel, exhibits, movies, and books focused on Asia highlight the increasing interest in Chinese art, architecture, design, and health, while a booming Chinese economy supports a growing international design exchange.

HISTORICAL AND SOCIAL

Chinese history develops through the rise and fall of dynasties. Throughout much of the long history, emperors and their various dynasties govern an agrarian, feudal society. Trade and contacts with Europe begin during the Han dynasty (206 B.C.E.–220 C.E.). Caravan routes, established around the 1st century C.E., support trade along the "silk road," the only land route out of China. During this time, Oriental silks and lacquers arrive in Rome. Taoism and Confucianism, two seemingly opposing philosophies, develop during the period. Taoism concerns itself with the individual and his or her relationship to nature, while Confucianism focuses on ethics and groups of people. It promotes the idea that one can attain peace through correct relationships and respect for order and authority. Religions impact both philosophies.

China's first golden age occurs at the inception of the Tang dynasty (618–907 C.E.). Times are stable, and there is

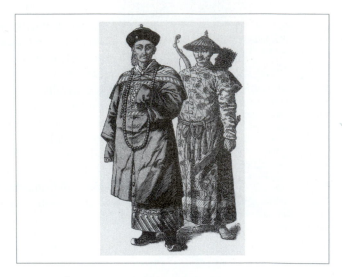

2-1. Male costume.

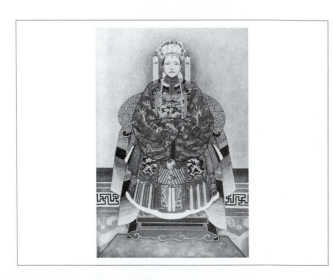

2-2. Empress Tze-hsi on her throne.

economic and cultural prosperity. Emperors establish diplomatic relationships with the eastern Roman Empire, Japan, and Korea. However, civil wars end this prosperity. Buddhism, which entered China in the 5th century B.C.E., becomes the national religion during this dynasty. Providing consolation in life and salvation at death, Buddhism promises enlightenment through right thinking, speaking, and acting. The period of the Five Dynasties (907–1368 C.E.) ushers in a second golden age when China reestablishes trade with Europe. Venetians Marco Polo, his father,

16

and uncle travel extensively in Asia and China in the late 1260s and 1270s. *The Travels of Marco Polo*, Marco Polo's account of his travels, gives Europeans their first glimpses of China. Trade routes across Central Asia bring such Chinese innovations as gunpowder, paper, printing methods, and the compass into Europe from the 14th century onward.

During the Ming dynasty (1368–1644) in the early 17th century, the British East India Company organizes trade routes, through the port of Canton, between China, India, and England. In the late 17th century, the Dutch East India Company establishes import and export routes through Indonesia and Japan with stops in China. Soon, Chinese silks, spices, and porcelains begin flooding Europe. After the introduction of tea in England in 1657, England becomes the only tea-drinking country in contrast to others that prefer coffee.

During the Qing dynasty (1644–1911) in the 19th century, China and Britain clash in the Opium Wars resulting in the loss of Hong Kong to Britain and an influx of Western influences. Later, China seeks to rid the country of foreigners during the Boxer Rebellion. Also during this time, the United States and Canada import Chinese "coolies" to work on the westward expansion of the railroads, bringing a new cultural influence to North America.

Dynastic rule ends in China with the emergence of the new Republic of China (1911–1949), a period characterized by the dominance of warlords. The Cultural Revolution of 1949 brings stability, communism, and authoritative control to the country along with significant upheaval and isolation. During the late 20th century, China opens up contact with the Western world, engendering economic prosperity, design changes, new buildings, and cultural reforms. The country also exports traditional ideas about health, wellness, and living spaces that directly affect the design of interior environments in the West. Feng shui becomes recognized and practiced by Western advocates.

CONCEPTS

Unity, harmony, and balance govern Chinese art and architecture. Forms develop early and are maintained throughout China's long history. Religious influences from Confucianism, Buddhism, Taoism, and Christianity cultivate the inner character and affect rituals, symbols, and spatial ordering. The duality of *yin* (negative, feminine, dark) and *yang* (positive, masculine, and light) guide universal life. The laws of the five elements of wood, fire, earth, metal, and water govern relationships in the natural environment. *Feng shui* (wind and water), a system of orientation, uses the earth's natural forces to balance the yin and yang to achieve harmony. It affects all design components of architecture, interiors, and furnishings including relationships, spacing, color, form, and patterns. Subjects realistically depict Chinese nature, historical images, people, landscapes, and animals. Figures are always seen in relationship to nature and therefore are less significant, which is unlike the prevailing European view.

DESIGN CHARACTERISTICS

Artistic designs and landscapes emphasize Taoist qualities such as asymmetrical compositions, empty space, infinity, parts of elements representing the whole, and nature. This contrasts sharply with the Confucian order of symmetry, balance, finiteness, and regularity seen in architecture and interiors. Architecture emphasizes modules with definite and fixed proportional relationships. Chinese conservatism and control is evident in the repetition of forms and hierarchy in building plans. Symmetry is very important, but uneven numbering systems based on religion and nature often define roof layers, details, and spacing. Interiors reflect strong axial relationships and hierarchy based on age and status. Furnishings emphasize symmetry, elegant proportions, simple outlines, and excellent wood quality.

■ *Motifs.* The Chinese employ numerous motifs, many symbolic, used alone or in combinations. Common motifs (Fig. 2-3, 2-4, 2-6) for architecture, interiors, furnishings, and decorative arts are lions (Fig. 2-7), dragons (Fig. 2-5), the phoenix, fret, the lotus (purity), clouds (Fig. 2-5), fruits (Fig. 2-3), chrysanthemums, the *shou* (long life), and calligraphy. Others include the bat (happiness—five bats represent the Five Blessings—longevity, wealth, serenity, virtue, and an easy death), the pine or evergreen, the stork, and the tortoise (longevity). The eight Immortals are a Tao symbol. The flaming wheel, the endless knot (*ch'ang*), and state umbrella (*san*) are Buddhist emblems. Animal motifs

2-3. Chinese ornament.

2-4. Chrysanthemum motifs.

2-5. Dragon and cloud motifs.

2-6. Architectural details.

include Lions of Buddha, the tiger, the dragon, and the phoenix. Naturalistic motifs are the lotus, peonies, chrysanthemums, and bamboo. Also evident are the meander motif and diaper patterns.

ARCHITECTURE

The Chinese value the site, the pattern of the building, and tradition over the building itself. Architecture, as a framework for the country's social system, is governed by ordering systems such as axiality and hierarchy. Silhouettes are distinctive, but few stylistic changes appear over time. Traditional palace complexes, as centers of government, continually reflect historical design features that inspire through their monumental scale and beauty. Construction, detailing, decoration, and color articulate a design language of beauty based on the principles of feng shui. Forms and elements grow out of construction methods and are governed by traditions that develop in the Zhou dynasty (c. 1000 B.C.E.). Later characteristics (not emphasized here) gradually come from 19th- and 20th-century international influences including Victorian, Classical Revival, and Bauhaus.

Timber-frame construction is composed of foundation, columns, and roof. A complex bracketing system creates non-load-bearing walls and adds decoration. Consequently, Chinese architecture is known for decoration that is integrated into the structure. Bright colors often highlight the various elements. Color, form, and orientation may be symbolic. Social position and function determine the size, plan, and amount of embellishment.

Public Buildings

■ *Types*. Characteristic buildings include *pagodas* (a Buddhist temple in the form of a tower; Fig. 2-8), shrines (Fig. 2-9), temples (Fig. 2-10, 2-12), monasteries, mausoleums, commercial structures, and imperial palaces, both urban and country.

■ *Site Orientation*. Sites and orientation are important. They are carefully chosen and planned practically and spir-

2-7. Lion, Forbidden City, 19th century; Beijing.

2-8. Wild Goose Pagoda, 10th–13th centuries; Xi'an.

2-9. Tower of Long-Hua; Shanghai.

2-10. Temple of Heaven, primarily Ming and Qing dynasties; Beijing.

itually. Structures orient to the south (superiority), toward the sun, and away from the cold (evil) north from which barbarians may come. Main buildings are sited on a north–south axis with lesser structures on an east–west axis. The most important structure is the greatest distance from the entrance. Buildings stand in isolation from one another but bridges, courtyards, gates, and other structures create a series of views and connections.

■ *Gateways.* Chinese architecture is noteworthy for its variety of gateways (Fig. 2-12, 2-13, 2-14). Varying in size, they serve as important focal points of entry and emphasize procession along a linear axis. The effect of procession may be enhanced by covered walkways. Elaborate gate designs include geometric shapes that may be round, scalloped, rectangular, or angled. In palaces, small gate pavilions surmounted by guardhouses punctuate exterior entry walls, with bright colors accenting the opening.

2-11. Dragon Conquering Temple; Chengdu.

2-12. Gateway, Huating Temple, 17th century; Kunming.

2-13. Walkway, Summer Palace, 18th–19th centuries; Beijing.

2-14. Gateway, Forbidden City, 19th century; Beijing.

■ *Floor Plans*. Plans are modular, consisting of rooms and courtyards, which can be added or subtracted at will. Function and respect for tradition govern the placement of individual rooms. Important public rooms such as the reception room are large, centrally located, and placed on a processional axis. In palaces, the axis develops through

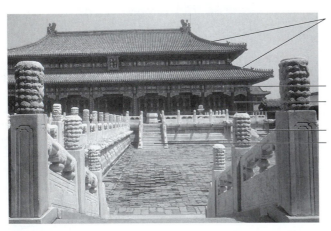

Double tiered tile roof with animal motifs on corners for protection

Decorative frieze
Red columned facade
Stepped terrace
Walkway for Emperor

2-15. Forbidden City, begun in 1406; Beijing. (Color Plate 3)

Design Spotlight

Architecture: The *Forbidden City* (Color Plate 3) is a walled complex of public and government buildings in Beijing. Centrally located and restricted to court use, the city houses the royal residences of the emperor. The most important building in this compound is the Hall of Supreme Harmony, which is the throne room and a place for ceremonies. As befits its significance, the space is centrally located and raised on a stepped terrace. Procession to the hall begins on a south axis with entry through a series of gate pavilions that lead to open courtyards. A visual layering of pierced walls and smaller buildings accents the processional path of arrival. The hall features a rectangular plan, box shape, red columned facade with eleven bays, and double-tiered tile roof.

doors placed on a north–south orientation allowing an emperor (royalty) to walk from the main entry door through a vestibule to a large throne hall. Entry doors are located on the long side and not on the gabled end.

■ *Materials*. Buildings stand on foundations of earth with terraces of marble, brick, or stone (Fig. 2-10, 2-15). Wooden or stone columns rise from stone bases. Columns may be round, square, octagonal, or animal shaped. Above, a bracketing system supports the roof, which is tiled and often curves upward (Fig. 2-9, 2-11, 2-16, 2-17). The wood-framed construction method is resistant to earthquakes and easily standardized. Few early structures survive as they were of impermanent materials. The almost constant warfare and upheaval also destroy many.

■ *Facades*. Facade design varies from plain to elaborately embellished (Fig. 2-10, 2-11, 2-18, 2-20). Because entries are important, they usually feature decoration and color.

■ *Windows*. Windows are typically rectangular with wooden shutters or grilles.

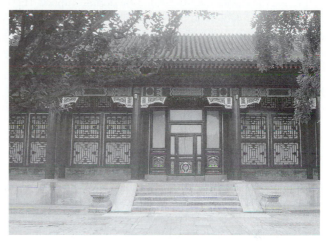

2-18. Entry facade, Summer Palace, 1750–1903; Beijing.

2-16. Chinese Lantern Temple; Singapore.

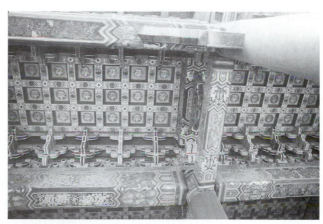

2-19. Ceiling detail, Forbidden City; Beijing.

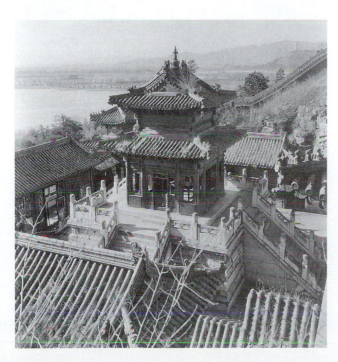

2-17. Overview, Summer Palace, 1750–1903; Beijing.

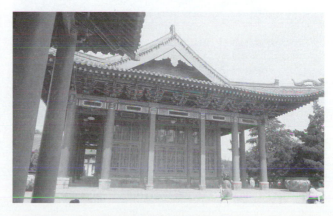

2-20. Huaqing Hot Springs Palace; Xi'an.

■ *Doors*. Doors are rectangular, made of paneled wood, and often embellished with carving, painting, and gilding. Some doors have latticework (large-scaled geometric pattern; Fig. 2-21) or fretwork (small-scaled geometric pattern).

■ *Roofs*. Upward-curving roofs are a distinguishing feature designed to deter evil spirits (Fig. 2-9, 2-10, 2-11, 2-17, 2-20). Roofs may be single or double hipped (Fig. 2-15, 2-17) or gabled on important buildings; occasionally they are flat. Shed (pent) roofs are common on taller structures. Ceramic roof tiles in rust, yellow, green, or blue are secured to rafters by fasteners with decorative animal motifs (*chi shou*). On temples and important public buildings, these motifs symbolize authority, protection from evil spirits, and the blessing of the gods.

■ *Later Interpretations*. Chinese influences in architecture are evident in styles developing during the 18th and 19th centuries. Designers in Regency England do not attempt to design and site buildings in the Chinese manner, but adopt some Chinese motifs such as latticework, fretwork, and upward-curving roofs. Late 19th-century America exhibits a greater appreciation for Chinese architecture by directly copying architectural images for gateways and garden houses (Fig. 2-24, 2-25, 2-26). Art Deco movie theaters feature exotic and fantasy themes, as in the Grauman's (Mann's) Chinese Theater in Hollywood.

2-23. Tomb model of a House, 1st century C.E. (Eastern Han dynasty, 25–220 C.E.).

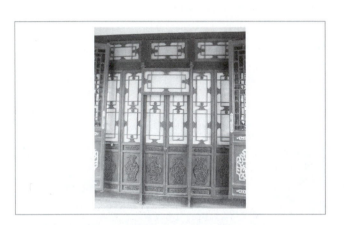

2-21. Latticework.

2-24. Later Interpretation: Chinese garden, 1990s; Montreal, Canada.

2-22. Facade, typical house; Dunhuang.

2-25. Later Interpretation: Tea house at Marble House, late 19th century; Newport, Rhode Island.

2-26. Later Interpretation: Chinatown Plaza, c. 1930; Los Angeles, California.

Private Buildings

■ *Types*. Building types primarily include residential dwellings.

■ *Site Orientation*. Homes are carefully oriented to the south, usually facing the street. Variety and tranquillity between and among natural and artificial elements distinguish the surrounding gardens.

■ *Floor Plans*. Houses are centered on one or more courtyards. The main hall or living room and women's quarters are farthest from the entrance. The hall consists of three spaces; the main reception room is in the center.

■ *Materials*. Like public buildings, homes are constructed of impermanent materials. Larger homes of finer materials proclaim wealth.

Important Buildings and Interiors

■ **Beijing:**
—Forbidden City with the Hall of Supreme Harmony, begun in 1406. (Color Plate 3)
—Summer Palace, 1750–1903.
—Temple of Heaven, primarily Ming and Qing dynasties.

■ **Kunming:** Huating Temple, Han dynasty.

■ **Shanghai:** Pagoda of Long-hua.

■ **Suzhou:**
—Bao'en Temple Pagoda, 1131–1162.
—Wangshi Gardens, Ming and Qing dynasties.

■ **Xi'an:**
—Wild Goose Pagoda, 10th–13th century.
—Huaqing Hot Springs Palace.

■ *Facades*. Facades are generally plain and unembellished (Fig. 2-22). Entrances are recessed and may have inscriptions to ensure happiness and protection. Excavations of pottery models of houses (Fig. 2-23) built during the Han dynasty reveal multilevels and a geometric ordering of architectural features.

■ *Roofs*. Roofs are similar in shape, material, and color to public buildings.

■ *Later Interpretations*. Residential buildings outside of Asia rarely copy Chinese architecture. Notable examples of the late 19th and early 20th century are private structures found in Hong Kong and the West Coast of the United States.

INTERIORS

Chinese interiors are as carefully planned and arranged as the buildings themselves. Symmetry is important. Some rooms are lavishly embellished. The few furnishings are of high quality.

Public and Private Buildings

■ *Relationships*. Some rooms feature large windows and doors that open to exterior courtyards and gardens. Formality and symmetry govern shapes, the arrangement of doors and windows, and furniture placement (Fig. 2-27, 2-28). Hierarchy is important for room and furniture placement (Fig. 2-29).

■ *Color*. Colors are strong and bright because pigments are seldom mixed. The palette includes red (for fire, symbolizing

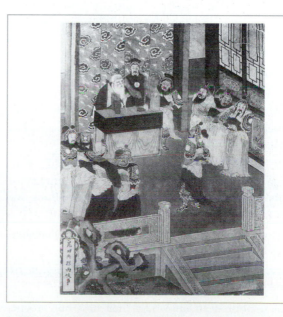

2-27. Painted panel of lantern.

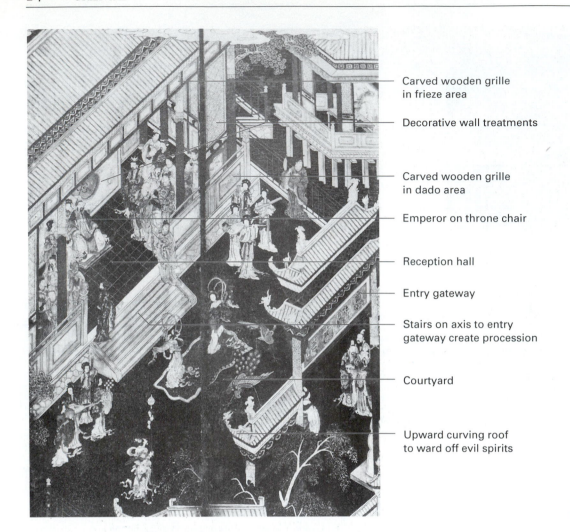

Carved wooden grille
in frieze area

Decorative wall treatments

Carved wooden grille
in dado area

Emperor on throne chair

Reception hall

Entry gateway

Stairs on axis to entry
gateway create procession

Courtyard

Upward curving roof
to ward off evil spirits

2-28. Detail from
a Coromandel screen.

happiness on doors or buildings), yellow (earth), gold, green (prosperity), and blue (heaven). Walls, columns, doors, and window frames may be red. Color and gilding may highlight details and motifs. Interior color comes from applied decorations such as painting and carving (Color Plate 4).

■ *Lighting.* Courtyard windows provide natural light. Lamps give minimal artificial light.

■ *Floors.* Floors may be of dirt, wood, or masonry. Marble floors highlight important rooms in imperial palaces. Felt rugs, mats, and pile rugs may cover floors.

■ *Walls.* Walls may be plain or partially embellished. Natural wood enriches surfaces, with architecturally integrated and elaborately carved wooden grilles often defining and accenting walls, particularly in the frieze area (Fig. 2-30).

■ *Windows.* Windows are rectangular with wooden shutters or grilles being most typical.

■ *Doors.* Doors to courtyards feature fretwork or grilles to integrate interior and exterior space.

■ *Textiles.* Chinese are known for their silks. Silk production dates back 4,000 years. Traditional motifs such as

clouds or the lotus are characteristic. All European silk comes from China until the 12th century, when the silk industry is established in Italy. Common fabrics (Fig. 2-44) exported to Europe include damasks, brocades, and embroideries.

■ *Rugs.* Rug weaving apparently came late to China. The earliest surviving examples date from the end of the 17th century. Chinese rugs (Fig. 2-44) differ in colors, density of patterning, and motifs from Middle Eastern rugs. Rugs may be of wool or silk and feature Persian knots with borders around an open field. Colors are bright and clear with much less dense patterns than Middle Eastern rugs. Motifs, which are symbolic, include flowers, buildings, and religious images.

■ *Ceilings.* Ceilings in important public spaces may feature repetitive geometric designs with traditional motifs. Large beams that are elaborately carved and painted often divide ceilings into sections.

■ *Later Interpretations.* In the 18th century, Rococo interiors in France incorporate *Chinoiserie*, motifs and forms in the Chinese manner. During the same time, Georgian

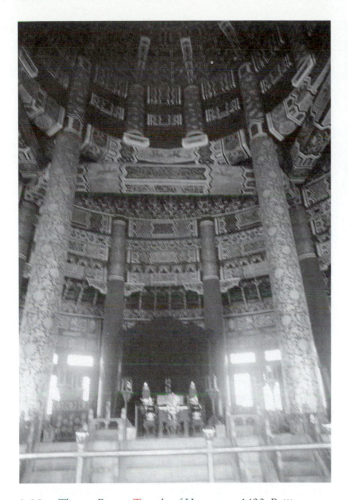

2-29. Throne Room, Temple of Heaven, c. 1420; Beijing.

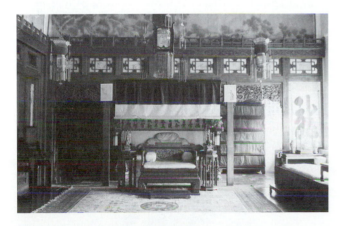

2-30. Reception Room, Forbidden City, 19th century; Beijing.

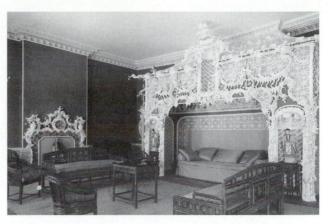

2-31. Later Interpretation: Chinese Room, Claydon House, mid-18th century; England; by Luke Lightfoot; Early Georgian.

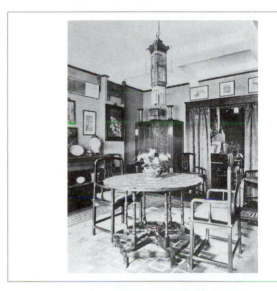

2-32. Later Interpretation: Dining room, late 19th century; New York City.

2-33. Later Interpretation: *Chinoiserie* wallpaper, c. 1770; China.

homes in England and America feature rooms with a Chinese emphasis. *Chinoiserie* reflects a romanticized view of China. Numerous wallpapers with *Chinoiserie* designs develop beginning in the 18th century and continue being produced (Fig. 2-33). Among England's most notable inte-

riors is the Chinese Room (Fig. 2-31) in Claydon House dating from the mid-18th century. Late-19th-century interiors (Fig. 2-32) may have Chinese furniture and other elements, but are not recreations of Chinese interiors.

FURNISHINGS AND DECORATIVE ARTS

Chinese furniture, like interiors, exhibits formality, regularity, symmetry, and straight lines. Furniture generally relies on simplicity, structural honesty, and refined propor-

tions for beauty instead of applied ornament. Imperial pieces are often massive and carved and/or embellished (Fig. 2-37). Designs follow templates that reflect boxy forms with limited diversity in visual image. The finest examples date from the 17th-century Ming period. Most furniture is of polished wood or bamboo, but lacquered sets are found in imperial palaces. As trade routes develop between China and Europe, numerous furnishings and decorative arts find their way into homes in England, France, and other countries.

Public and Private Buildings

- *Types.* Typical types include stools, chairs, couches, beds, chests, cabinets, and tables.

- *Distinctive Features.* Legs may be quadrangular with soft corners, circular, elliptical, or cabriole. The hoof foot with a slight inward curve is typical.

- *Relationships.* Furniture generally lines the walls (Fig. 2-27). It may be against or at right angles to the wall, but

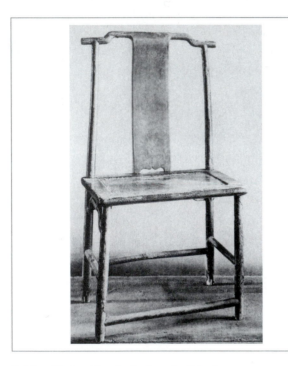

2-34. Chair with yoke back and solid splat.

Design Spotlight

Furnishings: Chairs are important symbols of authority and honor. Most chairs have a rectangular yoked back with splat, a round or horseshoe-shaped back (Fig. 2-36) that also forms the arms, or a fretwork back. Seats are rectangular wood or cane and are usually higher than those of European chairs. Stretchers connect the four legs. The front stretcher is high to raise the feet off cold, damp floors. Back splats may be pierced, carved, or painted or feature decorative panels of marble or porcelain.

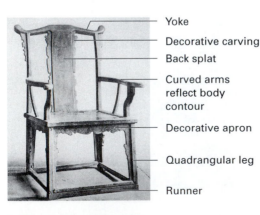

Yoke

Decorative carving

Back splat

Curved arms reflect body contour

Decorative apron

Quadrangular leg

Runner

2-35. Armchair with splat.

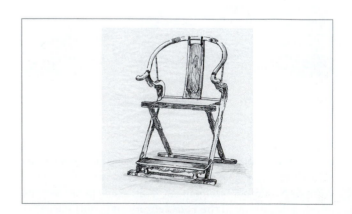

2-36. Folding chair.

is never angled. The place of honor is as far from the door as possible, facing south, and at the host's left. Armchairs are seats of honor.

■ *Materials.* Most furniture is constructed of solid local hardwoods such as *tzu-t'an* (red sandalwood), *hua-li* (rosewood), chestnut, elm, or oak. Some woods, such as ebony, are imported. Several types of wood may be combined in one piece. Furniture from the south incorporates bamboo. Some pieces feature gilding or inlay. Lacquer (an opaque finish made from the sap of a tree) protects against insects. Red lacquer colored with cinnabar is highly prized. Joinery is intricate with no nails or dowels and very little glue; mitered and mortise and tenon joints are typical. Pieces are shaped by hand instead of by turning. Most moldings are part of the furniture, not applied.

■ *Seating.* Stools have four legs or may be cylindrical drums. Couches, also used for sleeping, are large with low backs and arms. Backs may be solid or feature fretwork. Originally, Chinese homes featured a movable or built-in platform for sitting or reclining called a *k'ang* (Fig. 2-38, 2-39). The built-in version extends on one wall, is heated from below, and is covered with a mat. The *k'ang* has its

own furniture, which includes a low table and chests or cabinets to hold bedding and cushions.

■ *Tables.* Tall tables with stools support dining, writing, or form units with two chairs (Fig. 2-27, 2-40). Dining tables

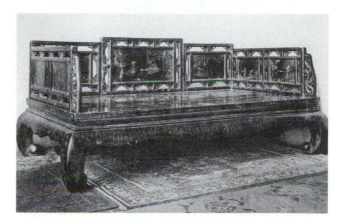

2-39 Couch.

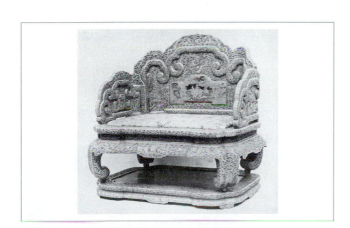

2-37. Throne.

2-40. Table.

2-38. *K'ang; Dunhuang.*

2-41. Cupboard.

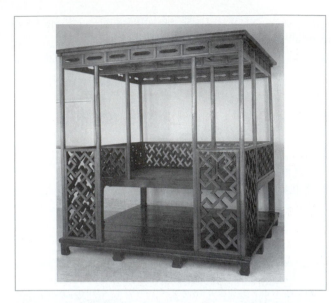

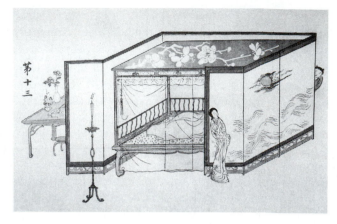

2-43. Canopy bed with screen, table, stool, and candlestand.

2-42. Canopy bed, 15th–16th centuries; Ming dynasty. [The Nelson-Atkins Museum of Art, Kansas City, Missouri. Huanghuali wood and painted soft wood. 91 × 86¼ × 84¼ inches (231.1 × 219.1 × 214.0 cm)]

generally are square or round. Rectangular side tables line walls and may be used for display, writing, and painting. Some have four legs, while others have trestle bases. Stretchers, single or double, may be near the apron, which is usually shaped and/or carved. Round incense stands with beautiful flowing lines are popular until the Qing dynasty when they evolve into tea tables.

■ *Storage*. Chests and cabinets (Fig. 2-41), small and large, store items in the Chinese house. Doors and surfaces

may be plain with beautiful wood grains or elaborately decorated. Large ones are often in pairs. Metal hardware, an important and integral part of the design, may be round, square, or bat shaped.

■ *Beds*. Similar to a *k'ang* and lower than a chair seat, the movable canopy bed (Fig. 2-42, 2-43) is rectangular, has low railings, features four or six posts, and is embellished with latticework, fretwork, and draperies. People sit or recline in beds during the day. The short legs often terminate in hoof feet. Footstools are usually placed in front of the bed.

■ *Decorative Arts*. Chinese interiors feature carved lacquerware, bronze and porcelain vases (Fig. 2-46, 2-47), and collections of jade. Many artifacts survive because trea-

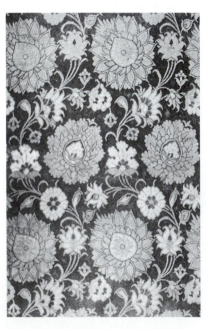

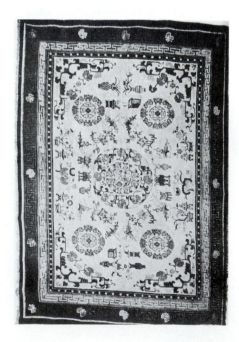

2-44. Chinese textile and rugs.

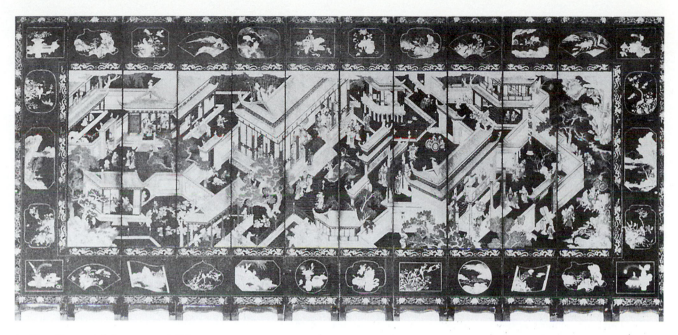

2-45. Coromandel screen, c. 1690.

sured items that were buried in tombs to help people in the afterlife have been excavated during the 20th century.

■ *Screens.* Interiors commonly feature screens, folding or set in a frame. They are lacquered or painted in bright colors with symbols of health and happiness. Coromandel, a polychrome lacquer with inlays of mother-of-pearl and other materials, is the best known (Fig. 2-28, 2-45).

■ *Porcelain.* Porcelain originates in China during the T'ang dynasty. A search for a pure white body produces true porcelain, which contains *kaolin* (china clay) and *pai-tun-tzu* (china stone). The subsequent Sung period produces many pieces of excellent design decorated with monochrome glazes, such as *celadon* (the color varies from delicate green to gray-blue). Ming period blue and white (Fig. 2-47, Color Plate 5) is the best known of Chinese porcelains, but the period also produces polychrome enameled porcelains, which Europeans classify according to color and distribution (*famille verte, famille jaune, famille rose*).

Porcelain Exportation. Chinese porcelains reach Europe in the 15th century, causing a sensation. Highly prized pieces are mounted in silver and gold and proudly displayed by the wealthy. In the late 17th and early 18th centuries, European desire for porcelain is at its height. Ming blue and white is the most avidly collected. Entire rooms are devoted to porcelain displays. Even after Europeans learn to make porcelain themselves in the early 18th century, they still desire Chinese wares. In addition to wares with Chinese shapes and decoration, the Chinese make pieces for the European market such as wig stands, sugar castors, and dining sets. Production becomes increasingly commercial. Standard patterns such as Fitzhugh, Canton, and Nanking appear by 1800. Designs of the 19th century, such as Mandarin and Rose Medallion, are crowded and fussy.

■ *Later Interpretations.* Imported lacquered furniture begins characterizing European rooms in the 17th century. *Japanning,* an English imitation of Chinese lacquer, is

2-46. Bronze vessels.

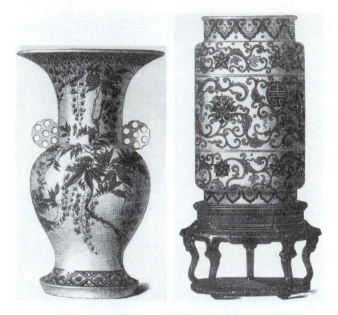

2-47. Porcelain ceramics with floral motifs.

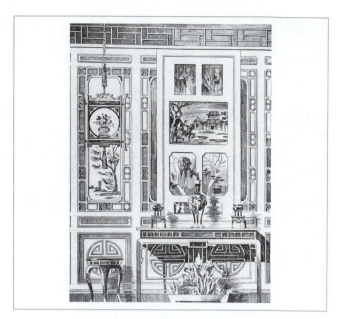

2-49. Later Interpretation: Wall and furniture, mid-18th century; England; after work by Sir William Chambers.

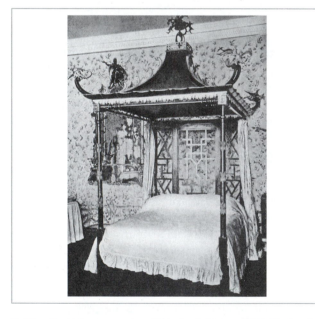

2-48. Later Interpretation: *Chinoiserie* bed, c. 1754; England; by John Linnell; Early Georgian.

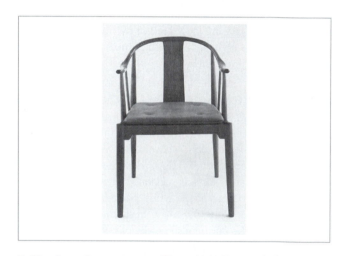

2-50. Later Interpretation: Chair, 1944; Denmark; by Hans Wegner.

fashionable for 17th- and 18th-century furniture. It also becomes a popular hobby among the wealthy. Queen Anne furniture (early 18th century) adopts the spoon back, yoke shape, solid splat, and cabriole legs of Chinese furniture. Chinese Chippendale (mid-18th century) employs such Chinese motifs as faux bamboo, pierced and solid fretwork, and pagoda shapes (Fig. 2-48, 2-49). Similarly, English Regency furniture features Chinese motifs in the early 19th century. French Rococo furniture often incorporates Chinese lacquered panels and *Chinoiserie* (motifs that are vaguely Chinese). The French develop their own lacquers that imitate Chinese decoration in lighter, brighter colors. In the 20th century, Chinese designs become popular during the Art Deco period, particularly for movie theaters and with Scandinavian designers, who found models of simplicity in Chinese furniture (Fig. 2-50).

3. JAPAN

A west room of the main southeast hall was made ready to receive her. New curtains were hung and new screens set out, as were forty cushions, more comfortable and less ostentatious, thought Genji, than ceremonial chairs. In spite of the informality, the details were magnificent. Wardrobes were laid out upon four cupboards inlaid with mother-of-pearl, and there was a fine though modest array of summer and winter robes, incense jars, medicine and comb boxes, inkstones, vanity sets, and other festive paraphernalia.

Lady Muraski, *The Tale of the Genji*, 1020

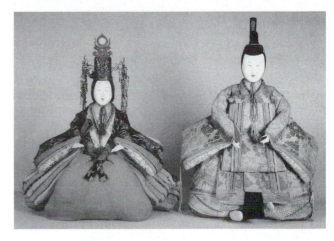

3-1. *Kyôho-bina*, Imperial couple (Japanese dolls), c. 1750; Kyoto.

Developing from Chinese influences and evolving largely in isolation, Japan is a 2,000-year-old civilization that epitomizes the concepts of aesthetic beauty, simplicity, modularity, and attention to detail. Relationships to nature are important. Various religions shape activities of daily life and establish rituals that define the overall character of design. Within the confines of a strict society governed by hierarchy and tradition and ruled by emperors and *shogun* warlords, the culture nourishes artists, designers, and scholars. Trade with Asian countries and later with the West provides numerous venues for the receipt and distribution of design influences. Like China, elements of Japanese architecture, interiors, furnishings, and decorative arts are widely imitated, most notably in Western countries after the establishment of trade routes in the 17th century. Interpretations continue through the 18th, 19th, and 20th centuries in Western paintings, furnishings, textiles, and decorative arts.

HISTORICAL AND SOCIAL

From prehistoric times, Japanese cultural and building traditions evolve largely independent of outside influences. However, in 552 C.E. with the introduction of Buddhism from China via Korea, a cultural transformation occurs. The Japanese take from China a centralized government, a form of writing, and Buddhism, which is the national religion by the end of the period. During the next century, Buddhism expands and peacefully coexists with the native Japanese religion, Shinto. During the 7th and 8th centuries, Chinese and Korean artists emigrate to Japan and bring with them Chinese concepts of art, city planning, and court protocol.

In the capital of Kyoto, throughout the 9th century, wealthy families surrounding the imperial court form a highly refined court culture in which good taste, manners, and carefully controlled emotions are supremely important. Art, architecture, poetry, and prose become more nationalistic as artists and writers choose and assimilate those Chinese influences that best suit their own culture. Feudalism develops around large estates of the *daimyo* (lord) who controls his domain with the help of his *samurai* (warriors).

Throughout the ensuing Kamakura period (1185–1392), *shoguns* (military dictators) from powerful families rule, maintaining political and military authority. Feudalism increases in strength, and individual ownership of land disappears. Restored contacts with China bring new architectural styles, tea, and Zen Buddhism. Zen rapidly grows in popularity and becomes the dominant Buddhist sect. Warriors find its emphasis on self-reliance, simplicity, and attaining enlightenment through everyday activities, such as archery or the tea ceremony, appealing. Eventually, Zen concepts affect all aspects of Japanese life including the arts.

In the Muromachi period (1392–1568), Chinese influence brings another cultural renaissance as court nobles again become great art patrons. Traders from Spain and Holland as well as Christian missionaries arrive. The merchant class increases in wealth, but they still cannot own land. In the mid-16th century, the Japanese begin exporting goods to the West, and a period of economic growth

ensues. The *cha-no-yu* (formal tea ceremony) becomes a social institution. Its equalizing rituals unite host and guest in the common pleasure of conversations about everyday things. The tea ceremony intends to develop repose, modesty, sincerity, and politeness. The specially designed tea house's characteristic simplicity, textural contrasts, and integration with nature soon affect the design of dwellings.

From 1568 to 1603, civil wars devastate the country in part because the court is more interested in art and Zen than in government. In 1603, peace comes, but at the cost of an increasingly repressive government and isolation from the world. Neo-Confucianism, which demands loyalty to the State, begins to replace Zen Buddhism as the state religion. The Edo period (1603–1868) is a golden era for the arts, and the middle class gains affluence. However, in 1635, the government fears that the influx of European traders and numerous Japanese converts to Christianity may precipitate an invasion. This leads to a prohibition of travel abroad, with many foreigners being expelled.

Throughout the 18th century, the powerful merchant class, continued peasant unrest, and an increasing awareness of the Western world contribute to the demise of feudalism in 1871. In the early 19th century, more and more traders and explorers visit Japan. In 1854, after a show of force, U.S. commodore Matthew Perry signs a treaty that permits trade between the United States and Japan, and Japan establishes trade relations and embassies in various European cities. New policies modeled after Western ones encourage industry and trade.

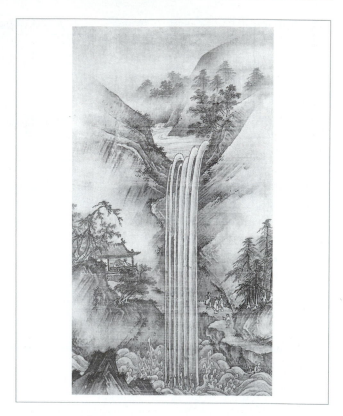

3-2. Waterfall; by Kano Motonobu.

CONCEPTS

Through periods of isolation and contact, the Japanese receive and assimilate those outside characteristics that suit their own cultural preferences. As in China, ideas of unity, harmony, and balance govern Japanese art and architecture. *Shibui*, the highest aesthetic level of traditional Japanese design, is articulated through simplicity, implicitness or inner meaning, humility, silence, and the use of natural materials. It affects all visual arrangements and daily activities. Because an individual's relationship to nature is important, the Japanese view the physical division between nature and the man-made differently than do people in the West. In Japan, for example, houses open directly onto a garden so the division of space is seamless and elements of nature appear throughout the interiors.

DESIGN CHARACTERISTICS

Economy of line, colors from nature, textural harmony with diversity, meticulous detailing, uncluttered space, and

3-3. Decorative patterns.

Fan Flower Flower

3-4. *Katagami* (textile stencil patterns) illustrating fan and flower motifs.

3-5. Botanical motifs: wood-block print and open fretwork *ramma*.

modularity are trademarks of the Japanese design expression. Art and architecture show respect for materials through natural finishes and exposed structure. Contrasts dominate examples: simple versus ornate, traditional in relation to new, logical as opposed to contradictory. Religion controls the expression and affects the ordering, balance, and regularity of expression. Architecture emphasizes fixed proportional relationships.

Unlike the Chinese, the Japanese place greater emphasis on asymmetry than on symmetry. The asymmetric balance between right and left creates a dynamic sense of beauty for most Japanese. This appreciation appears in the way a building rambles, as well as in roof layers, details, spacing, and overall image. Interiors are simple, ordered, elegant, refined, and well detailed. Space is not fixed, as in the West, but can change freely in size, shape, and configuration with sliding panels and screens.

■ *Motifs*. Naturalistic, geometric, and figurative motifs embellish surface designs. Those derived from nature (Fig. 3-2, 3-4, 3-5) include flowers such as the cherry blossom, the iris, the chrysanthemum, and wisteria along with bamboo leaves, birds, waves, and whirlpool designs. Geometric designs (Fig. 3-3, 3-6) feature stripes, grids, swirls, latticework, and frets. Figurative motifs (Fig. 3-1) derive from men and women in traditional costumes. The family crest, a highly stylized design appearing in art and on clothing,

3-6. Open work walls, Kara-mon Gate, Temple Complex; Nikko.

often develops within a circular form that may also evolve into a decorative repeat pattern.

■ *Later Interpretations*. In the late 19th century, the Arts and Crafts Movement and the Aesthetic Movement reflect the "Japonisme" expression with Japanese prints (Fig. 3-7, 3-8), motifs, details, and decorative arts.

3-7. Later Interpretation: *Caprice in Purple and Gold, The Golden Screen*, 1864; painting by James Abbott McNeill Whistler; Aesthetic Movement.

3-8. Later Interpretation: *The Peacock Skirt*, drawn to illustrate Oscar Wilde's *Salome*, c. 1894, England; drawing by Aubrey Beardsley.

ARCHITECTURE

Public and private buildings appear as works of art in beautiful environments. Like the Chinese models, architecture is governed by ordering systems such as axiality and hierarchy. Traditional building forms vary little over time, but evolve as unique and distinctive expressions of the country. Public complexes often express monumental scale to impress, but may be composed of many separate buildings that individually offer personal intimacy. Construction, detailing, decoration, and color reflect the various religions and the importance of nature.

Timber construction appears exclusively beginning in the 5th century C.E. Like the Chinese model, it is composed of foundation, timber columns, and most important, the roof. After the roof is completed, the physical division of spaces begins within the structure. Since there are few fixed walls, spaces divide with movable partitions, allowing the interior volumes and the relationship between interior and exterior to be modified easily. The openness of plan also accommodates the need for cross ventilation in the hot and humid Japanese summers. While the Chinese are known for decoration integrated into the structure, the Japanese are known for the beauty of their construction methods and joinery and their use of natural materials.

Because of the possibilities of earthquakes and fire, houses are constructed so they are easy to rebuild. Town houses, which often include areas for shops, are generally smaller than country houses because there is less land available in the city and more requirements for outbuildings in the country. During the 8th through 12th centuries C.E., the appearance of rambling country houses marks Japan's first major indigenous expression of architecture.

Public Buildings

■ *Types.* Public buildings include temples, shrines, *pagodas*, and shops.

■ *Shrines.* Shinto requires shrines (dwellings for gods) more than temples, unlike Buddhism. The shrine complex is located on sacred sites isolated by forests, mountains, and/or water. The *torii* (main entrance) gate (Fig. 3-12), formed by two columns topped by two horizontal beams,

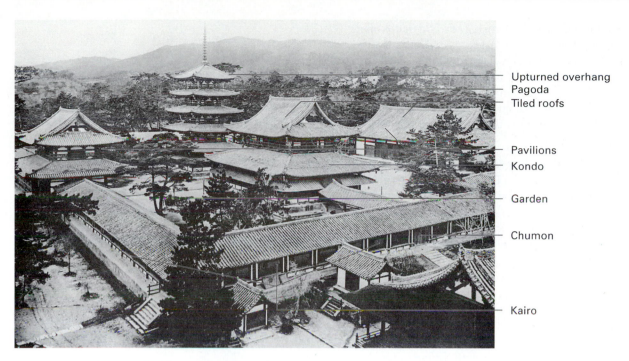

Upturned overhang
Pagoda
Tiled roofs

Pavilions
Kondo

Garden

Chumon

Kairo

3-9. Overview, Horyu-ji Buddhist monastery, Asuka period, 607 C.E., rebuilt in 670–693 C.E.; Nara.

Design Spotlight

Architecture: The monastery complex (Fig. 3-9, 3-10, 3-11) expresses the concept of axiality defined through a layering technique with entrance from a main south-facing gate that connects to the *chumon*, which connects to a *kairo* that surrounds the sacred area. On the center entry axis, the corridor leads to the *kondo*, which is sur-rounded by smaller pavilions and a *pagoda*. Wooden posts and beams define the structural framework. Tiled roofs are low, gabled, and double hipped with wide, upturned overhangs to protect walls from rain. The *pagoda* roof stacks in many layers.

3-10. *Kondo* (Golden Hall), Horyu-ji Buddhist Monastery, Asuka period, c. 693; Nara.

introduces the complex. Constructed of wood that is often left unpainted, shrines (Fig. 3-13) feature a floor raised by columns, thatched or wooden gable roofs, and one or two interior spaces. Human scale and simplicity are characteristic. Although traditional form is important, shrines eventually become more formal and often attach to Buddhist complexes. The prototype is the Ise Shrine, said to date from the 4th century C.E.

■ *Temples.* Following Chinese models, Buddhist temple complexes (Fig. 3-9, 3-10, 3-11, 3-15) use a layering technique with entrance from a main south-facing gate that leads to the *chumon* (middle gate), which connects to a *kairo* (roofed corridor) that surrounds the sacred area. Typically within the complex are a *pagoda* (monument), a *kondo* (image hall), a *kodo* (lecture hall), quarters for priests, and storage areas. Covered walkways connect the main building to smaller pavilions. Early examples organize axially and symmetrically, but with off-center gates as in China. Later temple complexes maintain axiality but position structures asymmetrically within the grounds. Japanese complexes integrate more fully with the landscape than Chinese models. Zen Buddhist temples generally are located near natural features such as mountains and ponds (Fig. 3-14).

■ *Floor Plans.* Early temple plans (Fig. 3-9) have a large central space flanked or surrounded by smaller spaces or aisles. Eventually, the need for space for worshippers dictates the addition of a space in front of the central space.

■ *Materials.* As there are numerous forests in Japan, wooden posts and beams define the structural framework (Fig. 3-10, 3-11, 3-15, 3-20). Cedar, pine, fir, and cypress are typical building woods. This variety produces a deep appreciation for the diversity in wood color, luster, texture, and fragrance. Non-load-bearing walls are of plaster, wood panels, or lightweight sliding partitions. Pillar bases, foundation platforms, and fortification walls are of stone, which is less readily available for construction. Stone buildings emphasizing defensibility are popular during the 16th and 17th centuries.

■ *Facades.* Exteriors (Fig. 3-10) are defined by structural modules that create dark wooden frames with light rectangular center spaces. Solids juxtapose with voids, light areas with dark ones, and large rectangles adjoin small ones, creating a quiet rhythm and harmony. Large columns, repetitively spaced, support verandahs (Fig. 3-16) that surround the building. In traditional architecture, the *shin-kabe* (plaster wall with exposed structure) is typical. On some buildings, the wall area under the eaves exhibits painted decoration in bright colors, such as red, blue, or yellow. Entries are important and usually feature some type of emphasis through placement, design, materials, or color.

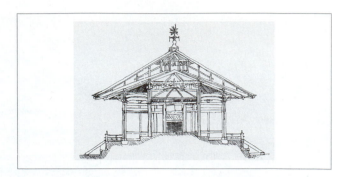

3-11. Cross section, Temple, Horyu-ji Buddhist monastery, Asuka period, 607 C.E., rebuilt in 670–693 C.E.; Nara.

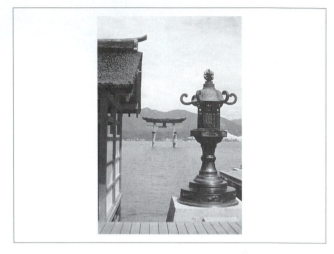

3-12. *Torii* gate and lantern, Itsukushima Shinto Shrine, 1241–1571; Miyajima.

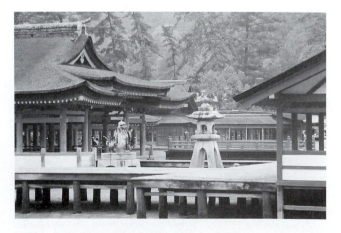

3-13. Itsukushima Shinto Shrine; Miyajima.

Important Buildings and Interiors

- **Himeji City:** Himeji Castle, c. 1601–1614.

- **Hiroshima area:** Itsukushima Shinto Shrine, 1241–1571, Miyajima.

- **Hyogo:** Furui farmhouse, c. 16th century.

- **Kamakura:** Shariden at Enkakuji, Namokucho period, c. 1333–1392.

- **Kyoto:**
 —Golden Pavilion of Yoshimitsu, Kinkaku-ji, 1394–1427.
 —Katsura Detached Palace, c. 1615–1663, by Kobori Enshu. (Color Plate 6)
 —Myokian Tea Ceremony Room, c. 1582, attributed to Sen-Rikyu.
 —Nijo Castle, 1603–1624.
 —Phoenix Hall, Byodo-in Temple in Uji, Heian period, c. 1053 C.E.
 —Shishin-den, Imperial Palace, 1855.
 —Sumiya Residence, Edo Period, 1657, Shoin Style.

- **Nara:**
 —Horyu-ji Buddhist Monastery, Asuka period, 607 C.E., rebuilt in 670–693 C.E.
 —Toshodai-ji Kondo, late Nara period, middle 8th century.
 —Yakushi-ji Pagoda, early 8th century.

- **Nikko:** Toshogu Shrine, 1636.

- **Osaka:** Yoshimura House, 16th century, reconstructed in 1620s.

- **Shiga Prefecture:** Ishiyamadera Temple, Kamakura period, 1194 C.E.

- **Shimane Prefecture:** Shinto Temple of Izumo, rebuilt in 1744.

- **Tokyo:** Shrine at Ise, early 1st century C.E., rebuilt in 1993.

3-14. Zen Buddhist temple garden, Ryan-ji, begun in 16th century; Kyoto.

ical with a *shibi* (stylized dolphin's tail) accenting each end of the roof ridge. The *pagoda* roof (Fig. 3-9) stacks in many layers with a *hosho* (finial) crown.

- *Later Interpretations.* Throughout the late 19th and 20th centuries, elements of Japanese influence (Fig. 3-26) in spatial organization, exterior design, human scale, standardization, respect for materials, and/or integration of outside and inside appear in the work of Arts and Crafts Movement designers Frank Lloyd Wright (Fig. 3-27), Le Corbusier, Mies van der Rohe, Clodagh, and numerous contemporary designers (Fig. 3-28).

Private Buildings

- *Types.* Typical domestic building types include noble residences, palaces (Fig. 3-19, 3-21) or castles, town houses, *besso* (country houses), and farmhouses (Color Plate 7).

- *Shinden Style.* Aristocratic residences during the Heian period reflect the Shinden style, which features a *shinden* (main dwelling) in the center with covered walkways extending to one-story rectangular pavilions to the east and west. The *shinden* typically faces a courtyard to the south in which entertainment and ceremonies take place. Kitchens and other utilitarian spaces are located at the rear of the buildings and connect to them by covered walkways. During the 12th century, the *shinden* complex becomes less symmetrical, and spatial differentiation comes from interior partitions instead of physical distance.

- *Tea Houses.* Simplicity, naturalism, careful planning, and integration into the landscape characterize tea houses (Fig. 3-20). It is in these small pavilions that the tea ceremony occurs. Visual surprises, such as spots of bright color,

- *Roofs.* Roofs (Fig. 3-9, 3-10, 3-15, 3-16) are low, gabled, and single or double hipped with wide, upturned overhangs to protect walls from rain. Typically, surfaces are either shingle or tiled. Zen Buddhist temples may have cypress-bark roofs. As in China, a complex bracket system supports the roof and provides ornament. Parts may be highlighted with color. In traditional architecture, *kokera-buki* construction (wood shingles in multiple layers) is typ-

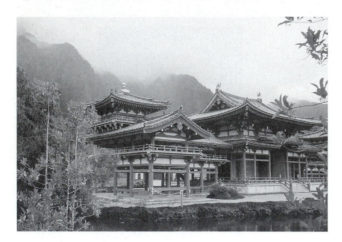

3-15. Byodo-in temple (replica, Oahu, Hawaii), Heian period, c. 1053; Kyoto.

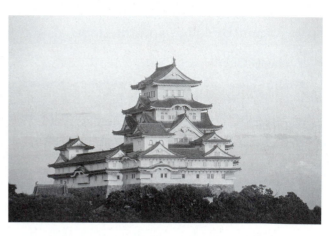

3-17. Himeji Castle, c. 1601–1614; Himeji City.

are common. Asymmetrical planning reflects nature, and harmony among setting, building, and utensils used in making tea govern design concepts.

■ *Site Orientation.* Typically, the dwelling complex sites within a landscaped garden on the edge of a pool. Gardens, which are intended for meditation and seclusion, combine natural and man-made elements and mix broad vistas with small views that surprise and delight. Unlike the Western custom, Japanese people view a garden from verandahs (porches) as well as walking through them. Small stones comprise the paths, requiring the viewer to continually look down and consciously stop to examine the trees, lakes,

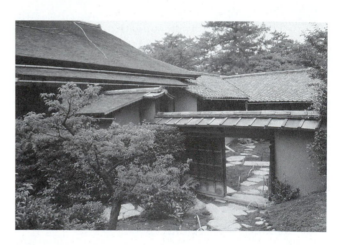

3-18. Entry gate, Katsura Detached Palace, c. 1615–1663; Kyoto; by Kobori Enshu.

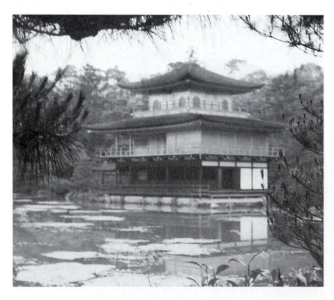

3-16. Golden Pavilion of Yoshimitsu, Kinkaku-ji, 1394–1427; Kyoto.

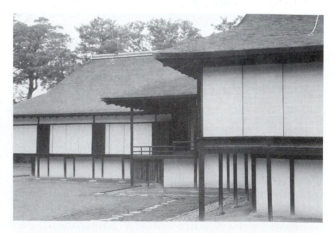

3-19. Facade detail, Katsura Detached Palace, c. 1615–1663; Kyoto. (Color Plate 6)

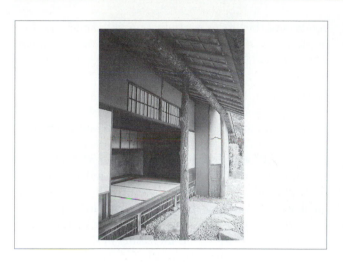

3-20. Shokin-Tei Pavilion (tea house), Katsura Detached Palace; Kyoto.

3-22. Entry gate, City House; Kyoto.

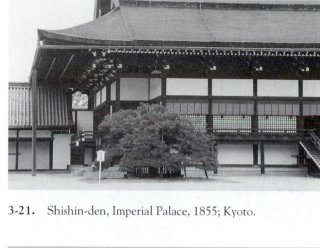

3-21. Shishin-den, Imperial Palace, 1855; Kyoto.

Design Spotlight

Architecture: *Katsura Detached Palace, Kyoto.* Sited within a landscaped garden, this rambling palace (Fig. 3-18, 3-19, 3-20, 3-33, Color Plate 6) features repetitive modules around the exterior perimeter illustrating the contrast of natural wood infilled with white plaster. Verandahs connect the outside garden area with the inside spaces. A modular plan based on the *Ken* using *tatami* mats controls the ordering of the building. Spaces are fluid, interlocking, and flow into one another in a casual, informal manner with no major room defined by a specific function. *Shoji* and *fusuma* screens partition the spaces and support fluid movement. Furnishings are limited primarily to *zabutons*, small tables, and *tansus*.

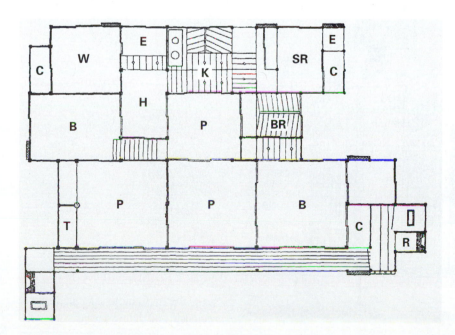

B — Bedroom
BR — Bathroom
C — Closet
E — Entry
H — Hall
K — Kitchen
P — Parlor
R — Restroom
SR — Servant's room
T — *Tokonoma*
W — Waiting room

3-23. Floor plan, house, c. 1880; Tokyo.

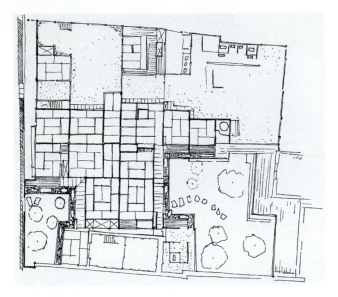

3-24. Floor plan, Yoshijima House, 1907; Takayama City, Japan.

bridges, plantings, and tea houses. Zen gardens feature rectangular forms, raked gravel grounds, and a few asymmetrically placed rocks representing natural features.

Town houses are often compact or narrow to take maximum advantage of limited space. Because of crowded conditions, they focus centrally on small gardens on one or more sides. The most private rooms face the garden. The room closest to the street usually has some business function.

■ *Floor Plans.* Beginning in the 12th century, house plans are usually modular based on the *Ken*, a system derived from the arrangement of structural pillars and *tatami* mats (Fig. 3-23, 3-24, 3-31, 3-32, 3-33, 3-38). The mats are modules 3'-0" wide by 6'-0" long and 2" or 3" thick with a woven rush cover and a rice straw core, and are bounded by black cloth. They are positioned parallel and perpendicular to one another in various configurations. Room dimensions derive from the arrangement of the *tatami* mats with important rooms increasing in size accordingly and rooms labeled as to the number of mats they contain. The mats rest on the structural framework of the building and are easily removed for recovering. Spaces are fluid, interlocking, and flow one into another in a casual, informal manner with no major room defined by a specific function.

Houses are generally one or two stories with the important rooms in the rear facing the garden. The *besso* develops from a series of connecting rectangles that ramble to create asymmetry and informality, therefore appearing less formal and austere than palaces. Most town houses are close to the street and have a formal entry that often

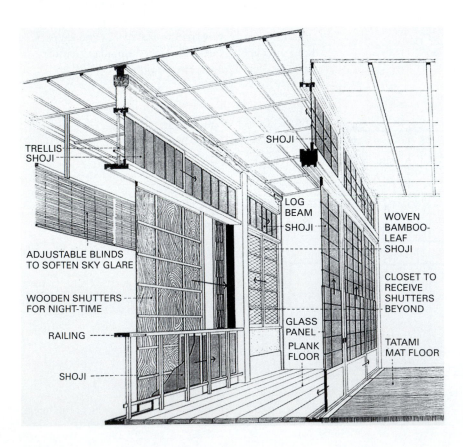

TRELLIS SHOJI

SHOJI

LOG BEAM SHOJI

WOVEN BAMBOO-LEAF SHOJI

ADJUSTABLE BLINDS TO SOFTEN SKY GLARE

CLOSET TO RECEIVE SHUTTERS BEYOND

WOODEN SHUTTERS FOR NIGHT-TIME

GLASS PANEL

RAILING

PLANK FLOOR

TATAMI MAT FLOOR

SHOJI

3-25. Wall detail showing shutters, verandah, and sliding screens.

3-26. *Later Interpretation: Japanese Ho-o-den Pavilions, World's Columbian Exposition, 1893; Chicago. Frank Lloyd Wright was influenced by his visit to this building.*

becomes an area for conducting business. Farmhouses are small rectangular structures emphasizing shelter with only a few rooms and one or more outbuildings.

■ *Materials.* Timber construction (Fig. 3-19, 3-21) dominates in producing the *besso* and the farmhouse. Castles may be composed of a large complex of wooden buildings,

usually covered with plaster, grouped around a keep or *tenshu* (main structure) or multistoried complexes of stone, such as the Himeji Castle (Fig. 3-17), with high, battered protection walls surrounding the castle complex.

■ *Facades.* Facades are generally plain and unembellished with repetitive modules (Fig. 3-19, 3-20, 3-21) around the exterior perimeter. Exterior surfaces are either of natural wood, painted black wood, or natural wood infilled with plaster modules. Entrances for city houses are through gates (Fig. 3-18, 3-22) located to the side or corner, while those for castles are typically larger, more important, and placed prominently on center axis. Large complexes and castles generally have walls surrounding the landscaped property to ensure privacy and protection. Castle facades have small slits and/or battlements from which to shoot.

■ *Windows and Doors. Shoji* screens (flexible sliding partitions; Fig. 3-25) serve as both windows and doors on many Japanese buildings. They shield the outer portions of a building during poor weather, establish a visual rhythm, help integrate inside and outside, and subdivide the interior spaces. Each lightweight panel is approximately 3'-0" wide by 6'-0" high and consists of a wooden lattice grid traditionally covered with rice paper. When open, the *shoji* frames a natural garden setting that serves as a landscaped mural. Solid sliding screens and wooden doors with

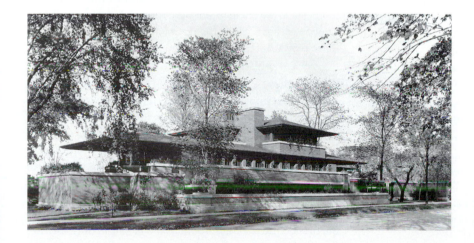

3-27. *Later Interpretation: Robie House, 1909–1910; Chicago, Illinois; by Frank Lloyd Wright; Prairie style.*

Design Practitioners

Typically, carpenters build and maintain shrines, temples, and castles or dwellings for powerful families. They may attach to a particular project or work freelance on any number of projects. The government maintains bureaus of master and common carpenters as a means of controlling and providing work. In the 12th century, carpenters and other artisans organize into guilds, but they continue to attach to temples and other sites or do freelance work. By the 15th century, individual contacts replace the guild or bureau as a means of acquiring work. Training is by apprenticeship.

3-28. Later Interpretation: Japan Exhibit, EXPO, 1967; Montreal, Canada.

latticework, carved decoration, or covered decorative painting are also common (Fig. 3-25).

■ *Doors.* Wooden doors are gates separating the public and private worlds. Most doors are sliding panels 6'-0" high. Exterior ones typically are *shoji*, as their paper coverings admit light. *Tatami* mats determine door widths.

■ *Roofs.* Residential dwellings typically have long, low gable or single- or double-hipped roofs with clay tiles or wooden shingles. Roof overhangs create verandahs that offer transitional spaces between the outside and inside. Farmhouses have steep gables and thatched roofs. Castles have roofs piled in layers with gables facing different directions. Corners of roofs typically turn upward with elaborate wood or stone brackets supporting the eaves.

■ *Later Interpretations.* Following the exhibitions of Japanese art and architecture in London and Philadelphia in the 1860s and 1870s, characteristics of Japanese design begin to appear in American and English dwellings. Space planning, modularity, and simplicity derived from Japanese examples characterize contemporary style and other dwellings beginning in the early 20th century (Fig. 3-27). During the 1950s, the modern ranch house often reflects Japanese concepts inside and out.

INTERIORS

Defined by exposed structure, Japanese interiors express beauty, harmony, flexibility, and serenity. A strong ordering system develops based on the positioning of *tatami* mats. Interior walls reflect exterior design features and structural divisions. A variety of screening devices subdivide interior spaces and support spatial flexibility by enlarging the size of a room or rooms in succession or by closing off one or more rooms. *Fusumas* (opaque sliding screen partitions between rooms and the exterior) and *shoji* are the most typical. Interior ceilings are low since people sit on the floor rather than on chairs. Backgrounds generally are neutral with decorative objects providing color and pattern contrasts.

Public and Private Buildings

■ *Types.* In temples, the *kondo* features a raised platform on which the image sits. Walls may have painted decorations or scrolls depicting landscapes and religious themes. Unlike in the West, domestic and some temple interiors are multipurpose and size, use, and shape change as needed.

In residences, the formal entry serves as a separating point between the outer (unclean) world and the (clean) privacy of the home. Here, the outside life is left behind as people remove their shoes, store them, and put on slippers. Living areas generally face to the south or southeast to take advantage of the light, but may rotate to a darker side during summer months. The main reception space in a noble dwelling may feature a raised area for emphasis and to support the noble's authority.

Bathing is important to the Japanese, not only as a matter of cleanliness, but because it also provides an opportunity to share the activities of the day with family and friends. This social activity requires an area for washing oneself outside the tub and features a fragrant cypress tub filled with water deep enough to cover the shoulders of someone seated. Since the *furo* (bath) is considered an area for relaxation, it is quite common to have a view from the bath into a garden.

■ *Shoin Style.* Developing in the 15th century from elements taken from Zen Buddhist religious dwellings and tea houses, this aristocratic style takes its name from the *shoin* (decorative alcove with window and desk). It also features a *tokonoma* (built-in alcove evolving from private altars; Fig. 3-37) that may hold a scroll or *ikebani* (container with formal flower arrangement; Fig. 3-48) and reflects items related to changing seasons and a *tana* (a series of shelves originally used for Buddhist scrolls). These elements frequently define the main room that the *shogun* or noble uses for official duties and receptions.

■ *Relationships.* Interiors (Fig. 3-29, 3-30, 3-31, 3-32) feature the same strong geometry, respect for materials, contrasts, and harmony as exteriors. Sliding partitions open spaces to the outside (Fig. 3-31, 3-34, 3-35), unlike in the West, creating little need for solid doors and/or windows. Exterior–interior relationships and harmony with the landscape serve to create a total environment.

■ *Materials.* Untreated natural materials are common including plaster, straw, linen, wool, paper, and natural wood.

3-29. Interior, Itsukushima Shinto Shrine, 1241–1571;
Miyajima.

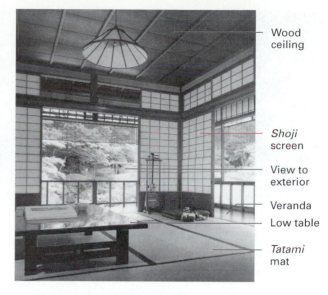

Wood
ceiling

Shoji
screen

View to
exterior

Veranda

Low table

Tatami
mat

3-32. Interior with *tatami* mats, table, *zabutons*, and *shoji*
screens; Kyoto.

3-30. Farmhouse kitchen with well in foreground, stove to
left, c. 1600; Kabutoyama.

■ *Color.* Colors reflect nature and appear in harmony with
the structure. The palette emphasizes white, brown, black,
straw, and gray. Other interior colors, which may be bright,
derive mainly from the display of decorative arts.

■ *Lighting.* Natural light filters softly through the translu-
cent paper of *shoji* adding to the feeling of serenity. Inside,
lamps (Fig. 3-32, 3-34) such as the *andon* (oil lamp), usu-
ally sit on stands and supply artificial light. Additional
metal candlesticks also provide light. Outside, lanterns are
an important aspect of most gardens. Those of stone are
popular as well as the *chochin* (paper outdoor lantern; Fig.
3-39), a portable spiral of thin bamboo covered by a layer
of rice paper that folds flat when not in use.

3-31. Interior with *tatami*, *tokonoma*, storage pieces, table for
ikebani, *fusuma*, and *shoji*.

3-33. Rooms of Hearth and Spear, Katsura Detached Palace,
early-mid 17th century; Kyoto; by Kobori Enshu.

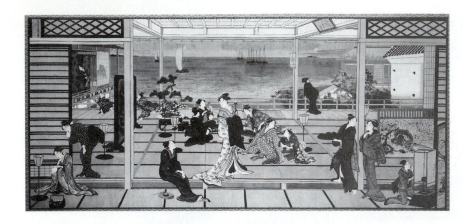

3-34. Interior, *Moonlight Revelry at the Dozo Sagami*, Edo period; painting by Utamaro. (Courtesy of the Freer Gallery of Art, Smithsonian Institution, Washington, D.C.)

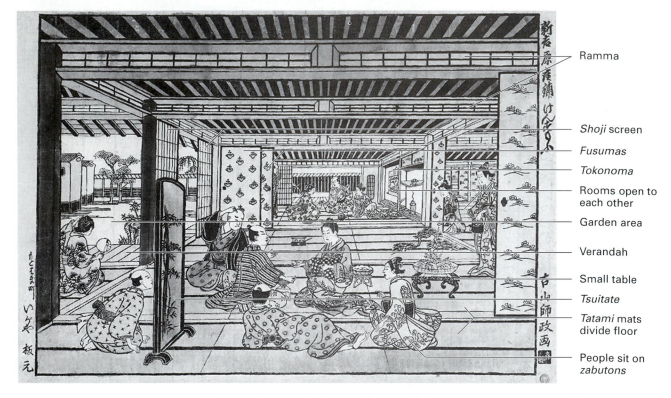

Ramma

Shoji screen

Fusumas

Tokonoma

Rooms open to each other

Garden area

Verandah

Small table

Tsuitate

Tatami mats divide floor

People sit on *zabutons*

3-35. Interior, *Moromasa, a House of Pleasure 18th century Yoshiwara.* The woodblock print was formerly in the collection of Frank Lloyd Wright. [Courtesy of The Metropolitan Museum of Art, Frederick C. Hewitt Fund, 1911. (JP655)]

3-36. Cross section, Yoshijima House; 1907; Takayama City, Japan.

3-37. Interior showing *tokonoma*, alcove, *tatami* mats, and *fusumas*.

3-38. Sleeping room showing *tatami* mats, bedroll, *shoji* screens, and storage.

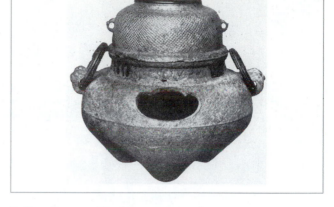

3-40. Cast iron *hibachi*.

Design Spotlight

Interiors: *Moromasa: A House of Pleasure in 18th Century Yoshiwara.* This wood-block print (Fig. 3-35) reflects the Shoin style of architecture. Also ordered by *tatami* mats, the interiors highlight the relationship of inside to outside, sitting at floor level, the limited use of furnishings, and an architectonic character. *Shoji, fusuma,* and *tsuitate* screens articulate and define the spaces. The transom area features a perforated *ramma* to support air flow and light filtration. Furnishings include small tables, *zabutons,* metal candlesticks, and decorative accessories.

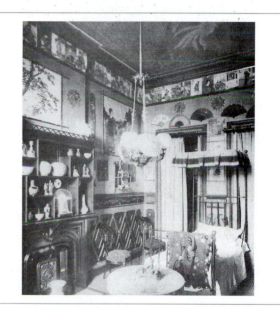

3-41. Later Interpretation: Dr. William A. Hammond's Japanese bedroom; New York City; published in *Artistic Houses,* 1883; Aesthetic Movement.

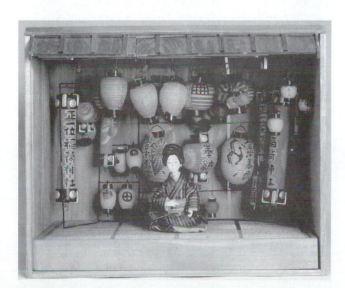

3-39. Lighting fixtures: Lanterns. (Courtesy of Peabody Essex Museum)

■ *Heating.* Heating comes from a portable *hibachi* (charcoal brazier; Fig. 3-40), which also serves as a cooking unit. Beautifully designed in bronze, iron, earthenware, porcelain, or wood lined with metal, it contains ashes and a few coals.

■ *Floors.* Raised floors are common in all areas except service spaces. *Tatami* mats (Fig. 3-31, 3-32, 3-33, 3-34, 3-35) on the floor define the room's dimensions. Wood planks cover floors in corridors (Fig. 3-25), verandahs, and lavatories. Earthen floors are typical in service areas as well as the entrance in farmhouses. Temples have wooden floors instead of earthen ones.

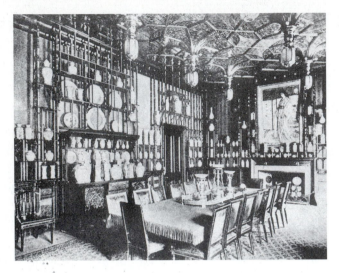

3-42. Later Interpretation: *Harmony in Blue and Gold: The Peacock Room*, dining room, Frederick Leyland House, 1876–1877, London, England; by Thomas Jeckyll and James Abbott McNeil Whistler; Aesthetic Movement.

3-43. Later Interpretation: Living room, Meyer May House, 1909; Grand Rapids, Michigan; by Frank Lloyd Wright; Prairie style.

■ *Walls*. Walls, which are composed of sliding solid partitions and paper-covered screens, may be plain or decorated. *Fusumas* partition the spaces and support fluid movement and interchangeability in function (Fig. 3-33, 3-35, 3-36). Folding screens may also temporarily divide space. Within formal or reception rooms in the Japanese house, the architectonic *tokonoma* (Fig. 3-37) or *tana* integrates with the wall composition and showcases changing arrangements of special items related to the various room functions. A transom area above the sliding panel features a *ramma* (decorative panel; Fig. 3-5, 3-34), often perforated or elaborately carved to support air flow and light filtration.

■ *Windows and Doors*. *Fusumas* and *shoji* become doors and/or windows. Other screening devices (Fig. 3-25) separating the outside from the inside include woven bamboo blinds, reed screens, wooden grilles, and *norens* (split curtains). These flat hanging cloth or hemp curtains can also act as shades blocking undesirable views.

■ *Textiles*. Woven and dyed textiles are historically important sources of color and pattern in interiors. They may cover screens, hang at doors, or embellish seating. Designs emphasize asymmetry. Japanese woven silk differs from Chinese in its geometric motifs, such as zigzags or diapers. One of the most popular dyed textiles, *katagami* (pattern paper; Fig. 3-4), derives from elaborately cut paper stencils. Appearing in Japanese wood-block prints, its deep blue color is a result of indigo dyes.

■ *Ceilings*. Traditional buildings exhibit ceilings (Fig. 3-35, 3-36) that may vary in height and are coved, coffered, latticed, and may possess elaborate truss and bracketing systems. Height variations articulate and define

spaces. In temples, a false lower ceiling for decoration hides irregularities in the spacing of rafters. In residences, low ceilings are common, primarily because of the custom of sitting on the floor.

■ *Later Interpretations*. In the late 19th and early 20th centuries, the Arts and Crafts Movement and the Aesthetic Movement reflect the "Japonisme" expression (Fig. 3-41, 3-42, 3-43). These interiors reflect simplicity, asymmetry, harmony, rectilinearity, revealed structure, and natural materials common to Japanese design. Throughout the 20th century, designers create interiors with simplicity, geometric forms, and sparse furnishings that are closer to authentic Japanese. In the 1950s, sculptor Isamu Noguchi experiments with traditional Japanese paper and bamboo lanterns and creates a new lantern series called *Akari* (the Japanese word for light).

FURNISHINGS AND DECORATIVE ARTS

Japanese interiors feature limited examples of freestanding furniture and selected decorative accessories. People sit on their knees on *zabutons* (square floor cushions), and often the focus of a group seating arrangement will be the *hibachi*. Furnishings are often built in. Decorative arts enrich the overall interior color effect through the use of brighter hues to include red, pink, gold, green, blue, brown, white, and black. Unlike Westerners, the Japanese do not display their entire collection at once, preferring to show one or two objects at a time.

3-44. Old print illustrating two tables used for calligraphy lessons.

3-47. Decorative arts store showing accessories including porcelain, c. 1895.

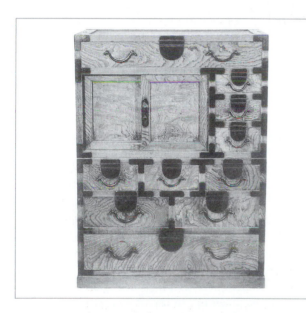

3-45. *Tansu* (in two parts).

3-48. *Ikebani* basket.

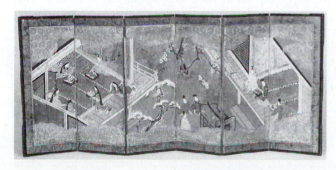

3-46. *Byôbu* (folding screen), c. 1800; Tokyo. (Color Plate 8)

3-49. Later Interpretation: Anglo-Japanese sideboard, c. 1867; ebonized wood and stamped paper; Edward M. Godwin; Aesthetic Movement.

3-50. Later Interpretation: Wallpaper with designs of New York State and Japanese ceramics, 1883–1885; United States. Aesthetic Movement.

- *Types*. Tables, chests, stands, and screens are typical.

- *Distinctive Features*. Lacquerwork is important in the country. It features a black or red (less often) background and floral motifs in gold and typically covers small objects, such as writing boxes and accessories associated with the tea ceremony.

- *Relationships*. Furniture orients for use and typically is parallel to walls. Folding screens add angles. In contrast to the simplicity, strong geometry, and often neutral colors of exteriors and interiors, furnishings may have brightly colored floral motifs and gilding.

- *Materials*. Oak and chestnut are popular woods for furniture.

- *Seating*. The Japanese sit at floor level on *zabutons* (Fig. 3-31, 3-32). There are few chairs or stools. Brightly colored textiles embellished with typical motifs often provide a soft and warm place to sit on floors. *Samurai* sit on folding stools that may be elaborately carved or painted.

3-51. Later Interpretation: Bed, 1990s; manufactured by Roche Bobois; France.

- *Tables*. The most important table (Fig. 3-31, 3-32, 3-34) is the one used for dining and the tea ceremony. It is square and of wood, very low to the floor, typically has straight carved legs, and often features a top with a series of small curves. Small lacquer-covered tables (Fig. 3-44) provide surfaces for writing, presentation, or the tea ceremony.

- *Storage*. Often works of art, chests or coffers in various sizes store possessions. The *tansu*, (a type of chest of drawers; Fig. 3-45) is often located behind a *fusuma* as in a closet. Generally, built-in or freestanding cupboards line walls for storage. In the kitchen, storage cabinets for dishes may take the form of a flight of stairs that provides access to storage spaces in the attic. A variety of small decorative boxes may store stationery supplies.

- *Beds*. People can sleep in almost any room where the soft *tatami* mats provide a resilient base (Fig. 3-38). Thick rolled *futons* (comforters) serve as bed and bed covering; they are stored when not in use. A kimono, for sleeping, serves instead of sheets. A small box with an attached cushion serves as a pillow and provides head support.

- *Screens*. The *byôbu* (decorative screen; Fig. 3-46), an important accessory in the interior, adds color and pattern, provides privacy, and protects from drafts. It may have two, three, or six folding panels approximately 5'-0" high with decorative designs on both sides. The *tsuitate* (single-panel screen; Fig. 3-34, 3-35) has two supporting legs. While not very large, it is important in screening views, partitioning space, or controlling drafts.

- *Porcelains and Ceramics*. Dutch traders first bring Japanese pottery and porcelains to Europe during the 17th century. Two types of porcelain (Fig. 3-47) are particularly popular with Westerners. *Kakiemon* porcelain has simple, asymmetrical designs in red, yellow, green, and blue, sometimes with gilding. Colors and patterns exploit the white porcelain body and adapt to the octagonal, hexagonal, and

square shapes. *Imari* porcelain features crowded, elaborate patterns in strong blue, red, and gold. Additionally, low-fired, glazed, and irregularly shaped earthenware tea bowls, often done as *raku* (earth-fired pottery), appear in the formal tea ceremony, a part of the Zen social life.

■ *Baskets.* Woven baskets are staples of the traditional secular or spiritual place as they hold flowers during the tea ceremony. Varying in design, size, and complexity, the baskets are made of split bamboo, roots, or branches and are thought of as highly collectible. Many of the prized baskets are *ikebani*.

■ *Japanese Prints.* Derived from the Chinese, Japanese multicolored wood-block prints or *ukiyo-e* (pictures of the floating world) become very popular about 1765. These prints feature a variety of subjects including figures in architectural settings, scenic views, famous beauties, or actors. Compositions are flat patterns of color arranged asymmetrically.

■ *Later Interpretations.* Japanese style furniture and decorative arts (Fig. 3-49) appear in the 19th century as part of the fashion for Oriental design and flourish through the early 20th century. As Japanese rooms have minimal furniture, designers apply such Japanese (and Far Eastern) characteristics as bamboo, ebonized finishes, lacquer work, fretwork, asymmetry, shelves or brackets to display porcelain, and Japanese motifs to Western types and form. Throughout much of the 20th century (Fig. 3-50, 3-51), designers such as Eileen Gray and George Nakashima, as well as noted furnishings manufacturers, are inspired by the Japanese aesthetic.

C. ANTIQUITY

c. 3000 B.C.E.–c. 476 C.E.

Antiquity refers to the times following the development of written records to the beginning of the Middle Ages, when Christianity becomes the official religion in Rome. The architecture, motifs, and, to a lesser degree, interiors and furniture of ancient Egypt, Greece, and Rome have been the basis of many subsequent Western developments. Various elements and attributes from the three have reappeared or been reinterpreted in nearly every subsequent period or style beginning with the Renaissance.

These civilizations influence each other, yet their own arts and architecture develop within three individual cultures. In Egypt, surviving temples and tombs depict a society that emphasizes death and eternal life. The magnificence of its dynastic culture asserts itself in massive building projects. Greek architecture expresses a search for perfection in proportion and distribution and delineation of forms and elements. Roman architecture glorifies the Empire, and its huge public building projects aim to unify diverse peoples.

Each culture makes unique contributions to architecture, interior design, and furnishings with an architectural vocabulary that defines and articulates new structures. Influences from these styles are reflected in later interpretive revivals. Egypt introduces the column, cornice, pylon, and obelisk, which appear in subsequent furniture and motifs. Greek orders, temples, mathematical proportions, optical refinements, moldings, and motifs influence countless later buildings. Furniture designers adopt the Greek klismos form into the 20th century. The Romans contribute the Tuscan and Composite orders, as well as temple and house forms. Numerous public and private buildings feature Roman motifs, arches, barrel and groin vaults, domes, interior treatments, and Roman-influenced furniture.

Wheel appears in Mesopotamia	3000 B.C.E.
Stonehenge built	c. 2800 B.C.E.
Pyramids begin to be built in Egypt	2650 B.C.E.
First appearance of the Book of the Dead in Egypt	c. 2060–1786 B.C.E.
Minoan Palace civilization develops	c. 2000 B.C.E.
Abraham lives	c. 1800 B.C.E.
First Suez Canal built by Egyptians	c. 1470 B.C.E.
Tutankhamen succeeds to throne of Egypt	c. 1333 B.C.E.
Troy invaded by Greeks	c. 1260 B.C.E.
Tradition of exodus from Egypt	c. 1200 B.C.E.
Babylonians invent glassblowing	1200 B.C.E.
David, King of Israel, makes Jerusalem capital of Israel	c. 1000 B.C.E.
First Olympic Games held in Greece	776 B.C.E.
Rome founded	c. 753 B.C.E.
Nebuchadnezzar exiles Jews to Babylon	586 B.C.E.
Roman republic founded	509 B.C.E.
Homer's *Iliad* and *Odyssey* formalized	c. 500 B.C.E.
Athenians defeat Persians at Battle of Marathon	490 B.C.E.
Euripedes, Greek playwright, dies	406 B.C.E.
Plato founds Academy of Athens	c. 460 B.C.E.
Socrates dies	399 B.C.E.
Aristotle, great Athenian philosopher, born	384 B.C.E.
Hippocrates, Greek physician, born	377 B.C.E.
Alexander founds Alexandria, Egypt	332 B.C.E.
Alexander the Great dies	323 B.C.E.
Hannibal crosses the Alps on his way to Rome	218 B.C.E.
Rome brings Greece under Roman rule	146 B.C.E.
Sparticus leads slave revolt against Rome	71 B.C.E.
Romans conquer Judah, present-day Israel	63 B.C.E.
Glassblowing begins in Palestine	50 B.C.E.
Julius Caesar institutes Julian calendar	45 B.C.E.
Julius Caesar assassinated	44 B.C.E.
Cleopatra and Marc Antony die	31 B.C.E.
Christ born in Bethlehem	c. 4 B.C.E.
Division of B.C.E. (Before the Common Era) and C.E. (Common Era)	
Virgil writes *Aeneid*	18 C.E.
Christ crucified in Jerusalem	c. 33 C.E.
Heron develops steam engine	c. 50 C.E.
Petronius writes *Satyricon*	60 C.E.
Saint Paul dies	c. 67 C.E.
Rome burns—Emperor Nero blames the Christians	64 C.E.
Gospel of Mark written	65 C.E.
Vesuvius destroys Pompeii	79 C.E.
Roman Empire adopts Christianity	80 C.E.
Apicius writes first cookbook On Cookery (*De Re Coquinaria*)	c. 100 C.E.
Rome has a population of 1 million	100 C.E.
Jewish Diaspora or Great Dispersion from Palestine begins	c. 135 C.E.
Huns from Asia invade Europe	c. 360 C.E.
Goths invade Rome	410 C.E.
Rome falls to barbarians	476 C.E.
Collapse of Rome	500 C.E.

4. Egypt

. . . as my eyes grew accustomed to the light, details of the room within emerged slowly from the mist, strange animals, statues, and gold—everywhere the glint of gold. . . . it was all I could do to get out the words, "Yes, wonderful things . . ."

Howard Carter on opening the tomb;
from *The Tomb of Tut-Ankh-Amen*, 1923

4-1. Egyptian costume.

One of the most powerful and enduring civilizations of the Middle East is Egypt, whose culture develops over a span of roughly 3,000 years. As a society immersed in religion, the country reflects a formal, ordered, and timeless feeling in its art and architecture. The most significant buildings are pyramids, temples, and tombs—structures associated with the spirituality of life and death. Noteworthy introductions to the architectural vocabulary include the column, capital, cornice, pylon, obelisk, and dressed stone construction. Many of these features serve as prototypes for later Greek and Roman developments. In addition, Egyptians are known for achievements in medicine, astronomy, geometry, and philosophy.

HISTORICAL AND SOCIAL

Egypt, situated in North Africa, fronts on the Mediterranean to the north, the Red Sea to the east, and on deserts to the south and west. For most of its history, geography isolates the country and keeps it relatively free from foreign invasions. The Nile River, the world's longest, runs through the country's interior. An essential water source, cities, villages, and cemeteries line its banks. The river supports an agrarian economy, and annual floods nourish the land. The Nile also is an important trade and communication route. Vegetation along its banks serves as models for motifs that appear in art and architecture. For the Egyptians, the Nile is life itself.

Little is known about Egypt's origins and history before the institution of dynasties, families of rulers. About 3150 B.C.E., a single ruler unites Upper and Lower Egypt and establishes the first dynasty. The Old Kingdom (c. 2700–c. 2190 B.C.E.) spans five centuries and the 3rd through the 6th dynasties. During the period, a strong central government becomes a theocracy as people regard pharaohs, absolute monarchs, as divine. The capital is at Memphis.

Pharaohs undertake massive building projects, such as the pyramids, to proclaim their power and assure immortality. Accomplishments in other disciplines match architectural and engineering feats. Astronomers create a solar calendar based on 365 days, and physicians have great knowledge of anatomy and antiseptics.

The 7th through the 10th dynasties, the First Intermediate Period, reflect unrest and anarchy as northern and southern Egypt again struggle for power. They unite again by the Middle Kingdom (2040–1674 B.C.E.; 11th–13th dynasties), but conditions remain unsettled. Few building projects are attempted; even fewer survive. However, it is a golden age for Egyptian literature. A Second Intermediate Period (14th–17th dynasties) follows the invasion of the Hyksos, a Semitic people from Asia. Turmoil and disunity mark the period, but the invaders leave a permanent imprint on Egypt by importing horses, instituting innovations in warfare, and expanding trade and diplomacy. The New Kingdom begins with the founding of the 18th dynasty. The period is a golden age with numerous powerful rulers who expand territories and effect grand building programs. A new and magnificent capital is built at Thebes. Noteworthy rulers include Akhenaton and Nefertite, Tutankhamen, and Rameses II. Hatshepsut becomes the first female to rule as pharaoh.

By the middle of the 20th dynasty, decline begins anew. Subsequently, Egypt is rarely free of foreign domination. Alexander the Great conquers her in 332 B.C.E. Under Ptolemy I, one of Alexander's generals, and his descendants, Egypt again becomes a great power. She expands her borders, but ultimately loses territory to the Romans. The

51

last Ptolemaic ruler is Cleopatra VII who joins Julius Caesar and Mark Antony in an attempt to maintain power. In 30 B.C.E., the Romans conquer Egypt.

Egyptian society, headed by pharaoh, is hierarchical. The elite sector, less than 10 percent of the population, is composed of those who control the government, the military, and religion. Lesser priests, master craftsmen, and middle-ranking officials comprise the next class, about one third of the population. The largest sector is composed of artisans and laborers who make up half of society. Of this group, the artists, scribes, and craftsmen, particularly those who work for the king, can achieve high status. Until the New Kingdom, slaves, the lowest class, are few.

Egyptians are polytheistic, worshipping many gods and goddesses. From earliest times, they regard their rulers as divine and as links to the gods. Egyptians revere both local and national gods who are depicted as humans, animals, and half-human, half-animal. Osiris, god of the dead, is depicted as human, while Horus, the sky god, has a hawk's head and human body. Some gods take different forms in different parts of the country or over time. For example, Ra, the sun god, appears at times as a beetle or a cobra.

Egyptian society's overarching belief is in life after death, which is considered much like that on earth. Consequently, those who can afford them have tombs to house the *ka*, their spirit doubles. Necessities of daily life fill the tombs as provisions for the *ka*, and walls feature painted images of the deceased in various activities. Paintings, statuettes, and mummified bodies provide dwelling places to further entice the *ka* to return. Believing that these practices ensure immortality, Egyptians carefully hide the burial chambers in tombs to prevent robbers from disturbing them.

CONCEPTS

The timeless character of Egyptian art and architecture reflects a highly religious society that sees the world in repeating cycles and unchanging patterns evident in the annual floods of the Nile, the changing seasons, life and death. In addition, geographic isolation limits foreign influence. Art and architectural patterns develop early and repeat consistently over time. Although variations occur, novelty and change are not important considerations. Far more significant are order and balance, which reflect the cultural vision.

The principal sources of information about royal and upper-class life in ancient Egypt are temples and tombs. The paintings and objects in them supply information about daily life and practices. Few written records survive, although apparently there were many. Archaeology has uncovered towns, worker housing near building projects, palaces, and other dwellings.

DESIGN CHARACTERISTICS

Consistency is the most obvious characteristic of Egyptian art and architecture. Once developed, patterns and forms repeat throughout history with some variations. There is little evidence of stylistic development, and similar concepts apply to almost all periods. Objects and forms are formal and convey monumentality through simplicity, order,

4-2. Egyptian ornament.

4-3. Tomb ceiling painting.

4-4. Winged disk.

and balance. Careful organization, geometry, and stylization (simplification) reflect the essence, regarded as an eternal principle. Huge scale dwarfs humans and is a visual metaphor for power, might, and the majesty of rulers and gods. Symmetry, repose, and ponderation also are characteristic principles.

■ *Motifs*. Geometric or stylized naturalistic designs (Fig. 4-2, 4-11, 4-19, 4-26) include the lotus (symbolizing purity), the papyrus, and palm (Fig. 4-3); hieroglyphics (picture writing); the sun disk and vulture (Fig. 4-4), which appear frequently over temple doors to avert evil; and the sacred beetle or scarab (symbolizing eternal life). The Egyptians introduce the guilloche (twisted circular bands), spiral, palmette, and wave patterns. Figures are idealized and shown frontally (Fig. 4-1) according to a typical system of proportions. They and other motifs may be outlined with incised lines and exhibit slight modeling, but there are no highlights, shading, or shadows. Size indicates importance, and scenes appear in bands.

ARCHITECTURE

Solidity and monumentality characterize surviving architecture, which consists mainly of tombs and temples built of stone. Architectural compositions portray axiality, simple forms, geometric volumes, rectangular shapes, and straight lines. Walls are thick, solid, and usually unbroken by fenestration. Colorful decoration highlights walls and columns. Since the climate is hot but even, structures offer protection from heat and light. In temples, grand scale, axial procession, and massive gateways symbolize society's strong religious emphasis and social hierarchy. Important features include hieroglyphics, the post or column (part of the post and lintel system), and nature-inspired motifs.

4-5. Great Sphinx with pyramids of Khafre (left) and Menkaure (right), c. 2575–2475 B.C.E.; Giza.

Important Buildings and Interiors

■ **Abu Simbel:** Temple of Rameses II, c. 1275–1225 B.C.E.

■ **Abydos:** Mortuary Temple of Seti I, 1312 B.C.E.

■ **Deir el-Bahri:** Mortuary Temple of Queen Hatshepsut, c. 1520–1480 B.C.E.; Senmut.

■ **Edfu:** Temple of Horus, 237–57 B.C.E.

■ **Giza:**

—Pyramid of Khafre (Chephren), c. 2575–2525 B.C.E.

—Pyramid of Khufu (Cheops), c. 2600–2550 B.C.E.

—Pyramid of Menkure (Mycerinus), c. 2525–2475 B.C.E.

—Statue of Khafre (later known as the Great Sphinx), c. 2500 B.C.E.

■ **Karnak:** Temple of Amon-Ra, c. 1580–323 B.C.E.

■ **Luxor:** Temple of Amon, 1408–1300 B.C.E.

■ **Sakkara:** Stepped Pyramid of King Zoser (Djoser), c. 2778–2750 B.C.E., Imhotep.

■ **Thebes:**

—Mortuary Temple of Rameses II, 1301 B.C.E.

—Temple of Luxor, c. 1408–1300 B.C.E.

Design Practitioners

■ Teams of royal officials, including the architect, plan and oversee building of temples and tombs. Surviving examples from later periods suggest that earlier architects may have worked from drawn plans.

■ *Imhotep*, the first known architect, designed the stepped pyramid complex of Zoser at Sakkara, one of the first monumental building complexes. Worshipped as a god in later periods, he is credited with translating early timber and reed forms into stone.

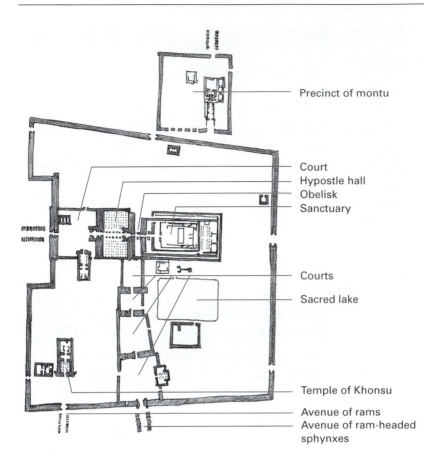

Precinct of montu

Court
Hypostle hall
Obelisk
Sanctuary

Courts

Sacred lake

Temple of Khonsu

Avenue of rams
Avenue of ram-headed
sphynxes

4-6. Site plan, Temple complex, Amon-Ra, c. 1580–323 B.C.E.; Karnak.

Few domestic structures survive as they are generally built of impermanent materials. The hierarchy of buildings reflects the cultural belief in eternal life.

Public Buildings

■ *Types.* Significant examples include *mastabas*, royal pyramids, rock-hewn tombs, and cult and mortuary temples.

■ *Tombs. Mastabas* (rectangular funerary mounds covered with brick or stone, with sloping sides and a flat top) and subterranean burial chambers develop during the 1st dynasty in the Old Kingdom. Stepped pyramids appear in the 3rd dynasty. These large structures, which protect the king's mummy, are visual metaphors for his absolute and divine power. The Stepped Pyramid of King Zoser (c. 2778–2750 B.C.E.) is the earliest surviving example of this type of monumental architecture. The pyramids, built beginning in the 4th dynasty, reveal the Egyptians to be master builders and mathematicians. Smaller pyramids are built in the Middle Kingdom. They do not prevent robberies, so they are supplanted by rock-hewn tombs, which dominate the following periods. These tombs exhibit the fundamental spaces of Egyptian architecture: a vestibule, a columned hall, and a sacred chamber. All three tomb types form complexes with temples, other tombs, and processional paths.

■ *Temples.* Mortuary temples support the worship of a king's patron god and the king himself after death. They become especially magnificent in scale and ornament during the New Kingdom, such as the unique one of Queen

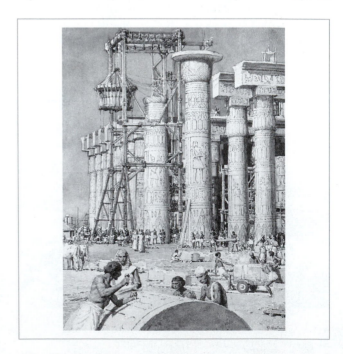

4-7. Temple of Amon-Ra; Karnak.

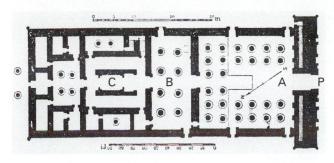

4-8. Floor plan, Temple of Khons, c. 1198 B.C.E.; Karnak. The plan features a pylon (P), open courtyard (A), hypostyle hall (B), and sanctuary (C).

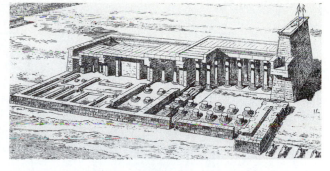

4-9. Section (reconstructed drawing), Temple of Khons; Karnak.

Hatshepsut (c. 1520–1480 B.C.E.). Cult temples for the worship of a god or gods follow a traditional form that develops from rituals and ceremonies. This form creates a sense of progression from small to large and from low to high, usually on an axial alignment. In some tomb and temple complexes (Fig. 4-6), avenues of sphinxes (Fig. 4-5) lead to walled areas and serve as guardians to tombs. A pylon (monumental gateway flanked by paired towers; Fig. 4-10, 4-12) delineates a temple entrance facade. A typical temple plan (Fig. 4-8) features entry past pairs of obelisks (monolithic pillars tapering to a pyramid-shaped top) and through a huge pylon (P) with slanted (battered or canted) walls. Immediately behind is an open courtyard (A) leading to a vestibule or hypostyle hall (B), a covered area filled with tightly clustered columns (Fig. 4-19) that may be decorated with figures, symbols, and hieroglyphics. A chosen few may enter the hypostyle hall. Behind the hall is

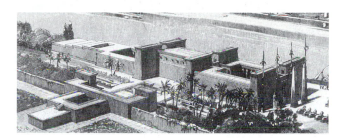

4-10. Temple of Luxor, c. 1408–1300 B.C.E.; Thebes.

a sanctuary (C) holding the statue of the king or god. Treasure rooms surround the sanctuary, which only pharaoh and the priests may enter.

■ *Site Orientation*. Mastabas, pyramids, and temples (Fig. 4-6) are sited in axial, walled complexes with a variety of

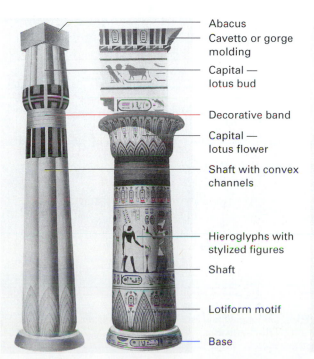

Abacus
Cavetto or gorge molding
Capital — lotus bud
Decorative band
Capital — lotus flower
Shaft with convex channels
Hieroglyphs with stylized figures
Shaft
Lotiform motif
Base

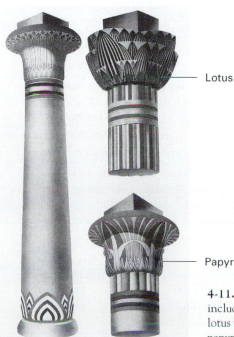

Lotus

Papyrus

4-11. Posts and capitals include the lotus bud, lotus flower, foliated, and papyrus blossom.

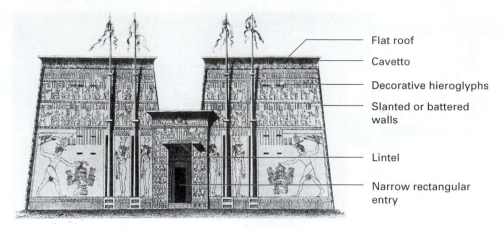

Flat roof

Cavetto

Decorative hieroglyphs

Slanted or battered walls

Lintel

Narrow rectangular entry

4-12. Temple of Horus, c. 237–57 B.C.E.; Edfu.

attendant buildings. Since subsequent rulers add to the complexes, relationships among structures are not planned as a whole, as Greek structures are. The most magnificent temple complex is that of Amon-Ra at Karnak (Fig. 4-7).

■ *Materials.* Monumental and funerary architecture is built of stone, befitting its eternal purpose. Egyptians consistently use trabeated or post and lintel construction, possibly because its simplicity equates with timelessness. Egyptians know the arch but rarely incorporate it except in the lower portions or ceilings of some tombs and buildings. Some stone forms and details derive from predynastic timber and reed building, such as convex polygonal column shafts that resemble reeds tied together (Fig. 4-11).

■ *Posts.* The vertical post (Fig. 4-11), or column, has a base, shaft, and distinctive capital. It may be either freestanding or engaged. Shafts are plain or polygonal with concave or convex channels—prototypes of fluting and reeding. Capitals illustrate stylized plant forms such as the lotus bud, papyrus, or palm. Columns may feature incised (low relief carving) and painted figures, hieroglyphics, and geometric or stylized native plant motifs. Figures may be used as columns, particularly in mortuary temples and rock tombs.

■ *Lintel.* The lintel (Fig. 4-18, 4-20), a horizontal beam, is crowned with a cornice, the most common of which is the cavetto or gorge (quarter circle in section). Decorative moldings include the roll, scroll, and bead. Architraves (lintels) feature decorative carving and painting.

■ *Facades.* Facades are massive with thick walls that are often slanted inside for stability and rarely broken by openings (Fig. 4-10, 4-12). They are colorfully decorated with figures of gods and rulers, hieroglyphics, and other characteristic motifs.

■ *Windows and Doors.* The few doors and windows (Fig. 4-20) are usually tall and rectangular. Windows are high on the wall. Center columns in hypostyle halls are taller to permit clerestory windows for light into the center. Pylons often have slits to light inner staircases.

■ *Roofs.* Flat roofs are typical in public and private buildings.

■ *Later Interpretations.* Egyptian architectural forms and motifs are copied beginning in the 18th century and continuing to the present, with noteworthy examples

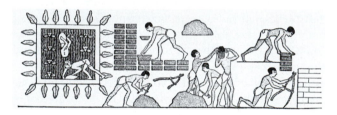

4-13. Brick making (copy of a wall painting).

4-14. Floor plan and section, nobleman's villa, 1500–1400 B.C.E.; Tell-el-Amarna.

4-15. Sarcophagus of Menkere.

4-17. Later Interpretation: Luxor Hotel, 1990s; Las Vegas, Nevada.

in France, England, and America. Nineteenth-century Egyptian Revival is one of many styles architects choose depending on associations. Examples include fraternal organizations, medical facilities, cemeteries, and prisons (Fig. 4-16). Later 20th-century models may represent fantasy or hospitality environments (Fig. 4-17).

Private Buildings

■ *Types.* Archaeology, clay models, and tomb paintings illustrate palaces and wealthy and common dwellings more often than extant examples.

■ *Site Orientation.* Towns reflect ordered grid planning with palaces and wealthy houses sited along wide streets. Common homes are located in crowded areas with narrow streets. Large walled complexes of palaces and upper-class dwellings include numerous buildings, gardens, and pools. All, regardless of size, focus inward, usually toward courtyards.

■ *Floor Plans.* Domestic dwellings (Fig. 4-14) vary in size and configuration with class and wealth. Simple houses have one or two stories with three to four rooms, while great mansions have many rooms and several courtyards. Public areas, usually on the north or cooler side, include a reception room and office for conducting business, with circulation to private spaces. Some living rooms have built-in clay daises, benches, and tables. Private areas, such as bedrooms, bathrooms, and women's quarters, are usually secluded. Bedrooms sometimes have platforms for sleeping or niches for wooden beds. Service areas include kitchens, granaries, stables, and storage rooms and may be separated from main living areas.

■ *Materials.* Palaces and dwellings are made primarily of sun-dried mud brick, plastered and whitewashed.

4-16. Later Interpretation: New York City Halls of Justice and House of Detention (The Tombs), 1835–1838; New York, New York; by John Haviland; Egyptian Revival.

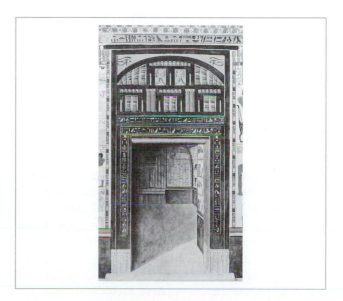

4-18. Entrance (reconstructed), Tomb of Puyemre, 15th century B.C.E.; Thebes.

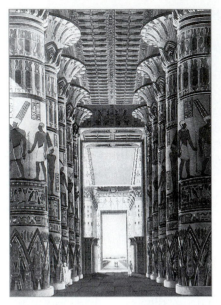

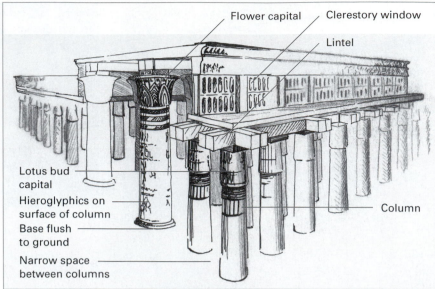

4-19. Hypostyle Hall (restored and reconstructed views), Temple of Amon-Ra, c. 1580–323 B.C.E.; Karnak.

■ *Facades.* Extant examples depict plain facades. The Sarcophagus of Menkere (Fig. 4-15), shaped like a house, has slanted (battered or canted) walls and framed doors with a grilled window above. It is capped by a large cavetto molding.

■ *Roofs.* Flat roofs provide additional storage and sleeping areas in very hot weather. They often have vents to catch breezes.

INTERIORS

The extant interiors are in tombs, but knowledge of wealthy domestic ones comes from excavations, painted images in tombs, and models. Rooms are rectangular with relatively straight walls, flat ceilings, few windows (often clerestory), and limited architectural details. Little is known about the interiors of the dwellings of common people.

Public and Private Buildings

■ *Color.* Typical colors include blue-green, rust-red, gold, black, and cream, mainly derived from earth pigments. Architectural details (Fig. 4-20) may be highlighted in orange, green, and blue paint. The tomb of Queen Nefertari (Fig. 4-21, Color Plate 9) features colorful paintings showing her in various activities. Color may be symbolic.

■ *Lighting.* Common forms of lighting include saucers with wicks in oil and torches of twisted plant material smeared with fat. Some lamps have naturalistic forms, such as the alabaster lamp (Fig. 4-22) shaped like a lotus plant with two buds and a flower growing in a pond.

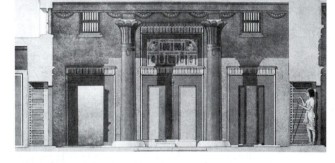

4-20. Deep Hall of General Ra-mose (reconstructed elevation), c. 1370 B.C.E.; Tell-el-Amarna.

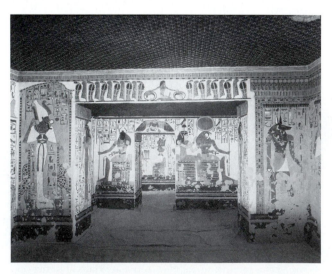

4-21. Interior, tomb of Queen Nefertari, c. 1290–1224 B.C.E.; Thebes. (Color Plate 9)

Design Spotlight

Architecture: *Temple of Amon-Ra, Karnak.* The grandest of all Egyptian temple complexes, this temple (Fig. 4-7, 4-19) is an accretion as each ruler adds more temples and buildings. Massive pylons feature battered walls, trabeated construction (post and lintel system), rolled moldings, slit windows, and flagstaffs. Incised in the walls are images of the pharaoh conquering his enemies. Columns in the hypostyle hall have decoration of figures, symbols, and hieroglyphics. The decoration arranges in horizontal bands in contrast to the more common practice of vertical orientation for decoration.

■ *Floors.* Tomb and dwelling floors are mostly of pressed clay; a few are of brick. Finer houses have polished plaster floors, sometimes decorated. Floor mats of woven rushes are common.

■ *Walls.* Interior walls are plastered and whitewashed. Tomb decorations usually depict the deceased in various activities arranged in bands. In grand houses, walls in important rooms are painted. The lower portion is white, black, or dark blue with patterning above. A frieze near the ceiling depicts abstractions of nature or other symbols.

■ *Windows.* Windows, which are small and rectangular, often have wood grilles (Fig. 4-20) or rolled mat coverings woven of reeds.

■ *Doors.* Doors are typically wooden boards with pivot hinges; double doors may define important rooms. Rolled mats may also cover openings. Post and lintel doorways (Fig. 4-18) may be surrounded by hieroglyphics and other symbols; commonly used symbols relate to the monarch, life, fertility, and wealth.

■ *Ceilings.* Most ceilings are flat; a few, often in rock-hewn tombs, are barrel vaulted. Similar to hypostyle halls, some dwellings and palaces have ceilings of important rooms raised by columns for clerestory windows that add light and air circulation.

■ *Later Interpretations.* The 19th- and early 20th-century Egyptian Revivals interpret interiors and furnishings using architectural details and motifs. Examples include churches (Fig. 4-23), fraternal organizations, stage sets (Fig. 4-24), and movie theaters. Egyptian architectural details define some domestic spaces as well.

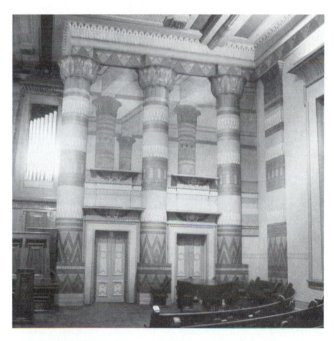

4-23. Later Interpretation: First Presbyterian Church, 1848–1851; Nashville, Tennessee; by William Strickland; Egyptian Revival.

4-22. Lamp, c. 1334–1325 B.C.E.; found in Tutankhamen's tomb.

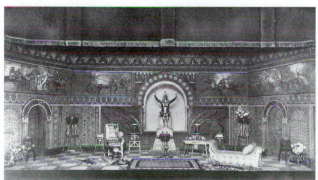

4-24. Later Interpretation: Stage set; published in *Rooms Beautiful*, 1915.

FURNISHINGS AND DECORATIVE ARTS

Egyptian furniture is generally rectangular with few curves. It may be plain or decorated. Most surviving examples are from royal or upper-class tombs. The discovery of King Tutankhamen's tomb (Fig. 4-32) in 1922 provided the world with a more accurate image of the lifestyle, furnishings, and decorative arts associated with Egyptian royalty. Little is known of common furnishings.

■ *Types.* The limited types of furniture include chairs with and without arms, folding and rigid stools, footstools, chests, tables, and beds.

■ *Distinctive Features.* Chairs, stools, and beds are distinctive with front and rear animal legs positioned naturally and raised on a cylinder, often beaded. Lion legs are the most common leg form (Fig. 4-33); typical feet include hooves or lions' paws.

■ *Materials.* Acacia or sycamore are the local woods; cedar, cypress, and ebony are imported. Poor-quality woods are often veneered or painted to imitate better woods. Egyptians develop a type of plywood composed of small wood pieces glued together. Inlay materials include ebony, ivory, faience (tin-glazed earthenware), and precious stones. Sheet, foil, and leaf gold or silver are common on luxury furniture. Furniture construction, which is sophisticated, primarily incorporates mortise and tenon, dovetail, miter, or butt joints.

■ *Seating.* The typical chair is simple and square in form with a slightly curved, sloping back supported by two or three uprights. Seats, which vary in height, may be made of plaited rushes or leather, and may be supported by grouped

Design Spotlight

Furnishings: *Golden Throne of Tutankhamen.* This elaborate throne (Fig. 4-26, Color Plate 10) is of wood overlaid with gold and silver foil and inlaid with semiprecious stones, faience, and glass. Shown on the back is the king seated in a chair with a cushion and his feet resting on a stool. His queen attends him. Nearby is a stand holding a tray. Lions' heads surmount the front legs, and lions' paw feet are raised on cylinders (blocks). Colors, mainly derived from earth pigments, include blue-green, rust-red, gold, black, and cream.

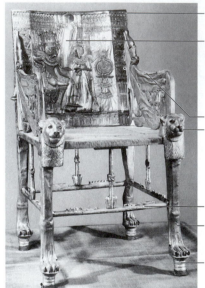

Rectangular back shape

Decorative hieroglyphs on back with male and female figures; embellished with gold ornamentation

Curved arms

Lion's head

Stretcher

Animal leg and feet arranged naturally

Beaded cylinder drum

4-26. Golden throne of Tutankhamen, 1500–1400 B.C.E. (Color Plate 10)

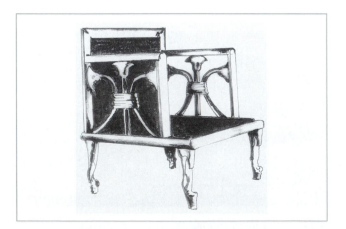

4-25. Chair of Queen Hetepheres, 4th dynasty.

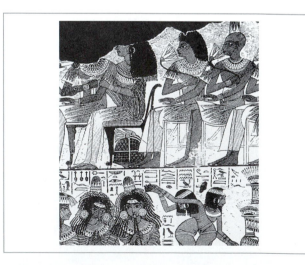

4-27. Chairs, 20th and 28th dynasties, from wall paintings in tombs; Thebes.

4-28. Stools, 1500–1400 B.C.E.

4-29. Table, 18th dynasty.

4-31. Small chest, c. 1334–1325 B.C.E.; from Tutankhamen's tomb.

4-30. Chest, c. 1334–1325 B.C.E., belonging to Tutankhamen.

4-32. Inside of Tutankhamen's tomb, 18th dynasty; Valley of the Kings.

4-33. Figures seated on a bed, c. 2325 B.C.E.

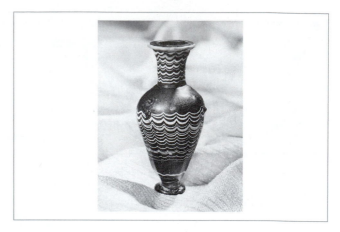

4-35. Glass vessel, c. 1500–1400 B.C.E.

papyrus with bull legs mounted on small drums (Fig. 4-26). Loose feather-filled cushions of bright colors may be added for comfort. Other examples (Fig. 4-25, 4-27) have animal legs with paw feet placed naturally and raised on a cylinder. Throne chairs (Fig. 4-26), as symbols of royalty, are the most elaborate. Stools (Fig. 4-28) are more numerous and made in various heights. Folding stools, used by military commanders, are symbols of authority. The popular folding stool has legs terminating in ducks' heads and a seat of either leather, canvas, or woven grass. Stools that do not fold often have a sloped wooden seat and four animal or turned legs.

■ *Tables.* Small tables (Fig. 4-29, 4-32) with rectangular or round tops for eating and display are typical. Wicker stands are more common than tables.

■ *Storage.* Chests and baskets, which store possessions, linen, clothing, and food, differ in size and form based on

function. Interiors of chests are divided into small compartments to hold various objects. Decoration (Fig. 4-30) may include designs of ebony and gilded symbols of divine life or ivory and silver inlay (Fig. 4-31).

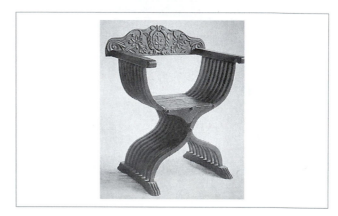

4-36. Later Interpretation: Savonarola chair, 15th–16th centuries; Italy; Italian Renaissance.

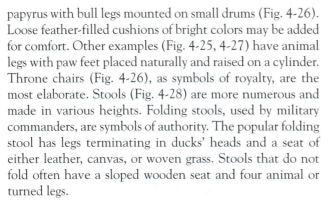

4-34. Clay jug on stand.

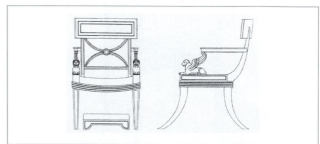

4-37. Later Interpretation: Armchair, early 19th century; England; by Thomas Hope; English Regency.

■ *Beds*. Beds have wooden frames with leather or rush webbing, They are richly carved and have footboards but no headboards (Fig. 4-33). Many layers of folded linen serve as a mattress. One of Tutankhamen's beds could fold for traveling, a precursor of camp or field beds. Headrests of alabaster or wood substitute for pillows.

■ *Decorative Arts*. Tableware is made of pottery, alabaster, copper, bronze, gold, or silver. Typical items include storage jars, bowls, jugs (Fig. 4-34), washbasins, and mirrors. Glassmaking probably begins as a royal monopoly during the 18th dynasty. Objects are formed around a clay and sand core that is dipped into molten glass. Colored rods applied to the hot glass are hooked or dragged to create chevron patterns (Fig. 4-35). Wealthy women use glass vessels for scents, cosmetics, or ointments.

■ *Later Interpretations*. Many Egyptian furniture forms serve as precursors to later furnishings as functional requirements expand and construction techniques evolve. The **X**-form stool becomes the Roman *sella curulis* in the 1st century B.C.E., the Italian Renaissance *Savonarola* (Fig. 4-36) in the 15th century, and the Bauhaus Barcelona chair in the early 20th century. Square-leg wooden tables are revived as Parson's tables in the late 20th century. Other revival examples appear primarily in the 19th and early 20th centuries through the developments of the French Empire, English Regency (Fig. 4-37), and Egyptian Revival styles.

5. GREECE

1000–146 B.C.E.; Golden Age in the 5th Century

Take architecture. It is an art, that is a rational faculty exercised in making something. In fact there is no art which cannot be so described, nor is there any faculty of the kind which is not art.

Aristotle, *The Ethics of Aristotle*

Greek cultural developments in art, architecture, literature, philosophy, and music have served as sources of design inspiration since their inception. The visual images establish a language and grammar for architecture, interiors, furniture, and decorative arts copied by successive generations. Greek (and Roman) elements and forms dominate Western architecture until well into the 20th century. Terms describing components of Greek architecture, such as *column*, *capital*, and *base*, have become an integral part of our architectural vocabulary. No other culture except Rome has had such a significant impact on the evolution of the Western architectural landscape.

5-1. Caryatid.

HISTORICAL AND SOCIAL

In ancient times, Greece was geographically separated from any neighbors and therefore developed an individual identity. The country is a peninsula with rocky seacoasts surrounded by numerous islands and a mountain range to the north. Early inhabitants were Mycenaeans, who were driven out by the Dorians, a militant tribe from the north that settled in Sparta and southern Greece. Those Mycenaeans who stayed maintained their identity on the peninsula of Attica, specifically in the southeastern city of Athens, and became known as Ionians. Numerous mountain ridges divide the country into small areas, which fosters the development of independent city-states, each with its own governmental, political, and economic identity. These governments encourage individual citizen participation and form models for later democracies.

Significant Greek developments include the literary works and dramas penned by Aristotle, Plato, Socrates, and Homer that promote logic, questioning, and critical thinking; the first coinage system used in bartering; and the visually recorded accomplishments of many artists. Greeks are polytheistic, worshipping gods who are powerful and immortal, but have human forms and attributes.

Their religion fosters respect for order, as reflected in nature and humankind. Males possess independence, wealth, ownership, and education. Women, on the other hand, are their fathers' or husbands' property, being restricted by law, politics, custom, and family relationships. Their main duties are to bear children and tend the family household. Few women artists are known, and nothing by those acknowledged survives.

As there is little farmland, trade is important. Not only does trade stimulate the economy, but also it brings historical influences from Egypt and the near East, Europe, and Asia. City-states establish their own colonies throughout the Mediterranean, spreading Greek culture and receiving foreign goods and effects in return. Wars waged with the Persians and Assyrians also bring new forms and ideas. The mixture of these influences produces a rich and varied culture. Later, the exploits of Alexander the Great (336–323 B.C.E.) bring additional ideas into the country as he conquers vast areas to expand his empire. During this period of cross-fertilization, Greeks call themselves Hellenes and recognize their own distinctiveness.

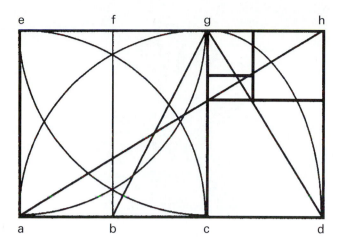

5-2. Golden Section: aceg = square; bf = half square; bg = bd and determines smaller Golden Mean; adhe = Golden Mean.

CONCEPTS

Greek architecture and art searches for the ideal, the perfect in proportion and distribution of forms and parts, as well as those attributes or qualities that contribute to and enhance the ideal image. The Golden Age of the 5th century has continually provided a model for the classical language of architectural form, order, and proportion. Form is characteristically expressed in the Greek temples, while order is expressed in the relationship of the parts to the whole. Proportion, tied to religion and the attainment of perfection, relates to the human body (Fig. 5-1), often cited by the Protagorian axiom "man is the measure of all things." One derivative of this concept is the golden section (Fig. 5-2), developed by the Greek mathematician Euclid. He diagrammed a geometric relationship between rectangles and squares based on a system of proportioning. Classical qualities also include clarity, symmetry, repose, and simplicity. Thus, the term *classical* refers to the elements (columns, pediments, and the like) and attributes (symmetry, repose, etc.) of Greek (and Roman) architecture.

DESIGN CHARACTERISTICS

The overall architectural design illustrates a formal, refined image and emphasizes human proportions, the golden section, monumental scale, symmetrical balance, and ordered spatial arrangements. The ordering of the principal structural members distinguishes the building form. Arrangements are logical and rational, reflecting natural harmony. Parts, articulated for clarity and to emphasize the architectonics, relate to each other and the whole. Equally important principles and attributes are repose, horizontality,

symmetry, stability, and clarity. These principles, particularly simplicity and perfection in form, extend to the decorative arts, including furniture. In contrast to Egypt where timelessness and tradition are important, Greece continually seeks perfection in the proportion and distribution of parts. Consequently, stylistic changes are definable.

■ *Geometric or Orientalizing Period* (c. 1100–650 B.C.E.). Little survives from this early period. Mud-brick temples and tombs are chief architectural forms. Vases are the dominant surviving art form.

■ *Archaic* (c. 660–475 B.C.E.). Monumental stone architecture and sculpture originate in the 7th century B.C.E. and develop throughout the period. The architectural form and vocabulary that characterize Greek buildings evolve. The Doric and Ionic orders appear, and builders search for perfection in the proportion and distribution of parts. Athens begins its ascendancy as the dominant city-state.

■ *Classical* (c. 475–323 B.C.E.). During the 5th century, Athens is the capital of cultural expression, social invention, and classical style, a result of her victory over the Persians. The search for perfection culminates in the great Doric temples of the period, particularly the Temple of Aphaia in Aegina and the Parthenon in Athens. Ionic temples are jewels of perfection also. The Corinthian order develops and is used only for interiors. Architectural vocabulary is fully developed, and no new introductions, only variations, appear. During the 4th century B.C.E., builders begin to deviate from classical forms and proportions. Athens loses her dominance. Alexander the Great expands the Greek empire, spreading Greek culture and influence.

■ *Hellenistic* (323–30 B.C.E.). Following Alexander's death in 323 B.C.E., his generals divide the empire. At this time, Greek society is more sophisticated, and new building types appear in response. Architecture becomes more subjective, deviating even more from the established architectural language. New types of capitals appear, and proportions vary from the classical. Ornament becomes more important.

■ *Motifs.* Ornamental motifs are common and often painted to enhance their attractiveness. Those derived from nature include the acanthus leaf (Fig. 5-3), palmette, anthemion (often appears as a running band on friezes; Fig. 5-4), lotus bud (Fig. 5-4), honeysuckle vine, antefix (may conceal the open end of a row of roof tiles; Fig. 5-5), rosette (stylized circular floral motif), scroll, and rinceau (linear pattern of scrolling foliage; Fig. 5-4). Those developed from geometry are the fret (Greek key; Fig. 5-6), guilloche (Fig. 5-7), dentil (frequently accentuates cornices; Fig. 5-8), egg and dart (Fig. 5-9), and swastika. Mythical beasts, such as the sphinx, griffin, and chimera, are also important (Color Plate 12).

5-3. Acanthus plant.

5-5. Antefix.

5-6. Greek fret.

5-7. *Guilloche*.

5-4. Anthemion, lotus, rinceau, Greek fret, egg and dart, and wave motifs.

5-8. Dentil molding.

5-9. Egg and dart.

ARCHITECTURE

Architectural influences from the Middle East and Egypt merge with indigenous forms to shape the contextual image of the Greek landscape. Bright sun alternating with rainy periods contributes to a strong emphasis on building orientation, light and dark contrast, and covered walkways. Each part of a building has its own importance and logical arrangement. Harmony among parts is achieved through the repetition of forms and numbers and carefully planned, articulated transitions. Symmetrical and horizontal structures evidence clarity, repose, and stability. The addition of optical refinements to correct optical illusions and enhance the structure indicates a psychological understanding of architecture. Temples dominate building until the Hellenistic period. As ceremonies and rituals take place outside, exteriors are more important than interiors.

Public Buildings

■ *Types.* Public buildings include temples, theaters, and treasuries. Many structures, such as large civic centers for political gatherings and sports centers for athletic events, focus specifically on outdoor activities.

■ *City Planning.* City centers are a planned arrangement of structures with each building focused on a different activity. Structures include markets, stoas, public buildings, and occasionally, temples and *tholoi* (small round building with columns). The Greek agora (marketplace) corresponds to the later Roman forum, but the stoa (colonnaded porch), a Greek innovation, has no corresponding Roman form. Athens, Olympia (site of the first Olympics in 776 B.C.E.), and Delphi illustrate the ordered composition.

■ *Sacred Sites.* Sanctuaries with temples and other sacred buildings are often sited on high promontory points for recognition, protection, and orientation. Unlike in Egyptian processional and axial temple complexes, each building in a Greek sanctuary is an individual element integrated to

Important Buildings and Interiors

■ **Athens:**

—Choragic Monument of Lysicrates, c. 334 B.C.E.

—Erechtheion on the Acropolis, c. 406 B.C.E.

—Parthenon on the Acropolis, c. 447–436 B.C.E., Ictinus and Callicrates. (Color Plate 11)

—Stoa of Attalos II, c. 150 B.C.E.

—Temple of Athena Nike on the Acropolis, c. 424 B.C.E., Callicrates.

—Theater of Dionysos at the Acropolis.

—Tower of the Winds, c. 40 C.E.

■ **Corinth:** Temple of Apollo, c. 540 B.C.E.

■ **Delphi:**

—Athenian Treasury, c. 510 B.C.E.

—Sports stadium, c. 500s B.C.E.

—Temple of Apollo, c. 510 B.C.E.

■ **Didyma:** Temple of Apollo, c. 313 B.C.E., Paionios of Ephesos and Daphnis of Miletos.

■ **Epidaurus:** Theater, c. 350 B.C.E.

■ **Olympia:**

—Palaestra sports complex.

—Sports stadium.

—Temple of Hera; c. 590 B.C.E.

—Temple of Zeus, c. 470 B.C.E., Libon of Elis.

■ **Paestum:** Temple of Neptune, c. 460 B.C.E.

■ **Sounion:** Temple of Poseidon, c. 444–440 B.C.E.

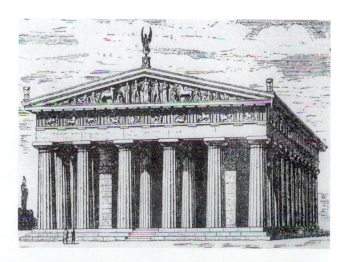

5-10. Temple of Zeus, c. 470 B.C.E.; Olympia.

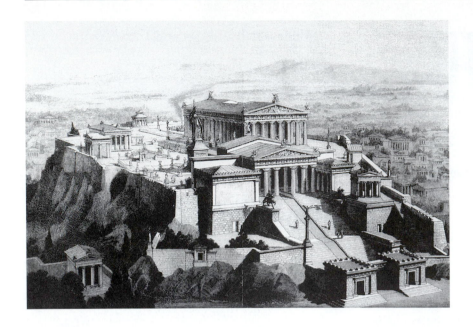

5-11. Acropolis (reconstruction drawing), 5th century; Athens. (Color Plate 11)

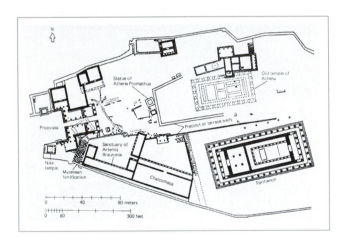

5-12. Site plan, Acropolis (reconstruction drawing); Athens.

natural features of the landscape. This arrangement reflects the cultural vision of each citizen as an individual who unites with others for a common purpose. Sited on a promontory plateau in the city, the Acropolis (Fig. 5-11, 5-12) shows an ordered arrangement of buildings that includes the Propylea (left foreground), a complex entrance structure designed by Mnesicles; the Parthenon (Fig. 5-13; right rear, see Design Spotlight); the Erechtheion (Fig. 5-14, 5-15; left, illustrating the use of caryatids); and the Temple of Athena Nike (Fig. 5-16; right, with an Ionic colonnade).

■ *Temples.* Temples, the dominant building type until the Hellenistic period, pay homage to a particular god, such as Zeus (king of the gods, sky), Apollo (sunlight, reason), Hermes (messenger, travel), or Nike (victory). Conceived

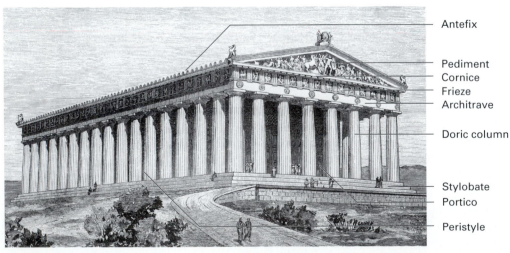

Antefix

Pediment
Cornice
Frieze
Architrave

Doric column

Stylobate
Portico

Peristyle

5-13. Parthenon, c. 447–436 B.C.E., Acropolis, Athens.

as sculpture and an offering to the gods, temples typically impress from the exterior view, with less attention paid to the interiors, as illustrated in the Temple of Zeus (Fig. 5-10). The emphasis is primarily on function—housing cult statues and treasures—over excessive decoration.

Standard floor plans (Fig. 5-12) for small temples include a small rectangular room (cella or naos) with columns only in front forming a portico or porch (prostyle; Fig. 5-10) or in front and back (amphiprostyle). Early temples had columns between extended exterior walls in front (in antis). Larger temples have several rooms with columns on all four sides forming a peristyle. A single row of columns is peripteral, while a double row is dipteral. In the Hellenistic period, round temples appear.

On the main temple portico or porch, a small entry door leads to the rectangular naos (inner sanctuary). It

Design Practitioners

■ Several Greek architects are known, such as Ictinus and Callicrates. Since design and construction were traditional trades passed from builder to builder, drawings probably are not used. Scaled measuring instruments are unknown, so dimensions are calculated from the building's foundations. Details are shown in full-scale models.

Design Spotlight

Architecture: *The Parthenon.* Dedicated to the goddess Athena (war, wisdom) and designed by Ictinus and Callicrates, the Parthenon (Fig. 5-13) epitomizes the typical Greek temple form—one that speaks to perfection, unity, harmony, and balance. Massive in scale and raised on a stylobate, the peristyle is a single row of Doric columns. Architectural adjustments to correct perceived optical illusions enhance the building, its visual impression, and the overall psychological impact. Lavishly decorated with sculpture, the pediment is filled with three-dimensional larger-than-life figures, and the Ionic frieze depicts a procession of gods surrounding the cella. Antefixes embellish the roof cornice. The Parthenon, like many other structures, has elaborate painted decoration applied in bright flat colors, although little evidence remains. Within the temple, the naos (Fig. 5-28) accommodates a huge wood, gold, and ivory statue of Athena (38'-0"h) by the sculptor Phidias. A double row of Doric columns supports the roof that may have been partially open. (Color Plate 11)

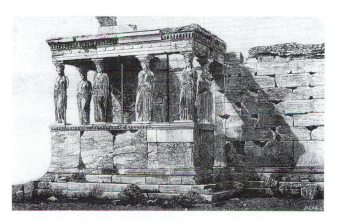

5-14. Porch of the Maidens, Erechtheion, c. 406 B.C.E., Acropolis; Athens.

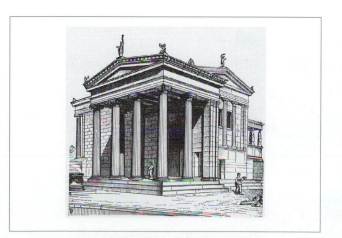

5-15. Northwest facade, Erechtheion; Athens.

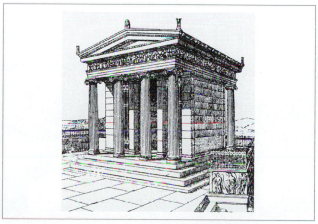

5-16. Temple of Athena Nike, c. 424 B.C.E., Acropolis; Athens; by Callicrates.

5-17. Theater at Epidaurus, c. 350 B.C.E.

houses the statue of the god, large in scale and placed prominently on the center axis. The deity is usually surrounded by one or two inner rows of free-standing or engaged columns. From the rear portico, the entry door leads to the treasury (smaller room), a religious space for public offerings. Interiors develop with an emphasis on axial procession, scale variety, and classic ordering with a repeat of the exterior design treatment. Today, temples are still the most representative icon of the Greek culture.

■ *Theaters.* Often used for dramatic productions, theaters are almost circular with a stage at center surrounded by rising tiers of seats. This shape enhances acoustical quality and has been imitated in contemporary theaters. In the Theater at Epidaurus (Fig. 5-17), the best-preserved stone

5-18. Market; Athens.

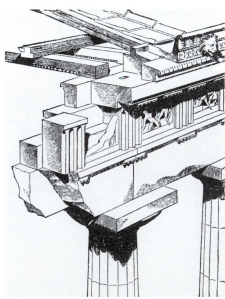

5-19. Doric order and Doric temple construction.

example, the seating (cavea) and orchestra where the chorus of a play danced and sang remain. The stage buildings behind the orchestra, where actors stood, are in ruins.

■ *Classical Orders*. A Greek building develops from the ordering of principal structural members—stylobate, column, and entablature, as shown in the Athens market (Fig. 5-18). This composition translates into the Greek (and later Roman) interior, and later accentuates the ordering of many walls. Orders differ in proportion and details with capitals being the most distinguishing feature (Color Plate 12).

■ *Stylobate*. The stylobate (Fig. 5-10, 5-13) is the top step or platform for the bases of columns. A precursor to the Roman pedestal, it later evolves into the interior wainscot and dado.

■ *Column*. The column has a distinguishing capital, shaft (vertical post), and base. Doric and Ionic, the primary orders, differ from each other in proportion and detail. The shafts are fluted (concave grooves). Doric shafts usually have entasis (convex profile). Caryatids (female figures; Fig. 5-1, 5-14) sometimes substitute as vertical posts. Until the Hellenistic period when engaged columns appear, columns are used structurally, rarely decoratively.

■ *Pilasters and Engaged Columns*. Pilasters (rectangular projections from a wall with the general appearance and proportions of a column) commonly adorn the corners of cella walls behind the porch, corresponding to columns. They are called antae when there are columns between them. Interior pilasters are rare, even in the Hellenistic period. Engaged columns (columns attached to the wall; circular in section view) appear occasionally in the 5th century B.C.E. on temple exteriors and interiors. By the Hellenistic period, they are common on temples, stoas, agoras, and other structures.

■ *Doric Order*. The Doric capital (Fig. 5-19) consists of an abacus (square block between the echinus and entablature) and an echinus (rounded cushion). The heavy shaft has about 20 flutes and no base. Its height varies from four to seven times its diameter (five and a half is typical). Near the neck of the capital are three annulets (grooves). The earliest Doric columns are slender, but in the Archaic period they become very thick with a pronounced taper and heavy, bulging echinus. Classical Doric shafts are slimmer and not as tapered. The echinus is not so pronounced. Shafts become even thinner in the Hellenistic period. Above a plain architrave (series of blocks directly above

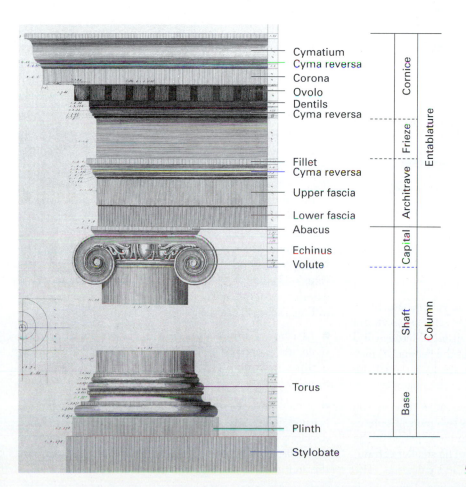

Cymatium
Cyma reversa
Corona
Ovolo
Dentils
Cyma reversa

Fillet
Cyma reversa
Upper fascia
Lower fascia
Abacus
Echinus
Volute

Torus

Plinth
Stylobate

Cornice
Frieze — Entablature
Architrave
Capital
Shaft — Column
Base

5-20. Ionic order.

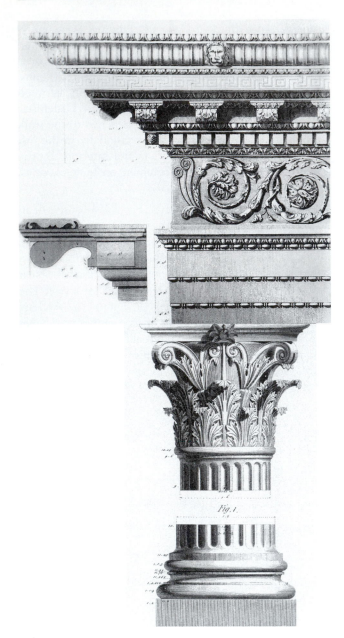

5-21. Corinthian order.

5-22. Choragic Monument of Lysicrates, c. 334 B.C.E.; Athens; featured in the 1762 English publication *Antiquities of Athens*.

the column), triglyphs (blocks with three divisions) and metopes (flat slabs recessed between triglyphs) characterize the Doric frieze. A triglyph typically is centered over and between each column and ends the frieze. Metopes and the tympanum (triangular enclosure of the pediment) may have sculptures. Most large temples are Doric until the Hellenistic period when the Ionic order dominates.

■ *Ionic Order*. Developed about the same time as the Doric, the Ionic order (Fig. 5-20) has two pairs of volutes (spiral scroll), one in front and one in back, joined at the side by a decorated concave cushion. The smaller echinus usually has an egg-and-dart molding and palmettes. The

architrave has three fascia (vertical faces each projecting beyond the other). The Ionic frieze, when present, is carved with reliefs. Dentil moldings delineate the cornice (Fig. 5-8). The order has a taller shaft and a contoured base. From a base, the Ionic column rises between nine and ten times its diameter. Its shaft is more tapered than that of Doric columns and may have between 20 and 48 flutes (24 is typical).

■ *Corinthian Order*. Developed as a variation of the Ionic order, the Corinthian order (Fig. 5-21) is similar except for the capital. Shaped like an inverted bell, the lower portion has two rows of eight acanthus leaves (Fig. 5-3). Rising from the upper leaves are volutes. The abacus is concave and ends in a point. The tall shaft is more slender than that of the Ionic order. Originally used inside temples, the Corinthian order was first used on exteriors during the Hellenistic period. The Choragic Monument of Lysicrates (Fig. 5-22) may be the first use of Corinthian capital on an exterior; it significantly influenced Neoclassical concepts in England and America.

■ *Moldings*. The Greeks are the first to develop and extensively use a series of moldings (Fig. 5-23) to delineate the outlines of buildings. This idea is adopted later by the Romans and continues in successive periods.

■ *Entablature*. Resting on top of columns, the entablature features a cornice, frieze, and architrave. The cornice develops from a series of three-dimensional moldings, the frieze displays the carved or painted ornamentation, and the architrave is a flat, wide band.

■ *Optical Refinements.* The Greek adoption of a series of architectural adjustments that enhance the building, create dynamism, and correct any perceived optical illusions indicates a psychological understanding of the art and perception of building not seen again until the Renaissance. After the 5th century B.C.E., most temples incorporate only some of the refinements, as they are costly and complicated to build. The Parthenon, as befits the wealth and preeminence of Athens, features the entire repertoire. *Entasis* (slight outward curve), the most common optical refinement, makes the columns appear to be responding to the weight of the entablature and counters any perception of thinness in the center of the shaft. The corner columns are thicker, spaced more closely together, and lean inward slightly to avoid the appearance of weakness or outward fall. Triglyphs and metopes space more closely outward from the center. The floor curves up about 4″ to remedy any semblance of sagging. Consequently, the architrave, frieze, cornice, and roof gables also curve, and capitals distort to fit the architrave. There are few straight lines or rectangular blocks in the building. Inscriptions closer to the viewer are smaller than those farther away, so that they all appear the same size. These refinements create a pyramid shape, which is perceived as more stable than a rectangle. Curving lines of the stylobate and entablature are more pleasing to the eye.

■ *Materials.* Early structures are made of wood cut from plentiful dense forests. Methods of construction and some detailing in wood subsequently translate to buildings of stone, the primary material for most public architecture.

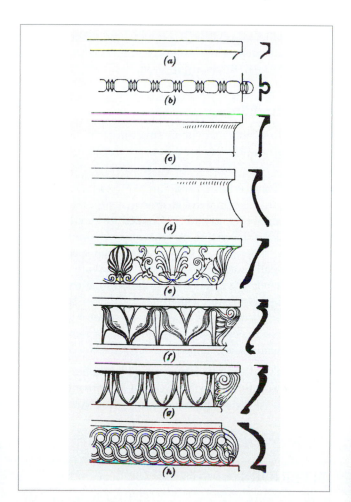

5-23. Moldings: (a) fillet (flat band); (b) bead (series of small elements); (c) cavetto (concave shape); (d) scotia (concave shape appearing at the base of a column); (e) cyma recta (concave shape above and convex shape below); (f) cyma reversa (the opposite of cyma recta); (g) ovolo or echinus (egg shaped); and (h) torus (large convex shape that is sometimes decorated with strapwork).

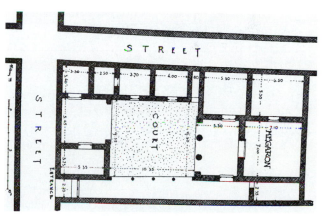

5-24. Floor plan, house, c. 4th century; Priene.

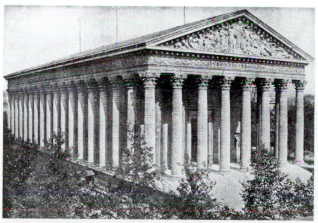

5-25. Later Interpretation: Church of the Madelaine, 1804–1849; Paris, France; by Pierre Vignon; French Empire.

Marble and limestone are chosen frequently due to availability, ease of cutting, sharp edges, whiteness, and reflectance in strong light. Stone blocks are put together with no mortar and only metal dowels or clamps. Greek buildings are trabeated (constructed using posts and lintels) until the 4th century B.C.E., when arches and barrel vaults appear behind traditional facades of some tombs and other structures.

■ *Color.* Color, which rarely survives, enhances and emphasizes the details of temples, such as moldings, friezes, and triglyphs (ornamental striped banding). It is applied in flat areas or as patterns in blue, red, black, or golden yellow. Terra-cotta (unglazed tile) also contrasts in color with stonework; different colors of stone provide contrast to white marble (Color Plate 12).

■ *Facades.* Temples (Fig. 5-10, 5-13, 5-15, 5-16) feature a columned portico, accenting the front and back of the building and providing a symbolic entry centered on a longitudinal axis. Columns creating a peristyle (colonnade) surround the building plan. Moldings (Fig. 5-23), sculpture, and paint accentuate important lines and features.

■ *Roofs.* Temple roofs pitch on center, have curved terra-cotta or marble tiles, incorporate wood ceiling joists forming a truss system, and feature antefixes (ornamental blocks covering the ends of roof tiles) and acroteria (a pedestal with ornament). A triangular pediment faces the front and back.

■ *Pediment.* Defining the building's profile, the pediment (Fig. 5-18) has a triangular shape culminating from the gabled end of the roof. The tympanum (center), often filled with three-dimensional larger-than-life figures, is surrounded by a cornice and raking (angled) cornices.

■ *Later Interpretations.* Greek temples provide inspiration for later interpretations by Andrea Palladio, Robert Adam, Thomas Jefferson, Michael Graves, and many others. Examples may represent the periods of French Empire (Fig. 5-25), and Greek Revival (Fig. 5-26, 5-27).

Private Buildings

■ *Types.* Residences are simple structures with one to four stories until the Hellenistic period when palaces begin to be built.

■ *Floor Plans.* Typical residences (Fig. 5-24) evidence symmetrical and asymmetrical arrangements of space often around a central courtyard surrounded in wealthy homes by colonnades (peristyle). Some houses feature rooms on either side of a pastas, a long, narrow open space. Vistas help to visually enlarge small spaces. Rooms are rectangular and include the kitchen, dayroom, dining rooms with couches, bedroom, and sometimes an indoor bathroom. Often, living spaces have shops at the street front. Separated spaces typically include the owner's family suite, women's quarters, and unmarried daughters' rooms.

■ *Materials.* Many houses are of mud brick, but some are of masonry or stucco. Roofs are tiled. Columns are of wood or stone in wealthy homes. Door and window frames are wooden.

5-26. Later Interpretation: Orton Plantation, early 19th century; Wilmington, North Carolina; Greek Revival.

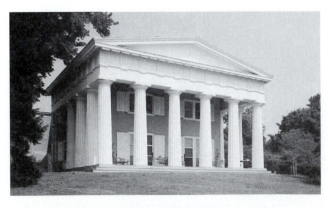

5-27. Later Interpretation: Andalusia, 1836–1838, Bucks County, Pennsylvania, by Thomas Walter; Greek Revival.

INTERIORS

Public interiors express an interconnected design relationship to exteriors, with repeats of architectural treatments, proportioning, materials, and colors. Temples feature more architectural details than residences. Few public and no private interiors survive. Information about interiors and furnishings comes from archaeology, literature, vase paintings, reliefs, and statuettes.

Public Buildings

■ *Color.* Color palettes primarily feature red, blue, and black and gradually expand as more is known about pigment mixture. Greeks use color to highlight and emphasize. Doric temples sometimes have painted, rather than carved, moldings.

■ *Floors.* Temple floors may be of stone or mosaic tiles.

■ *Walls.* In temples, the capital selection might vary from outside to inside. The entablature features brilliant painted

decoration to distinguish architectural detailing; the frieze usually has the most elaborate ornamentation. Interior decoration becomes more important in the Hellenistic period, which features complex painting schemes similar to those developing later in Pompeii, veneers of finer materials (marble and alabaster), stuccowork, or engaged columns articulating walls.

■ *Ceilings.* Ceilings are flat and beamed or coffered (sunken panels; Fig. 5-29).

Private Buildings

■ *Lighting.* Candelabras (Fig. 5-30) or floor candlesticks provide the primary source of lighting. They are made of wood and metal with decoration accenting classical motifs.

■ *Floors.* Historical studies indicate that most residential floors feature packed earth and may have important rooms accented with mosaics, a Greek innovation. Early tesserae (small components of mosaics) are made of pebbles but later are made of clay, marble, or glass. Some patterns outline important furnishings, such as dining couches, or resemble rugs with borders and central medallions. Upper floors are of wood or clay in poorer homes.

■ *Walls.* Residential interiors have walls embellished with stucco and paint. Tiers of flat color often decorate the surfaces; stylized horizontal or vertical bands of colored patterns may be added. Red is a favored color. No pictorial depictions have been excavated, but they may have existed.

■ *Ceilings.* Ceilings are flat or beamed. Cedar is especially popular because of its distinctive smell. Coffers, similar to those in public buildings, highlight some ceilings.

■ *Later Interpretations.* Variations of Greek interiors appear throughout history. Furnishings of the 1930s by

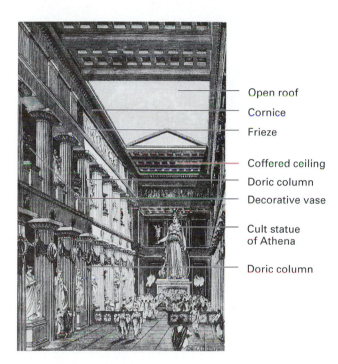

Open roof
Cornice
Frieze
Coffered ceiling
Doric column
Decorative vase
Cult statue of Athena
Doric column

5-28. Naos, Parthenon (reconstruction drawing), c. 447–436 B.C.E., Acropolis; Athens.

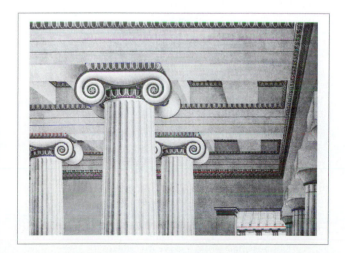

5-29. Architectural details on Greek temple.

5-30. Candelabras.

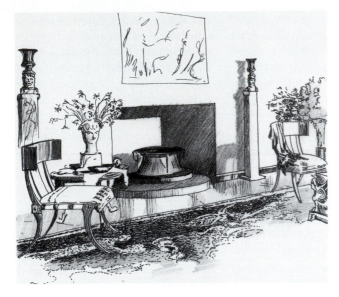

5-31. Later Interpretation: Showroom, 1936; New York, New York; furnishings by T. H. Robsjohn-Gibbings and produced by John Widdicomb in the United States.

T. H. Robsjohn-Gibbings (Fig. 5-31) were modeled from originals in Greece and produced by John Widdicomb in the United States.

FURNISHINGS AND DECORATIVE ARTS

Examples of Greek furniture and decorative arts exist in vase paintings, grave steles (upright stone), terra-cottas, theaters, and sculpture. The emphasis is primarily on function with limited embellishment. Individual pieces vary in scale and weight based on use and placement. Rooms have few furnishings.

■ *Types.* Furniture pieces include chairs, stools, chests, tables, and couches.

■ *Distinctive Features.* Animal, turned, or rectangular legs are typical. The deer and lion leg interpretation produced a quadruped leg form replicated in later periods. The rectangular leg featuring a cutout center accented with knobs and palmettes is a Greek innovation.

■ *Materials.* Furniture is constructed of wood, marble, bronze, and iron.

■ *Seating.* An important Greek innovation is the klismos (Fig. 5-32, 5-33, and Design Spotlight), a simple light chair that appears in varying forms in later periods. Throne chairs, seats of dignity, are richly decorated with inlays of gold, silver, ivory, and precious stones. Some have seats high enough to require footstools. Armchairs with animal

Design Spotlight

Furnishings: *Klismos.* The klismos (Fig. 5-32, 5-33), the most important seating example developed by the Greeks, features a curved yoke and back splat contoured to the body and outward curving legs mortised into a frame with a woven seat. Its beauty comes from its proportion and linear quality. Often found in the home, variations of this form appear in theaters as seating for aristocrats.

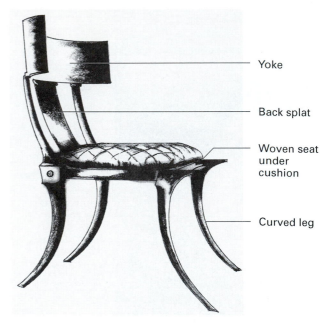

Yoke

Back splat

Woven seat under cushion

Curved leg

5-32. Klismos chair.

5-33. Klismos chair (from a grave monument).

legs and classical motifs are typical (Fig. 5-34). The most common seating piece is the diphros, a rectangular stool with four shaped legs and a seat of woven leather or plant thongs, sometimes topped with a cushion (Fig. 5-35). Another stool form derived from Egyptian influence has an X-shaped folding base.

■ *Tables.* Primarily used for meals, tables (Fig. 5-36, 5-37) have round or rectangular tops with animal legs for bases. Some have stretchers. Tables, used to serve food, slide under couches when not in use.

■ *Storage.* Chests for storage change from rectangular boxes with paneled sides to ones with arched lids. Small objects for daily use are stored on shelves or hung on walls.

■ *Beds.* The *kline* or couch (Fig. 5-38) is for sleeping or for reclining during meals and at other times. A Greek innovation, it usually has a mattress stuffed with feathers or

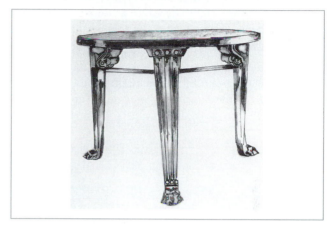

5-36. Three-legged table.

5-34. Armchair.

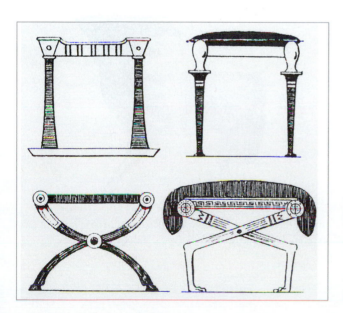

5-35. Greek stools.

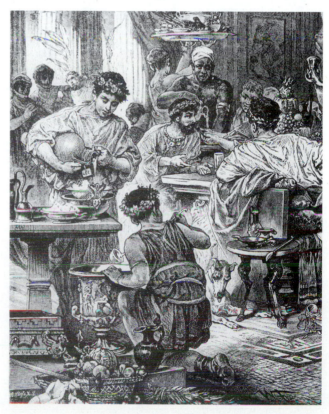

5-37. Interior for dining.

straw. Couch legs, unlike those of thrones, often are raised on bases. The head, which is higher, features a volute.

■ *Textiles*. Greek textiles, as seen in vase paintings, are especially fine. Common documented materials include wool, linen, and some silk. They are woven by women at home or by men in commercial enterprises for trade. In the home, textiles hang flat or gathered on walls, at door openings, or around beds and are often used as cushion and bed covers. Colors are rich and saturated, and designs may be woven, painted, embroidered, or a combination. Common documented dye colors are purple, saffron, crimson, violet, and green.

■ *Pottery*. The most important example of Grecian decorative arts is the beautiful ceramic pottery, used as household objects or for interior decoration. Clay vases (Fig.

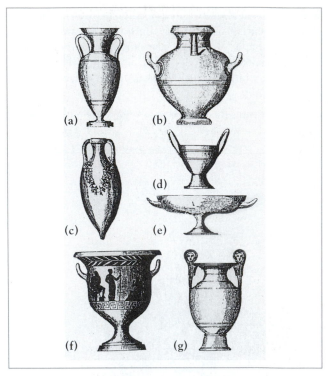

5-40. Greek vases: (a) amphora (storing wine); (b) hydria (water jar); (c) amphora; (d) kantharos (drinking cup); (e) kylix (mixing wine and water); (f) bell krater (vessel for mixing); and (g) volute krater.

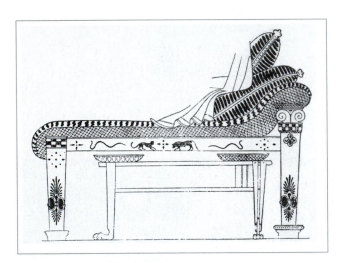

5-38. Couch.

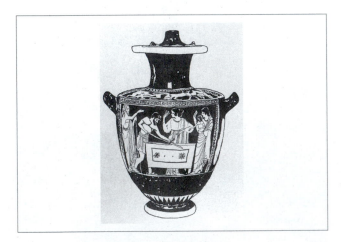

5-39. Vase with chest.

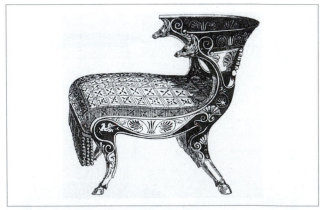

5-41. Later Interpretation: Curule chair, c. 1851; Italian; exhibited at the Great Exhibition, London, 1851.

5-42. Later Interpretation: Elgin Major side chair, 1990s; Nierman Weeks; United States.

5-39, 5-40) vary in shape and size, are wheel thrown, and may have extensive surface decoration. Black, red, and cream colors provide the typical palette. Vases often feature furniture, people, and motifs. They are a primary source of historical information, as surviving furnishing examples are rare.

■ *Later Interpretations.* The **X**-form stool serves as a precursor to the Roman sella curulis as well as later examples evolving during the 15th through 20th centuries. Interpretations of the klismos chair and reclining couch develop during the late 18th and early 19th centuries (Fig. 5-41) due to an increased interest in antiquity. New materials inspire mass-produced variations in the late 20th century (Fig. 5-42). Pottery forms serve as images for inspiration throughout history.

6. Rome

509–27 B.C.E., Roman Republic; 96–180 C.E., Height of the Roman Empire

Architecture depends on Order, Arrangement, Eurythmy, Symmetry, Propriety, and Economy.

Pollio Marcus Vitruvius, *The Ten Books on Architecture*, 1st century C.E.

Ancient Rome, the center of a great empire, assimilates a mixture of cultures and ideas, principally from the Greek colonists to the south and the Etruscans to the north. She interprets them with imagination and innovation. As with Greece, the visual images establish a language and grammar for architecture, interiors, furniture, and decorative arts copied by successive generations. Romans are the first to use extensively the arch and vault and concrete as a building material. Rome's influences spread through Western civilizations in many ways. Many modern legal systems follow Roman government, Latin forms the base of the romance languages, and Roman urban planning concepts define many modern cities.

6-1. Roman woman's costume.

HISTORICAL AND SOCIAL

During the 7th and 6th centuries B.C.E., the Etruscans settle Etruria (north and central Italy) and the Greeks inhabit the southern coastal regions of what is now Italy. Close trading relations exist between the two cultures, and the mixture of Etruscan traditions with Greek influences creates a distinctive style of architecture and wall painting. Beginning in 750 B.C.E. Latin-speaking peoples inhabit the early village of Rome. By 509 B.C.E., the Romans overthrow the last Etruscan king and establish the Roman Republic that is governed by a Senate composed of wealthy citizens (patricians). Through various alliances and conquests, the Romans control the entire Italian peninsula by 275 B.C.E. Territorial expansion continues beyond Italy to the Mediterranean, as well as modern France and Spain.

Immense growth eventually strains Republican government and resources, and civil wars threaten the empire. In 46 B.C.E., Julius Caesar emerges victorious and establishes himself as dictator. After his assassination in 44 B.C.E., his heir Octavian takes over governmental reigns. In 27 B.C.E., he assumes the title of Augustus, the supreme ruler of the empire. When Augustus becomes *Pontifex Maximus*, the highest religious official, in 12 C.E., he lays the foundation for worship of the emperor as god of the state. A powerful ruler, Augustus ushers in the *Pax Romana*, 200 years of peace and stability. Rome's subsequent history is of a series of dynasties and individual emperors, good and bad, tyrannical and benevolent.

The empire is at its largest under Trajan (98–117 C.E.), but internal strife and disorder, civil wars, economic instability, and sheer size contribute to its downfall. After splitting into western and eastern segments after 330 C.E., the western division continues in decline until 476 C.E. when a Germanic chief seizes power. The eastern portion survives as the Byzantine Empire until 1453 when its surrenders to the forces of Islam.

At its height, the Roman Empire occupies about half of Western Europe as far north as modern Scotland, most of the Middle East to the Persian Gulf, and the entire northern coast of Africa. It is a vast land area, but the city of Rome remains its heart. Law and government unite its diverse population of 50–70 million inhabitants. To further allegiance and unity, the government engages in vast building campaigns of temples, baths, structures for public entertainment, and public works such as roads to move troops and people and aqueducts for water. Emperor worship also intends to unite its diverse citizenry.

Society's upper class (patricians) comprises the wealthiest individuals and members of the Senate. Citizens and slaves form the lowest and largest class (plebeians). Families are patriarchal. As long as their father lives, sons cannot own property or have legal authority over their own children. Extended families make up most households. Parents arrange marriages, often for economic benefits. Women have few rights until the 1st century C.E. Many have a formal education; some become shopkeepers, physicians, or writers. Romans are polytheistic, worshipping their own and Greek gods whom they give Roman names. Some adopt the religions of their conquered peoples. Christianity becomes the empire's official religion in 312 C.E. Recreation is important to the Romans as numerous public buildings and entertainment spaces testify.

CONCEPTS

Roman art and architecture has neither the timeless consistency of Egypt nor the stylistic development of Greece. Distinctly different, art and architecture is much like Rome itself—a melting pot of diverse influences and cultures, aggressively interpreted, and lavish in form and decoration. Art is secondary to the Romans who regard it a means to glorify the empire, commemorate its exploits, and unify its peoples. Consequently, few artists or architects are known. Despite their borrowings from others, the Romans develop their own classical language and forms visibly expressed in architecture, sculpture, and decorative arts. Art standardizes throughout the empire, but room for regional interpretations remains evident.

Although influenced by Greek and Etruscan developments, Roman architecture expresses a new engineering genius with a building image that is more complex, decorative, and diverse. Roman architecture develops its own classical grammar, adopts arches and vaults, and uses concrete to create a variety of building types to suit its cosmopolitan society. Vitruvius (born c. 70 B.C.E.), official architect to the emperor Augustus, codifies the Greek proportional systems through his *Ten Books on Architecture*, an architectural guidebook of design standards for provincial builders throughout the empire. The earliest surviving architectural treatise, it becomes the major reference on classical architecture both then and later.

DESIGN CHARACTERISTICS

Classical elements and attributes developed in Greece appear in Roman art but are often reinterpreted according to Roman thought. Roman buildings maintain ordered spatial arrangements, have more lavish decoration, and illustrate more variety in design than Greek or Egyptian

buildings (Fig. 6-6, 6-11). Builders develop two additional orders and pay homage to classical language by using elements of the post and lintel system (columns, entablatures) on exteriors. The Romans are the first to make widespread use of the round arch. Arches, vaults, and domes of concrete liberate buildings from rectilinearity and enable builders to create monumental open interior spaces. They explore relationships among spaces of different scales, shapes, and sizes, beginning in imperial palaces and continuing in large public buildings. Roman design history reflects developing technology and increasing sureness in construction.

- *Republican* (510–60 B.C.E.). During this age of expansion, Etruscan influence is strong early, but Grecian forms and elements begin to dominate after 146 B.C.E. when Greece is conquered. Romans use the Greek orders, particularly Corinthian, but with different proportions. The 1st and 2nd centuries B.C.E. feature the main advancements in arched construction and builders' mastery of concrete.

- *Early Imperial or Late Empire* (60 B.C.E.–285 C.E.). Builders continue to develop arcuated (arched) construction and master concrete as a building material. They introduce new building types such as basilicas and amphitheaters. Standardization of forms and decoration occurs throughout the empire, although some regional differences appear.

- *Late Imperial or Late Empire* (285–395 C.E.). Interiors are often more important than exteriors as builders explore the relationships among spaces of different sizes and shapes. Large-scale public building campaigns continue despite economic difficulties and the empire's decline. Materials are increasingly reused as the empire declines.

- *Motifs*. Many motifs derive from Greece, such as the human figure (Fig. 6-1, 6-4, 6-5), acanthus (Mediterranean plant; Fig. 6-2, 6-5), rosette (Fig. 6-2), rinceau (Fig. 6-3, 6-5), swan, eagle, monopodium (head and chest of a lion attached to a paw), lion (Fig. 6-42, 6-44, 6-45), oxen, sphinx, griffin, grotesque, arabesque (plant pattern with curving lines and tendrils, often symmetrical with vertical shape), wave pattern, festoon, anthemion, fret, laurel wreath, and architectural details (Fig. 6-31).

6-2. Acanthus leaf with rosette.

6-5. Marble ornament with vase and classical motifs.

6-3. Rinceau.

6-6. Structure, Theater of Marcellus, 23–13 B.C.E.; Rome, Italy.

6-4. Cameo.

ARCHITECTURE

Roman architecture is a synthesis of forms adopted from its conquered peoples and its own innovations. Temple forms and the arch come from the Etruscans who are early inhabitants. The orders, other classical elements, and increased refinement develop from Greek sources. Architecture illustrates spatial innovation made possible by Roman engineering abilities, concrete as a building material, arches and vaults, and domes spanning great spaces. Developing technology and sureness in construction produce many building types quickly and efficiently. Designers use Greek classical language but develop their own grammar. Public buildings often glorify the state and the emperor, while domestic buildings reflect the Roman fondness for comfort and luxury.

Public Buildings

■ *Types.* Rome's complex civilization demands numerous building types such as temples, forums, basilicas, theaters, amphitheaters, circuses, coliseums, baths, gymnasiums, palaces, and aqueducts (water supply system).

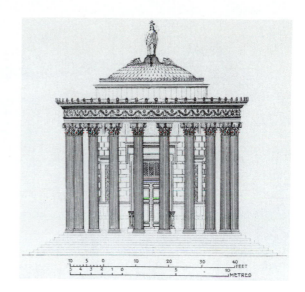

6-7. Circular temple (with reconstruction drawing), Roman Forum, 1st century B.C.E.; Rome, Italy.

Important Buildings and Interiors

- **Nîmes, France:** Maison Carrée, c. 1–10 C.E.
- **Palestrina, Italy:** Sanctuary and Temple of Fortuna Primigenia, late 2nd century B.C.E.
- **Pompeii, Italy:**
 —House of Vetti, 62–79 C.E.
 —Villa of Mysteries, c. 60–50 B.C.E..
- **Rome, Italy:**
 —Arch of Titus, after 81 C.E.
 —Baths of Caracalla, 212–216 C.E.
 —Circus Maximus, 1st century B.C.E.
 —Colosseum, c. 72–80 C.E.
 —Domus Aurea (Golden House), 4–68 C.E.
 —Forum of Augustus, late 1st century B.C.E.
 —Forum, Basilica, and Market of Trajan, c. 100–112 C.E.
 —Apollodorus of Damascus.
 —Forum of Caesar, begun 51 B.C.E.
 —Pantheon, 118–125 C.E. (Color Plate 13)
 —Theater of Marcellus, 23–13 B.C.E..
- **Spalato, Yugoslavia:** Palace of Diocletian, c. 300–305 C.E.
- **Tivoli, Italy:**
 —Hadrian's Villa, c. 130–138 C.E.
 —Temple of Vesta, early 1st century B.C.E.

- *Forum.* The forum (Fig. 6-13) in the center of a city is the core of religious, civic, and social life. Housed here are religious and public buildings as well as markets and colonnades. At one end stands the chief temple. Early forums feature regular plans, but later ones are irregular as each emperor adds a monument to himself. Nevertheless, strict axial alignment and vistas are maintained. Relationships among individual buildings are not as carefully orchestrated as in Greece.

- *Temples.* Roman temples range from small and individual to large complexes and create a vista or focal point by being set on a longitudinal axis. They are usually in the forum, but may be scattered throughout the city and countryside. Like the Greeks, Romans typically pay homage to a particular god. While the functional attribute of the god

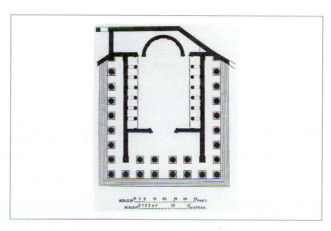

6-8. Floor plan, Temple of Mars Ultor, late 1st century B.C.E. to early 1st century C.E.; Rome, Italy.

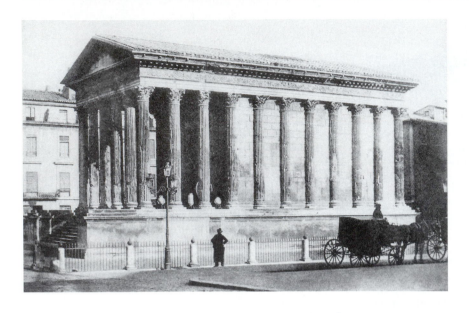

6-9. Maison Carrée, c. 1–10 C.E.; Nîmes, France.

may be the same in both countries, the Romans develop new names such as Jupiter (instead of Zeus; king of the gods, sky), Venus (instead of Aphrodite; love, beauty), Phoebus (instead of Apollo; sunlight, reason), and Mercury (instead of Hermes; messenger, travel). Roman temples (Fig. 6-7, 6-8, 6-9, 6-10, 6-18, 6-19, 6-27) combine Etruscan and Greek characteristics into a unique form. Most rise from the ground and rest on a podium, an Etruscan characteristic. Entrance is by a single set of stairs on one end through a porch in the Etruscan manner to a windowless cella that houses the deity and trophies of conquest. Rectangular temple floor plans resemble the Greek prostyle plan (columns in front), but Roman structures have engaged columns on three sides creating the impression of a peristyle (pseudo-peripteral). Some temples have round plans with or without columns. Two of the best known Roman temples are the Pantheon (round; Fig. 6-18) and the Maison Carrée (rectangular; Fig. 6-9).

Design Practitioners

■ Despite the many large urban building programs undertaken by Roman emperors, few names of Roman architects, artists, designers, and cabinetmakers are known. Organized by specializations, craftsmen form guildlike groups of which membership passes from father to son. Standardized construction and furnishings suggest that craftsmen, designers, architects, and cabinetmakers traveled all over the empire. Treatises and pattern books probably helped systematize design as well as techniques.

■ *Apollodorus of Damascus.* Architect for Emperor Trajan (97–117 C.E.), he constructs baths, bridges, and markets.

■ *Celer and Severus.* Architects of Nero's (54–68 C.E.) Golden House, they create a country villa in the heart of Rome with its own artificial lake, revolving banquet hall, and baths.

■ *Vitruvius.* A Roman architect of the 1st century B.C.E., he builds the Basilica of Fano and works under Emperor Augustus to rebuild Rome. Vitruvius's treatise, *De Architectura*, is the only surviving architectural treatise from antiquity. In it, he defines good architecture and promotes technical training and theoretical understanding for architects. The book opens with descriptions of the functions and types of architecture and the training of architects and continues with various subjects including building materials, temples, public buildings, residences, the orders, walls, floors, ceilings, and stuccowork. It does not cover concrete, arches, and interior space, for which Roman architecture is known. Written evidence indicates that architects still used the treatise in the 3rd and 4th centuries, and it becomes the main authority on ancient architecture for Renaissance architects such as Leon Battista Alberti.

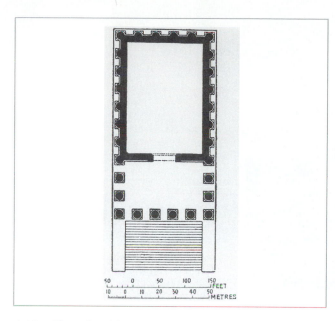

6-10. Floor plan, Maison Carrée.

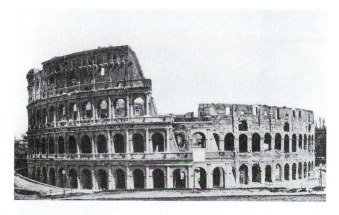

6-11. The Colosseum, c. 72–80 C.E.; Rome, Italy.

6-12. Section and elevation, the Colosseum.

■ *Basilicas*. Basilicas (Fig. 6-13, 6-20), used for religious, legal, and meeting purposes, feature large central rectangular spaces with lower side aisles, clerestory windows, and usually an apse on one end. Developing from Hellenistic Greece and first appearing in the Roman Forum, basilicas adapt to church forms in the 4th century C.E.

■ *Public Baths*. Early baths are modest, but during the late Republican and early Imperial periods they become increasingly monumental and imposing (Fig. 6-28, 6-29). Romans use them for bathing, exercising, relaxing, and socializing. Public baths maintain axial symmetry and sequential space planning with numerous domed and vaulted, small and large spaces. The variety of spaces within lends itself to innovations in space planning.

■ *Public Entertainment*. Types include amphitheaters (double theaters), theaters (Fig. 6-6), circuses or hippodromes for racing, and stadiums. Concrete vaulting makes these

6-13. Forum, Basilica, and Market of Trajan (reconstructed 19th-century view), c. 100–12 C.E.; Rome, Italy.

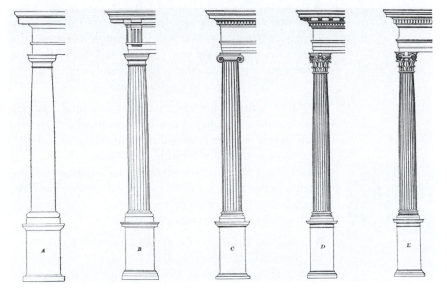

6-14. Columns: (A) Tuscan, (B) Doric, (C) Ionic, (D) Corinthian, and (E) Composite.

large structures possible. The Flavian Amphitheater or Colosseum (Fig. 6-11, 6-12) has numerous barrel-vaulted corridors that support the seating and move spectators in and out of the arena. Roman theaters resemble Greek theaters in form, but rise from the ground instead of emerging from a hillside.

■ *Site Orientation.* A forum, basilica, and market (Fig. 6-13, 6-20) usually define a city center. Colonnades and public buildings form the other sides. Most Roman cities are organized on a grid system, which is emulated even today.

■ *Classical Orders.* Romans adopt the classical language of Greek architecture, such as entablature, column, and pediment. They often use elements of the post and lintel system (columns, pediments) to organize exteriors or for

articulation or decoration. An example employed from late Republican times is the arch order, a motif of engaged columns (column attached to a wall; circular in section view) carrying an entablature framing an arch (Fig. 6-6, 6-11). The arch order on multistory buildings features Doric over Ionic over Corinthian engaged columns.

■ *Column.* Like the Greek prototype, the Roman column (Fig. 6-14) has a distinguishing capital, a shaft (vertical post), and a base. The base may be raised to form a pedestal. Romans use columns more decoratively than the Greeks.

■ *Capitals.* The Romans use all Greek orders, but with different proportions. For example, their Ionic capital (Fig. 6-15) is smaller in scale than the Greek Ionic and has a four-sided volute (spiral scroll) capital. They also intro-

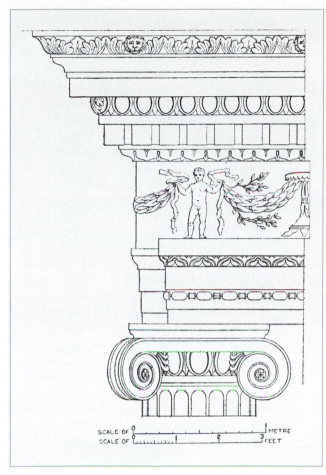

6-15. Roman Ionic order.

6-16. Roman Corinthian order.

duce the Tuscan and Composite orders. The Tuscan column, based on the Greek Doric column, has a smaller capital, a molded base, and no fluted shaft. The Composite column (Fig. 6-17) resembles the Corinthian (Fig. 6-16), but the capital integrates volute forms with acanthus leaves.

■ *Podium.* The podium replaces the Greek stylobate, forms the base of the temple (Fig. 6-9), and raises the building several feet from the ground. This idea later translates in the interiors as the dado (lower wall area) or wainscot (facing applied to the lower portion of the wall). Examples of this appear beginning in the Renaissance and continue to the present.

■ *Arches, Vaults, and Domes.* Romans adopt round arches to span openings and articulate the exterior ordering (Fig. 6-11, 6-18, 6-21, 6-27, 6-28), often repeating them in sequence, as shown in an aqueduct. A true arch consists of wedge-shaped blocks called voussoirs, with the top center one identified as a keystone. The Romans introduce arcades (a series of arches carried on columns) in the Late Imperial period. The arch may develop into a barrel (tunnel) vault, groin (cross) vault, or dome (hemispherical round shape vault set on a circular or square base). Round domes may cover small rectangular spaces or large round ones.

■ *Materials.* Materials include brick, concrete, marble, travertine, tufa, and granite. Stucco, marble, or stone cover concrete or brick walls. Builders use trabeated and arcuated construction systems. Color comes primarily from building materials, unlike Greece or Egypt.

■ *Concrete.* Concrete, an important and easy-to-use building material perfected by the Romans (Fig. 6-11, 6-18), supplies the architecture's distinctive character. A composition of gravel and rubble in a mortar of lime and sand, concrete often has stones, brick, or tiles embedded in it. Wood frames shape the concrete form, which is a faster and more economical building method than stonecutting. It also relies less on skilled labor. Concrete's greater cohesion can, when combined with arches and vaults, span great distances. Thus, it creates an architecture of space in

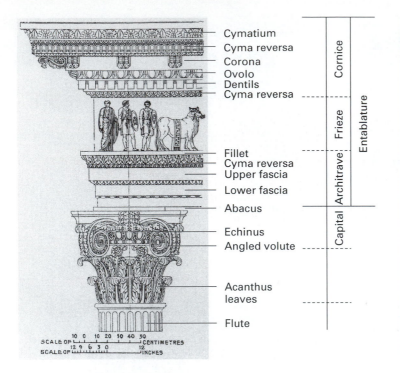

Cymatium
Cyma reversa
Corona
Ovolo
Dentils
Cyma reversa

Cornice

Fillet
Cyma reversa
Upper fascia

Frieze

Entablature

Lower fascia

Abacus

Architrave

Echinus
Angled volute

Capital

Acanthus
leaves

Flute

SCALE OF
SCALE OF

6-17. Roman Composite order.

a previously unknown scale. Marble, stucco, or brick cover concrete walls, a somewhat less honest aesthetic than Greek marble. Brick veneer dominates in the Late Imperial period. Concrete also gives architectural unity throughout the empire.

■ *Facades.* Exteriors are treated three ways: with structural or engaged columns, with arches and engaged columns on piers, or with little or no articulation. Limited articulation is common on structures whose exterior shapes reflect complex interior planning. Roman buildings have less

Design Spotlight

Architecture: *The Pantheon.* One of the best known Roman temples is the Pantheon (Fig. 6-18, 6-19, 6-27, Color Plate 13), dedicated to the gods representing the planets. As a masterpiece of Roman technical achievement and influence, its portico has a pediment supported by Corinthian columns. Behind it, a concrete rotunda culminates in a dome. The full potential of concrete as a building material is recognized here. In contrast to the sculptural exterior of the Greek Parthenon, the Pantheon exterior is plain and simply articulated with three string courses and a cornice. The plan shows the juxtaposition of the round domed cella and rectangular entrance porch, which was originally masked by a colonnaded forecourt. The circular space features alternating circular and rectangular niches that held statues. The interior is a hemisphere as high as it is wide. It boasts decoratively patterned marble floors, engaged columns and pilasters embellishing the walls, and niches with classical figures, in contrast to the plain interiors of the Greek Parthenon. The entablatures visually separate the wall plane from the domed ceiling. An oculus (opening in the center of the dome) allows in light and reduces weight at a critical point. The ceiling is coffered in repetitive geometric shapes. The coffers in the dome originally were covered with blue stucco and gilded rosettes.

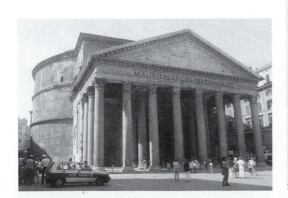

6-18. Pantheon, 118–125 C.E.; Rome, Italy. (Color Plate 13)

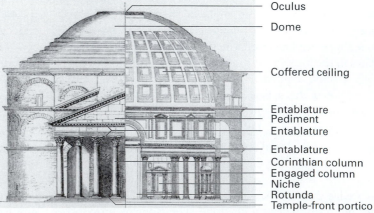

Oculus

Dome

Coffered ceiling

Entablature
Pediment
Entablature

Entablature
Corinthian column
Engaged column
Niche
Rotunda
Temple-front portico

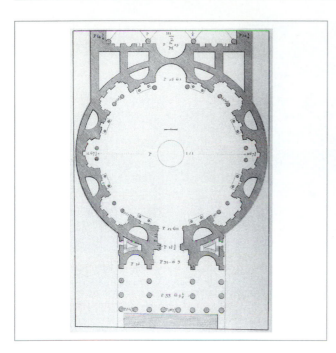

6-19. Floor plan, Pantheon.

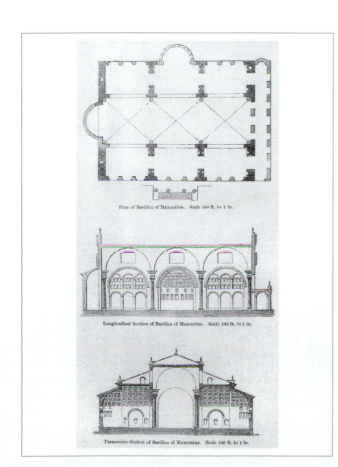

6-20. Basilica of Maxentius.

6-21. Aqueduct (carries water to towns and cities), early 1st century to early 2nd century C.E.; Segovia, Spain.

6-22. Insula (reconstructed view), 2nd century C.E.; Ostia, Italy.

sculpture than Greek buildings, but are similarly articulated with a variety of moldings. In the 1st century C.E., the Romans deviate from Greek classical repose by introducing concave and convex movement on facades, and broken pediments and entablatures.

■ *Windows.* Rectangular and arched windows and openings are common on many public buildings, although some, such as temples, have none. Baths feature rows of rectangular, arched, or thermae windows, a semicircular form divided by two mullions into three lights.

■ *Roofs.* Roofs are usually flat, double pitched, domed, or vaulted.

■ *Later Interpretations.* Thomas Jefferson used the Maison Carrée as a model for the Virginia State Capitol (Fig. 6-25, 28-4) and the Pantheon as a model for the Rotunda at the University of Virginia (Fig. 28-11). Roman public buildings are copied or interpreted extensively throughout history, particularly during the Italian Renaissance, Late Georgian, Greek Revival, Classical Revival, Post Modern, and late 20th century (Fig. 6-26) periods.

6-23. Villa Papyri (reconstruction at the Getty Museum, California); Herculaneum, Italy.

Private Buildings

■ *Types.* Residential buildings include villas (country farms and mansions), *domuses* (private houses), and *insulae* (apartment blocks).

■ *Site Orientation.* Imperial palaces, often vast complexes of numerous structures, and *villas* (country farms and mansions) develop from the landscape. Roman towns have numerous *insulae* (apartment houses; Fig. 6-22) where most city dwellers live. These complexes are up to four stories high and have light wells or courtyards in the center. Apartments vary in size from one or two rooms to occupying several floors. Housing often fronts on the street with shops on the ground floor. Rome has few *domuses* because of the high cost of land.

■ *Palaces and Villas.* Palaces and luxury *villas* feature a variety of room shapes, including octagonal and circular, with separation of public and private spaces and often with two distinct levels. Space planning emphasizes a sequential ordering, usually based on room size and use.

■ *Domus.* Villa (Fig. 6-23) and *domus* (private house; Fig. 6-24) plans are similar as depicted in extant examples mostly from the 1st century C.E. Entering from a vestibule, they focus inward to the open atrium (Fig. 6-30; derived from the Etruscans). The atrium serves as a forecourt and features a *impluvium* (central pool) where rainwater collects from the sloping roof. Larger atriums may have columns supporting the roof opening (*compluvium*). Smaller rooms surround the atrium, including the tablinium, usually on the main axis, which serves as an office or master bedroom. The atrium usually connects to a *peristyle* (Fig. 6-23, 6-24; open courtyard, derived from the Greeks) which creates a vista, adds light, and is a cool, pleasant

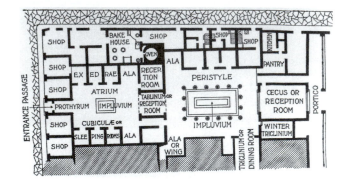

6-24. Floor plan, House of Pansa, 1st century C.E.; Pompeii, Italy.

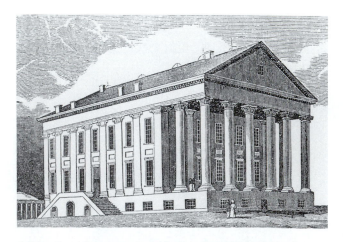

6-25. Later Interpretation: Virginia State Capitol (the first example of an American public building in a Roman temple form), 1785–1788; Richmond, Virginia; by Thomas Jefferson; Federal; Jeffersonian classicism.

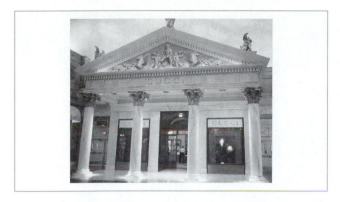

6-26. Later Interpretation: Gucci Store at Caesars Palace, 1990s; Las Vegas, Nevada.

garden space. It usually has a fountain or pool, statues, paintings, and mosaic floors and is surrounded by a covered walkway. The *peristyle* may be surrounded by *cubicula* (sleeping rooms; Fig. 6-31) with a *triclinium* (dining room; Fig. 6-32), kitchen, and service areas nearby.

■ *Facades*. The exterior of domestic buildings generally has little or no articulation. The windows are usually small and high in the wall. Some paintings at Pompeii depict homes with richly treated entrances and/or roof gardens.

■ *Later Interpretations*. The Roman *domus* with its atrium and *peristyle* emerges as a dominant domestic house form for numerous centuries. Sequential space planning of places has a significant impact on Italian Renaissance interiors as well as those of the Neoclassic period.

INTERIORS

Roman interiors, particularly domestic, were largely unknown until the discovery of Pompeii and Herculaneum, two Greco-Roman cities buried by the eruption of Mount Vesuvius in 79 C.E. Excavated beginning in the mid-18th century, these environments reveal a detailed record of early material culture. In contrast to Greek interior decoration, Roman interior decoration is more lavish and varied. Interiors and their decoration are important features of many public and domestic buildings. Spaces vary from luxurious to utilitarian in scale and treatment.

Public Buildings

■ *Color*. Bright and bold colors enliven dimly lit interiors. Typical colors include black, gold, rust, Pompeiian red, turquoise, and green (Fig. 6-31, Color Plate 14).

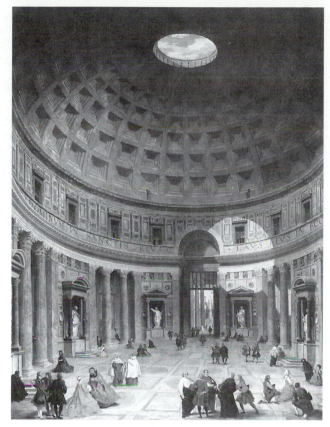

6-27. Pantheon, 118–125 C.E.; Rome, Italy.

■ *Lighting*. Torches, candles, and lamps provide minimal light. Lamps (Fig. 6-37) are made of bronze, lead, wrought iron, gold, silver, glass, stone, or pottery.

■ *Floors*. Floor materials vary from brick to terra-cotta, mosaics, and marble (Fig. 6-31). Combinations of circles and rectangles are common.

■ *Walls*. The interior relates to the overall form of the exterior, but may emphasize decoration over function. Only public buildings, the grandest rooms in villas, and a few domestic spaces feature orders, niches, real and painted columns, pilasters, and moldings to either articulate or order the walls. Walls may be ordered like the exterior (Fig. 6-28). Brightly colored marbles, mosaics, painting, and gilding decorate walls and ceilings. Niches holding sculptures and fountains are common. Doors in temples and other public structures are often of bronze, gilded or otherwise decorated.

■ *Ceilings*. Ceilings with barrel and cross vaults are common in public buildings. They are likely to be coffered (sunken panel) and gilded or painted (Fig. 6-27, 6-28). Those in temples and basilicas are flat and beamed or coffered.

6-28. Baths of Caracalla (reconstructed drawing of frigidarium), 212–216 C.E.; Rome, Italy.

6-29. Floor plan, Baths of Carcalla.

Private Buildings

Floors. Many materials cover floors—brick, terra-cotta, marble (in wealthy spaces), black stone (cement with charcoal dust), and mosaics. The Romans fully develop mosaic techniques and use many materials and patterns including geometric, deities, animals, masks, and portraits. Some mosaics resemble rugs or relate to ceiling designs. Imported rugs from the East and animal skins also cover floors.

6-30. Atrium (reconstructed drawing).

■ *Walls.* Some *domuses* and *villas* feature elaborate interior decoration to expand and lighten space (Fig. 6-22). Frescoes enliven public rooms in houses whose walls divide into dado, fill, and frieze (Fig. 6-23, 6-25, 6-26). Paintings vary from imitations of marble to trompe l'oeil renderings of architecture or landscapes, portraits, still lifes, and narratives. Wall mosaics may have brighter colors than floor mosaics. Another common treatment is low-relief stucco decoration of compartmentalized colored and plain backgrounds with raised designs.

■ *Pompeiian Wall Painting.* Pompeiian interiors feature elaborate wall frescoes of varying designs. Four styles have been identified. The First Style resembles marble or masonry panels. The Second Style (Fig. 6-31, 6-34, Color Plate 14) features architectural illusionism with realistic renderings of architecture against vistas of towns, cities, and sky. The architecture is weighty and substantial. The Third Style (Fig. 6-35, 6-36) has solid black, blue, and white backgrounds against which small paintings and illusionistic, attenuated architecture seem to float. Crowded, complex compositions of illusionistic architecture, vistas, and wall paintings characterize the Fourth Style (Fig. 6-36, Color Plate 15).

■ *Doors and Windows.* Imperial palaces often feature doors of bronze, gilded or otherwise decorated, while those in houses are of wood. Colorful fabrics sometimes substitute for doors. Draperies and awnings in the atrium and *peristyle* give sun protection. Shutters and blinds are more common than curtains. Glass panes appear during the 1st century C.E.

■ *Ceilings.* Ceilings may be brightly painted, gilded, or plain. Some have mosaics or low-relief stucco decoration.

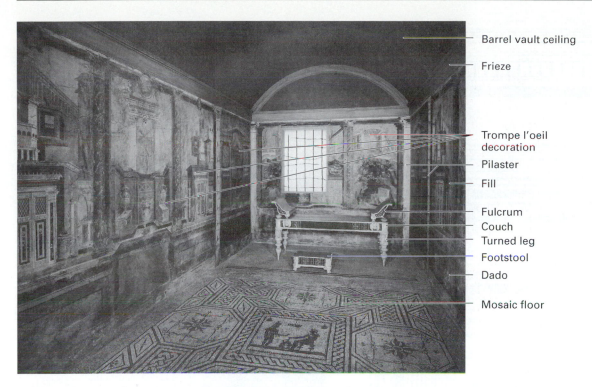

Barrel vault ceiling

Frieze

Trompe l'oeil decoration

Pilaster

Fill

Fulcrum

Couch

Turned leg

Footstool

Dado

Mosaic floor

6-31. *Cubiculum*, c. 40–30 B.C.E.; Boscoreale, near Pompeii, Italy. [Courtesy of the Metropolitan Museum of Art, Rogers Fund, 1903. (03.14.13) Gift of J. Pierpont Morgan, 1917. (17.190.2076) Anonymous gift, 1945. (45.16.2)] (Color Plate 14)

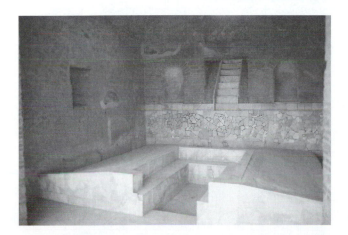

6-32. *Triclinium* (dining room); Pompeii, Italy.

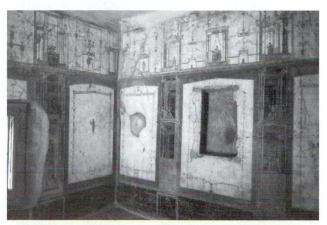

6-33. Interior; Pompeii, Italy. Pompeiian interiors feature elaborate wall frescoes of varying designs.

■ *Later Interpretations*. Pompeiian interiors serve as important sources of design inspiration throughout the Renaissance and the Neoclassical periods in the late 18th and early 19th centuries. The Etruscan Room at Osterley Park (Fig. 6-38, Color Plate 68) was inspired by the 18th-century excavations of Pompeii and Herculaneum. French Empire (Fig 6-39) emulates Roman motifs and forms mixed with Greek and Egyptian features. Late 19th century designers reinterpret interior features of public and private buildings such as the Roman bath (Fig. 6-40).

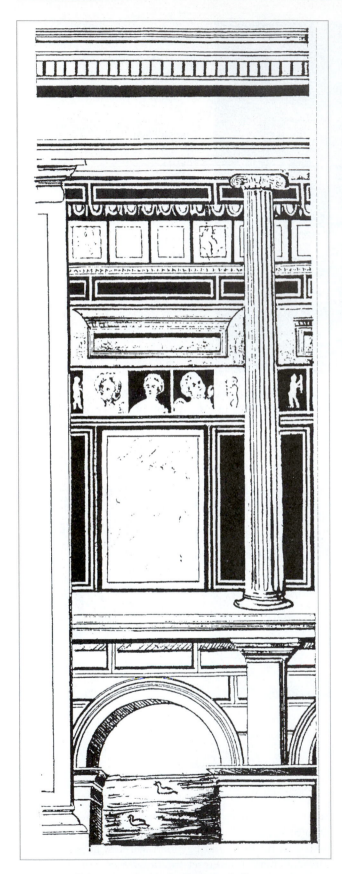

6-34. Wall fresco, second style; Pompeii, Italy.

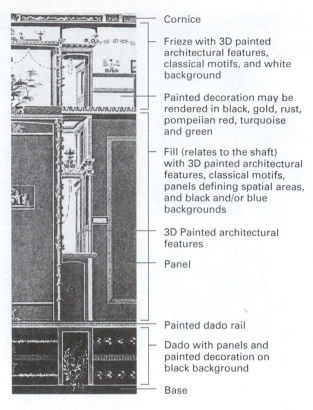

Cornice

Frieze with 3D painted architectural features, classical motifs, and white background

Painted decoration may be rendered in black, gold, rust, pompeiian red, turquoise and green

Fill (relates to the shaft) with 3D painted architectural features, classical motifs, panels defining spatial areas, and black and/or blue backgrounds

3D Painted architectural features

Panel

Painted dado rail

Dado with panels and painted decoration on black background

Base

6-35. Wall fresco, third style, c. 50 C.E.; Pompeii, Italy.

6-36. Wall frescoes, third and fourth styles; Pompeii, Italy. (Color Plate 15)

6-37. Lamp stands.

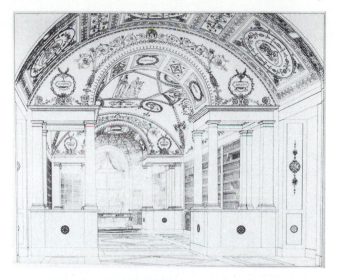

6-39. Later Interpretation: Library, Chateau Malmaison, 1827; near Paris, France; interiors by Percier and Fontaine in the early 19th century; French Empire.

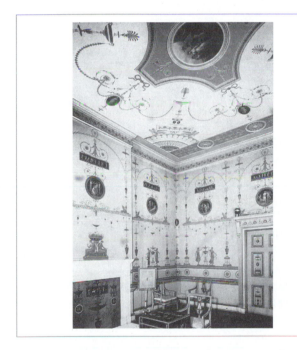

6-38. Later Interpretation: Etruscan dressing room, Osterley Park, 1761–1763, room completed in 1779; Middlesex, England; by Robert Adam with decoration by artist Angelica Kauffmann; Late Georgian. (Color Plate 68)

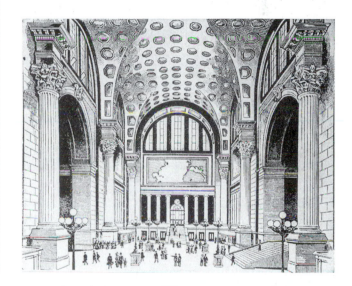

6-40. Later Interpretation: Waiting room, Pennsylvania Station, 1910; New York City, New York; by McKim, Mead, and White; Beaux Arts.

FURNISHINGS AND DECORATIVE ARTS

Examples of Roman furniture and decorative arts may be seen in wall paintings, sculpture, tombs, and extant relics. Romans adapt Greek furniture forms and motifs to suit their taste for luxury. Furniture shapes and forms are similar throughout the empire. Most furniture pieces, especially luxury items, evidence large scale and grand proportions. Rooms are sparsely furnished until the Late Imperial period.

■ *Types*. Furniture types include thrones, footstools, couches, tables, and storage cabinets. Innovations include the couch with a back, barrel-shaped tub chair, and distinctive table forms.

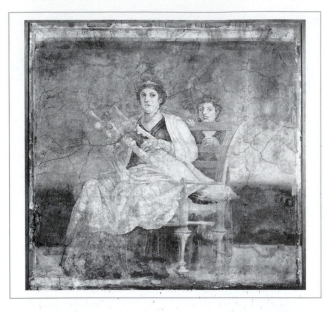

6-41. Lady playing the cithara, from the Villa at Boscoreale, 1st century C.E.; Italy.

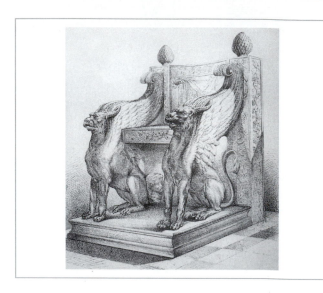

6-42. Roman white marble chair.

■ *Distinctive Features.* Legs are turned, rectangular, and shaped like animal legs, including the quadruped (deer-shaped with hoof; Fig. 6-43).

■ *Materials.* Woods include maple, cedar, and oak. Citron and ebony are highly prized. Some pieces, particularly tables, are of metal, marble, or other stone. Construction is sophisticated and refined. Decoration includes veneer, metal plating, inlay, and painting. Veneer and inlay consist of exotic and costly woods, tortoise shell, bronze, ivory, gold, and silver. Painting often disguises inexpensive woods.

■ *Seating.* Thrones (Fig. 6-41, 6-42), probably adapted from Greek prototypes, are elaborately decorated and

important status symbols. One of the most important seating examples is the *sella curulis*, an **X**-shaped folding stool with an added back often used by Roman curules or city magistrates. It is more elaborate in shape and decoration

Design Spotlight

Furnishings: *Tripod Tables.* New and unique tripod tables (Fig. 6-43) are a Roman contribution to furniture design. A typical Pompeiian table is a bronze tripod in the Greek style with a winged sphinx sitting on a quadruped leg.

Rectangular table in marble

Round table with tripod base in bronze

Tapered leg with fluting

Quadruped leg

Animal paw foot

Cylindrical base

6-43. Tables.

than Greek prototypes. The *sella curulis* with a back replaces the Greek klismos in Republican times. Barrel-shaped tub chairs of plaited straw and other materials are another innovation. Some dining rooms feature built-in platforms (Fig. 6-32).

■ *Tables*. Roman tables (*mensae*; Fig. 6-43) copy and enrich Greek ones. Particularly common are tables with a single center support, round tables with three animal legs (Fig. 6-43, 6-44), and rectangular tables with slab ends (Fig. 6-45), which are copied in the Renaissance. Large marble tables appear in the garden or peristyle.

■ *Storage*. Common items include chests, cupboards, and wardrobes in rectangular shapes. Wardrobes and cupboards have doors with shelves inside.

■ *Beds*. The Romans introduce the couch with a back (Fig. 6-46), which serves for eating, relaxing, and sleeping. Couches, as the most expensive item in the home, have lavish decoration, particularly the rounded *fulcrum* (headrest) against which diners lean. Most have turned legs of varied heights; runners sometimes connect the legs.

■ *Heating*. As houses do not have fireplaces, Romans use charcoal *braziers* for heat (Fig. 6-47). Very luxurious houses may have hot water pipes in the floors.

■ *Textiles*. Few textiles survive, but mosaics, paintings, and bas-reliefs show loose coverings on furniture, pillows, and cushions. Common fabrics are wool, linen, silk, and cotton in bright colors, sometimes embellished with patterns or embroidery.

6-44. Table with lion heads.

6-46. Couch.

6-45. Marble table supports, House of Cornelius Rufus, Rome, Italy.

6-47. Heating implements.

6-48. Portland vase (copied in the 18th century by Josiah Wedgwood), 3rd century C.E. (Courtesy of British Museum, London)

6-50. Later Interpretation: Barcelona chair, 1929; designed for the Barcelona Pavilion in Spain; by Mies van der Rohe; Bauhaus period.

6-49. Later Interpretation: **X**-shaped folding stool (copies the Roman *sella curulis*); by Percier and Fontaine in the early 19th century; French Empire.

■ *Decorative Arts*. Glassblowing begins during the 1st century C.E., and soon becomes a major industry throughout the Roman Empire. Numerous bottles, glasses, bowls, and other objects are free- and mold-blown. Cameo glass (Fig. 6-4, 6-48) is an innovation. Most Roman houses are well equipped with tableware and other metal, ceramic, and glass objects.

■ *Later Interpretations*. The Roman *sella curulis* and other furniture serve as sources of inspiration for furnishings of the early 19th and early 20th centuries, including a French Empire stool (Fig. 6-49) and the Barcelona chair (Fig. 6-50) of the Bauhaus period. Cameo glass is copied later by Neoclassic designers, such as Josiah Wedgwood (Fig. 6-48).

D. Middle Ages

c. 500–1500 c.e.

The term *Middle Ages*, "the age in the middle," describes the period between Late Imperial Rome (c. 330 c.e.) and the rebirth of classicism during the Renaissance (c. 1400 c.e.). Encompassing approximately 1,100 years, the period reflects invasions from Germanic tribes from the North and Moslems from Africa and the Middle East leading to social and political unrest, religious conflict, the Crusades, and artistic changes throughout Europe. The turbulent times turn people toward religion.

Ecclesiastical building—churches and mosques—dominates the Middle Ages. With the exception of the Gothic period, ecclesiastical architectural developments in Eastern and Western Europe look to antiquity in varying degrees. Early Christian churches (3rd–7th centuries c.e.) are adapted from Roman basilicas. Reinterpreted classical images appear in Christian iconography. The Byzantine Empire (c. 330–1453 c.e.) develops Roman centrally planned structures and construction techniques into a distinctive ecclesiastical architecture. The Romanesque style (8th century–1150 c.e.) fashions Roman elements such as the round arch and construction techniques such as vaulting into the first international architectural style. The Gothic style (1150–1550 c.e.), which strives for lightness and verticality, does not rely on antiquity. It does, however, build on Romanesque innovations. In the Middle East and Spain, Islam (7th–17th century c.e.) develops the mosque, which is common in form throughout its empire.

Little domestic architecture from the Middle Ages survives, particularly from the early periods. Significant developments include castles and Islamic palaces, which are combinations of residences and fortresses, and half-timber construction. Toward the end of the period as times settle, unfortified residences become more common. Except for Islamic and some Gothic examples, exteriors and interiors of dwellings do not adopt characteristics of prevailing ecclesiastical styles. Most noble interiors in the Middle Ages rely mainly on textiles for warmth, color, and pattern. Furnishings are few; portability is important as nobles move often to oversee their lands.

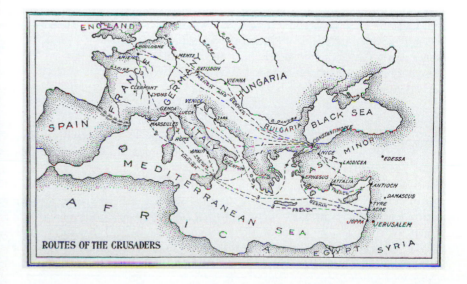

ROUTES OF THE CRUSADERS

7. Early Christian

3rd–7th Centuries

Constantine Augustus built the basilica of blessed Peter, the apostle. . . . He made a vaulted apse in the basilica, gleaming with gold, and over the body of the blessed Peter, above the bronze which enclosed it, he set a cross of purest gold, . . . the altar itself of silver overlaid with gold, adorned on every side with gems, 400 in number. . . .

> The Book of the Popes (Liber Pontificalis)
> from the life of Pope Sylvester I

The term *Early Christian* refers to buildings and iconography related to the Christian religion that evolve during the 3rd through 7th centuries. After Christianity is recognized, receiving official approval from the Roman Empire, Christians begin constructing religious structures adapted from Roman prototypes. They also develop Christian images and symbols to inspire and educate believers. Western churches and religious structures for centuries following are based on these building forms and the iconography.

HISTORICAL AND SOCIAL

Christianity comes into being following the crucifixion of Jesus of Nazareth about 33 C.E. For the next three centuries, membership increases, but Christianity has little legal standing in the Roman Empire. Followers attempt to evade attention by meeting mainly in private houses and building only a few small and insignificant churches. Their worship services are simple and informal with little ceremony. Early Christians do not believe in cremation, so they bury their dead in catacombs (underground tunnels and openings) because of the high cost of land.

In 313 C.E., Roman emperor Constantine wins a decisive battle that he attributes to the Christian god. In gratitude, he issues the Edict of Milan, which gives tolerance for all religions. He personally sanctions Christianity, thereby raising its status. Soon, Christian churches, memorial structures, and mausoleums spring up in Rome, Constantinople, and other cities. Constantine himself is the patron for the old Basilica of S. Peter (Fig. 7-3, 7-4, 7-8) in Rome. Additionally, he promotes the faith and positions himself as head of the church as well as of the empire. Although emperors are no longer considered divine, he

7-1. Typical costumes of the Early Christian period.

rules with the same absolute authority as his predecessors. These precedents continue in the Byzantine Empire.

In 330 C.E., Constantine moves his capital to Constantinople, today's Istanbul, and rules the Roman Empire from the east. Upon his death, the division of the empire into east and west accelerates. The western portion's trouble with internal strife and invaders from the north continues. Emperor Honorius moves the capital to Ravenna in 404 C.E. in an effort to prevent its being overtaken. His

efforts are unsuccessful, as in 476 C.E. Odacer overtakes both Ravenna and Rome, marking the fall of the western Roman Empire. With fewer invasions, the eastern portion prospers as the Byzantine Empire. The period marks the transition from the classical, pagan world to the Christian Middle Ages. Some regard the founding of Constantinople and the establishment of Christianity as the official religion of the Roman Empire as the beginning of the Middle Ages.

CONCEPTS

Once officially sanctioned by Constantine, Christianity requires impressive settings and ceremonies to reflect its new importance. Late Imperial Roman architecture supplies the models: the basilica or meeting hall, the atrium of the house, baths, tombs, and mausoleums. These are adapted to suit Christian liturgical requirements. Similarly, paintings and mosaics that blend Roman traditions with Christian images adorn church walls and ceilings. Until the fall of the western Roman Empire, they create glittering, otherworldly interiors as backgrounds for worship of the Christian god. These buildings and their furnishings are the most significant development of the Early Christian period. They also constitute the main extant artifacts.

ARCHITECTURE

Early Christian buildings follow basilica or centralized plans. To avoid images of paganism, Christian builders do not look to temples as models. Temples, which were not intended

for large congregational gatherings, are architecturally unsuited to the need for interior space to accommodate worshippers and rituals. Builders adapt the Roman basilica, or civic hall, with its nave (central portion on the main axis), aisles (spaces flanking the nave), and apse (semicircular or polygonal space on the eastern end). To house the relics of saints and provide more space, they add a transept (space at right angles to and crossing the nave), thereby creating a Latin cross plan (one long arm and three short, perpendicular arms). The plan is practical and symbolic of the faith, and many small and large basilica churches are constructed in the eastern and western portions of the Roman Empire. Centrally planned structures, such as baptisteries, are adapted from Roman baths or tombs.

Secular public structures and dwellings constructed during the period follow late Roman forms and decoration. In Rome, Constantine builds baths, basilicas, and triumphal arches in the grand style of his predecessors. Private citizens build homes as before, and the wealthy continue to live in large, impressive villas with a variety of room shapes and sizes.

■ *Symbols and Motifs.* The cross is the main symbol; others are the fish, dove, and lamb (Fig. 7-2, 7-18). The Greek letters chi (X) and rho (P) form the monogram of Christ. Common images include shepherds and sheep representing Christ the Good Shepherd, Mary (the mother of Christ), and the apostles and various saints.

Public Buildings

■ *Types.* Newly developed forms are churches, baptisteries, mausoleums, and memorial structures at sacred sites.

■ *Orientation.* The apse, which houses the altar, orients to the east because Christ was crucified in Jerusalem. The entrance is opposite it on the west side.

■ *Floor Plans.* Most churches follow the Roman basilica plan (Fig. 7-3, 7-4). They usually have a portal (main entrance) that opens into a large colonnaded forecourt

Important Buildings and Interiors

■ **Milan, Italy:** S. Lorenzo, c. 378 C.E.

■ **Ravenna, Italy:**

—Mausoleum of Galla Placidia, c. 425 C.E.

—S. Apollinare in Classe, c. 533–549 C.E. (Color Plate 16)

■ **Rome, Italy:**

—Old Basilica of S. Peter, 319 C.E., replaced by new S. Peter's in 1505

—S. Costanza, c. 350 C.E.

—S. Clemente, 11th and 12th centuries; S. Maria Maggiore, c. 432–440 C.E.

—14th-century campanile and 18th-century facade

—S. Paolo Fuori le Mura, begun c. 385 C.E.; S. Sabina, c. 422–432 C.E.

7-2. Early Christian motifs carved on a sarcophagus.

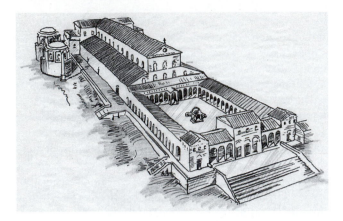

7-3. Old Basilica of S. Peter (reconstruction drawing), c. 320–330 C.E.; Rome, Italy; torn down in 1505 to make way for the newer S. Peter's in Vatican City.

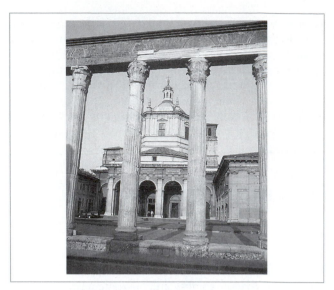

7-5. S. Lorenzo, c. 378; Milan, Italy.

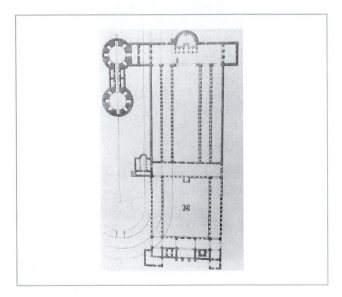

7-4. Floor Plan, Old Basilica of S. Peter; Rome, Italy.

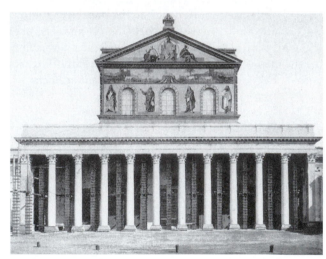

7-6. S. Paolo Fuori le Mura (S. Paul's Outside the Walls; reconstruction of the original), begun c. 385 and rebuilt in 1823; Rome, Italy.

(like the atriums of Roman houses) leading to a narthex (porch) that gives access to a larger nave. An entablature on columns or an arcade separates the rectangular nave from the side aisles. Opposite the entrance are a short transept at a right angle to the nave and an apse. The longitudinal axis from forecourt entry to narthex to apse forms a processional path. A triumphal arch (monumental arch) frames the apse, which has seats for clergy and a throne in the center for the bishop. A screen separates the apse from the altar. Columns surmounted with a canopy highlight the altar, under which are often the remains of a martyr or saint. A variation for churches and a typical form for baptisteries and mausoleums is a circular or polygonal plan with an altar or other sacred form in the center sur-

rounded by a two-story colonnade (Fig. 7-10). Some mausoleums have Greek cross plans (four arms equal in length).

■ *Facades.* Walls are of plain brick or stone with little articulation except doors and windows. The center of the nave is high to accommodate clerestory windows. Windows are rectangular or arched. Unadorned exteriors, as in S. Apollinare in Classe (Fig. 7-7), contrast sharply with the interior architectural delineation and decoration. At S. Lorenzo (Fig. 7-5), the plain front hides a four-lobed centralized plan with rounded corners. Columns, masonry, and roof tiles are pillaged from Roman buildings in the poorer western Roman Empire and its remnants.

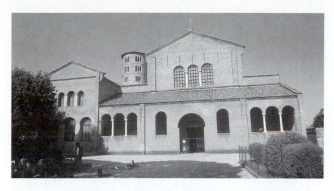

7-7. S. Apollinare in Classe, c. 532–549 C.E.; Ravenna, Italy.

- *Door*. Doors are either carved wood or bronze. Surface decoration may enrich the portals (Fig. 7-6).

- *Roofs*. Roofs are gabled on basilicas and domed on central plans. Rust-colored clay tiles usually cover the surface.

- *Later Interpretations*. Subsequent Western European churches adopt the basilica plan. The Byzantine Empire adopts central plans almost exclusively. Plain exterior design continues from the early Middle Ages to the Romanesque period.

INTERIORS

The new Christian churches have many wall surfaces that require embellishment, so they feature wall decoration on an unprecedented scale. Frescoes or mosaics that blend classical types and precedents with divine persons and Christian symbolism are characteristic. The richness of the decoration contrasts with the plainness of the exteriors. Secular interiors follow Roman Imperial traditions in form and decoration.

Public Buildings

- *Floors*. Floors are black and white, gray, or colored marble; some floors have elaborate patterns (Fig. 7-15).

- *Walls*. The nave arcade, triumphal arch, and apse display marble panels, frescoes, or mosaics (Fig. 7-9, 7-13, 7-14, 7-15). Decoration, which is simple to maximize legibility, glorifies the Christian God and helps to educate believers. Frescoes and mosaics adapt Jewish (Jesus of Nazareth and the first believers were Jews), Christian, and Imperial Roman traditions and include popular motifs. However, few of these early frescoes survive except in the catacombs.

- *Mosaics*. The tesserae (individual parts) of Early Christian mosaics are of glass rather than the earlier marble.

Design Spotlight

- **Interior:** *Old S. Peter's*. The interior of the old S. Peter's (Fig. 7-8) illustrates typical basilica features including the volumetric nave, clerestory windows, timber truss ceiling, columned arcade, and lower side aisles. A triumphal arch frames the apse. The apostle Peter's grave was under a marble canopy in the apse.

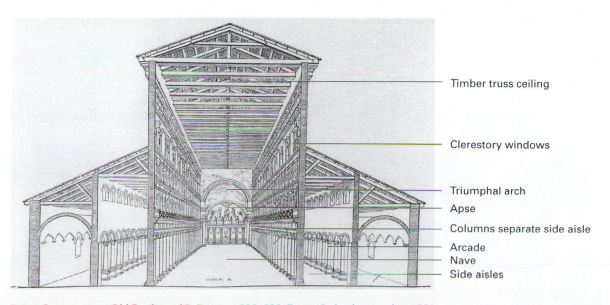

Timber truss ceiling

Clerestory windows

Triumphal arch
Apse
Columns separate side aisle
Arcade
Nave
Side aisles

7-8. Section view, Old Basilica of S. Peter, c. 320–330; Rome, Italy; destroyed in 1550.

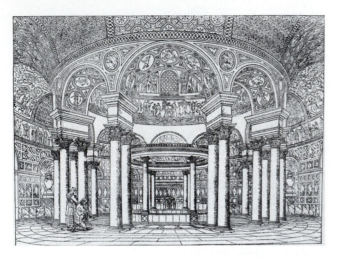

7-9. Central area, S. Costanza, c. 340 C.E.; Rome, Italy; built as a mausoleum.

Glass gives an intense range of colors but little tonal variation. Colors include blue, green, purple, red, and gold. Tesserae, which are larger than before, are set unevenly to enhance light reflection. The glittering glass surface dematerializes the walls and creates the impression of a heavenly realm populated with celestial beings. The uncertainty in content and style of earlier works has disappeared. Artists freely adapt Roman poses, gestures, and illusionistic devices. Although simplified, figures are solidly modeled and cast shadows. Overlap and foreshortening are common. After thought and debate on His proper depiction, Christ evolves from a teacher-philosopher into a divine, princely figure. Imperial symbols enhance this image. Some mosaics feature architectural backgrounds in the Pompeiian tradition. Later periods will use and adapt the Christian imagery developing in this period. During the Byzantine Empire, mosaic technique and images evolve into a flat, linear style.

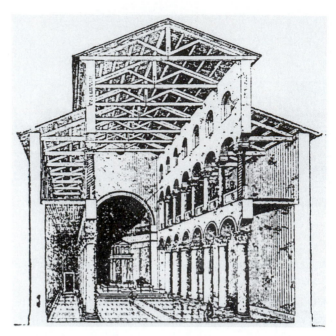

7-11. Section view, S. Agnes, begun c. 340; Rome, Italy.

■ *Columns.* Reused Roman or new classicizing columns carry the arcade or entablature separating the nave and the aisles (Fig. 7-11, 7-12, 7-13, 7-14, 7-15). Capitals and columns frequently do not match.

■ *Ceilings.* Ceilings feature exposed timber trusses (Fig. 7-11) or beams (Fig. 7-9, 7-12, 7-13).

■ *Later Interpretations.* Although some elements appear, few Early Christian designs are reproduced entirely in later developments. However, some of the architectural forms, such as the arcade, provide inspiration for some late-19th-century interiors (Fig. 7-16).

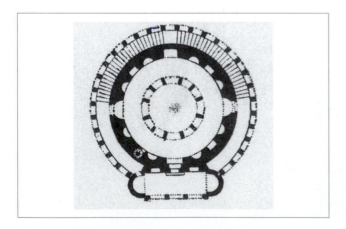

7-10. Floor plan, S. Costanza.

Design Spotlight

■ **Interior:** *S. Apollinare in Classe.* The semivaulted apse above the altar is covered with a mosaic depicting the hand of God, Moses and Elijah, a jeweled cross in a blue medallion, S. Apollinare, sheep, trees, flowers, and birds (Fig. 7-14, Color Plate 16). Images of Christ and symbols of the four evangelists (Matthew, Mark, Luke, and John) fill the triumphal arch. Symbolic of martyrdom and triumph over death, the images above the altar are intended to inspire and uplift. An arcade, topped with medallions containing religious figures, defines the nave. This decorative concept repeats in other basilicas (Fig. 7-13).

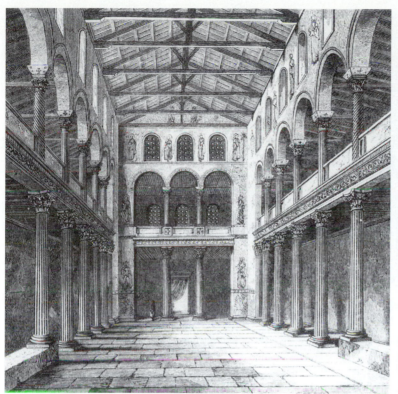

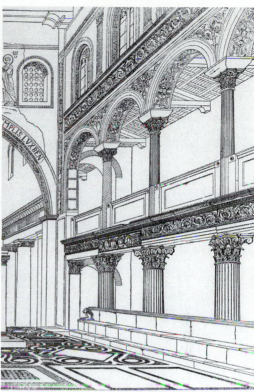

7-12. Nave, S. Lorenzo Fuori le Mura (S. Lorenzo Outside the Walls), c. 378; Rome, Italy, using fragments of Imperial Roman buildings.

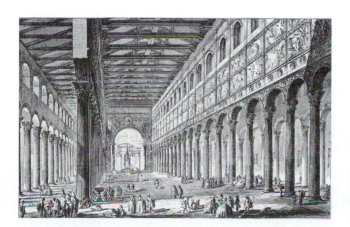

7-13. Nave, S. Paolo Fuori le Mura (S. Paul's Outside the Walls), c. 385; Rome, Italy; from an engraving by Piranesi.

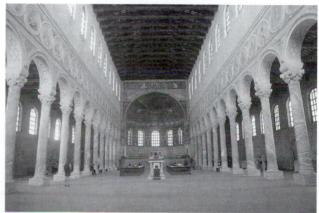

7-14. Nave, S. Apollinare in Classe, c. 533–549 C.E.; Ravenna, Italy. (Color Plate 16)

Clerestory window

Triumphal arch

Decorative mosaics

Altar

Apse

Arcade separating
side aisle

Screen

Nave

Decorative
marble floor

7-15. Nave, S. Clemente, 11th and 12th centuries; Rome, Italy.

7-16. Later Interpretation: Grand staircase with view to central dome, Public Library, 1897; Chicago, Illinois; by Charles A. Coolidge; Late Victorian.

FURNITURE

Early Christian furniture is limited. The most important pieces are the storage items found in churches. Church furnishings are richly decorated with carving, gilding, and frequently, jewels. Secular furnishings, such as coffers, follow earlier Roman types and forms; they often mix pagan and Christian images.

■ *Seating.* Stools are more common than chairs and resemble Roman prototypes. A manuscript illustration shows S. Matthew (Fig. 7-17) wearing a toga, sitting on a curule (**X**-form) stool, and writing on a lectern.

■ *Storage.* Emblems belonging to the Christian faith decorate furniture as well as architecture. Examples (Fig. 7-18) include the peacock (symbolizing immortal life), grapevines, and the cross.

7-17. S. Matthew, Coronation Gospels, c. 800–810.

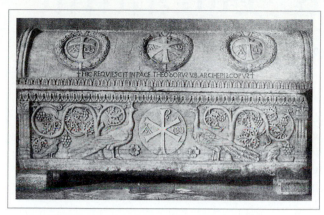

7-18. Sarcophagus, Ravenna, Italy.

8. Byzantine

330–1453 C.E.

So the church [Hagia Sophia] has been made a spectacle of great beauty, stupendous to those who see it and altogether incredible to those who hear of it, the beholders are quite unable to select any particular [interior] element which they might admire more than all the others. . . .

Procopius of Caesarea, *Buildings*, c. 550 C.E.

The Byzantine, or eastern Roman Empire, maintains Roman culture and building traditions before and after the fall of the city of Rome in 476 C.E. Imperial patronage encourages the Christian religion and the building of new structures. The empire sustains a long history of distinctive church architecture and decoration as well as classical scholarship. Following their development during the 16th century, they became the chief architectural image of Byzantium. Orthodox Byzantine churches are domed and centrally planned with distinctive iconographic mosaics.

8-1. The emperor Justinian.

HISTORICAL AND SOCIAL

The Byzantine Empire is a bastion of Roman influence for nearly 1,000 years after the fall of Rome. In 330 C.E., Emperor Constantine moves his capital east to escape the aggression of Germanic tribes. He chooses Byzantium, an ancient Greek city, which he renames Constantinople (now Istanbul, Turkey) for himself. There is great prosperity in the eastern empire in contrast to the decline in the west. Life in Constantinople is very like that of Rome. Citizens, who call themselves Romans, look to Roman institutions and culture; however, they speak Greek.

As emperor, Constantine strives to protect Roman traditions, buildings, and religions. At the same time, he sanctions and promotes Christianity, creating a precedent for a theocratic state. Justinian creates that state when he makes Christianity the only legal religion in the 6th century. He and subsequent emperors maintain an autocratic rule that combines the positions of bishop and caesar. In this, the emperor, as an earthly ruler appointed by Christ, strives to maintain the orthodoxy of the faith. Soon, court and church become synonymous. In 1054, the eastern church finally separates from the western church over doctrinal issues about which they have disagreed for centuries.

Byzantine history is one of rise and fall, growth and decline. In the 6th century Emperor Justinian attempts to recapture former empire holdings and reunite the former empire. His building campaigns attempt to reestablish the glory of the Roman Empire. He and his wife Theodora regain much of North Africa, Italy, and parts of Spain, but at great cost. Subsequently, the empire cannot maintain its holdings around the Mediterranean or in Italy. Weakened by attacks from the Persians and Arabs, the Byzantine Empire shrinks in size and power. Another period of prosperity and expansion occurs between the 9th and 12th centuries. The Crusades, beginning in 1095, revive trade and commerce. The empire again increases its holdings. Decline begins anew in 1203–1294 when crusaders sack Constantinople. The city eventually falls to the Ottoman Turks, ending the empire in 1453.

In addition to maintaining Roman laws, government, and culture, the Byzantine Empire preserves ancient Greek culture. Throughout its long history, the empire supports a vigorous intellectual life in which classicism is a source of inspiration and renewal. Scholars safeguard and copy ancient Greek manuscripts. They write new reference works and study mathematics and astronomy. These learnings live on after the fall of the empire. Byzantine scholars fleeing Constantinople in 1453 help initiate the study of Greek manuscripts in Italy, which contributes to the development of the Renaissance.

CONCEPTS

The Byzantine Empire continues classical Roman and Early Christian traditions, blending them into a distinctive church architecture and decoration that reflects an imperial, princely Christ and saints at the head of a theocratic society.

DESIGN CHARACTERISTICS

Byzantine church architecture exhibits Roman scale with volumetric and spatial variety, but not Roman construction techniques. Plans are basilica type or centralized, and often complex. Outlines are complicated domes and regular massing. Exteriors are simple and plain until the 11th century, when they become more complex in form and exibit colorful brickwork and more ornamentation. Some churches sacrifice their ordered massing for the addition of more chapels. Interiors are richly decorated with paintings, marble panels, and shimmering mosaics. Linear, stylized figures are characteristic.

Byzantine churches have little sculpture because of iconoclasm. This ban on figural images, beginning in 726 C.E., results from the empire's major defeats and loss of territory at the hands of the Persians, which is attributed to ignoring the Old Testament ban on graven images. In place of figures, iconoclasm combines Christian symbols, such as the cross, with floral, geometric, and animal forms. Thus, decoration comes to resemble Islamic decorative art. In 843 C.E., when the prohibition of figures ends, images become even flatter and more stylized to resemble human form as little as possible.

■ *Motifs*. Motifs include images of Christ, Mary, the apostles, rulers, and various saints (Fig. 8-1), foliage (Fig. 8-2), frets, waves, geometric designs (Fig. 8-3, 8-22), guilloches, lozenges, rosettes, and animals (Fig. 8-22).

ARCHITECTURE

Early Byzantine architecture continues Late Roman and Early Christian forms, becoming distinctive by the 6th century with the building of Hagia Sophia (meaning "divine wisdom"). Early churches follow the basilica or centralized plan, but eventually most are centralized and square with domes. By the Middle Byzantine period (9th–11th centuries or roughly coeval with the Romanesque period), numerous monastic churches are built, which are smaller with more exterior ornamentation and patterned brickwork. Variations of the Greek cross (four arms of equal length) and central domes are typical. Taller, narrower forms, more domes, and more exterior ornamentation characterize Late Byzantine churches beginning in the

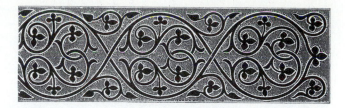

8-2. Decorative patterns of the Byzantine Empire.

8-3. Floor tiles of the Byzantine Empire.

12th century (roughly coeval with the Gothic period). The surface decoration of interiors moves to exteriors, and they relate more closely through pattern and ornamentation. Examples are opulent and picturesque.

Architectural innovations include the *pendentive* (a triangular curving form that allows construction of a circular dome over a square or rectangular space), combined centralized and basilica plans in churches, and the skillful use of light as a mystical element.

Public Buildings

■ *Types*. Churches are the most common building types, but Roman forms compatible with Byzantine culture, such as baths and hippodromes, continue.

■ *Floor Plans*. Church plans are symmetrical, ordered, and often complex. Centralized plans with circular and polygonal forms are the most common (Fig. 8-7). Hagia Sophia's plan combines the longitudinal axis of the basilica with a centralized plan (Fig. 8-5). Following it, on a smaller scale, is a square plan with four crosslike arms that terminate in rectangles or apses (Fig. 8-9).

■ *Materials*. Brick, which permits more plastic elevations, supersedes Roman concrete. Vaults and domes are of brick

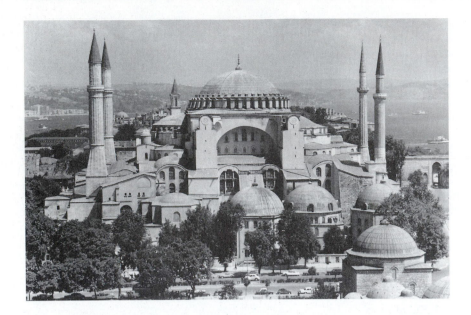

8-4. Hagia Sophia, 532–537 C.E.; Constantinople (Istanbul), Turkey; by Anthemius of Tralles and Isidorus of Miletus and built by Justinian.

Design Spotlight

Architecture: *Hagia Sophia.* The Hagia Sophia (Fig. 8-4) is the grandest of all Byzantine churches as befits its imperial purpose as church of the emperor. The exterior is characteristically plain in articulation, but more complex in form and outline. The atrium or colonnaded porch no longer exists, and the Islamic minarets are later additions. The large rectangular plan (Fig. 8-5) is bounded by piers with pendentives (Fig. 8-13, Color Plate 17), a Byzantine contribution to architecture. The pendentives support the massive and dominant central dome. The dome covers a square space with smaller apses and niches at each end. Forty windows pierce the dome and filter light within so that it appears to float over the vast open space. Inside, rich colors and decorations of mosaic and marble surfaces contrast with the plain exterior, a visual metaphor for a Christian's rich spiritual or inner life. The section (Fig. 8-14) shows the relationship of the centrally domed space and surrounding half-domed niches. Marble columns screen vaulted aisles.

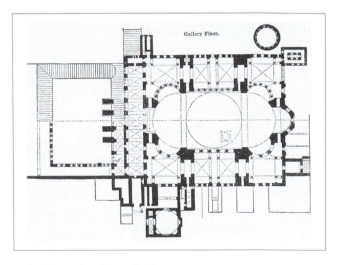

8-5. Floor plan, Hagia Sophia.

to eliminate centering. Iron tie-rods reinforce arches and vaults. Brick usually is covered with stucco, marble, stone, or mosaics.

■ *Facades.* Walls of earlier churches are smooth, plain, and unadorned (Fig. 8-4, 8-6). Later ones are articulated with architectural elements, as in S. Mark's (Fig. 8-8),

which combines Byzantine, Romanesque, and Gothic influences. As time passes, facades grow more complex in form following interior shapes. Movement in and out; circular or polygonal forms; and the repetition of walls, windows, arches, and other elements creates a lively, rhythmic pattern in Middle and Late Byzantine examples. Later Russian Orthodox churches are particularly rich and complex in form and ornamentation.

■ *Columns.* Columns are usually unfluted with an inverted pyramidal impost block (which separates the capital from the springing of the arch). Both impost block and

Domed tile roof

Round arched windows

Movement in and out of facade

Plain brick exterior

8-6. San Vitale, 526–547 C.E.; Ravenna, Italy.

Design Practitioners

■ Byzantine architects are usually scientists or mathematicians. They are trained in theory as well as practical matters.

■ *Anthemius of Tralles*, an expert in geometry, is one of the builders of Hagia Sophia.

■ *Isidorus of Miletus*, who taught physics, also works on Hagia Sophia.

Important Buildings and Interiors

■ **Hosios Lukas, Germany:** Katholikon, c. 1020.

■ **Istanbul, Turkey:**
—Hagia Sophia, 532–537 C.E. (Color Plate 17)
—Anthemius of Tralles and Isidorus of Miletus.

■ **Palermo, Italy:** Palantine Chapel, 1132–1143.

■ **Perigueux, France:** Cathedral at S. Front, c. 1125–1150.

■ **Ravenna, Italy:** San Vitale, 526–547 C.E.

■ **Salonika, Greece:** Church of the Holy Apostles, 1310–1314.

■ **Venice, Italy:** S. Mark's, begun in 1063 C.E.

8-7. Floor plan, San Vitale.

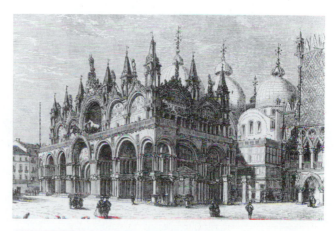

8-8. S. Mark's, begun 1063 from the designs of a Greek architect; Venice, Italy.

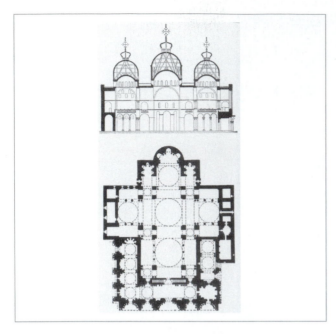

8-9. Floor plan and section, S. Mark's.

capitals (Fig. 8-10) have simple profiles, but are covered with complex, elaborate, and pierced lacy undercut foliage or geometric shapes. They may incorporate anthemions, acanthus leaves, grapevines, crosses, and the initials of rulers.

■ *Windows*. Windows with round tops punctuate walls and domes. Following Hagia Sophia, windows are often placed in the drums of domes so the dome appears to float.

■ *Roofs*. Sloped and gabled rooflines are complicated. Domes over plan centers or crossings are universal. Small chapels may also be domed or semidomed.

■ *Later Interpretations*. A mixture of influences reminiscent of Byzantine design appears in the Cathedral of S. Basil (Fig. 8-11) in Moscow with its array of onion domes (originally white) and arches. Later variations include other picturesque examples such as the Corn Palace (Fig. 8-12) in South Dakota.

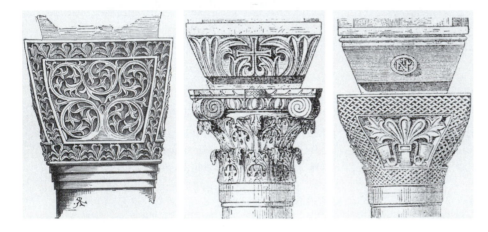

8-10. Capitals.

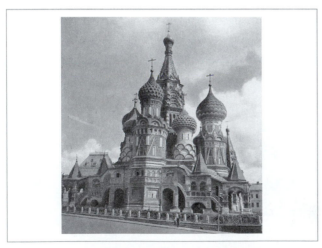

8-11. Later Interpretation: S. Basil, 1555–1561; Moscow, Russia; built by Ivan the Terrible.

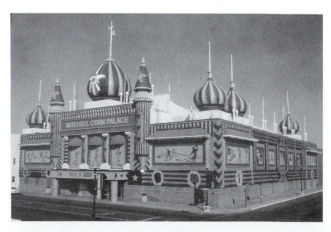

8-12. Later Interpretation: Corn Palace, 1921; Mitchell, South Dakota; by Rapp and Rapp.

INTERIORS

Byzantine church interiors are opulent, formal, and sumptuous. Surface decorations in rich colors and materials are typical. Paintings, mosaics, and/or marble panels that build on Early Christian forms cover floors, walls, and ceilings. Although decoration combines Christian iconography with classical elements, the impression is not classical but one of immense wealth and richness. Shimmering gold mosaics and natural light unite to create an otherworldly feeling.

Few secular interiors survive intact. Writings and illustrations indicate that homes of wealthy citizens and clergy followed Late Roman forms and decoration. However, treatments imitate the opulence of churches.

Public and Private Buildings

■ *Colors.* The palette incorporates various shades of gold, red, green, and blue (Color Plate 17).

■ *Floors.* Floors (Fig. 8-3) have patterns of marble, stone, or mosaics, often in geometric patterns.

■ *Walls.* Walls (Fig. 8-13, 8-14, 8-15, 8-16) are articulated with columns, pilasters, and cornices and/or are covered with frescoes, mosaics, marble panels, or hangings; all are richly colored. Images of divine persons, geometric forms, foliage, and Christian symbols are common.

■ *Mosaics.* Byzantine churches are noted for their mosaics that continue and develop further Early Christian forms and images. As in the Early Christian period, figures and forms often are adaptations of classical and pagan images. Unlike those of the Early Christian period, Byzantine mosaics have more gold and reflective surfaces as a symbol of Christ as the light of the world. Placement of figural decoration is hierarchical. Scenes of Christ and the Virgin Mary occupy central domes, while visions of the ascension of Christ fill the apse. Curved surfaces, such as pendentives, and upper walls are covered with scenes from the life of Christ. Lesser saints and other dignitaries occupy lower walls. Figures, particularly following the iconoclastic controversy, are linear, flat, and stylized. Forms and figures in bright colors are laid out with no overlap or perspective against shimmering gold backgrounds. Foliage, geometric forms, and Christian symbols form borders or are interspersed among the figures.

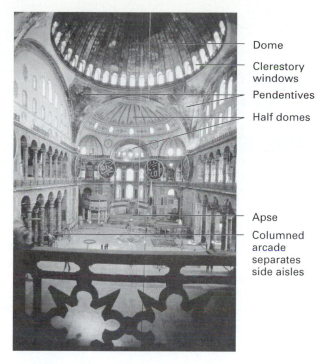

Dome

Clerestory windows

Pendentives

Half domes

Apse

Columned arcade separates side aisles

8-13. Nave, Hagia Sophia, 532–537 C.E.; Constantinople (Istanbul), Turkey. (Color Plate 17)

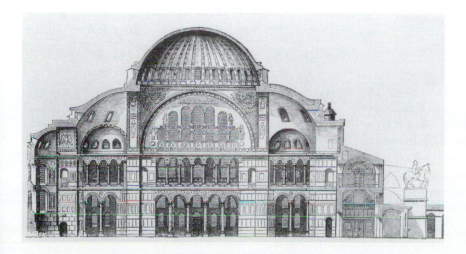

8-14. Section view, Hagia Sophia.

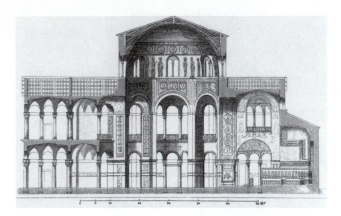

8-15. Section view, San Vitale, c. 526–547 c.e.; Ravenna, Italy.

8-17. Later Interpretation: Tiffany Chapel, World's Columbian Exposition, 1893; Louis Comfort Tiffany; reinstalled 1996: The Charles Hosmer Morse Museum of American Art, Winter Park, Florida.

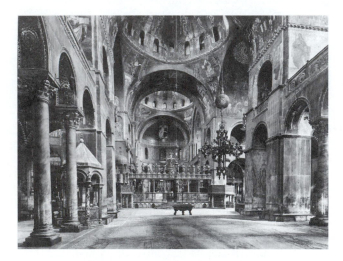

8-16. Nave, S. Mark's, begun 1063 from the designs of a Greek architect; Venice, Italy.

8-18. Later Interpretation: S. Jude's Catholic Church, 1908–1910; Hampstead Garden Suburb, London, England; by Sir Edwin Lutyens.

■ *Windows.* Windows are often numerous and made of glass or alabaster.

■ *Doors.* Doors are of iron, bronze, or wood.

■ *Ceilings.* Centers or crossings of churches have domes surrounded by smaller domed and half-domed spaces. The central domes (Fig. 8-13, 8-14, 8-15, 8-16) are supported by pendentives, which provide a transition from the circular dome to the vertical post of the square plan. Almost all ceilings feature painted and mosaic decorations.

■ *Later Interpretations.* Significant interpretations appear in the work of Islamic builders and in compositions by American designer Louis Comfort Tiffany (Fig. 8-17) and English architect Sir Edward Lutyens (Fig. 8-18) during the late 19th and early 20th centuries.

FURNISHINGS AND DECORATIVE ARTS

Little furniture of the Byzantine era survives, but illustrations in manuscripts and mosaics show that some classical forms are retained for chairs and tables. A few pieces are draped with fabric; seating often has cushions. Surface decoration characterizes many storage pieces.

■ *Materials.* Furniture is wood, metal, and ivory using simple construction. Some pieces are jeweled or have gold and silver inlay.

8-19. Maximianus throne, c. 547 C.E.

8-20. Throne chair, 9th century, from an ancient manuscript.

8-21. Reliquaries.

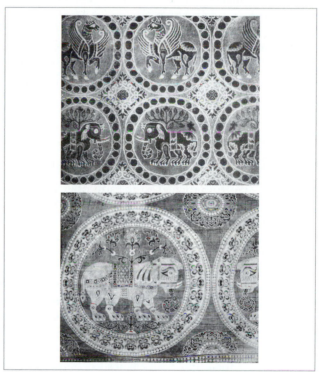

8-22. Textiles, 10th and 11th centuries.

■ *Seating.* Architectonic thrones and chairs are often illustrated in manuscripts (Fig. 8-20). The Maximianus throne (Fig. 8-19), made for an archbishop, is constructed of ivory carved with animals, birds, and foliage. The panels show saints and scenes from the life of Christ. Some chairs, stools, and benches are X-shaped and often of metal.

■ *Textiles.* Silk and velvet are common materials, with designs featuring animals, geometric patterns, and Persian influence (Fig. 8-22).

■ *Decorative Arts.* Elaborately decorated reliquaries (Fig. 8-21) hold religious objects of veneration. The richness of the details, jewel-encrusted surface treatments, and complex geometric carvings characterize Byzantine work. During the 6th century C.E., icons become increasingly important for public and private worship. They feature stylized images of divine persons set against gold backgrounds. Ivory carving often decorates book covers, plaques, and reliquaries.

9. Islamic

7th–17th Centuries

When I came within the Dore, that which I did se was verrie wonderful unto me . . . the sighte whereof did make me almoste to thinke that I was in another worlde.

Thomas Dallam at the Sultan's Court, 1599 from Michael Levy, *The World of Ottoman Art*

The unique form and decoration of Islamic art and architecture are influenced by religion, the design traditions of its various peoples, and the aesthetic sensibilities of its own artists and builders. Common to all the arts are dense, flat patterns composed of geometric forms and curving tendrils. This decoration dematerializes forms and creates visual complexity. Unique to Islam is calligraphy, which is effectively integrated into the decoration of almost all structures and objects.

9-1. Figure in Arabic dress.

HISTORICAL AND SOCIAL

Islam, meaning "to surrender to the will of God," is the third of the great monotheistic Semitic religions following Judaism and Christianity. Established in the 7th century C.E., it derives from the teachings of the prophet, Muhammad. A wealthy merchant in Mecca on the Arabian peninsula, he receives revelations from God and begins proclaiming a new faith in one god, Allah. Local citizens who are polytheists strongly oppose him, so Muhammad flees to Medina in 622 C.E. There he establishes the first community of followers who meet in his home compound for teachings and prayer. As converts increase, the prophet becomes a spiritual and political leader. After he and his followers become powerful in Medina, they conquer Mecca. At his death in 632 C.E., Muhammad has become the leader of a large and increasingly powerful Arab state. Subsequently, his followers continue conquests for land in the name of Islam. In just over a century, they extend their territories as far as southern France and North Africa to the west and north, and into northern India to the east.

Peoples of the vast territories unite through their new faith. Believers, called Muslims, live according to the Koran (recitation), the sacred book of the prophet's revelations. There are no formal rituals or ceremonies, as each believer has individual access to God. Rules for living are simple. Members adhere to the five pillars of Islam: accepting and submitting to the will of Allah, praying five times a day facing Mecca, giving alms to the poor, fasting in the

month of Ramadan, and if possible, going on at least one pilgrimage to Mecca. Families are patriarchal, and polygamy is permitted although rarely practiced. Extended families of two or three generations are common. Family structures are fluid, often changing with the addition of widows, orphans, or others. Islam extends some rights to women, but their freedom varies by time period and geographic location. Some women become prominent rulers and art patrons. A few become artists and calligraphers.

The prophet establishes a new theocratic social order that replaces traditional nomadic tribes. His example as a single ruler, in whose hands are political and spiritual leadership, continues after his death in the caliphs. They claim descent from the prophet or his early followers. The first dynasty of caliphs, the Umayyads (ruling 661–750 C.E.) in the Middle East, are aggressive Bedouins. They extend Islam's holding to India and southern France. Builders during this period synthesize elements from their conquered cultures resulting in structures expressing great power. The next dynasty of caliphs, also called Umayyads (ruling 756–1031) in Spain, are great art patrons. The Abbasid caliphate (ruling 750–1258) also extends Islamic territory. Its leaders promote culture, learning, science, and the arts.

The caliphate disintegrates in the 9th century, and the empire fragments into many regions. Iran and surrounding areas become the most important region politically, socially, and artistically. Noteworthy dynasties with dis-

116

tinctive art styles include the Seljuk Turks (ruling mid-11th century–1157), the Timurids (ruling western Iran 1378–1502), and the Safavids (ruling all of Iran 1502–1736). Between 1299 and 1922, the Ottomans rule Turkey. They expand the empire into Egypt and Syria, are great builders, and conquer Constantinople in 1453.

Between the 9th and 13th centuries, Islam contributes to education and science and its university system promotes cultural development. Muslim men and women are probably more literate than others during the Middle Ages because of Islam's emphasis on studying the Koran. Scholars excel in mathematics and philosophy and make important discoveries in medicine, the natural sciences, and astronomy. Various rulers or wealthy patrons support their efforts.

DESIGN CHARACTERISTICS

Allover surface patterns and visual complexity mark Islamic art and architecture, giving it a unique character that is remarkably consistent among the arts. Decoration consists of dense repeating patterns that are independent of structure and/or specific architectural features. Unity and variety within a geometric grid are common. Although there is uniformity, each element is distinguished according to its importance. There is no focal point, but infinite unity and variety exist in this intricate decorative system, known as *arabesque*, which can expand in size, direction, or form, as need demands. Patterns are generally nonfigural (aniconic) and derive from geometric and stylized naturalistic forms and calligraphy. Because of the Koran's admonitions against idolatry, the human figure never appears in

religious art and architecture. Sculpture is rare. Humans and animals may appear in nonreligious works.

Calligraphy is an important pattern on objects, architecture, and illuminated manuscripts. Since the Koran is in Arabic, copying this venerated book becomes a holy task. Designers soon exploit the decorative nature of Arabic script. Sayings from the Koran, beautifully integrated into the design, highlight architecture and objects in borders, cartouches, and medallions. Islamic calligraphy assumes

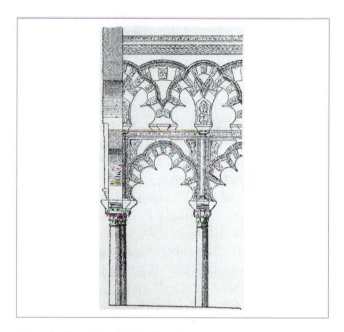

9-3. Scalloped (multilobed) arch.

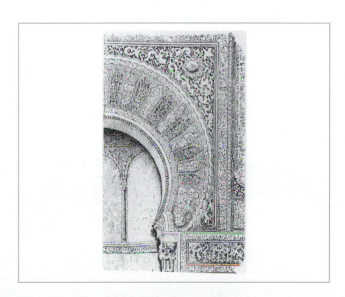

9-2. Horseshoe (Moorish) arch.

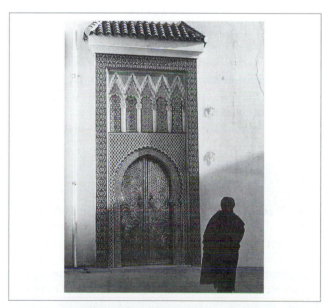

9-4. Entrance, Royal Palace; Morocco.

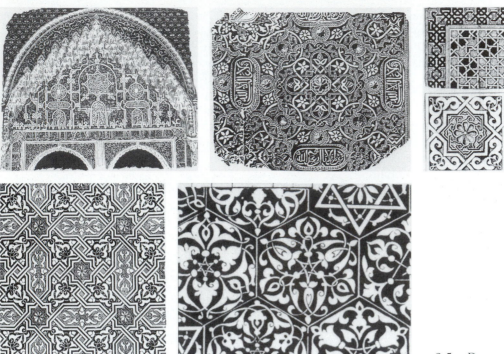

9-5. Decorative motifs.

many styles including the early *Kufic* (vertical script) and *Muhaqqaq* (horizontal script). Manuscript illumination becomes a highly developed art form practiced by both men and women.

■ *Motifs*. Common motifs (Fig. 9-5, 9-20, 9-35) are meanders, stars, swastikas, frets, rosettes, vines, scrolls, palm leaves, tendrils, and calligraphy.

ARCHITECTURE

Islamic architecture is consistent in form, construction, and decoration throughout its empire and across its cultures. Despite differing regional resources and climates, this new architectural image is universally identifiable as Islamic. Since nomads lack an architectural tradition, early builders assimilate construction techniques and ornamen-

Design Practitioners

■ *Sinan* (c. 1490–1588) is chief architect for Suleyman, the great Ottoman sultan who promotes building on a grand scale. Sinan's finest work is the Selimiye Cami (Mosque of Selim) in Turkey, which is greatly influenced by the Hagia Sophia. He also completes more than 300 commissions including palaces, baths, hospitals, schools, and mosques.

tation from their conquered peoples in Byzantium, Greece, Egypt, and the Middle East. This helps them to develop their own distinctive building types and unique forms in response to their culture's strong emphasis on religion and climactic needs for shade from the relentless desert sun and heat after dark.

The Koran's definition of the individual's position in society and the family, as society's building blocks, translates into clear distinctions between public and private sectors of both cities and houses. Streets and commercial areas are public, while private houses focus inward behind plain walls. Guests, male friends, and business associates are

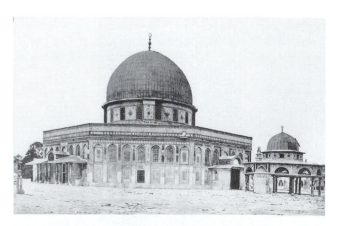

9-6. Dome of the Rock, begun in 684; Jerusalem, Israel; built on the spot where the prophet is believed to have been carried to heaven.

received and entertained in the public *selamlik* or men's area. The *haremlik* or women's areas are private and secluded, housing women, children, and servants. Only the head of the house and related males may enter. Plans clearly separate these two areas.

Particularly characteristic is the architectural decoration. Independent of structure, intricate patterns completely cover exteriors and interiors from foundations to roofs creating visual complexity and dematerializing form. Patterns, which are intended to obscure the structural system, are dense yet flat. Domes in various shapes are characteristic. Arch forms, such as the horseshoe (rounded and narrower at the bottom, similar to a horseshoe), are also unique to Islamic buildings.

Public Buildings

- *Types.* The most common building types are *mosques* (houses of worship), *madresahs* (religious schools usually attached to mosques), and mausoleums (commemorative tombs). Building complexes are centrally organized, but often incorporate a random arrangement of separate spaces linked together.

- *Mosque.* As the most important building, the mosque serves as a gathering place for prayer, a school, and a town hall (Fig. 9-6, 9-7, 9-8, 9-17). Its unique form, which is

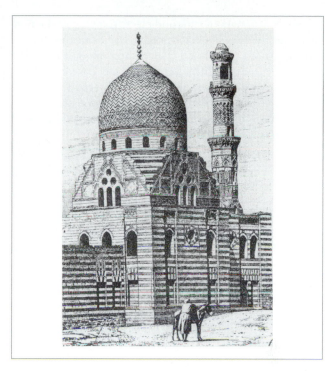

9-7. Grand Mosque, 1475; Cairo, Egypt.

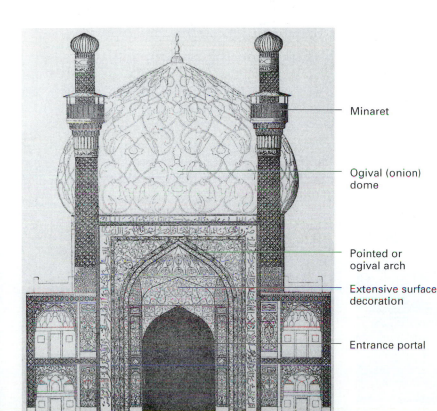

Minaret

Ogival (onion) dome

Pointed or ogival arch

Extensive surface decoration

Entrance portal

Design Spotlight

Architecture: *Masjid-i-Shah* (Great Mosque). Originally in hypostyle form, the mosque (Fig. 9-8) was remodeled in the 17th century into a four-iwan plan. An impressive gateway flanked by minarets and two domes completes the refurbishing. Colored tiles cover the bulging domes. The curving tendrils enhance the shape without obscuring it.

9-8. Masjid-i-Shah, 1612–1638; Ispahan, Iran.

consistent throughout time and place, responds to the new faith that requires space for prayer but has neither formal ceremony nor a priesthood. The earliest mosques resemble the prophet's house with its courtyard and covered area for prayer. Mosque interiors, intended for prayer and contemplation, neither awe nor exalt. Following the conquest of Syria in the late 7th century C.E., Muslims adapt the aisled spaces of basilica churches into mosques.

Three mosque plans develop and characterize mosques throughout the empire for centuries. The earliest consists of a courtyard and hypostyle hall. The four-iwan mosque plan features four barrel-vaulted spaces facing a central courtyard similar to religious schools. Later mosques are domed and centrally planned. All are axial, oriented toward Mecca, and have similar components.

When praying, Muslims face the *qibla* (prayer wall), which faces Mecca. Centered in the *qibla* is the *mihrab* or niche (Fig. 9-18). A dome on the exterior often signals the interior *mihrab*. Nearby is the *minbar*, a pulpit in which the *imam* (leader) declares the *khutba* (sermon and affirmation of allegiance by the community). It may have a *maqsurea* (screen or enclosure) for protection. The faithful are called to prayer from *minarets*, distinctive towers that identify religious buildings. Surrounding spaces may include soup kitchens where meals are prepared for the poor, libraries, and hospitals.

■ *Madrasah*. These theological colleges or schools of religion are usually attached to the mosque. Four vaulted halls surround a center courtyard. The *qibla* side hall is the largest. Apartments, schoolrooms, and other spaces surround the halls. Exterior decoration, unlike that on other public buildings, only surrounds openings and marks the roofline.

■ *Mausoleum*. Memorials to holy men or rulers, mausoleums are centrally planned and domed. The most famous is the Taj Mahal (Fig. 9-9), built by a Muslim Indian ruler as a memorial to his wife. It features lacy marble walls, large portals, minarets, domes, and elaborate decoration.

■ *Site Orientation*. Religious structures are strategically located on hills, near ruler's palaces, or at the intersections of main roads.

■ *Materials*. Buildings are arcuated (use arches), consisting of vaults and domes carried on columns and piers similar to Roman and Byzantine examples. Materials include brick, local stone, marble, stucco, glazed tile, wood, and metals for roofs, grilles, and tie-rods. Tiles, mosaics, marbles, and paint supply color, an important design element. Typical tile colors are blue, red, green, and gold. Tile shapes include stars and rectangles. A Muslim innovation is luster, a shiny glaze resembling metal that is used on tiles and objects.

■ *Arches*. Characteristic arches include the horseshoe (Fig. 9-2, 9-4), pointed or ogival (curving, pointed arch), and scalloped or multilobed arches (Fig. 9-3, 9-4, 9-13). Their forms develop from a desire for visual complexity instead of structural innovation. Islam's pointed arches do not cover spaces of different heights, nor are they part of a structural system as in Gothic design. Surface decoration on arches is common. Elaborate stuccowork (called *yeseria* in Spain), tilework, or mosaics cover exterior and interior arches. *Voussoirs* may be in alternating colors (Fig. 9-17).

■ *Domes*. Domes (Fig. 9-6, 9-7), another characteristic feature, cover prayer halls and other spaces. Squinches (small arches filling the space between the dome and

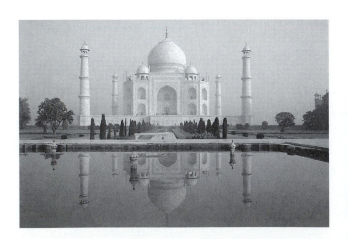

9-9. Mausoleum of the Taj Mahal, 1630–1653; Agra, India.

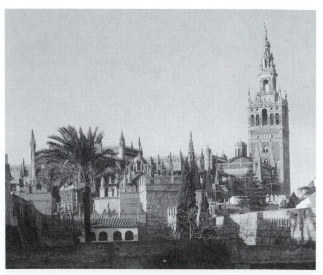

9-10. Alcazar, 1364; Seville, Spain.

drum) carry Islamic domes instead of the pendentives (triangular shapes) of Byzantine architecture. On the exterior, domes may be melon shaped or ogival (double curve) giving rise to the Western name "onion dome." Inside, domes may be round, octagonal, multilobed, or star shaped and have complex, nonstructural bracketing. Some feature *muqarnas* (interlocking brackets or corbels) that become increasingly complex in form. Of stucco, they resemble stalactites. *Muqarnas* may also cover arches.

■ *Facades.* Mosques usually feature a large entrance portal (Fig. 9-4, 9-8), one or more *minarets* (tall towers; Fig. 9-9), an arcaded portico, and an imposing dome. Elaborate surface decoration with Islamic motifs (Fig. 9-5, 9-7, 9-8) is characteristic. Interior courtyards feature arcades carried on piers or columns.

■ *Doors and Windows.* Wooden doors exhibit marquetry in many colors and inlay of silver, ivory, and other materi-als. Mosque windows (Fig. 9-6, 9-18), usually placed high in the wall, may have decorative wood, stone, or stucco grilles and/or colored glass.

■ *Roofs.* Roofs are flat or vaulted and of masonry, wood, metal, or rusticated Mediterranean tile (Fig. 9-13). Domes and the pinnacles of minarets are sometimes of lead.

■ *Later Interpretations.* Westerners do not generally copy Islamic building types because the structures are unsuitable for Western lifestyles and expensive to build and decorate. Individual elements, such as arches or domes, appear beginning in the 18th century. Notable examples in the 19th century include the exotic Royal Pavilion at Brighton (Fig. 9-15) in England and Frederick Church's home Olana in New York. The American Queen Anne style often uses onion-shaped domes and multilobed arches. Noteworthy

Design Spotlight

Architecture: *The Alhambra.* This palace (Fig. 9-11, 9-12) is the best surviving Moorish structure in Spain and features some of Islam's best stuccowork. Proportioned according to the Golden Mean, the Court of the Lions (Fig. 9-13, Color Plate 18) has slender single, double, and triple columns with richly carved capitals. They carry multilobed arches covered with colored stucco decorations that obscure and deny the stonework beneath them. *Yeseria* decoration (Fig. 9-14) on the walls enhances the organic, lacy image. The interiors (Fig. 9-23, 9-24) boast elaborate decoration with brightly colored tilework on walls and floors, *artesonades* (carved wood) ceilings, and horseshoe or Moorish arches.

9-11. The Alhambra, 1338–1390 and later; Granada, Spain.

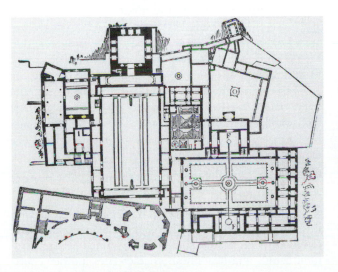

9-12. Floor plan, the Alhambra.

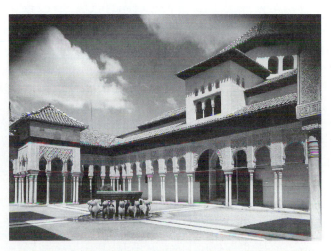

9-13. Court of the Lions, the Alhambra, 1338–1390 and later; Granada, Spain. (Color Plate 18)

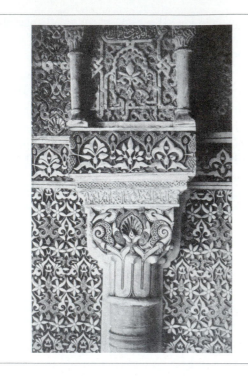

9-14. Wall decoration, the Alhambra.

9-15. Later Interpretation: Royal Pavilion, 1815–1821; Brighton, England; by Henry Holland; remodeled by John Nash; English Regency.

early-20th-century examples include the Fox Theater in Atlanta, the Shriners' Auditorium in Los Angeles, and Wise Temple (Fig. 9-16) in Cincinnati.

Private Buildings

■ *Types.* Rulers and the wealthy build large urban and desert palace complexes (called *alcazars* in Spain) and town houses. Often fortified, they are walled for seclusion as well as protection. Both palaces and houses have one or more interior courtyards with additional rooms and courtyards added as needed. Rulers and the wealthy live splendid, luxurious lives. Others live as comfortably as their finances permit.

■ *Site Orientation.* Palaces may be sited on high promontory points or in defendable areas. In cities, residential districts are separate from public and commercial areas. Wealthy areas have wide streets with parks and squares. Poorer districts have narrow, winding streets. Both palaces and houses focus inward for protection and privacy. Facades of both are plain with windows high in the wall. In courtyards, lush gardens in geometric patterns with fountains and water channels are prominent as a type of Muslim paradise.

■ *Floor Plans.* Palaces and houses consist of groups of rectangular rooms interconnected around courtyards and gardens (Fig. 9-12). An arcaded loggia surrounding the courtyard provides a transition and filters light from the sunny exterior to the darker interior. Entrance doorways generally open into important public spaces such as reception halls (Fig. 9-21, 9-23), which are always located in men's quarters. The main reception hall(s) or *iwan* is located on the north (summer) or south (winter) side of the main courtyard and may have its own fountain. Enclosed on three sides, it is the most elaborately decorated room in the house and has the finest furnishings to convey the wealth and status of the household. Men's areas are distinctly separate from women's by location. Each has its own reception room(s) surrounded by sleeping rooms and storage places. Most dwellings have many guestrooms due to the Muslim emphasis on hospitality. Upper floors may have balconies overlooking the garden. Ancillary spaces may include baths similar to those of the Romans, offices, and mosques. Kitchens and other service areas are separate from the main rooms.

■ *Materials.* Most domestic structures, even palaces, are of wood on stone or brick foundations.

■ *Facades.* Palaces, like castles, have plain exteriors with little architectural detailing except at the main portal and rooflines. Rich embellishment with numerous architectural details and decoration characterizes interior courtyards (Fig. 9-10, 9-13). Town houses have two or three

9-16. Later Interpretation: Isaac M. Wise Temple, 1866; Cincinnati, Ohio; Turkish/Exotic Revival.

stories that project over each other. Carved beams that support the projecting floors may be the only embellishment. Like palaces, private homes have facades that are plain, concealing the luxury within. Elaborate stucco decoration may embellish courtyard arches and surrounds (Fig. 9-10). Vertical surfaces (Fig. 9-5, 9-14) have arabesques and calligraphy. Colorful tile dadoes are an important architectural feature throughout many homes and palaces.

■ *Windows.* Windows (Fig. 9-10) typically vary in size and placement, depending on the function of the interior space. Most have shutters for privacy. Many have tile surrounds with iron or wood grilles, and may be rectangular or feature distinctive arch shapes.

■ *Roofs.* Clay tile roofs are common on domestic structures.

INTERIORS

As with exteriors, most interiors exhibit complex surface patterns and color on floors, walls, and ceilings and arched, vaulted, or domed spaces. The complex, abstract patterns remind Muslims of infinity and the divine presence whose creation features eternal patterns. In homes, the decoration of walls, floors, and ceilings conveys the owner's status. Water and light are important design elements. Limited furnishings are typical in both mosques and houses.

Private Buildings

■ *Types.* Room use is flexible; several activities may occur within a space. For example, the multifunctional reception

room serves as a dining, entertaining, and at times, sleeping space.

■ *Color.* The interior palette mainly derives from decorative tiles, stucco, painting, and rugs. Typical colors include rich tones of red, blue, green, gold, black, and cream (Fig. 9-20, Color Plate 19).

■ *Floors.* Floors feature tile or mosaic patterns, often with borders, medallions, and geometric forms (Fig. 9-20). *Iwans* and other important spaces often have more than one level. The *tazar* or main reception area in the *iwan* is a step or two higher than the entry. Rugs usually cover floors.

■ *Walls.* Walls are decorated with marble, tile, stuccowork, wood, painting, and calligraphy (Fig. 9-20, Color Plate 19, 9-21, 9-22, 9-23, 9-24, 9-25). Decoration may be in bands or panels. Often tile dadoes are at least four feet high. Poems or inscriptions in calligraphy invite closer study and remind of the divine presence. Cupboards and niches display prized objects. Small arches high on the wall filter air from one space to another.

■ *Doors.* Dark wood doors, either plain or with geometric carving, are typical. They have iron hinges and door handles. Some are accented with decorative nailheads.

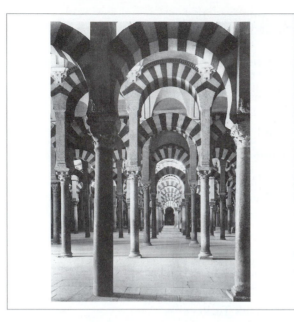

9-17. Interior, Great Mosque, begun in 785; Córdoba, Spain.

9-19. Interior showing Ibur Sena, a poet, philosopher, and diplomat who lived 980–1037.

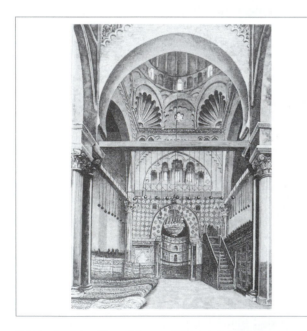

9-18. Interior, Great Mosque, 836 and onward; Quairouan, Tunesia.

9-20. The Damascus (Nur al-Din) Room, 1707; Damascus, Syria. (Courtesy of The Metropolitan Museum of Art, The Hagtop Kevorkian Fund, 1970) (Color Plate 19)

■ *Textiles*. Rooms feature numerous textiles that add to the feeling of luxury and comfort. Rugs (Fig. 9-19, 9-35), hangings, curtains at doors or between columns, covers, or cushions are both functional and decorative, adding richness, warmth, pattern, and color. Patterns of textiles, ceramics, and applied decoration on walls, floors, and ceilings are remarkably similar. Types include plain and embellished silks, damasks, velvets, and printed cottons in highly saturated colors.

■ *Ceilings*. Ceilings may consist of domes, vaults, or beams and are highly decorated. In Spain, the *artesonades* ceiling (geometrically carved wood panels; Fig. 9-20, 9-24) is an important and distinctive architectural detail. A honey-

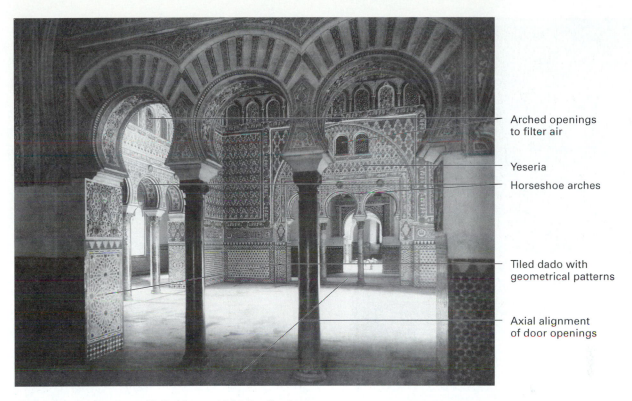

Arched openings
to filter air

Yeseria

Horseshoe arches

Tiled dado with
geometrical patterns

Axial alignment
of door openings

9-21. *Iwan* or Reception Hall, Alcazar, 1364; Seville, Spain.

Design Spotlight

Interior: *Reception Hall, Alcazar, Seville.* This *iwan* (Fig. 9-21) or main reception hall is the most elaborately decorated room in the palace and would feature the finest furnishings to convey wealth and status. These may include divans, ottomans, hexagonal tables, and Persian and Turkish rugs in rich colors. Complex surface patterns on the walls incorporate horseshoe arches, *yeseria*, decorative colored tiles, and geometric designs. Cross-axial circulation supports movement to secondary spaces and to the adjacent courtyard.

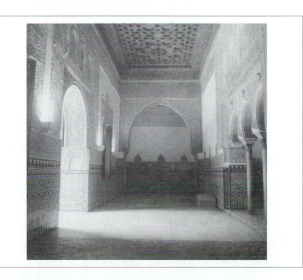

9-22. Apartment, Alcazar; Seville, Spain.

comb or stalactite dome (Fig. 9-23) may surmount important reception halls.

■ *Later Interpretations.* Fascination with the exotic leads homeowners in the 1880s to create a Turkish corner or a smoking den (Fig. 9-26, 9-27). The Turkish corner is a small draped space with a divan and numerous pillows (Fig. 9-28). Many interiors exhibit at least some Turkish details in accessories or furniture. Tiles, drapery with cusps, brass objects, hanging lamps, and Oriental rugs often hint

at romance, even slight promiscuousness, in these late-19th-century rooms. In the early 20th century, many public buildings, such as theaters, mosques, churches, and Shriner and Masonic temples (Fig. 9-29), incorporate Islamic influences with domes, arches, and patterned tilework.

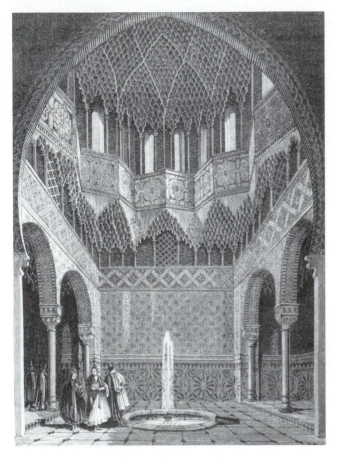

9-23. *Iwan* or Reception Hall, the Alhambra, 1338–1390 and later; Granada, Spain.

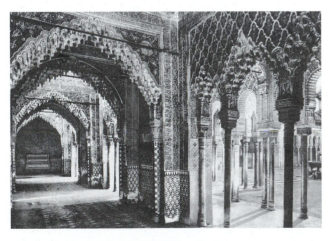

9-24. Interior, the Alhambra; Granada, Spain.

9-25. Interior of harem, Topkapi Palace, started 1454; Istanbul, Turkey.

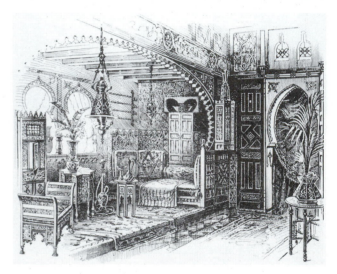

9-26. Later Interpretation: Turkish Corner, 1880s; Turkish/Exotic Revival.

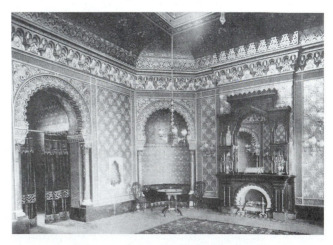

9-27. Later Interpretation: Oswald Ottendorfer's Moorish Pavilion; Manhattanville, New York; published in *Artistic Homes*; Vol. I, 1883; Turkish/Exotic Revival.

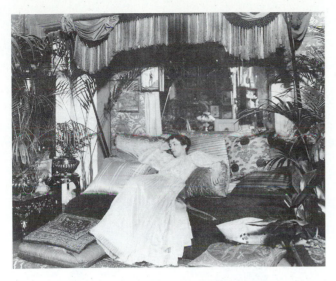

9-28. Later Interpretation: Elsie De Wolfe in her cozy corner, Irving House, New York, 1896.

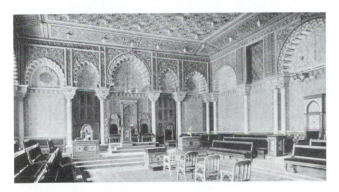

9-29. Later Interpretation: Masonic Temple, Philadelphia, c. 1890.

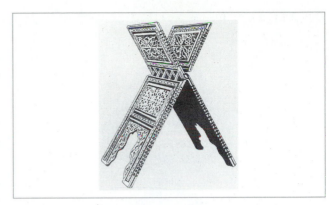

9-30. Koran stand made of inlaid and pierced wood.

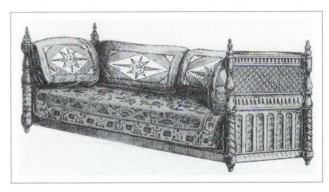

9-31. Turkish divan emphasizing cushions.

FURNISHINGS AND DECORATIVE ARTS

Following the nomadic heritage of the Arabs, most Islamic interiors have little movable furniture. Dining sets, beds, sideboards, and the like, are not used until European influences appear in the 19th century. Area rugs cover floors and, along with pillows, provide general seating areas. Coffers (chests) serve as storage. Important personages sit under canopies. Only rugs, basins for ablutions, and lamps appear in mosques.

■ *Seating.* Movable seating, such as chairs and stools, is rare in households. Large cushions or rugs provide general seating. A divan (a benchlike seat with cushions) outlines the walls of important rooms (Fig. 9-31); its name derives from the privy council of the Ottoman Empire. Seats often vary in height, and the tallest is reserved for the most important guest.

■ *Tables.* Small movable tables of wood inlaid with ivory and ebony (Fig. 9-19) are noteworthy for their hexagonal shape and overall decorative treatments; they reappear in the late 19th century during the Turkish/Exotic Revival (Fig. 9-26). The Koran stand (Fig. 9-19, 9-30), which holds the holy document, is important and typically very elaborate.

■ *Rugs.* Originally made by nomadic tribes for many utilitarian purposes, rugs (Fig. 9-18, 9-19, 9-35) evolve into a highly developed art form. Once made in imperial factories, rulers give them as gifts, for recognition, or as political favors. In the 19th century, rugs begin to be woven specifically for Western markets. Rugs exhibit the same decorative system, colors, and visual complexity as other ornaments. Handmade rugs with a knotted pile are known as Oriental, Turkish, or Persian.

■ *Rug Construction and Decoration.* Oriental rugs are made with piles of wool, silk, and occasionally, cotton. The warp

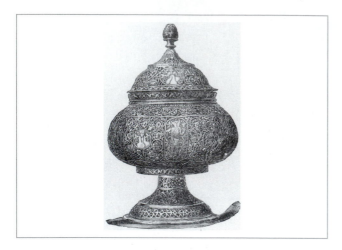

9-32. Incense burner of engraved brass.

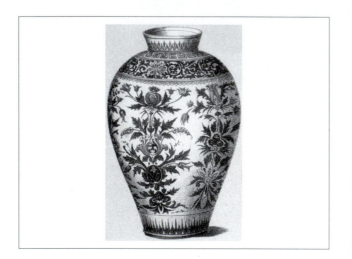

9-33. Ceramic with floral motif.

9-35. Persian rugs, 16th and 17th centuries.

9-34. Ghiordes (e.g., Turkish) and Senna (e.g., Persian) carpet knots.

and weft are usually cotton. Yarns originally are colored with natural dyes, but now synthetics are used. The pile consists of numerous Turkish (*ghiordes*, symmetrical) or Persian (*senna*, asymmetrical) knots (Fig. 9-34) tied around two warps. The Persian knot yields a finer pile and more defined pattern. The finer the rug, the more knots per square inch. Rugs have major and minor borders and central fields with geometric or curving patterns (Fig. 9-35). Colors are rich and vibrant; green and yellow are rare. Patterns consist of repeated motifs, such as *gulls* or *meri-boteh*,

9-36. Later Interpretation: Turkish parlor chair from Sears, Roebuck and Company catalog, late 19th century; Turkish/Exotic Revival.

9-37. Later Interpretation: Moorish table and stools; Florence, Italy; by Andre Bacceti, c.1890.

all-over patterns such as garden or hunting designs, prayer patterns, and center medallions. The modern paisley motif comes from the pinecone or meri-boteh motif.

■ *Decorative Arts.* Decorative arts consist of glassware, metalwork (Fig. 9-32), ceramics (Fig. 9-33), and ivories. All feature the motifs and decorative systems of the architecture and interiors.

■ *Later Interpretation.* In the 19th century, furniture labeled as Turkish consists of overstuffed, deeply tufted sofas; divans; ottomans; chairs trimmed with long, heavy fringe (Fig. 9-36); and tables with carved and inlaid decoration (Fig. 9-37). Companies such as Sears, Roebuck and Company mass-produce these furnishings to meet consumer demand.

10. Romanesque

8th century–1150 C.E.

What is God? He is length, width, height, and depth.

What profit is there in these ridiculous monsters, in that marvellous and deformed comeliness, that comely deformity?

> Bernard of Clairvaux, 1127 from *Literary Source of Art History*, ed. E. G. Holt

Romanesque architecture derives its name from its similarity to ancient Roman buildings, most notably its reliance on the round arch and stress on individual parts to create unity. An international style with numerous regional variations, the builders look to older construction methods and forms for ways to respond to functional needs. Primarily manifest in churches, Romanesque structural developments, such as the rib vault, will be carried further in the subsequent Gothic style.

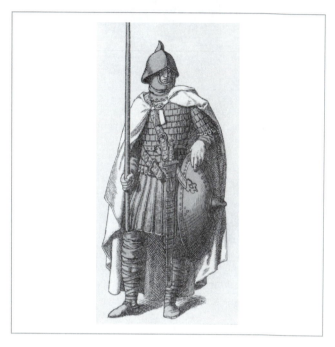

10-1. Costume of a crusader.

HISTORICAL AND SOCIAL

Several institutions and precedents that significantly affect Romanesque and Gothic life and art arise during the Early Middle Ages (5th–9th centuries). After the Roman Empire disintegrates in the 5th century C.E., Europe fragments into groups of tribal alliances. The Catholic Church is the only surviving major institution. Through its evangelism, Europe becomes Christianized and the church exerts more spiritual, political, and economic influence. It becomes central to medieval life and thought, but its unifying abilities are limited because local rulers sometimes do not acknowledge its authority.

Beginning in the 6th century, various religious orders found monasteries, which become important medieval institutions. These devout societies combine a strict religious rule with intellectual and artistic endeavors. Male members called monks include in their studies architecture, mathematics, and medicine. They also write books and copy ancient manuscripts. More important, monasteries preserve knowledge and culture. Their schools maintain and disseminate education. Religious rule requires manual labor, so monks also clear forests, build roads, and cultivate gardens and fields.

Feudalism and seignorialism organize society into classes of warrior-nobility, clergy, and commoners. The nobility bond together under feudalism whereby a king or noble grants a fief (usually land) to a baron or vassal who, in turn, swears loyalty and political and military service to the lord. The system maintains order and controls territory when governments are nonexistent or weak. Seignorialism or manorialism, closely related to feudalism, forms social, political, and economic relationships between a lord or landholder and his dependent farmers or peasants (serfs). Both systems dominate medieval society until their decline begins in the 14th century.

Significant building, with the exception of monasteries and churches, before the 11th century is rare because of constant warfare and poor economic conditions. Most churches continue the basilica plan and form from the Early Christian period. An important exception is stimulated by Charlemagne (771–814 C.E.), who attempts to revive the Roman Empire and its culture. He encourages his builders to study and adopt Roman building principles and methods. Their models include Late Roman, Early Christian, and Byzantine. Charlemagne's Palatine Chapel closely emulates San Vitale in Ravenna (526–547 C.E.)

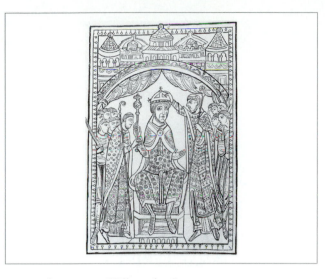

10-2. Coronation, William the Conqueror.

through its centralized planning, but the emphasis on weight and mass and careful architectural articulation foreshadows Romanesque designs.

In the 10th century invasions begin anew. Vikings attack in the north, Magyars from Asia invade the east, and Muslims terrorize the Mediterranean. In the middle of the century, the eastern portion of Charlemagne's empire unifies under the Ottonians. Successors to the Holy Roman Empire, these rulers preserve and advance the institutions and culture of Charlemagne.

The 11th and 12th centuries of the Romanesque period are a turning point in Western Europe as she emerges as a separate entity from Byzantium and Islam. The millennium arrives with no apocalypse, as many had feared. Under the leadership of William the Conqueror, the Normans defeat the Anglo-Saxons at the battle of Hastings in 1066, which unites England and France. Eventually, the great invasions cease, but lack of political unity, widespread illiteracy, and poor communication remain. Feudalism and seignorialism continue dominating society, while individual nations struggle to arise. During this time, Mediterranean trade routes reopen, stimulate the economy, and produce a new middle class of artisans and merchants. The expansion of towns, commerce, industry, and populations creates a building boom.

More important, Christian influence, and with it education and culture, continues to spread across Europe. The Catholic Church provides stability and unity through shared faith, diplomacy, and administration of justice. Monasteries flourish and continue to foster and support intellectual and artistic expression. Many become wealthy

and are instrumental in the building of numerous churches. Clergy and laypeople sponsor and join the Crusades to liberate Jerusalem from the Muslims beginning in 1095. This joining of secular and religious forces creates the ideal of the warrior-priest that, in turn, influences knighthood and its code of chivalry. The code includes piety, concern for the poor, loyalty, valor, and chaste love and respect for women. Although men dominate, a few women, such as Eleanor of Aquitaine, hold power and exert influence.

Pilgrimages reflect the period's religious zeal. Favored sites are Jerusalem and Rome. Neither is easily accessible, so Santiago de Compostella in Spain becomes the most important sacred site. People, buildings, and wealth concentrate along the four main pilgrimage routes to Santiago. Stimulated by the Crusades, pilgrimages, and the needs of cities, many churches are constructed, renovated, or rebuilt. Romanesque architecture flourishes throughout France, England, Italy, Germany, and Spain.

CONCEPTS

Romanesque architecture springs up all over Europe as builders grapple with the problems of providing larger, structurally stable churches to accommodate crowds of pilgrims and worshippers, good light and acoustics, and fire resistance. They cease to copy buildings they know and strive to respond to current architectural, practical, and liturgical needs and patrons' desires. Often, they look to local surviving Roman architecture and construction methods, a precedent set in the time of Charlemagne.

Responses to individual needs and the variety of models produce numerous regional church styles that differ in appearance, but relate in their use of such Roman architectural characteristics as vaults and round arches, and their careful delineation of various parts to create unity. The style assimilates many influences, including Byzantine, Islamic, Carolingian, Ottonian, Celtic-Germanic, and Norman. Stylistic and construction innovations spread quickly as clergy, pilgrims, and builders travel from site to site.

Domestic buildings of nobles must provide protection for many people, including knights and serfs. Throughout the Middle Ages, noble households are large and fluid. They are composed of immediate and extended family, guests, and numerous attendants and servants, most of whom are male.

Spaces in both religious and domestic structures often are multifunctional, utilitarian, and basic. Central to medieval life is the hall, which is used for entertaining, sleeping, conducting business, and dispensing justice. Because nobles move from one locale to another to oversee their lands, most furnishings are portable.

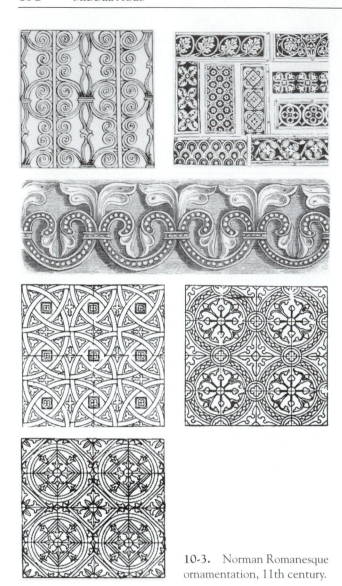

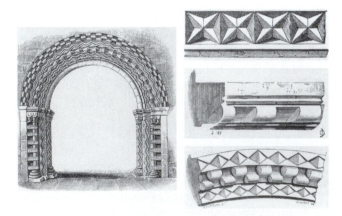

10-3. Norman Romanesque ornamentation, 11th century.

10-4. Norman moldings, 12th century.

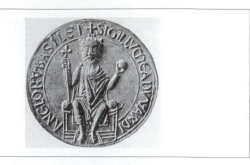

10-5. Great Seal of Edward the Confessor.

DESIGN CHARACTERISTICS

Emphasis is on massing, architectural elements, moldings, and sculpture to articulate design features (Fig. 10-4, 10-11). Symmetrical compositions and ordered arrangements of building forms are common. Religious structures convey the best examples of design vocabulary. Innovations include variations of pier forms, triforium (arches or a gallery over the nave arcade; it may have three arches, hence the name), regular crossings (square or nearly square with four arches equal in size that correspond to the four arms of the church), and more architectural sculpture. Other common characteristics include the round arch, regularly repeated modules (standardized units in plans and facades), towers, buttresses, ribbed vaults, ambulatories, thick walls, and masonry building materials. Forms, features, and aesthetic elements develop, in part, through engineering advances in response to practical and liturgical needs.

■ *Motifs*. Important motifs (Fig. 10-2, 10-3, 10-4) include the round arch, figures, corbel tables (projecting walls composed of brackets connected by round arches), animals, grotesques and fantastic figures, foliage, heraldic devices, linenfold, zigzags, lozenges, and geometric forms. Molding designs (Fig. 10-4) include the zigzag, star, *billet* (dentil-like), and lozenge (diamond shaped).

ARCHITECTURE

Romanesque is an international ecclesiastical architectural style with regional variations. Forms and details grow from a common and logical architectural language that is an outgrowth of a more intellectual approach to building that replaces tradition and intuition. Exterior and interior architectural elements are articulated for order, unity, readability, and monumentality. Romanesque revives the use of figural and nonfigural sculpture. Capitals, windows, portals, and arches illustrate sculptural delineation.

Public Buildings

■ *Types.* Churches (Fig. 10-11) and monasteries (Fig. 10-12) are the primary building types. Churches serve as places of worship, eateries, and hostels. Other types of architecture include public buildings, town houses, cas-

tles, manor houses, and farmhouses. The few secular structures that survive, mainly castles, rarely exhibit stylistic characteristics.

■ *Site Orientation.* Churches are usually located along pilgrimage routes or in town centers. In monasteries, the cloister, dormitory, refectory, and kitchen surround the church, a visual metaphor for its centrality to monastic life. Other structures include guesthouses, schools, libraries, barns, stables, and workshops. Monasteries are walled for protection and privacy.

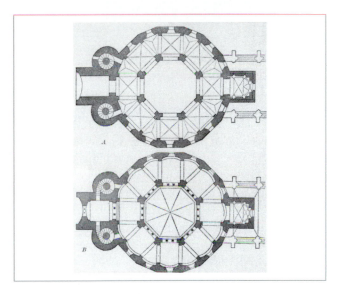

10-6. Floor plan, Palatine Chapel, Charlemagne's Palace, 792–805 C.E.; Aachen, Germany; by Odo of Metz.

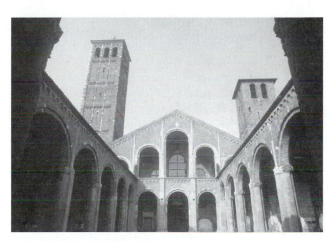

10-8. S. Ambrogio, c. 1080–1128; Milan, Italy; a significant example of the Lombard-Romanesque style.

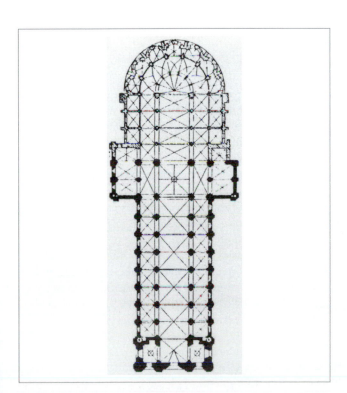

10-7. Floor plan, S. Etienne (Abbaye-aux-Hommes), c. 1060–1081; Caen, France.

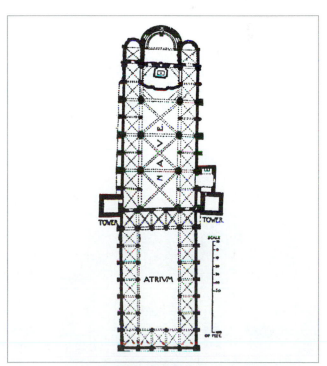

10-9. Floor plan, S. Ambrogio.

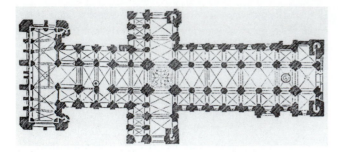

10-10. Floor plan, Durham Cathedral, 1093–1133; Durham, England.

■ *Floor Plans*. An early example of a round church plan reflecting the Byzantine influence is the Palatine Chapel (Fig. 10-6), Charlemagne's palace in Aachen, Germany, with 16 sides and a tall, vaulted ceiling. Many churches, however, follow the pilgrimage plan (Fig. 10-7, 10-10) in which the side aisles flanking the nave extend around the transept and circular apse. Besides adding needed space, this innovation allows clergy to continue their duties despite the crowds. Plans are based on a module composed of one nave bay. Aisles are half of this unit in width. Modules allow infinite variation in size and configuration. The crossing is square or nearly so and marked by a tower or octagonal dome. Some Italian churches retain the Early

Design Practitioners

■ *Master masons*. Anonymous master masons build most Romanesque churches. They prepare sketches, design individual elements, coordinate and supervise other craftsmen, and even obtain stone and other building materials.

Christian colonnaded forecourt or atrium (Fig. 10-9) and narthex (porch).

■ *Materials*. Churches are primarily of masonry to prevent fires. A few retain wooden ceilings and roofs. Local stone dominates because of transportation difficulties. Exteriors often feature several types in contrasting colors. Areas lacking good building stone use brick. The Lombard style in Italy features plain brick exteriors (Fig. 10-8). Elaborate marble facades (Fig. 10-14) distinguish the Pisan style.

■ *Facades*. Round arches and delineated architectural elements are key features. Fronts may have three parts, each with a portal (main entrance with tympanum). Twin towers are common. Earlier westworks, multistoried combinations of towers and entrances, survive mainly in Germany. Simple to elaborate sculpture programs embellish facades. Front and side walls are divided into bays (Fig. 10-13, 10-14,

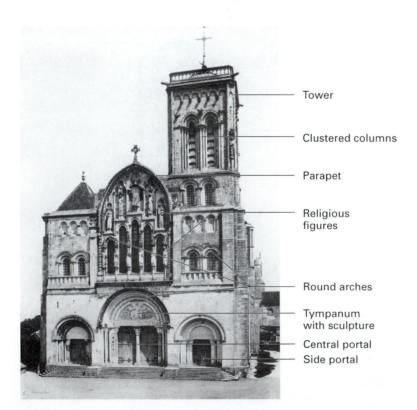

Tower

Clustered columns

Parapet

Religious figures

Round arches

Tympanum with sculpture

Central portal

Side portal

Design Spotlight

Architecture: *S. Madeleine, Vézelay, France*. Three portals highlight this façade (Fig. 10-11) with its single tower. Sculptures accent the tympanum and large arch over the central portal. Round arches dominate the composition. Inside (Fig. 10-21, Color Plate 21), transverse arches with colored voussoirs articulate the barrel-vaulted nave. Similarly, colored voussoirs accent the round nave arcade. Decorative carving also highlights and emphasizes the nave arcade, clerestory windows, stringcourse, and transverse arches.

10-11. S. Madeleine, c. 1104–1132 and later (restoration complete in 1859 by Viollet-le-Duc); Vézelay, France.

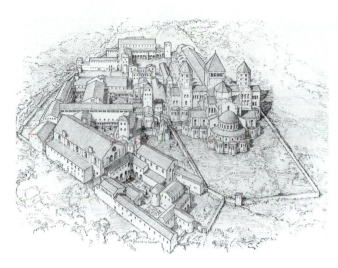

10-12. Abbey (reconstruction drawing), 910–1156; Cluny, Burgundy, France.

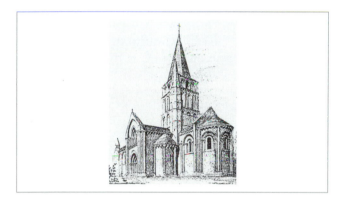

10-13. S. Pierre, 1140–1170; Aulnay, France.

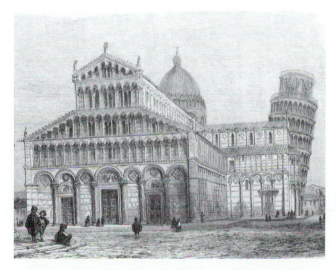

10-14. Pisa Cathedral 1063–1092, baptistery 1153–1278, campanile 1174; Pisa, Italy; designed by Buscheto (cathedral), Rainaldo (cathedral facade), Diotisalvi (baptistery), and Bonanno Pisano (campanile); Pisan-Romanesque style.

Design Spotlight

Architecture: *Abbey, Cluny, France.* Abbeys or monasteries consist of groups of monks or nuns headed by an abbot or abbess. Leaving the world behind, they take vows of obedience, poverty, and celibacy. Abbeys are centers of learning and havens for scholars. Like many monasteries, Cluny (Fig. 10-12) is renowned for its scholarly and artistic pursuits. The abbey complex illustrates the relationship of buildings and architectural forms common to the period.

10-17) using buttresses, engaged columns, or pilasters, often corresponding to interior units. Arcades with round arches accent facades and towers (Fig. 10-11, 10-14). Corbel tables emphasize roof angles, spires, and parapets (walls projecting above the roof; Fig. 10-8, 10-11). Italian examples often have marble veneer in panels and stripes.

■ *Doors and Windows.* Rounded doors, windows, and arcades display figural and nonfigural sculptures. Stone sculpture had all but disappeared in Europe, so its revival in the Romanesque period is an important innovation. Romanesque sculpture typically relates to the architecture. In the Gothic period, sculpture will be integrated even more. Recessed portals (Fig. 10-11, 10-15) feature columns forming the jambs and sculpture in the tympanum and *archivolts* (arch moldings). To help educate the parishioners, sculptures illustrate biblical stories and history and incorporate Christian symbols. Windows are as large as construction permits. Stained glass emerges late in the period.

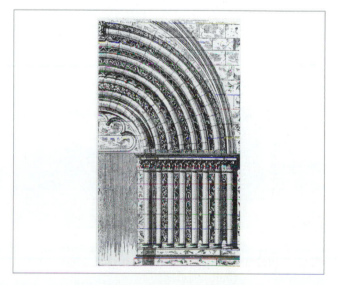

10-15. Portals.

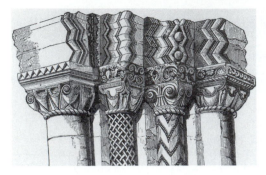

10-16. Capitals.

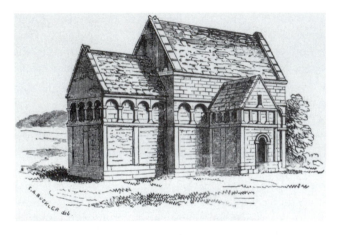

10-17. Saxon Church; Bradford-on-Avon, Wilts, England.

■ *Roofs*. Timber roofs are usually gabled with less pitch than Gothic roofs. Chapels and towers may have conical or pyramidal roofs. The nave and flanking aisles sometimes have their own roofs (Fig. 10-14).

■ *Later Interpretations*. Characteristic elements reappear in the 19th century as Romanesque Revival as illustrated in the Smithsonian Institute's "Castle" (Fig. 10-18) in Washington, D.C., and also in the work of Henry Hobson Richardson through examples such as Trinity Church (Fig. 10-19) in Boston, Massachusetts.

INTERIORS

Church interiors feature many of the common Romanesque characteristics: round arches, repeated modules, ribbed vaults, compound piers, triforium, thick walls, and

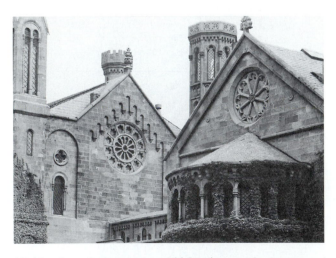

10-18. Later Interpretation: Old Smithsonian Institute Building 1847–1855; Washington, D.C.; by James Renwick, Jr.; Romanesque and Gothic Revival.

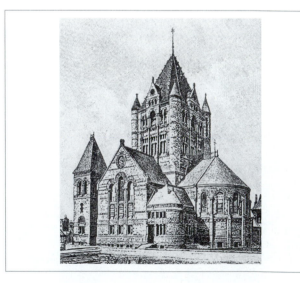

10-19. Later Interpretation: Trinity Church, 1873–1877; Boston, Massachusetts; by Henry Hobson Richardson; Romanesque Revival.

Important Buildings and Interiors

- **Aachen, Germany:** Palatine Chapel, Charlemagne's palace, 792–805 C.E., Odo of Metz.

- **Aulnay, France:** S. Pierre, 1140–1170.

- **Burgundy, France:** Autun Cathedral, c. 1120–1132.

- **Caen, France:** S. Etienne (Abbaye-aux-Hommes), c. 1060–1081.

- **Cologne, Germany:** Trier Cathedral, 1016–1047.

- **Cluny, France:** Abbey, 910–1156, with later additions.

- **Conques, France:** Sainte-Foy, c. 1050–1120.

- **Durham, England:** Durham Cathedral, 1093–1133. (Color Plate 20)

- **Lorsch, Germany:** Torhalle (gatehouse), Lorsch Monastery, c. 800 C.E.

- **Milan, Italy:** S. Ambrogio, c. 1080–1128

- **Pisa, Italy:**
 —Cathedral, baptistery, and campanile, 1063–1265
 —Buscheto (cathedral), Rainaldo (cathedral facade) Diotisalvi (baptistery), and Bonanno Pisano (campanile).

- **Poitiers, France:** Notre-Dame-la-Grande, c. 1130–1145.

- **Santiago, Spain:** Santiago de Compostela, 1078–1124.

- **Speyer, Germany:** Speyer Cathedral, c. 1030.

- **Toulouse, France:** S. Sernin, 1077–1119 and later.

- **Vezélay, France:** S. Madelaine, c. 1104–1132. (Color Plate 21)

- **Worms, Germany:** Worms Cathedral, late 11th century.

- **Yorkshire, England:** Fountains Abbey, c. 1137–1200.

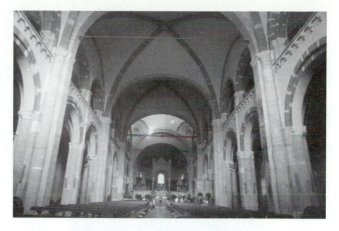

10-20. S. Ambrogio, c. 1080–1128; Milan, Italy.

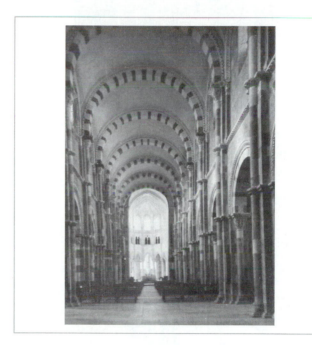

10-21. S. Madeleine, c. 1104–1132; Vezelay, France. (Color Plate 21)

masonry ceilings. Like exteriors, interiors articulate elements to create rhythm and order, unlike the earlier simple basilica spaces with flat ceilings and walls. These Romanesque interiors appear very different from the glittering, otherworldly interiors of Early Christian and Byzantine churches. Architectural elements delineate individual bays or units, but emphasis is on weight and mass, in contrast to the lightness of Gothic architecture. Sculpture is mostly architectonic—outlining nave and transverse arches, windows, and moldings, and forming capitals.

Few Romanesque domestic interiors survive intact. Emphasis seems to have been on hangings instead of woodwork or furniture. Interiors reflect the importance of ceremony and rank though lavish appointments, textiles, and furniture. Living patterns do not change significantly from the Romanesque to the Gothic period. (Domestic medieval interiors are more fully discussed in Chapter 11, Gothic.)

Public Buildings

■ *Color.* Most Romanesque church walls and ceilings are painted, which emphasizes their architectonic nature. Treatments vary from simple washes of color to extensive

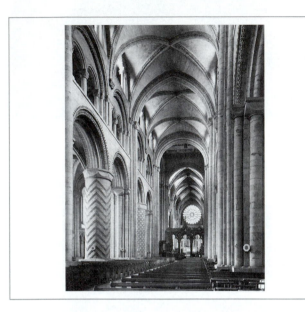

10-22. Durham Cathedral, 1093–1133; Durham, England. (Color Plate 20)

figural and decorative schemes. Colors include yellow ocher, sandstone, gray, or red. Contrasting color, borders, or ornamental patterns highlight architectural elements (Fig. 10-21). Some transverse arches (an arch or rib formed from pilasters or engaged columns rising from a pier and crossing the ceiling to the opposite pier) have structural or painted voussoirs in contrasting colors. Italian examples often continue the Byzantine traditions of mosaics and colored marble panels.

■ *Floors.* Floors are important design elements because there are no pews or seats and few furnishings. Treatments vary from plain stone or brick with simple washes of color to elaborate patterns in tile or marble.

■ *Walls.* Nave walls feature round arches (Fig. 10-20, 10-21, 10-22, 10-23, 10-24), reminiscent of those used in Roman aqueducts, basilicas, and baths. Two- and three-story nave elevations are typical. The lower portion is an arcade carried on piers. Above is the triforium, composed of two or more round arches carried on columns. Clerestory windows, also with round arches, only appear in groin or rib-vaulted naves. Openings reveal wall thickness and emphasize weight. In Britain, Normandy, Germany, and Italy, churches often have passages within their thick upper walls. Largely an articulation device, columns and arches separate these passages from the main space.

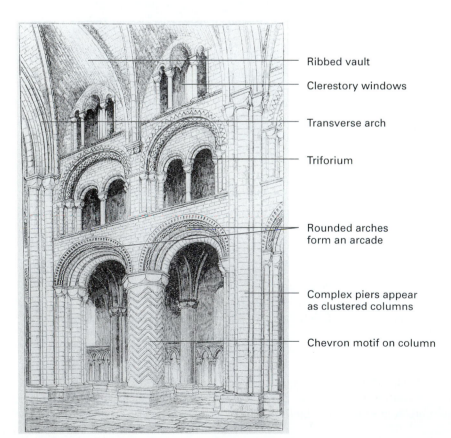

Ribbed vault

Clerestory windows

Transverse arch

Triforium

Rounded arches form an arcade

Complex piers appear as clustered columns

Chevron motif on column

10-23. Arches in the Nave, Durham Cathedral.

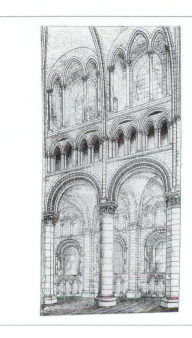

10-24. Arches in the Choir, Canterbury Cathedral, late 12th century; Canterbury, England.

10-25. Later Interpretation: Masonic Temple, c. 1900; Philadelphia, Pennsylvania; Romanesque Revival.

■ *Later Interpretation.* Romanesque influences appear primarily as a Romanesque Revival during the late 19th and early 20th centuries. Fraternal organizations interpret various historic motifs and design features in their buildings, as evident in the elaborately decorated Masonic Temple (Fig. 10-25) in Philadelphia, Pennsylvania.

FURNISHINGS AND DECORATIVE ARTS

Church furnishings consist mainly of altars, canopies, and shrines. Accessories, such as silver chalices, are particularly luxurious and elaborate. (Secular medieval furnishings are more fully discussed in Chapter 11, Gothic.)

■ *Nave Vaults.* The earliest nave vault is the barrel vault, which requires thick walls for support. Consequently, there are no clerestory windows. A variation is a pointed barrel vault with pointed transverse arches and a nave arcade. Besides allowing greater height, pointed forms permit the addition of a triforium and clerestory windows. Some builders experiment with groin vaults for naves (Fig. 10-20), but do not generally adopt them, except in France. Ribbed vaults, a significant Romanesque innovation, move from the aisles to cover a nave for the first time at Durham (Fig. 10-22, 10-23). Pointed arches, ribbed vaults, the triforium, and clerestory windows begin to dematerialize thick Romanesque walls. Gothic innovations will complete this process.

■ *Piers and Transverse Arches.* Piers (Fig. 10-20, 10-21, 10-22) are compound, single spiral, double fluted, plain round, and quadrangular. Complex piers emphasize bays and articulate the interior. A center pier may extend upward and across the nave ceiling to form a transverse arch. Most masonry ceilings have them, but more for articulation than support. Capitals (Fig. 10-16) are similar in form to Corinthian capitals, but are decorated with animals, figures, and foliage. They also exhibit geometric designs such as the chevron, zigzag, and guilloche.

■ *Ceilings.* When defense is not a concern, ceilings are flat and beamed, as at Pisa Cathedral. When defense or fireproofing is necessary, ceilings (Fig. 10-20, 10-21) are of masonry and vaulted. In any case, the roof structures are of timber.

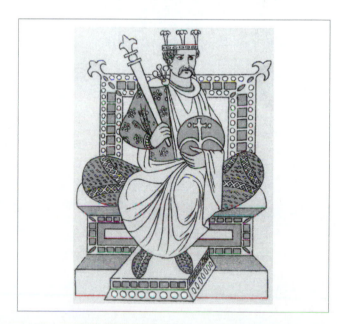

10-26. Throne chair.

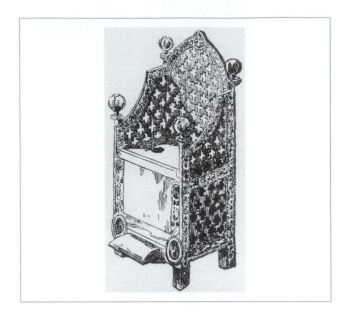

10-27. Throne chair.

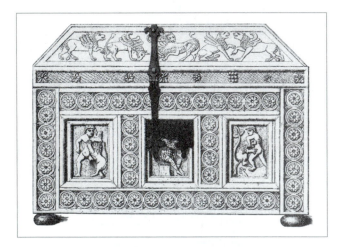

10-28. Casket in ivory.

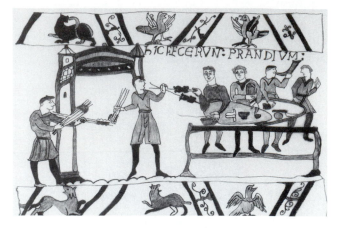

10-29. Bayeux Tapestry, 1066–1082; embroidered wool on linen (230′ 0″ × 1′ 8″)

■ *Materials.* - Local woods, such as oak, walnut, and elm, are used because transportation difficulties prevent obtaining wood from any distance. Simple board construction is characteristic; veneer and inlay are unknown. Turning and painting in bright colors are the main decoration.

■ *Seating.* There is a limited use of chairs during the period. Elaborate, massive throne chairs (Fig. 10-26, 10-27) proclaim the status of the ruler. Occasional chairs are large, heavy, and simple in design.

■ *Storage.* Chests and ivory caskets (Fig. 10-28) with decorative patterns store important materials. Rosettes, animals, and figures may embellish the surface.

■ *Textiles.* The most well known textile of the period is the Bayeux Tapestry (Fig. 10-29; detail of knights feasting at a makeshift table), an embroidery of wool on linen that depicts the Norman defeat of the Anglo-Saxons at the battle of Hastings in 1066, which unites England. It celebrates William the Conqueror's victory and the beginning of Norman rule.

■ *Decorative Arts.* Illuminated manuscripts, produced in monasteries, have flat spaces, lively lines and patterns, ornamental initials, and bright colors.

11. Gothic

1150–1550

The outburst of the 1st century crusade was splendid even in a military sense, but it was great beyond comparison in its reflection in architecture, ornament, poetry, color, religion, and philosophy.

Henry Adams, *Mont-Saint Michael and Chartres*

Gothic cathedrals and churches occupy town centers throughout England and Western Europe. In this great style of the Christian religion, architecture and theology combine to create a visual metaphor of a period in which faith is all-important. Although primarily ecclesiastical, Gothic architectural elements also appear in secular buildings, interiors, furnishings, and decorative arts. The Gothic style was reborn in the 18th century and lasted until the end of the 19th century as Gothic Revival.

11-1. Costume of a clergyman.

HISTORICAL AND SOCIAL

A period of stability and peace begins in Europe about 1100. Newly formed central governments in England, France, and Spain facilitate economic and social growth. Cities and towns change from isolated settlements to cosmopolitan centers as people return to look for work. Trade and commerce increase, creating a prominent merchant class. Universities join monasteries as centers of learning. Feudalism declines as lords trade their fortified residences for country or manor houses and build stately mansions in town.

By 1200, the power and prestige of the Catholic Church is at its peak, so it is the major patron for new and repaired cathedrals, parish churches, abbeys, priories, and convents. Women are admired in song and verse, and chivalry is at its height. The esteem for the Virgin Mary manifests itself in the many cathedrals and chapels dedicated to her. The relative peace and prosperity shatters during the 14th century with the Hundred Years War between France and England and the Black Death, a plague that eliminates over one third of Europe's population.

The Gothic style, like religion, is intimately intertwined with medieval life. The great cathedrals (from *cathedra* meaning "seat of a bishop") are physical manifestations of Christian faith and civic pride. Serving as town halls, public meeting places, and tourist attractions, their

11-2. Medieval lord and lady.

construction involves the entire community. Wealthy patrons or local guilds donate chapels, windows, and other elements. Others give what money they are able or supply physical labor. Local clergy often direct the project. Besides a great cathedral, every village or town has one or more parish churches. Secular and religious organizations and wealthy families have their own chapels or churches.

141

CONCEPTS

The term *Gothic* refers to the Goths, the Germanic tribes that brought about the downfall of the Roman Empire. Its name begins as a derogatory reference by classicists of the Renaissance. In the Gothic style, spiritual and material elements unite and visually manifest in the great European cathedrals. Vertical lines, pointed arches, stained glass, and religious iconography designed to educate the masses characterize Gothic structures. Biblical numbers such as 3, 7, and 12 are used in the creation of doorways, windows, bays, and other features. Church authorities often oversee ecclesiastical building projects to ensure that appropriate ideas are conveyed.

An outgrowth of thought regarding what constitutes the great church and its form, the first Gothic structure is the Abbey of S. Denis (begun in 1135) in the Ile de France, a domain of French royalty. Abbot Suger directs the enlarging and remodeling of the abbey where French nobility is interred. He wants it to become the spiritual center of France and, as such, to inspire, to awe, and to capture patriotic and religious imaginations. The elements that accomplish this, found in the chevet (circular apse with ambulatory and radiating chapels), are pointed arches, slender columns, groin vaults, and stained glass combined with mathematical proportions. None of these elements is new individually, but their combination imparts a lightness and openness not found in Romanesque architecture. For Suger and others, light is a metaphor for divine illumination and mathematical proportions represent divine order and harmony. From S. Denis, the Gothic style spreads to other areas of France. In just over 100 years, it becomes an international style.

DESIGN CHARACTERISTICS

National and regional varieties in church architecture abound. Dimensions are mathematically related within a single structure, but not consistent among buildings. Proportions are slender and attenuated. Common shapes are the square and equilateral triangle. Each country has a unique interpretation of the common features: the pointed arch, groin or ribbed vaults, cluster or compound columns, large windows with tracery (curving stone or wood subdivisions in the upper part of an architectural opening) and stained glass, and flying buttresses (exterior arch forms for additional support). Pinnacles (terminating elements), towers, and spires (pointed construction rising from a tower, turret, or roof) are also characteristic. Eventually, many architectural characteristics find their way into domestic buildings and interiors as details and on furniture as motifs.

■ *Motifs.* Motifs include heraldic devices (Fig. 11-3), the pointed arch, trefoils (three-lobed form; Fig. 11-5), quatrefoils (four-lobed form), cinquefoils (five-lobed form), grotesques (fantastic figures such as gargoyles or dwarfs; Fig. 11-6), birds, foliage (Fig. 11-4, 11-7), oak leaves (Fig. 11-8), crockets (stone carved with foliage that mark raking

11-3. Heraldic motifs.

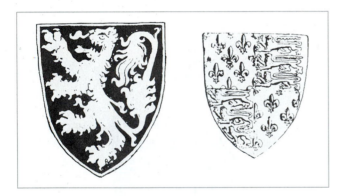

11-4. Illuminated manuscript.

11-5. Window detail with tracery.

11-6. Gargoyle.

11-7. Foliage diaper pattern.

11-8. Rinceau with meandering leaf motif.

11-9. Linenfold panel motif.

11-10. Metalwork, c. 14th–15th centuries; England and Italy.

angles of spires and canopies), and linenfold (resembling folds of fabric; Fig. 11-9). Some geometric shapes, such as lozenges (diamond-shaped design) or zigzags, continue from the Romanesque period.

ARCHITECTURE

Images and symbols of faith and prosperity manifest in cathedrals through cruciform (cross-shaped) plans with altars toward the east, soaring lines, mystical light, and decorative programs that explain doctrines to the many who cannot read. Although pointed arches and ribbed vaults appear in Romanesque buildings, the Gothic style breaks with the earlier style in intent, appearance, and construction. Pointed arches and piers form a structural skeleton not found in ancient or earlier medieval buildings. This framework reduces the need for load-bearing walls and permits taller buildings with larger windows that support the intentions of lightness, divine illumination, and mystical experience. Government and university buildings sometimes resemble the overall design of churches with towers marking major circulation areas.

Many secular structures are of a military or fortified nature, including castles and walled towns such as Carcassone (Fig. 11-23). Function and defense are important, particularly early in the period when conservatism, construction methods, and local materials determine appearance instead of styles. Castles, developing from ancient fortification techniques, are the defensive residences of

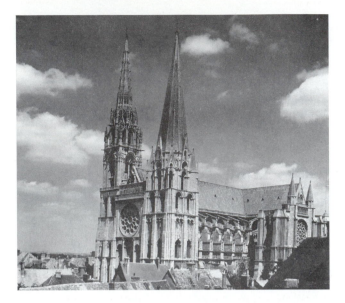

11-11. Chartres Cathedral, c. 1194–1220; Chartres, France.

Architecture: *Notre Dame, Paris.* Characteristics derived from the Romanesque period include the buttresses that divide the facade (Fig. 11-12, Color Plate 22) into three parts, the portals, three stories, and the numerous figural sculptures. In the Gothic style, the elements are more carefully organized, both vertically and horizontally, evidence of Suger's ideal of mathematical proportions and order. The facade is visually lighter because of the large windows, the arcade of pointed arches, and the large openings in the towers. The towers have soaring conical roofs. The rose window with stained glass is a dominant feature and filters rich colors into the interior. In the nave, single columns and square bays (Fig. 11-41) are reminiscent of the Romanesque period, but the lightness and verticality are Gothic. Pointed arches lead the eye upward as do the responds rising unimpeded to the vault ribs. Large clerestory windows and slender architectural elements make the walls seem thin.

monarchs, lords, bishops, and knights throughout the Middle Ages. An integral part of medieval life, their primary purposes are defending lands and maintaining order. By the 11th century, emphasis in castle planning (Fig. 11-25, 11-36) changes from defense to comfort. Town houses and manor houses often resemble castles (Fig. 11-22, 11-34,

11-36) with stone facades, roof battlements (fortified parapet), towers, drawbridge entries, and interior courtyards. This image continues the concept of protection and fortification from earlier. They may also feature half-timber

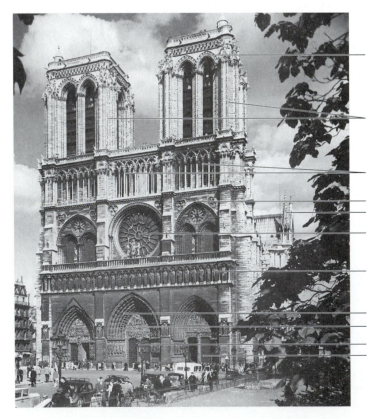

Pointed arch

Twin towers

Pointed arches in bands form gallery

Pointed arch
Pinnacle

Rose window

Religious figures provide decorative band

Archivolt
Tympanum

Central portal
Side portal

11-12. Cathedral of the Notre Dame, 1163–1250; Paris, France. (Color Plate 22)

11-13. Salisbury Cathedral, 1220–1266; Salisbury, England.

Design Practitioners

- *Architect.* Although rarely used, the term *architect* usually applies to an overseer of a project, such as Abbot Suger. As earlier, master builders or master masons complete the construction aided by carpenters, metalworkers, glaziers, and other craftsmen.

- *Guilds.* Craft guilds, including those of the building trade, form in the 12th century. All practitioners of a single craft, including a few women, belong to a guild. The guilds set and maintain standards of craftsmanship, regulate wages and working conditions, and train new members.

- *Training.* Formal education in building or architecture does not exist. Building practices are passed from father to son, master to apprentice. Master masons may work from sketches, most of which are not to scale. Plans might be drawn on the ground to guide construction. A few instructional treatises appear, such as *The Sketchbook of Villard de Honnecourt*, which was written in the first quarter of the 13th century.

- *Pierre de Montreuil* directs several important projects in Paris, including S. Denis and Notre Dame.

- *Guillaume (William) de Sens*, a Frenchman, builds many projects including Canterbury Cathedral, 1174–1178.

- *Henry Yevele*, an Englishman, works on Westminster Abbey and other buildings in London during the 14th century.

- *Parler Family.* Heinrich, Peter, and Wentzel Parler work in Cologne, Prague, and Vienna in the 15th century.

construction (structural wood framing with infill of brick, plaster, or other materials) with steep roofs (Fig. 11-32, 11-35).

Public Buildings

- *Types.* Cathedrals, parish churches, and other ecclesiastical structures are the most common building types. Universities, the newly formed guilds, and prosperous towns build halls (Fig. 11-21) and meeting places.

 France. French cathedrals (Fig. 11-11, 11-12, 11-15, 11-41) accentuate height and verticality. Early and High Gothic (1150–1250) structures are monumental in size and height. As if a reaction to this huge scale, Rayonnant buildings (13th–14th centuries) are smaller and more elegant. Windows, which are larger than before, feature complex radiating tracery patterns. Following the Hundred Years War, many structures adopt the Flamboyant style (14th–16th centuries) with tracery on all surfaces, including vaults. Tracery patterns include stars, adaptations from the English Decorated style, and the flamelike forms that give the style its name.

 England. English cathedrals (Fig. 11-13, 11-14, 11-42, 11-43) tend to be longer and more horizontal than French cathedrals. Early English Gothic cathedrals are generally simple with shorter towers. This style grad-

ually becomes the more complex Decorated style (c. 1240–1330), which is characterized by elaborate tracery and ogee (double) arches. The Perpendicular style (c. 1330–1530) features extravagant towers, rectilinear vertical forms with cusps (intersecting points of tracery), and fan vaulting (ribs like a fan; Fig. 11-43). Decorated and Perpendicular interiors emphasize elaborate vaulting with numerous complex patterns of structural and nonstructural ribs.

 Germany, Spain, Italy. Complex vaulting is also a specialty in Germany (Fig. 11-18), where hall churches, with nave and aisles the same height, are particularly characteristic. Germany's later Gothic structures are among the finest in Europe. Spain copies the French

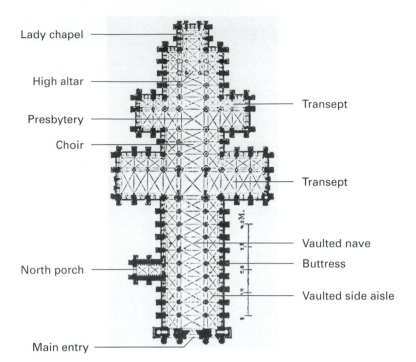

Lady chapel

High altar

Presbytery

Choir

Transept

Transept

Vaulted nave

Buttress

North porch

Vaulted side aisle

Main entry

11-14. Floor plan, Salisbury Cathedral.

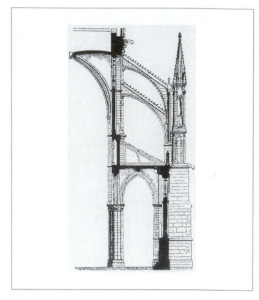

11-16. Buttress.

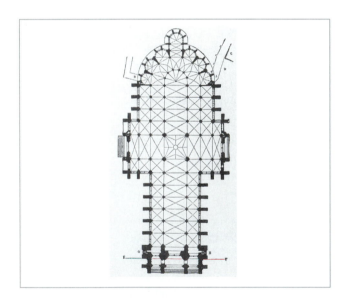

11-15. Floor plan, Amiens Cathedral.

11-17. Capitals.

■ *Site Orientation*. Indicating their importance in town life, most Continental cathedrals are in the center of town, surrounded by markets, dwellings, and other secular structures. In contrast, lawns and trees surround most English cathedrals.

■ *Floor Plans*. Cathedral plans continue the earlier Latin cross/pilgrimage type composed of nave, side aisles, and radiating chapels in the apse. Plans have numerous square or rectangular bays, forming modules that can be added or subtracted as needed. Some French models (Fig. 11-15, 11-41) shorten the transept. English examples (Fig. 11-14, 11-42) often have flat eastern ends and more than one transept. Monasteries with a cloister (covered walkway surrounding a court) may be attached to important churches (Fig. 11-13).

Gothic, with the finest examples constructed along her northern border. Later Spanish Gothic style has two substyles: Isabelline and Plateresque, which have no European counterpart (see also Chapter 13, Spanish Renaissance). Italy (Fig. 11-20), except for the north, is little influenced by the Gothic style, but some secular Venetian examples mix Gothic with Byzantine influences.

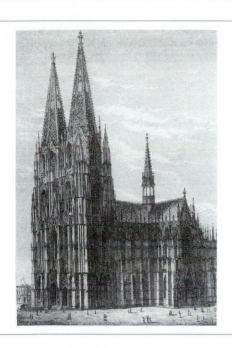

11-18. Cologne Cathedral, begun 1284, completed 1880; Cologne, Germany.

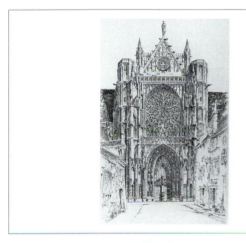

11-19. Sens Cathedral facade, from an etching by John Taylor Arms.

■ *Materials*. Cathedrals and important buildings are of local stone or brick because transporting over distances is too difficult. Italians continue using colored marbles in geometric patterns, colored stone arranged in stripes, and decorative Romanesque mosaics (Fig. 11-28).

■ *Structural System*. The structural system in cathedrals (Fig. 11-16, 11-41, 11-42), composed of pointed arches, ribbed vaults, and buttresses, allows walls and ceilings to be less supporting. Vault ceilings, filled in after the ribs are constructed, appear weblike, and walls have more space for

11-20. Milan Cathedral, c. 1385–1485, Milan, Italy; by Nicolas de Bonaventure and Filippino degli Organi; facade completed in 1809.

11-21. Town Hall, 1401–1455; Brussels, Belgium.

11-22. Palazzo Vecchio, 1298–1314; Florence, Italy.

windows. This system dematerializes the material and opens space, allowing more flow between spaces and larger vistas. Elements of the skeleton assert themselves by dividing the plan and interiors into units marked by columns, responds (half pillars rising from arcade columns to the springing of the ribs), and ribs.

■ *Facades*. Cathedral facades display considerable variety. Vertical tripartite divisions, marked by buttresses, correspond to the nave and aisles. Sculptures; rose windows; tall, pointed arched windows; or arcades with pinnacles organize in horizontal and vertical areas and bands. Twin towers that may be of unequal height crown fronts (Fig. 11-11, 11-12, 11-18). Buttresses, instead of columns or

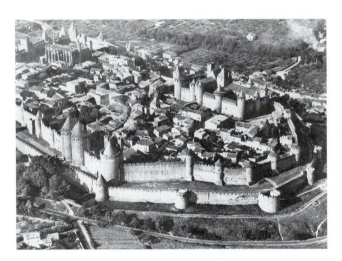

11-23. Wall city of Carcassone, 13th century (restored in the 19th century); France.

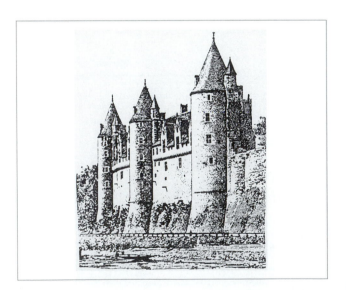

11-24. Château de Josselin, 12th century (rebuilt in the early 16th century); Brittany, France.

pilasters, divide walls into bays. Flying buttresses (Fig. 11-11, 11-13, 11-16) provide additional support and create a graceful rhythm on side walls. Towers with spires accent crossings. English cathedrals emphasize horizontality with bands of sculpture and stringcourses. They usually have shorter facade towers and fewer flying buttresses. Especially important are the towers at the crossing. Italian models, relying on the Roman/Byzantine technique of tie-rods (horizontal metal connectors providing additional support to arches and the outward thrust of vaults), have few pointed arches and no flying buttresses or clerestories.

■ *Windows*. Windows repeat the pointed arch shape. Tracery and stained glass depict biblical scenes, the lives of saints, and patrons or rulers in rich colors such as ruby red or dark blue. Large single figures fill clerestories, while aisles and chapels have smaller figures and biblical scenes to invite closer inspection. Rose windows often accent front facades and/or transepts (Fig. 11-11, 11-12, 11-19). Side windows have two vertical lights (glass) surmounted by a circular or lobed form. Other window forms (Fig. 11-5, 11-12, 11-28, 11-29) include trefoil, quatrefoil, or cinquefoil.

■ *Doors*. Church facades typically have three recessed or projecting portals (doorways) capped with pointed arches and pinnacles. Figural sculptures (Fig. 11-12, 11-19) enhanced with decorative carving, usually geometric, line

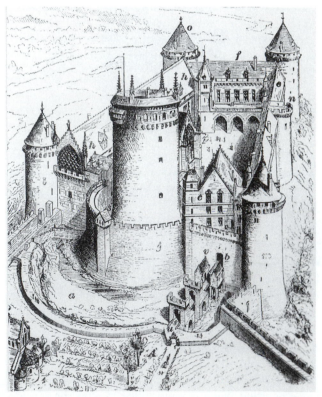

11-25. Castle of Coucy, 13th century; Laon, France.

the jambs, lintels, archivolts (faces of the arch), and tympanums. Tall, narrow windows and/or a rose window surmount some portals. Doors are of wood.

■ *Roofs.* All roofs are steeply pitched and covered with copper or slate. Some English cathedrals have wooden roofs, however. Multiple roofs identify the nave, transept, and radiating chapels.

■ *Later Interpretations.* Gothic architecture provides a vocabulary for revivals or interpretations in architecture, interiors, and furniture during the 18th, 19th, and 20th centuries. The Gothic Revival in England (Fig. 11-35) and America (Fig. 11-38) produces picturesque buildings that

Design Spotlight

Architecture: *Raby Castle, Durham, England.* The plans of Raby Castle (Fig. 11-26) illustrate the manner in which fortified structures are modified over time and how smaller rooms can be located within the thickness of walls. The vaulted great hall (main living space) is in close proximity to the kitchen.

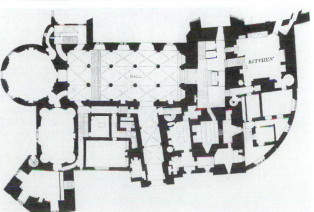

11-26. Floor plans, Raby Castle; Durham, England.

copy manor houses, churches, and half-timbered structures. Until the mid-20th century, Gothic was the preferred style for churches. Numerous college buildings from the late 19th century are Gothic Revival.

Private Buildings

■ *Types.* Types include castles, palaces, town houses, manor houses, and country houses (*châteaux* in France). The lessened threat of invasion and the use of gunpowder reduce the need for fortified structures, so fewer castles are built, particularly at the end of the period.

■ *Site Orientation.* Like fortresses, castles are sited for defense and protection of territory, usually on hills or along lines of defense, rivers, or Roman roads. Moats, sometimes filled with water, and/or earthworks surround some. Manor houses are situated in parks surrounded by green space to set them off. Some attention is still given to protection, so usually the lawn is devoid of bushes near the main house.

■ *Floor Plans.* The earliest castles are erected on a raised mound (motte) with one or more walls enclosing the bailey (open area). Support buildings, such as the stables, are sited in the bailey (Fig. 11-25). After their 1066 conquest, the Normans introduce in England a tall tower or keep, which contains living quarters for the owner and provisions for lengthy sieges. Eventually, the rectangular keep changes to round, a more defensible shape. By the 13th century, castles grow into walled complexes with towers at the corners or other strategic locations and entry by way of a gatehouse (Fig. 11-25). Towers become metaphors of power and wealth. Castles and other dwellings center on the great hall. Kitchens are usually separate buildings until stone and brick construction develops. Staircases are often spirals, located in turrets with narrow windows.

Houses grow upward and outward (Fig. 11-30, 11-32, 11-35), usually based on family need. Dwellings of the gentry often have two or more stories with a courtyard (Fig.

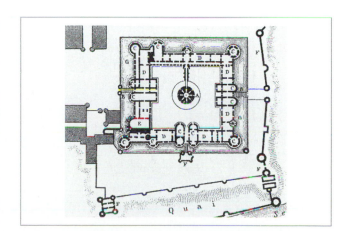

11-27. Floor plan, Old Louvre Palace; Paris, France.

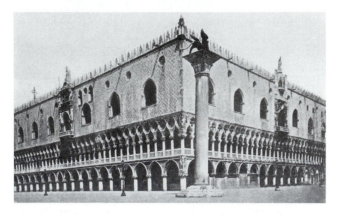

11-28. Doge's Palace, c. 1309–1424; Venice, Italy.

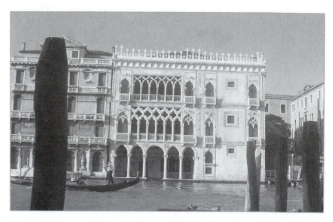

11-29. Ca d'Oro, c. 1430; Venice, Italy.

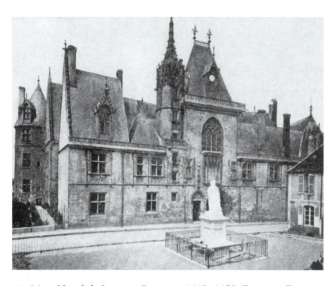

11-30. Hôtel de Jacques Coeur, c. 1442–1453; Bourges, France.

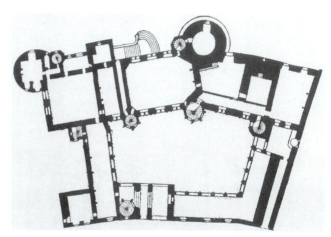

11-31. Floor plan, Hôtel de Jacques Coeur.

11-32. Town residence; Tours, France.

11-33. Doorway; northern European.

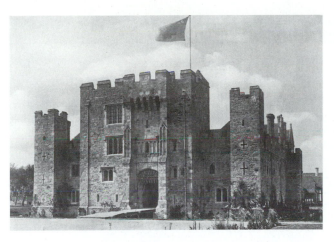

11-34. Hever Castle, c. 15th century; Kent, England.

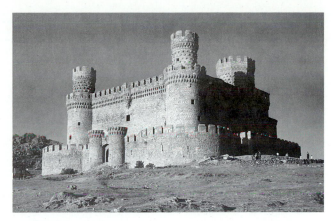

11-36. Manzanares el Reale, late 15th century; Madrid, Spain.

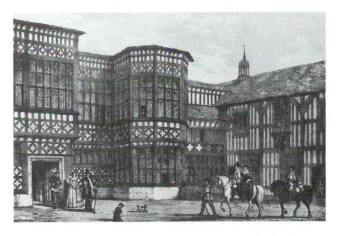

11-35. Bramhall Hall, 15th century; Cheshire, England.

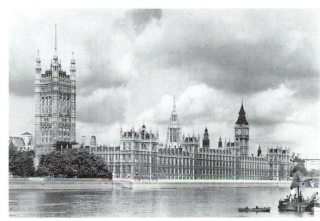

11-37. Later Interpretation: Houses of Parliament, 1836–1868; London; by Sir Charles Barry and A. W. N. Pugin; Victorian Gothic Revival.

11-22, 11-27, 11-31, 11-34). Rooms typically proliferate in number around the great hall and gradually take on greater variety in function as owners begin leading less public lives.

■ *Materials.* Originally built of wood, castles are later built of brick or stone. Like plans, construction becomes increasingly sophisticated after the Crusades bring men into contact with military buildings in the East. Most town houses and manor houses are of local stone or brick. Some adopt half-timber construction (Fig. 11-32, 11-35) consisting of a structural wood frame with an infill of wattle (sticks) and daub (mud or clay). Brick infill is common in France; stone and brick infill is common in England. The earliest surviving examples of this type date from the 13th century.

■ *Facades.* Facade design varies (Fig. 11-22, 11-29, 11-30, 11-32, 11-34, 11-35). Irregularity achieved through the

changing depths of surface planes provides movement and visual complexity (Fig. 11-34). Some structures evidence architectural details common to churches, such as tracery or pointed arches (Fig. 11-30). Venetian Gothic combines pointed arches, columns, and lacelike tracery in bands (Fig. 11-28, 11-29). Towers and gatehouses carry over from castles. Castle walls are unadorned to prevent easy entrance by enemies. They are crowned with merlons (solids) and crenellations (openings) forming battlements, which offer greater defense and are derived from the East. The main access is by a drawbridge to an opening containing a portcullis, a massive wood and iron-plated door (Fig. 11-33). Windows usually vary in size and placement depending on need instead of symmetry. They often exhibit tracery late in the period. Castle windows are tiny slits high in the walls. Half-timbered structures have bargeboards (decorative boards under the edges of the roof);

Important Buildings and Interiors

- **Bourges, France:** Hôtel de Jacques Coeur, 1442–1453.

- **Brussels, Belgium:** Town Hall, 1401–1455.

- **Cambridge, England:** King's College Chapel, 1446–1515 (Perpendicular). (Color Plate 23)

- **Carcassone, France:** Walled city of Carcassone, 13th century.

- **Chartres, France:** Chartres Cathedral, c. 1194–1220 (Early Gothic).

- **Cheshire, England:** Bramhall Hall, 15th century, half-timber construction.

- **Cologne, Germany:** Cologne Cathedral, begun 1284, completed 1880.

- **Durham, England:** Raby Castle.

- **Essex, England:** Castle Hedingham, c. 1140.

- **Exeter, England:** Exeter Cathedral, c. 1275–1370 (Decorated style).

- **Florence, Italy:**
 —S. Croce, c. 1294, Arnolfo di Cambio.
 —Palazzo Vecchio, 1298–1314.

- **Gloucester, England:** Gloucester Cathedral, 1089–1100 (Perpendicular).

- **Hildesheim, Germany:** Abbey Church of S. Michael, c. 1001–1033.

- **Kent, England:**
 —Hever Castle, 15th century.
 —Penshurst Place, 1341–1348.

- **Leon, Spain:** S. Miguel de la Escalada, 913 C.E.

- **Lincoln, England:** Lincoln Cathedral, 1073–1140 (Early Gothic).

- **London, England:**
 —Tower of London, c. 1086–1097.
 —Westminster Abbey, 1245–1269 and later (Decorated style).

- **Madrid, Spain:** Manzanares el Reale, late 15th century.

- **Milan, Italy:** Milan Cathedral, c. 1385–1485, facade completed in 1809, Nicolas de Bonaventure and Filippino degli Organi.

- **Orleans, France:** Cathedral of Orleans, late 15th century (Flamboyant style).

- **Oviedo, Spain:** S. Mariz de Narance, 848 C.E.

- **Orvieto, Italy:** Orvieto Cathedral, 13th–14th centuries.

- **Paris, France:**
 —Abbey of S. Denis, c. 1135–1144 and later (Early Gothic).
 —Cathedral of Notre Dame, 1163–1250 (Early Gothic). (Color Plate 22)
 —Old Louvre Palace.
 —S. Chapelle, 1242–1248 (Rayonnant style).

- **Reims, France:** Reims Cathedral, 1211–1481 (High Gothic).

- **Rouen, France:** Palais de Justice, 1493–1508.

- **Salisbury, England:** Salisbury Cathedral, 1220–1266 (Early Gothic).

- **Shropshire, England:** Stokesay Castle, 1285–1305.

- **Siena, Italy:** Siena Cathedral, c. 1260–1360.

- **Ulm, Germany:** Ulm Minster, 14th–16th centuries.

- **Venice, Italy:**
 —Ca d'Oro, c. 1430.
 —Doge's Palace, 1309–1424.

- **Windsor, England:** Windsor Castle, c. 1170 with later additions.

overhanging upper stories often house the main living spaces with shops on the ground floor (Fig. 11-32).

- *Roofs.* Circular towers with conical roofs (Fig. 11-24) are typical of medieval fortified castles. Roofs on houses are gabled, trussed, and often thatched. They pitch steeply and are of masonry, wood, or thatch. Stone houses may have parapets (wall plane above the roof line), or

roof dormer windows. Half-timber houses usually have thatched roofs.

- *Later Interpretations.* Castles are a primary source of inspiration in the 19th century for the Victorian Gothic Revival period (Fig. 11-37, 11-39). They continue to inspire in later hospitality-fantasy environments such as Sleeping Beauty's castle in Disneyland (Fig. 11-40).

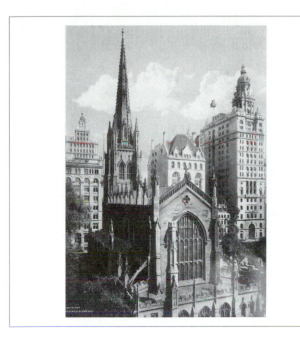

11-38. Later Interpretation: Trinity Church, 1839–1846; New York City, New York; by Richard Upjohn; Victorian Gothic Revival.

11-39. Later Interpretation: Louisiana State Capitol, 1847–1850; Baton Rouge, Louisiana; by James H. Dakin; Victorian Gothic Revival.

INTERIORS

Cathedral interiors, like the exteriors, emphasize verticality. Verticality, height, and architectural elements open the space, but individual units are defined as before. The effect is one of openness, weightlessness, and unity. With the larger expanses of glass, light continually changes in color and intensity. The immense height and dim light filtered through stained glass emphasize the mystery of faith (Fig.

11-40. Later Interpretation: Sleeping Beauty Castle, 1955; Disneyland Park, California.

11-41, 11-42, 11-43). Decoration derives from the architecture, but some examples feature polychrome in rich, saturated colors.

Few secular interiors survive unaltered. Knowledge comes from written descriptions and artistic representations, and therefore is limited. Archaeology supplies some information about vernacular interiors. Domestic and public buildings adopt Gothic details instead of the structural system; exceptions are chapels or large vaulted spaces. Manuscript illustrations indicate that interiors of this period were colorful and richly decorated with hangings but had little furniture. Lavish appointments and furniture continue to demonstrate the importance of ceremony and rank. Characteristic features of a private interior space late in the period (Fig. 11-49) include a patterned stone floor, small diamond-pane casement windows, a wood-beamed ceiling, large stone mantel, and sparse box-shaped furniture.

Public Buildings

■ *Relationships.* As on exteriors, pointed arches, compound piers, ribbed vaults, tracery, and stained glass characterize cathedral interiors.

■ *Materials.* Continental cathedrals feature walls of local stone. Color largely comes from stained glass, except in England and Italy. Contrasting stone colors delineate architectural elements in England. Because of large stands of timber, English cathedrals often have vaults with wooden ribs. Patterned stone floors and polychrome walls are common in Italy.

■ *Walls.* Most cathedral walls have three stories like Romanesque cathedrals. The lowest portion is an arcade of pointed arches supported by compound piers or columns

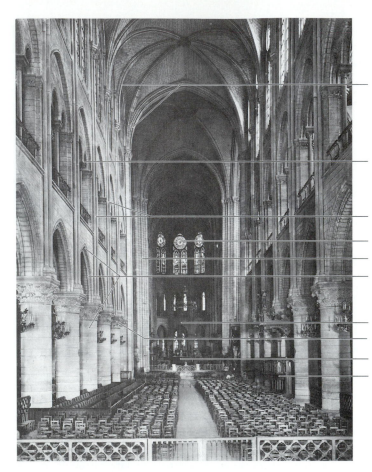

Ribbed vaults

Triforium

Responds

Stain glass windows

Clustered columns

Columned arcade
with pointed arches
separates side aisles

Apse

Foliated capital

Altar

Pulpit

11-41. Nave, Cathedral of the Notre Dame, 1163–1250;
Paris, France.

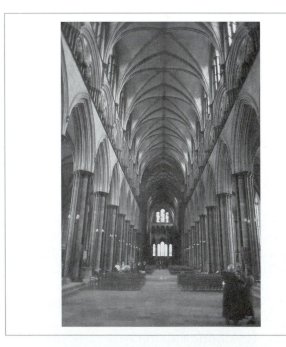

11-42. Nave, Salisbury Cathedral, 1220–1266; Salisbury,
England.

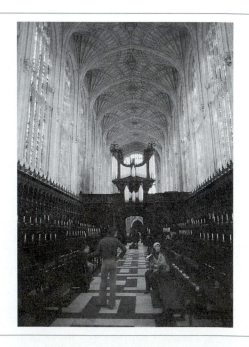

11-43. Nave with fan vaults, King's College Chapel,
1446–1515; Cambridge, England. (Color Plate 23)

(Fig. 11-41, 11-42). Next is the gallery or triforium with shorter arched openings into the nave. Clerestory windows are above. Despite large areas of glass, interiors remain dim. In the 1240s, French master masons begin to eliminate the triforium in favor of windows beneath the clerestory for more light. These windows often have lighter-colored or gray and white glass.

- *Columns and Capitals.* Arcade supports may be single round columns, compound columns of pier and engaged columns, or clusters of columns. Common capital motifs (Fig. 11-17) are human and animal forms entwined in vines or foliage. Some feature foliage only, while others reflect classical influence in form and shape.

- *Ceilings.* Ceilings are vaulted with four or more ribs in each bay (Fig. 11-41, 11-42). Sometimes ribs form fans (Fig. 11-43), stars, or other shapes, particularly in Germany and England. The masonry between ribs may be painted blue with gilded stars or other motifs. Some Italian ceilings are flat and beamed like those of the Early Christian period.

11-44. Interior, c. 1300.

Design Spotlight

Interior: *Great Hall, Penhurst Place.* This hall (Fig. 11-45) is a multipurpose space for entertaining, dining, and sleeping. It features a screen embellished with wood paneling that protects from drafts, with a minstrels' gallery above for the musicians. The oak ceiling with large trusses resembles the hull of a boat. Floors are typically of dirt or stone. Fire pits are initially located in the center of the room. Torches and a few candles provide minimal illumination. Gothic windows are later additions.

Truss framework ceiling resembling a boat hull

Brace support

Heraldic motif

Minstrels' gallery

Torches

Screen

Passageway

Tapestry hangings

Dining at trestle tables around perimeter of room

Central fire pit

11-45. Great Hall, Penhurst Place, 1341–1348; Kent, England.

■ *Later Interpretations*. Interiors and furniture designs are revived in the 18th century (Fig. 11-50) and 19th century (Fig. 11-51, 11-52). Usually the Gothic Revival style places a greater emphasis on human scale in comparison to the impressive heights of the original style. Revival interiors do not imitate medieval living patterns.

Private Buildings

■ *Great Hall*. The hall (Fig. 11-45, 11-46), the most characteristic room in the medieval house, is a multifunctional living space until well into the 12th century (and later on the Continent). Evolving from an aisled space to a large vaulted or wooden-roofed room, this is the space where the lord demonstrates his power and wealth, entertains,

and conducts estate business. It often serves as a sleeping dormitory for less important guests and servants. The upper end has a dais for the owner, his family, and their guests. At the lower end, a screen, sometimes embellished with wood paneling, serves as a passage divider and protects people from drafts. Sometimes, a minstrels' gallery is set above the screen. Fire pits are initially located in the center of the room, later moving to a side wall as a fireplace. The number of smaller, private rooms around the hall increases during the period and includes the solar (from *sol* meaning "floor" or *solive* meaning "beam" in French), a withdrawing room, and the great chamber. (Color Plate 24)

■ *Color*. Favored colors are highly saturated green, blue, scarlet, violet, white, brown, and russet. Finishes and textiles provide rich, varied colors. (Color Plate 25)

■ *Lighting*. Firelight, torches (Fig. 11-45), and a few candles or lamps supply minimal lighting. Light fixtures and candleholders usually are made of wrought iron.

■ *Floors*. Floors are of dirt, stone, clay, or brick. Although textile floor coverings are rare, straw rushes appear frequently. Wood, stone, and earthenware tiles in geometric patterns of yellow, red, black, brown, or green are typical. Upper floors are usually of wood. Some woven materials, such as rush matting, cover floors, but rugs are rare. Oriental rugs covering tables appear in the wealthiest homes after the 13th century.

■ *Walls*. Walls (Fig. 11-44, 11-45, 11-46, 11-47, 11-48, 11-49) are of wood paneling, stone, and whitewashed or

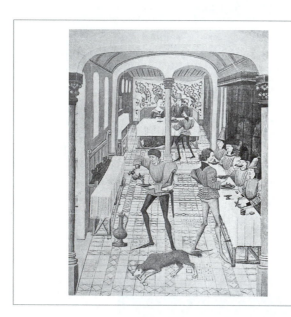

11-46. Great Hall, mid-15th century, from an illuminated manuscript of the period.

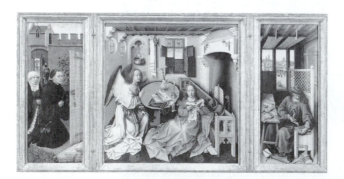

11-47. Mérode altarpiece showing interior, c. 1425–1433; Flanders; by Robert Campin. (Courtesy of The Metropolitan Museum of Art, The Cloisters Collection, 1956)

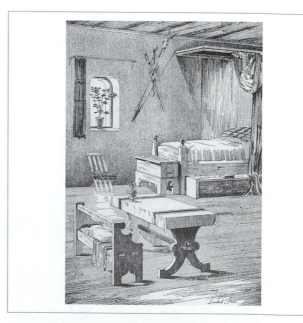

11-48. Bedroom. [Courtesy of The Metropolitan Museum of Art, The Cloisters Collection, 1956. (56.70)]

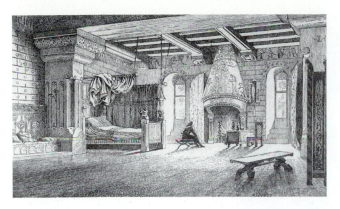

11-49. Bedroom; France.

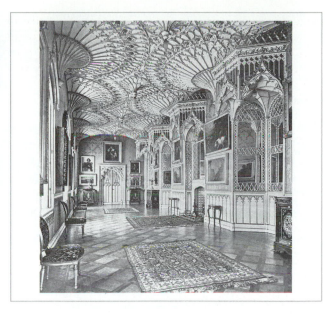

11-50. Later Interpretation: Long Gallery, Strawberry Hill, 1747; Twickenham, England; Georgian (side chairs added later).

colored plaster. Wood walls may be left as plain planks, painted, or paneled. Wainscoting consists of narrow panels that are often richly carved with pointed arches, tracery, and linenfold, sometimes enhanced with color. Softwood panels typically are painted; green is favored. Painted decorations on stone and plaster include imitations of stone blocks, literary or biblical scenes, and heraldic motifs in rich colors, enlivened with gold. Fabric or tapestry hangings often add warmth and color. During the period, the center fireplace moves to an outer wall (Fig. 11-45, 11-49) and becomes a focal point. Stone hoods are lavishly embellished with heraldic devices and other carving.

■ *Windows*. Early in the period, windows are small and have square casements. As the need for protection decreases, they gradually become larger and begin to form bays (projecting outward and located at ground level), oriels (projecting outward and located above ground level), and lancets (two tall, slender lights). Sizes and types vary on facades. Glass remains a luxury so only the upper portions of windows are glazed; diamond-shaped panes between iron mullions are common. Most windows have shutters and iron bars for security or covers of oiled paper or animal horn. By the 15th century, stained glass appears in wealthy homes and helps to denote rank.

■ *Doors*. Gothic motifs surround some doorways later in the period. Most doors are rectangular and board and batten. The wealthy have paneled doors, sometimes covered with tapestries or hangings. Elaborate wrought iron (Fig. 11-10) is used as reinforcement and for hinges on doors.

■ *Textiles*. Fabric hangings are the most common wall treatment in the period. They transport easily, and many types are available. The humblest consist of canvas, linen, or painted wool. The grandest houses of northern Europe and England adopt tapestries after the 14th century when tapestry weaving is established in Paris, Arras, Tournai, and Brussels. Gothic tapestries have small or no borders. Figures and motifs are largely two dimensional. Made in

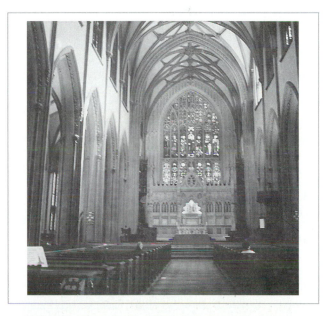

11-51. Later Interpretation: Trinity Church, 1839–1846; New York City, New York; by Richard Upjohn; Victorian Gothic Revival.

sets, themes are biblical and literary. Millefleurs (thousand flowers; Fig. 11-58) designs are popular, as is the unicorn series. In addition to hangings, people use textiles for fireplace coverings in summer, table and buffet covers, and loose seat and back covers for chairs and thrones. Canopies denote a person of rank and/or importance. Some textiles,

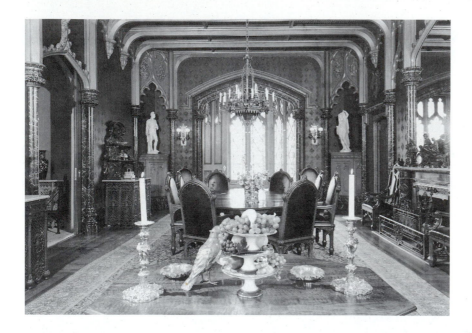

11-52. Later Interpretation: Dining Room, Lyndhurst, 1838 and 1865–1867; Tarrytown, New York; by Alexander Jackson Davis; Victorian Gothic Revival.

particularly for churches, are embellished with embroidery in gold and silver thread.

- *Ceilings*. Vaulted, beamed, or timber-roofed ceilings, sometimes decorated with carving and painting, are common. Large halls have trussed framework ceilings of oak or chestnut that look like inverted boat hulls (Fig. 11-45). Triangular frameworks feature multiple braces and struts by the early 14th century. Ceilings in smaller houses are typically beamed. A new ceiling consisting of flat boards and applied moldings with cornice emerges at the end of the 15th century.

- *Types*. There are only a few types of furniture: chairs, benches, stools, tables, cupboards, buffets, chests, and beds.

- *Materials*. Pine, oak, and walnut are the most common woods. Board construction simply pegs boards together. Joined construction adopts framed panels. Turning and carving are the most common decorations. Many pieces are painted in bright colors or gilded to highlight turning and carving. Some folding stools are of iron.

- *Seating*. Chairs and thrones are few, ceremonial, and feature turned elements. Typical pieces (Fig. 11-44, 11-53)

FURNISHINGS AND DECORATIVE ARTS

Surviving examples of early medieval furniture are very rare, especially before the 14th century. Information, which comes from extant pieces, pictorial representations, and written descriptions, reflects upper-class practices. Furniture is generally rectilinear with heavy proportions. Small-scale architectural motifs, such as pointed arches, highlight a relationship between architecture and furniture. Despite more settled conditions and a more stable economy, many nobles still move from place to place, necessitating mobile furniture and wall hangings. Rooms may have rich treatments and wall hangings, but furniture and accessories are few. Some pieces, such as the buffet, are important conveyors of status. Cabinetmaking as a craft revives during the period. Joined (joyned) construction, introduced at the end of the 15th century, soon supplants earlier board construction because pieces are lighter in weight and sturdier.

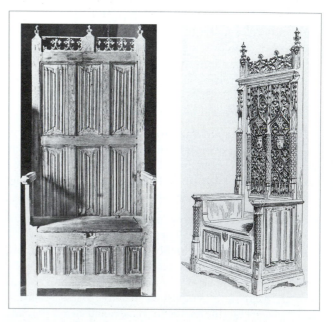

11-53. Choirstall.

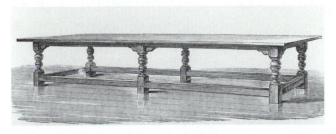

11-54. Table, 14th century.

<div>

Design Spotlight

Furnishings: *Chest.* Chests (Fig. 11-48, 11-55) are the chief storage pieces, but also transport goods and serve as seats, beds, and tables. Simplicity, rectangular shapes, and decorative Gothic motifs are common. Most are of oak, walnut, or pine with iron hardware.

</div>

Tracery similar to church windows
Iron hardware
Pointed arch
Heraldic motif
Quatrefoil

Oak leaf
Acorn

11-55. Chests.

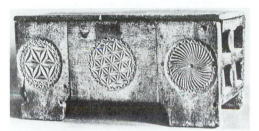

11-56. Dresser.

include turned, **X**-frame, and choirstall chairs and trestle-form stools and benches. Choirstall chairs, derived from churches, are boxes with tall backs, solid paneled arms, and storage in their bases. Thrones and chairs demonstrate rank or precedence, particularly when placed on a dais under a canopy. However, stools and benches far outnumber chairs, even in the finest homes. Stools are more common than chairs, and some resemble Roman prototypes.

■ *Tables.* Trestle tables (Fig. 11-46, 11-54) with unattached tops that can be taken apart after meals are common and used mainly for dining. Cloths conceal their crude construction. Tops become permanently attached during the period, although people continue to eat where it is warmest or most convenient.

11-57. Illuminated manuscript, *Book of Hours.*

11-58. Millefleurs tapestry, c. 15th century; Belgium and France.

11-60. Later Interpretation: Bed, Rosedown Plantation, early 19th century; St. Francisville, Louisiana; Victorian Gothic Revival.

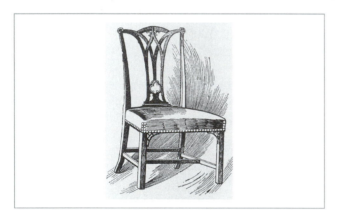

11-59. Later Interpretation: Chair, mid-18th century; England; in the style of Thomas Chippendale; Early Georgian.

11-61. Later Interpretation: Stained glass window, Castle Howard chapel; c. 1860s; Yorkshire, England; by Edward Burne-Jones and William Morris. (© Copyright Dorling Kindersley)

■ *Storage*. Chests or coffers and boxes (Fig. 11-55) are the most common items and the chief storage pieces, but also transport goods and serve as seats, beds, and tables. Some are embellished with Gothic or other motifs, while others are plain. Display pieces (Fig. 11-56), which assert rank and are associated with dining, include the buffet or dresser. The buffet originates as a set of shelves for displaying plate (silver), the shelf number being dependent on the owner's rank. Linen cloths hide the buffet's simple construction. The term *cupboard* refers to various pieces with doors and shelves used to store food, dishes, linen, and clothing.

■ *Beds*. Most Gothic beds are boxlike in form and crudely constructed, but surrounded by lavish draperies suspended from hooks, cords, or wooden rods. They are draped for warmth and privacy (Fig. 11-49). Some beds (Fig. 11-48) feature elaborate turning and carving. Bed hangings are pulled up and bagged when not in use. Pillows and bed linens are often luxurious.

■ *Textiles*. Attached upholstery on seating is unknown, but people use cushions for comfort. Fabrics include cotton, linen, and silk in plain and twill weaves, damasks, and velvets. Wool is the most common furnishing fabric. Colors are brown, blue, green, russet, violet, and scarlet.

■ *Decorative Arts*. Books (Fig. 11-57) are an important form of artistic expression throughout the Middle Ages. Illustrations in illuminated manuscripts often portray figures, landscapes, buildings, and furnishings, and therefore are important historical documents. Newly reformed guilds guide the production of silver during the Gothic period. Much silver made for the state and church is elaborately decorated.

■ *Later Interpretations*. Gothic designs provide a rich source of inspiration for furniture throughout the 18th (Fig. 11-59), 19th, and 20th centuries. Later pieces (Fig. 11-60) feature pointed arches, tracery, cluster columns, and an imposing scale. Some are contemporary in form with Gothic details, while others copy and interpret Gothic designs. Those of the Arts and Crafts period (Fig. 11-61) feature decorative painting of medieval stories and legends.

E. RENAISSANCE

1400–1600

Meaning "rebirth," the Renaissance is a period of heightened interest in classical antiquity that appears first in Italian literature, then in culture and art during the 14th century. This interest arises from the study of ancient texts and structures. Greek and Roman forms and details reappear in architecture during the 1420s in Florence, Italy, in response to demands from wealthy patrons. By the middle of the 15th century, treatises create a theoretical and practical base for High Renaissance architectural developments. Renaissance architecture seeks to emulate, but not copy, antique examples. In interiors, the Renaissance establishes the principle of unity in decoration and furnishings. Classical elements are less evident in interiors because there are few extant ancient examples, and ancient texts rarely discuss them. Similarly, since little ancient furniture is known, Renaissance furniture exhibits architectural details and proportions.

Renewed interest in antiquity coincides with the emergence of humanism and its emphasis on the individual. Scientific studies of the body and the natural world and technological developments in navigation, mechanics, and warfare support humanist concerns and aid the Renaissance itself. Exploration of new continents brings contact with new civilizations and opportunities for trade and greater prosperity. After 1450, the printing press helps spread new ideas and learning. European states begin to assume their modern boundaries, and feudalism declines. Manners and fashion, products of leisure and money, are increasingly important.

Warfare, travel, and books spread Italian concepts to France, Spain, and England where it first appears as decorative elements grafted onto Gothic and indigenous forms. Each country gradually assimilates Renaissance design principles, but its interpretation of them is unique. Climatic adaptations account for some design differences, particularly in Northern Europe.

Oil paints developed	1405
Joan of Arc burned at stake	1430
Jan van Eyck paints *Arnolfini and his Wife*	1434
European slave trade with Africa begins	1445
Constantinople falls to the Turks	1453
First glasses for nearsightedness developed	1455
First Guttenberg Bible printed	1456
Acropolis of Athens falls to Turks	1458
Thomas Mallory writes *The Morte D'Arthur*	1470
Albert Durer born	1471
Spanish Inquisition begins	1480
Suits of cards invented in France	1480
Botticelli paints *Birth of Venus*	1485
Columbus lands in America	1492
Moslems expelled from Spain	1492
Da Vinci paints *The Last Supper*	1495
First pocket watch invented	1502
Michelangelo finishes *David*	1504
Machiavelli writes *The Prince*	1513
Chocolate introduced into Spain as a drink	1519
Cortes destroys Aztec Empire in Mexico	1521
Magellan's crew first to sail around world	1522
Charles V of Spain tries to ban tequila	1529
Oranges planted in Florida	1539
University of Mexico founded	1551
Venetians develop glass mirrors	1555
Nostradamus publishes book of predictions	1555
Elizabeth I crowned in England	1558
English begin slave trade to Americas	c. 1560
Spain founds first settlement in U.S. at S. Augustine, FL	1564
Palladio publishes *The Four Books of Architecture*	1570
Massacre of Huguenots in France	1572
Francis Drake sails into San Francisco Bay	1579
Gregorian calendar introduced	1582
England begins colonizing North America	1584
Defeat of Spanish Armada by English	1588
Shakespeare begins writing plays	1590
Remains of Pompeii discovered	1592
Flush toilet invented in England	1594
Edict of Nantes grants religious freedom	1598
Goeblins factory established	1599
Queen Elizabeth I dies	1603
Tea arrives in Europe from Asia	1605
Jamestown, first English settlement in North America	1607
Quebec founded in Canada by French	1608
Galileo finds that the sun is the center of the universe	1609
Pilgrims prepare Thanksgiving feast	1621
First works by Shakespeare published	1623
Dutch purchase Manhattan from Indians	1626
Harvard University founded	1636

12. *Italian Renaissance*

1400–1600

Beauty is "the harmony and concord of all the parts achieved in such a manner that nothing could be added or taken away or altered except for the worse."

Leon Battista Alberti, *De Re Aedificatoria*

The Italian Renaissance represents a return to classicism in culture, art, and architecture. Designers, artists, scholars, patrons, and other influential individuals regard the Renaissance as separate from the Middle Ages, characterizing it as a new era and a rebirth (*rinascita* in Italian) of classical antiquity. Artists and architects study Roman buildings and strive to compete with and/or surpass the achievements of the ancients. Consequently, the period is extraordinarily creative and produces numerous buildings, architects, and artists of significance. Italian architecture, interiors, and furnishings are widely imitated throughout Europe and are the foundations for later stylistic developments.

12-1. Italian figures in costume.

HISTORICAL AND SOCIAL

Italy in the 15th century is a country of individual republics or city-states. Those around and north of Rome are extremely prosperous and ruled by bankers, merchants, and traders. This wealthy, urban, commercial society contrasts with most of Europe, which remains medieval, feudal, and rural. It provides ideal conditions for renewed interest in the classical past, language, poetry, history, philosophy, and humanism, which values the creative efforts of the individual.

The Renaissance begins in Florence around 1400 as she emerges victorious from attempts at subjugation by the powerful Duke of Milan. The Florentines see their city as a "new Athens." Essential to this concept is the prosperity in trade and banking that creates a strong economy with much building activity. Great families, such as the Medici, Pitti, and Strozzi families, possess the wealth and leisure to commission fine homes and works of art. Their courts, such as that of Cosimo de' Medici the Elder, foster the study of classicism, which produces enthusiasm for Roman art and architecture. By the second half of the 15th century, the Renaissance spreads to other cultural centers north of Rome. As in Florence, wealthy and powerful families in Pisa, Milan, Venice, Mantua, and Urbino embrace the Renaissance and extend commissions to artists who have studied or worked in Florence. The artists are primarily male. Women are not allowed apprenticeships and must learn their skills in convent schools or as part of their private education. Few of their names are known.

Despite the favor of great patrons, artists and architects are regarded as craftsmen because their works lack a sound theoretical base. As they associate with scholars and poets throughout the 15th century, they come to see themselves not only as artists, but also as intellectuals and scientists. The notion of the Renaissance man who distinguishes himself in several arts or in both art and science takes hold. Artists and architects begin to write treatises espousing their ideas and theories. The invention of the printing press in the mid-15th century aids the spread of these works and the conceptual base of the Renaissance throughout Europe.

By the beginning of the 16th century, political turmoil interrupts artistic progress in northern Italy. Rome becomes the artistic center, where popes and wealthy families commission architecture and works of art. Pope Julius II aspires to transform Rome from a medieval town to a modern ideal city based on classical forms. He hopes to return the city to its former Roman glory. Subsequent popes who are scholars and patrons of the arts continue to support the transformation of the city. Artists are more highly regarded than ever before. The period features great accomplishments in art and science, as well as a few individual artistic geniuses, such as Leonardo da Vinci, Raphael, and Michelangelo.

Prosperity and progress are short lived, disrupted by the Protestant Reformation beginning in 1517, a plague in 1522–1524 that devastates Rome's population, and the sack of Rome in 1527 by Charles V, Holy Roman Emperor. Artists and architects leave Rome for work elsewhere, spreading the High Renaissance throughout Europe. During the 16th century, many aristocratic and merchant-class women become great patrons of the arts. They, like Isabella d'Este in Mantua, collect manuscripts, books, and ancient and modern art. Colonization of the New World by Spain, France, and England brings unprecedented wealth and knowledge to Europe and the papacy. The Catholic Church begins a Counter-Reformation in 1545, which will define the subsequent Baroque style.

CONCEPTS

Italian Renaissance designs are based on, but do not copy, classical antiquity. Designers recognize that centuries separate them from the ancients, so instead of reviving the ancient styles, they aspire to create modern works that vie with or, even better, surpass antiquity. To these ends, they adopt classical ideas and seek classical approaches to design, such as order, balance, symmetry, and the direct observation of nature. Architects begin to study and measure extant Greco-Roman monuments and pour over previously unknown ancient texts. Works such as Vitruvius'

Ten Books on Architecture (late 1st century B.C.E.), which described and codified the Greek proportional systems, influence the period. To emphasize the rational basis of art and architecture, designers adopt a mathematical approach to design through linear perspective and simple proportional ratios. The classical orders of architecture reappear, as do round arches, pilasters, pediments, and a careful articulation of parts.

In response to charges of lacking a sound theoretical base, artists in the second half of the 15th century begin writing treatises on proportion, perspective, and classical design principles based on Vitruvius and their own study of Roman buildings. Chief among these works are *De Re Aedificatoria*, written in 1452 and printed 1485–1486, by Leon Battista Alberti; *Treatise on Architecture*, published irregularly from 1537–1551, by Sebastino Serlio; *Regole delle cinque ordini*, 1562, by Vignola; and *I Quattro Libri dell Architettura*, 1570, by Andrea Palladio. Palladio's work is the first to include illustrations of Roman architecture as well as his own designs. All affect subsequent design developments.

DESIGN CHARACTERISTICS

Buildings are often large to impress, but relate to human scale, reflecting the humanism of designers and patrons. Classical elements and attributes, such as symmetry, regu-

12-2.　Italian ornament.

larity, unity, proportion, and harmony, are important design principles in both facades and plans (Fig. 12-24). Designers carefully articulate parts, which relate to each other and the whole, in proportional relationships. Structures and plans follow geometric forms—rectangles, squares, and circles. Proportions often develop mathematically following methods used in Greece and Rome. Palladio and others calculate proportional room dimensions by numerical ratios derived from harmonic relationships within Greek musical scales. In the Mannerist period (16th century), designers deliberately manipulate classical principles to create confusion and disorder.

Important architectural features include columns, engaged columns (columns partly built into the wall), pilasters, arches, pediments, moldings, and modillioned (small decorative bracket) cornices (Fig. 12-26, 12-28, 12-35, 12-37). Designers use triangular and segmental pediments as decoration. Palladio frequently places temple fronts on his villas (Fig. 12-26). In interiors, large architectural surfaces—walls, floors, and ceilings—receive the most attention, and their designs often relate to one another. Architectural details, such as columns and pediments, appear on furniture.

■ *Early Renaissance* (1420–1500). Filippo Brunelleschi reintroduces the orders in the dome of the Florence cathedral in 1420 (Fig. 12-4), thus ushering in the Early Renaissance in architecture. He and others experiment with the orders, proportions, and ancient construction techniques. With the exception of palaces that retain a fortified appearance, Early Renaissance structures appear light due to slender construction. There is a feeling of tension or awkwardness as designers learn to use classical design principles. Classical details may be used incorrectly, and designers borrow freely from antiquity and the Middle Ages.

■ *High Renaissance* (1500–1527). Following the development of architectural theory, architects show a better understanding of classicism and experiment with forms and elements only within the rules of classicism (Fig. 12-6). Numerical ratios and geometric forms dominate designs. Although architects of the High Renaissance use the same vocabulary as those of the Early Renaissance, the feeling is very different, one of balance, repose, rationality, and stability. Architecture emulates, but does not copy, antiquity. Architects tend to fall into two categories: those who follow classical rules and those who follow Michelangelo's inventiveness. Rome is the artistic center.

■ *Late Renaissance* (1527–1600). No single city dominates the artistic expression in the Late Renaissance. Some artists continue to follow High Renaissance principles, but others create a parody of classicism known as Mannerism. As interpreted in painting and sculpture, it conveys a distorted human body and compressed spaces. In architecture, classical elements are put together incorrectly or in odd ways (Fig. 12-10, 12-12). Classical proportions are rejected, and lightness and tension reappear. Mannerism does not reject classicism but deliberately breaks its rules.

■ *Motifs.* Classical motifs (Fig. 12-2, 12-36, 12-37, 12-43) appear extensively as embellishment and include the classical figure, cherub, swag, rinceau, rosette, scroll, *cartouche* (oval medallion), and geometric patterns.

ARCHITECTURE

Key concepts in architecture are a return to the classical orders, the adoption of classical forms, and a mathematical approach. Following Brunelleschi, architects begin to relate the parts of buildings using simple whole-number proportions, usually derived from musical harmonies. While Gothic builders had used musical proportions, they did not do so with the directness and intent of those from the Renaissance. Harmonious proportions and classical elements create a stable, articulate, and rational language for Renaissance architecture. A fundamental issue for architects throughout the Renaissance is the application of classical elements and forms to nonclassical structures such as churches or chapels.

Public Buildings

■ *Types.* The most important building types include churches and public structures.

■ *Site Orientation.* Most Renaissance buildings stand in self-contained isolation with little relationship to their surroundings. A notable exception is Michelangelo's plan for the Capitoline Palace in Rome (Fig. 12-14), a complex of

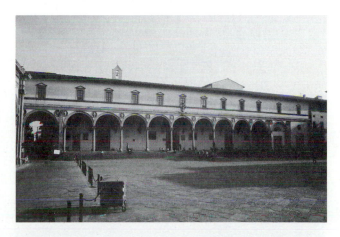

12-3. Ospedale degli Innocenti (Foundlings' Hospital), begun 1419; Florence, Italy; by Filippo Brunelleschi.

Design Spotlight

Architecture: *Tempietto (S. Pietro in Montorio).* Designed by Donato Bramante and the first important example of the High Renaissance, this small, centrally planned shrine (Fig. 12-6, 12-7, 12-34, Color Plate 26) where S. Peter was supposedly crucified is one of the most influential buildings in architectural history. Bramante's design incorporates classical elements such as a dome, balustrade, and Tuscan columns and classical attributes such as stability, clarity, and repose. It follows Vitruvian concepts for proportional relationships by imitating Roman (and Greek) temples. The conical form is one of the most stable.

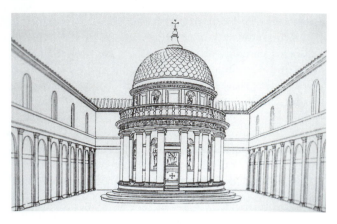

12-6. Tempietto (S. Pietro in Montorio),1502; Rome, Italy; by Donato Bramante, the first monument of the High Renaissance. (Color Plate 26)

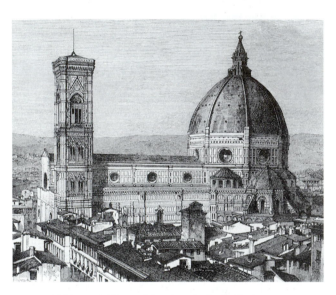

12-4. S. Maria del Fiore (Florence Cathedral), dome, 1420–1436; Florence, Italy; by Filippo Brunelleschi.

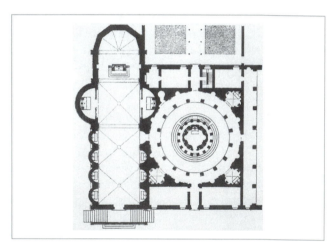

12-7. Floor plan, Tempietto. (Circular courtyard was not completed.)

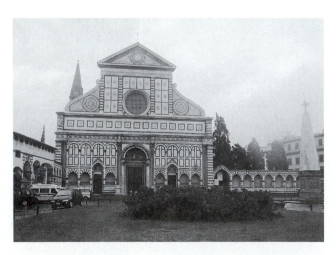

12-5. S. Maria Novella, begun 1279, facade 1456–1470; Florence, Italy; by Leon Battista Alberti.

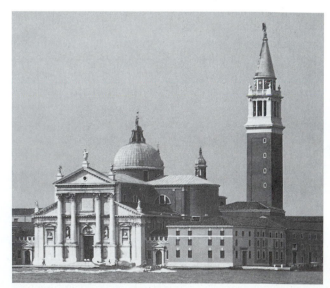

12-8. S. Giorgio Maggiore, begun 1565; Venice, Italy; by Andrea Palladio. (Color Plate 27)

Design Practitioners

■ *Architects*, who benefit from the elevation in status of art and artists, come from many backgrounds, such as sculpture, goldsmithing, and painting. Only a few, such as Palladio, have experience in the building trades. There is no system of training; some learn through apprenticeships and workshops. Patrons, armed with architectural treatises, can influence a building's design as much as the architect. By the 16th century, architecture has become profitable; architects no longer require additional skills and positions to survive.

■ *Architectural drawing techniques* advance in the Renaissance. Brunelleschi's improvement of linear perspective enables designers to create realistic drawings of their own and antique buildings. In addition to perspectives, Alberti stresses the importance of plans, elevations, and sections. Eventually, sets of drawings to the same scale appear, probably first in Raphael's studio in 1519. Architects continue the medieval practice of building wooden models of details and entire projects to explain design concepts to their patrons.

■ *Leon Battista Alberti* writes *De Re Aedificatoria*, the first architectural treatise since ancient times. In it, he reinterprets classical theory and promotes a system of ideal proportions and the subordination of parts to the whole. He is an early advocate of the importance of drawn plans, sections, and elevations. His projects include S. Maria Novella in Florence, S. Andrea in Mantua, and Palazzo Rucellai in Florence.

■ *Donato Bramante*, who previously worked in Milan, moves to Rome and designs the Tempietto (S. Pietro in Montorio), the first monument of the High Renaissance. As papal architect, he also creates a Greek cross plan for the new S. Peter's.

■ *Filippo Brunelleschi* designs the first complete building of the Renaissance, Ospedale degli Innocenti (Foundlings' Hospital) and the famous dome of S. Maria del Fiore (Florence Cathedral) in Florence. His work, which greatly influences others, incorporates modules of circles or squares and simple proportional ratios among parts.

■ *Andrea Palladio* is one of the most imitated Renaissance designers, primarily because he authors several books that include his work and establishes a vocabulary for churches and *villas*, the most famous of which is the Villa Rotunda. Like others, he calculates room dimensions by numerical ratios.

■ *Giulio Romano* completes Raphael's unfinished paintings and frescoes after Raphael's death. In 1524, Romano goes to Mantua to work for the Gonzagas. His best-known architectural commission is the Palazzo del Tè, a country *villa* filled with Mannerist characteristics.

■ *Michelangelo di Buonarroti Simoni.* The same individuality evident in Michelangelo's sculpture and painting appears in his architecture, which serves as a model for Mannerism. Important works include the Capitoline Palace, the Laurentian Library, and the dome of the new S. Peter's.

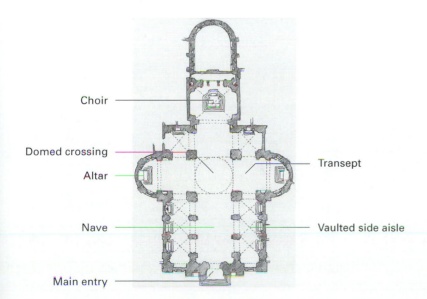

Choir

Domed crossing

Altar

Nave

Main entry

Transept

Vaulted side aisle

12-9. Floor plan, S. Giorgio Maggiore.

civic buildings symmetrically grouped around a trapezoidal *piazza* (public square surrounded by buildings) on the Capitoline Hill.

■ *Floor Plans.* The typical church plan is a Latin cross (Fig. 12-9, 12-11). Plans feature carefully articulated square modules. In the second half of the 16th century, architects begin replacing side aisles with small chapels. They do so partly after Alberti's precedent in S. Andrea in Mantua

and partly in response to the Counter-Reformation. Some architects, beginning with Brunelleschi, experiment with centralized plans but find them unsuitable for church liturgy. Small memorials, such as the Tempietto (Fig. 12-6, 12-7), or chapels often feature centralized plans. Public buildings, such as the Palazzo della Ragione, may feature rectangular plans defined by symmetrical columns and architectural openings (Fig. 12-13).

■ *Materials.* Builders use local stone or brick for private and public buildings. They do not experiment with concrete like the Romans. The Renaissance does not introduce any new construction techniques, so the most common construction system for churches is arcuated (using arches).

■ *Church Facades.* Most church facades resemble the gable ends of ancient temples with triangular pediments supported by arches and pilasters and engaged columns dividing the composition into regular bays. Repetitive modules are common. Three bays reflect the interior nave and side

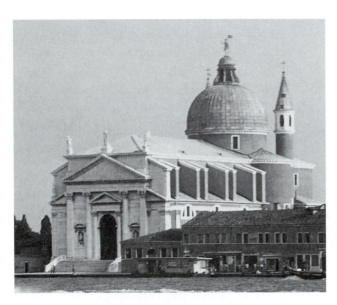

12-10. Il Rendentore, 1577–1592; Venice, Italy; by Andrea Palladio in the High Renaissance style.

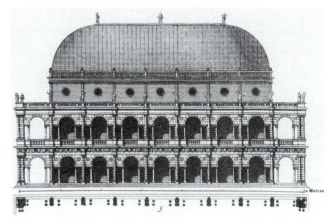

12-12. Palazzo della Ragione (Basilica), 1545–1617; Vicenza, Italy; the first public building by Andrea Palladio.

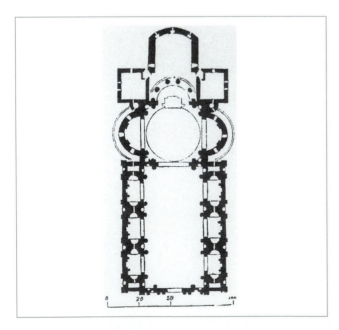

12-11. Floor plan, Il Rendentore.

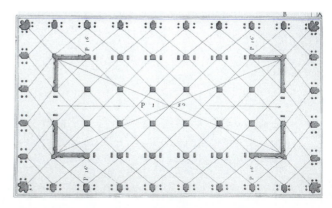

12-13. Floor plan, Palazzo della Ragione (Basilica).

aisles. At S. Maria Novella, Alberti (Fig. 12-5) incorporates Romanesque and Gothic features and uses volutes to unite the taller nave and shorter side aisles. Palladian facades (Fig. 12-8, 12-10) feature superimposed temple fronts, monumentality, and strong visual organization. Towers are not typical.

■ *Other Building Facades*. Classical imagery, details, and organization are characteristic of other buildings (Fig. 12-14, 12-15). Brunelleschi's first building facade (Fig. 12-3) features repeated modules of arches carried by slender Corinthian-like columns. A distinctive new architectural form is the Florentine arch (Fig. 12-30) which is composed of a rounded arch accented with molding and a center keystone and ending at capitals supported by columns or pilasters. Palladio's facades (Fig. 12-12, 12-16) incorporate arcades with bays defined by piers, columns, arches, balustrades, *oculi* (round windows), and the Palladian window/door.

■ *Windows and Doors*. Windows and doors are arched or rectangular. Rounded Roman arches appear more frequently during the Early Renaissance. Sebastino Serlio is the first to publish an elaborately articulated tripartite window/door form with a centered round arch flanked by rectangular openings. Palladio adopts this form (Fig. 12-12, 12-16) and uses it extensively on his buildings. Sometimes closed niches holding classical figures replace openings.

■ *Roofs*. Roofs are gabled and/or domed. Brunelleschi's dome for S. Maria del Fiore (Florence Cathedral; Fig. 12-4) features the first use of the orders since antiquity. It has terra-cotta roof tiles, which appear on many buildings.

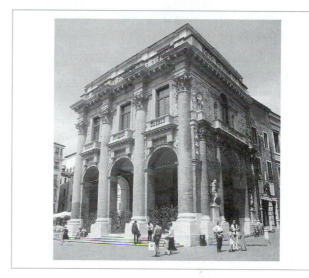

12-16. Loggia del Capitaniato, 1565–1572; Vicenza, Italy; originally designed by Andrea Palladio as an appendage to the main *palazzo*.

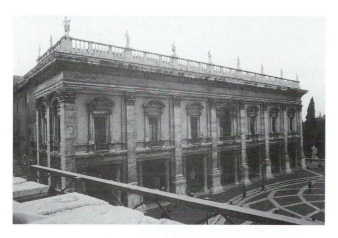

12-14. Capitoline Palace, c. 1538–1564; Rome, Italy; by Michelangelo di Buonarroti Simoni; Mannerist.

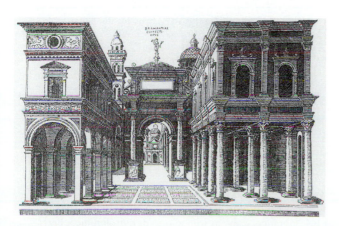

12-15. Street view, Italy; by Donato Bramante.

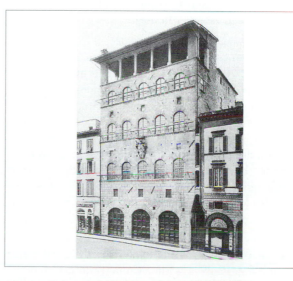

12-17. Palazzo Davanzati, mid-14th century (fifth-story roof terrace added in the 16th century); Florence, Italy.

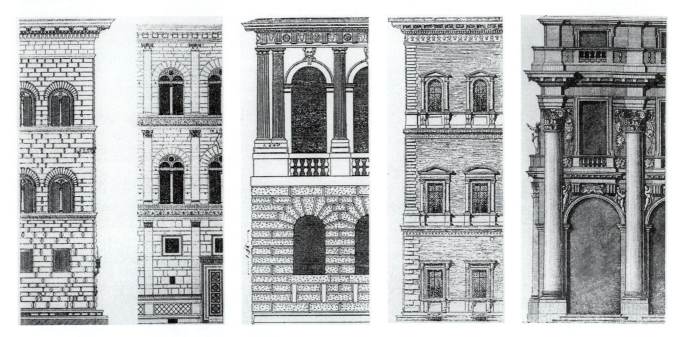

12-18. Building facades of Palazzo Strozzi, Palazzo Rucellai, Palazzo Pompeii, Palazzo Farnese, and Palazzo del Capitaniato, 15th–16th centuries; Early Renaissance rusticated facade to the High Renaissance classical detailing to the Late Renaissance embellished articulation.

■ *Later Interpretations.* Numerous subsequent public and private buildings follow Italian Renaissance precepts including those in the Louis XIV, Early Georgian, American Georgian, Late Georgian, Renaissance Revival (Fig. 12-32), and Post Modern (Fig. 12-33) periods.

Private Buildings

■ *Types.* Typical building types include *palazzi* (urban palaces) and *villas* (country houses).

■ *Site Orientation. Palazzi* (urban palaces) front on streets in towns like Vicenza (Fig. 12-25), Verona, and Florence (Fig. 12-19, 12-20) and on streets or canals in Venice (Fig. 12-22). Architects design *villas* (country houses) individually in rural locales to suit function, site, region, and patron. Palladio creates functional winged *villas* with central residential pavilions for Venetian noblemen who occupy and farm their land. Consequently, his *villas* focus outward to the land, are often sited on hills, appear as visual monuments, and have broad sweeping vistas as illustrated in his Villa Barbaro and Villa Rotunda (Fig. 12-24, 12-26).

■ *Floor Plans.* Palace plans are rectangular with square and rectangular rooms that focus inward to a central *cortile* (courtyard; Fig. 12-29, 12-30). Symmetry, although desirable, depends on the site. Interior walls are parallel or at right angles to the facade, and dimensions may be propor-

tionally derived. Venetian *palazzi* typically are longer and narrower than others are. A side entrance leads to the courtyard. Shops and family businesses are on ground floors during the Early Renaissance; they are later replaced by service areas. The most important rooms are on the *piano nobile* (first floor, above ground level), including the *sala* (main reception room). Facing the street, these spaces sup-

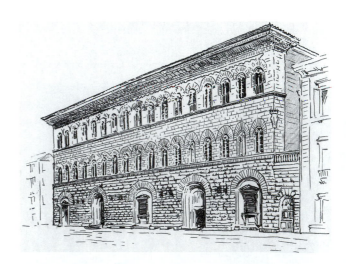

12-19. Palazzo Medici-Riccardi (Medici Palace), begun 1444; Florence, Italy; by Michelozzo di Bartolommeo; Early Renaissance.

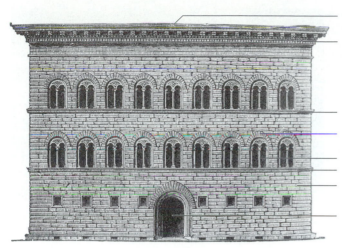

Low pitched
roof hidden

Cornice

String course

Rounded roman
arch

Bifora window

String course

Rusticated stone

Main entry

12-20. Palazzo Strozzi, begun 1489; Florence, Italy; by Benedetto da Maiano and Il Cronaca.

12-21. Palazzo Pitti, 1458–1466, enlarged by Ammannati 1558–1570; Florence, Italy; built to the plans of Filippo Brunelleschi with a heavily rusticated facade in the fashion promoted by Giulio Romano and Sebastino Serlio.

port entertaining and family activities and are lavishly decorated. Family rooms are on the *piano noble*, and rooms for lesser family members and/or servants are on the third floor. The *camera* (owner's bedroom) features a studio, a small private space nearby where the owner keeps his most treasured possessions. The apartment, a series of rooms associated with one person, appears in the late 15th century. Usually arranged in linear sequence, these rooms progress from public to private, and from larger to smaller. Most houses have no grand staircases or hallways, but do have small passages for servants near the *camera* and apartments. Palladian *villas* often feature symmetrical plans (Fig. 12-27) with rectangular and square rooms developed around

12-22. Palazzo Vendramin-Calergi, 1509; Venice, Italy; by Mauro Coducci.

12-23. Second floor bay, Library of S. Mark's, begun 1537; Venice, Italy; begun by Jacopo Sansovino and completed by Vincenzo Scamozzi.

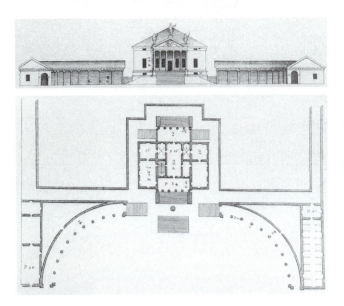

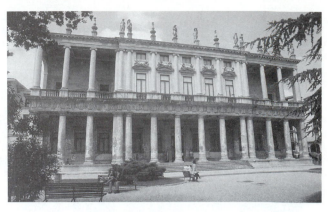

12-25. Palazzo Chiericati, 1550–1560; Vicenza, Italy; by Andrea Palladio and derived from a Serlio woodcut.

12-24. Elevation and plan view, Villa Barbaro, 1554–1558; Maser, Italy; by Andrea Palladio with assistance from the owners.

a large dominant *sala*. In his structures, service areas may be in wings (also called pavilions) or below ground.

■ *Materials.* Dwellings are of local stone or brick. Venetians use marble. The most common construction system for houses is trabeated (post and lintel) incorporating local stone. Some lower stories are vaulted.

■ *Facades.* The typical facade is three stories high, separated by string courses, and capped by a large cornice. Early

Renaissance palaces (Fig. 12-17, 12-18, 12-19, 12-20) feature heavy rustication that lightens and becomes smoother on each story. High Renaissance examples are less heavily rusticated and exhibit more classical details (Fig. 12-18, 12-21, 12-28). Venetian palaces (Fig. 12-22) have balconies and no rustication. Balustrades accent balconies and door areas. Tripartite Palladian *villa* facades (Fig. 12-24, 12-25, 12-26) incorporate temple fronts. Late Renaissance facades exhibit less unity.

■ *Cortile.* Courtyards feature three stories like facades. The lowest story often has round arches carried by columns, which often appear light and weak in the corners (Fig. 12-30). In the High Renaissance, piers with engaged columns carry the round arches, which helps to solve the

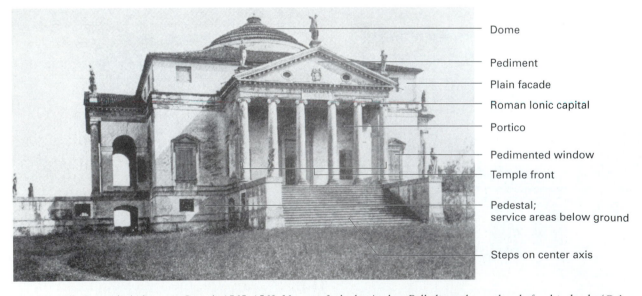

— Dome

— Pediment

— Plain facade

— Roman Ionic capital

— Portico

— Pedimented window

— Temple front

— Pedestal; service areas below ground

— Steps on center axis

12-26. Villa Rotunda (Almerico-Capra), 1565–1569; Vicenza, Italy; by Andrea Palladio and completed after his death. (Color Plate 28)

perceived weak appearance of the building corners. The upper stories may have round arched windows with two lights (panels of glass).

■ *Windows.* In the Early Renaissance, bifora windows (which open in two parts; Fig. 12-18, 12-19, 12-20) have round arches. High Renaissance windows are pedimented or framed with *aedicula* (columns or pilasters carrying a pediment) adding three-dimensionality.

■ *Roofs.* Roofs are generally flat or low-pitched, and often hidden behind cornices.

■ *Later Interpretations.* Two of the more important later renditions of Palladio's *villa* concept were the Neo-Palladian Chiswick House (Fig. 12-31) in England and Thomas Jefferson's Monticello in Virginia (see Chapter 28, Federal).

Design Spotlight

Architecture: *Villa Rotunda.* Designed by Andrea Palladio and completed after his death, this country house (Fig. 12-26, 12-27, 12-46, Color Plate 28) is his most famous work and his only freestanding pavilion. Appearing as a visual monument, this rural retreat sites on a high hill with beautiful views of surrounding farmlands. The plan features bilateral symmetry defined by passageways to four porticoes adapted from Roman temples. Pedimental windows identify the piano nobile. A large dome crowns the central round *sala*, which leads to square and rectangular rooms primarily used for entertaining. The service areas are below in the raised base so the building appears smaller than it actually is.

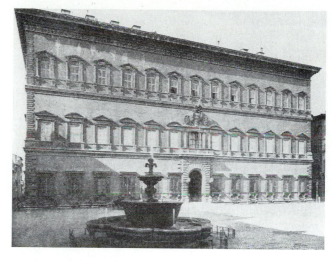

12-28. Palazzo Farnese, 1517–1589; Rome, Italy; by Antonio da Sangallo, the Younger with additions by Michelangelo; this palace set the standard for the High Renaissance. (Courtesy of Alinari/Art Resource, New York)

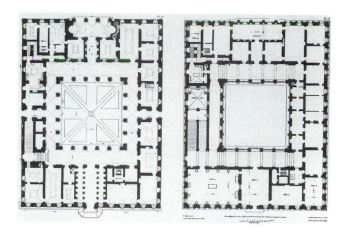

12-29. Floor plan, Palazzo Farnese.

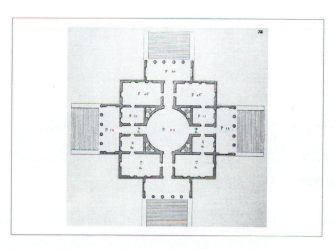

12-27. Floor plan, Villa Rotunda.

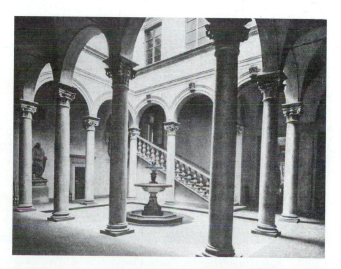

12-30. Interior *cortile*, Palazzo Gondi; Florence, Italy.

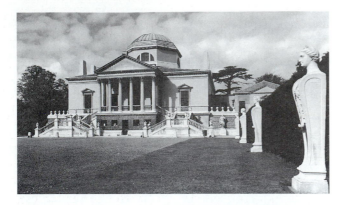

12-31. Later Interpretation: Chiswick House, 1725; London, England; by Lord Burlington and William Kent. The Neo-Palladian exterior pays homage to the Villa Rotunda.

INTERIORS

The notion of interior unity becomes important during the Renaissance. Artisans and craftsmen of various trades work in a common vocabulary. Few Renaissance architects design entire interiors. They might work out a general concept and create a few details, such as chimneypieces, but for the most part they leave interiors to artisans. Designers do not derive interior shapes and decorations from antiquity, as few of these spaces survive for study.

Church interiors (Fig. 12-40) follow traditional patterns and are symmetrical, regular, formal, and majestic. Carefully planned spatial and proportional relationships are

12-32. Later Interpretation: Boston Public Library, 1887–1893; Boston, Massachusetts; by McKim, Mead, and White; Renaissance Revival.

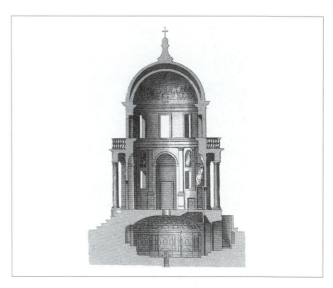

12-34. Section view, Tempietto (S. Pietro in Montorio),1502; Rome, Italy; by Donato Bramante.

12-33. Later Interpretation: Piazza d'Italia, 1978–1979; New Orleans, Louisiana; by Charles Moore; Post Modern plaza.

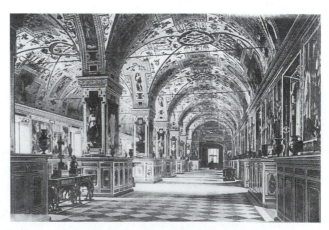

12-35. Vatican Library, 1517–1519; Vatican, Rome, Italy; by Domenico and Davide da Ghirlandaio; original frescoes by Melozzo da Forli have been destroyed. This space served as a model for the Spanish Renaissance library at El Escorial.

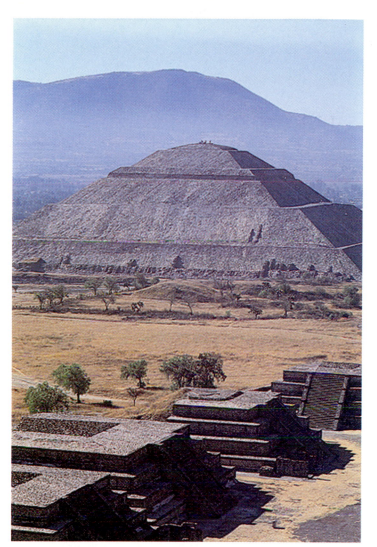

Color Plate 1. Temple grounds, Teotihuacan, 100 B.C.E.–1525 C.E.; Central Mexico.

Color Plate 2. Mollas, Kuna Indians, 20th century; San Blas Islands, Panama.

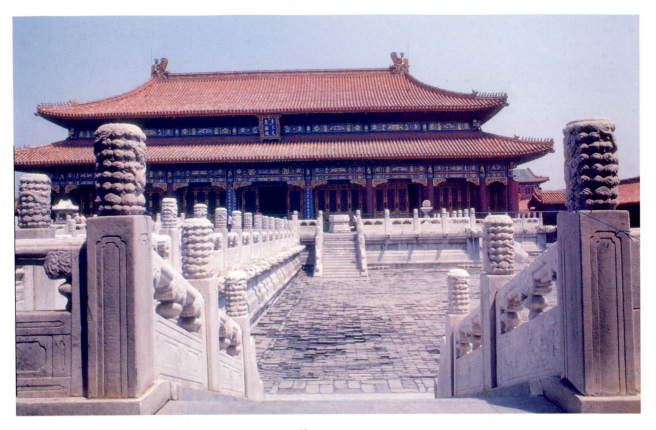

Color Plate 3. Forbidden City, begun in 1406; Beijing, China.

Color Plate 4. Chinese ornament.

Copyright Dorling Kindersley. British Museum

Color Plate 5. Plate, Yuan Dynasty, 14th century; China.

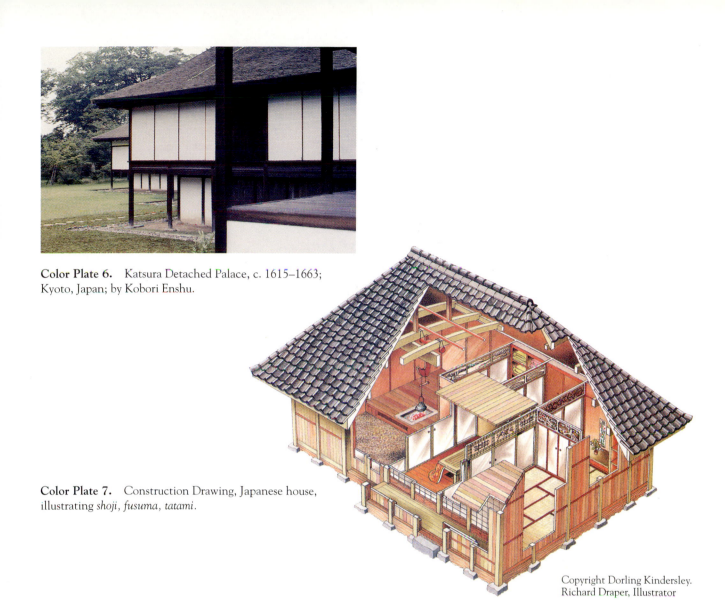

Color Plate 6. Katsura Detached Palace, c. 1615–1663; Kyoto, Japan; by Kobori Enshu.

Color Plate 7. Construction Drawing, Japanese house, illustrating *shoji, fusuma, tatami*.

Copyright Dorling Kindersley.
Richard Draper, Illustrator

Color Plate 8. Byobu (folding screen), c. 1800; Tokyo, Japan.

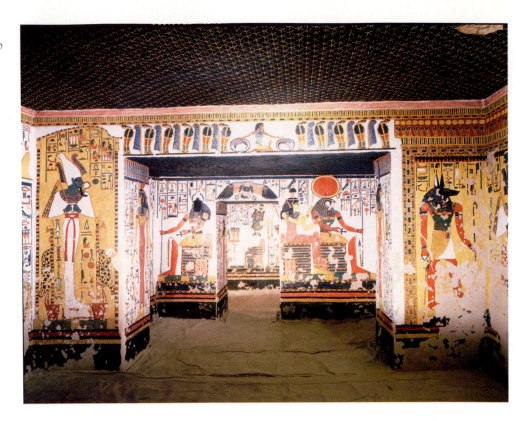

Color Plate 9. Interior, tomb of Queen Nefretari, c. 1290–1224 B.C.E., Thebes, Egypt.

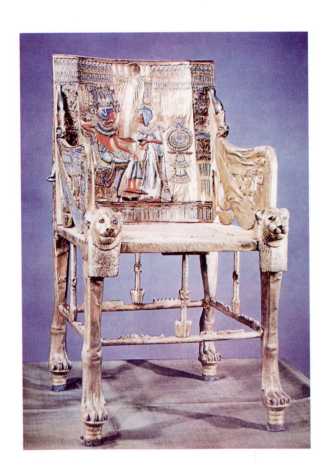

Color Plate 10. Golden throne of Tutankhamon, c. 1500–1400 B.C.E.; Egypt.

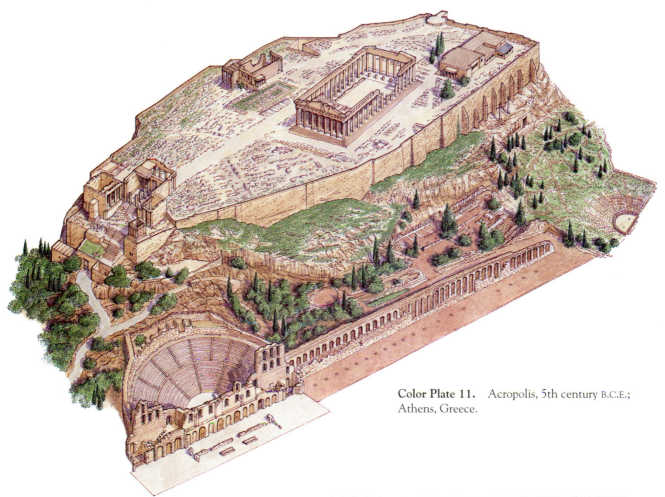

Color Plate 11. Acropolis, 5th century B.C.E.; Athens, Greece.

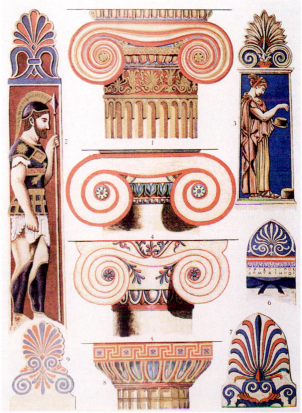

Color Plate 12. Greek ornament, including painted Doric and Ionic capitals, c. 500 B.C.E.

Color Plate 13. Section, Pantheon, 118–125 C.E.; Rome, Italy.

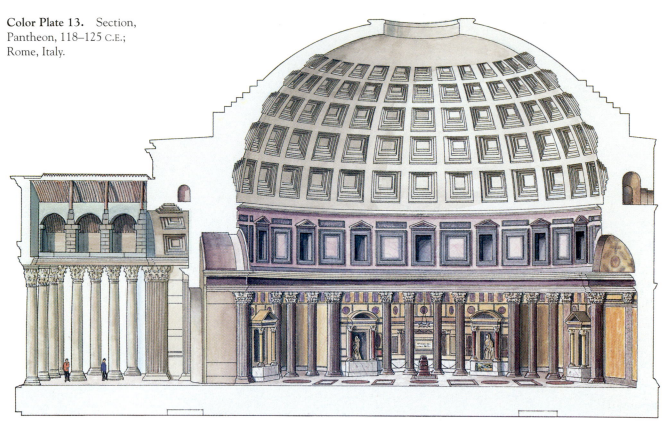

Color Plate 14. Cubiculum, c. 40–30 B.C.E.; Boscoreale, near Pompeii, Italy.

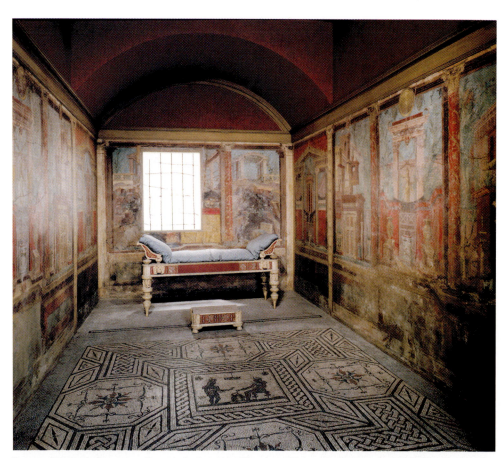

Roman. Paintings. Pompeian, Boscoreale. Late Republican, 1st Century B.C. Bedroom (*cubiculum nocturnum*) from the villa of P. Fannius Synistor. Mosaic floor, couch and footstool come from other Roman villas of later date. Fresco on lime plaster. H. 8′ 8½″ (2.62 m); L. 19′ 1⅞″ (5.83 m); W. 10′ 11½″ (3.34 m). The Metropolitan Museum of Art, Rogers Fund, 1903. (03.14.13). Photography by Schecter Lee

Color Plate 15. Wall frescos; c. 50 C.E.; Pompeii, Italy.

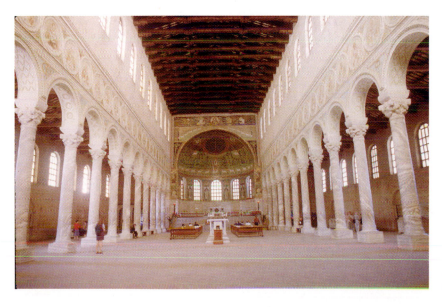

Color Plate 16. Nave, S. Apollinare in Classe, c. 533–549 C.E.; Ravenna, Italy.

Color Plate 17. Nave, Hagia Sophia, 532–537 C.E., Constantinople (Istanbul), Turkey.

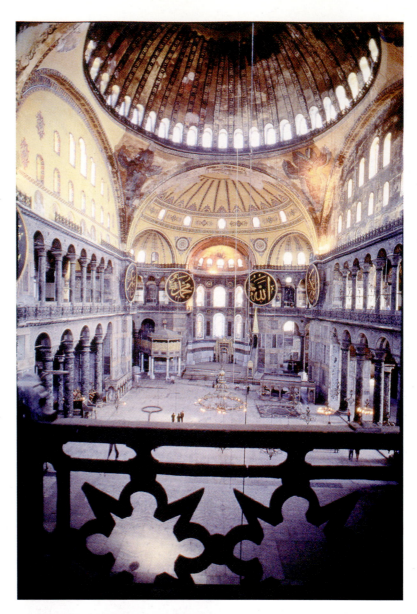

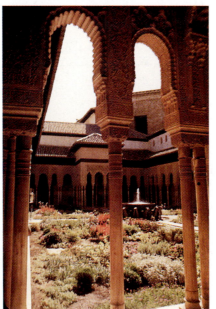

Color Plate 18. Court of the Lions, The Alhambra, 1338–1390; Granada, Spain.

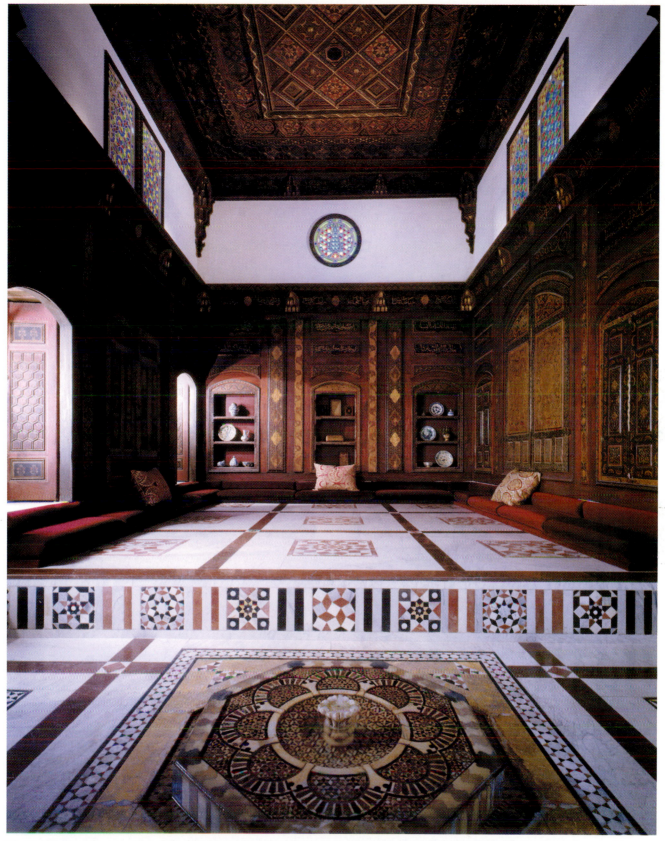

The Metropolitan Museum of Art, Gift of the Hagtop Kevorkian Fund, 1970. (1970.170). Photograph © 1995 The Metropolitan Museum of Art

Color Plate 19. The Damascus (Nur al-Din) Room, 1707; Damascus, Syria.

Color Plate 20. Side Aisle, Durham Cathedral, 1093–1133;
Durham, England.

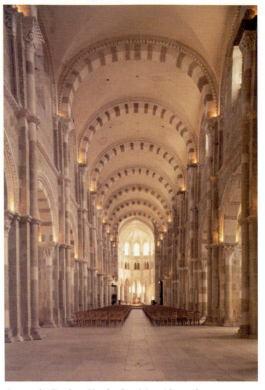

Color Plate 21. Nave,
S. Madeleine, c. 1104–1132;
Vezelay, France.

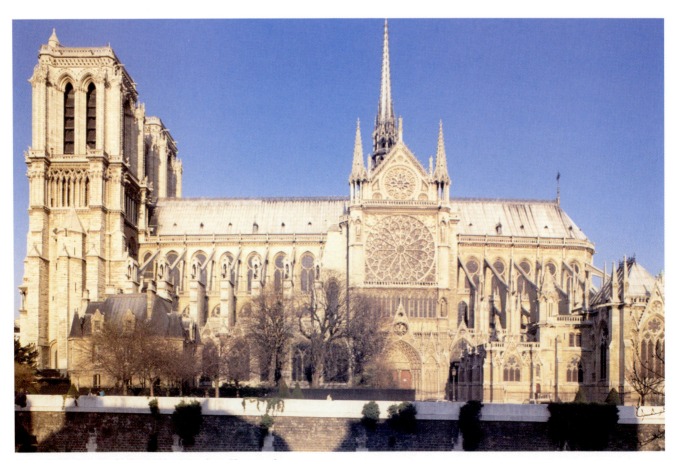

Color Plate 22. Cathedral of the Notre Dame, 1163–1250; Paris, France.

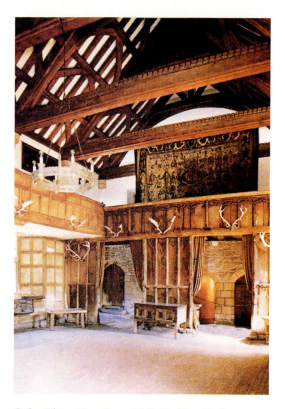

Color Plate 23. Nave, King's College Chapel, 1446–1515; Cambridge, England.

Color Plate 24. Great Hall. Haddon Hall, 14th–17th centuries; Derbyshire, England.

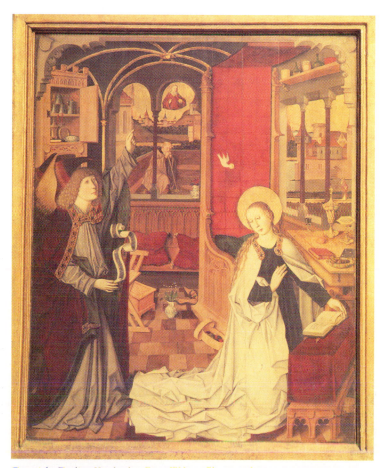

Color Plate 25. The Annunciation, painted panel, 15th century; Vienna, Austria

Color Plate 26. Tiempetto (S. Piertro in Montorio), 1502; Rome, Italy; by Donato Bramante.

Color Plate 27. S. Giorgio Maggiore, begun 1565; Venice, Italy; by Andrea Palladio.

Copyright Dorling Kindersley. John Heseltine, Photographer

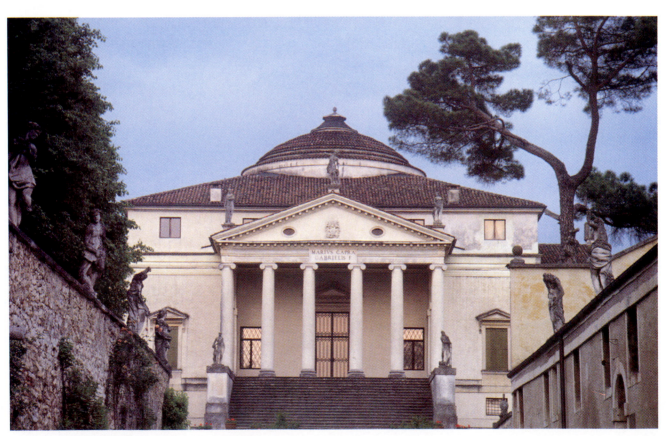

Copyright Dorling Kindersley. Roger Moss, Photographer

Color Plate 28. Villa Rotunda (Almerico-Capra), 1565–1569; Vicenza, Italy; by Andrea Palladio.

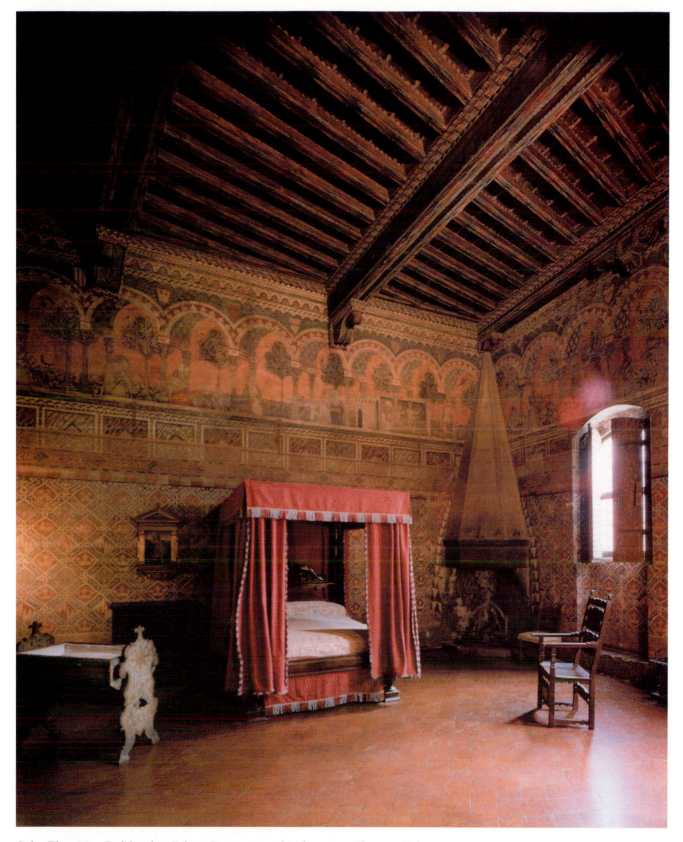

Color Plate 29. Bedchamber, Palazzo Davanzati, mid 14th century; Florence, Italy.

Color Plate 30. El Escorial Church Courtyard, 1562–1582; near Madrid, Spain; Juan Bautista de Toledo.

Color Plate 31. Library, El Escorial, 1562–1582; near Madrid, Spain; Juan Bautista de Toledo.

Copyright Dorling Kindersley. Max Alexander, Photographer

Color Plate 32. Chateau de Chaumont, 1465–late 15th century; Loire Valley, France.

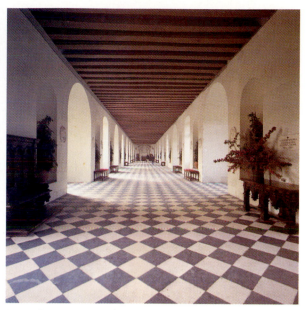

Color Plate 33. Grande Galerie, Chateau de Chenonceaux, 1556–1559; Loire Valley, France.

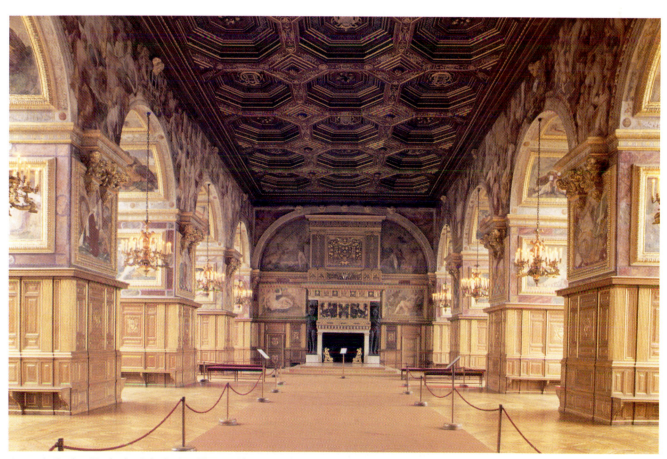

Color Plate 34. Galerie de Henri II, Palais de Fountainebleau, 1528–1540; Foutainebleau, France.

Color Plate 35. Harvard House and Garrick Inn, 1485–1660; Stratfordshire, England.

Color Plate 36. Hardwick Hall, 1590–1597; Derbyshire, England; by Robert Smithson.

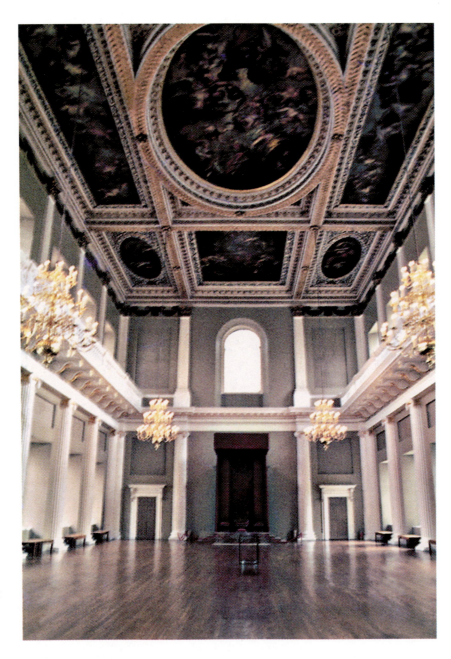

Color Plate 37. Banqueting Hall, Whitehall, 1619–1622; London, England; by Inigo Jones.

often mathematically derived with appropriate adjustments made in height and width. Early Renaissance interior spaces are light in scale and simply treated. Nave arcades feature round arches mounted atop slender columns. Sedate color schemes are common. Later interiors become more monumental and ornate with arches carried by piers and details articulated by colored marbles, gilding, and coffered ceilings.

Important Buildings and Interiors

Early Renaissance

- **Florence, Italy:**
 - —S. Maria del Fiore (Florence Cathedral), dome, 1420–1436, Filippo Brunelleschi.
 - —Ospedale degli Innocenti (Foundlings' Hospital), begun 1419, Filippo Brunelleschi.
 - —Palazzo Davanzati, mid-14th century. (Color Plate 29)
 - —Palazzo Medici-Riccardi (Medici Palace) begun 1444, Michelozzo di Bartolommeo.
 - —Palazzo Pitti, 1458–1466, built to the plans of Filippo Brunelleschi, enlarged by Ammannati 1558–1570.
 - —Palazzo Rucellai, facade 1446–1451, Leon Battista Alberti.
 - —Palazzo Strozzi, begun 1489, Benedetto da Maiano and Il Cronaca.
 - —S. Lorenzo, 1421–1425, Filippo Brunelleschi.
 - —S. Maria Novella, begun 1279, facade 1456–1470 by Leon Battista Alberti.
- **Mantua, Italy:** Camera degli Sposi, Palazzo Ducale, 1465–1474, Mantegna.
- **Urbino, Italy:** Studiolo of Federico da Montefeltro, Palazzo Ducale, c. 1444–1482.

High Renaissance

- **Rome, Italy:**
 - —Loggia of Raphael, Vatican, 1508–1520.
 - —Palazzo Farnese, 1517–1589, Antonio da Sangallo, the Younger, with additions by Michelangelo.
 - —Tempietto, S. Pietro in Montorio, 1502, Donato Bramante. (Color Plate 26)
 - —Villa Farnesina, 1505–1511, Baldassare Peruzzi.
- **Venice, Italy:**
 - —Palazzo Vendramin-Calergi, 1509, Mauro Coducci.
 - —Palazzo Grimani, begun 1556, Michele Sanmicheli.

Late Renaissance

- **Florence, Italy:**
 - —Laurentian Library, 1524–1533.
 - —Michelangelo di Buonarroti Simoni, staircase (by Ammanati) completed 1559.
 - —Studiolo of Francesco de' Medici, Palazzo Vecchio, 1570–1572, Vasari.
- **Mantua, Italy:**
 - —Palazzo del Tè, 1525–1534, Giulio Romano.
 - —Sala dei Giganti, Palazzo del Tè, 1530–1532, Giulio Romano.
- **Maser, Italy:**
 - —Room of Bacchus, Villa Barbaro, c. 1561, Veronese.
 - —Villa Barbaro, 1554–1558, Andrea Palladio.
- **Poiana Maggiore, Italy:** Villa Poiana, 1549, Andrea Palladio.
- **Rome, Italy:**
 - —Capitoline Palaces, c. 1538–1564, Michelangelo di Buonarroti Simoni.
 - —Palazzo Massimo alle Colonne, 1532–1534, Baldassare Peruzzi.
 - —Sistine Chapel ceiling, Vatican, 1509, Michelangelo di Buonarroti Simoni.
 - —Villa Giulia, 1551, Vignola.
- **Venice, Italy:**
 - —Il Rendentore, 1577–1592; Andrea Palladio.
 - —S. Giorgio Maggiore, begun 1565, Andrea Palladio. (Color Plate 27)
- **Vicenza, Italy:**
 - —Palazzo della Ragione (Basilica), 1549–1617, Andrea Palladio.
 - —Loggia del Capitaniato, 1565–1572, Andrea Palladio.
 - —Palazzo Chiericati, 1550–1560, Andrea Palladio.
 - —Teatro Olimpico, begun 1580, Andrea Palladio.
 - —Vicenza Cathedral, 14th–16th centuries; Andrea Palladio.
 - —Villa Rotunda (Almerico-Capra), 1565–1569, Andrea Palladio. (Color Plate 28)

Theater interiors imitate Roman designs by separating audience seating, front stage, and rear stage. They also reflect new influential developments in using three-dimensional perspective on buildings and painted scenery (Fig. 12-38, 12-41), as illustrated in Palladio's Teatro Olimpico.

Unified and lavishly decorated domestic interiors are sparsely furnished. Architectural treatises discuss interior planning and illustrate details, but do not focus on entire rooms. Other than sketches of some details, architects leave the interior design of residences to artisans.

12-36. Ceiling details.

12-37. The Loggie of Raphael, 16th century; Vatican, Rome, Italy.

12-38. Stage setting, 1540–1551; by Sebastiano Serlio and published in *D'Architettura*.

Public Buildings

■ *Materials.* Stone and marble are common in most church interiors. *Pietra serena* (gray stone) appears extensively in Brunelleschian churches. Palladian examples are mostly white, relying on articulation, relationships, and light for interest (Fig. 12-40).

■ *Floors.* Stone or tile floors are typical. Brunelleschi defines interior modules in floor decoration.

■ *Walls.* Walls develop with classical ordering to include a dado, shaft, and entablature (Fig. 12-34, 12-35, 12-39, 12-41). Moldings, arches, and pediments accent doors and windows imitating the exterior design. Walls may be plain or embellished with painted *trompe l'oeil* (photographically realistic) decoration.

■ *Ceilings.* Most interiors feature groin or barrel-vaulted ceilings (Fig. 12-35, 12-36, 12-40). Nave ceilings are high to accommodate windows; some have flat and coffered ceilings with vaulted side aisles. Crossings are usually domed. Ceilings may be plain, have coffers or compartmentalized ceiling paintings, or feature painted *trompe l'oeil* decoration.

Private Buildings

■ *Relationships.* Regular, rectangular interiors reflect the orderly arrangement of exteriors, with many featuring classical details.

■ *Architectural Details.* Pilasters and other classical details articulate some rooms, while others are painted (Fig. 12-42, 12-43, 12-45). Fireplaces are a focal point for decoration. Easy to decorate flat pyramids or wedge-shaped hoods replace earlier conical ones. Decoration includes cornices, moldings, and coats of arms. Hoods disappear by the 16th century, and mantel decoration becomes more architectural with a cornice, frieze, and architrave.

■ *Color.* Color comes from construction materials, fresco (water-based painting on lime plaster) decoration, textiles, and paintings. Typical pigment colors include scarlet, cobalt blue, gold, deep green, and cream.

■ *Lighting.* Interiors are dark both night and day. Shutters, blinds, and awnings block light and heat. At night, candles and firelight give little illumination. Consequently, rooms feature strong colors and furnishings with high reliefs and shiny surfaces. Candleholders, floor stands, and wall sconces

12-39. Vestibule, Laurentian Library, 1524–1533; staircase completed 1559; Florence, Italy; by Michelangelo di Buonarroti Simoni.

12-40. Nave, S. Giorgio Maggiore, begun 1565; Venice, Italy; by Andrea Palladio.

12-41. Stage area, Teatro Olimpico, begun 1580; Vicenza, Italy; one of Andrea Palladio's most accomplished projects; illusionistic perspective rear stage designed in 1584 by Vincenzo Scamozzi.

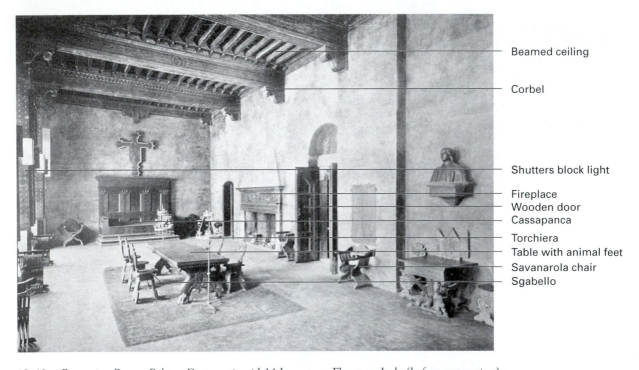

Beamed ceiling

Corbel

Shutters block light

Fireplace
Wooden door
Cassapanca

Torchiera
Table with animal feet
Savanarola chair
Sgabello

12-42. Reception Room, Palazzo Davanzati, mid-14th century; Florence, Italy (before restoration).

are typically of wood, iron, brass, and bronze. A candlestick (single-stem unit) may be hand-held, placed on a table, or put in a stand. A *candelabrum* (multiarm unit) may be placed on a table (usually in pairs as *candelabra*) or put in a stand. *Torchiera* (floor candle stands) are the most important and may hold a candlestick or *candelabrum* (Fig. 12-48). Chandeliers and oil lamps are rare.

■ *Floors.* Tiles and bricks commonly cover floors, with herringbone being the most favored pattern. Some tiles have inlaid or relief patterns in contrasting colors (Fig. 12-47). The best rooms feature marble or *terrazzo* (marble chips in cement). Wood in boards or patterns cover upper floors. During the 16th century, floor designs often correspond to ceilings. Knotted pile rugs, imported from Spain

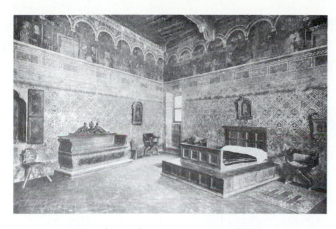

12-43. Bedchamber, Palazzo Davanzati, mid-14th century; Florence, Italy.

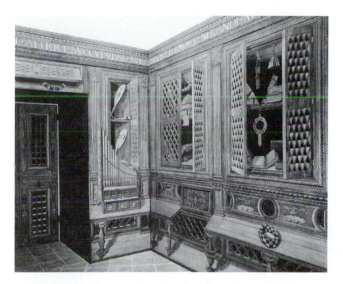

12-44. Corner detail with perspective *intarsia* (inlaid wood), Gubbio Studiolo, c. 1478–1482; Gubbio (near Urbino), Italy; by Francesco di Giorgio Martini. (Courtesy of The Metropolitan Museum of Art, Rogers Fund, 1939)

or the Near East, cover floors and tables. People use natural fiber matting in summer months.

■ *Walls.* Wall treatments progress from plain stone or plaster to examples incorporating architectural details such as pilasters. Wood paneling is either plain, inlaid, or painted. Plastered walls have at least a white or colored wash (Fig. 12-42). *Frescoes* in repeating patterns, imitations of textiles or marble, *trompe l'oeil* architecture (Fig. 12-44, Color Plate 29), or actual textile hangings cover the walls in important rooms (Fig. 12-43). Frescoes, executed by artists such as Veronese, are common features in Palladian and other *villas*. Tapestries are rare because of their expense. Gilded leather hangings dominate fashion during 16th century. Some Italians apply small panels of printed paper or larger panels of engravings to walls for embellishment, although actual wallpaper develops later. Rush matting, plain or patterned, sometimes covers walls.

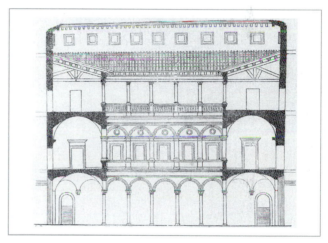

12-45. Section view, Palazzo Strozzi, begun 1489; Florence, Italy; by Benedetto da Maiano and Il Cronaca.

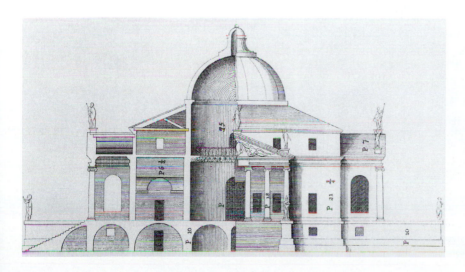

12-46. Section view, Villa Rotunda (Almerico-Capra), 1565–1569; Vicenza, Italy.

12-47. Floor detail; Florence, Italy.

■ *Windows and Doors.* Window curtains are very rare; shutters block light and give privacy. As important decorative features, doors are inlaid, painted, or surrounded by *aedicula*. *Portieres* (curtains hanging across doorways) are plain or embroidered cloth or woven tapestries at very grand doorways.

■ *Ceilings.* Ground-floor ceilings are usually vaulted (Fig. 12-46). Those on upper floors are either beamed with supporting corbels (brackets usually supporting a beam; Fig. 12-42, 12-43), compartmented (a grid of rectangular panels defined and divided by three-dimensional moldings; Fig. 12-36), or coffered (a suspended grid of three-dimensional geometric panels). Painting, gilding, or carving decorate both. By the second half of the 16th century, frescoes dom-

12-48. Lighting fixtures: *torchiera* and candlestick.

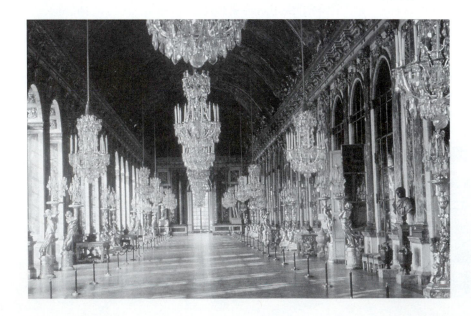

12-49. Later Interpretation: Galerie des Glaces (Hall of Mirrors), Versailles, 1678–1687; Versailles, France; begun by Charles Le Brun and completed by Jules Hardouin-Mansart; Louis XIV.

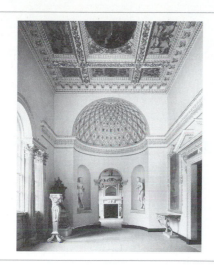

12-50. Later Interpretation: Gallery, Chiswick House, 1725; London, England; created by Lord Burlington and William Kent; Neo-Palladian.

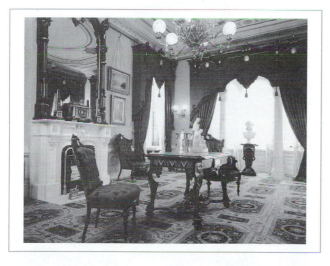

12-51. Later Interpretation: Parlor, Jedediah Wilcox House, 1870; Meriden, Connecticut; Renaissance Revival. (Courtesy of The Metropolitan Museum of Art, Gift of Josephine M. Fiala, 1968)

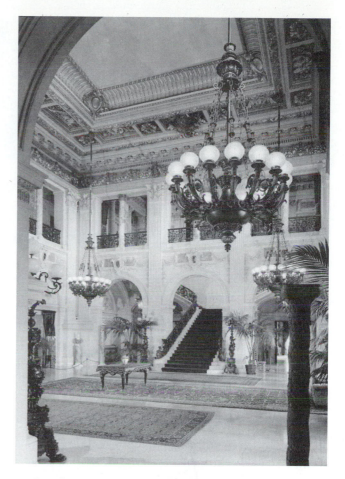

12-52. Later Interpretation: Stair hall, The Breakers, 1892–1895; Newport, Rhode Island; by Richard Morris Hunt for Cornelius Vanderbilt; Beaux Arts "cottage."

inate ceiling decoration. Also in the 16th century, wall, floor, and ceiling decorations relate to one another.

■ *Later Interpretations.* The Italian Renaissance influences all European Renaissance developments. Italian artists brought into France influence Louis XIV interiors (Fig. 12-49) with *trompe l'oeil* decoration, furniture designs, mirrors, textiles, and color usage. Subsequent design periods, such as the Neo-Palladian and Renaissance Revival (Fig. 12-50, 12-51, 12-52), borrow heavily in their use of proportion, scale, architectural detailing, plan arrangement, and the *cortile.*

FURNISHINGS AND DECORATIVE ARTS

Furniture is rectilinear and massive with classical ornament and proportions. Classical details first appear in church furniture and later spread to domestic examples. The most common decorations are carving, inlay, painting, and gilding. Early Renaissance furniture is simple with sparse carving in low relief or inlay. High Renaissance furniture is grander and more influenced by architecture. Late Renaissance furniture derives many concepts from Michelangelo, particularly his love of figures, exaggerated scale, and unusual architectural motifs. High-relief carving dominates, while classical proportions and purity of ornament decline.

■ *Types.* The most common pieces of furniture include the *sedia* (box-shaped armchair with runners), folding chairs of X-form including the *Dante* (X-form with four legs, sometimes a seat of honor) and *Savonarola* (X-form with many interlacing slats, often used by scholars), trestle

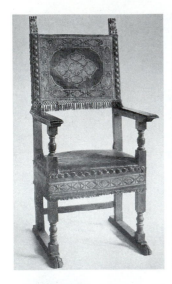

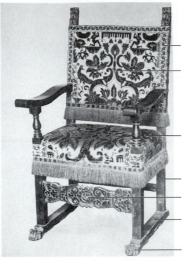

Rectangular back

Fabric trimmed
with fringe

Rectangular seat

Wood frame

Decorative stretcher

Runner

Animal paw feet

12-53. *Sedia,* 15th–16th centuries.

Design Spotlight

Furnishings: *Sedia.* Armchairs (Fig. 12-53) are rare before the 16th century, but by the end of the century, they appear in most rooms. Some grand dining spaces have sets of armchairs. Decoration becomes more elaborate as the period progresses. Size denotes high status—the larger the chair, the higher the sitter's status. Back and seat may be leather or fabric trimmed with fringe. Arm supports and front legs may be turned. Runners and/or stretchers may connect legs.

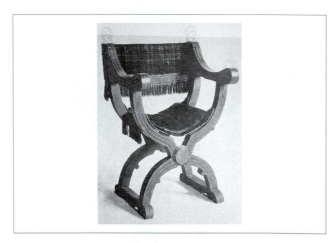

12-54. *Dante* chair, 15th century; Florence, Italy.

table, *cassone* (chest or coffer with hinged lid), and *cassapanca* (a long wooden bench with a seat and back; seat has a hinged lid).

■ *Distinctive Features.* Armchairs and side chairs feature quadrangular or turned legs with side runners terminating in lion's heads. Back legs form the back uprights, and front arm posts form the front legs. Some have carved stretchers beneath the seat. A carved or arcaded horizontal stretcher connects dining table trestles. Large storage pieces may feature animal feet. *Certosina* (an inlay of ivory or bone in geometric patterns) may embellish chairs and storage pieces (Fig. 12-54).

■ *Materials.* Walnut is the main wood, but oak, cedar, and cypress are also typical. Construction gradually increases in complexity. Some stools are made of iron.

■ *Seating.* Chairs include *sedias* (Fig. 12-53), ladder-backs with rush seats, the *Dante* (Fig. 12-43, 12-54), and the *Savonarola* (Fig. 12-42, 12-55). Two main types of stools (Fig. 12-56) are those with turned, carved, or plain legs and box stools with solid sides. A back added to a two-sided box stool creates the *sgabello* (stool chair; Fig. 12-42, 12-57).

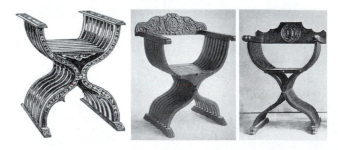

12-55. *Savonarola* chairs; named for Savonarola, a monk.

■ *Tables.* Tables include long, narrow, oblong trestle tables for dining (Fig. 12-42, 12-59), tables with marble or *pietra dura* (semiprecious stones inlaid in wood) tops, folding tables, and small tables similar to box stools. Small side tables or sideboards support meal service.

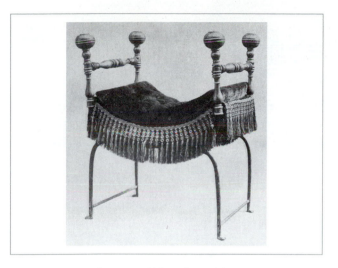

12-56. Brass and iron stool/chair, late 16th century; Sienna, Italy.

12-57. *Sgabello*, late 16th century.

■ *Storage. Cassones* (chests; Fig. 12-60), used for storage and seating, are the most important storage pieces and come in various sizes and designs. Some have *cartouches* carved with the owner's coat of arms or initials. Mid-15th century Florence introduces the *casapanca* (chest with a back used as a seat; Fig. 12-43, 12-58), sometimes placed on a *dais* (platform) at the end of a room to emphasize importance. Chests of drawers appear at the end of the 16th century. A variation of this is the *credenza* (Fig. 12-61), an oblong chest with drawers in the frieze and doors beneath separated by a narrow panel or pilaster.

■ *Beds.* Beds include the *lettiera* (which has a high headboard and rests on a platform surrounded by three chests; Fig. 12-43), four-poster beds, and simple boards with legs derived from the Middle Ages. A few trundle and folding beds exist, which are used mainly by nurses or the infirm.

12-58. *Casapanca*, 15th century.

■ *Textiles.* Armchairs and side chairs have velvet or leather seats and decorative panels between the back uprights (Fig. 12-62). Some seat covers, cushions, and coverlets are made of tapestries. Professional workshops or ladies of the house

12-59. Tables, 16th century.

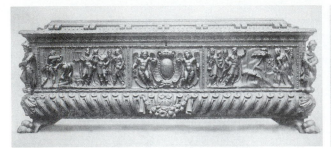
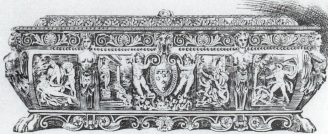

12-60. *Cassones*, 16th century.

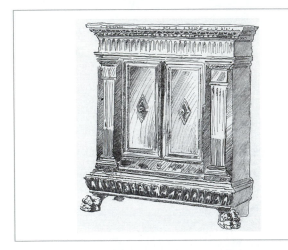

12-61. *Credenza*, 16th century.

Design Spotlight

Decorative Arts: *Textiles*. Textiles, more expensive than furniture, include brocades, velvets, taffetas, damasks, and brocatelles (Fig. 12-62). The most common are domestic and imported woolens. Important textile factories are in Lucca, Genoa, and Palermo. Ogee repeat patterns with stylized flower and fruit designs are common, usually rendered in deep reds, golds, blues, and greens.

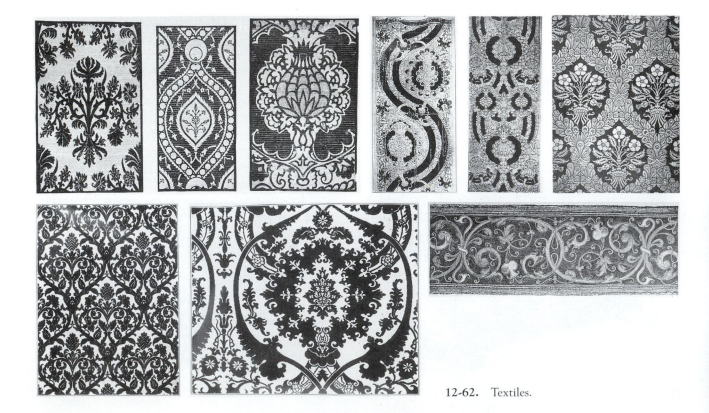

12-62. Textiles.

12-63. Della Robbia earthenware.

12-64. Later Interpretation: "Honor Bilt" dining room set, Sears, Roebuck and Company, early 20th century; Chicago, Illinois.

embroider fabrics, cushions, and wall and bed hangings. Bed hangings provide privacy and warmth. Before poster beds, bed coverings were suspended from hooks, rods, or a dome attached by a cord to the ceiling. Summer bed hangings and coverlets are of dimity or Indian printed cottons.

■ *Decorative Arts.* Most mirrors are polished steel until the 16th century, when Venice begins producing small silvered glass mirrors. To protect them from marring or scratching, most have curtains, shutters, or special cases. Ewers, basins, inkwells, candlesticks, and other decorative objects are of bronze and brass. By 1600, most rooms have at least one print or painting. Devotional scenes are common in bedrooms, while portraits and maps hang in halls, galleries, and reception rooms. Many people collect bronze, terracotta, or plaster statuettes, but the wealthy more often collect antique sculptures or commission new pieces.

■ *Earthenware.* Decorative objects and informal dinnerware are made of Italian *majolica* (tin-glazed earthenware painted in bright colors). The Della Robbia family in Florence makes the most outstanding *majolica*, producing devotional reliefs and decorative tiles of religious figures, fruits, and flowers (Fig. 12-63). Italians highly prize Chinese porcelain and try to reproduce it. Among the most notable attempts to make porcelain is the Medici porcelain made in Florence between 1575 and 1585.

12-65. Later Interpretation: Quarta chair, 1984; by Mario Botta.

■ *Later Interpretations.* Italian Renaissance furnishings influence all European Renaissance developments, the Louis XIV and Renaissance Revival periods, early 20th century catalog furniture (Fig. 12-64), as well as more contemporary designs (Fig. 12-65).

13. Spanish Renaissance

1480–1650

The rediscovery of the Classical past was one of the two great adventures that informed the Renaissance. The other was the exploration and conquest of America.

Spiro Kostof, A History of Architecture

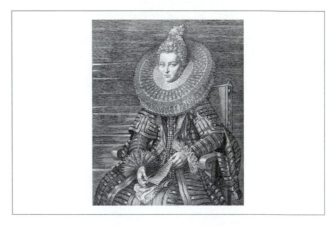

13-1. Portrait of Isabella Clara Eugenia, Infanti of Spain, 1615; by Peter Paul Rubens.

Spain dominates the world in the 16th century, but she, like others, looks to Italy for inspiration in architecture, interiors, and furnishings. Initially, the Spanish blend Renaissance design principles and motifs with 800 years of Moorish influences and a tradition of lavish surface decoration. Major architectural projects often exhibit a blend of classical and Moorish designs. High Renaissance design concepts and details appear early in the 16th century and become more severe throughout the century.

HISTORICAL AND SOCIAL

Spain acquires her present borders late in the 15th century. The marriage of Ferdinand V of Aragon and Isabella of Castile in 1469 unites their respective states. The conquest of Granada and the annexation of Navarre complete the unification. Policies and actions of these two monarchs will lay the foundations of Spain's domination as a great world power in the 16th century. Ferdinand and Isabella establish the Inquisition in 1478, ostensibly to maintain the purity of the Catholic faith, but it becomes a powerful tool for expanding the powers of the Crown. Ferdinand and Isabella sponsor the expedition of Christopher Columbus to discover new western trade routes to Asia in 1492. Within 20 years, the Spanish are expanding their territorial holdings into the Americas. Ferdinand also makes alliances with various European royal houses. When his grandson, Charles, ascends the Spanish throne in 1516, the power of the Spanish court is unmatched in Europe.

During the 16th century, Spain leads the world in exploration, trade, and colonization. By the 1550s, she controls most of South and Central America, Florida, Cuba, and the Philippines. Newly discovered gold and silver mines in the Americas bring enormous wealth into Spanish coffers. More European territory, including the Netherlands and Burgundy, comes with Charles V's election as Holy Roman Emperor in 1519. Spain leads European politics and plays a large monetary and ideological role in the Counter-Reformation.

Charles's son, Philip II, becomes the ruler of a major world power when he takes the throne in 1556. Through his four marriages to daughters of royalty in Europe, he enhances Spain's stature and financial resources with important connections to England, France, and Italy. The peace that prevails early in his reign soon vanishes in the face of religious conflicts, domestic turmoil, and epidemics that threaten economic and political stability. Maintaining Spanish territories proves costly, as does the rivalry with France, discontent in the Netherlands, and war with England. Philip's attempts at an absolute monarchy and his strong allegiance to the Catholic faith contribute to the decline of Spanish power. In addition, the Inquisition's conservatism prohibits new ideas. The defeat of the Spanish Armada by the English in 1588 marks the end of Spanish domination in both Old and New Worlds. As the 16th century ends, so does Spain's Golden Age.

CONCEPTS

Political ties with Italy bring the new image of the Renaissance to Spain. This first appears as Italian Renaissance details applied to Gothic forms. Renaissance motifs freely mix with Gothic and Moorish motifs. Surface richness, as an indication of wealth and an expression of Spain's Moorish heritage, is characteristic and distinctive. Italian High Renaissance classicism abruptly appears in the second quarter of the 16th century. Bearing little resemblance to

native Spanish designs, it becomes more formal, severe, and accurate by the end of the century. Associated primarily with the court, it has little impact on interiors or furniture. The Spanish love of ornament reasserts itself in the Baroque movement, which begins in Spain about 1650.

DESIGN CHARACTERISTICS

Rich surface decoration that freely mixes Moorish, Gothic, and Renaissance motifs characterizes the early Renaissance in Spain. Ornament, often complex and layered within a geometric grid, reveals an Islamic origin. Symmetry and correct proportions are not concerns. By the second quarter of the 16th century, Spanish Renaissance enters a more Italian phase. Revealing antecedents in Italian High Renaissance and antique buildings, classical articulation and details replace surface decoration. Symmetry, order, and harmonious proportions are characteristic. By the end of the century, design becomes severe and formal with little decoration.

13-2. Hispano-Moresque platter, 15th century.

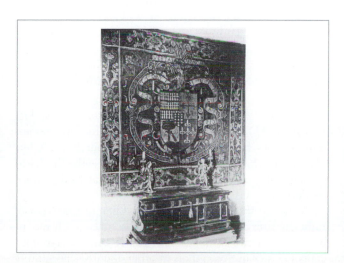

13-3. Tapestry wall hanging.

- *Hispano-Moresque* (8th–15th centuries) reflects the Moorish architecture and decoration of Spain during Islamic domination.

- *Mudéjar* (13th–16th centuries) appears after the conquest of the Moors by Christians. Many Christian buildings of this period use Moorish details such as the horseshoe arch.

- *Plateresque* (late 15th to early 16th centuries) describes the transition from Gothic to Renaissance. The characteristic minute, profuse surface ornament in low relief resembles silverwork, after which it is named.

- *Isabelline or Gothic Plateresque* (c. 1480–1504), the early phase, is Gothic in form. Gothic motifs, such as pinnacles and crockets, dominate.

- *Renaissance Plateresque* (1504–1556), the latter phase, reveals more classical motifs, such as decorated pediments, pilasters, and baluster columns. The two phases, Gothic and Renaissance, are sometimes parallel with each other, and some designers work in both styles.

- *Classical, Desornamentado, or Herreran Style* (1556–1650) reveals an understanding of classical design principles and ordering. Symmetrical and carefully proportioned, decoration is architectonic and more accurately emulates Italian High Renaissance forms. With the building of El Escorial, the interpretation becomes plainer, more severe, and the official architectural style of Spain. It dominates Spanish architecture through the 17th century.

- *Churrigueresque or Baroque-Rococo* (1650–1750), named for the Churriguera family of architects, flourishes after the Renaissance (see Chapter 20, European Baroque). The style highlights architectural ornament such as stuccowork, twisted columns, and an inverted obelisk.

- *Motifs.* Moorish motifs (Fig. 13-2) are ogee arches, interlaced arabesques, and geometric shapes. Gothic motifs are heraldic symbols (Fig. 13-3), pointed arches, pinnacles,

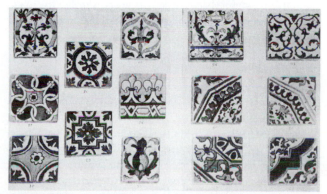

13-4. Renaissance tiles.

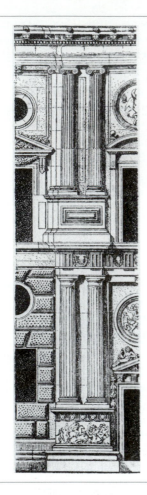

13-5. Detail, Palace of Charles V, 1527–1568; Pedro Machua; Classical, Desornamentado, or Herreran style.

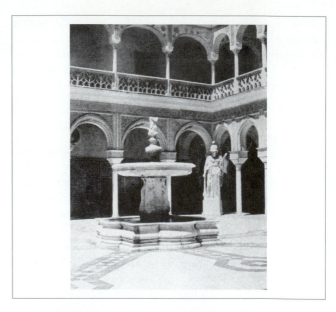

13-6. Courtyard, Casa de Pilatos; Seville; Mudéjar.

Design Practitioners

■ *Juan de Herrera*, who is knowledgeable about architecture in Italy and Flanders, succeeds Juan Bautista de Toledo as official architect to Philip II and completes El Escorial. The austere style of El Escorial dominates Spanish architecture through the 17th century.

■ *Diego de Siloe*, a sculptor and architect, studies Italian work in Naples, Italy. However, he is one of the leading Plateresque architects in Spain. His most noted work is Granada Cathedral.

■ *Juan Bautista de Toledo* is official architect to Philip II, the first to hold that title. Formerly an assistant to Michelangelo at S. Peter's in Rome, Toledo designs the monumental ground plan for El Escorial.

and crockets. Decorated pediments, pilasters, baluster columns, and grotesques appear and distinguish Renaissance Plateresque. Classical-style decoration more accurately copies Italian Renaissance forms and motifs (Fig. 13-4, 13-5) and includes columns, pilasters, pediments, medallions, stylized leaves and flowers, scrolls, fretwork, shells, and figures. Fewer Classical motifs are used on Spanish architecture than in Italy and France.

ARCHITECTURE

The Renaissance in Spanish architecture begins as the Plateresque style in the late 15th century. A transition between Gothic and Renaissance, its Gothic form features lavish surface decoration combining Moorish, Gothic, and Renaissance elements. Ornamentation, which concentrates around doors and occasionally windows, is not related to the structure and contrasts with surrounding blank walls. Around portals (principal entrances; Fig. 13–10, 13–11), decoration extends to the roofline, resembling *retables* (screens behind altars in churches). A few plans derive from Italian examples, specifically, the Latin cross plan for churches and the central courtyard plan for residences.

Although the early phase is very different from that of Italy, the later classical Spanish Renaissance closely resembles the Italian. Assimilation of Renaissance design concepts is easier in Spain than in other countries because of its close proximity, political ties, and climatic similarities

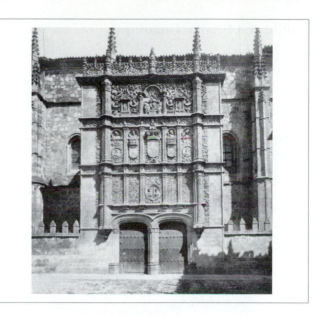

13-7. Doorway, Palace of the Condes de Miranda, 16th century; Spain; Mudéjar.

13-10. Facade, University, 1415–1529; Salamanca; Gothic and Plateresque.

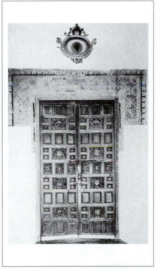

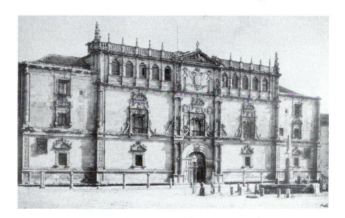

13-11. University, 1537–1553; Acalá de Henares; Rodrigo Gil de Hontañón.

13-8. Door, 16th century; Seville; Mudéjar.

13-9. Doorway, Convent of Santa Clara with polychrome tiles; Seville.

to Italy. Despite a varied climate, most Spanish structures are designed for hot weather with small windows, flat or low-pitched roofs, and *patios* (courtyards) similar to those in Italy.

The classical Renaissance is more Italian in concept and appearance and reveals the influence of Bramante, Palladio, and Vignola. Plain wall surfaces articulated with rustication and classical details replace *Mudéjar* (synonym for Moorish) surface ornamentation. Most structures reflect human scale. Plans and facades often reveal Italian antecedents as Spanish architects study Italian buildings and treatises. Nevertheless, some Spanish characteristics are retained, such as ornate portals, iron grilles at windows, and tilework. Following the precedent shown in the building of El Escorial, Spanish Renaissance architecture becomes very plain with little or no ornamentation. With the exploration of the Americas during the 16th and 17th centuries, these distinctive Spanish Renaissance features travel to the New World in the form of churches, government buildings, and residences (see Chapter 17, American Colonial: Spain).

Public and Private Buildings

■ *Types.* Spanish building types, which are more varied than those in Italy, include churches, civic buildings, universities, hospitals, palaces, town houses, and *rancheros.*

■ *Site Orientation.* Churches are dominant structures in the city or town environment (Fig. 13-14). Most city buildings front on narrow streets. Public buildings and palaces may face squares or *plazas* (Fig. 13-16).

■ *Floor Plans.* Most churches have Latin cross plans. Other structures, including palaces and houses, center on *patios* for privacy (Fig. 13-6, 13-16, 13-17). Like the earlier Moorish structures, rooms generally open out to one or more outdoor spaces. Rooms (Fig. 13-21, 13-22) are often long and narrow in shape; their dimensions are not mathematically derived. Symmetry in plan is not important until the classical period.

■ *Materials.* Granite, limestone, sandstone, glazed ceramic tile, and brick are typical building materials. Gray granite with contrasting white stucco details marks the classical style. The scarcity of wood limits its use. The Spanish are known for wrought-iron window grilles, handrails, and other decoration (Fig. 13-13).

■ *Facades.* Walls are usually symmetrical and divided into bays. Surfaces (Fig. 13-10, 13-11, 13-14, 13-15) typically are plain with little or no rustication until the classical period. Sometimes string courses separate stories. Ornamentation, which varies with the style, reaches the roof line (Fig. 13-20, 13-23, 13-24).

■ *Windows.* Plateresque or Classical decoration surrounds rectangular or arched windows that have one or two lights (Fig. 13-11, 13-15). Some have *rejas* (wrought-iron grilles).

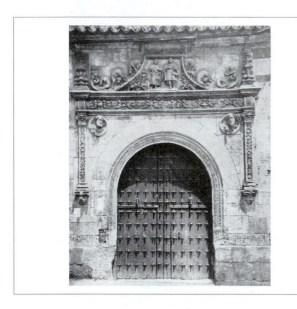

13-12. Iglesia de S. Justo; Salamanca; Plateresque.

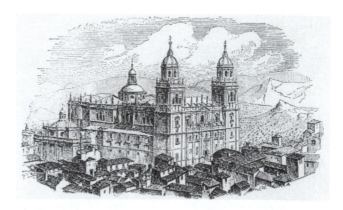

13-14. Cathedral of Jaen, begun 1532; Spain.

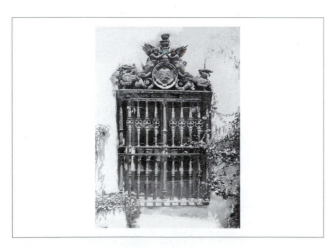

13-13. Window detail, Casa de Pilatos, early 16th century; Seville; Plateresque.

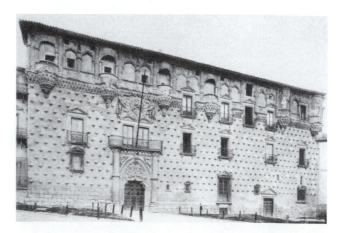

13-15. Palace of the Duques del Infantado, begun 1461; Guadalajara; Gothic and Mudéjar.

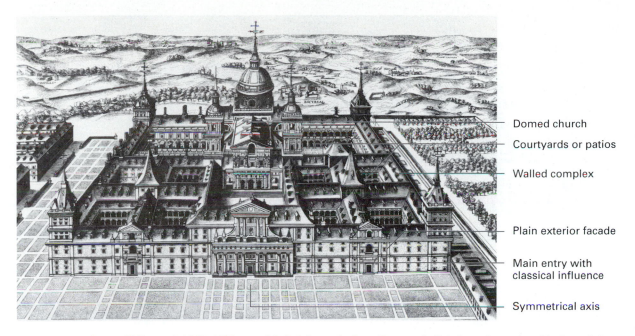

Domed church

Courtyards or patios

Walled complex

Plain exterior facade

Main entry with classical influence

Symmetrical axis

13-16. Aerial view, El Escorial, 1562–1582; near Madrid; begun by Juan Bautista de Toledo and completed by Juan de Herrera; Classical, Desornamentado, or Herreran.

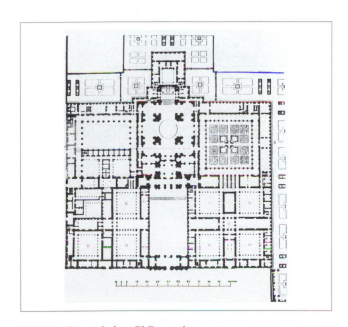

13-17. Ground plan, El Escorial.

■ *Doors.* Decorative surrounds emphasize entrances and are a distinctive Spanish feature. Rectangular doors typically have carved wood panels, often with geometric designs (Fig. 13-7, 13-8, 13-9, 13-10, 13-12, 13-15, 13-24).

■ *Roofs.* Roofs are flat or low pitched. Following the completion of El Escorial (Fig. 13-18, 13-19), many houses have corner towers (Fig. 13-20).

Design Spotlight

Architecture: *El Escorial.* Constructed over a 20-year period, this complex (Fig. 13-16, 13-17, 13-18, 13-19, 13-28, 13-29, 13-30, 13-31, 13-32, Color Plates 30, 31) features a monastery, church, college, and state apartments for Philip II. The site plan develops around spacious courtyards, some with gardens. Begun by Juan Bautista de Toledo and completed by Juan de Herrera, the buildings reflect the Classical, Desornamentado, or Herreran style with design attributes from Palladio and other Italian Renaissance architects and artists. The gray granite facade is austere and simple with little ornamentation, but major entries are highlighted with columns, pilasters, arches, pediments, and sculptures. Symmetry and impressive scale are important. Within, the rooms vary, illustrating Moorish elements in the state apartments and Italian Renaissance architectural concepts in the library. Elaborate paintings by artists such as El Greco enhance the interior compositions. Simple furnishings spotlight traditional 16th-century Spanish designs.

■ *Later Interpretations.* During the 17th century, Spanish forms travel to the Americas as abstracted and simplified renditions of their *Mudéjar*, classical, and Baroque precursors resulting in Spanish Colonial interpretations in Mexico, Central and South America, and the south-

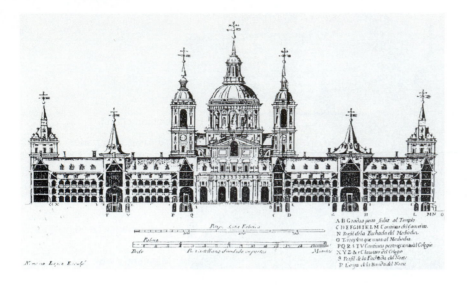

13-18. Section view, El Escorial.

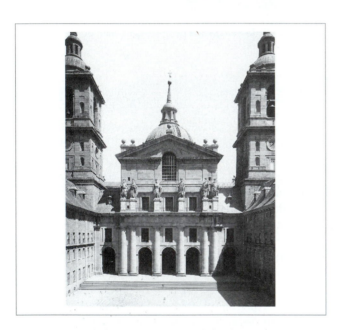

13-19. Patio de los Reyes, El Escorial. (Color Plate 30).

13-20. Corner Tower, Monterey Palace; Salamanca; Plateresque.

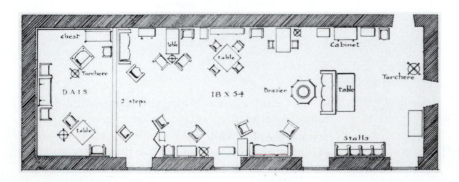

13-21. Floor plan, Salon in the Palace of the Duquesa de Parcent; Madrid.

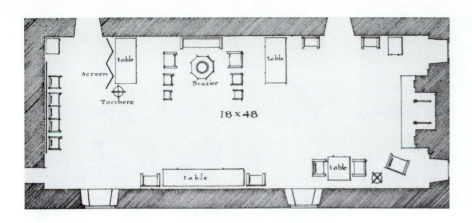

13-22. Floor plan, Salon in the Palace of the Condesa de Creciente; Avila.

Important Buildings and Interiors

- **Acalá de Henares:** University, 1537–1553, Rodrigo Gil de Hontañón.

- **Granada:**

 —Granada Cathedral, 1528–1563, Diego de Siloe, Plateresque.

 —Palace of Charles V, 1527–1568, Pedro Machuca, Classical, Desornamentado, or Herreran style.

- **Madrid:** El Escorial, 1562–1582, begun by Juan Bautista de Toledo, completed by Juan de Herrera, Classical, Desornamentado, or Herreran. (Color Plates 30, 31)

- **Salamanca:** University facade, 1514–1529, Gothic and Plateresque.

- **Santiago de Compostela:** Royal Hospital, 1501–1511, Enrique Egas, Isabelline.

- **Seville:**

 —Casa de Ayuntamiento (Town Hall), 1527–1564, Diego de RiaÒo, Plateresque.

 —Casa Lonja, 1583–1598, Juan de Herrera, Classical, Desornamentado, or Herreran.

- **Toledo:**

 —Afuera Hospital of San Juan Bautista, 1542–1578, Bartolome de Bustamante, Plateresque.

 —Alcazar, 1537–1553, Alonso Covarrubias, Plateresque.

13-23. Entablature, Casa de Zaragossa; Spain.

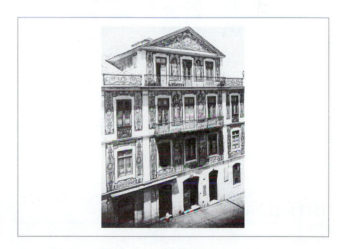

13-24. House facade covered with *azulejos*; Lisbon, Portugal.

western United States (Fig. 13-25). Detailing is often crude due to the limited abilities of the craftsmen. Early-20th-century Spanish Colonial Revival (Fig. 13-26) in the Americas adopts some Plateresque characteristics and ornamentation in its efforts to copy earlier structures. It features the plain walls, tile roofs, and ornamentation concentrated around doors and windows. Many houses and public buildings center on *patios*.

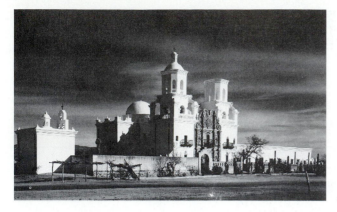

13-25. Later Interpretation: Mission San Xavier del Bal, 1767–1797; Tucson vicinity, Arizona; Spanish Colonial.

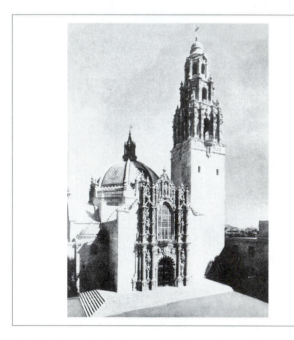

13-26. Later Interpretation: California Tower, Panama-California International Exposition, 1915–1916; Balboa Park, San Diego, California; by Bertram Goodhue, Spanish Colonial Revival.

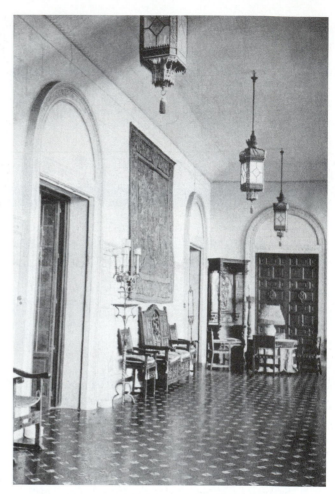

13-27. Cloister walk, former convent of Santa Maria de la Sisla, 16th century; Toledo.

INTERIORS

As on exterior facades, interior ornamentation concentrates around openings, and Moorish, Gothic, and Renaissance characteristics and motifs mix freely. Elaborately carved plasterwork often surrounds doors and windows and accents walls just below the cornice. Ceilings feature complex geometric designs. Rooms have few furnishings, even in the wealthiest homes. Furniture usually lines the perimeter of the room.

Private Buildings

■ *Color*. Colors, which are highly saturated, include reds, yellows, blues, and greens primarily appearing in *azulejos* (tiles in blue and white), textiles, and decorative objects. Plasterwork is usually white. Ceilings and furnishings may be a combination of natural wood, color, and gilt.

■ *Lighting. Torcheres* (floor candle stands), torch stands, hanging lanterns, *braccios* (lanterns mounted on iron brackets), *candelabra*, and chandeliers are common in all types of spaces (Fig. 13-27, 13-35, 13-47, 13-48, 13-49). Designs may be plain or elaborate and often copy a particular design influence to incorporate *Mudéjar* or classical features. Materials are typically of iron and/or wood.

■ *Floors*. Lower floors are of tile, brick, or stone, while wood is typical for upper floors (Fig. 13-27, 13-35, 13-37, 13-38, 13-47). Knotted-pile rugs with elaborate designs and woven mats cover floors.

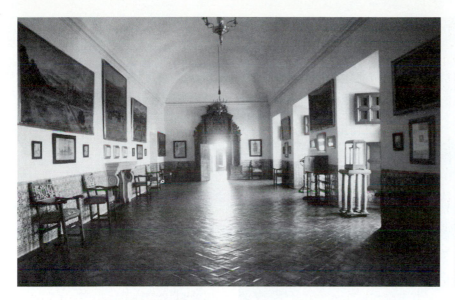

13-28. Hallway, El Escorial, 1562–1582; near Madrid; Juan Bautista de Toledo; Mudéjar and Renaissance Plateresque.

13-29. Door detail in Hallway, El Escorial.

13-30. Bedchamber and Reception Room in apartments of Philip II, El Escorial.

13-31. Window recess in apartments of Philip II, El Escorial.

■ *Walls.* Walls are smooth white plaster (Fig. 13-30, 13-34, 13-35). Colorful earthenware tiles (*azulejos*) highlight dadoes, door and window facings, window seats, stair risers, and interiors of wall niches (Fig. 13-28, 13-33, 13-37, 13-38, 13-39, 13-43, 13-44, 13-45, Color Plate 31). Grand stairways (Fig. 13-39, 13-40) may spotlight elaborate decoration and detailing. Aristocratic houses feature wall hangings of silk, velvet, or damask (Fig. 13-27). Some are embellished with embroidery or braid and fringe.

Because Spain is a leading center for leatherwork, painted and gilded cordovan leather often appears as a wall cover.

■ *Windows and Doors. Yeseria* (elaborately carved plasterwork) often frames doors and windows. Doors of wood or with iron grilles may be used to separate interiors from *patios.* Doors and shutters may be plain, painted, or carved. Curtains are rare (Fig. 13-29, 13-31, 13-33, 13-34, 13-35, 13-37, 13-41, 13-42, 13-46).

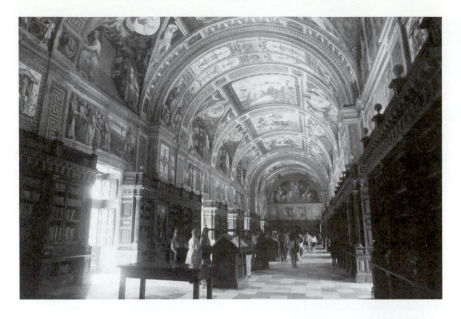

13-32. Library, El Escorial; Classical. (Color Plate 31)

■ *Ceilings.* Ceilings are focal points in many interiors. Most are of pine. Those in important rooms feature elaborate geometric shapes with complex ornamentation enriched with painting, gilding, and *artesonades* work (carving). Beams and coffers are similarly decorated (Fig. 13-32, 13-34, 13-35).

■ *Heating.* Fireplaces and *braziers* heat rooms during the winter (Fig. 13-35, 13-36, 13-43, 13-44). Large-scaled mantels with classical features usually dominate the main wall in important rooms. Occasionally, plasterwork decorates chimneys. *Braziers* of elaborate metal, copper, or silver supply additional heat and are portable.

13-33. Doorway detail, Casa del Conde de Toledo, 16th century; Toledo; Mudéjar and Plateresque.

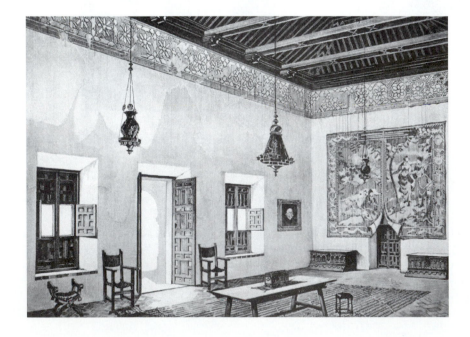

13-34. Main Salon, Palace of the Duke of Alba, 16th century; Seville.

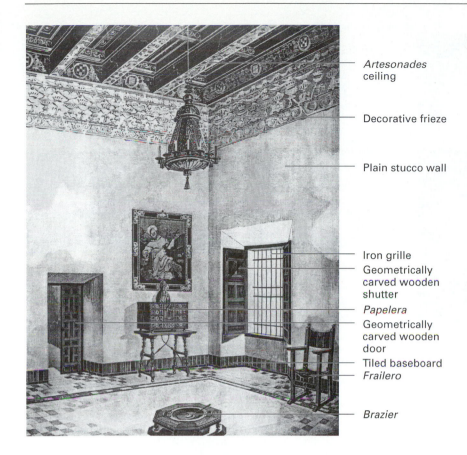

Artesonades ceiling

Decorative frieze

Plain stucco wall

Iron grille
Geometrically carved wooden shutter
Papelera
Geometrically carved wooden door
Tiled baseboard
Frailero

Brazier

Design Spotlight

Interior: *Salon, Palace of the Duke of Alba.* This interior is an excellent example of the Spanish Renaissance design statement. Used by an important family, this impressive space features a tile floor and baseboard, off-white plain stucco walls, geometrically carved wooden doors and shutters, a decorative frieze, an *artesonades* ceiling, a *brazier*, a *vargueño*, a *frailero*, and a chandelier.

13-35. Ground Floor Salon, Palace of the Duke of Alba.

13-36. *Braziers*, early 17th century.

13-37. Stair Hall, Palace of the Duke of Alba.

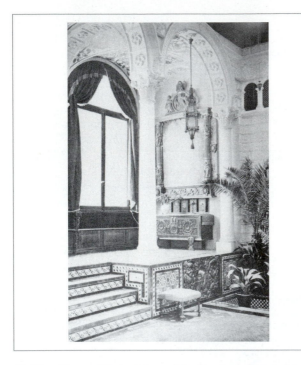

13-40. Stairway, La Santa Cruz, 16th century; Toledo; Plateresque.

13-38. Covered *Patio*, Palace of the Conde de Casals; Madrid.

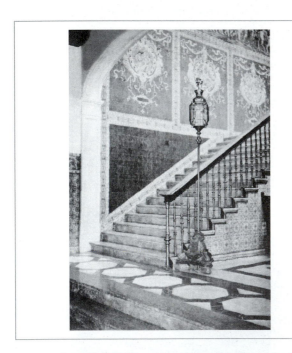

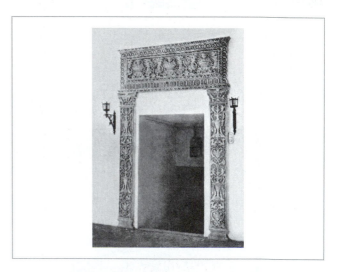

13-41. Doorway, Palace de las Dueñas, 16th century; Seville; Renaissance Plateresque.

13-39. Stair Hall, Palace of Don Javier Sanchez Dalp; Seville.

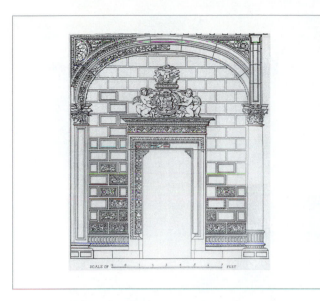

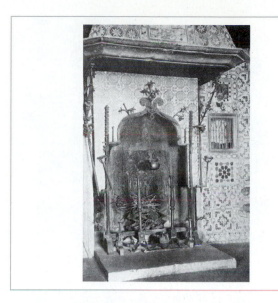

13-42. Doorway, Episcopal Palace, 16th century; Acala de Henares; Classical.

13-43. Tiled chimney area, Casa de Conde de las Almenas; Torrelodones.

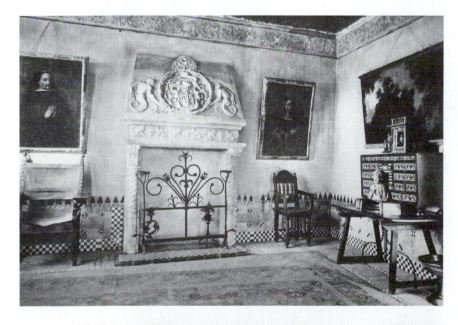

13-44. Salon, Casa de El Greco, 16th century; Toledo.

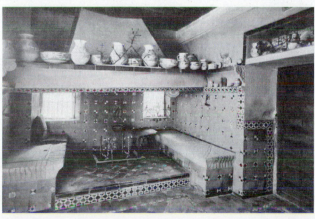

13-45. Kitchen, Casa de El Greco.

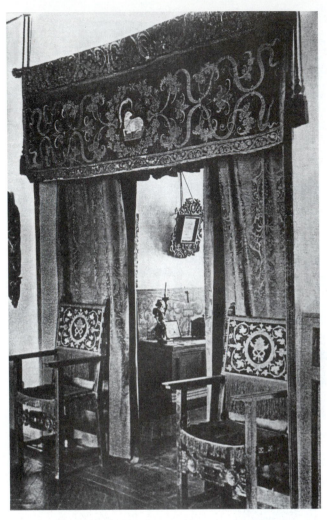

13-46. Doorway with embroidered lambrequin and damask curtains; Madrid.

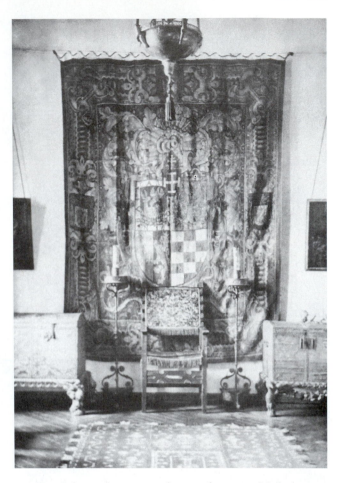

13-47. Salon with marriage chests and tapestry; Madrid.

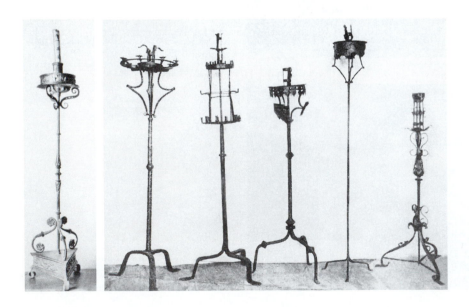

13-48. Lighting fixtures: Iron *torcheres* and torch stands.

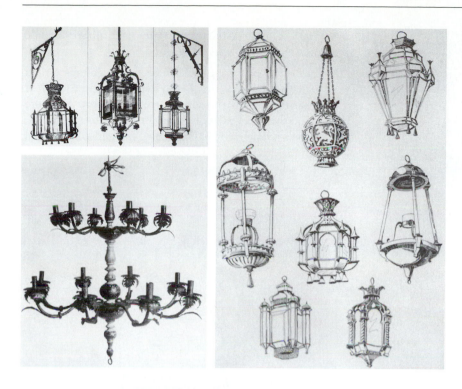

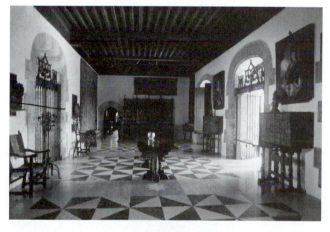

13-49. Lighting fixtures: Hanging lanterns and chandelier.

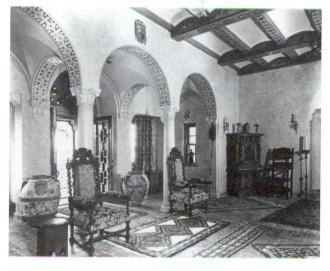

13-50. Later Interpretation: Entry Hall, Columbus House, c. 16th–17th centuries; Santo Domingo, Dominican Republic; Spanish Colonial.

13-51. Later Interpretation: Entry Foyer, McNay Residence, 1920s–1930s; San Antonio, Texas; Spanish Colonial Revival.

■ *Later Interpretations.* As with the architecture, Spanish Colonial interiors (Fig. 13-50) reinterpret the character of Spain in a simple manner, with less ornateness and decoration. Plain walls, tile floors, and dark-beamed ceilings are common. Spanish Colonial Revival (Fig. 13-51) also features plain walls, tiled floors, and dark-beamed ceilings of the earlier period, but with the addition of plasterwork, decorative tiles, and arches. The Mediterranean style of the 1960s–1970s also derives from Spanish sources.

FURNISHINGS AND DECORATIVE ARTS

Renaissance furniture is simple in design and construction and rectilinear in form with few moldings and architectural details. The scale of Spanish furniture is often heavier than comparable Italian or French furniture. The bold, vigorous ornamentation shows Moorish and classical influence. Particularly characteristic are wrought-iron mounts, locks, and underbraces.

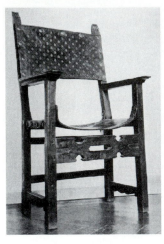
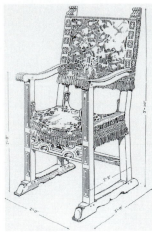

13-52. *Fraileros*, 16th century.

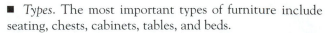

■ *Types.* The most important types of furniture include seating, chests, cabinets, tables, and beds.

■ *Distinctive Features.* Typical chairs have medium-to-high backs with ball or leaf finials and spiral, baluster-turned, or quadrangular legs with runners. Trestle supports are more common than legs on benches and stools. Tables, benches, and stools may have iron braces that are gilded for formal rooms.

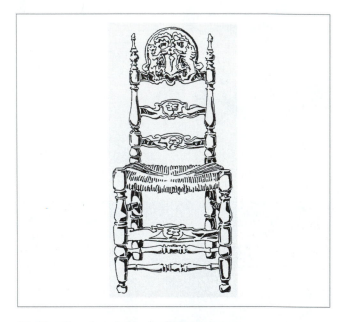

13-55. Barcelona ladder-back chair.

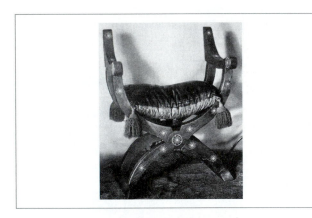

13-53. X-form stool.

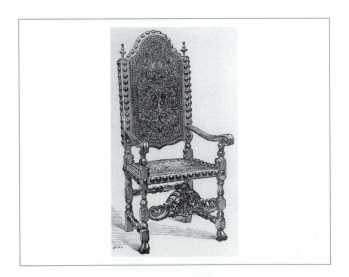

13-54. Tooled leather chair, early 17th century.

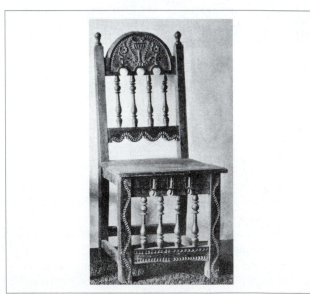

13-56. Wood side chair with spindles.

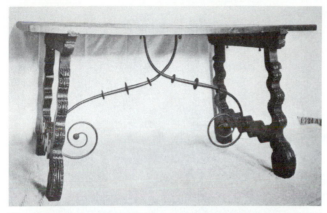

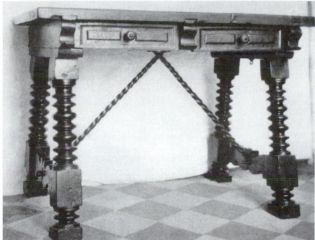

13-57. Walnut tables with iron bracing.

■ *Materials.* Walnut is the most used wood, followed by oak, pine, and chestnut. Luxury pieces are made of exotic woods such as ebony or mahogany. Decoration includes inlay, carving, painting, and gilding. Inlay of bone or ivory shows Moorish influence in its intricate designs of minute details in geometric and stylized floral patterns. Silver from the New World often forms inlay or applied details. Silver furnishings become so popular and detrimental to the economy that an edict published in 1594 prohibits their use.

■ *Seating.* Seating includes a *frailero* (an Italian-style rectangular arm and side chair), X-shaped chairs, the Barcelona ladder-back chair, stools, and benches (Fig. 13-28, 13-31, 13-34, 13-46, 13-52 through 13-56). Chairs are less common than benches and stools. Built-in seating

Design Spotlight

Furnishings: *Vargueño.* Used for writing or to hold documents, the *vargueño* (Fig. 13-58) is the most distinctive piece of Spanish Renaissance furniture. It consists of a drop front cabinet on a base. Wrought-iron mounts and locks provide the only decoration on the facade. Inside are numerous small drawers and doors. The most characteristic base has splayed legs and iron braces. It, like the *papalera*, was designed to travel with wealthy landowners as they moved between city and country houses.

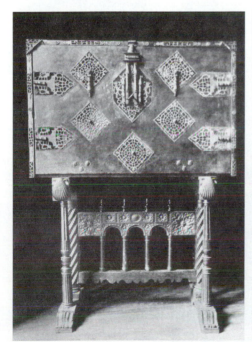

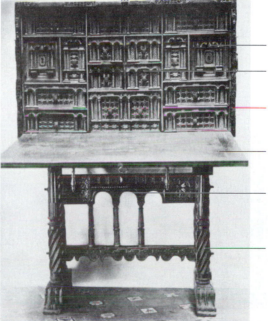

Classical details

Small drawers and doors for storage

Wood construction

Drop front for writing

Italian Renaissance arch

Columned legs

13-58. *Vargueños.*

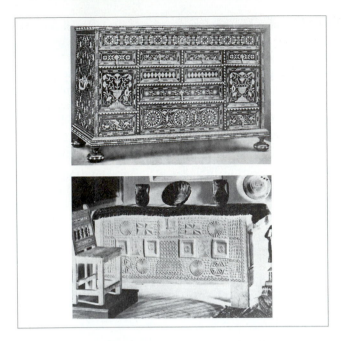

13-59. Chests.

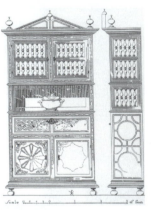

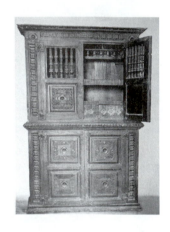

13-60. *Papalera.*

highlights many rooms, and ladies sometimes sit on cushions on a dais in the Moorish fashion.

■ *Tables.* Most tables are simply constructed and covered with cloths or carpets. Some oblong tables have turned, splayed legs connected with curving iron braces (Fig. 13-57).

■ *Storage.* Typical storage pieces (Fig. 13-35, 13-37, 13-47, 13-59) include chests in various sizes, built-in cupboards, the sacristy cupboard (Fig. 13-61), the *armario* (wardrobe), and the *fresquera* (a ventilated food cabinet decorated with

13-61. Cupboards.

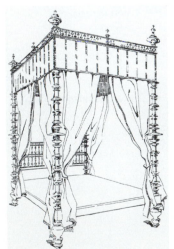

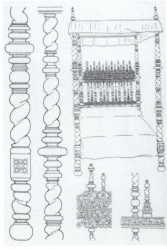

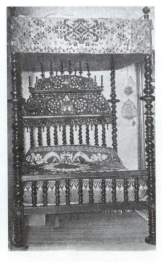

13-62. Beds and turning details showing spiral and clavated turnings.

13-63. Textiles, wool and silk, 16th century.

spindles and lattice that hangs on the wall). The *vargueño* (Fig. 13-58) is the most distinctive piece of Spanish furniture (see Design Spotlight). Similar to the *vargueño*, the *papalera* (Fig. 13-60) is an elaborate cabinet without a drop front or a permanent base.

■ *Beds.* Spanish beds (Fig. 13-30, 13-62) typically have four plain wood posts and elaborately carved headboards; some posts feature spirals and carving. Other beds are of iron or bronze. As in other countries and imitating the Italian Renaissance, many are richly draped. However, because of the hot Spanish climate, some beds have no canopy frames.

■ *Textiles.* Chairs, benches, and stools could be covered completely with fabric. Rectangular armchairs and side chairs have velvet, damask, or leather backs and seats decorated with fringe (Fig. 13-54, 13-63).

■ *Decorative Art Objects.* Dining rooms often have *lavabos* (wall fountains) made of copper, pewter, or pottery and placed in a niche faced with tiles. Sometimes small leather-covered chests and small boxes decorate tabletops. A Moorish legacy in the Spanish home is an extensive use of small boxes and canopies and/or cushions trimmed with braid, cord, tassels, or nailheads.

■ *Later Interpretations.* Spanish Colonial Revival copies and adapts furniture pieces, particularly characteristic ones such as high-back chairs and *vargueños*. The Mediterranean style of the 1960s–1970s adopts some features such as dark wood and heavy, elaborate carving.

14. French Renaissance

1515–1643

Que sais-je? What do I know?

Montaigne

After the French become acquainted with Italian Renaissance designs through invasions in Italy, they eagerly seek to adopt the stylistic character in their homes and lives. Early French Renaissance combines indigenous characteristics, Gothic forms, and Mannerist elements to form a picturesque image most evident in the *château* (monumental country house). During the 16th century, the French develop their own unique classical style that features less emphasis on rules and correct proportions and more on inventiveness and surface richness. By the end of the period, that classicism, an absolute monarchy aware of the power of art to exalt, and the demand for luxury set the stage for the grandeur of the court of Louis XIV and Versailles.

14-1. Costumes of the French Renaissance.

HISTORICAL AND SOCIAL

In the mid-15th century, France unites as one kingdom. At the end of the 15th century, Charles VIII invades Naples and Milan. Although the campaigns are unsuccessful, the French return home eager to adopt the new Renaissance style in all its aspects. Charles VIII himself brings Italian crafts people to France. The next two French kings, Louis XII and François I, also attack Italy and become acquainted with the Italian culture. The Renaissance flowers during the reign of François I as the country prospers and life grows more stable. A wealthy, leisured class arises and demands suitable accompaniments to a more refined way of life. François I supports and promotes the arts and learning. He attracts many Italian artists, such as Leonardo da Vinci and Benvenuto Cellini, and scholars to his court. He himself is a great builder of palaces in the Loire Valley and the Ile de France. He also increases the power and prestige of the French monarchy. The marriage of his successor, Henri II, to Catherine de' Medici of Florence enhances Italian ties. Catherine, great-granddaughter of Lorenzo the Magnificent and herself an art patron, sponsors a new wing of the Louvre and initiates the creation of the Tuileries gardens. Her collection of books and manuscripts is unmatched in France.

Religious civil wars between Catholics and Huguenots (Protestants) disrupt domestic peace and paralyze the country in the last half of the 16th century. Economic decline and political instability add to the turmoil. Henri III, who is the last of the Valois dynasty, dies in 1584. Henri of Bourbon, king of Navarre, is next in line to be king, but Catholics oppose him because he is a Protestant. Nevertheless, he assumes the throne in 1589 as Henri IV, the first of the Bourbon dynasty. He converts to Catholicism and in 1598 issues the Edict of Nantes granting partial religious freedom to all his subjects. Henri IV restores peace, promotes economic recovery, fosters the development of French arts and crafts. His reign marks a turning point in French cultural development. Recognizing the power of art to exalt the monarchy, in 1608 he begins the policy of providing free workshops in the Louvre for artists and craftsmen. In addition, he brings artisans to France to create new industries, including the production of silk.

In 1610, Louis XIII becomes king following the assignation of his father, Henri IV. During his reign and with the aid of his minister Cardinal Richelieu, trade flourishes, towns expand, the power of the nobility decreases, and the Crown's power increases, ultimately creating an absolute monarchy. Richelieu establishes the *L'Académie Française* (French Academy) to promote literature and standardize the French language in 1635. He lays the foundation for great luxury, grandeur, and magnificence in court life, which leads to the opulence of the court of Louis XIV and Versailles.

206

CONCEPTS

Because the Gothic style originates in France and is best understood there, its heritage is difficult to overcome. Therefore, the Renaissance first manifests as classical elements grafted onto Gothic forms in architecture, interiors, and furniture. The style evolves throughout the 16th century as Gothic elements fade and classical ones assert themselves. French Renaissance style never resembles the Italian, however, except in some furnishings. It maintains French elements, which it freely mixes with Renaissance, Roman, and a few Flemish characteristics.

French designers develop an understanding of classical design principles, but they usually do not learn of the Renaissance first hand. Italian artists and craftsmen who come to France often bring Late Renaissance (Mannerist) motifs and characteristics, such as elaborate decoration or abrupt scale changes. Additionally, the French study Italian treatises and prints and examine their own surviving Roman buildings. Some visit Rome. Through these means, they develop their own national style and are writing their own design treatises by the end of the 16th century.

DESIGN CHARACTERISTICS

Early manifestations of French Renaissance designs are Gothic in form with classical details, such as pilasters, used as decoration. The French regard classicism as an ordering system. Hence, regularity, order, and symmetry are common design principles, which appear early and continuously. The French generally do not emphasize mathematical relationships and the correct use of classical elements like the Italians. Instead, they value inventiveness over rules and rich surface decoration over proportions. Even as it becomes more formal and classically correct, French design remains more lively and picturesque than Italian design. Visits of prominent Italian designers, such as Sebastiano Serlio, and the spread of Italian treatises further acquaint designers with classicism, most often in its Late Renaissance form. Therefore, Italian Mannerism is a stronger influence than the High Renaissance. Unlike the Italians, the French also absorb motifs and elements from Flemish designers and their treatises.

■ *Motifs.* Motifs include pilasters (Fig. 14-32, 14-37), columns (Fig. 14-8, 14-32, 14-38), arches (Fig. 14-19,

14-2. Louis XII interior represented in a tapestry showing costumes and furniture.

14-3. Wall elevation with door, Louis XIII period.

14-4. Decorative motifs.

14-5. Wall detail with salamander and crown from Château de Blois, style of François I.

14-43), pediments (Fig. 14-19), figures in low relief (Fig. 14-3, 14-25, 14-35), pinnacles (Fig. 14-11), brackets (Fig. 14-20), scrolls, linenfold (Fig. 14-28, 14-40, 14-46), tracery (Fig. 14-44), strapwork (ornament of interlacing bands; Fig. 14-4), grotesques, caryatids, fruit, flowers (Fig. 14-25, 14-50), heraldry, fleur de lis (Fig. 14-4), stars, and diamonds. Crowns and initials (Fig. 14-4, 14-5, 14-25, 14-26, 14-50), such as F, H, C, and L, which are symbols of royalty, appear at entrances and on ceilings, furnishings, and decorative arts. Additionally, French kings use animal motifs, such as the François I salamander (Fig. 14-5, 14-26) and Louis XII porcupine (Fig. 14-13) on entrances and overmantels to identify their individual *châteaux*.

ARCHITECTURE

During the first half of the 16th century, fortification and protection remain important so *châteaux* resemble castles and feature large entry gates, round turrets with conical roofs, and central courtyards. *Hôtels* (town houses) continue to exhibit Gothic half-timbered construction, but with the addition of arches, brackets, and larger windows. Generally, rooflines stay irregular in silhouette and asymmetrical in organization while order, regularity, and symmetry organize and articulate exterior walls. Pilasters often frame symmetrically placed windows, and stringcourses (horizontal bands) separate different stories. Buildings freely mix Gothic and Mannerist details.

The arrival of Sebastiano Serlio to France and visits of French architects to Italy help institute a more confident classicism. Therefore, by the second half of the 16th century, the French are more adept in their handling of classical elements, which are no longer confined to country houses. Some buildings feature adapted Renaissance and Roman details. By the end of the century, rusticated quoins (corner blocks), window surrounds, and *chaînes* (vertical bands of rusticated masonry dividing facades into panels or bays) are characteristic. Even as they assume a more classical appearance, French buildings retain climatic differences from Italy, such as steep roofs, prominent chimneys, and large windows. French designers retain the traditional *pavilions*, distinctive structures that mark the center and ends of buildings. These features, along with more surface decoration, give French buildings a more animated, vertical, and picturesque appearance than Italian ones.

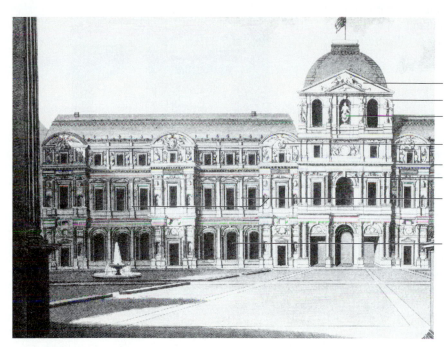

Pediment
Pavilion
Classical figure

Classical motifs

String course
Round arch

Pilasters divide facade

Repetitively sized and shaped windows

14-6. Elevation and facade detail, Louvre, Square Court, 1546; Paris; by Pierre Lescot.

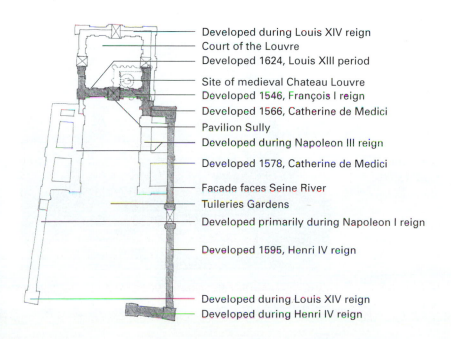

Developed during Louis XIV reign
Court of the Louvre
Developed 1624, Louis XIII period

Site of medieval Chateau Louvre
Developed 1546, François I reign
Developed 1566, Catherine de Medici
Pavilion Sully
Developed during Napoleon III reign

Developed 1578, Catherine de Medici

Facade faces Seine River
Tuileries Gardens
Developed primarily during Napoleon I reign

Developed 1595, Henri IV reign

Developed during Louis XIV reign
Developed during Henri IV reign

14-7. Site plan, Louvre and the Palais des Tuileries, 1546–1570; Paris; by Philibert de l'Orme.

Public and Private Buildings

■ *Types.* The *château* (Fig. 14-9, 14-12, 14-16, 14-18) is the main building type, but churches, *hôtels* (Fig. 14-8), and public buildings (Fig. 14-6, 14-7) are constructed.

■ *Site Orientation.* Henri IV institutes Italian urban planning concepts in Paris. Unlike in Italy, where public buildings site in squares, French squares are frameworks for private houses. Other urban environments locate churches near the city center, and town houses are positioned on streets in close proximity to the main square. *Châteaux*, as country houses, are sited within natural landscapes featuring long vistas; many are located on high hills and/or along rivers.

Design Practitioners

■ *Builders.* Most builders in the 16th century are master masons. Formal architectural training does not exist. Designers serve apprenticeships, labor in workshops, or learn from treatises. French architects do not enjoy the same high status as their Italian counterparts. Treatises written by designers help elevate the profession.

■ *Jean Bullant,* who visits Italy, introduces colossal (two-story) orders to France in the pavilion at the Château d'Ecouen in 1538. Although inspired by Philibert de l'Orme, Bullant's works feature more Mannerist elements than de l'Orme's. Surviving works include the Petit Château in Chantilly and the gallery over de l'Orme's bridge at Chenonceaux.

■ *Pierre Lescot* designs the Square Court of the Louvre in 1546, the building that establishes classicism in France. Of noble birth, he is well educated in mathematics, painting, and architecture.

■ *Philibert de l'Orme* is an inventive designer whose work establishes a French version of classicism. Having studied in Rome, his buildings show Italian and ancient Roman references that are interpreted in a French way. His classically restrained designs often have unexpected features such as colored marbles or his own classical order. De l'Orme influences architects of the early Baroque period, such as François Mansart. His most important works are the arched bridge at Chenonceaux and the Palais des Tuileries.

■ *Floor Plans.* Churches continue the traditional Latin cross plan. Domestic floor plans exhibit more regularity than was previously evident. The plan at Chambord (Fig. 14-17) develops as a fortified rectangular compound with a central courtyard and corner turrets; within it, the main building has a Greek cross and introduces the *appartement*, a suite of rooms consisting of antechamber, chambre, and

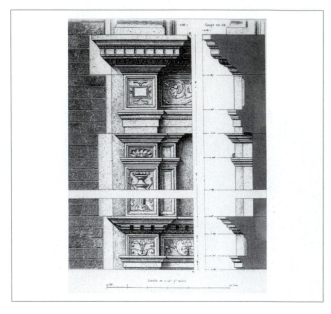

14-8. Architectural details, Hôtel de Lasbordes; style of François I.

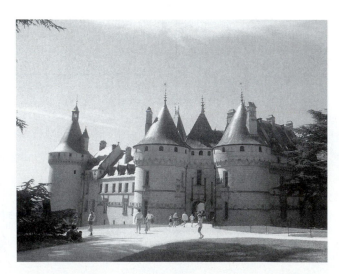

14-9. Château de Chaumont, 1465–late 15th century; Loire Valley. (Color Plate 32)

cabinet. The *appartement* and the *salon* (an elegant apartment or living room) will characterize French domestic architecture for the next 200 years. Most homes have no interior hallways. Fontainebleau exhibits the first long gallery (Fig. 14-25), which will become common in France and England. *Hôtels* center on courtyards but have no typical plans, as sites are irregular. Shops often occupy the

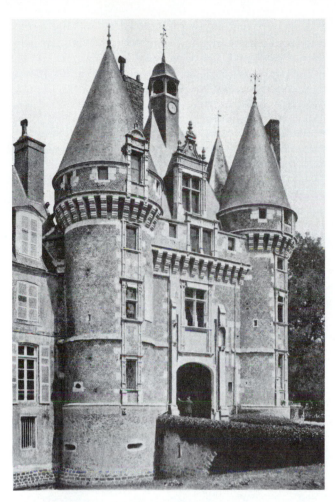

14-10. Château de S. Agil, 16th century; France.

14-11. Facade details, Château de Blois, 1515–early 17th century; Loire Valley.

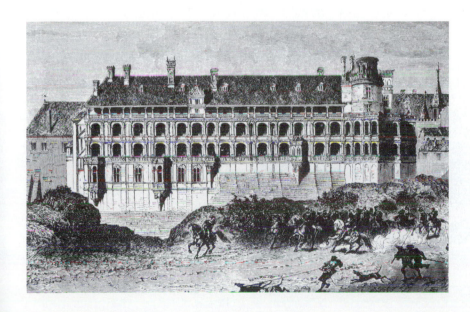

14-12. Château de Blois, 1515–early 17th century; Loire Valley.

ground floor, with living spaces on the first floor (level above the ground) and bedchambers on the upper floors.

■ *Materials.* Stone is the most preferred building material followed by brick. Roofs are usually of slate. Vernacular buildings commonly adopt *briqueté entre poteaux* construction (half-timber construction with brick infill covered with plaster) or *pierrotage* (half-timber construction with stones and clay; Fig. 14-20, 14-21, 14-22). These types of construction methods appear in New France (see Chapter 18, American Colonial: France).

■ *Facades.* Exteriors of *châteaux* (Fig. 14-12, 14-14, 14-16) exhibit symmetry, an Italian bay system, windows placed directly over one another (Fig. 14-19), and horizontal emphasis from cornices and string courses. Walls typically are not rusticated. On other buildings, pilasters, arches, and string courses articulate the *pavilions* (Fig. 14-19) in centers and on ends. Churches exhibit Gothic proportions, buttresses, vaults, and pinnacles.

■ *Windows.* Windows, which vary in size, remain large as previously to allow in the maximum light. Most have mullions forming a Latin cross with four or six lights (Fig. 14-11, 14-15). Dormers often have elaborately shaped surrounds. Church windows have rounded tops, tracery, and stained glass.

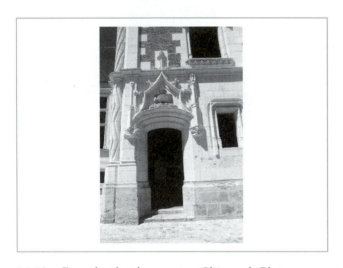

14-13. Entry detail with porcupine, Château de Blois.

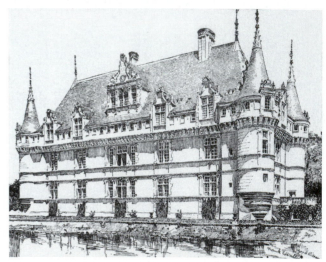

14-14. Château D'Azay-le-Rideau, 1518–1529; by Gilles Berthelot.

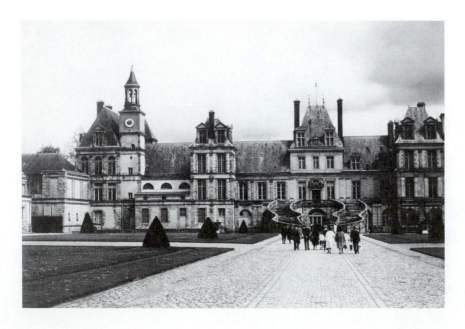

14-15. Palais de Fontainebleau, 1528–1540; Fontainebleau; by Gilles le Breton.

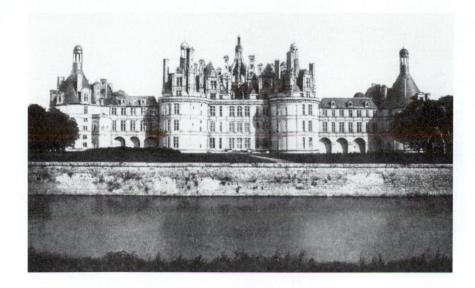

14-16. Château de Chambord, 1519–1547; Loire Valley.

Design Spotlight

Architecture: *Château de Chambord.* Developed by François I to reflect the grandeur of his reign, this majestic stone palace (Fig. 14-16, 14-17, 14-33) has 440 rooms, over 80 staircases, and 365 fireplaces with numerous chimneys that decorate the roof. Directly inspired by Italian Renaissance models, the design emphasizes grand scale, symmetry, classical ordering, and the monarchy's symbolic value. Large rectangular and arched windows flanked by pilasters symmetrically order the lower facade. String courses temper their verticality. The exuberant roofs feature balustrades, lanterns, chimneys, and dormers with classical columns and pilasters, lozenges, roundels, brackets, and pinnacles. Double dormer windows feature parapet roofs with François's initial. The castlelike plan features a walled enclosure with four corner towers surrounding an open courtyard that contains the keep or *donjon.* The Greek cross plan has four vaulted halls with a monumental double staircase in the center. The keep also houses guard chambers, the main public spaces, and private apartments. Characteristic interior details include round arches, deep cornices, large stone chimneypieces, elaborate balustrades, and coffered and beamed ceilings, along with minimal but very ornate furnishings.

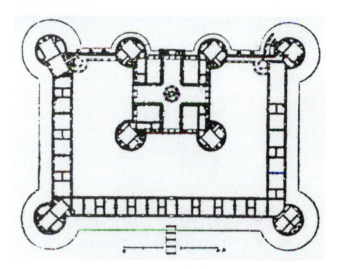

14-17. Plan view, Château de Chambord.

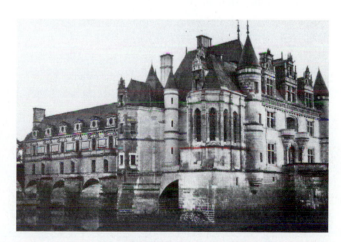

14-18. Château de Chenonceaux, 1515–1523; bridge, 1556–1559 by Philibert de l'Orme; gallery, 1576 by Jean Bullant and Jacques-Androuet du Cerceau; Loire Valley.

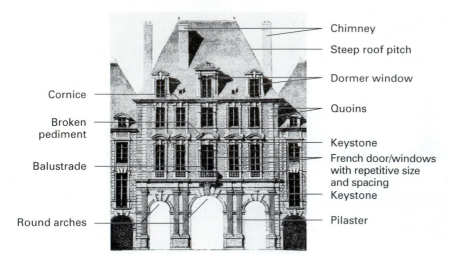

Chimney

Steep roof pitch

Dormer window

Cornice

Quoins

Broken pediment

Keystone

Balustrade

French door/windows with repetitive size and spacing

Keystone

Round arches

Pilaster

14-19. Pavilion du Midi, Palais de Royale; Paris; style of Henri IV.

Important Buildings and Interiors

■ **Burgundy:** Courtyard, Château Ancy-le-Franc, c. 1541–1550, Sebastiano Serlio.

■ **Dijon:** Maison Milsand, c. 1561, Hugues Sambin.

■ **Fontainebleau:** Palais de Fontainebleau, 1528–1540, Gilles le Breton, Chambre de la Duchess d'Etampes, 1533–1540, Galerie de François I, 1533–1540, Staircase of Primaticcio, 1533–1540 all by Rosso Fiorentino (Giovanni Battista Rosso) and Francesco Primaticcio. (Color Plate 34)

■ **Loire Valley:**

—Château de Blois, 1515–early 17th century.

—Château D'Azay-le-Rideau, 1518–1529; Gilles Berthelot.

—Château de Chambord, 1519–1547, possibly Domenico da Cortona.

—Château de Chaumont, 1465–late 15th century. (Color Plate 32)

—Château de Chenonceaux, 1515–1523; bridge, 1556–1559 by Philibert de l'Orme, gallery, 1576 by Jean Bullant and Jacques-Androuet du Cerceau. (Color Plate 33)

■ **Paris:**

—Hôtel Carnavalet, 1550, Pierre Lescot.

—Louvre, Square Court, 1546, Pierre Lescot, sculpture by Jean Goujon.

—Palais des Tuileries, 1546–1570, Philibert de l'Orme.

—S. Etienne du Mont, begun 1517.

—S. Eustache, 1532–1640.

14-20. Facade detail, early French half-timbered house.

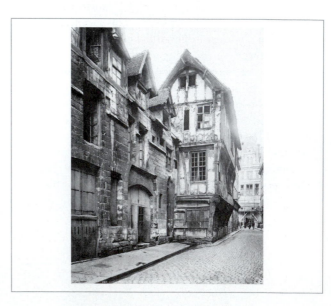

14-21. Half-timbered house; southern France.

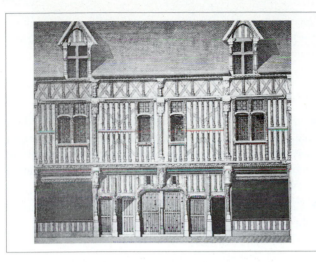

14-22. Facade, half-timbered construction, Maison à Gallardon; style of François I.

■ *Roofs.* *Château* roofs (Fig. 14-9, 14-10, 14-14, 14-15, 14-16, 14-18) exhibit irregular outlines with lanterns, turrets, dormers, and chimneys decorated with classical, Mannerist, and Gothic motifs. Later buildings have steeply pitched gables with fewer picturesque details. Throughout the period, numerous tall, decorative, and prominent chimneys accentuate rooflines.

■ *Later Interpretations.* The Châteauesque style copies and adapts elements from the French Renaissance *château* during the late 19th century in France and England, and through the 20th century in America (Fig. 14-23). Only the wealthy can afford to build in this expensive style. Most buildings are architect-designed. Biltmore (Fig. 14-24) in Asheville, North Carolina, replicates this image as well as the curved staircase at Blois.

14-23. Later Interpretation: Old Post Office, 1892–1899; Washington, D.C.; Romanesque and Renaissance Revival.

Important Treatises

■ *Collections de Meubles,* 1550; Jacques-Androuet du Cerceau the Elder.

■ *Differents Pour Traicts de Menuiserie,* c. 1580; Hans Vredeman de Vries.

■ *Le Premier Tome de l'Architecture,* 1567; Philibert de l'Orme.

■ *Les Plus Excellents Bâtiments de France,* 1576; Jacques-Androuet du Cerceau the Elder.

■ *Livres d'Architecture,* 1559–1572; Jacques-Androuet du Cerceau the Elder.

■ *Oeuvre de la Diversité des Terms Dont on Use en Architecture,* 1572; Hugues Sambin.

■ *Regole Generali de Architettura,* parts 1–6, 1537–1551 and part 7, 1575; Sebastiano Serlio.

■ *Reigle générale d'architecture,* 1568; Jean Bullant.

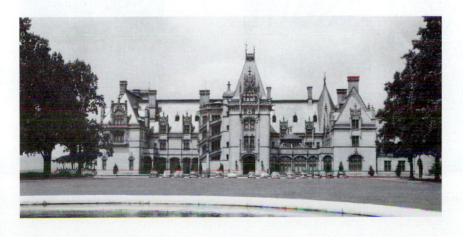

14-24. Later Interpretation: Biltmore, 1890–1895; Asheville, North Carolina; by Richard Morris Hunt; Châteauesque.

INTERIORS

Italian artists Rosso Fiorentino and Francesco Primaticcio create the first French Renaissance interiors at Fontainebleau in the 1530s–1540s. They work in a Mannerist mode influenced by early excavations of Roman interiors. Characteristics include slender nymphs with clinging drapery, garlands, scrolls, strapwork, grotesques, and stucco figures. They have few followers. Like architecture, interiors continue to feature Gothic and classical elements with classical becoming dominant.

Most rooms are rectangular, but dimensions are not derived mathematically as in Italy. Doors, windows, and stairways (Fig. 14-27, 14-33) are important architectural features. Large, prominent chimneypieces are focal points. Decoration concentrates on floors, walls, and ceilings. Rooms have few furnishings, even in wealthy homes, and room use is flexible.

Public and Private Buildings

■ *Color.* Colors are rich and highly saturated. Gold, deep blue, olive green, brown, cream, and rust are important hues and most often appear in wall and bed hangings, tapestries, fabrics, tiles, painted ceilings, and decorative art objects.

■ *Lighting.* Shutters, instead of curtains, control natural light and privacy. Candles and fireplaces give minimal artificial lighting (Fig. 14-38).

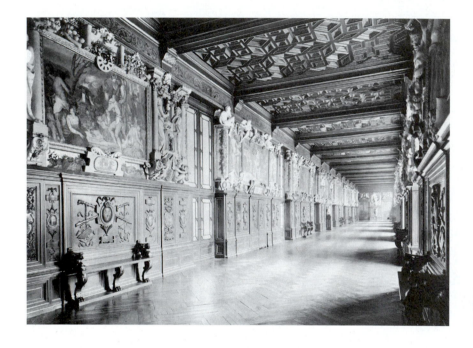

14-25. Galerie de François I, Palais de Fontainebleau, 1533–1540; Fontainebleau.

 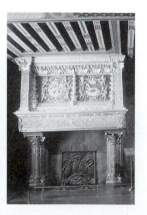

14-26. Chimneypieces; style of Francois I.

14-27. Stair Hall, Château de Gaesbeek.

■ *Floors*. Most floors (Fig. 14-25, 14-28, 14-30, 14-36) are wood in boards or parquet patterns. A few, particularly on lower floors, are of masonry or tiled (Color Plate 33). Rugs are rare.

■ *Walls*. Interior walls are often white plaster (Fig. 14-29) or wood paneling (Fig. 14-31, 14-36, 14-37, Color Plate 34). Gilding is common in important rooms in greater houses. Wall treatments include paneling, painting, and hangings. Tall, narrow panels retaining Gothic proportions sometimes feature carving or painted Gothic or classical decoration. Wall paintings may imitate stone or textile patterns. Hangings consist of plain or embellished fabric, imported and domestic tapestries (Fig. 14-28, 14-29), or leather. Some fragments of French wallpaper survive.

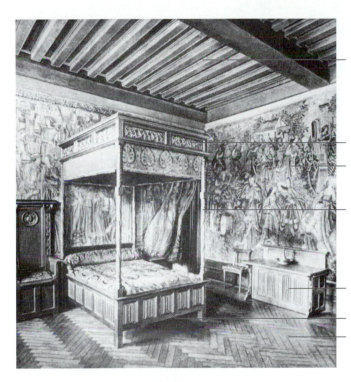

Beamed ceiling

Massive tester

Tapestry on wall

Turned and carved posts on lit/bed

Chest/coffer with linenfold panels

Linenfold panels

Wood floor in herringbone pattern

14-28. Bedchamber, Château de Gaesbeek.

14-29. *Salon*, Château de Chaumont, 1465–late 15th century; Loire Valley.

14-30. *Bibliothéque*, Maison de Flamande.

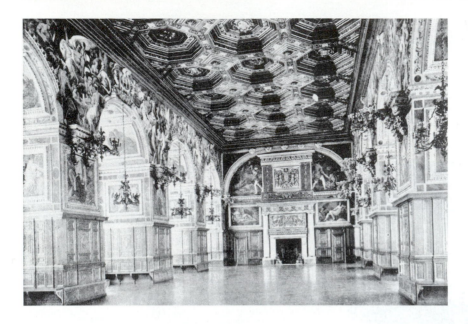

14-31. Galerie de Henri II, Palais de Fontainebleau, 1528–1540; Fontainebleau. (Color Plate 34)

14-32. Chimneypiece, Galerie de Henri II, Palais de Fontainebleau. (Color Plate 34)

Design Spotlight

Interiors: *Galerie de Henri II, Palais de Fontainebleau.* Begun by François I and embellished in the Italian Renaissance manner by a succession of French kings, this monumental space (Fig. 14-31) serves as a formal reception room. Large round arches articulate and define the length while a monumental chimneypiece provides a focal point on the width. The opulent interior features classical ordering, elaborate gilded paneling, a carved coffered ceiling, numerous paintings by Italian artists, and a wood parquet floor. This room, and the famous Galerie of François I decorated by Rosso and Primaticcio, set a fashion for European decoration (Color Plate 34).

■ *Chimneypiece*. The chimneypiece (Fig. 14-26, 14-31, 14-32, 14-35) is the largest and most important decorative feature of the interior. The projecting hood may be decorated with classic and Gothic details, coats of arms, and/or royal and period motifs. It does not have classical proportions, but entablatures, pilasters, and columns shape the overall design. Rooms without fireplaces have large porcelain stoves or *braziers*.

■ *Windows and Doors*. Curtains, which are limited to wealthy homes, are functional, not decorative. Doorways are placed where needed and are not always symmetrical. Door panels usually match wainscoting.

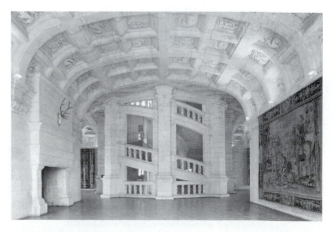

14-33. Stair Hall, Château de Chambord, 1519–1547; Loire Valley; possibly by Domenico da Cortona. (© Copyright Dorling Kindersley. Photographer John Parker)

14-34. Bedchamber, Château de Chenonceaux, 1515–1523; bridge, 1556–1559 by Philibert de l'Orme; gallery, 1576 by Jean Bullant and Jacques-Androuet du Cerceau; Loire Valley.

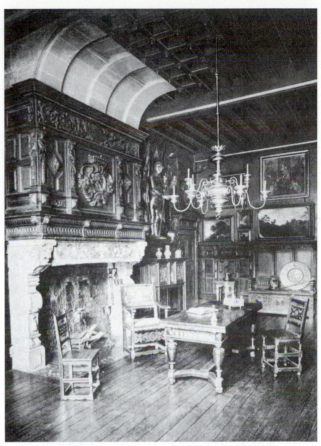

14-36. *Salle* Louis XIII, Hôtel de M. E. Brahy-Prost; Liége.

14-35. Chimneypiece; style of Louis XIII.

14-37. Wall elevation, *Salon* in Louis XIII style.

■ *Textiles.* French interiors feature bed and wall hangings; cushions; and fabrics thrown over chairs, benches, and stools. Tapestries (Fig. 14-28, 14-34, 14-49) become more common in wealthy homes during the period.

■ *Ceilings.* Beamed ceilings (Fig. 14-25, 14-28, 14-30) are embellished with carving and/or brightly colored stripes, arabesques, or other repeating motifs. Coffers in geometric patterns typically are carved, painted, or gilded. Plaster ceilings are usually left plain.

■ *Later Interpretations.* In the late 19th century, some Châteauesque dwellings and homes in a variety of other styles replicate French Renaissance interiors (Fig. 14-39). The wealthy often import entire Renaissance rooms and incorporate them into new homes.

14-38. Louis XIII and his court in a hall witnessing a play.

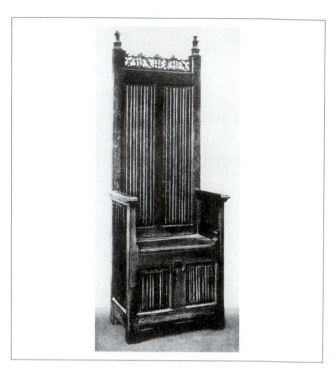

14-40. Choirstall chaise with linenfold paneling.

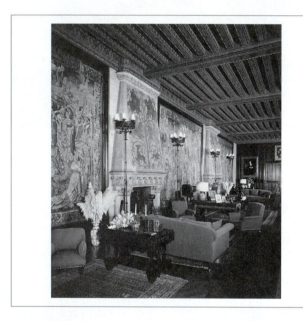

14-39. Later Interpretation: Tapestry Gallery, Biltmore Estate, 1890–1895; Asheville, North Carolina; by Richard Morris Hunt; Châteauesque.

FURNISHINGS AND DECORATIVE ARTS

Several overlapping styles comprise the period. As in architecture, the earliest is Gothic in form with Renaissance decoration. Gradually, more Italian influence appears in architectural details, refined proportions, and classical motifs. Desire for comfort and awareness of new artistic movements encourages the development of new furniture types. Pattern books help spread Italian and Flemish influence and promote French designs.

Two important schools of furniture design arise in Burgundy and Paris. In Burgundy, Hugues Sambin's work features carving in high relief of figures and fantastic beasts. In Paris, Jean Goujon, whose style consists of attenuated figures and motifs in low relief, is the design leader.

- *Early Renaissance or François I (1483–1547).* Furniture evolves from Gothic form and ornamentation to Gothic form with classical ornamentation. Most pieces are of oak and simply constructed following medieval traditions. Carving is the main decoration. Motifs include linenfold, strapwork, and grotesques.

- *Middle Renaissance or Henri II (1547–1589).* French furniture begins to resemble that of Italy as Italian influence increases. Walnut supersedes oak as the main furniture wood. Most pieces are simple in design with good proportions. The principal decoration is carving. Human figures and animals are common.

- *Late Renaissance or Louis XIII (1589–1643).* Massive and heavy, furniture is even more decorated and ornamental. Forms and motifs derive from Italian, Flemish, and Spanish influences. Carving and turning are common. Veneering and marquetry (an elaborate pattern of wood, shell, and/or ivory set into veneers) are introduced during the period. Paneling with heavy moldings is typical.

- *Types.* Typical furnishings include seating, tables, storage pieces, and beds.

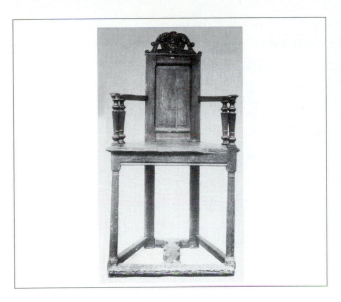

14-41. *Caquetoire.*

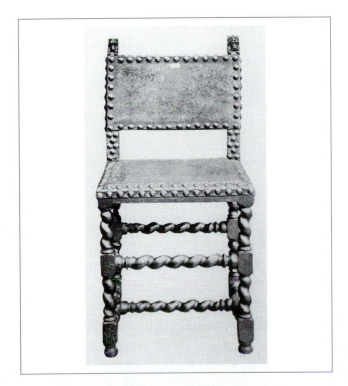

14-42. *Chaise,* early 17th century.

Design Spotlight

Furniture: *Caquetoire.* Developed in the middle of the 16th century, this armchair (Fig. 14-41) takes its name from the French word *caqueter* meaning "to chatter, cackle, or gossip." Characterized by a trapezoid seat, it has a tall, narrow back embellished with carved, decorative period motifs and outward-curving arms. Stretchers near the floor connect its legs.

14-43. Tables *l'Italienne.*

14-44. Coffer with Gothic influences.

■ *Distinctive Features.* Legs may be columns, baluster, or spirals and are usually connected with stretchers. Spiral carving turns left to right or in opposite directions for symmetry. Feet may be ball or bun. Low- and high-relief carvings highlight most pieces.

■ *Materials.* Construction becomes more sophisticated and refined over the period. Carving is the main form of decoration until the Late Renaissance when turning, veneer, inlay, painting, and gilding come into greater use. Walnut supplants oak. Cabinetmakers sometimes use

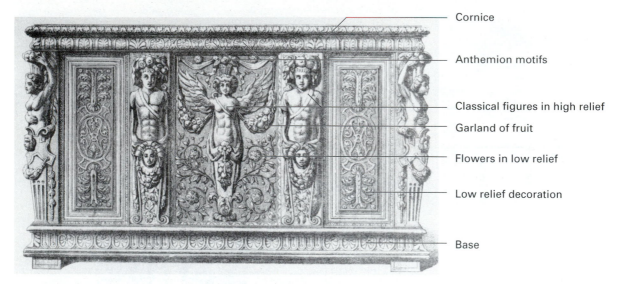

Cornice

Anthemion motifs

Classical figures in high relief

Garland of fruit

Flowers in low relief

Low relief decoration

Base

14-45. Chest, 16th century.

imported ebony for very fine pieces, hence the term *ébéniste* for them. Gothic polychrome falls out of favor.

■ *Seating.* Chairs include the Gothic choirstall (Fig. 14-40), the **X**-form (Fig. 14-30), the *caquetoire* (Fig. 14-41), the *chaise* (rectangular side chair; Fig. 14-30, 14-36, 14-42), and the *chaise à bras* (armchair). The *caquetoire* has a trapezoid seat, tall narrow back with carving, and outward-curving arms. Stretchers near the floor connect its legs. Chairs become lighter and more moveable. Stools and benches outnumber chairs.

■ *Tables.* Typical tables include trestles with removable tops and round or rectangular tables with single center supports. The table *l'Italienne* (Fig. 14-43) features supports of figures, griffins, or eagles joined by a complex stretcher. It resembles Italian forms.

■ *Storage.* Typical storage pieces are chests (Fig. 14-29, 14-44, 14-45) in many forms, *dressoirs* (Fig. 14-47), *buffets* to display plate, and *armoires* (Fig. 14-46). The *armoire à deux corps* has a narrower upper portion, usually capped by a pediment, and a lower portion with doors flanked by columns, human figures, or fantastic animals.

■ *Beds.* The typical *lit* (bed; Fig. 14-28, 14-34, 14-48) has four elaborately turned or carved posts supporting a massive, richly carved tester. Headboards exhibit lavish carving; there are no footboards. Important beds in wealthy homes typically have elaborate bed hangings of Italian silk designs or tapestry with braiding and *appliqué* work.

14-46. *Armoire* with linenfold paneling, 16th century.

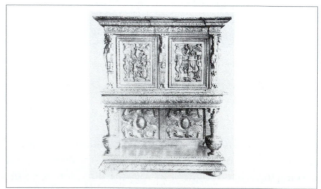

14-47. *Dressoir*, 1570; Burgundy.

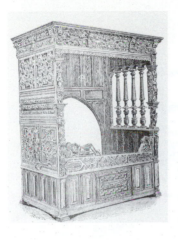
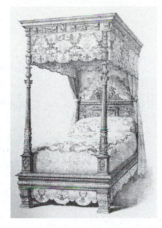
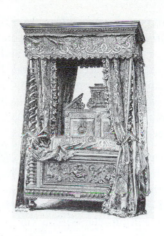

14-48. Beds illustrating carving and hangings.

14-49. Tapestries illustrating people and landscapes. [Photo at right courtesy of The Metropolitan Museum of Art, The Cloisters Collection, Gift of John D. Rockefeller, Jr., 1937. (37.80.6)]

14-50. Textiles.

■ *Textiles.* As in the previous period, textiles (Fig. 14-50) are more important than furniture. Great houses feature more fabrics than lesser ones. Frames of chairs, stools, and beds sometimes are covered with fabric attached by gilded or brass nails. Chairs, stools, and benches often have cushions trimmed with braid and tassels. Tables may be covered with a carpet or cloth that matches other upholstery. Beds are draped with an abundance of rich, colorful fabrics.

■ *Tapestries.* François I begins a tapestry factory at Fontainebleau using Flemish and French weavers. The French also purchase tapestries from other weaving centers. Renaissance tapestries (Fig. 14-49) have wider borders than Gothic tapestries and exhibit classical motifs or depict classical scenes.

■ *Ceramics and Enamel.* Ceramics centers at Rouen, Quimper, Nantes, Nîmes, and Nevers produce *faiénce* (tin-glazed earthenware). Bernard Palissy is the most famous ceramist of the time. Known as the "Huguenot potter," he creates the earthenware grotto in the Tuileries gardens (destroyed). His platters with high-relief polychrome and naturalistic decoration are much copied, even today. Limoges is a center for enamelware that produces cutlery with handles decorated in Renaissance motifs executed in enamel over precious metals. The little silver from the period that survives follows Mannerist traditions and shows influence from pattern books.

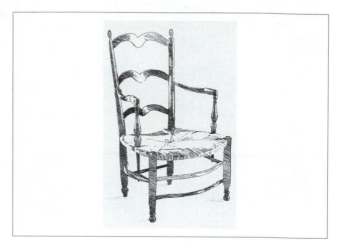

14-51. Later Interpretation: Slat-back armchair, Houmas House, c. late 18th–early 19th century; Burnside, Louisiana.

■ *Later Interpretations.* Variations of French Renaissance furniture forms appear beginning in the 17th century in New France, with distinctive examples evident in the vernacular interpretations of French Canada and Louisiana (Fig. 14-51). In the mid-19th century, interpretations of French Renaissance appear in Renaissance Revival interiors. In the late-20th-century, renditions also develop as a response to furnishing French Colonial houses in America.

15. English Renaissance

Tudor, Elizabethan, and Jacobean 1485–1660

The ancient manours and houses of our gentemen are yet, and for the most part of strong timber. . . . Howbeit such as latelie builded are commonlie either of brick or hard stone; their rooms large and comlie. . . . So that if ever curious building did flourish in England, it is these our years, wherin our workmen excell, and are in manner comparable with skill with old Vitruvius, and Serlio . . . great profusion of tapistrie, Turkey worke, pewter, brass, fine linen, and thereto costly cupboards of plate.

William Harrison, *The Description of England*, Book II, 1577

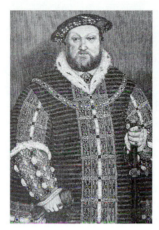

15-1. Portrait of Henry VIII.

15-2. English Renaissance costumes.

As in other countries, English architecture, interiors, and furniture gradually change from the Gothic to Renaissance style. In England, however, the style is more eclectic than in other countries and reveals more French and Flemish than Italian influence. Mannerism, as derived from pattern books and foreign craftsmen, defines the Renaissance in the Tudor, Elizabethan, and Jacobeans periods. More classical Renaissance work of architect Inigo Jones in the 17th century is an exception. It has little impact until the second half of the century.

HISTORICAL AND SOCIAL

Wars, plagues, and internal strife dominate the 15th century. A dispute between the royal houses of Lancaster and York over the throne escalates into the War of the Roses (1450–1485). Control passes back and forth between the two houses until Henry Tudor takes the throne with a weak Lancaster claim. A strong and capable ruler, Henry restores orderly government to England. A period of growth in trade and commerce as well as of peace and prosperity follows. The war brings an end to feudalism, and a wealthy merchant class arises. The nobility and wealthy merchants build large, gracious manor houses set in great parks, which replace feudal castles.

Henry's son, Henry VIII (Fig. 15-1), also is a capable ruler, but his inability to beget a male heir mars his reign. His desire for a divorce from Catherine of Aragon leads to a split with the Catholic Church and to the founding of the Church of England with Henry at its head. Subsequently, Henry dissolves the monasteries, nunneries, and friaries. He sells the land to nobles and gentry in the 1530s, thereby facilitating the building of more country houses. He also imports Italian, French, and Flemish craftsmen to work on the royal palaces.

Henry's daughter, Elizabeth I, takes the throne in 1558. Under her leadership, and that of Sir Walter Raleigh, England defeats the Spanish Armada in 1588. Now able to rule the seas, England soon replaces Spain as the major world power and begins extensive colonizing, especially in the New World. Elizabeth's stable government promotes trade and commerce. Her rule encompasses a golden age in English literature and drama with works by Spenser, Marlowe, and Shakespeare. It also is an age of luxury and splendor in the court and among the nobles. Elizabeth herself builds little, but the nobles construct new homes or enlarge existing ones in anticipation of a visit by her and the court. Elizabeth leaves no heirs, so her cousin James IV of Scotland, son of Mary Queen of Scots, becomes James I of England thus uniting England and Scotland.

The first of the Stuarts, James desires an absolute monarchy as in France. However, England has a strong middle class and an independent Parliament who oppose him. Religious conflicts arise between Protestants and the Catholic James. Puritans also become disenchanted with the Church of England, adding to the turmoil. Despite the

225

religious and political differences, the first four decades of the 17th century are prosperous. The growth of England's colonies brings greater trade. James, unlike previous rulers, ardently admires the Italian Renaissance, and England's contacts with the Continent increase during his reign.

Like his father James, Charles I admires the Renaissance and demonstrates this by collecting antique art. His marriage to Louis XIII's sister creates strong ties to France. However, while Charles tries to continue his father's policies, England is plunged into civil war in 1642. Charles's followers, the Cavaliers, clash with the Roundheads, Puritan members of Parliament, under the leadership of Oliver Cromwell. Charles is captured, tried, and executed in January 1649. Charles II, his son, flees to France. Cromwell abolishes the monarchy and the House of Lords. He declares England a commonwealth. As Lord Protector, he rules with a military hand but maintains an effective foreign policy. England continues expanding her trade and colonization. As a reaction to the ostentation of the royal courts, Cromwell's rule brings simplicity and austerity. Despite the prosperity and relative peace, many despise the government and Cromwell himself for ordering the death of Charles I. Following Cromwell's death in 1658, the commonwealth collapses. Charles II is able to return in 1660.

CONCEPTS

As the last country to experience the Renaissance, England accepts its design principles only after a period of resistance. Examples are highly eclectic and hardly classical until the work of Inigo Jones in the early 17th century. Most English contacts with the Renaissance come secondhand, though trade, foreign craftsmen, or architectural pattern books. Italian craftsmen are brought to England early in Henry VIII's reign but have little effect. By Elizabeth's time, Englishmen know of Italian and Roman treatises,

particularly those of Serlio and Vitruvius, but French interpretations of Italian Mannerism at Fontainebleau and French and Flemish architectural treatises have significantly more influence. In the Jacobean period, numerous foreign craftsmen arrive in England and spread an even more exaggerated form of Mannerism as interpreted by de Vries and Wendall Dietterlien (see Chapter 14, page 215). Consequently, Italian influences intermingle with those from France and Flanders, thereby creating a unique English expression. The fact that designs are assemblages from a variety of artisans further enhances the English Renaissance style's individual character and uniqueness.

DESIGN CHARACTERISTICS

A gradual increase in order, regularity, and emphasis on proportions characterize Renaissance development in England. In architecture, silhouettes and rooflines remain irregular and picturesque. Forms and motifs from Italy, France, and Flanders intermix on roofs and facades, in interiors, and on furniture. Architectural details from many sources include strapwork, grotesques, pilasters, columns, pediments, arches, parapets in Flemish designs, balustrades, and towers.

■ *Tudor* (1495–1558). Late Gothic and a few Renaissance characteristics freely mix in the period. Some symmetry and order are evident.

■ *Elizabethan* (1558–1603). Regularity, symmetry, and mixed classical and Mannerist elements characterize design. Decoration tends to be lavish, particularly in interiors and on furniture. Foreign influences dominate design.

■ *Jacobean* (1603–1642). Named after King James (Latin word for James), Jacobean follows Elizabethan patterns, but

15-3. Heraldic motifs.

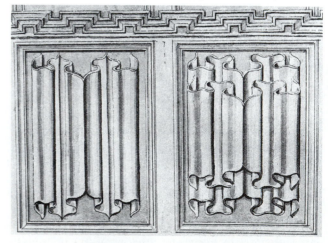

15-4. Linenfold panel.

with less individuality and more stylistic unity. Interiors remain lavishly decorated, but furniture design is simpler.

■ *Inigo Jones.* Jones introduces classicism to England as a method of building and not merely decoration. He is one of the first English designers to travel and study in Italy. On his second trip, he examines Roman ruins first hand using Palladio's *Four Books of Architecture* as a guide. Upon his return, he becomes Surveyor to the King and designs several classical buildings for the Crown; however, he designs no furniture. His work has little influence outside of the royal court until later.

■ *Motifs.* Motifs (Fig. 15-7) include heraldic symbols (Fig. 15-3, 15-41), strapwork (Fig. 15-48, 15-49, 15-65), roundels, portrait busts, arabesques, grotesques, obelisks, caryatids, Tudor roses, cabochons (oval or round convex form resembling a gemstone), acanthus, and vines (Fig. 15-5), and architectural features (Fig. 15-46) such as columns, pilasters, and arcades. Panel types include linenfold (Fig. 15-4), composite (Fig. 15-6, 15-41, 15-66), and arcaded (Fig. 15-6, 15-66, 15-67). Many are copied or adapted from pattern books.

ARCHITECTURE

English architecture shows an increasing application of Renaissance details to buildings over the period. Designs remain eclectic, borrowing from numerous sources besides and including Italian. Architecture does not become truly classical with the exception of buildings completed by Inigo Jones. English buildings more closely resemble French than Italian buildings because of similar climatic attributes that necessitate large windows, steeply pitched roofs, and tall chimneys. Domestic buildings dominate the period.

■ *Tudor.* Houses become more outward looking than earlier and center on courtyards. Facades are irregular and often move in and out, roofs vary in design and height, and windows change randomly in size. Elements from military architecture, such as towers and battlements, decorate facades. Distinctive towered gatehouses form entrances.

15-5. Pargework ceiling with vine and leaf motifs.

15-6. Door with composite and arcaded panels, Great Chamber, Chastleton, 1614; Oxfordshire.

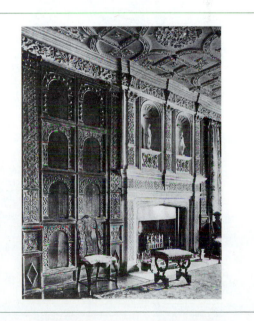

15-7. Drawing room wall with arcaded panels, niches, pilasters, strapwork, Tudor arch, lozenge panel, and strapwork decoration, Quenby Hall, c. 17th century; Leicestershire.

Half-timbered construction continues in both urban and rural locations.

■ *Elizabethan.* Horizontal emphasis and regularity on the lower portions distinguish Elizabethan buildings. Roofs, which have irregular silhouettes, are composed of parapets, balustrades, pinnacles, lanterns, towers, roofs, and chimneys similar to those of France. The scale of Elizabethan architecture is grander than that of the Tudor period. Plans and ornamentation derive from Italian, Flemish, German, and Dutch sources. Designs are highly individual.

■ *Jacobean.* Jacobean buildings feature more stylistic unity than Elizabethan buildings, although eclecticism and foreign influences remain strong. Towers, turrets, and parapets define rooflines, which are less complex than those of the Elizabethan period. Classical features, such as the orders, usually are confined to ornamental fronts.

Private Buildings

■ *Types.* The most common building types are mansions, manor houses, and town houses in contrast to Italy where primary Renaissance expressions are churches and palaces. England has many churches from the Middle Ages, and the monarchs do not undertake large building campaigns.

■ *Site Orientation.* Because of settled conditions, houses become more outward looking throughout the period. From the Elizabethan period onward, houses are sited in parks surrounded by lawns, terraces, and gardens. A forecourt with gatehouse and lodges marks the entrance. On one side of the house is a formal garden, often with an intricate design of beds, paths, and fountains. Orchards and kitchen gardens highlight the other sides of the house. Garden designs relate to the house but the two are not necessarily unified with each other.

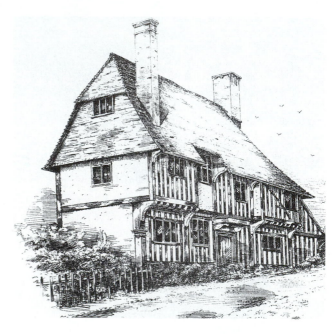

15-9. House with half-timbered construction; Puckley, Kent.

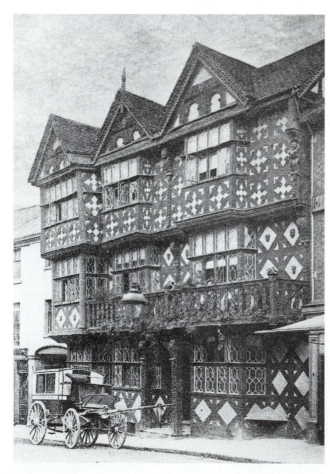

15-8. Feathers Inn showing half-timbered construction; Ludlow, Shropshire.

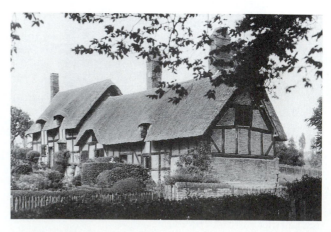

15-10. Anne Hathaway's cottage; Stratford-on-Avon.

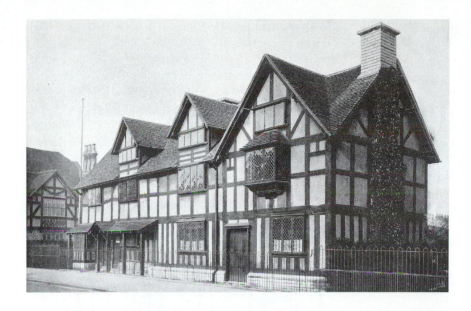

15-11. Shakespeare's house; Stratford-on-Avon.

■ *Floor Plans*. Tudor (Fig. 15-15) and Elizabethan (Fig. 15-21) plans consist of rooms organized around one or more quadrangular courtyards. During the Elizabethan and Jacobean periods (Fig. 15-22), courtyards are replaced by more compact H-shaped, E-shaped, U-shaped, or rectangular plans. Plan outlines are irregular with projecting bays and corner towers, and symmetry is not an important design principle. Spaces are organized for comfort instead of defense as earlier, and arrangements vary greatly. Most spaces are rectangular but not necessarily symmetrical.

Rooms vary in scale according to their use as well as the significance of the house. Monumentality equates with importance. Symmetry in door and window placement increases in the period. Room dimensions do not derive from mathematical formulas until Inigo Jones (Fig. 15-26, 15-54), who often uses mathematical formulas, such as the double cube, for rooms. Staircases assume more

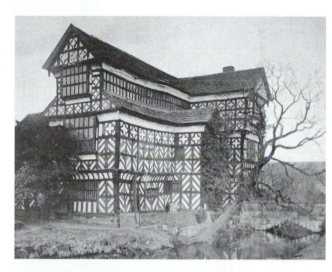

15-12. Moreton Old Hall, mid-16th century; Cheshire.

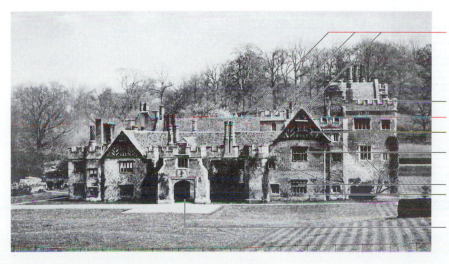

Variety in roof design and height

Battlements
Steeply pitched gable
Half timber construction
Irregular facade

Random sized windows
Brick

Main entrance

15-13. Compton Wynyates, 1480–1520; Warwickshire.

Design Spotlight

Architecture: *Compton Wynyates.* Evoking the image of a medieval castle, this brick and half-timber manor house (Fig. 15-13, 15-14, 15-15, 15-34) depicts the essence of the Tudor period. Designed for the Compton family, the house faces outward and centers on courtyards. The facade moves in and out, the roof varies in design and height, chimneys are located based on function, and windows change randomly in size. The appearance is jumbled and irregular, lacking any symmetry. Elements of fortification, such as battlements and towers, punctuate the form. The interiors feature half-timbered construction and oak paneling, rooms of varying scale, and beamed ceilings.

prominence during the Elizabethan period (Fig. 15-48). Joining earlier straight forms are square or rectangular wooden stairs with landings at each turn. A more architectural form, the open-well staircase (stairs rise on the walls of a square, leaving the center open) makes its first appearance at Knole c. 1605. Newels (main posts), balusters, handrails, and strings (open side beneath the steps) are massive in scale and covered with carved or painted strapwork and other ornamentation.

■ *Materials.* Brick and stone (Fig. 15-13, 15-16, 15-18) begin to supersede wood during the Tudor period, although half-timbered houses (Fig. 15-8, 15-9, 15-10, 15-11, 15-12,

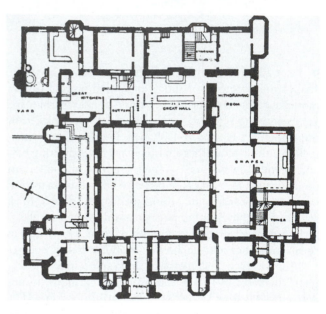

15-15. Floor plan, Compton Wynyates.

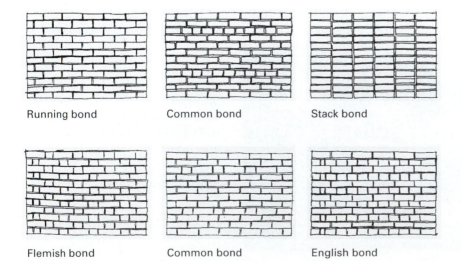

15-14. Courtyard with bay window, Compton Wynyates.

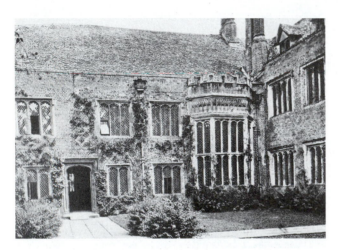

Running bond Common bond Stack bond

Flemish bond Common bond English bond

15-16. Brick patterns.

Color Plate 35) continue to be built throughout the 16th century. Stone and brick become even more common during the Elizabethan period. Many Jacobean houses are brick with stone quoins. Most houses follow trabeated masonry construction.

Brick Bonds. Flemish (alternating headers or ends and stretchers on the long side) and English bonding (alternating rows of headers and stretchers) are most common in brick construction (Fig. 15-16). Common bonds (five rows of stretchers, one row of headers) and Dutch cross bonds (alternating rows of headers and stretchers with colored mortar that creates diamond patterns) are less typical.

■ *Facades.* Tudor houses (Fig. 15-13, 15-17, 15-18) are somewhat symmetrical with a few classical details. They feature battlements, towers, and gatehouses. Large windows dominate Elizabethan and Jacobean facades (Fig. 15-19, 15-20, 15-23, Color Plate 36). Facades are rarely flat as numerous bays and pavilions create a rhythmic

sequence articulated by stringcourses and pilasters. Lower portions of Elizabethan and Jacobean exteriors are regular and symmetrical with classical and other motifs and details. Roofs and skylines are highly irregular in Elizabethan architecture but become more simplified in Jacobean architecture. Both periods feature corner towers with parapets or dome-shaped roofs. Jacobean houses often have frontispieces decorated with a full range of classical and Mannerist details. Exceptions are Jones's

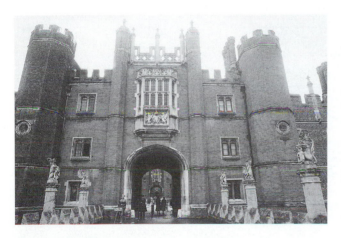

15-17. Hampton Court Palace, 1472–1530; London.

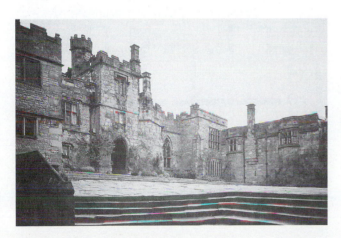

15-18. Haddon Hall, 1477–1545; Derbyshire.

Design Practitioners

■ *Architect.* The term *architect* is rarely used. Earlier, master masons may create designs or oversee the construction process or both, depending on patron involvement. With no formal architectural training available, practitioners learn the building trade through apprenticeships or in workshops. Until Jones, master masons rarely travel abroad to study. They learn of new styles through other craftsmen and architectural pattern books. Great houses may be designed by a master craftsman and/or the owner who rely on Italian, French, and Flemish pattern books for plans, forms, and details.

■ *Master masons* may draw "platts" (plans to scale), "uprights" (elevations) that are not to scale, and perspectives. They do not use drawings to communicate ideas or explain the building process, however. Inigo Jones, who does both, is an exception.

■ *Upholsterers*, the closest artisans to modern decorators, provide textile furnishings such as wall and bed hangings, cushions, upholstered furniture, rugs and table covers, furniture covers, and curtains. From their shops, upholsterers acquire, make, and install textiles. Most are men who rely on women to do the sewing. Some women provide textiles to the upholsterers.

■ *John Shute*, a self-described painter and architect, is sent by the Duke of Northumberland to Italy in 1550. The result is an early English architectural treatise mainly derived from Sebastino Serlio, *First and Chief Groundes of Architecture*, written in 1583. The book contains illustrations and descriptions of the orders.

■ *Robert Smythson*, a master mason, works at Longleat and designs Wollaton Hall and Hardwick Hall. Like others, he is influenced by Sebastino Serlio and J. Vredeman de Vries.

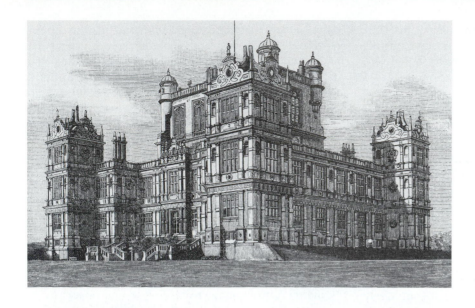

15-19. Wollaton Hall, 1580–1585; Nottingham; by Robert Smythson.

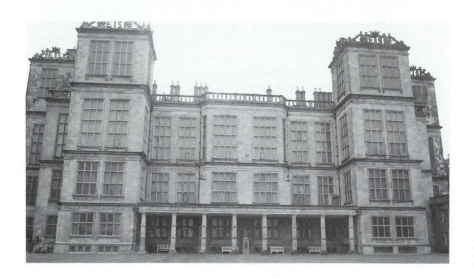

15-20. Hardwick Hall, 1590–1597; Derbyshire; by Robert Smythson. (Color Plate 36)

buildings (Fig. 15-24, 15-25, 15-27), which are symmetrical; carefully proportioned; and articulated with classical columns, pilasters, pediments, swags, and balustrades.

■ *Windows.* Stone mullions divide the large rectangular windows into as many as 16 smaller lights in Elizabethan and Jacobean architecture. Windows, arranged over one another, may be flanked by pilasters or engaged columns. Bay windows (large windows projecting from the ground up; Fig. 15-14) and oriel windows (windows projecting from an upper story; Fig. 15-17) contribute to the plan and facade irregularity.

■ *Doors.* Door surrounds may be arched or rectangular and surmounted by a pediment or other decorative element. Doors are located in the gatehouse of Tudor houses,

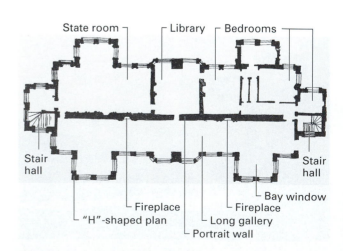

15-21. Floor plan, Hardwick Hall.

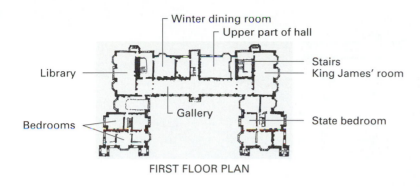

Winter dining room
Upper part of hall
Library
Stairs
King James' room
Gallery
Bedrooms
State bedroom

FIRST FLOOR PLAN

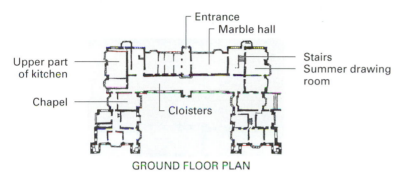

Entrance
Marble hall
Upper part
of kitchen
Stairs
Summer drawing
room
Chapel
Cloisters

GROUND FLOOR PLAN

15-22. Floor plans, Hatfield House, c. 1607–1611; Hertfordshire.

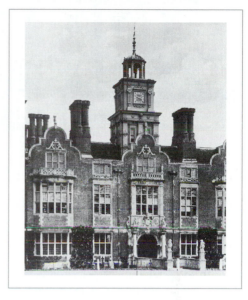

15-23. Blickling Hall, 1616–1625; Norfolk; by Robert Lyminge.

Design Spotlight

Architecture: *Palace, Whitehall.* Designed by Inigo Jones and only partially completed, this palace (Fig. 15-24, 15-53, Color Plate 37) illustrates his interpretation of Palladio's classical theories and concepts in England. Using mathematical proportions, the symmetrical facade is ordered by repetitively scaled and spaced engaged columns and windows. Classical details and moldings embellish and define the three levels. As with Renaissance buildings, a balustrade and heavy projecting cornice separate the roof from the walls, and stone varies from rough at the bottom to smooth at the top. Emulating the exterior, the rectangular banqueting hall articulates the classical language with columns, pilasters, pediments, brackets, and a compartmented ceiling. White is the dominant color.

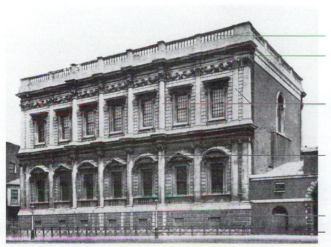

Balustrade at roof

Cornice

Repetitively spaced
pilasters separate
repetitively scaled
windows

Segmental arch

Rough stone
Box shape

15-24. Banqueting Hall and Palace, Whitehall, 1619–1622; London; by Inigo Jones.

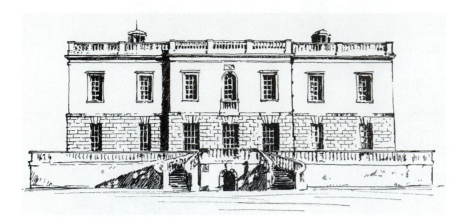

15-25. Queen's House, Greenwich, 1616–1635; London; by Inigo Jones.

centrally in Elizabethan houses, and in the frontispiece of Jacobean houses.

■ *Roofs*. Flat, gabled, parapet, and hipped roofs are common, and several may be combined (Fig. 15-13, 15-20). In addition to chimneys, parapets, and Flemish gables, Elizabethan and Jacobean houses often have towers and types (domed roof elements that light an interior staircase) with curvilinear roofs on the corners of exterior walls and interior courtyards. Roof towers sometimes become banqueting rooms where sweet wines and desserts are served after dinner.

■ *Later Interpretations*. During the English Restoration period, Sir Christopher Wren interprets classicism (Fig. 15-28), following in the footsteps of Inigo Jones. In the English Regency period, designers create houses with Tudor or Elizabethan elements, such as picturesque compositions and medieval military features. Richard Norman Shaw and others adapt elements from all three periods in late-19th-century Queen Anne architecture. In the mid to late 19th century, the English Arts and Crafts Movement (Fig. 15-29) borrows heavily from medieval and Tudor forms, while the American Stick Style evokes the Tudor image form and replication of balloon frame construction (Fig. 15-30). Tudor Revival houses (Fig. 15-31, 15-32) are a popular alternative to Colonial Revival in late-19th- and early-20th-century America.

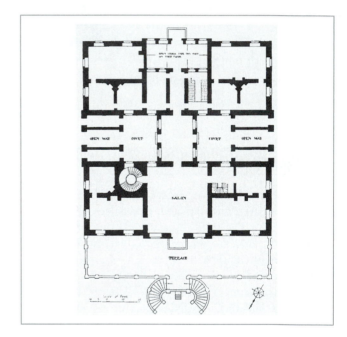

15-26. Floor plan, Queen's House, Greenwich.

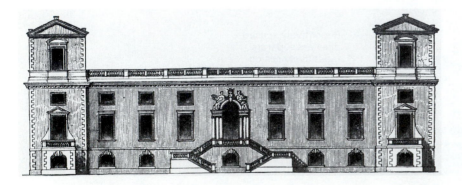

15-27. South front, Wilton House, c. 1635–1640; Wiltshire; by Isaac de Caus, Inigo Jones, and John Webb.

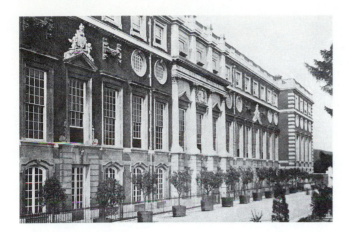

15-28. Later Interpretation: Addition to Hampton Court Palace, 1689–1694; London; by Sir Christopher Wren; English Restoration.

15-29. Later Interpretation: Red House, 1859–1860; Bexleyheath, Kent; by Philip Webb; English Arts and Crafts.

15-30. Later Interpretation: Griswold House, 1862–1863; Newport, Rhode Island; by Richard Morris Hunt; Stick Style.

Important Buildings and Interiors

Tudor

- **Cambridgeshire:** Burghley House, 1522–1587.
- **Cheshire:** Little Morton Hall, 1559.
- **Derbyshire:** Haddon Hall, 1477–1545.
- **Hampshire:** Long Gallery, The Vyne, c. 1520.
- **London:** Hampton Court Palace, 1472–1530.
- **Stratford-on-Avon:**
 —Anne Hathaway's cottage, 16th century.
 —Shakespeare's house, 16th century.
- **Surrey:** Palace of Nonesuch, 1538 (destroyed 1687).
- **Warwickshire:** Compton Wynyates, 1480–1520.

Elizabethan

- **Derbyshire:**
 —Hardwick Hall, 1590–1597, Robert Smythson, Great Chamber, 1597, Long Gallery, 1590–1596. (Color Plate 36)
 —Long Gallery, Haddon Hall, 1567–1584.
- **Nottingham:** Wollaton Hall, 1580–1585, Robert Smythson.
- **Sommerset:** Montacute House, 1599, Great Hall, c. 1595–1601, Parlor, c. 1595–1601.
- **Wiltshire:** Longleat House, 1567–1575, Robert Smythson.
- **Yorkshire:** Great Chamber, Gilling Castle, c.1585.

Jacobean

- **Hertfordshire:** Hatfield House, 1607–1611, Robert Cecil and Robert Lyminge.
- **Kent:** Cartoon Gallery, Knole, 1607–1608.
- **London:**
 —Palace, Whitehall, 1619–1622, Inigo Jones. (Color Plate 37)
 —Charlton House, Greenwich, 1607.
 —Queen's House, Greenwich, 1616–1635, Inigo Jones, with later additions by John Webb.
- **Norfolk:** Blickling Hall, 1616–1625, Robert Lyminge.
- **Warwickshire:** Aston Hall, 1618–1632.
- **Wiltshire:** South front addition, Wilton House, c. 1635–1653, Isaac de Caus, Inigo Jones, and John Webb, furnishings by Thomas Chippendale and William Kent, c. early 18th century.

15-31. Later Interpretation: Branch House, 1918; Richmond, Virginia; by John Russell Pope; English Tudor and Elizabethan.

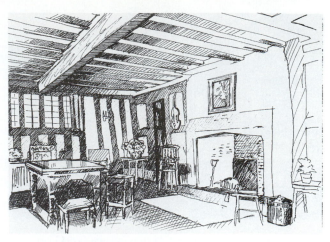

15-33. Tudor Hall, half-timbered house, early 16th century.

15-32. Later Interpretation: Residence, c. 1930s; Greenwich, Connecticut; by W. Stanwood Phillips; Tudor Revival.

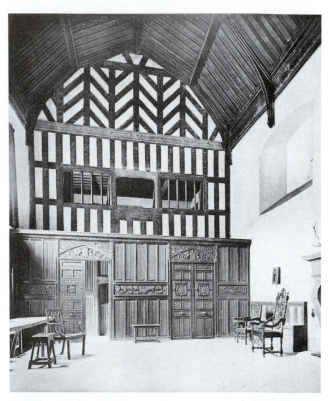

15-34. Banqueting Hall, Compton Wynyates, 1480–1520; Warwickshire.

INTERIORS

Interiors of the period do not adopt the classical Renaissance characteristics as a whole, but often exhibit selected, mostly Mannerist, details that are copied from pattern books or executed by foreign craftsmen. Created as assemblages of decorative elements, rooms lack the new unity evident elsewhere in Europe. As in architecture, the few interiors by Inigo Jones are exceptions. Throughout the period, because of closer proximity and similar climatic conditions, other countries exert more influence than Italy. English designers and artisans rely on Italian, Flemish, French, and German pattern books for inspiration as well as specific details to embellish interior elements, such as panels, cornices, and chimneypieces.

■ *Tudor*. Interiors are largely medieval and somber in feeling. They exhibit few classical details, but as the period progresses, they grow more lively with colorful finishes and textiles.

■ *Elizabethan*. Interiors are exuberant with brilliant colors and every surface decorated with carving, painting, gilding, or plasterwork. Classical details, mostly derived from Mannerist sources, are more evident than in Tudor buildings. Strapwork and grotesques are common.

■ *Jacobean*. These interiors continue Elizabethan traditions of exuberant Mannerism with the exception of those

by Inigo Jones or influenced by him. Classically proportioned, Jones's work tends to rely more on architectural details for definition and interest than color or surface decoration.

Private Buildings

■ *Types.* Typical spaces include the great hall (Fig. 15-35, 15-37, 15-40, 15-49, 15-53), great chamber, long gallery (Fig. 15-39, 15-43, 15-50), chapel, summer and winter parlors, and bedchambers (Fig. 15-36, 15-44) or lodgings. The great chamber, the most richly decorated room in the house, begins to supersede the great hall in importance. The approach to the great chamber is ceremonial and designed to impress. Attached to the great chamber are one or more withdrawing rooms, one of which usually is the owner's bedchamber. Long galleries become characteristic features of Elizabethan houses. They occupy one side of the house on the ground or first floor and often give access to important rooms. Numerous smaller spaces, such as summer and winter parlors, increase throughout the period. Suites of rooms, appropriate for a person of rank, distinguish homes built or enlarged to receive Elizabeth and her court. She requires a presence chamber for formal receptions, a privy chamber for private entertaining, a withdrawing chamber, a bedchamber, and a guard chamber. These spaces usually occupy two sides of a courtyard.

■ *Architectural Details.* Architectural details usually derive from pattern books and are often Mannerist in character. For example, columns may become more narrow at the bottom than at the top. More classical architectural details over doors and windows appear during the Jacobean era, particularly in the work of Jones (Fig. 15-56).

■ *Color.* Throughout the period, interiors feature highly saturated, even garish, colors in textiles and finishes. White walls are common especially if they have hangings. Occasionally, walls may be blue or green. Paneling generally is painted stone color or brown to resemble wood. Graining and marbling highlights some walls and/or architectural details. Ceilings are white or blue. As a contrast, Inigo Jones's interiors (Fig. 15-53, 15-54, Color Plate 37) tend to be white or light colored.

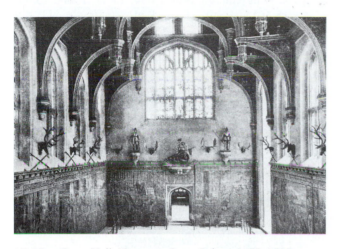

15-35. Great Hall, Hampton Court Palace, 1472–1530; London.

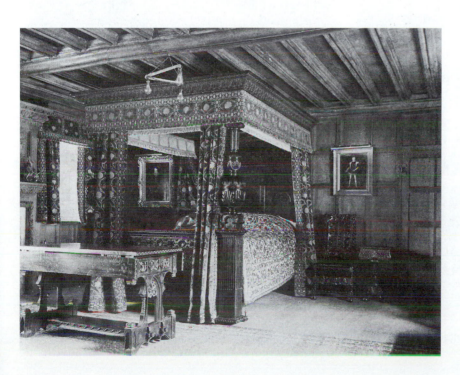

15-36. Henry VIII's chamber, Hever Castle, c. 15th century; Kent.

15-37. Banqueting Hall, Haddon Hall, 1477–1545; Derbyshire.

15-38. Hall Screen, Ockwells Manor, 16th century; Berkshire.

■ *Lighting.* Artificial lighting (Fig. 15-33, 15-52) is minimal, consisting of chandeliers or lanterns, wall sconces, and candlesticks.

■ *Floors.* Stone, brick, marble, and wood are common flooring materials. Hard plaster and tiles are used occasionally. Oak, either in random-width planks or parquet, dominates wood flooring. Woven matting replaces loose rushes as floor coverings. Turkish and Persian carpets, imported since the Middle Ages, occasionally adorn floors; more often, because of their value, they cover tops of tables and cupboards. Needlepoint and other types of rugs also cover floors.

■ *Walls.* Wall paneling (Fig. 15-34, 15-37, 15-44, 15-45, 15-49, 15-50) is usually of oak. Early panels are small and plain or with carved linenfold (resembling folds of linen;

15-39. Long Gallery, Little Moreton Hall, 1559; Cheshire.

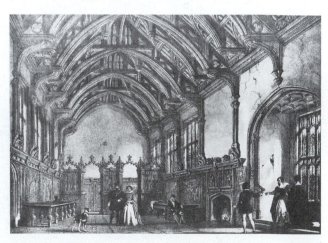

15-40. Banqueting Hall, Milton Abbey, 16th century; Dorsetshire.

called wavy work during the period; Fig. 15-4), Gothic motifs, or Romayne work (profiles of heads in roundels). As time passes, panels become larger with more elaborate carving, and the wood left natural or painted. Plaster walls (Fig. 15-53) are treated in a number of ways—painted in solid colors, stenciled in repeat patterns, embellished with elaborate arabesques and other complex designs, or decorated with mythological or biblical scenes. Typical hangings are of plain, patterned, or painted fabrics, imported or domestic tapestries, or leather. Some are embroidered or appliquéd. Use of wallpaper increases during the 16th century. A favorite pattern features heraldic devices in black and white.

- *Chimneypiece.* The chimneypiece (Fig. 15-40, 15-41, 15-42, 15-50, 15-55) is a focal point in all three periods. Earlier ones feature the Tudor arch surrounded by paneling. Those of the 16th century often have large rectangular openings with more elaborate mantels and overmantels of stone, marble, or wood. Mantels feature columns or pilasters, strapwork, and cabochons (Fig. 15-42, 15-50) often derived from pattern books.

- *Windows.* Windows are rectangles, bays, or oriels. Glass is expensive, so horn or blinds of cloth or canvas substitute in lesser houses. Small diamond lattice panes of glass leaded together are another alternative. Some glass is painted or stained. Great houses use curtains in winter as protection from the cold.

- *Doors.* Door panels generally match wainscoting. In larger houses, pilasters or columns supporting an entablature often flank doors (Fig. 15-46). For extra emphasis, particularly in drafty spaces, doors become a part of an interior porch that is elaborately carved and decorated with columns and strapwork. Curtains may also be used at doors.

- *Textiles.* Numerous textiles (Fig. 15- 36, 15-42, 15-54, 15-61, 15-62, 15-71, 15-72) provide color, warmth, and comfort to wealthy and royal interiors in all periods, but increase in luxury and refinement in the late 16th and

15-41. Chimneypiece with Tudor arch, composite panels, and heraldic motif, Aubourn Hall; Lincolnshire.

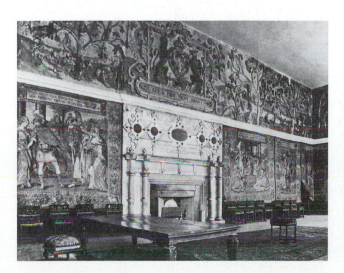

15-42. Presence Chamber, Hardwick Hall, 1590–1597; Derbyshire; by Robert Smythson.

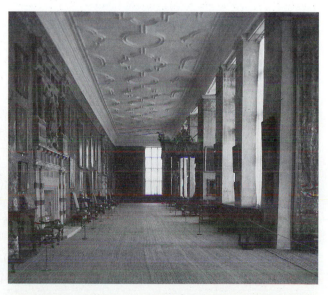

15-43. Long Gallery, Hardwick Hall, 1590–1597; Derbyshire; by Robert Smythson.

early 17th centuries. Lesser houses make do with fewer textiles. Many types of imported and domestic fabrics and leathers adorn walls; hang at windows or doors; drape beds; and cover tables, cupboards, chairs, stools, and cushions. Types include wool and silk velvets; wool, silk, or blended damasks; satins; cut and uncut velvets from Genoa, Italy; plushes; gold or silver cloth; and painted or resist-dyed cottons (chintzes and calicoes) imported from the Far East by the East India Company. Domestic linens, woolens, and imported silks dominate early in the period; cottons are rare until imported from India beginning in the late Elizabethan and early Jacobean periods. Textiles in a room do not match because dyes are not consistent. Colors include blue, crimson, russet, purple, green, yellow, pink,

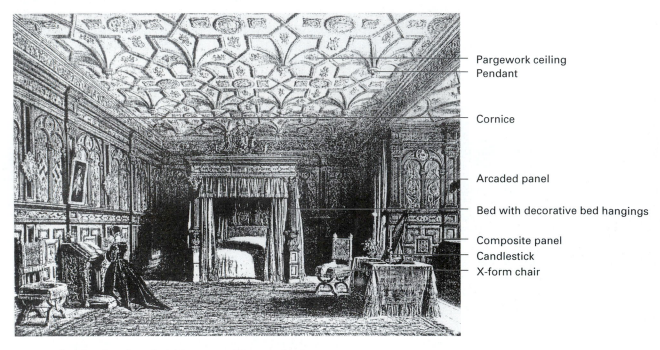

Pargework ceiling
Pendant

Cornice

Arcaded panel

Bed with decorative bed hangings

Composite panel
Candlestick
X-form chair

15-44. Bedchamber, Sizergh, 16th century; Westmoreland.

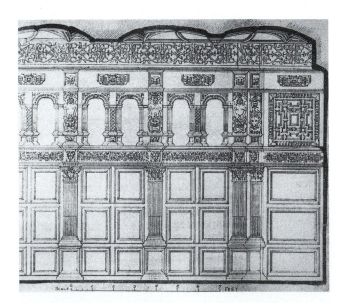

15-45. Wall elevation, Star Hotel, 1595–1600; Great Yarmouth.

15-46. Archway to Stairway Hall, Claverton, early 17th century; Somerset.

and black. Gold or silver fringe, lace, and tassels increase the sense of luxury and color.

■ *Ceilings.* Some Tudor ceilings have medieval trusses (Fig. 15-34, 15-35, 15-37, 15-39, 15-40). Others are beamed or coffered (Fig. 15-36, 15-38, 15-56). During the Elizabethan period, pargework (plastering in patterns over beams; Fig. 15-44, 15-47, 15-50, 15-51) appears. The earliest designs are small and geometric, but they grow more complex. Some ceilings copy Gothic ribbed vaulting with pendants (large hanging ornaments). Others, and those of the Jacobean period, follow allover patterns of interlacing curved or geometric patterns with Tudor roses, cartouches,

strapwork, and scrolls. Sometimes color is applied. Plasterwork becomes compartmentalized (Fig. 15-53) with the influence of Inigo Jones, who is thought to have introduced the cove ceiling in England.

■ *Later Interpretations.* The most direct interpretation of interiors may be viewed in small-scaled vernacular and coeval adaptations in America (Fig. 15-57). Variations of Inigo Jones's work appear in the 18th century, most notably in Neo-Palladian manor houses (Fig. 15-58). Late in the English Regency period, Tudor, Elizabethan, or Jacobean features may be incorporated into rooms. Elements are taken from or based on earlier houses. Features of the three

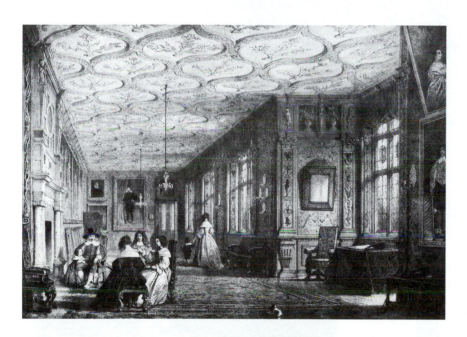

15-47. Cartoon Gallery, Knole, 1607–1608; Kent.

15-48. Stairway with strapwork detailing, Hatfield House, 1607–1611; by Robert Cecil and Robert Lyminge.

Design Spotlight

Interiors: *Marble Hall, Hatfield House.* Designed by the owner Robert Cecil, this house (Fig. 15-22, 15-48, 15-49) was conceived to impress and to receive royalty. The great hall, a multifunctional space in the center of the manor house, reflects the Jacobean and Mannerist interpretation of classicism. The walls are ordered by pilasters, rectangular panels, and door surrounds that feature round arches. Elaborate brackets support the minstrels' gallery, and an arcaded screen shields the musicians. The ceiling is compartmented.

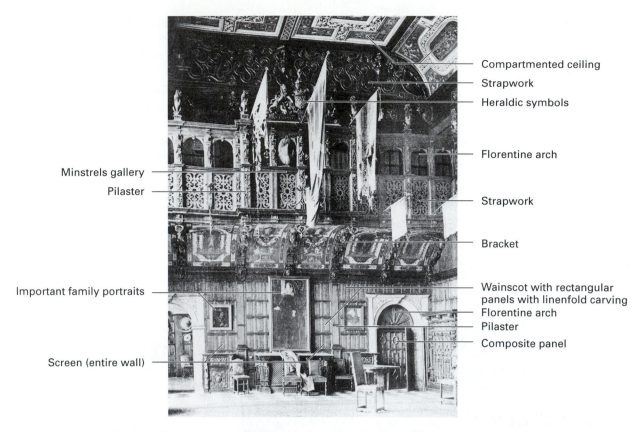

Compartmented ceiling
Strapwork
Heraldic symbols

Florentine arch

Strapwork

Bracket

Minstrels gallery
Pilaster

Important family portraits

Wainscot with rectangular panels with linenfold carving
Florentine arch
Pilaster
Composite panel

Screen (entire wall)

15-49. Marble Hall, Hatfield House, 1607–1611; by Robert Cecil and Robert Lyminge.

15-50. Long Gallery, Aston Hall, 1618–1632; Warwickshire.

15-51. Ceiling detail, Long Gallery, Aston Hall, 1618–1632; Warwickshire.

15-52. Lighting fixtures: Candlesticks.

15-53. Banqueting Hall, Whitehall, 1619–1622; by Inigo Jones. (Color Plate 37)

15-54. Double Cube Room, Wilton House, c. 1635–1653; Wiltshire; by Inigo Jones and John Webb; furnishings by Thomas Chippendale and William Kent, c. early 18th century.

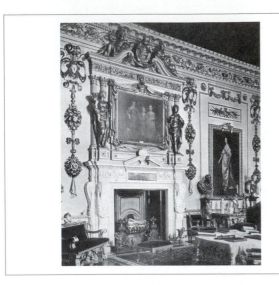

15-55. Chimneypiece, Double Cube Room, Wilton House.

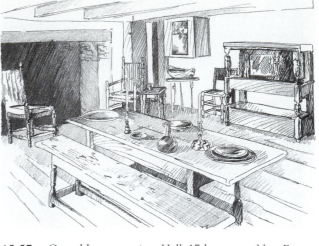

15-57. Coeval Interpretation: Hall, 17th century; New England; American Colonial: England.

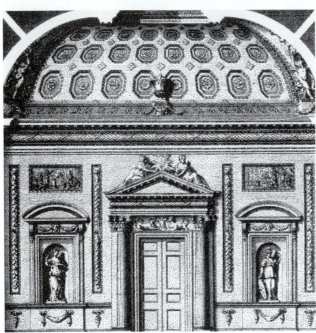

15-56. Wall elevation, Cube Room, early 17th century; by Inigo Jones.

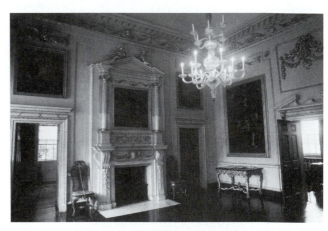

15-58. Later Interpretation: Saloon, Marble Hill House, 1728–1729; Twickenham near London; by Roger Morris; Neo-Palladian.

15-59. Later Interpretation: Stair Hall, Griswold House, 1862–1863; Newport, Rhode Island; by Richard Morris Hunt; Stick style.

periods remain in fashion throughout the Victorian and Edwardian periods, although stylistic distinctions are made among them. English Renaissance styles also influence 19th-century design reformers, such as William Morris, who copy and abstract elements from them. In America, they appear first in Renaissance Revival in the mid-19th century and continue as Tudor and Elizabethan styles (Fig. 15-59) later in the century and into the 20th century.

FURNISHINGS AND DECORATIVE ARTS

Early in the 16th century, London becomes a center for furniture making. Numerous English, French, Flemish, Dutch, and German artisans open shops in the city and introduce Renaissance design elements as well as finer construction techniques, such as veneering. During the period, furniture making begins to require the skills of several craftsmen instead of only the joiner. Craftsmen begin to specialize as carvers, joiners, turners, and metalworkers. As in architecture, Renaissance design elements are slow to appear.

■ *Tudor.* Tudor furniture is similar to medieval furniture in form and decoration. Renaissance elements mix, often incongruously, with Gothic elements. Romayne work is characteristic.

■ *Elizabethan.* Elizabethan furniture is massive with heavy proportions, rich carving, and inlay. It shows strong Flemish influence along with classical elements. Strapwork, geometric decoration or inlay, and gadrooning (repeating carved decoration) are common details. Rooms may have

Design Spotlight

Furnishings: *Wainscot Chair.* This important rectangular chair (Fig. 15-60) typically has a paneled back, turned legs, and runners or stretchers. The back decoration varies to include carved motifs such as the lozenge, Tudor rose, arcaded panel, acanthus, and strapwork. Typically made of oak with open arms, the chair is often placed against a paneled wainscot wall. Front legs are more ornate than the plain back legs.

more furniture than Tudor rooms, but continue relying on textiles and surface decorations for interest. A desire for comfort increases the use of upholstery.

■ *Jacobean.* Jacobean furniture continues Elizabethan traditions, but is simpler with more formal and naturalistic carving. Strapwork, arabesques, lozenges, applied pendants, and split baluster turnings are characteristic. Upholstery continues to increase in use. As earlier, rooms have few wood furnishings.

Private Buildings

■ *Types.* Types, which include seating, tables, storage pieces, and beds, remain limited and do not vary much from earlier times.

■ *Distinctive Features.* The heavy, elaborately carved, bulbous support (Fig. 15-64, 15-68, 15-69, 15-70) is a definitive characteristic of Elizabethan and Jacobean furniture. Originally from the Low Countries, it is called a cup and cover or melon support. Early examples are very large, but gradually decrease in size and amount of embellishment. Legs may be turned, chamfered, or fluted. They typically terminate in bun feet. Stretchers are plain and close to the floor.

■ *Relationships.* Rooms have little furniture, and it lines the walls when not in use. Although declining, the practice of placing the best bed in the hall or great chamber continues until the end of the 16th century.

■ *Materials.* Most furniture is of oak. A few Jacobean pieces are of walnut. Joiners construct Tudor furniture following simple medieval traditions. Construction becomes more sophisticated during Queen Elizabeth's reign. In the late 16th century, Flemish craftsmen reintroduce board construction, which uses dovetails to make wide pieces and

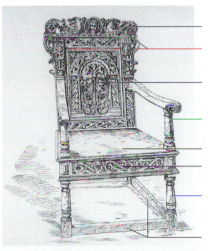

Rectangular back

Carved decoration

Arcaded panel

Baluster turned arm support

Wood seat

Strapwork on apron

Baluster turned leg

Runner

15-60. Wainscot chairs.

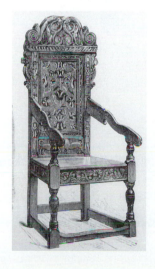
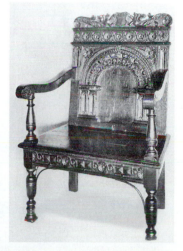

enables makers to use veneer. Joined construction soon dies out except in rural areas. Carving and inlay are the main types of decoration for furniture; there is little painting and gilding. Surface richness is more important than the quality of carving.

■ *Seating.* Seating include chairs, settees, daybeds, stools, benches, and settles.

Chairs. Three main types of chairs are turned (turneyed or thrown, an old term for turning; Fig. 15-62), **X**-form folding chairs (Fig. 15-50), and wainscot (panel-backed; Fig. 15-60) chairs. The farthingale chair (back stool; Fig. 15-61) appears at the end of the 16th century. During the Elizabethan and Jacobean periods, sets of furnishings in matching fabrics are introduced. Beginning late in the Tudor period, **X**-form chairs typically have fabrics attached to their frames with brass or gilded nails. Backs and cushions have fringe trim secured by

nails and decorated with tassels. Often shown in portraits, they symbolize rank and status.

Daybeds and Settees. Daybed is a modern term for a long seat with a fixed or adjustable inclined end, which resembles a chair back. They first appear in the 16th century. Some in the 17th century have two adjustable ends and closely resemble a sofa. Seats have cushions for comfort. Settees with upholstered backs and seats appear in the early 17th century.

Stools, Benches, and Settles. Joined stools, relatively common items, consist of an oblong seat, turned or fluted columnar legs, and a continuous stretcher near the floor. They may be upholstered and/or have cushions. Some Elizabethan benches are of trestle form with splayed solid supports. Settles, which may be movable or built in, have high backs and paneled arms and sides.

■ *Tables.* During the Elizabethan period, permanent tabletops replace removable ones, and the drawtop (leaves pull out on either side to extend the top) is introduced. The principal table form (Fig. 15-63) is long, narrow, and rectangular. Aprons may have inlay of geometric shapes. Top edges are gadrooned. Other types include small tables imported from Flanders, Italy, and France and the gate-leg

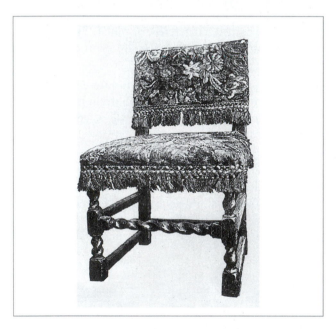

15-61. Farthingale chair.

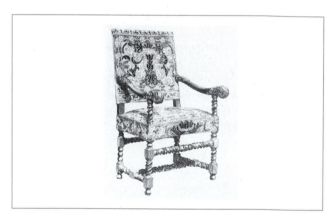

15-62. Turned armchair.

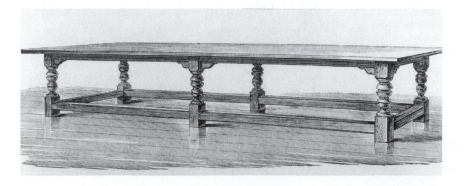

15-63. Long table.

(falling leg) table. Tables intended to be covered with carpets are simply constructed of plain wood. The gate-leg table becomes common after its introduction in the early 17th century.

■ *Storage.* Case pieces include chests for storage (Fig. 15-66, 15-67, Color Plate 38), cupboards for display in the hall or great chamber, and chests of drawers (introduced from the Continent late in the 16th century). Early chests of drawers are massive in scale, and doors conceal the drawers. The court cupboard (Fig. 15-68), introduced from France at the end of the 16th century, consists of open shelves about 48″ high. Richly carved, it displays plate in the hall or great chamber. Cupboards vary in design. One type has a closed upper portion resting on an open stand. Another variety reveals an upper portion divided into thirds with canted panels on either side of a central panel. A third type combines doors in the upper portion and drawers in the lower.

■ *Beds.* Typical beds are wooden boxes covered and draped with fabric or draped four-posters. Some examples are massive with heavy turned posts and a tester with architectural moldings (Fig. 15-36, 15-44, 15-69, 15-70). The headboard is richly carved with architectural and naturalistic motifs. Sometimes the two footposts detach from the bed frame to allow draperies to enclose the bed. Because of the textiles, the bed is the most expensive piece of furniture in the home.

■ *Bed Hangings.* Rich hangings not only give warmth, but also demonstrate rank and status. A set of hangings

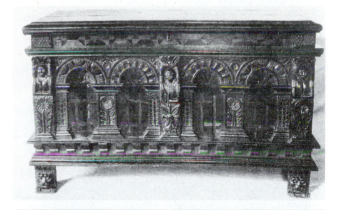

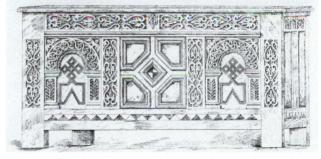

15-66. Chests with arcaded, composite, and lozenge panels.

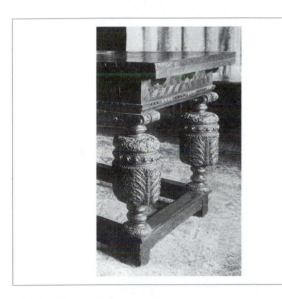

15-64. Cup and cover detail.

15-65. Strapwork detail.

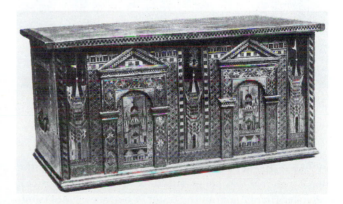

15-67. Nonesuch chest, late 16th century. (Color Plate 38)

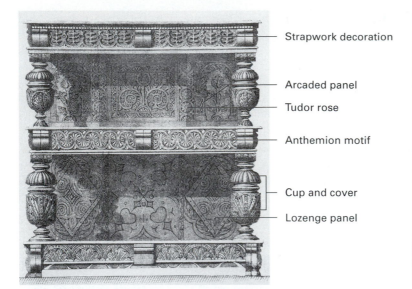

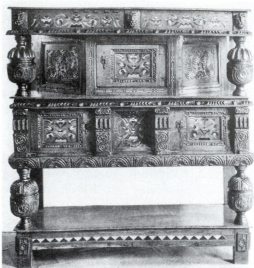

Strapwork decoration

Arcaded panel

Tudor rose

Anthemion motif

Cup and cover

Lozenge panel

15-68. Court cupboard and cupboard late 16th–early 17th centuries.

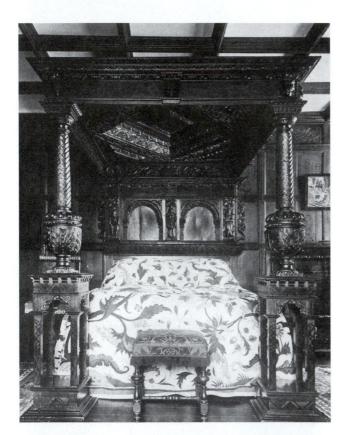

15-69. Bed, State Chamber, Anthehampton Hall, 16th century; South Dorset.

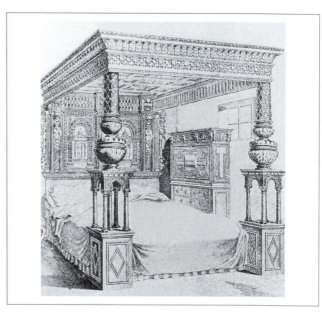

15-70. Great Bed of Ware, Saracen's Head; 16th century; Ware.

includes the head cloth (behind the headboard at the head; Fig. 15-36), ceiler (inside the tester or cornice), valances (hanging from the tester or cornice), bases (similar to today's dust ruffle), curtains on all four sides, and the counterpoint or counterpane (coverlet). Hangings do not necessarily match other textiles in the room and may combine different colors and/or types of fabrics including gold or silver cloth. Braid, tape, fringe, lace, embroidery, and tassels embellish hangings. Valances often have complicated outlines emphasized by tape and trims. To protect valuable hangings, case curtains of a plain fabric hang from rods surrounding the bed. Bed furniture includes pillows, bolsters, mattresses, sheets, quilts, and blankets.

15-71. Fabrics and wallpaper, 16th century.

15-72. Mortlake tapestry, early 17th century.

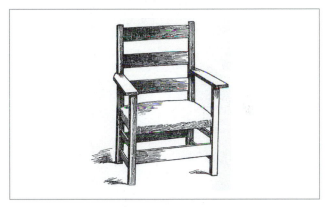

15-73. Later Interpretation: Side chair, c. early 20th century; American; by Gustav Stickley.

■ *Textiles.* For warmth and comfort, wealthy homes often have chairs, stools, settees, and footstools completely covered with fabric and richly embellished (Fig. 15-61, 15-62, 15-71). Cushions provide additional comfort for chairs and stools. Large cushions may be used for sitting on the floor. Silk or wool damask or velvet cushions are trimmed with gold or silver lace, embroidery, braid, cord, and tassels. Furniture cases (slipcovers) usually protect expensive textiles. Close or necessary stools, which conceal chamber pots, are upholstered (incongruously) in velvet or, more appropriately, in leather. In addition to carpets, fabric adorns the tops of tables and cupboards. Table covers, which vary in length, usually are embroidered, trimmed, or otherwise embellished. In the mid-16th century, Turkey work or Norwich work, a textile that imitates Oriental rugs, becomes common for upholstery. In the early 17th century, some bed hangings feature crewelwork (designs embroidered in worsted wool thread in a chain stitch on linen) embroidered by the ladies of the house or by professional embroiderers. Typical patterns feature trees, flowers, and foliage rising from mounds combined with animals. Early designs are dense with patterning nearly covering fabrics, but embroidery gradually lessens throughout the period. Palampores, coverlets with similar painted and resist-dyed designs imported from India, occasionally are used for coverlets on beds or as hangings.

■ *Decorative Arts.* Tableware is made of wood, silver, horn, or glass. From Italy and the Netherlands comes tin-glazed earthenware (*faience* or delft). Objects made of silver or gold include saltcellars, sconces, plates, ewers and basins, flagons, drinking vessels, spoons, spice boxes, and snuffers. Many are large and elaborately decorated or encrusted with jewels. Stylistically, silver follows the other arts in slowly adopting Renaissance motifs. Other accessories are portraits, paintings, and armor. As the English begin their

domination of the seas, Oriental rugs, porcelains, crewel-work, and palampores appear in their homes. Highly prized Chinese porcelain is set in gold and silver, as are such exotic items as ostrich eggs. Glass comes from Venice. Nearly every room in the home contains base-metal objects of brass, iron, tin, pewter, or copper. Besides tablewares, other metal items include chandeliers, candlesticks, snuffers, andirons and other hearth furniture, warming pans, and kitchen items.

■ *Later Interpretations.* In the 1820s, people begin collecting Elizabethan furniture and making replications. Reproductions of Tudor, Elizabethan, and Jacobean furniture begins about mid-century and continues into the 20th century. Design reformers such as William Morris, Philip Webb, Bruce Talbert, and Gustav Stickley (Fig. 15-73) look to medieval or Elizabethan furnishings for inspiration. They regard early furniture as honest in construction and materials, traits to be emulated.

16. American Colonial: England

1608–1720

. . . their Lord hath been pleased to turn all the wigwams, huts, and hovels the English dwelt in at their first coming, into orderly, fair, and well-built houses, well furnished many of them, together with Orchards filled with goodly fruit trees, and gardens with variety of flowers . . .

> Edward Johnson, *Wonder-Working Providence of Sions Saviour in New England (1654)*, p. 211 of the 1910 edition; from Morrison, Hugh. *Early American Architecture*. Oxford, England: Oxford University Press, 1952.

16-1. Pilgrim and southern landowner costume.

English colonists, who settle the eastern seaboard, reproduce the houses and furnishings they knew at home. Although settlement patterns are different in the South and New England, house types and furnishings are similar with some regional differences. At first, dwellings and furniture are medieval English vernacular forms constructed of local materials. Later, colonists adopt newer styles borrowed from England or created locally.

HISTORICAL AND SOCIAL

The English and French establish colonies along the eastern seaboard from Newfoundland to the Carolinas. The French settle in Acadia or Nova Scotia in 1604 with the English establishing their first permanent settlement in Jamestown, Virginia, in 1607. In 1620, a group of Separatists or Puritans settle in Plymouth, Massachusetts, followed by colonies in Rhode Island and Connecticut. By 1640, England has seven thriving settlements in the New World. Her colonies increase throughout the second half of the 17th and early 18th centuries. Corporations granted charters by the English Crown settle North and South Carolina, New Jersey, New York (taken from the Dutch), Pennsylvania, Maryland, and Georgia. In the second half of the 17th century, immigrants from other areas of Europe join the English. Settlers include Swedes, Finns, Flemish, Dutch, and French Huguenots. However, English culture dominates.

The founders of Jamestown envision another London—a bustling city of trade and commerce. Nevertheless, the settlers quickly abandon town life for land on which they can raise tobacco, an extremely profitable crop. Settlement patterns form around large farms or plantations with few urban centers until after the American Revolution. Southern immigrants usually are artisans, farmers, and gentlemen. As Anglicans, they have little concern for religious freedoms. Busy with agriculture, they import clothing, furnishings, and other items from London, so little is made in the colony. In contrast, New Englanders are mainly middle-class farmers, yeomen, and artisans, many of whom have come to America for religious freedom. Settlement patterns follow small, self-sufficient farms united by villages until the second half of the 17th century. As more colonists prosper through trade and commerce, they move to urban centers, such as Boston, which soon become populous and thriving.

America's troubles with England begin early. Following the English Civil War, the government attempts to exert more control over the colonies, particularly in commerce. Trade with non-English colonies or countries is forbidden by a series of laws that colonists largely ignore. Following the restoration of the monarchy in 1660, controls become even stricter. Colonists in New Hampshire, Massachusetts, New York, and New Jersey rebel against becoming royal provinces under Crown control. Under the rule of William

and Mary (1689–1702), relations with the French, England's chief territorial rival, deteriorate. War at home and in the colonies soon follows. In addition, expansion takes its toll on Native American population and supports the importation of African slaves, who become the dominant labor force in the South.

CONCEPTS

Architecture, interiors, and furniture of the English settlers reflect the forms with which they are familiar—house and furniture types that have passed from generation to generation. Because function is more important than style, classicism in any form is rare before the end of the 17th century. Colonists are unfamiliar with it as they immigrate before the general adoption of the Renaissance in England. Fashionable furnishings are not concerns early in the settlement period as many struggle simply to survive. Others are too busy growing and harvesting crops. By the end of

16-2. Interior architectural details.

the 17th century, however, prosperous colonists are following fashionable English styles such as those set by William and Mary. In areas where settlers from other countries mix, English influence tends to dominate, such as in New York and New Jersey. The English do absorb some influences from other ethnic groups, such as gambrel roofs and pattern brickwork.

DESIGN CHARACTERISTICS

Early dwellings, interiors, and furnishings follow English vernacular examples, which are medieval. Modest scale and vertical proportions are typical, with function a more important concern than fashion. Structure is frankly expressed, and materials are used honestly. Decoration and motifs, when present, follow English styles. Some regional differences are evident in material and form. Classical design principles and motifs appear at the end of the 17th century (earlier in the South).

■ *Motifs.* Houses and interiors have few architectural details and little applied decoration. Motifs for furniture include flowers (Fig. 16-43, 16-44, Color Plate 39, 16-45), scrolls, strapwork, or geometric shapes (Fig. 16-43, 16-46, 16-48). The sunflower, tulip, or Tudor rose (Fig. 16-37) is common in Connecticut. Typical William and Mary motifs include **C** and **S** scrolls, baluster shapes (Fig. 16-39, 16-41), and balls.

ARCHITECTURE

The earliest shelters are primitive, consisting of dugouts, wigwam forms with chimneys, and small huts of wattle and daub with thatched roofs. All are known in England. As soon as they are able, colonists recreate the homes and other buildings they knew in England—mostly rural, vernacular types that reveal little knowledge of classically inspired Renaissance design concepts. The earliest houses are small and functional with little embellishment. Settled times and prosperity bring larger homes in Tudor, Elizabethan, or early classical modes. Plans and materials sometimes vary with location, but most structures share such medieval characteristics as steeply pitched gable roofs, casement windows, and framed construction.

Public and Private Buildings

■ *Types.* Building types are dwellings (Fig. 16-6, 16-7, 16-8, 16-11, 16-12, 16-13, 16-14, 16-15, 16-16, 16-17, 16-18), churches (Fig. 16-4), meeting houses (Fig. 16-5), collegiate buildings, roadhouses and inns, and a few statehouses (Fig. 16-3). Nonresidential structures resemble dwellings in scale, materials, and fenestration.

■ *Site Orientation.* Houses are located near sources of water and/or transportation routes for crops. Orientation is often haphazard, with backs or sides, instead of the front, sometimes facing the road. There is no decorative landscaping, even on Southern plantations, because the areas surrounding the home are workspaces. As such, they are littered with tools and debris, and domestic animals roam freely. Southern houses often have outbuildings such as kitchens, slave quarters, or stables. New England churches and meetinghouses (Fig. 16-3, 16-5) form town centers around a green with dwellings located nearby.

■ *Floor Plans.* Church plans reflect worship patterns (Fig. 16-4), with the nave and altar areas being the most important spaces (Fig. 16-21). Southern Anglican churches are long and narrow with the entrance on the west and altar on the east. A step, a rail, or a screen separates the congregation from the chancel. In New England, square or nearly square meetinghouses have a single open space with the pulpit in the center. They also serve as town halls or schools. Unlike the Anglican church, the meetinghouse

16-3. Old State House, 1713; Boston, Massachusetts. From its balcony, the Declaration of Independence was read for the first time in Massachusetts.

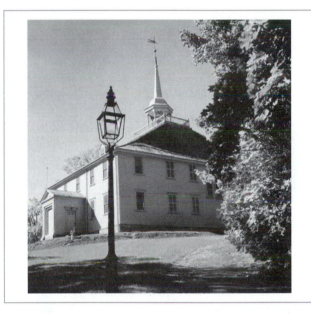

16-5. Old Ship Meeting House, 1681, 1731–1755; Hingham, Massachusetts.

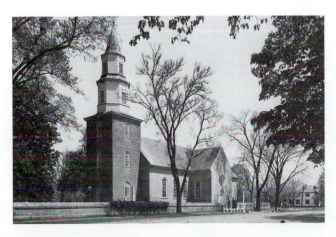

16-4. Bruton Parish Church, 1711–1715; Williamsburg, Virginia.

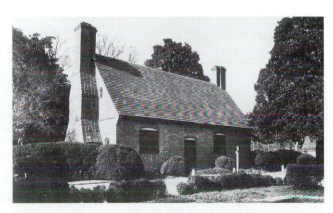

16-6. Adam Thoroughgood House, 1636–1640; Princess Anne County, Virginia.

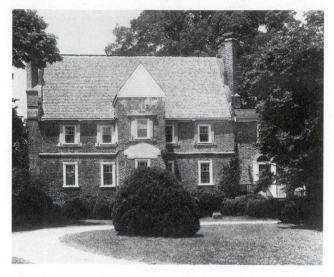

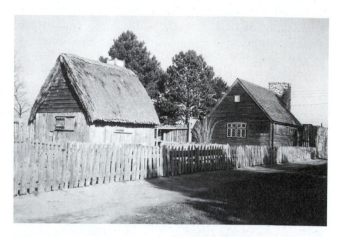

16-7. Bacon's Castle, c. 1655–1665; Surry County, Virginia.

16-8. Early houses, 17th century; Plymouth, Massachusetts.

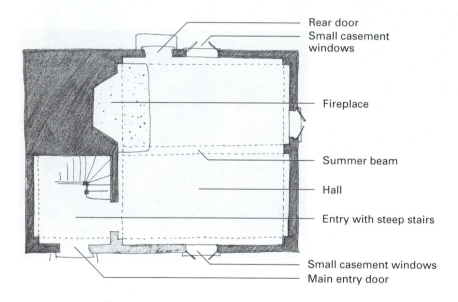

Rear door
Small casement windows

Fireplace

Summer beam

Hall

Entry with steep stairs

Small casement windows
Main entry door

16-9. Floor plan, one-room house, 17th century; Guilford, Connecticut.

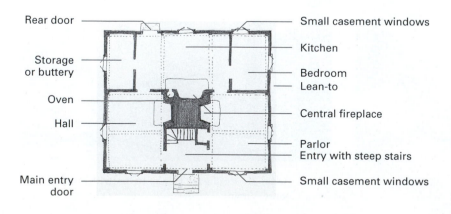

Rear door

Storage or buttery

Oven

Hall

Main entry door

Small casement windows

Kitchen

Bedroom
Lean-to

Central fireplace

Parlor
Entry with steep stairs

Small casement windows

16-10. Floor plan, multiroom house with lean-to; 17th century; Connecticut.

has no English prototype, as Puritans met in houses. Public buildings or statehouses resemble domestic structures in scale and composition. Collegiate buildings are similar or follow **E** plans.

Typical domestic plans (Fig. 16-9, 16-10) include the hall, the hall and parlor, and the lean-to with one, one and a half, or two stories. These configurations appear in both New England and the South from early times. Plans typically expand as more space is needed, an additive principle of construction common to medieval-style buildings. Windows are often consciously placed opposite each other, particularly in the South, to enhance air flow and ventilation.

Hall Plan. The vast majority of early houses are one story with one multipurpose room (hall) and a chimney on the end (Fig. 16-9). Lofts provide storage or additional sleeping space.

Hall and Parlor Plan. Hall and parlor plans have two rooms. In New England, the chimney usually is in the center for heat distribution. A door opens into a small entry abutting the chimney, and steep stairs (Fig. 16-22) lead to the loft or upper story. Chimneys on Southern hall and parlor houses are usually on the ends; houses often have central passages. As colonists prosper, they construct two-story, two-room houses (also called **I** houses). Upper chambers may be used for sleeping or storage.

Lean-to Plan. For more space, some add two or three rooms behind the hall and parlor forming a lean-to or saltbox form (Fig. 16-10). Rooms include a buttery or pantry, a kitchen, and a chamber or two. Later this is to become a popular Colonial Revival house form.

■ *Materials.* Structures are timber framed and unpainted (Fig. 16-8, 16-11, 16-12, 16-13, 16-16, 16-17, 16-18). Uprights (posts) are mortised into horizontal sills, girts, or plates. New Englanders fill the spaces between timbers with wattle (straw, reeds, etc.) and daub (mud or clay) or brick for insulation. Finish materials include plaster, shingles, or unpainted clapboards. Rhode Island houses often have stone ends and clapboard facades (thus the name stone-enders). English settlers rarely construct log cabins, as they are largely unknown in England due to diminished timber stands. Although surviving examples are made of brick (Fig. 16-6, 16-7), most early Southern homes are of wood. Southerners use more brick than New Englanders

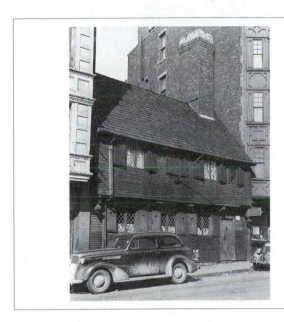

16-11. Paul Revere House, c. 1658–1676; Boston, Massachusetts.

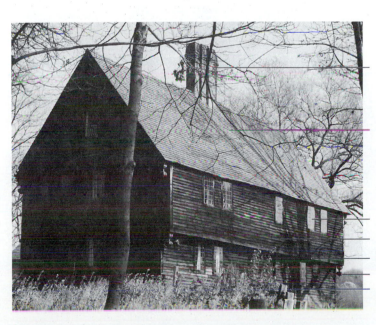

Central chimney

Steeply pitched gable roof

Small sash windows (added later)

Clapboard siding, unpainted

Second story overhang

Pendant

Board and batter door

16-12. Parson Capen House, 1683; Topsfield, Massachusetts.

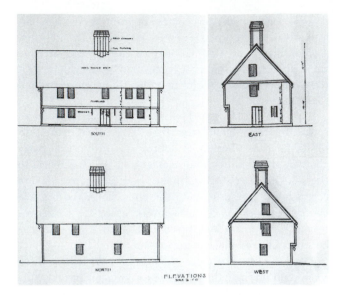

16-13. Elevations, Parson Capen House, 1683; Topsfield, Massachusetts.

Design Spotlight

Architecture: *Parson Capen House.* Representative of many New England wood-frame houses, this rural farmhouse (Fig. 16-12, 16-13) interprets the medieval tradition in America. It incorporates traditional framing methods, unpainted clapboard siding, a second-story overhang with pendants, a steep pitched roof, a central chimney, and small windows (the sash windows were added later). With a two-and-a-half-story hall and a parlor, the large dwelling asserts the Reverend Joseph Capen's important position in the community. The interiors are plain, simple, large and functional. Furnishings are sparse.

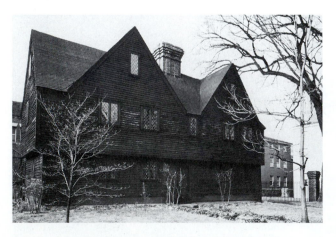

16-14. John Ward House, 1684; Salem, Massachusetts. (Courtesy Peabody Essex Museum)

because many are masons or bricklayers who come from a region in England where brick is common. The South also has more suitable clay. In the 17th century, Flemish bonding (alternating headers or ends and stretchers on the long side) and English bonding (alternating rows of headers and stretchers) are most common in brick construction (Fig. 15-16).

■ *Facades.* Walls are plain, not divided into bays, and unarticulated, although additions of moldings and door surrounds are common as prosperity increases (Fig. 16-11, 16-12, 16-14, 16-16, 16-17, 16-18). Upper portions of New England houses are more visually complex with multiple roofs, dormers, and chimneys (Fig. 16-14). Embellishment on Southern houses includes stepped chimneys, decorative brickwork, and dormers (Fig. 16-6, 16-7). Some New England houses are jettied (upper story extends beyond lower) on the front and back sides to avoid sagging, with pendants (drops or pendills) adorning the corners. Chimneys are large and prominent.

■ *Windows and Doors.* Small and placed where needed, windows are covered with oiled paper or horn, or have shutters. Glass, imported from England, is very expensive. Nevertheless, some structures have casements with small

Design Practitioners

■ Colonists rely on *itinerant carpenters* or *master masons* to build their homes and, occasionally, make furnishings. Joiners make most furniture until the end of the 17th century when cabinetmakers become more common. Unlike England, America has no guild system to perpetuate and regulate crafts, although apprenticeships are typical.

■ *Samuel Clement* is a cabinetmaker who works in Flushing, New York, in the early 18th century. Few pieces by him survive; he signs and dates one high chest of drawers, a rare practice at the time.

■ *Thomas Dennis* is a joiner who works in Ipswich, Massachusetts; he marries Searle's widow. Elizabethan-style chairs and chests by him survive.

■ *Edward Evans* is an early-18th-century cabinetmaker in Philadelphia. A bureau-cabinet signed by him is one of the earliest surviving 18th-century American pieces.

■ *William Searle* (1634–1667) is a trained joiner working in Ipswich, Massachusetts, who immigrates from Devonshire, England. His work is especially fine and exhibits distinctive motifs from West County in England.

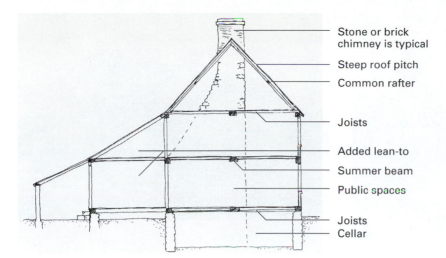

Stone or brick
chimney is typical

Steep roof pitch

Common rafter

Joists

Added lean-to

Summer beam

Public spaces

Joists
Cellar

16-15. Cross section, Connecticut saltbox house, 17th century.

leaded diamond panes that open out (Fig. 16-11, 16-12, 16-26). Casements may be single, double, or triple. Typical doors are board-and-batten and do not have elaborate surrounds until the end of the 17th century.

Important Buildings and Interiors

- **Boston, Massachusetts:**
 —Old State House, 1713.
 —Paul Revere House, c. 1658–1676.
- **Farmington, Connecticut:** Stanley-Whitman House, 1664–1720.
- **Hingham, Massachusetts:** Old Ship Meetinghouse, 1681.
- **Ipswich, Massachusetts:** Whipple House, 1639.
- **Isle of Wight County, Virginia:** St. Luke's Church, 1632.
- **Medfield, Massachusetts:** Peak House, 1690.
- **Princess Anne County, Virginia:** Adam Thoroughgood House, 1636–1640.
- **Salem, Massachusetts:** John Ward House, 1684.
- **Saugus, Massachusetts:** Boardman House, c. 1686.
- **Surry County, Virginia:** Bacon's Castle, c. 1655–1665.
- **Topsfield, Massachusetts:** Parson Capen House, 1683.
- **Williamsburg, Virginia:** Bruton Parish Church, 1711–1715.
- **Wethersfield, Connecticut:**
 —Buttolph-Williams House, 1710.
 —Captain Thomas Newsom House, 1710.

■ *Roofs.* Gabled or gambrel roofs (two pitches on either side of a ridge) are of thatch or wood hand-riven shingles (pie-shaped and cut from a log) (Fig. 16-6, 16-12, 16-13, 16-14, 16-16, 16-17, 16-18). Pitches are steep, a carryover from medieval times to allow snow and water to run off thatch.

■ *Later Interpretations.* Some 17th-century characteristics appear in the Shingle Style of the 1870s, but most Colonial Revival examples reflect the 18th century. The overhanging upper stories of many Colonial Revival houses (Fig. 16-19) come from the New England jetty. The Cape Cod house (Fig. 16-20) copies the hall or hall and parlor house. Additionally, some suburban houses of the late 20th century reinterpret the New England character.

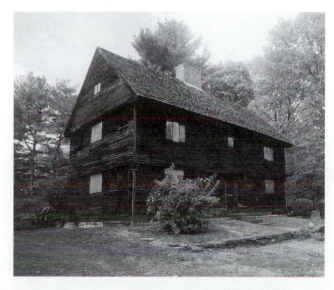

16-16. Buttolph-Williams House, 1710; Wethersfield, Connecticut.

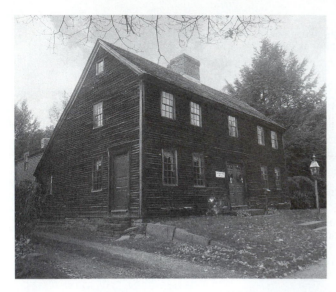

16-17. Captain Thomas Newsom House, 1710; Wethersfield, Connecticut.

16-18. Stanley-Whitman House, 1720; Farmington, Connecticut.

16-19. Later Interpretation: Suburban house, 1930; illustrated in *Pencil Points*, September 1930, vol. 11, no. 9, p. 727.

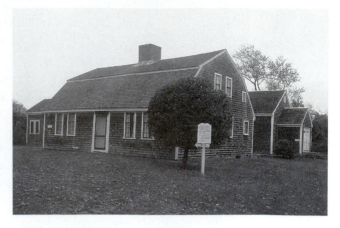

16-20. Later Interpretation: Cape Cod house, c. 1960s; near Chatham, Massachusetts.

INTERIORS

Interiors follow vernacular medieval traditions. Scale is modest, function is important, and structure is visible. Textures are rough, ceilings are low, and large fireplaces dominate rooms. Rooms are multifunctional as furnishings attest. Living patterns are uniform across classes except that the wealthy have larger houses and more possessions. As times become more settled and people prosper, interiors become more refined. Colonists travel to England and bring back fashionable items or order them from London suppliers. Local craftsmen, who are often recent immigrants, are familiar with the newest fashions in interiors and furnishings. Soon, there is only a small time lag between home country and colony.

Private Buildings

■ *Types.* In domestic structures, the hall is the center of family life where cooking, eating, and socializing take place (Fig. 16-23, 16-24, 16-27, 16-30, 16-31, Color Plate 40). A multifunctional space, it derives from the medieval great hall. Specific areas within the space are set aside for various activities. If a house has a parlor (Fig. 16-25, 16-28, 16-32, 16-33, 16-34), best room, or chamber (Fig. 16-29), it holds the family's treasured possessions, including the best bed. Like the hall it is multifunctional, supporting entertaining, dining, and sleeping. Upstairs rooms or chambers have few furnishings, mostly chests and beds, suggesting that people spend little time there.

■ *Materials.* Interior materials follow exterior ones. Architectural details derive from construction. Beams of upper floors form ceilings (Fig. 16-28, 16-29), for example. By the end of the 17th century, more rooms are paneled, and ceiling beams are covered with plaster.

■ *Color*. Colors, which come mainly from textiles and painted furniture, are highly saturated and do not necessarily match. The overall interior emphasizes the natural brown of wood, the cream of plaster, and a gray stone hearth with color accents in earth tones of Indian red, indigo, ochre, olive, and black.

■ *Lighting*. Artificial lighting (Fig. 16-30, 16-31, 16-35) is minimal, coming from fireplaces and a few candles or oil lamps. Only churches have chandeliers. Floor candle stands and table candlesticks, which derive from medieval prototypes, are typically plain and of iron, tin, or pewter. Pierced tin lanterns that hold candles are common late in the period. The popular betty lamp (from the German word *besser* which means "lamp") holds oil in a small saucer-shaped iron or tin dish with a handle; it may be placed on a table or suspended from a metal hook.

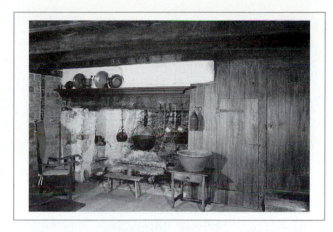

16-23. Joseph Gilpin House, c. 1695; Chadds Ford, Pennsylvania.

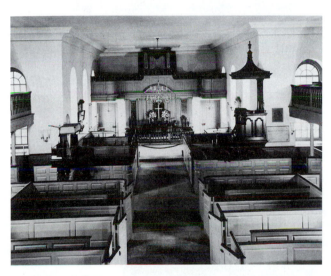

16-21. Nave and altar, Bruton Parish Church, 1711–1715; Williamsburg, Virginia.

16-24. Fireplace with ladder-back chairs, 17th century.

16-22. Stairs.

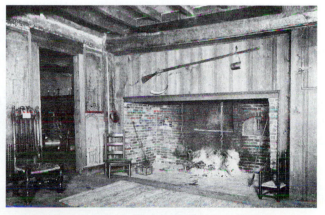

16-25. Parlor, Paul Revere House, c. 1658–1676; Boston, Massachusetts.

16-26. Wall elevation, Paul Revere House.

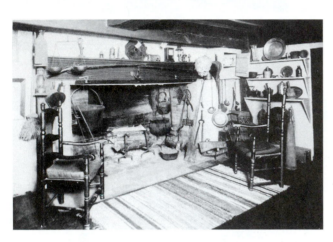

16-27. Fireplace, 17th century; Ipswich, Massachusetts.

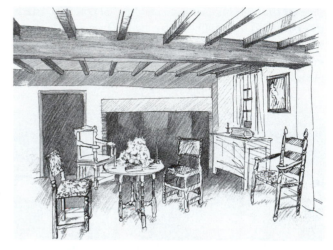

16-28. Parlor, Oyster Bay Room, after 1667; Oyster Bay, Long Island.

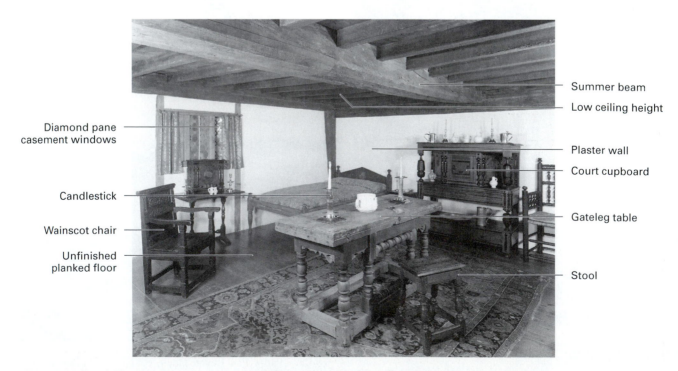

Diamond pane casement windows

Candlestick

Wainscot chair

Unfinished planked floor

Summer beam

Low ceiling height

Plaster wall

Court cupboard

Gateleg table

Stool

16-29. Hall and Chamber, Hart House, before 1674; Ipswich, Massachusetts. (Color Plate 40)

■ *Floors.* Floors are dirt, pressed clay, or random-width oak planks laid at right angles to floor joists. Most are uncovered; the few carpets are used as table coverings (Fig. 16-31).

■ *Walls.* Walls (Fig. 16-26, 16-33) are clay-daubed, plastered (Fig. 16-29, 16-30), or palisade (with vertical board paneling; Fig. 16-25). Late in the period and through the influence of the English Restoration style, paneling with rectangular panel shapes and beveled edges highlights fireplace walls (Fig. 16-32). Plaster, more common in the South, is usually whitewashed (Fig. 16-21). Paneling is usually unpainted, but Indian red is a common color when

it is. Marbling is common for paneling in Rhode Island. Wallpaper and textile hangings are rare except among the wealthy until late in the period. Beams and corner posts that project into rooms feature carving or chamfering.

■ *Distinctive Features.* Huge fireplaces with no mantels dominate rooms and are used for heat, light, and cooking. A wood lintel (Fig. 16-27, 16-28, 16-30) caps the opening; inside, hooks and nails are used for hanging pots and utensils. Bolection-type (molding with an outward roll that projects above the surface) mantels begin appearing late in the period (Fig. 16-34).

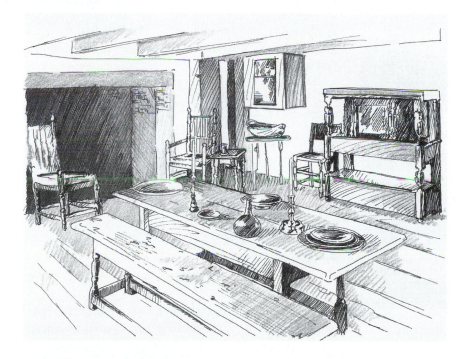

16-30. Hall, 1684; Essex, Massachusetts.

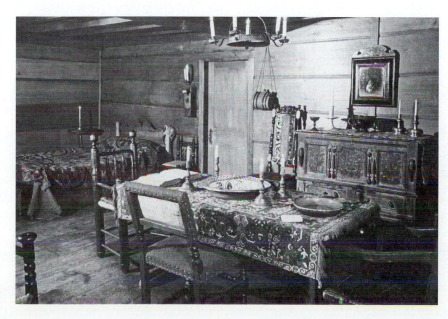

16-31. Hall, Wells-Thorn House, later 17th century (pre-1987 interpretation); Historic Deerfield, Connecticut.

■ *Windows and Doors.* Windows are small, simple, and plain; some have wood frames surrounding them. Doors are vertical boards; some have molded or feathered edges. Paneled doors appear at the end of the period. Wrought-iron hardware is typical throughout the period.

■ *Ceilings.* Ceilings are low and beamed. The main large support beam is called a summer beam (Fig. 16-28, 16-29). Some beams are painted or chamfered. Virginians tend to plaster the spaces between beams.

■ *Textiles.* Interior textiles are rare except among the wealthy. Curtains and floor coverings hardly exist; carpets cover tables (Fig. 16-31, 16-34) or cupboards.

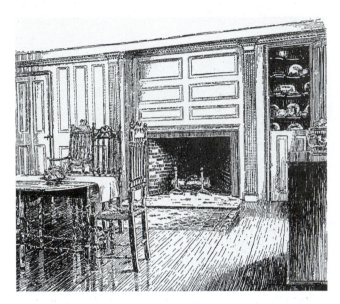

16-32. Parlor showing fireplace wall, late 17th century.

■ *Later Interpretations.* As in architecture, American Colonial rooms are rarely copied, except in kitchens, sometimes dining rooms (Fig. 16-36), or modern keeping rooms.

FURNISHINGS AND DECORATIVE ARTS

Colonists bring some furniture with them from Europe, but mostly they bring tools and farm implements. The earliest furniture is very crude because colonists are occupied with survival. As people become more settled, they begin to purchase or copy furniture in the newest modes: Jacobean and William and Mary. Very little Southern furniture from this period survives, as there are few cabinet-making centers.

Rooms may have many furnishings, particularly seating. Hall furnishings, which support the preparation and consumption of food, include seating, tables, cupboards, shelves, boxes, and chests. Additional pieces commonly are a bed, farm implements, and tools. The parlor houses the best bed in which the parents sleep, a cupboard, a table, and seating. Chairs line walls when not in use. Chambers usually have several beds.

Private Buildings

■ *Types.* Most homes have basic furnishings such as chairs, stools, tables, beds, and chests. The wealthy have similar-looking furniture but more pieces.

■ *Relationships.* Furniture often has an architectural character with heavy joined construction, overhanging upper

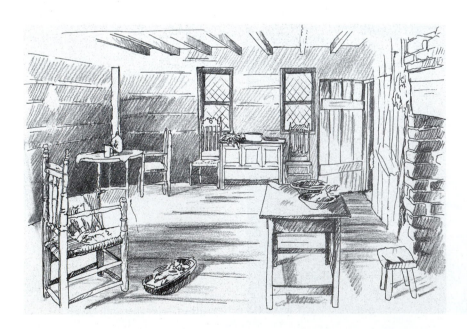

16-33. Parlor, Stanley-Whitman House, 1664–1720; Farmington, Connecticut.

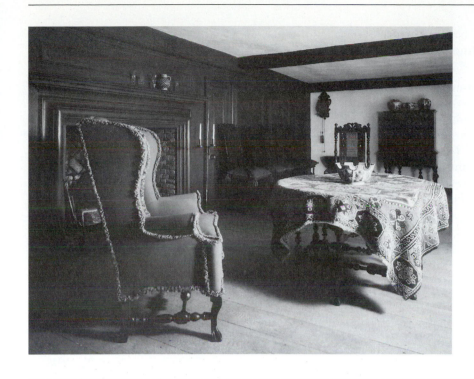

16-34. Parlor, Wentworth House, 1695–1700; Portsmouth, New Hampshire. (Courtesy of The Metropolitan Museum of Art, Sage Fund, 1926)

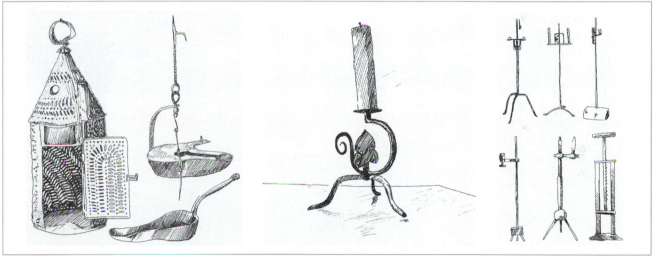

16-35. Lighting fixtures: Lantern, betty lamp, candlestick, and floor candle stands.

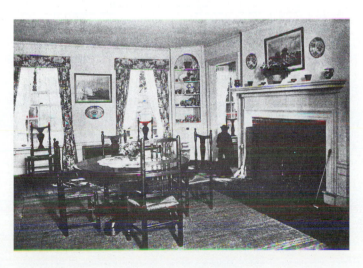

16-36. Later Interpretation: Dining Room, Arthur Whitney House, c. 1920s; Bernardsville, New Jersey.

portions, and applied pendants and bosses (circular or oval ornament). Like interiors, furniture is often multifunctional.

■ *Distinctive Features.* Colonial furniture closely follows English models. Earliest examples follow Elizabethan and Jacobean forms and details, with carving, spiral turning, split baluster spindles, and applied bosses (Fig. 16-45, 16-46). By the end of the 17th century, William and Mary characteristics (Fig. 16-34) are evident and distinctive (see Chapter 15). Furniture is lighter in weight and scale. Trumpet legs (tapered top to bottom; Fig. 16-42, 16-47)

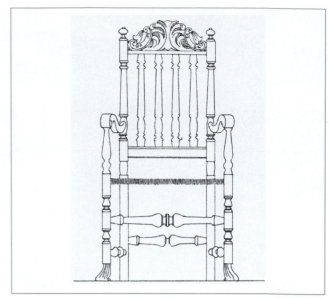

16-39. Banister-back chair.

16-37. Wainscot chair; Connecticut.

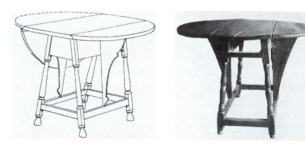

16-40. Butterfly table.

16-38. Carver chair, Plymouth Colony.

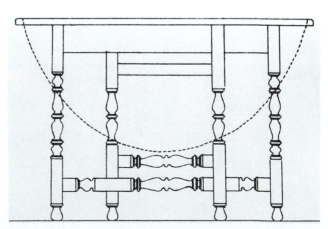

16-41. Gateleg table.

with bun or Spanish feet (Fig. 16-39) replace baluster ones with bell, mushroom, and inverted-cup turnings. Stretchers are generally curved (Fig. 16-42) and flat. Backs are curved or raked. Drawer pulls are wood or cast-metal acorn-shaped drops.

■ *Materials.* Early furniture examples are of red or white oak. Walnut, cherry, and maple replace oak in the William and Mary style. Jacobean examples are joined; that is, they are put together with mortise and tenon joints. By the second half of the 17th century, cabinetmaking techniques, such as intricate joints, veneering, and inlay, appear. Chairs and case pieces sometimes are painted in various combinations of black, red, yellow, white, and green.

■ *Seating.* Given the amount of seating pieces that survive, colonists seem to have been prolific furniture makers. The principal types of chairs are the wainscot (paneled back; Fig. 16-29, 16-37), farthingale or Cromwellian chairs (turned and upholstered-back stools; Fig. 16-28, 16-30, 16-31) with leather backs and seats, and the ladder-back

(Fig. 16-23, 16-24, 16-28). Turned chairs with and without arms are the most common. Two types are Carver (which has fewer spindles; Fig. 16-30, 16-31, 16-38) and Brewster (with double rows of spindles). (These two chair types were named in later times for two leaders during settlement.) Caned chairs are the most popular in the William and Mary period, followed by banister-back (Fig. 16-39) and leather chairs.

Easie chairs, with wings that protect the sitter from drafts, appear, and daybeds become much more common at the end of the century. Unlike today, both usually are found in the bedroom instead of the parlor. People have more stools and benches than chairs and also use boxes and chests for seating. The oak settle (a wooden high-back paneled sofa) is massive and heavy with storage below the seat; it may flank fireplaces or be built into a wall.

■ *Tables.* Most homes have at least one table. Trestle types are rare, but refectory, round, and oval ones are common (Fig. 16-30). Most people use several small tables for large dinners. Gateleg tables (falling tables; Fig. 16-28, 16-40, 16-41) and dressing tables (Fig. 16-42) appear at the end of the century. Chair tables sometimes are used in the hall.

■ *Storage.* Wall pegs perform many functions, but boxes and chests (Fig. 16-43), used for storage and seating, are important possessions. Based on English prototypes, they may be elaborately carved and painted or paneled (Fig. 16-48). Connecticut or Wethersfield chests (Fig. 16-31, 16-45) feature decorations of split spindles, applied moldings, and stylized Tudor roses (sometimes called sunflowers). Hadley chests (Fig. 16-44, Color Plate 39) come from an area between Hartford and Deerfield, Connecticut. Elaborately carved, stylized tulip designs distinguish them. Chests of drawers emerge as early as the 1640s in New England but remain rare until late in the century, and none actually survive. High chests of drawers (drawers resting on stands otherwise known in America as highboys;

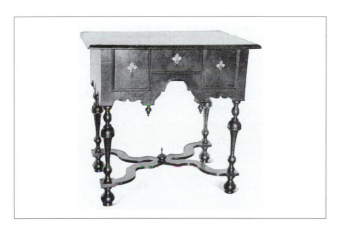

16-42. Lowboy or dressing table, William and Mary style, c. 1700.

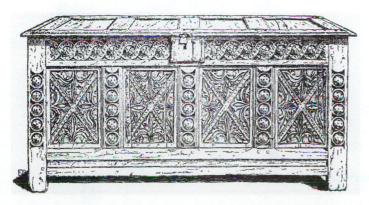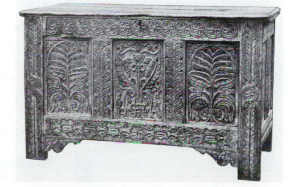

16-43. Oak chests.

Fig. 16-47) appear at the end of the 17th century. They quickly replace cupboards as conveyors of wealth and status. Like cupboards, they are used for display, and brightly colored textiles sometimes adorn the tops. Cupboards (Fig. 16-29, 16-30, 16-46) as luxury pieces are intended to impress, with most having both open shelves and enclosed storage spaces. Slant-front desks appear during the time of William and Mary.

■ *Beds.* Beds (Fig. 16-29, 16-31) include those with heavy posts and paneled headboards, turned types, and simple ones intended to be covered with hangings. Draped beds are the most costly item in the home, and not everyone owns one. Those who do often place them in the parlor as a sign of wealth. Trundles and palettes are common, especially for children and servants.

■ *Textiles.* Textiles are rare and are used mostly for cushions and bed hangings and to cover backs, seats, cupboards, and/or tables (Fig. 16-31). Red, green, and blue are favorite colors. Most are imported from England; linens and wools are more common than silk. Numerous luxurious table linens indicate wealth. Turkeywork (a textile that imitates Turkish carpets) replaces leather as the most fashionable textile in the middle of the 17th century. Stumpwork embroidery (Fig. 16-49), a raised type of appliqué needlework executed by women, highlights important objects, such as mirrors and boxes.

■ *Decorative Arts.* Decorative arts are limited to necessities in most homes, particularly early in the period. English and Dutch tin-glazed earthenware are the most common ceramics, although other types of earthenware and stone-

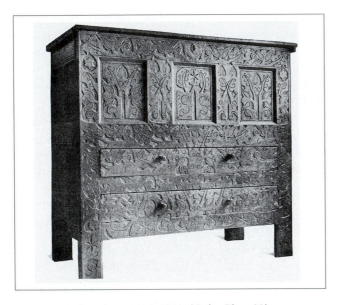

16-44. Hadley chest, 1690–1710. (Color Plate 39)

Design Spotlight

Furniture: *Connecticut or Wethersfield Chest.* This rectangular storage piece (Fig. 16-45), distinctive to New England, features a hinged storage area fronted with three panels over two rows of drawers. The panels have typical carved decoration with sunflowers and tulip patterns. Split spindles painted black ornament the stiles and provide a unique embellishment. The drawers may have geometric designs and/or oval bosses. Oak was the preferred material for construction.

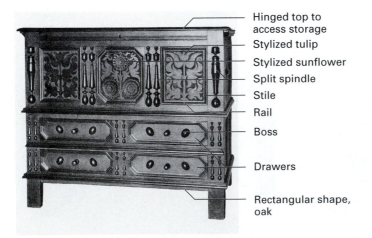

Hinged top to access storage
Stylized tulip
Stylized sunflower
Split spindle
Stile
Rail
Boss
Drawers
Rectangular shape, oak

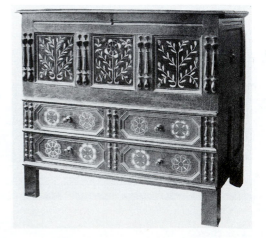

16-45. Connecticut Chests; Hartford, Connecticut.

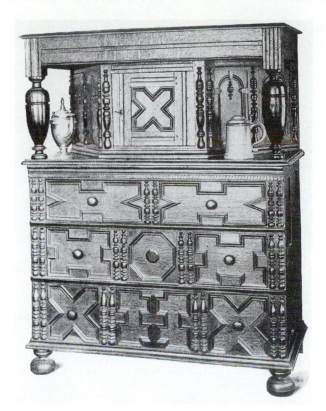

16-46. Press or Court Cupboard, 1675–1700.

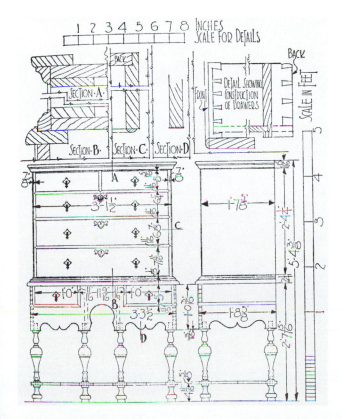

16-47. Highboy.

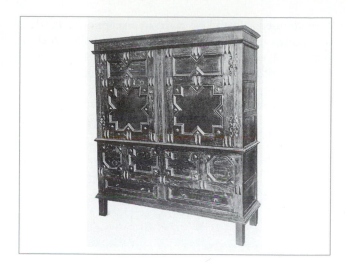

16-48. Oak clothes press, 1675–1700.

16-49. Looking glass with stumpwork embroidery, c. 1646.

16-50. Later Interpretation: Early American reproduction chair, 1990s.

ware are used. Most glass, with the exception of bottles, is imported from England. Tableware is usually wood or pewter. Silver is rare except in churches and wealthy homes. Most homes have at least one looking glass (mirror), which is small and simply framed. Only the wealthy have clocks, which rival bed hangings as the most expensive item in the home.

■ *Later Interpretations.* Some furniture forms continue in vernacular context, especially in more rural locations. A few reproductions of early pieces appear after the American Centennial celebration, but 18th-century furniture is more likely to be copied. Some pieces, such as ladder-back chairs, inspire Early American furniture (Fig. 16-50), beginning in the 1920s.

17. American Colonial: Spain

1600–1840s

The history of Spanish Colonial architecture, over a period of nearly 300 years, embraces a span of time nearly as long as the whole history of American architecture in other regions. The Spanish also differs from all other Colonial styles in its complete departure from the medieval.

Hugh Morrison, *Early American Architecture: From the First Colonial Settlements to the National Period*, 1952

More than other colonists, the Spanish adopt the local building traditions of their new land particularly in the southwestern United States and Florida, and they develop a distinctive regional architecture in their various colonies. No longer strictly medieval as elsewhere in the New World, Spanish Colonial architecture strives to follow contemporary Spanish Renaissance and, later, Baroque styles. Interiors and furniture are less current.

17-1. Costume.

HISTORICAL AND SOCIAL

Following the voyages of Christopher Columbus, Spain establishes her first colony in Santo Domingo, Hispanola (present-day Dominican Republic and Haiti) in 1496. By 1600, she has expanded her New World possessions into present-day Puerto Rico, Mexico, Latin America, Peru, and Chile. She also colonizes the present-day southwestern United States and Florida.

The earliest permanent settlement in the United States is at S. Augustine, Florida, founded in 1565. A military outpost, the city is sacked and burned several times, so only a few houses and other structures before 1740 survive. The British occupation between 1763 and 1783 further changes the character of the city as the English remodel and build new houses. At the end of the American Revolution, England formally returns Florida to Spain. Florida becomes part of the United States in 1821.

From the middle of the 16th to the 19th centuries, Spain dominates the Southwest. Colonization begins in New Mexico in the 1590s, followed by Texas in the 1680s, and Arizona and California in the 18th century. Spain cedes much of the southwest territory to the United States following the Mexican War in the 1840s. After gaining independence from Mexico in 1836, Texas becomes a separate nation until she annexes to the United States in 1845.

Unlike English settlements and other colonies, priests who seek to convert locals to Catholicism carry out much of the work of colonization particularly in Mexico and the Southwest. The Franciscans establish missions in Florida, New Mexico, and California, while the Jesuits do the same in Texas. In contrast, other colonizing Spaniards seek New World riches and envision a class system with Native Americans as peasants and themselves as nobles. The missions separate themselves from local Spanish governments, which are often exploitative, oppressive, and cruel. As a result, civil authorities have little effect on the development of mission architecture. Compared to the English colonies, the Southwest is sparsely populated. It also lacks the timber and natural resources found along the East Coast and in the central United States.

CONCEPTS

More than other colonists, the Spanish use impressive buildings to establish and emphasize individual, collective, or church authority and power. Unlike the buildings of the other colonies, which are largely medieval, Spanish buildings show influences from the Spanish Renaissance (Plateresque 1504–1556) and Baroque (Churrigueresque 1680–1780) periods. Building designers, who are often priests, are more aware of current architectural developments than are English colonists. However, these styles are interpreted in a provincial way as planners contend with local conditions, materials, and labor forces (mainly Native Americans). Thus, missions, in particular, develop a unique regional architectural style that combines Spanish and Native American traditions.

DESIGN CHARACTERISTICS

Characteristics derive from local materials, labor forces, and the intent and purpose of the structure. In churches and palaces, the Spanish interpret their heritage and strive for monumentality, large scale, symmetry, and applied surface decoration contrasting with plain walls. Although local materials and labor forces limit surface decoration, structures maintain elements of contemporary styles. Similarly, houses adapt to climate and materials, and interiors and furnishings follow Spanish prototypes. They generally are provincial or crude interpretations of contemporary styles, with the exception of imports. Overall, buildings and details lack Spanish unity and reflect Native American craftsmanship.

■ *Motifs.* Structures evidence Spanish Renaissance (including *Mudéjar* influences) and Baroque motifs as well as those that derive from the Native American culture. Typical features (Fig. 17-3, 17-4, 17-7, 17-9, 17-12, 17-13, 17-27) include towers, columns, *estípite* (broken pilaster composed of stacks of square balusters and a capital that tapers toward the base), niche-pilasters (pilasters whose shafts feature a niche with a figure and/or other elements), *zapatas* (bracket capitals), scrolls, garlands, swags, and foliated windows. Other motifs (Fig. 17-2, 17-10, Color Plate 41, 17-38, Color Plate 42), which are mainly evident in the decoration, include geometric shapes, concentric circles, colored stripes, floral and herringbone patterns, shells, animals, and various symbols.

17-2. Mexican design patterns.

ARCHITECTURE

Mission churches intend to impress new converts with the power and majesty of the Christian god and the Catholic Church. Each typically includes an adjoining cloister, *patios* (courtyard), living quarters, and assorted storehouses. Designs range from the unornamented geometric *adobe* forms of New Mexico and California to the domed and vaulted stone compositions with highly decorative portals in Texas and Arizona. California missions reflect the 19th-century Neoclassical style with a few classical elements evident. Always functional to support liturgical requirements, clarity of form dominates the style.

Each Spanish territory has a palace for the governor. It is typically larger and more prominently sited than other domestic buildings, but reflects the same design features. *Casas* (larger, more complex private dwellings) and smaller common houses in the Southwest emphasize protection from the harsh, arid climate and hostile attacks rather than

stylistic imitation. Materials and construction methods dictate a form that is unlike Spanish prototypes, although some characteristics, such as courtyards, are adapted. Structures have thick, plain *adobe* walls with no windows and focus inward to one or more *patios*. As the colonists become less fearful of attacks, porches, doors, and windows begin to punctuate facades. In 18th-century California, an Anglicized domestic architecture develops combining such English characteristics as pitched roofs and sash windows with Spanish *patios*, balconies, and tiles.

Florida dwellings combine Spanish characteristics, such as window grilles, with local materials and adaptations for a hot, humid climate. S. Augustine remains a military outpost with no civilian population or prosperity, so there is little to encourage elaborate private home building. Most larger homes date from the British occupation.

Public Buildings—New Mexico, Texas, Arizona, and California

■ *Types.* Mission and parish churches (Fig. 17-6, 17-9, 17-10, 17-12, 17-13, 17-14, 17-15, 17-16) are the main surviving building types in the United States; a few public

17-3. Cathedral of the Immaculate Conception, 1562–1664; Puebla, Mexico.

17-4. Cathedral, 1561–1598; Merida, Mexico.

17-5. Cathedral, 1563–1667; Mexico City, Mexico.

buildings are extant (Fig. 17-17). Churches (Fig. 17-3, 17-4, 17-5, 17-7), civic structures, and public buildings are more common in the Caribbean, Mexico, and Latin America.

■ *Floor Plans.* Church plans vary from simple elongated rectangles to the Latin cross. The *convento* (monastery) commonly adjoins the church, usually on the north side instead of the south as in Spain. An *atrio* (enclosed courtyard for burial grounds and outdoor services) is common in southwestern churches. United States examples do not ori-

ent to the east to allow maximum light for morning worship as in Europe.

■ *Materials.* Although stone is available, southwestern missions adopt the *adobe* (sun-dried clay brick of varying sizes; Fig. 17-6, 17-16) construction of the Native Americans who construct them. Wood is scarce and its use is limited to door and window frames and roofs. Typical woods available locally include pine, cottonwood, juniper, and red spruce. Other areas build exclusively in stone as in Spain. The stone churches in Mexico, Texas, and Arizona

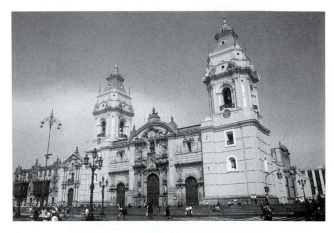

17-8. Cathedral, 1543–1551, rebuilt c. 1572, 1746–1750; Lima, Peru.

17-6. San Miguel Mission, 1610; Santa Fe, New Mexico.

17-7. Iglesia del Pilar, inaugurated in 1732; Buenos Aires, Argentina.

17-9. San Antonia de Valero (The Alamo), 1744–1777; San Antonio, Texas.

(Fig. 17-9, 17-10, 17-12), constructed by Spanish artisans with minimal local labor, follow more sophisticated construction methods using barrel and groin vaults and domes. Contrasting colors of stone, glazed tiles, or painted decorations (Fig. 17-10, Color Plate 41) highlight some facades as in Spain.

Adobe. The sun-dried clay brick of the Native Americans, known as *adobe*, is suitable to the climate, which is warm by day and cool at night. Instead of piling clay in layers in the manner of the Native Americans, the Spanish form rectangular bricks and lay them on top of one another. Then, the walls are plastered over with mud, which washes away over time and must be reapplied periodically, leaving rounded corners. Flat roofs are constructed on *vigas* (beams or logs) overlaid with *latias* (smaller beams or branches) and topped with mud. This construction method yields thick, massive walls, sometimes whitewashed, and simple geometric forms with little or no applied decoration other than painting.

17-10. San José y Miguel de Aguayo, 1768–1777; San Antonio, Texas; Pedro Huizar. The front facade rendering, completed in 1930s–1940s, is by noted San Antonio scholar Ernst Schuchard. (Color Plate 41)

17-11. Baptistery window detail, San José y Miguel de Aguayo; drawing by J. I. Arnold, published in *Pencil Points*, November 1930.

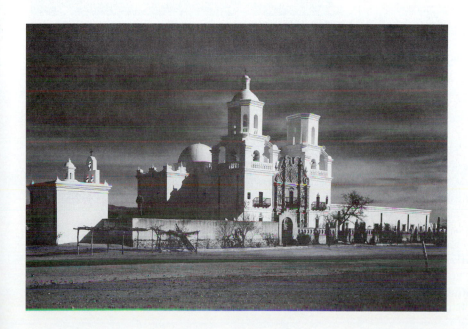

17-12. San Xavier del Bac, 1767–1797; near Tuscon, Arizona; by Ignacio Gaoma.

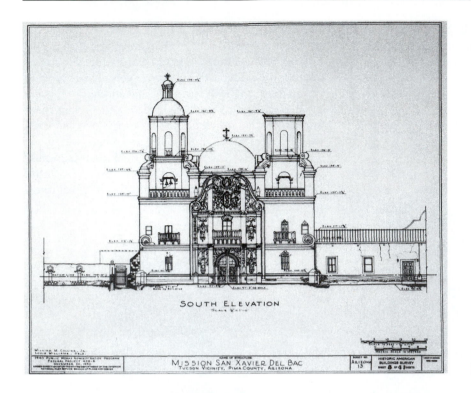

17-13. Front elevation, San Xavier del Bac, 1767–1797.

Design Spotlight

Architecture: *San Xavier del Bac.* As in the *adobe* mission, simple geometry defines the form and silhouette of this church (Fig. 17-12, 17-13), but the stone structure more closely resembles Spanish examples and is more sophisticated in design. Plain walls contrast with the surface ornament that concentrates at the entrance. Stringcourses and large volutes highlight the upper portions of the bell towers. The polychrome portal ornament, composed of figures, animals, scrolls, and naturalistic elements, is low in relief but crisply carved. *Estipites* identify the facade as Baroque. Also in the Baroque tradition is the close design relationship between the portal and the *retable* behind the altar inside.

17-14. San Diego de Alcala Basilica, 1774, rebuilt in 1803, 1812; San Diego, California.

■ *Facades.* Mission facades (Fig. 17-9, 17-10, 17-12, 17-14, 17-16) maintain a general Spanish/European appearance with towers, parapet walls, and surface decoration that contrasts with plain walls. They may combine Gothic, Islamic, Renaissance, and Baroque characteristics. Walls usually are plain and flat whether of *adobe* or stone and do not reflect the plasticity of the European Baroque style. *Adobe* walls may be battered (slanted). Glazed tiles or painted decoration representing them may highlight the stone walls as in Moorish Spain. Central windows mark the choir loft when present, and two bell towers usually

17-15. Santa Barbara Mission, 1786–1820 facade; Santa Barbara, California; Antonio Ripoll.

flank entrances and may serve as massive buttresses. In New Mexican churches, the wall between the towers sometimes has a balcony and extends above the roof to form a plain or shaped *espadaña* (parapet). In Texas, Arizona, California, Mexico, and South America, rich surface decoration concentrates at entrances with fenestration in the manner of high-style Spanish examples. California missions may mix classical details, such as pilasters, with various European ones, such as foliated windows or oval domes.

■ *Windows.* Most windows are rectangular casements or sashes, particularly in New Mexico. In Texas, Arizona, and California, elaborate quatrefoil or foliated windows highlight facades and emphasize important interior spaces such

as chapels (Fig. 17-11, 17-13). Most window reveals are deep due to construction materials, so the bright light filters softly in. Decorative *rejas* (iron or wooden grilles; Fig. 17-27) are often evident, particularly on important structures with strong Spanish Renaissance influences.

■ *Doors.* Doors are typically of carved wood (Fig. 17-26). Doorways are arched or rectangular with simple surrounds in New Mexico. In other areas, complicated carved and sometimes painted decoration surrounds entrances and extends to the roofline as in high-style Spanish prototypes. Motifs and carving generally are more intricate and refined in Mexico than in other areas. Carvings reflect Plateresque and Churrigueresque forms and motifs. Classical details, such as temple fronts or pilasters supporting an

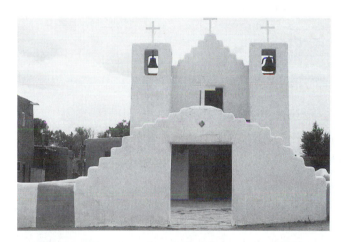

17-16. San Jerónimo Mission, after 1847, remodeled 1885, 1935, 1960s; Ranchos de Taos, New Mexico.

Design Spotlight

Architecture: *San Jerónimo.* Simple geometry resulting from *adobe* construction defines the form and silhouette of this mission church (Fig. 17-16). In the traditional European manner, the facade has two bell towers and a parapet roof. Because of the lack of materials and the limitations of local labor, there is no surface ornamentation typical of Spanish architecture. Plainness and clarity of form lend a dignity to the structure, which nevertheless intends to impress in the Baroque manner. Orange and white stripes divide the side facades into bays. The original mission church was destroyed in 1847.

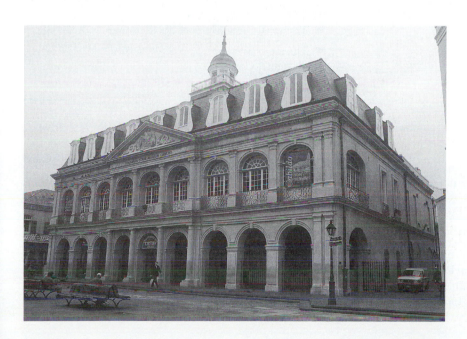

17-17. Cabildo (Town Hall), 1769–1801; New Orleans, Louisiana; by Gilberto Guillemard.

Important Buildings and Interiors

- **Acoma, New Mexico:** San Estevan, 1629–1642.

- **Acolman, Mexico:** Augustinian Church, 1560.

- **Buenos Aires, Argentina:** Iglesia del Pilar, inaugurated in 1732.

- **Carmel, California:** San Carlos Borromeo, 1793, Manuel Estevan Ruiz.

- **Congonhas do Campo, Brazil:** Cathedral, 1800–1805.

- **Laguna, New Mexico:** San José, c. 1700.

- **Lima, Peru:**
 —Cathedral, 1543–1551, rebuilt c. 1750.
 —Quinta de Presa, 1766.
 —Torre Tagle Palace, c. 1730.

- **Mexico City, Mexico:** Cathedral, 1563–1667.

- **Monterey, Mexico:** Cathedral, 1630–1800.

- **Monterey, California:**
 —Amesti House, 1824–1846.
 —Thomas Larkin House, 1835–1837.

- **New Orleans, Louisiana:** The Cabildo (Town Hall), 1769–1801, Gilberto Guillemard.

- **Oceanside, California:** San Luis Rey de Francia, 1811–1815, Antonio Peyri.

- **Ocotlán, Mexico:** The Sanctuary, c. 1745.

- **Puebla, Mexico:**
 —Cathedral, 1562–1664.
 —Casa del Alfeñique, c. 1780.

- **Querétaro, Mexico:** Ecala Palace, c. 1785.

- **Quito, Ecuador:** Mercedarian Monastery, c. 1630.

- **Ranchos de Taos, New Mexico:**
 —Kit Carson House, c. 1843.

 —San Francisco, c. 1780.
 —San Jeronimo Mission, after 1847; remodeled 1885, 1935, 1960s.

- **S. Augustine, Florida:** Oldest House, before 1727 with later additions.

- **San Antonio, Texas:** Governor's Palace, 1749.
 —Nuestra Señora de la Purisima Concepcion de Acuna, 1743–1755.
 —San Antonio de Valero (The Alamo), 1744–1777.
 —San José y San Miguel de Aguayo, 1768–1777, Pedro Huizar. (Color Plate 41)

- **San Diego, California:**
 —La Casa de Estudillo, c. 1829–1850s.
 —San Diego de Alcala Basilica, 1774, rebuilt in 1803, 1812.

- **Santa Barbara, California:** Santa Barbara Mission, 1815–1820, Antonio Ripoll.

- **Santa Fe, New Mexico:**
 —Governor's Palace, c. 1610, restored early 19th century.
 —Old adobe house, c. 16th century.
 —San Miguel Mission, 1610.

- **Santo Domingo, Dominican Republic:**
 —Cathedral, 1521–1541.
 —Columbus House, 16th–17th centuries. (Color Plate 42)

- **Taxco, Mexico:** Santa Prisca y San Sebastian, 1751–1558.

- **Trampas, New Mexico:** Santo Tomás, c. 1760.

- **Tuscon, Arizona:** San Xavier del Bac, 1767–1797, Ignacio Gaona.

entablature, mark the entrances of some California missions (Fig. 17-15).

- *Roofs.* Roofs are flat in *adobe* buildings, while stone structures have gabled or hipped roofs or domes. Early missions have thatched roofs, replaced later with fireproof red clay roof tiles, which become the standard treatment. The first fireproof roof tiles are developed in 1786 in San Luis Obispo, California.

- *Later Interpretations.* Spanish Colonial Revival begins in the 1890s with the Mission Style in California, but by the 1920s has spread to many parts of the United States and throughout Spanish America (Fig. 17-29, 17-31, 17-32). It continues as a popular style through the 1940s. Houses and resorts feature characteristics of Spanish Colonial missions, most notably the parapets, red clay tile roofs, and plain walls of the early missions. Some structures are literal copies of missions and include bell towers, but most simply feature tile roofs or roof parapets with complex curvilinear shapes.

Private Buildings—Mainly Southwest United States

- *Floor Plans.* For protection and distinctive of the Spanish influence, both *casas* and simpler dwellings have linear plans with a single row of rooms arranged on one side of or

around one or more *patios* (Fig. 17-23, 17-25). Houses expand based on wealth and need through the addition of independent rooms with no internal openings; circulation is mainly via a portal on one or more sides. Service areas and stables are behind the main *patio*. As colonists begin feeling more secure, houses become more outward looking with more windows, doors, and *corredores* (porches). California houses often have two stories on three sides that border a *patio*.

■ *Materials.* Southwestern dwellings and palaces are of *adobe,* while other areas use stone (Fig. 17-18, 17-19). The Spanish introduce wood-framed doors and windows, but use the beam-and-pole flat-roof construction of the Native Americans. Some very early houses and missions are half-timbered. In California, *adobe* ranch houses feature carved wooden grilles and balcony supports.

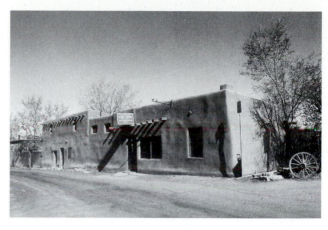

17-18. Old adobe house, c. 16th century; Santa Fe, New Mexico.

17-19. Columbus House, 16th–17th centuries; Santo Domingo, Dominican Republic.

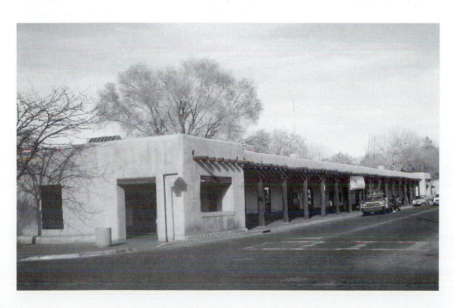

17-20. Governor's Palace, c. 1610, restored in 19th century; Santa Fe, New Mexico.

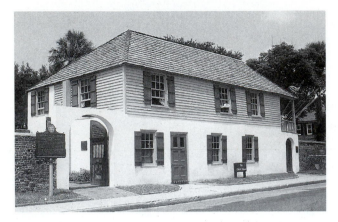

17-21. Oldest house, original house before 1727 with later additions; S. Augustine, Florida.

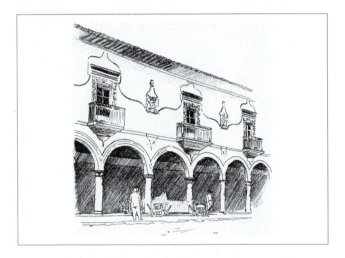

17-22. Casa de los Escudos, 18th century; Pátzcuaro, Mexico.

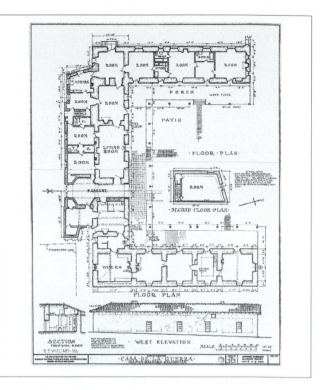

17-23. Floor plan, Casa de la Guerra, 1818–1826; Santa Barbara, California.

■ *Facades.* Early facades are plain with few windows and doors. Later examples (Fig. 17-19, 17-20, 17-22, 17-24) are more outward looking with windows, doors, porches, and portals with *zapatas*. *Adobe* dwellings have plain, unembellished walls that may be whitewashed (Fig. 17-18). *Vigas* (beams that support the roof; Fig. 17-20) may protrude through upper portions of walls and contrast in color to walls. Two-story facades in California feature wooden supports and carved brackets, as seen in the Thomas Larkin House in Monterey, California (Fig. 17-28), which reflects a local blend of folk traditions and *adobe* construction resulting in the "Monterey Colonial" style.

■ *Windows and Doors.* Casement windows appear first, but sashes replace them in the 18th century. Vertical plank exterior shutters are common in the 18th century. Doors (Fig. 17-26) are vertical planks or carved wood on grand houses. Borrowing from the Spanish tradition, decorative

rejas (Fig. 17-27) appear within and on the exterior of windows, and as gates for protection. Wood latticework also accents openings.

■ *Roofs.* *Adobe* houses have flat earth or *adobe* roofs or red clay tile roofs. Other houses have low-pitched roofs covered with red clay tiles. Some very early houses and missions have thatch roofs.

■ *Later Interpretations.* Spanish Colonial Revival (1890s–1940s) adopts characteristics from Spain and her colonies. Red clay tile roofs, plain walls, and surface decoration from Spanish sources typify the style (Fig. 17-30). Pueblo Revival (1910–present) copies the flat roofs, plain walls, and geometric shapes of *adobe* buildings. California architect Irving Gill is an early advocate of this style. The Monterey style (1920s–1950s) copies the balconied houses of 18th-century California.

Private Buildings—Florida

■ *Site Orientation.* Both common and luxurious houses (Fig. 17-21) front on the street and orient to catch breezes. Instead of front doors, entrances at the side of the house lead to rear *patios* with separate kitchens, other outbuildings, and service areas. The English introduce front entrances.

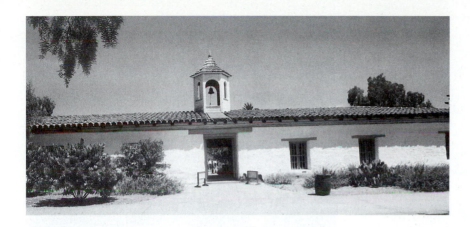

17-24. La Casa de Estudillo, 1829–1850s; San Diego, California.

Design Spotlight

Architecture: *La Casa de Estudillo.* Built c. 1829–1850s for the former commander of the San Diego Presidio, this house (Fig. 17-24, 17-25, 17-40, 17-41) exemplifies the character of the Spanish Southwest during California's Mexican period. Sited on the Plaza de Las Armas (located in Old Town San Diego), it has plain *adobe* brick whitewashed walls, *vigas* supporting a red clay tile roof, carved wooden doors, and horizontal wooden lintels over the window openings. The **U**-shaped floor plan features rooms opening directly to each other and to the *corredores*, which surround the *patio*. The *sala* (main family room) reflects the wealth and social status of the owners, while the kitchen area illustrates the utilitarian aspects of daily life.

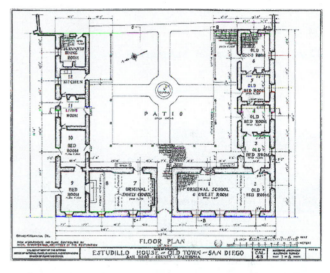

17-25. Floor plan, La Casa de Estudillo.

17-26. Doors from Cuernavaca, Pátzcuaro, and Puebla in Mexico.

17-27. *Reja* (iron grille) from Mexico.

17-29. Later Interpretation: Approach over the Puente Cabrillo, San Diego World's Fair, 1915; San Diego, California; by Bertram Goodhue; Spanish Colonial Revival.

17-28. Thomas Larkin House, 1835–1837; Monterey, California.

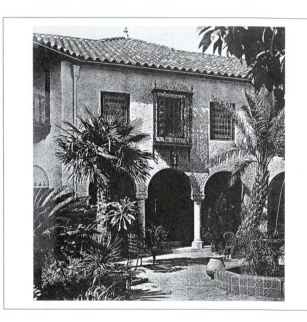

17-30. Later Interpretation: D. T. Atkinson House, 1930; San Antonio, Texas; published in *Pencil Points*, July 1930.

■ *Floor Plans.* From settlement onward, the majority of houses have one story and one room. Grander homes are two or more rooms wide and two stories high. At the rear runs a *loggia* (two-story porch) with a staircase. All rooms open onto the porch.

■ *Materials.* Houses are built of tabby (lime mortar with oyster shells) or *coquina* (a more permanent material of shell stone) and whitewashed. Doors, balconies, and *rejas* are of dark, carved wood. Spindlework commonly embellishes staircases.

■ *Facades.* Later facade examples are plain with numerous doors and windows opening to a *patio*. Walls are often whitewashed to prevent mildew. After the British occupation, details may be painted dull blue, red, or yellow ochre.

■ *Windows and Doors.* Windows on lower stories sometimes project onto the street. In place of glass, they have wooden *rejas* and interior shutters as in Spain. Second stories often have balconies on larger houses. The British introduce sash windows and outside shutters. Doors are

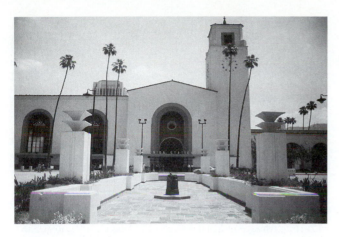

17-31. Later Interpretation: Union Station, 1939; Los Angeles, California; by John and Donald Parkinson, J. J. Christie, H. L. Gilman, R. J. Wirth; Spanish Colonial Revival.

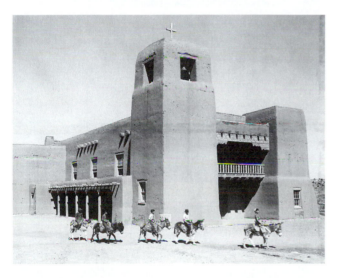

17-32. Later Interpretation: Cristo Rey Church, 1940; John Gaw Meem; Santa Fe, New Mexico.

vertical planks or of carved wood. Decorative iron grilles are popular.

■ *Roofs.* Hipped roofs are of thatch (early) and cypress shingles.

INTERIORS

The theme of many public and private interiors is contrast—of colors, shapes, light and dark. Church interiors often contrast voluminous spaces with plain walls, decorative paintings, and complex carved *reredos* (altarpieces). Some use such Baroque devices as light, sculptures, paint-

ings, and architecture to impress or inspire. Interiors of houses usually have whitewashed walls, dark wood trim, and dirt or wooden floors. They are sparsely but luxuriously furnished and display decorative arts.

Public Buildings

■ *Relationships.* In contrast to plain exteriors, interiors of southwestern churches often have wall and ceiling painted decorations and fancy *reredos*, like Spanish prototypes (Fig. 17-36).

■ *Materials.* Texas, Arizona, California, and Mexican stone churches use barrel and groin vaults and domes at crossings and at the arms of transepts (Fig. 17-35). They may use pilasters, engaged columns, and moldings to articulate and accentuate the architecture.

■ *Color.* Contrasting colors of different types of stone may accent architectural features. Nearly all churches have some decorative paintings on walls, ceilings, vaults, domes, and/or pendentives when present. Colors, such as red, yellow, blue, and green, are highly saturated. Paintings include Native American symbols, geometric shapes, floral patterns, and combinations of Catholic iconography.

■ *Lighting.* Designers use the Baroque device of indirect and unexpected light sources to create drama and mystery in churches. In the upper Rio Grande valley, naves usually have concealed transverse clerestory windows—long, narrow windows near the ceiling—from which light floods the interior at various times of the day. Similarly, churches in other areas feature windows in the drums of domes and

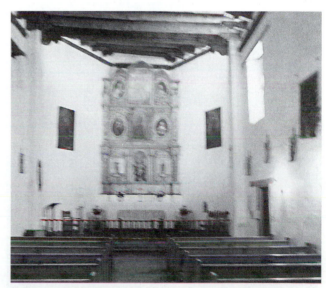

17-33. Nave, San Miguel Mission, 1610; Santa Fe, New Mexico.

upper portions of ceilings that allow a mystical light to permeate interiors (Fig. 17-37). Artificial lighting (Fig. 17-44) includes a *corona* (single or tiered iron or wood chandelier), which hangs in churches and important rooms in public buildings; *torcheres* (floor candle stands); *braccios* (wall-mounted bracket lights typically of iron); and *lanternas* (lanterns with metal frames).

■ *Floors.* Floors may be of stone, hard-packed earth, or unglazed clay tiles.

17-36. Nave, San Miguel Arcángel Mission, 1797; near San Isabel, California.

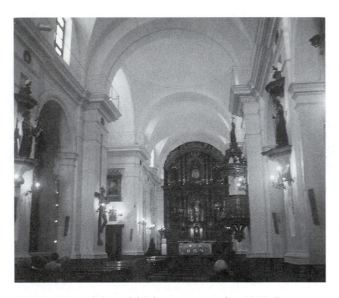

17-34. Nave, Iglesia del Pilar, inaugurated in 1732; Buenos Aires, Argentina.

17-37. Nave, San Diego de Alcala Basilica, 1774, rebuilt in 1803, 1812; San Diego California. This was the first mission to be built in California.

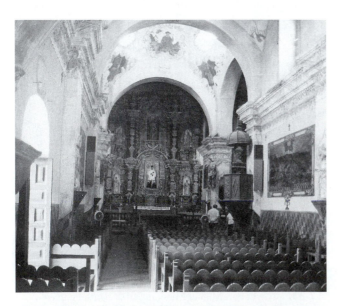

17-35. Nave, San Xavier del Bac, 1767–1797; near Tuscon, Arizona.

Design Spotlight

Interior: *San Xavier del Bac.* The interior (Fig. 17-35) is Baroque in intent although the execution is primitive. Beneath the foliated windows of the dome are paintings of saints in flat patterns of red, green, yellow, and blue. Architectural details highlight the dome and springing of the arches. In contrast to the flat paintings are the transept and chancel walls, which feature polychrome sculptures. *Estipites*, arches, and an entablature divide the space into two levels of three panels and relate in design to the exterior portal. Within the frame, complex and exaggerated carvings extend out of and within the architectural framework creating a three-dimensional, crowded interplay of texture and color. The central panels feature the Virgin Enthroned and S. Xavier. Despite a somewhat crude execution, the fanciful effect is typical of high-style Spanish Baroque.

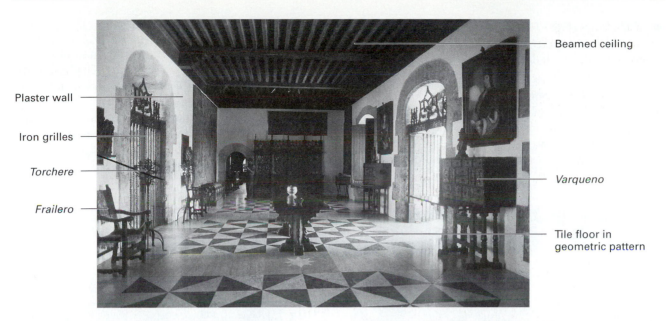

Beamed ceiling

Plaster wall

Iron grilles

Torchere

Frailero

Varqueno

Tile floor in geometric pattern

17-38. Entry, Columbus House, 16th–17th centuries; Santo Domingo, Dominican Republic. (Color Plate 42)

17-39. *Sala*, Governor's Palace, 1749; San Antonio, Texas.

17-41. Kitchen, La Casa de Estudillo.

17-40. *Sala*, La Casa de Estudillo, 1829–1850s; San Diego, California.

17-42. Kitchen, Kit Carson House, c. 1843; Taos, New Mexico.

■ *Walls.* Walls (Fig. 17-33, 17-34, 17-35, 17-37) may be of plaster, *adobe*, or stone. Some feature murals of Christian subjects, architectural details, and/or decorative paintings.

■ *Ceilings.* Heavy cross beams or logs supported by carved wooden brackets compose ceilings in New Mexican churches (Fig. 17-33, 17-43). Between beams and placed at a diagonal are smaller logs or poles, which may be painted in bands of red, yellow, white, and black. Some Mexican churches feature high-style ceiling paintings in the European Baroque manner.

Private Buildings

■ *Types.* The main spaces in the larger homes are the *sala*, chapel, dining hall, and bedchamber. The *sala* (main reception room, on the street side of the house in Florida) is furnished and decorated to impress (Fig. 17-39, 17-40). *Adobe* houses may have built-in seating. Main bedchambers are often located near the entry or open to the *patio*. Kitchens (Fig. 17-41, 17-42) are simple and usually feature a fireplace and a wooden table.

17-43. Ceiling details showing *vigas* and brackets.

17-45. Later Interpretation: Dining room, Casa Flores, c. 1920s; Pasadena, California.

17-44. Lighting fixture: *Lanterna.*

17-46. Later Interpretation: Ticket room, Union Station, 1939; Los Angeles, California; by John and Donald Parkinson, J. J. Christie, H. L. Gilman, R. J. Wirth; Spanish Colonial Revival.

■ *Relationships.* In contrast to the often plain exteriors, interiors may have colorful, luxurious furnishings.

■ *Materials.* Until the British occupation, S. Augustine, Florida, houses have no fireplaces but are heated with charcoal *braziers.* Conical, corner fireplaces are typical in the Southwest (Fig. 17-42).

■ *Lighting.* Iron, brass, or silver chandeliers and candle stands, and iron *torcheres* provide light (Fig. 17-42).

■ *Floors.* Hard-packed dirt or clay or unglazed clay tiles are typical for lower floors even in wealthy houses (Fig. 17-38). If there are upper floors, they are of wood planks.

■ *Walls.* White walls (Fig. 17-38, Color Plate 42, 17-39, 17-40, 17-41) are of plaster, *adobe,* or stone. Rarely are they decorated with architectural details or paintings except in palaces. Dark wood beams, trim, and furniture contrast with whitewashed walls. Plain or decorative tiles may embellish baseboards, steps, and sometimes kitchen walls.

■ *Textiles.* Trade with the United States brings more textiles into the Spanish American colonies in the early 19th century. Calico commonly covers the lower portions of walls to prevent whitewash from rubbing off on people sitting on built-in benches. *Jergas,* flat woven woolen rugs in a twill weave with two colors, also become common in the 19th century.

■ *Ceilings.* Beamed ceilings (Fig. 17-38, Color Plate 42) are typical and may feature painted and gilded decorations. *Vigas* are common in *adobe* structures, particularly southwestern Spanish governor's palaces (Fig. 17-39, 17-43).

■ *Later Interpretations.* All versions of Spanish Colonial Revival (Fig. 17-45, 17-46) copy the white walls, dark woods, glazed tiles for walls and floors, and wrought iron of the originals.

FURNISHINGS AND DECORATIVE ARTS

Numerous original Spanish Renaissance furniture pieces and decorative arts accompany missionaries and settlers to Florida, Texas, New Mexico, Arizona, California, Mexico, and other Spanish American colonies. As individual mission sites expand, furniture and artistic production becomes the responsibility of Native Americans or local craftsmen guided by the local priests. This relationship is similar to the crafts guilds of the Middle Ages. As a consequence, colonial furniture follows Spanish prototypes because there are no Native American examples. This image is more vernacular and provincial and cruder than Spanish precursors, reflecting simplicity in form and decoration. Forms and supports are rectilinear. Decoration is painted or shallowly carved. Spindles are carved and often flat instead of turned. Following the opening of the Santa Fe trail in 1821, English influences appear in form, construction, and decoration.

■ *Types.* Typical furniture examples imitate those of the Spanish Renaissance and include seating, chests, tables, and beds (see Chapter 13, Spanish Renaissance, furniture).

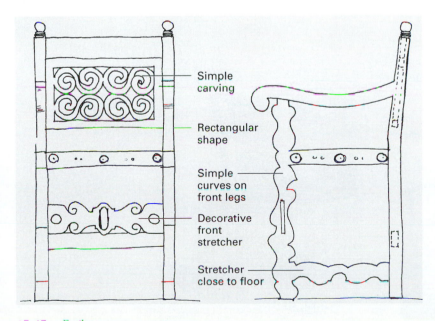

Simple carving

Rectangular shape

Simple curves on front legs

Decorative front stretcher

Stretcher close to floor

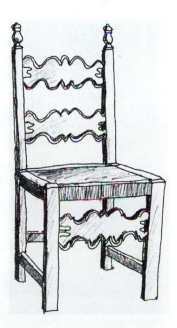

17-47. *Fraileros.*

17-48. *Equipal.*

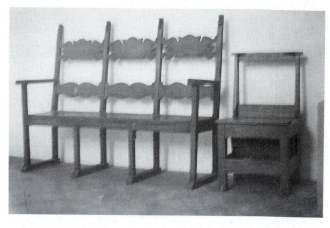

17-49. Settee.

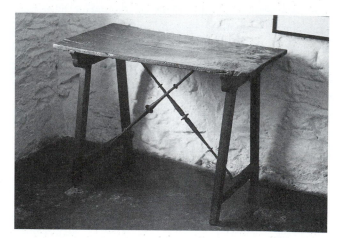

17-50. Table.

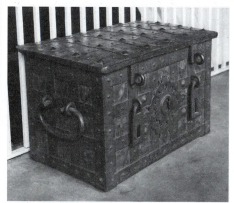

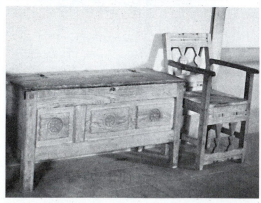

17-51. Chests.

17-52. Confessional, El San Tuario del Senor Esquipula, 1816; Chimayo, New Mexico.

- *Materials.* Colonial furniture is typically of yellow pine or some other local wood. Board construction for chests and case pieces continues well into the 19th century, long after it is outdated in English settlements.

- *Seating.* Chairs and benches are the most common forms of seating. The Spanish *frailero* (rectangular arm- and side chair; Fig. 17-47) develops a simpler design than the original version, with stretchers close to the floor and joining legs for stability. They are often grouped around tables.

The *equipal* (a chair with a circular seat supported by a cylindrical base of cedar splits; Fig. 17-48) was a popular chair in Mexico, particularly on *patios*. Long wooden benches (Fig. 17-49) have plank or spindle backs.

- *Tables.* Wooden tables with rectangular tops and iron supports are typical throughout *casas* and simpler houses. Most follow Spanish precursors and have curved or straight legs (Fig. 17-38, 17-50).

- *Storage.* The most important storage pieces are the chest (Fig. 17-51), *amario* (wardrobe), and *varqueño* (a drop-front cabinet on a base, used for writing or to hold documents; Fig. 17-38).

- *Beds.* Spanish Colonial beds are simple, plain, and utilitarian with little of the heavy decoration seen in the Spanish Renaissance examples. Beds in palaces are often of Spanish Renaissance origin or are later copies of the period.

- *Textiles.* The local craftsmen and Native Americans provide textiles to decorate beds and for wall hangings, as well as rugs for floors. Textile use is limited until trade with the East Coast and the Orient increases availability.

- *Decorative Arts.* The decorative arts display a fusion of Spanish and Native American characteristics. Accessories may be of Spanish Renaissance origin, made by local settlers, or produced by Native American craftsmen.

- *Later Interpretations.* Spanish Colonial furniture revives in the Spanish Colonial Revival style, and in the Mediterranean style of the 1960s–1970s.

18. American Colonial: France

17th–late 19th centuries

In the summer the walls are perfectly shaded from the sun and the house kept cool, while the passages are also shaded from the sun and protected from the rain. . . . These one-storied houses are very simple in plan. The two front rooms open into the street with French glass doors. Those on one side are the dining and drawing rooms, the other chambers. . . . The French and Continental Europeans generally live, I believe, as much to their own satisfaction in their houses as we do in ours, and employ the room they have to more advantage because they do not require so much space for passages.

Benjamin Henry Latrobe, New Orleans travel notes of 1819

From *The Art of the Old South—Painting, Sculpture, Architecture, & the Products of Craftsmen, 1560–1860*, Jessie Poesch, 1989.

France, England, and Spain are the three great world powers of the 17th century. France possesses more land in the New World than England, but like Spain, she colonizes only a small portion of it. French settlers, as others, recreate the society, homes, and furnishings of the mother country. Buildings and interiors are largely simple, but furniture borrows from 17th- and 18th-century French sophisticated (high-style) pieces. Although France loses her North American lands in the 18th century, French influence in architecture, interiors, and furniture remains in Canada, Louisiana, and pockets in the Mississippi River Valley.

HISTORICAL AND SOCIAL

France establishes Quebec in 1608, a strategic location at the mouth of the S. Lawrence River and gateway to the interior of the United States. For the next 75 years, she increases her holdings along the S. Lawrence River and Great Lakes and extends her territory through the entire Mississippi River Valley. Her holdings are complete in 1682 when René-Robert Cavelier (sieur de La Salle) arrives at the mouth of the Mississippi and claims all the land along the river and its tributaries for France. He

names the vast region *Louisiane* to honor King Louis XIV. France establishes forts to secure the Gulf of Mexico coast area at Biloxi (in present-day Mississippi) in 1699 and Mobile (in present-day Alabama) in 1702, and founds New Orleans in 1708.

France settles only a small part of her territory. Military outposts and small settlements dot the landscape, primarily along waterways: the S. Lawrence River, the Great Lakes, and the Mississippi River and its tributaries. Unlike England, France does not encourage large numbers of settlers, choosing instead to send armies and administrators to the New World to establish and maintain the absolutist policies of the Crown. Consequently, the French eagerly engage in fur trapping and trading with Native Americans and do not drive them from their lands. In the middle of the 18th century, only one in thirty colonists in the French territories is French; the rest are English.

Many of the first French settlers in Canada are fur traders, trappers, and missionaries. The territory known as New France is originally controlled by trade companies who do not encourage settlement. To foster a New World empire, Louis XIV takes charge of New France in 1675 and institutes changes to encourage stability, prosperity, and settlement. He tightens regulations for land grants, gives concessions to the Church, and attempts to encourage trade. He increases the practice of granting large parcels of land along the S. Lawrence to *seigneurs* (male landholders) who promise to populate it with *habitants* (tenant farmers) who agree to build homes and cultivate the land.

As a royal colony, Louisiana struggles financially and from lack of support and contact with France. In 1724, she comes under the control of a company headed by Scotsman John Law. His promotional schemes bring in many colonists, but word of the harsh conditions in the colony quickly discourages other settlers. In 1731, Louisiana again becomes a royal colony.

Society in New France is much like that at home. The governor, deputy governor, military officials, and *seigneurs* constitute a wealthy noble class. Merchants, military personnel, artisans, and the clergy are in the middle, with traders and tenant farmers at the bottom. Other French settlers include a large number of Huguenots (Protestants) who are driven out of France in 1685 when the Edict of Nantes is revoked, making all public worship illegal except

for the Roman Catholic faith. The Huguenots settle in Canada, Massachusetts, New York, and South Carolina. Many are excellent artisans and craftsmen. Subsequently, England deports many *Acadians* (French Canadian settlers who refuse to swear allegiance to England) from Nova Scotia in 1755. A group settles in the Louisiana frontier west of the Mississippi. *Cajuns*, as they are known, become the dominant ethnic group in the region.

France and England struggle with each other for control of Europe and North America. France, although the most powerful nation in Europe, cannot maintain her colonies and territories. A series of small conflicts beginning in 1686 culminates in the French and Indian War, fought from 1754 to 1763. These conflicts cause France to give up her New World possessions. In 1762, she gives Louisiana to Spain as an incentive to enter the war as a French ally. In the Treaty of Paris that ends the French and Indian War, France loses the rest of her North American possessions, giving Canada and her lands east of the Mississippi River to England. Spain receives French holdings west of the Mississippi in return for giving Florida to England. She keeps the area of Louisiana around New Orleans.

CONCEPTS

Architecture, interiors, and furnishings in New France closely resemble those in France and derive from the settlers' classes and regions of origin, some being more vernacular and others being more high-style. Forms and construction techniques are similar throughout the colony with the exception of adaptations to local climates and needs, which result in distinctive regional characteristics. Evidence of a collective European heritage appears in selected areas, with a particularly medieval peasant community apparent in Quebec. Along the Mississippi River Valley and in Louisiana, structures present a strong vernacular image, while in New Orleans the character is more sophisticated. Gradually, however, this becomes less apparent, as French colonies are not as heterogeneous as others. After the British take over Canada, buildings and furnishings illustrate more English influences and characteristics. When the Spanish leave New Orleans, building plans and designs often articulate the cultural characteristics of both Spain and France with influences from the West Indies.

DESIGN CHARACTERISTICS

Surviving domestic architecture reflects medieval design principles such as verticality, honest use of materials, evidence of structure, and function over style. Steeply pitched roofs, half-timber construction, and square shapes are common French characteristics. In the second half of the 17th

18-1. Motifs and patterns.

18-2. Decorative details.

century, French-influenced buildings become more outward looking than those of other colonies, with porches and large windows and doors. Some shared characteristics, such as flared-eave (double-piched roof with extending eaves) are evident. Furniture follows the French styles of Louis XIII, Louis XIV, and Louis XV. Usually, it is simpler in form, design, and decoration than high-style examples. Marquetry, veneers, and gilding are rare.

■ *Motifs*. Motifs (Fig. 18-1, 18-2) derive from French or folk traditions. Those found mostly on furniture and wall paneling are diamonds (diamond points), lozenges, shells, fruit, flowers, vines, stars, pinwheels, sunbursts, rosettes, crosses, local animals such as the beaver and caribou, trees, scrolls, and S curves.

ARCHITECTURE

French settlements encompass a range of climates from frigid to tropical with architecture adapting in both materials and construction. Overall, a medieval appearance

18-3. Villeneuve House, c. 1700; Charlesbourg, Quebec, Canada.

18-4. Marcotte Homestead, c. 1745–1750; Cap Santé Village, Quebec, Canada.

characterizes all settlements until the 18th century. There are only a few French colonial buildings because there are only a few French settlers. The chief house type—small, with a hipped roof, and with and without a porch—appears from Canada to New Orleans. Construction is similar in all colonies until methods more suitable to particular climates develop.

Private Buildings

■ *Types.* Although sharing construction methods and some characteristics, French colonial architecture develops several house types related to particular areas.

Quebec and French Canadian Wood or Stone Houses. Typical houses (Fig. 18-3, 18-4, 18-5) are square or nearly so, with one or one and a half stories and steeply pitched roofs with or without dormers. Earliest dwellings are *colombage* (half-timbered) in the medieval tradition.

18-5. Acadian House, c. 1830s–1850s; Winnepeg, Manitoba, Canada.

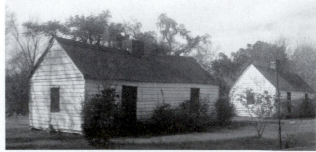

18-6. Double pen log house, Magnolia Plantation, c. mid–late 18th century; near Charleston, South Carolina.

Pièce-sur-pièce (log or wood construction) replaces half-timbering in the second half of the 17th century; it is more common in western Canada. Readily available, wood is inexpensive and offers good protection against the cold. However, because it is a fire hazard, stone gradually replaces it. Most stone houses are white-washed with the trim brightly colored. Although based on prototypes in Anjou, Normandy, and Brittany, Canadian houses adapt to a colder climate with thicker walls, board or shingle roofs, and storage instead of

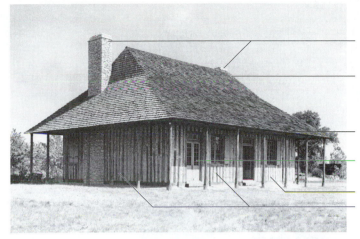

Few chimneys

Steep, double pitched roof with shingles and large overhang

Wood post supports overhang

French door with wood panel at base

Galerie (porch)

Poteaux sur sole construction

18-7. Cahokia Courthouse, 1737; Cahokia, Illinois.

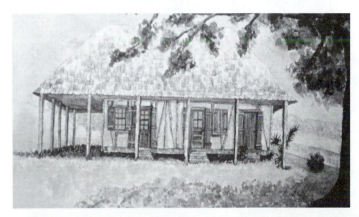

18-8. Aubin Roque House, c. 1750s–1770s; Natchitoches, Louisiana; by Augustus Metoyen.

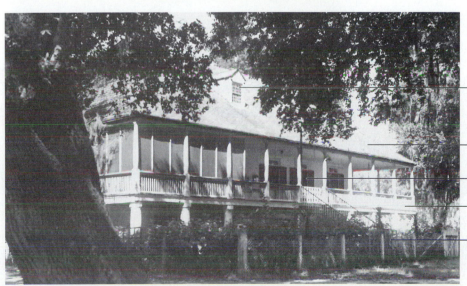

Dormer window

Steeply pitched hipped roof with overhang to shield sun on *galerie*

French doors with shutters

Galerie surrounds house on main living area

Service area on ground/first floor (like a raised basement)

18-9. Parlange Plantation, 1750; New Roads, Louisiana.

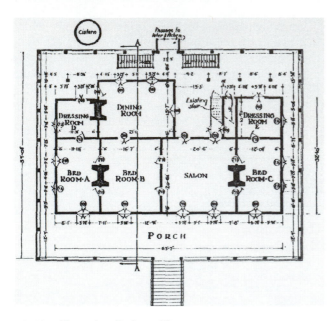

18-10. Floor plan, Parlange Plantation.

sleeping in upper stories. Variations beginning in the 19th century include porches, flared-eave or bell-cast roofs (see Chapter 19, American Colonial: Germany and Holland), and three stories separated by function. Farm and service areas are in basements with living

Design Practitioners

■ *Jean B. Cambus* and *Jean Baptiste Ortes* come from France and settle in S. Louis in the middle of the 18th century. Partners and cabinetmakers, they bring knowledge of prevailing styles in France to the New World.

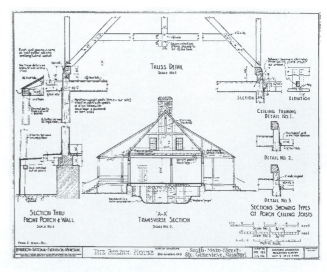

18-11. Houssaye House (Acadian House), Longfellow-Evangeline State Park, 1765; S. Martinsville, Louisiana.

Design Spotlight

Architecture: *Parlange Plantation.* Reflecting a raised basement construction type, Parlange Plantation (Fig. 18-9, 18-10) in Point Coupee Parish is the oldest surviving plantation house in Louisiana. It expresses the ambience of the vernacular Creole character on the exterior and some of the refinement of the French aristocracy on the interior. Vincent de Ternant, a French marquis, built the house in 1750 along False River. It is constructed of brick on the first or ground floor and mud and cypress on the second floor. A *galerie* surrounds both floors and serves as an extension of the living and service areas. As is typical of this house type, the ground floor supports service areas such as a wine cellar and food storage. The second floor, which really serves as the French first floor, features the main public and private living spaces and has French doors that open all around to catch the cool breezes from the river. The floor plan has some elements of symmetry, except for the arrangement of the central *salle* (parlor) and dining and *chambre* (sleeping) areas. The interior architectural features relate to the vernacular character of the exterior, but the furnishings reflect examples of sophisticated French Louis XIV and XV court pieces and American Empire, as well as a simple Louisiana Creole style.

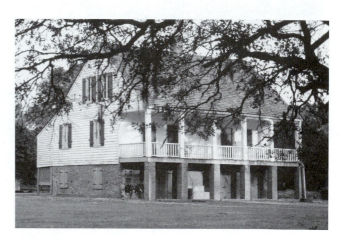

18-12. Section, Louis Bolduc House, c. 1770, 1845; S. Genevieve, Missouri.

areas on first floors and sleeping areas above. Homes of the wealthy are similarly constructed but larger with more rooms.

French Log Houses. Common in the Mississippi River Valley but found throughout the colony, the earliest examples of log houses (Fig. 18-6, 18-7, 18-8) have logs set *poteaux en terre* (vertically in the ground). Later types set logs *poteaux sur sole* (vertically into a sill; Fig. 18-7, 18-12). Logs are cut flat on two sides to form inner and outer walls, and the spaces between are filled with *bouzillage* (a mixture of grass and clay, which is called wattle and daub in England; Fig. 18-8) or *pierrotage*

(stone and clay). In Louisiana, this type is often referred to as a Creole cottage (Fig. 18-21, 18-22). It may not have been known in France. Some houses have surrounding porches or porches only on the front. Hipped roofs have steep single and steep double pitches. Wooden or brick pillars raise some houses off the ground particularly where moisture or flooding are concerns.

New Orleans Houses. Many French town houses and cottages in the city are *colombage sur sole* (half-timber construction; Fig. 18-13, 18-16) with spaces between timbers *briquéte-en-poteaux* (filled with brick and clay; Fig. 18-15) like those in France. Others are mainly of

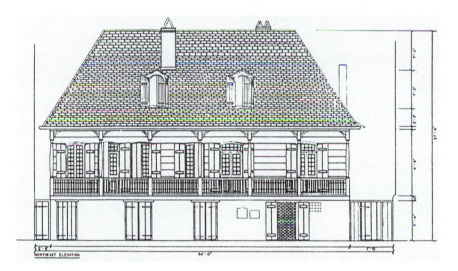

18-13. Front elevation, Madame John's Legacy, 1788; New Orleans, Louisiana; by Robert Jones.

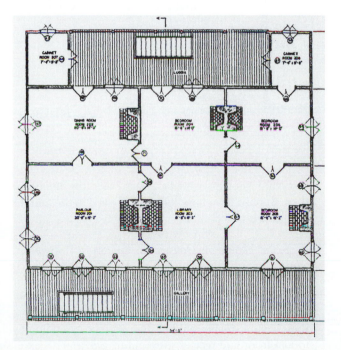

18-14. Floor plan, Madame John's Legacy.

18-15. Detail, *briquéte-en-poteaux* construction.

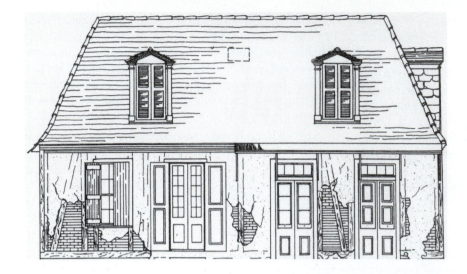

18-16. Front elevation, Lafitte's Blacksmith Shop, 1772–1791; New Orleans, Louisiana.

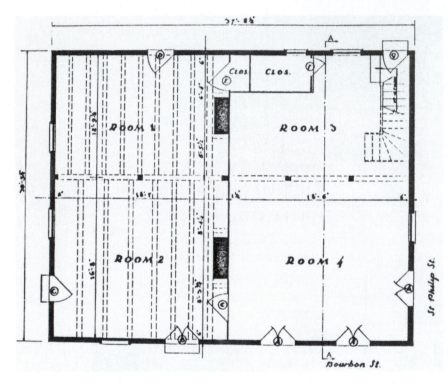

18-17. Floor plan, Lafitte's Blacksmith Shop.

Design Spotlight

Architecture: *Lafitte's Blacksmith Shop.* Located in the famous Vieux Carré (French Quarter), Lafitte's Blacksmith Shop (Fig. 18-16, 18-17) epitomizes the New Orleans *colombage sur sole* (half-timber construction). Spaces between cypress timbers are *briquéte-en-poteaux* (filled with brick and clay) with plaster covering the facade. Small in scale, the building is sited on a corner and reflects a vernacular image. The irregularly spaced French doors in the front open directly onto the streetscape. The hipped roof has dormer windows. Within, the floor plan divides in half to accommodate living quarters on one side and a shop on the other. Originally, both of these areas were subdivided.

brick construction. Many (Fig. 18-13, 18-24) are plastered and whitewashed or covered with boards. French doors opening to the street are common. Cottages (Fig. 18-30) have hipped or gable roofs that extend to protect the walls from sun and rain. Town houses may have two or three stories (Fig. 18-25, 18-26), which often include shops on the lowest floor. Shopkeepers live in a small *entresol* (intermediate story), and the owner lives on the third floor. Town houses enclose courtyards as living spaces away from the street. Many contain utilitarian spaces such as stables, kitchens, wash buildings, and servants' quarters. Access is on the side. Later houses have

cast- and wrought-iron lacework balconies, many of them shipped from New York and applied in the mid- to late 19th century.

Louisiana Plantation Houses. A late colonial development, plantation houses (Fig. 18-9, 18-10, 18-11, 18-23, 18-29) feature two stories and exterior stairs. As an adaptation to a warm, moist climate and probably derived from French Caribbean (Creole) influences, they have a steeply pitched hipped roof extending to form a front and rear or surrounding *galerie*. This exterior living space offers cool breezes and protection from

the sun to interior second-story *salle* or *salon* (parlor) and *chambre* (sleeping) areas. Access to the interior is through large French doors or windows. Architectural openings generally align on an axis to allow air to filter across rooms and throughout the interior. Dining, storage, and servant spaces are typically on the ground or first floor. The type is also known as a raised cottage.

Acadian (Cajun) Cabins or Houses. Typically small and of unpainted cypress, these houses (Fig. 18-20) have gable roofs that extend to form a front porch. Many have two French doors on the front and stairs on the porch. They may have one or one and a half stories with two rooms only or two rooms in front and two in the back. Chimneys that are within the walls may be of mud and sticks. Probably a Creole type unknown in Acadia, the form is largely identified with Louisiana Acadians or *Cajuns.* It is limited to urban and rural French south and central Louisiana (Fig. 18-18, Color Plate 43, 18-19) and is most often found along bayous and rivers.

■ *Floor Plans.* Early plans (Fig. 18-17) in all areas have one or two rooms with a central chimney and one or one and a half stories. Later plans, particularly in Louisiana, have two or three rooms across and are one or two rooms deep (Fig. 18-10, 18-14). The front rooms typically include a *salle* or *salon* and *chambre.* There are no interior hallways, but large windows and French doors open to porches or *galeries.* Some rural and urban houses (Fig. 18-27, 18-28) have a rear *cabinet* (an open loggia flanked by a room at each corner). Chimneys are on the ends or within walls. In Louisiana, urban and large rural or plantation houses may be raised off the ground up to the height of a story. Lower

18-20. Cajun cabin, late 18th–early 19th century; Cheneyville, Louisiana.

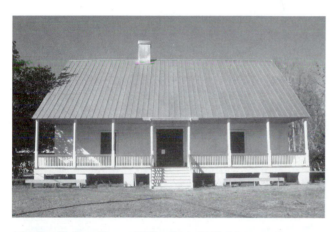

18-18. Defosse House, 1790, rebuilt 1850; Mansura, Louisiana. (Color Plate 43)

18-19. Hypolite Bordeleon House, 1790–1820; Marksville, Louisiana.

18-21. Creole cottage, late 18th–early 19th century; Jonesville, Louisiana.

Important Buildings and Interiors

- **Alexandria, Louisiana:** Kent Plantation House, 1796.

- **Austin, Texas:** The French Legation, 1841.

- **Baton Rouge, Louisiana:** Magnolia Mound Plantation, late 18th century.

- **Beauport, Quebec:** Girardin House, c. 1650s–1670s.

- **Cahokia, Illinois:** Cahokia Courthouse, 1737.

- **Cap Santé, Quebec:**
 —Gérard Moirsset House, c. 1696.
 —Marcotte House, c. 1745–1750.

- **Charlesbourg, Quebec:** Auclair-L'Heureux House, c. 1684–1719.

- **Hahnville, Louisiana:** Home Place/Keller House, 1790.

- **Ile d'Orléans, Quebec:**
 —Église Saint-François-deSales, begun 1734
 —Manoir Mauvide-Genest House, Saint-Jean, c. 1734.
 —Église Saint-Famille, begun 1743.

- **Louisbourg, Nova Scotia:** Chateau Saint-Louis, c. 1730s.

- **Mackinac Island, Michigan:** Beaumont House, c. 1800.

- **Mansura, Louisiana:** Defosse House, 1790; rebuilt c. 1850. (Color Plate 43)

- **Many, Louisiana:** Fort Jessup, 1822.

- **Marksville, Louisiana:** Hypolite Bordeleon House, c. 1790–1820.

- **Montreal, Quebec:**
 —Ferme Saint Gabriel, at Pointe Saint-Charles, begun 1698.
 —Maison du Calvet, c. 1770.

- **Natchez, Mississippi:** The House on Ellicott's Hill (Connelly's Tavern), 1798.

- **Natchitoches, Louisiana:**
 —Aubin Roque House, c. 1750s–1770s, Augustus Metoyen.
 —Magnolia Plantation, 1753.
 —Oakland Plantation, 1821.

- **New Orleans, Louisiana:**
 —Dilliole-Clapp House, 1820.
 —Font-Juncadella Building, c. 1806.
 —Lafitte's Blacksmith Shop, 1772–1791.
 —Madame John's Legacy, 1788, Robert Jones.
 —Pitot House, 1779.
 —S. Louis Cathedral, 1724–1727, rebuilt 1789–1794.
 —Ursuline Convent, 1727–1730.

- **New Roads, Louisiana:** Parlange Plantation, 1750.

- **Pascagoula, Mississippi:** Krebs House ("Old Spanish Fort"), early 18th century.

- **Quebec City, Quebec:**
 —Church of the Notre-Dame des Victoires, Place-Royale, c. 1688.
 —Hôpital-Général, Infirmary Wing, c. 1710–1712, Jean-Baptiste Maillou dit Desmoulins.
 —Jacquet House, c. 1675.

- **S. Genevieve, Missouri:** Louis Bolduc House, c. 1770; 1845.

- **S. Louis, Missouri:** La Veuve-Dodier House, 1766.

- **S. Martinsville, Louisiana:** Houssaye House (Acadian House), Longfellow-Evangeline State Park, 1765.

portions are service and dining areas with living and sleeping areas above. Kitchens are often in separate buildings.

- *Materials.* Stone construction is typical of French Canada, although it is used also in other areas of New France. Some houses combine stone and clapboards. A few houses are entirely of clapboards, particularly in South Carolina. Half-timbered houses typically have plaster and whitewash that may be colored. Louisiana plantation houses (Fig. 18-9, 18-11) have brick lower stories and wooden upper ones. Woods include mulberry, cedar, and cypress, which do not rot in warm, humid climates.

- *Facades.* In early examples, the facade features architectural openings and fenestration defined by use rather than by symmetry. This design principle becomes more important in the 18th century with the inclusion of stronger classical influences. Facades do not divide into bays.

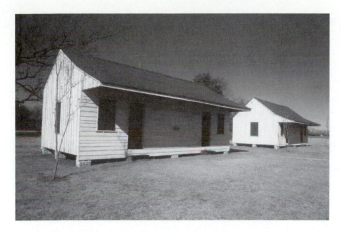

18-22. Double pen log house, late 18th–early 19th century; Jonesville, Louisiana.

18-23. The House on Ellicott's Hill (Connelly's Tavern), 1798; Natchez, Mississippi.

18-24. One-story colonial house, French Quarter, late 18th–early 19th century; New Orleans, Louisiana.

18-25. Two-story colonial house, French Quarter, early–mid-19th century; New Orleans, Louisiana.

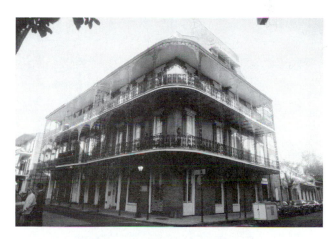

18-26. Three-story colonial house, French Quarter, early–mid-19th century; New Orleans, Louisiana.

■ *Windows and Doors.* Windows include small and large casements and sashes. Dormer windows are typical. Doors may be vertical planks or paneled. Houses with porches often have French doors for access to the outside. Windows and doors may have vertical plank shutters. In Canada, the majority of openings are on the south side of the house.

■ *Roofs.* Roofs, which are hipped or gabled of thatch, wood planks (in Canada), or shingles, are distinctive. Hipped roofs often extend to form a porch or *galerie*. They may have two pitches. A few roofs are made of tile.

■ *Later Interpretations.* High-style French examples are copied more often, but Colonial French, Creole, and Acadian-style houses and commercial buildings are common today in Louisiana (Fig. 18-31).

SECOND FLOOR

Service

Stair hall

Parlor

Gallery

FIRST/GROUND FLOOR

Kitchen

Stair hall

Shop

Courtyard

Porte ∼ *cochere* — Front entry

18-27. Floor plan, Flinard House, French Quarter; New Orleans, Louisiana.

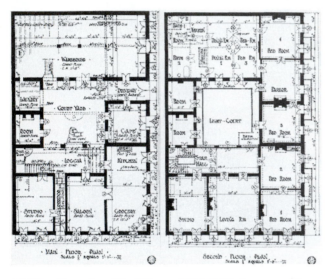

18-28. Floor plan, Girod House, 1800–1824; Latour and La Clotte, Architects, French Quarter; New Orleans, Louisiana.

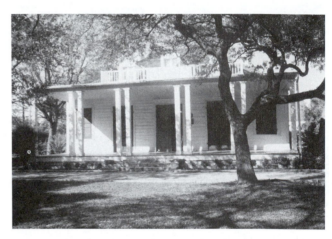

18-30. The French Legation, 1841; Austin, Texas.

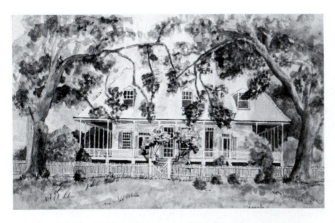

18-29. Oakland Plantation, 1821; Natchitoches, Louisiana.

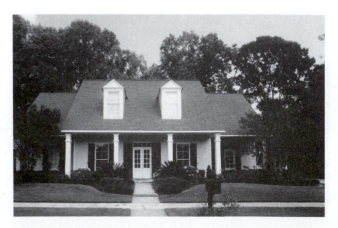

18-31. Later Interpretation: Suburban house, late 20th century; Baton Rouge, Louisiana.

INTERIORS

Most interiors are simply treated with paneled or plastered walls and low-beamed ceilings. Furnishings are few. Wealthy homes are similar but have tapestries, more upholstery and textiles, and more prints and paintings.

Private Buildings

■ *Types.* Most French settlers live, eat, and sleep in one or two rooms. The homes of the wealthy have more rooms. Specialized uses for rooms begin in the 18th century following French prototypes.

■ *Colors.* Blue and green dominate interiors in New France until the end of the 17th century. To the French, these colors have strong traditional and religious associations. Blue, the color of the Virgin Mary, appears in coats of arms to symbolize loyalty and fidelity. Green, common in tapestries, represents strength, honor, youth, and renewal. Both are colors of nature. Less used colors are red, black, and white. Yellow is rare, except to represent gilding or to contrast or highlight.

■ *Lighting.* Candles and fireplaces give minimal artificial lighting. Fixtures are simple or elegant imports, depending on the family's economic status and the region's contact with France. Typical lighting examples include *appliqué* (wall sconce), *flambeau* (candlestick), *candelabra* (branching candlestick), and *torchère* (floor candlestick). Materials vary according to locale, production methods, and stylistic interpretation. Metals and wood are common. (See examples in Chapter 23, Regence and Louis XV and Chapter 26, Louis XVI and French Provincial.)

■ *Floors.* Hard-packed dirt and wood plank floors are common in all areas. Canadians use cedar or pine planks. In Louisiana, lower floors are made of brick to prevent rotting from moisture. As elsewhere, rugs are rare except among the wealthy. Rush matting is slightly more common.

■ *Walls.* Most walls (Fig. 18-32, 18-33) are plastered and whitewashed. Color may be added to the whitewash. An alternative treatment for all homes is paneling. Patterns resemble furniture with rectangles, lozenges, curving tops, and moldings. Most paneling is painted, occasionally in contrasting colors.

■ *Doors.* As important decorative features, most interior doors are paneled and resemble wainscoting. They may be painted similar to paneling. In Canada during the 18th century, the wealthy follow the French tradition of painting scenes on or hanging paintings above doors.

■ *Ceilings.* Ceilings are usually low in colder climates to retain the heat, and high in warmer climates to let the heat rise and keep the interior cool. Most ceilings are either beamed or plastered and whitewashed.

18-32. Cross section, Parlange Plantation, 1750; New Roads, Louisiana.

18-33. Interior details.

FURNITURE

French Colonial furniture follows the French styles of Louis XIII (first half of the 17th century), Louis XIV (second half of the 17th to early 18th centuries), and Louis XV (first half of the 18th century). However, isolation and few outside stylistic influences in New France ensure that furniture based on these styles is simplified with mixed design characteristics. Forms and motifs continue after the originals have passed from favor in France. Louis XV style is the last French style to affect furniture in New France. More English styles and influences appear after 1760 in Canada. Early furniture, whether built in or movable, is more architectonic with a strong rectilinear outline, symmetry, and large scale. Later examples, following Louis XV style, feature more curves and a smaller, more human scale.

Colonial policy ensures that no craft trade in New France competes with the same trade in France. Carpenters, turners, and joiners who build homes and furnishings are excepted, however. Furniture, particularly built-in types, may be included in a contract for a house. Cabinetmakers make the more sophisticated furniture examples in New Orleans, where French influence is strong and the society is cultured. Homeowners and slaves make the less refined vernacular interpretations more common in regional areas.

Less affluent houses, particularly early examples, have few furnishings, most of which are necessities for there is little money or desire for display. In contrast, wealthy homes, although sparse by today's standards, have more furnishings, which are often brought or imported from France. The importance of display of wealth and status manifests in finer and more varied furniture, much of which is not necessary, and in more upholstery, textiles, and decorative accessories. Homes of the wealthy in New

Orleans exhibit great variety in furnishings, including large mirrors in carved and gilded frames and marble-top tables. As the 18th century progresses, a growing desire for comfort and display among the lower classes similarly affects furnishings.

- *Types.* Furniture includes side chairs and armchairs, plain and turned-leg tables, storage pieces, and beds.

- *Distinctive Features.* Colonial furniture resembles French examples with similar construction methods, lines, legs, and details. Simplification, the mixing of styles and motifs, and a certain naiveté or abstraction distinguishes colonial from high-style French designs. Many pieces embody highly personal and individualized designs based on the desires of the maker or purchaser.

Louis XIII. Examples have turned, baluster-shaped, or spiral legs; stretchers; and arm supports. Backs are paneled or banisters. Horizontal arms rest on extensions of front legs. Heavy moldings follow simple rectilinear outlines.

Louis XIV. Pieces are larger and more formal. Symmetry and a rectilinear outline emphasize the furniture's architectonic nature. Arms curve downward and legs terminate in bun feet. Unlike high-style examples, carving and gilding are rare in the colonies.

Louis XV. Curves describe backs, seats, cabriole legs, panels, and moldings. As in high-style examples, continuity of parts and asymmetrical, naturalistic decoration are common. Canadian Louis XV pieces have a distinguishing elongated S curve terminating in *pied balbé* (scroll) or *pied de biche* (hoof) feet (Fig. 18-38).

- *Relationships.* Some pieces, such as armoires and cupboards, are built into the walls usually by the carpenters who construct the house. Beds may enclose a corner of a

18-34. Slat-back chairs; Louisiana and Quebec, Canada.

18-35. *Fauteuil* (slat-back armchair); Louisiana.

room. Tables and chairs frequently occupy an end wall so that diners' backs are against the wall. Furniture, when not in use, lines the walls as in France and other European countries.

- *Materials.* Construction is similar to that in France. Because they must be imported, metals are scarce and costly. Nails are reused, and hardware is limited. Cherry, walnut, mahogany, and cypress dominate in Louisiana, while Canadians use oak, pine, and yellow birch. Pieces are either stained and varnished or painted to hide mismatched grains. Using more than one species of wood on a piece of furniture is typical. Red, blue, and green dominate over black, brown, and yellow in Canada until the end of the 17th century. After that, more and varied colors appear, and colors cease to be used traditionally and symbolically. In the second half of the 18th century, English influences appear in graining and *trompe l'oeil* details. Decoration may be carved or painted. Colonial furniture uses no veneer or marquetry; gilding is uncommon except for church furniture and decorative objects.

- *Seating.* Chairs follow French styles and types. Examples include the slat-back chair (Fig. 18-34), ladder-back chair with rawhide seat (Fig. 18-36), *chaise* (side chair), *fauteuil* (armchair; Fig. 18-35), and *bergères* (upholstered armchairs). Only the wealthy have textile or upholstered seats and backs until the 18th century; others typically have rush seats and cushions. The French in Louisiana have upholstered *fauteuils* and *bergères*. Furniture covers typically protect expensive fabrics. The ladder-back chair with rawhide seat is a vernacular, utilitarian example commonly found in rural areas. Canadians do not use *manchettes* (arm pads).

- *Tables.* Tables (Fig. 18-37) are typically rectangular with curved or straight legs. Some variations have stretchers and/or cloven-hoof feet.

- *Storage.* The *armoire* (wardrobe; Fig. 18-39) is distinctive, large, and the main storage unit in many rooms. Often made locally or built in, it may have single or double doors with applied moldings and/or inlay. Moldings and details often contrast in color to panels. The upper parts of panels feature asymmetrical curves in Louis XV examples. Bun or curving feet are typical. Louisiana examples exhibit more Louis XV characteristics such as curving panels,

18-37. Side tables, late 17th century, Louis XV style; Quebec Canada.

18-36. Ladder-back chair.

18-38. Leg detail with hoof foot.

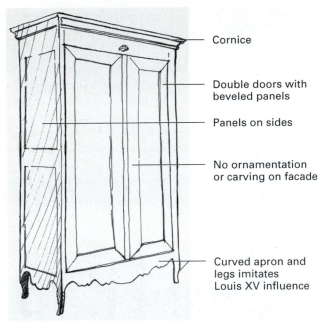

Cornice

Double doors with
beveled panels

Panels on sides

No ornamentation
or carving on facade

Curved apron and
legs imitates
Louis XV influence

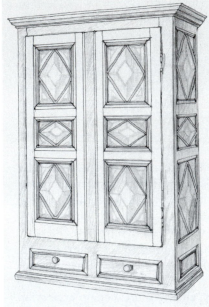

18-39. *Armoires*;
Louisiana and
Quebec, Canada.

Design Spotlight

Furniture: *Armoire*. Louisiana colonial furniture is noteworthy for its simplicity, as reflected in the *armoire* (wardrobe; Fig. 18-39). Borrowing heavily from provincial examples in France, it typically has a simple cornice, double doors, and a plain facade with no ornamentation. Curves are evident throughout the design, often seen in the apron and legs. It is usually constructed of several different local woods.

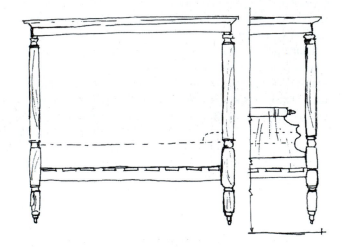

18-40. Bed.

cornices, and/or feet. They have little or no carving. Heavy cornices cap them. Other storage pieces include cupboards and *buffets*.

■ *Beds*. Four-posters and rectangular built-in beds are typical (Fig. 18-40). As in other colonies, most beds have

hangings, even in poorer homes, for warmth, privacy, and display of wealth.

■ *Later Interpretation*. Colonial French furniture is not revived later except in limited instances or as a French Provincial interpretation.

19. American Colonial: Germany and Holland

17th–19th centuries

Within the larger context, North America had been a goal of German emigration since before the American Revolution. Waves of Germans had come as early as 1710 in New York, New Jersey, Delaware, Pennsylvania, and Maryland. These were followed after 1735 by Germans who settled in the Carolinas, Georgia, and Louisiana. Throughout the 19th century, hundreds of thousands of Germans . . . settled . . . in the cities and farming communities of the Midwest. . . . After Texas gained its independence from Mexico in 1836, . . . the young republic was pictured as a new utopia in popular German travel literature.

Glen E. Lich, *The German Texans*, 1981

German and Dutch settlers, like the English, bring native medieval building and furnishing traditions to America. Most colonists have little knowledge of or experience with the more sophisticated European classicism of the Renaissance or Baroque. Each culture produces distinctive house types, but shares types and characteristics with colonists from other countries, particularly England. Neither culture has much effect on subsequent American developments except in the regional communities where initial settlements occur.

GERMANY

Despite numerous settlers and broad settlement patterns, Germans exert little influence on American architecture, interiors, or furniture, except in regional settlement areas. Germans are best known in Pennsylvania and Texas for their rural traditions in building and furniture.

HISTORICAL AND SOCIAL

Germany in the 17th century is comprised of small, independent German-speaking states, so immigrants form a diverse group that includes Germans, Swiss, Dutch, French Huguenots, Poles, Danes, Russians, Bohemians, and Austrians. Many of the early settlers come from areas that are largely feudal. Little more than slaves in their native lands, they are subject to harsh laws, crippling taxes, and oppressive overlords. They do not own land, but live in agricultural villages and farm nearby areas. The religious wars of the 17th century destroy their crops, homes, and families. Economic improvements in the 18th and 19th centuries allow ownership of land, but because of traditions, the oldest son inherits the land with no provisions for the other sons.

As a consequence, political and religious freedom along with social and economic improvements often motivate Germans to relocate to America. Frequently, the initial interest and contact develops through personal communication, agricultural apprenticeship, agricultural societies, and later, immigrant guidebooks. The political freedom touted by William Penn in Pennsylvania attracts colonists from many countries and with varied religious beliefs. Among them is the first group of Germans who arrive in 1638, two years after the colony's founding. By the 18th century, Germans pour into Pennsylvania attracted by individual, religious, and political freedom. Some remain in Philadelphia settling in Germantown, but the majority move just west to the countryside in Lancaster and Bucks counties. Other Germans migrate to Maryland, Virginia, Ohio, North Carolina, and Wisconsin establishing tight European enclaves in these areas. In the 19th century, this is also true as a second influx of German settlers populates the Midwest, Texas, and later California.

As they relocate, the Germans often maintain their cultural heritage, social customs, and building traditions, but alter their previous living patterns to adjust to their new environment. Early settlers are able to purchase some of the richest farmlands in the settlement areas and, therefore, thrive as farmers. Later ones prosper not only in rural communities, but also in urban areas as merchants and business owners. Some German religious groups, such as the Amish and Mennonites, maintain a distinct separation in language, religion, and culture from other German and English settlers. Others found communal towns during the early to mid-18th century, such as those in Ephrata and Bethlehem, Pennsylvania, and in Old Salem, North Carolina.

CONCEPTS

German colonists follow traditional medieval building and furnishing patterns with which they are familiar. Rural peoples tend to maintain traditional building and furnishing patterns with little outside influence, while those who remain in the cities are more likely to abandon traditional ways in preference for Anglicized ones.

DESIGN CHARACTERISTICS

Rural building traditions are largely medieval and defined by verticality, honesty in structure and material, and functional designs. Log cabins and large stone dwellings are distinctive, as are German painted furniture and *fraktur* (decorated documents), which share common motifs. Furniture, ornamental painting, and decorative arts draw from folk or rural traditions of the homeland, while urban design absorbs local English influences. This is especially evident in the 18th century with the adoption of Georgian plans, forms, and details and in the 19th century with the incorporation of Victorian interior decoration and design characteristics.

- *Motifs.* Motifs (Fig. 19-25, 19-30, 19-31, 19-35) include figures, birds, unicorns, lions, hearts, tulips, rinceaus, floral and scroll patterns, stars, and geometric shapes, such as hex signs. Designs come from many sources, reflecting the varied influences in Germany and the assimilation of English features. Motifs often have religious or symbolic meanings. However, Germans use particular designs in nails, not hex signs, to protect their barns from evil spirits.

ARCHITECTURE

Rural settlers maintain medieval building traditions well into the 19th century. Some patterns also reflect a collective European heritage such as the German transplant of stone and log homes to America. These building types become important icons with westward expansion. Construction methods and materials, however, do not initially adapt to the local climates. This occurs gradually. In the middle of the 18th century, prosperity and proximity encourage Germans in urban centers, particularly on the East Coast, to begin adopting English classicism. In the 19th century, improved communication and transportation systems support westward expansion and foretell the integration of Neoclassical and Victorian influences.

Private Buildings

- *Types.* Houses are the most common building type. Germans and Russians also build churches (Fig. 19-1) that

Design Practitioners and Entrepreneurs: German

- *Jacob Maser* is one of 45 known cabinetmakers in the Schwaben Creek area of the Mahantango Valley in central Pennsylvania who produce distinctive painted furniture. Stenciled designs in yellow, red, and black on bright backgrounds typify their work.

- *Johannes and Peter Ranck* are brothers who apprentice with craftsman Christian Selzer. Their work follows his in Lebanon County, Pennsylvania.

- *Christian Selzer* is a master craftsman who founds the Jonestown school of furniture decoration in Lebanon County, Pennsylvania, in the second half of the 18th century. Designs typically have two or three arched panels filled with vases of flowers.

- *Johannes Spitler* lives in the Shenandoah Valley. Inspired by a local *fraktur* painter, he is known for chests with painted geometric designs inscribed with flowers, birds, stags, and hearts in red and black on blue. He moves to Ohio in 1850 and continues painting furniture.

- *Henry William Stiegel* establishes several important glasshouses in Pennsylvania in the late 18th century. In addition to window glass and bottles, the factories produce a wide range of tablewares, such as decanters, tumblers, glasses, and bowls. Many are pattern molded (blown into a patterned mold, then removed and expanded by blowing) or painted with enamels in the manner of *fraktur*. Stiegel's factory produces the first lead glass products in America.

- *Caspar Wistar* begins a flourishing glasshouse in southern New Jersey in the late 1730s. The factory produces mainly bottles and window glass.

usually follow English examples. Communal groups such as the Moravians construct large dormitory-like structures (Fig. 19-11).

Log Houses. Although the Swedes build the first log houses in America, the Germans bring them to the mid-Atlantic region from Europe. As they migrate westward, they spread the building method to other areas. Chinks (spaces) between squared-off logs are filled with mud plaster. Various forms of notching (Fig. 19-10, 19-13), such as V, square, or dovetail, join corners. Log houses follow several forms no matter which culture produces them. These include the pen (a single room; Fig. 19-3, 19-6, 19-8, 19-9), the double pen or saddle bag (two rooms with a chimney between; Fig. 19-5,

19-7) and the dog trot (two pens with an open covered space between them; Fig. 19-14, 19-15, 19-16). As half-timber and stone construction dominate townscapes, this building form becomes more common in rural areas.

■ *Site Orientation.* Early German dwellings often combine barns, stables, service areas, and living areas under one roof. Later homesteads feature numerous outbuildings for service functions. Homes may be built into a hillside for coolness or to store foods or over a spring for water. Cellars function as storage or threshing areas, and attics may be used for smoking foods. Urban houses are sited on streets with service buildings in the rear or to the side.

■ *Floor Plans.* Most German houses are one and a half stories with three rooms and a loft (Fig. 19-15). Larger houses have two stories with two, three, or four rooms on each level (Fig. 19-12, 19-16). Typical spaces include the *stube*

19-1. Section, S. Michael's Cathedral, 1848; Sitka, Alaska.

19-2. Squire Boone House (Daniel Boone's birthplace), 1735; Baumstown, Pennsylvania.

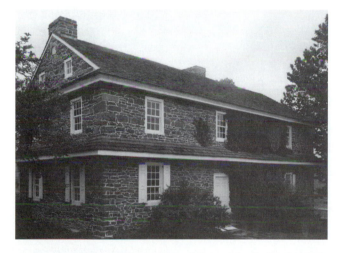

19-3. The Cloister, 1740–1743; Ephrata, Pennsylvania.

19-4. Fort Harrison (Daniel Harrison House), c. 1749; Dayton, Rockingham County, Virginia.

(parlor) for socializing and dining, the *küche* (kitchen; Fig. 19-22, 19-26), and the *krammer* (bedchamber). The side-by-side parlor and kitchen are almost equal in size. The bedchamber is behind the kitchen. Stairs, when present, are in a corner of the kitchen and near the entrance or outside, which is typical in warmer climates. Unlike the English fireplace, the distinctive German cooking fireplace features a *suppenherd* (raised hearth) that requires less bending and less wood to maintain heat. It supports heating the parlor next door. In the middle of the 18th century, many urban Germans adopt the English center passage or Georgian plan.

■ *Materials.* The majority of early German dwellings are of logs, but the wealthy build stone houses often with clapboard gables and quoins (cornerstones). Stone houses (Fig.

19-6. Booker T. Washington's birthplace, c. 18th century; near Roanoke, Virginia.

Design Spotlight: German

Architecture: *Log Houses.* Located throughout the United States, log houses (Fig. 19-5, 19-7, 19-8, 19-9, 19-10, 19-14, 19-15, Color Plate 44, 19-16, 19-17) express the rural traditions of early settlements and westward expansion. The single pen, double pen, and dog trot forms offer evidence of changing lifestyles requiring functional additions to the floor plans. Buildings in warm climates use the covered dog trot space or extended porch for living area extensions. Those in cold climates have steeply pitched roofs. Interiors are usually plain and simply furnished. More elaborate examples feature wood plank walls and ceilings, decorative painting, and larger-scaled spaces. Furnishings are often made locally.

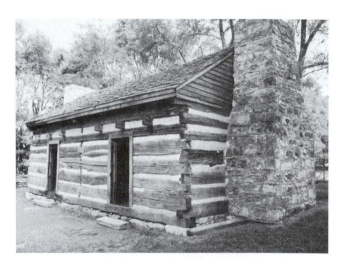

19-7. Double pen log house, c. 18th century; Savannah, Georgia.

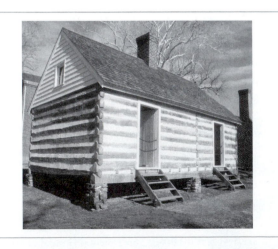

19-5. Double pen log house, c. 18th century; Appomattox, Virginia.

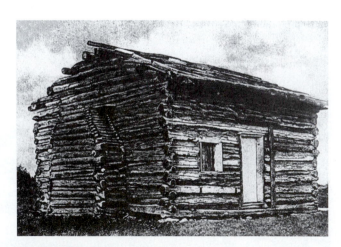

19-8. Abraham Lincoln's birthplace, 1808; Hodgenville, Kentucky.

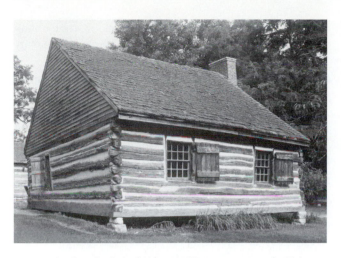

19-9. Andrew Jackson log house, Hermitage, c. early 19th century; Nashville, Tennessee.

19-2, 19-4, 19-17, 19-19) and those made entirely of clapboards become more common in the 19th century. Many houses mix materials, such as stone and brick (Fig. 19-11, 19-20) or half-timbering with stone (*fachwerk*; Fig. 19-17, 19-18) or brick infill. *Fachwerk* is common in Wisconsin and Texas. Spaces between timbers are filled with mud and straw or kiln-fired brick (nogging) and then covered with adobe or lime plaster. Ends or gables of *fachwerk* houses may be of clapboards. The few German churches and public buildings are generally of brick or stone.

■ *Facades.* Log house facades (Fig. 19-5, 19-6, 19-7, 19-8, 19-14, 19-15, Color Plate 44, 19-16) are simple and reflect the floor plan. Stone, brick, and half-timber houses are plain with fenestration generally placed for function instead of symmetry. Exterior plastering and whitewashing

19-10. Log construction detail, log house, Hermitage; Nashville, Tennessee.

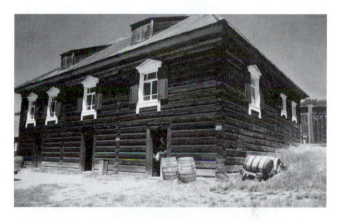

19-12. Russian settlement, 1812; Ft. Ross, California.

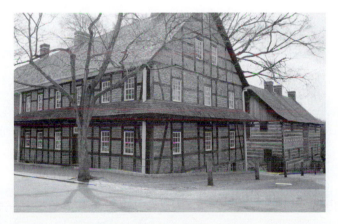

19-11. Moravian Village, 1766–1850; Old Salem, Winston-Salem, North Carolina.

19-13. Log construction detail, Zmerched-Lyndecker House, c. mid-19th century; near Brenham, Texas.

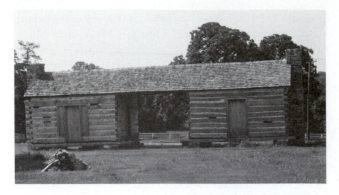

19-14. Dog trot log house, c. mid-19th century; Round Top, Texas.

are common on some stone houses. Brick or stone chimneys highlight end walls. Large front porches appear in warmer climates.

■ *Windows and Doors.* Buildings usually have the double-hung windows of the English or casement windows common to Germany. They may have exterior wooden shutters. Doors usually are planks or panels and may be divided in half. Distinctive are the small slanted, gabled, or curved hoods over doors and windows.

■ *Roofs.* Steeply pitched gables and flared-eave roofs are common in colder climates and along the East Coast. Lower-pitched roofs appear in warmer climates such as in Texas (Fig. 19-14, 19-15, Color Plate 44, 19-16). The pent

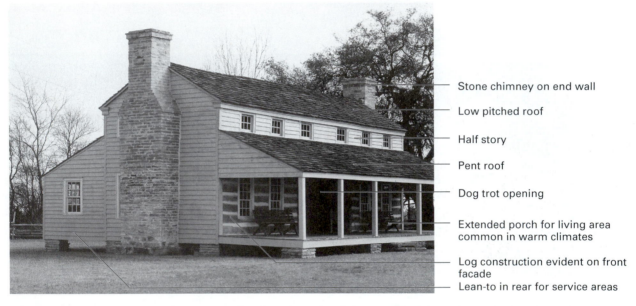

Stone chimney on end wall

Low pitched roof

Half story

Pent roof

Dog trot opening

Extended porch for living area common in warm climates

Log construction evident on front facade

Lean-to in rear for service areas

19-15. Dog trot log house with lean-to, c. mid-19th century; Henckel Square, Round Top, Texas. (Color Plate 44)

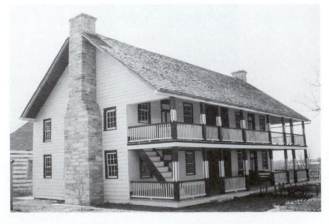

19-16. Lewis House, c. 1850s; Winedale Historical Center, Round Top, Texas.

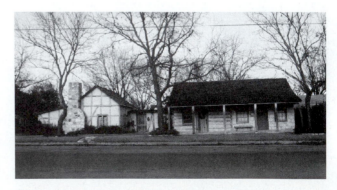

19-17. *Fackwerk* house and double pen log house, c. mid-19th century; Fredericksburg, Texas.

19-18. *Fackwerk* construction detail, Vogt House, c. mid-19th century; near Brenham, Texas.

19-21. Later Interpretation: Contemporary manufactured log home, 2001; Montana.

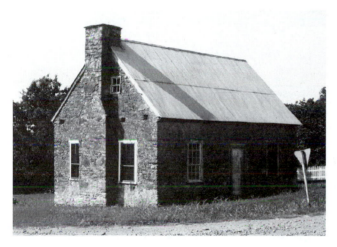

19-19. Stone house, c. mid-19th century; Castroville, Texas.

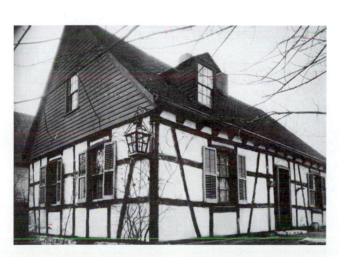

19-20. Hermann Oheim House, 1859; Kimmswick, Missouri.

Important Buildings and Interiors: German

- **Appomattox, Virginia:** Double pen log house, c. late 18th century.

- **Baumstown, Pennsylvania:** Squire Boone House (Daniel Boone's birthplace), 1735.

- **Ephrata, Pennsylvania:** The Cloister, 1740–1743.

- **Gonzales, Texas:** Eggleston log house, 1840.

- **Hodgenville, Kentucky:** Abraham Lincoln's birthplace, 1808.

- **Kimmswick, Missouri:** Hermann Oheim House, 1859.

- **Milback, Pennsylvania:** Georg Mueller House, 1752.

- **Nashville, Tennessee:** Andrew Jackson log house, Hermitage, c. early 19th century.

- **Oley Valley, Pennsylvania:** Johan and Debora De Turck House, 1767.

- **Roanoke area, Virginia:** Booker T. Washington's birthplace, c. 18th century.

- **Rockingham County, Virginia:** Fort Harrison (Daniel Harrison House), c. 1749; Dayton area.

- **Round Top, Texas:** Lewis House, Winedale Historical Center, c. 1850s.

- **Sitka, Alaska:** S. Michael's Church, 1848.

- **Winston-Salem, North Carolina:** Moravian Village, Old Salem, 1766–1850.

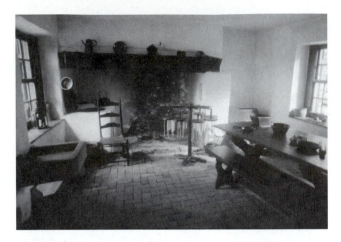

19-22. *Küche* (kitchen), log house, 1740–1743; Ephrata, Pennsylvania.

19-24. Parlor and Chamber, Andrew Jackson, 1804; log house, Nashville, Tennessee.

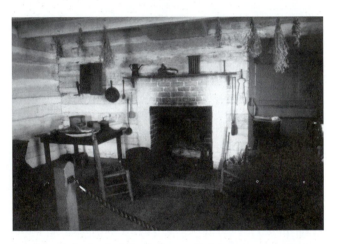

19-23. *Stube* (parlor), log house, c. 18th century; Appomatox, Virginia.

19-25. Reflected ceiling plan, Lewis House, c. 1850s; Winedale Historical Center, Round Top, Texas.

roof (a small sloped roof between stories; Fig. 19-2) is characteristically German and may even be found on log houses. Distinctive German gambrel roofs have a bell shape and decisive break where the two slopes meet and on the ends. Roofing materials include red clay tiles, wooden shingles, or thatch.

■ *Later Interpretations.* Although German rural houses and furnishings survive in some areas, German buildings rarely are or have been reinterpreted or copied. This is due, in part, to confusion over *Dutch* and *Deutsch* (the German word for *German*) and anti-German sentiment following the entry of the United States into World War I (1914–1918). Custom log homes of the late 20th century (Fig. 19-21) reflect a return to rural traditions.

INTERIORS

Interiors of German houses are simply treated (Fig. 19-22, 19-23, 19-24, 19-26), but colorful. Floors are made of wide boards, with wool or cotton rugs limited to the best rooms.

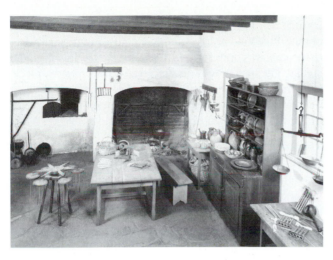

19-26. Salem Tavern, Moravian, 1771, rebuilt 1784; Salem, North Carolina.

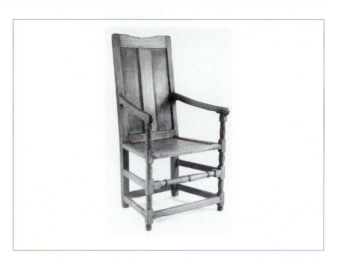

19-28. Armchair, c. 1740–1770; Shenandoah Valley, Virginia.

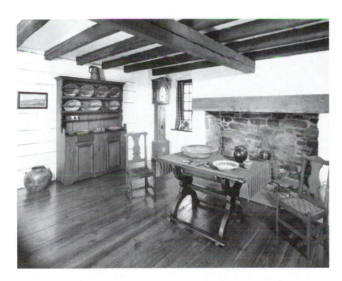

19-27. Piedmont Room, c. 1766; Guilford County, North Carolina.

19-29. Ladder-back chairs, c. mid-19th century; central Texas.

Walls are mainly whitewashed, particularly the parlor. Sometimes painted patterns in red, yellow, blue, green, brown, black, and white decorate plaster or wood plank walls. Designs include spirals, diagonals, stippling, marbleizing, or decorative painting (Fig. 19-25) with various motifs. The few examples of paneling are painted. Ceilings have exposed beams, are plastered, or may feature wood planks in the 19th century. Urban interiors may interpret vernacular, regional images or follow sophisticated English models after the 18th century (Fig. 19-27).

FURNITURE AND DECORATIVE ARTS

German furniture follows both rural and urban forms. Rural furniture in most areas maintains medieval traditions well into the 19th century. Urban furniture is influenced by and in turn influences English forms, construction, and decoration, particularly in Philadelphia. The best-known examples of German furniture are rural painted chests from Pennsylvania. Because settlements develop in Texas beginning in the 1830s, examples in the state reflect medieval

traditions as well as American Empire and Victorian characteristics. Craftsmen and artisans settle in central Texas during the mid- to late 19th century establishing several cabinetmaking centers.

Like those of other colonial settlers, German houses have few furnishings until the prosperity following the American Revolution. Religious Germans wish to avoid materialism and others place money in land, livestock, or bonds instead of furniture. Public rooms often have more farming implements than furniture and accessories. Parlors hold the best table and chairs or benches, a clock, and a bookshelf or hanging cupboard. The best chamber has the best bed, perhaps a less important bed, a wardrobe or clothespress, and a chest or chests of drawers. The bed and its hangings, wardrobe or clothespress, and tall clock are the most expensive items in the German home. Kitchen furnishings include dressers, work tables, and storage pieces.

■ *Materials.* Furniture is of walnut, poplar (tulip), pine, or other local woods. Poplar and pine are usually painted. Carving, inlay, and marquetry are more common in urban centers and rare in rural areas. Colors, which are bright, include red, blue, green, yellow, brown, black, white, and orange. Freehand and mechanical painted motifs may decorate chairs, cupboards, chests, chests of drawers, and clocks. The maker does not necessarily decorate the piece. Graining replaces painting in the 1830s. Although most German settlers use some painted furniture, the Moravians in North Carolina do not.

■ *Seating.* Germans introduce the arched-top slat ladder-back chair with rush seat to America (Fig. 19-29). Its comfort and low cost ensure long-lasting popularity. Some ladder-backs have cabriole legs and *crookt* feet (pointed pad feet). Loose cushions add comfort. Another distinctive German chair has a board back and seat with carving and stick legs (Fig. 19-28). Also distinctive is the German easy chair whose back, seat, and wings are upholstered, usually in leather. Chairs are rare as people stand to eat or sit on built-ins or benches.

■ *Tables.* A distinctive German table, called a sawbuck table, has **X**-shaped legs with a stretcher joining them at the crossing of the **X** (Fig. 19-27). Most other tables have

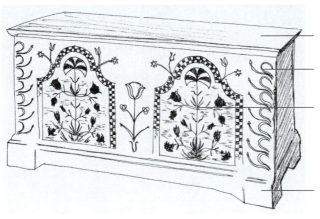

Foldup lid

Rectangular shape with painted surface

Painted flower decoration

Heavy base

19-30. Chest, c. late 18th century; Pennsylvania.

Design Spotlight: German

Furniture: *Painted Chest.* Common in Germany, painted chests (Fig. 19-30, 19-31, Color Plate 46) are typically made for an individual on a special occasion. Retaining European characteristics, they are large rectangular storage units with foldup lids and heavy base moldings. Most have decoration in various ethnic designs that are painted or incised. Raised panels, applied moldings, and bosses are common. Distinctive regional styles occur, such as those in Lancaster, Pennsylvania.

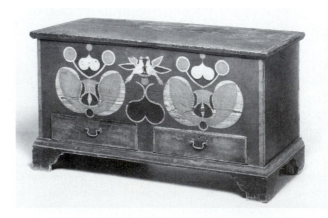

19-31. Chest, 1795–1810; Shenandoah County, Virginia. (Color Plate 46)

turned legs with stretchers and at least one drawer. The Germans also make drop-leaf and draw-top tables.

■ *Storage.* Like the English, Germans use dressers in their kitchens, but German examples have cupboards below the shelves. They may be called *schranks* (a German term for cupboard; Fig. 19-26, 19-32) or dressers. A distinctive German piece is the large wardrobe (Fig. 19-33) or clothes-press. The largest piece in the house, it may have single or double doors with an arched or flat top. Common decorations are applied moldings, carving, inlay, and later, graining. Other storage pieces include corner cupboards, hanging cupboards, and chests of drawers. Also distinctive are German chests, the most common of which are used for storage.

Painted Chests. Unlike other storage pieces, chests (Fig. 19-30, 19-31, Color Plate 46) typically are made for an individual, such as a young woman at the time of her marriage. Usually dovetailed at the corners, chests may have drawers and rest on straight or ogee bracket feet, runners, or no feet at all. Lids typically are flat, not pan-eled or arched. Painted decorations may combine with applied moldings and bosses. Motifs may be drawn free-hand or with a compass and ruler. Some decorators incise decorations or use templates. Stencils are rare before the early 19th century. Distinctive regional styles develop such as those from Lancaster, Pennsylvania, which typically have painted arched decorations combined with other motifs.

■ *Beds.* Beds may be built into the wall with curtains shielding against the cool air or simple, low, four-poster styles (Fig. 19-24, 19-34) with no decoration.

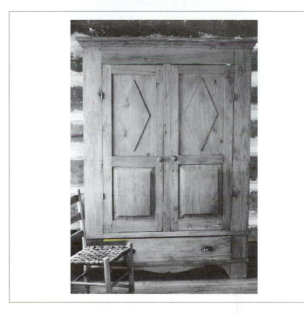

19-33. Wardrobe, c. mid- to late 19th century; Henckel Square, Round Top, Texas.

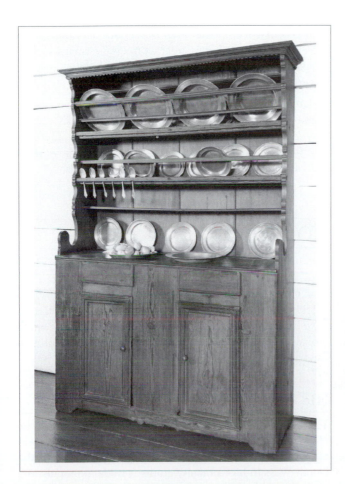

19-32. *Shrank* (kitchen cupboard) or dresser, 1760–1780; North Carolina.

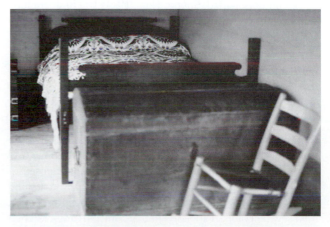

19-34. Storage chest and bed, c. mid- to late 19th century; Winedale Historical Center, Round Top, Texas.

19-35. *Fraktur* for Anna Hott, c. 1820; southwestern Virginia.

19-36. Redware bowl, 1805–1910; Hagerstown, Maryland; by Peter Bell.

■ *Fraktur*. Germans are known for hand-decorated texts or documents called *fraktur* (Fig. 19-35). These include hymn and scripture texts, marriage and birth announcements, and greetings. Schoolmasters create many of them. Colors typically are highly saturated greens, blues, reds, and yellows. Common motifs are angels, Adam and Eve, unicorns, flowers, and birds. To prevent fading, Germans do not hang *fraktur* on walls, but roll them up and place them in cupboards or paste them inside chest lids.

■ *Ceramics*. German slipware (Fig. 19-36) and *sgraffito* ware are distinctive for their highly saturated colors and typical German motifs, such as tulips. Slip, composed of clay and water in a creamlike consistency, may be washed over a piece or applied by trailing or painting. Potters often used several colors of slip. *Sgraffito* decorations are scratched into slip before glazing to reveal the body below, which contrasts in color.

■ *Glass*. Imported English glass dominates the American market in the 17th and 18th centuries. However, most glassmakers in America during the Colonial period are German. Few English glassblowers migrate because the industry is prospering at home. In addition, England attempts to stifle any glass competition in America. German glassmakers, on the other hand, face economic difficulties at home, so they immigrate freely. Germans such as Caspar Wistar establish the first successful glass houses in America during the 18th century.

■ *Later Interpretations*. Ladder-back chairs survive in numerous variations. Painted pieces, particularly chests, may be reproduced as folk art. Pennsylvania German ceramics and motifs continue in folk art or the work of individual craftsmen, especially among the Amish.

HOLLAND

Dutch merchants and traders settle in present-day New York and New Jersey and along the Hudson River. They soon cede their colonies to the English, so their influence quickly fades except in small areas. Urban Dutch houses have little impact in America, but the gambrel roof, which probably is not of Dutch origin, lives on in Dutch Colonial Revival.

HISTORICAL AND SOCIAL

The Dutch establish trading centers in New York and the Hudson River Valley during the early 1600s, but lose them before the end of the century. The 1621 charter of the Dutch West India Company grants it trade monopoly and exclusive rights to colonization in the Americas and Africa. It establishes the first Dutch colony, Fort Orange

(now Albany, New York) in 1624. In 1626, a second colony, New Amsterdam (now New York City), is established on Manhattan Island, which was purchased from Native Americans. The colonies grow slowly, hampered by neglect from the company and by conflicts with local tribes. The company attempts to encourage emigration by offering land, but few Dutch respond.

The English encroach on Dutch settlements on Manhattan and Long Island. Although the Dutch give Long Island to England in 1650, Charles II decides to take the entire region. The threat of invasion causes governor Peter Stuyvesant to cede Dutch holdings to England in 1664. The New Netherlands becomes the English colonies of New York and New Jersey. Although the English allow the Dutch settlers to remain, their influence soon fades except in small pockets, particularly along the Hudson River. There, Dutch landowners encourage Dutch immigration throughout the 18th century.

Dutch settlements are more heterogeneous than English settlements because of their emphasis on commerce and religious tolerance. Settlers come from Holland, Flanders, and France. Their cultures and building traditions intermingle as in Europe along shared borders or areas and through commerce. Following their takeover, the English influence Dutch culture and building.

CONCEPTS

As with other colonists, the Dutch recreate buildings and furnishings they had known at home, particularly in urban centers, which reflect medieval traditions instead of the classical Renaissance. Houses blend characteristics, such as roofs, from other ethnic groups and reveal some adaptations to local conditions. Reciprocity between England and Holland is particularly strong as the two cultures share common roof styles and brickwork. During the 18th century, some English Georgian characteristics appear on Dutch houses.

DESIGN CHARACTERISTICS

Since Holland maintains colonies only briefly, a colonial Dutch style manifests primarily in houses. Overall characteristics are medieval, with steeply pitched roofs that gradually become less so, honest use of materials, evidence of structure, and emphasis on function over style. Dutch houses are identified by roof types and patterned brickwork, which may be found in other colonies as well.

■ *Motifs.* Common motifs include decorative brickwork (Fig. 19-37; see Architecture, Materials), flowers, trees, and birds. Dutch motifs often resemble those of the Germans, revealing a common Continental heritage.

ARCHITECTURE

Dutch urban rowhouses arise from a common European tradition, but feature distinctive parapets and functions. In rural areas, however, Dutch house types result from the diversity within Dutch settlements. Three house types (see Private Buildings, Types) identified by roof styles are associated with the New Netherlands. Gable-end houses and straight-side gable houses are typical in cities. Straight-side gable and flared-eave or gambrel-roof houses are common in rural areas. The flared-eave farmhouse, which is common in the 17th and early 18th centuries, has no known Dutch counterpart; its origin is uncertain. Flared-eave houses also dot areas of French Canada. Gambrel roofs, although identified as Dutch Colonial Revival, are not Dutch in origin. Found on both Dutch and English rural houses after 1700, they may have evolved from the flared-eave roof.

Private Buildings

■ *Types.* Houses are the most common building type, although some public buildings occur. The few churches built are octagonal with pyramidal roofs. Later ones follow more traditional, rectangular patterns.

Gable-End Houses. Gable-end houses (Fig. 19-37, 19-38, 19-44) have the short side facing the street. They transplant directly from cities in Holland where street space is at a premium. Rowhouses similar to these have a long European tradition, so they are occasionally found in other colonies, particularly in the 18th century. These

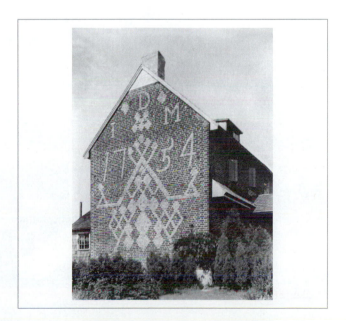

19-37. Dickinson House, 1754; Salem County, New Jersey.

houses are most often of brick or have a brick facade and wooden rear portion. Parapet walls, which extend beyond the roofline, include shapes with concave curves, convex curves, or Flemish gables, which are typical later, and the crow-step gable, which is stepped and the most common. Because Dutch merchants use their houses as shops, warehouses, and dwellings, two or three stories are common. After Dutch colonies become English, these houses are no longer built.

Straight-Side Gable Houses. Found in urban and rural areas, the long side of the straight-side gable house (Fig.

19-42) faces front. The straight gables pitch steeply (becoming less so as time passes) and have no overhang. End chimneys are inside exterior walls. These houses usually feature decorative brickwork and may have one, one and a half, or two stories. Similar English examples are found in the mid-Atlantic region.

Flared-Eave Houses. Featuring a distinctive double-pitch roof, flared-eave houses (Fig. 19-38, 19-40, 19-41, 19-46) are common in northern New Jersey and southern New York. Low and broad in proportion, they have one or one and a half stories and may or may not have a porch. Stone, wood, or a mixture is more common than brick.

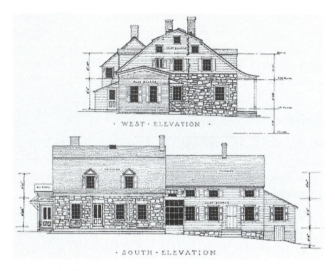

19-38. Terheun House, c. 1670 and later; Hackensack, New Jersey.

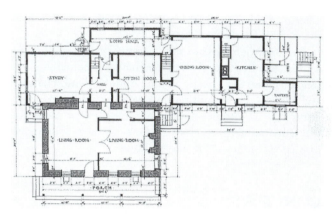

19-39. Original plan with later additions, Terheun House, c. 1670 and later; Hackensack, New Jersey.

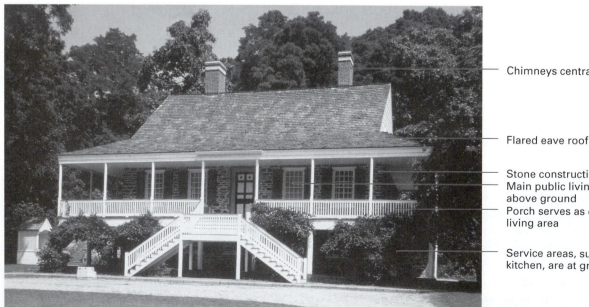

Chimneys centrally located

Flared eave roof

Stone construction
Main public living areas above ground
Porch serves as extended living area

Service areas, such as the kitchen, are at ground level

19-40. Van Cortlandt Manor, c. 1680s and later; Croton-on-Hudson, New York.

Gambrel Houses. Common in New York and usually of brick, later gambrel houses have a double pitch on either side of a ridge with little or no overhang and often have a shed roof over the front door. Sash windows and a raised front entrance are common. Following English examples, some built during the 18th century have a classical door surround.

- *Floor Plans.* Dutch house plans (Fig. 19-39, 19-43, 19-45) are more linear than others. They typically have three adjacent rooms of approximately equal size, a kitchen, a parlor, and a bedchamber. Additions usually join to existing rooms, especially on stone houses, as they are easier to construct than ells in the rear.

Important Buildings and Interiors: Holland (Dutch)

- **Brooklyn, New York:** Jan Ditmars House, c. 1700.
- **Croton-on-Hudson, New York:** Van Cortlandt Manor, c. 1680s and later (flared eave).
- **East Greenbush, New York:** Bries House, 1723 (straight-side gable).
- **Englewood, New Jersey:** Vreeland House, 1818.
- **Hackensack, New Jersey:**
 —Abraham Ackerman House, 1704 (gable with porch).
 —Terheun House, c. 1670.
- **New York City, New York:** Dyckman House, c. 1783 (flared eave with porch).
- **Rensselaer, New York:** Fort Crailo, 1642, remodeled 1762 (variation of urban house type).
- **Schenectady, New York:** Yates House, early 18th century (gable-end type).
- **Upper Mills, New York:** Philipsburg Manor, begun 1680.
- **West Coxsackie, New York:** Pieter Bronck House, 1670s; Leendert Bronck House, 1738 (flared eave).
- **Wyckoff, New Jersey:** Branford-Van Horne House, 1747, linear additions dating from 1760 and 1800.

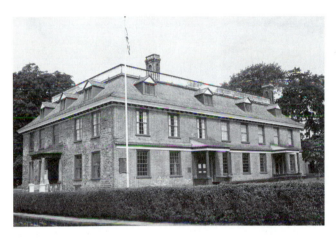

19-41. Philipsburg Manor, begun 1680; Upper Mills, New York.

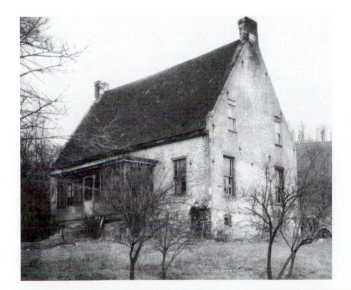

19-42. Briese House, 1723; East Greenbush, New York.

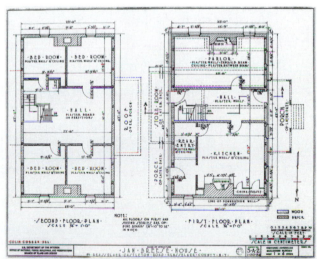

19-43. Floor plans, Briese House; East Greenbush, New York.

■ *Materials.* The Dutch use the traditional brick but also build in New World materials of wood and stone, which are uncommon in Holland. Typical are vertical or horizontal clapboards (mostly evident in southern New York and New Jersey), brick, fieldstone (usually found along the Hudson River), or a mixture of materials. Stone and brick houses often have clapboard gables. Some houses have rubble or stone foundations.

Brickwork. Decorative brickwork (Fig. 19-37) characterizes many Dutch houses. Zigzag patterns at roof edges are called *muisetanden* (mouse tooth). Diamond or chevron patterns created with colored brick are called diaper work or Dutch cross bond. Other patterns include triangles, checkers, and geometric florals. Blue, purple, and gray are typical colors.

■ *Windows and Doors.* Small casement windows are common in the 17th century. Double-hung windows replace them in the 18th century. Exterior vertical plank shutters are common in urban centers. Typical doors are planks or panels (later) and may be divided in half horizontally to keep out animals and allow in light and air (known as Dutch doors). Elaborate surrounds similar to English designs appear in the 18th century. Many houses have a raised front door and *stoep* (platform).

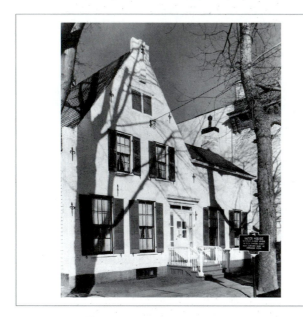

19-44. Yates House, early 18th century; Schenectady, New York.

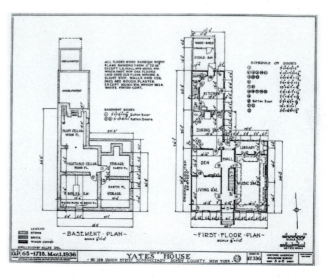

19-45. Floor plans, Yates House; Schenectady, New York.

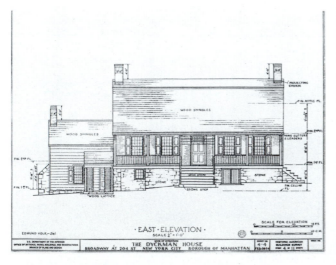

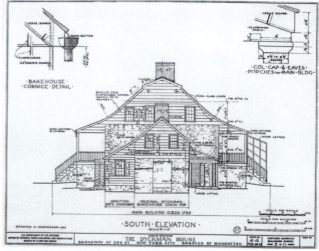

19-46. Elevations, Dyckman House, c. 1783 (flared eave with porch); New York City, New York.

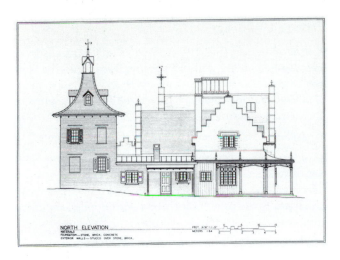

19-47. Later Interpretation: Sunnyside, late 17th century with Dutch additions 1835–1859; Tarrytown, New York.

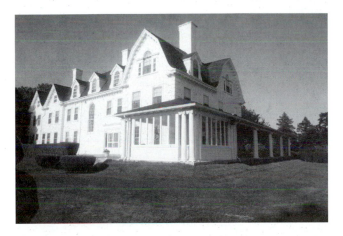

19-48. Later Interpretation: Dutch Colonial house, early 20th century; Newport, Rhode Island; Colonial Revival.

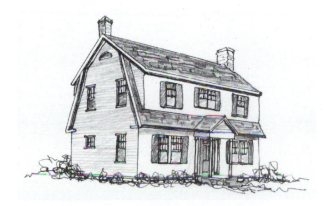

19-49. Later Interpretation: "The Van Jean," Dutch Colonial house, Sears Roebuck and Company, 1925; United States; Colonial Revival.

■ *Roofs.* Roofs are of thatch (early only), wood, slate, or clay tiles.

■ *Later Interpretations.* Characteristics of Dutch buildings live on in the Dutch Colonial Revival (Fig. 19-47, 19-48, 19-49) of the early 20th century and later, primarily in the flared-eave and gambrel roofs. Dutch Colonial houses, which do not closely imitate prototypes, commonly are of clapboard and often have dormers.

INTERIORS, FURNITURE, AND DECORATIVE ARTS

Dutch interiors (Fig. 19-52, 19-53) with tiles, ceramics, textiles, and paintings are more colorful than English ones. As many settlers are merchants, interiors often exhibit objects from around the world.

Design Spotlight: Holland

Architecture: *Van Cordlandt Manor.* Located along the east bank of the Hudson River just north of New York City, this stone manor house (Fig. 19-40) was home to the Van Cordlandt family for over 250 years. Surrounded by rich farmlands and forested hills, it expanded in size in concert with the family's fortune and requirements. The flared-eave roof extends to cover a large encompassing porch that serves as an extended living area. Connecting to the porch, the main interior public areas are above ground level. Service areas, including the old kitchen (Fig. 19-50), are at ground level. Interiors display plaster and paneled walls, beamed ceilings, and furnishings typical of a Dutch and 18th-century American character.

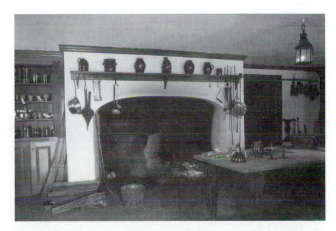

19-50. Kitchen, Van Cortlandt Manor, c. 1680s and later; Croton-on-Hudson, New York.

Furniture in the New Netherlands reproduces Dutch prototypes. As in other colonies, furniture may be brought from home or imported. Typical furnishings include seating, tables, and storage pieces. Beds are sometimes built into wall paneling, usually near the fireplace.

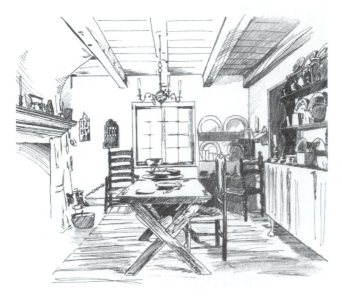

19-51. Kitchen, Philipsburg Manor, begun 1680; Upper Mills, New York.

Private Buildings

■ *Walls.* Interiors (Fig. 19-50, 19-51, 19-53) typically have whitewashed plaster walls. Dutch fireplaces retain the large hood over a hearth and cast-iron fireback. The surround is tiled, and a ruffled valance hangs from the hood to prevent smoke from entering the room.

■ *Ceilings.* Ceiling beams rest on decorative brackets.

■ *Storage.* The *kas* (wardrobe; Fig. 19-53, Color Plate 45) is a distinctive piece made by the Dutch in the Hudson River Valley. Used for storage, it resembles European examples. Some are of dark wood with applied moldings and bosses. Other examples display *grisaille* (monochrome gray) paintings of fruits and flowers on their facades. Most have double doors, a heavy cornice, and bun or ball feet.

■ *Delftware.* Dutch and English interiors commonly feature examples of this tin-glazed earthenware (Fig. 19-52) produced in Delft, Holland, beginning in the first half of the 16th century. Throughout the 17th century, Dutch potters copy designs on Oriental porcelains imported by the Dutch East India Company. They also produce biblical scenes, landscapes, and patriotic slogans. Although best known for blue and white tiles and other wares, potters create polychrome examples in the 18th century. Besides tiles, common wares include garniture (sets of vases for a mantel shelf) and chargers (platters or plates).

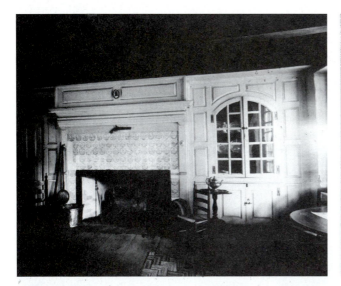

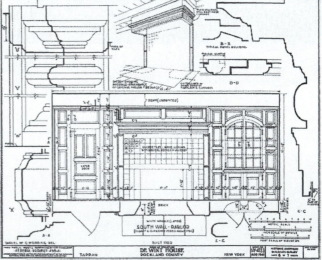

19-52. Parlor with Delft tiles on fireplace, De Windt House, 1700; Tappan, New York.

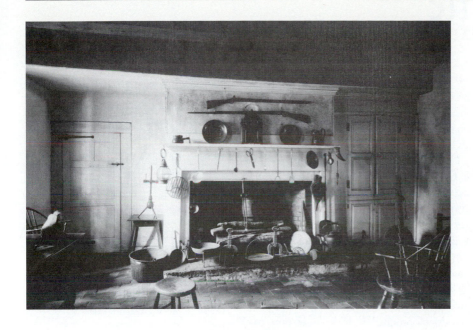

19-53. Kitchen, De Windt House, 1700; Tappan, New York.

19-54. Bedroom, J. G. Hardenbergh House, c. 1762; originally near Kerhonkson, New York.

19-55. Dutch door and hardware, c. 1700; New York.

F. Baroque

1600–1750

Baroque, an international style that dominates Europe in the 17th century, unites the grand scale, representational techniques, and architectural developments of the High Renaissance with the drama and emotion of the Late Renaissance. The style emerges in Rome at the end of the 16th century where it celebrates the victories of the Counter-Reformation and seeks to glorify the Christian god and the Catholic Church. At times classical and conservative, and at others plastic and exploitive, the Baroque combines monumental architecture, illusionistic painting, and dynamic sculpture to inspire, awe, and transport the viewer. Architecture, interiors, and furniture are more fully integrated and unified than during the Renaissance as they reflect these Baroque intentions.

Following Catholic military and theological victories over Protestantism, Pope Sixtus V resumes the building program in Rome in the 1580s. To construct a new city that reflects the magnificence of Christ and the Catholic Church, Sixtus institutes a vast program of urban development. Wide avenues punctuated with fountains and obelisks and highlighted by squares change the face of the city. New churches combine architecture, sculpture, and painting to create drama and inspire awe in worshippers.

From Rome where it promotes the church, the Baroque spreads to France where it becomes a tool to glorify the Sun King, Louis XIV. The magnificence of Louis's court inspires envy and the desire for similar expressions in the nobility of other countries. Similar examples spring up in Spain, Germany, Austria, and the New World. Protestant Holland and England remain largely unaffected by the Baroque period.

Although religious conflicts predominate during the Baroque era, global colonization and scientific developments proceed. The newly invented telescope and microscope further open the universe. The 17th century is the age of Shakespeare and great theater. Opera is born. Life at court is splendid and colorful with polished manners and ornate clothing.

Pascal invents first calculator	1645
French Academy of Arts founded	1648
Thirty Years War ends	1648
Taj Mahal completed	1648
Charles I beheaded; England declared a commonwealth	1649
First coffee house opens in London	1652
First opera house opens in London	1656
Vermeer paints *The Milkmaid*	1658
Moliere's first comedy performed	1659
Charles II brings monarchy back to England	1660
Great Plague begins in London; 60,000 die	1665
Great Fire destroys much of London	1666
Stradivarius makes violins in Cremona, Italy	1666
Moliere writes *Le Misanthrope*	1666
Louis XIV sponsors first art exhibit at Louvre	1667
Milton publishes *Paradise Lost*	1667
La Fontaine publishes *Fables*	1668
English establish Charleston, SC	1670
English given permission to trade in China	1670
English Hudson Bay Company founded	1670
Isaac Newton builds first reflecting telescope	1672
Lully produces first French opera	1672
John Bunyan's *The Pilgrims Progress* first appears	1674
Dr. Condom is said to have done his bit	1675
Fast-drying calico process invented in England	1676
Champagne invented in France	1678
Church of the Invalides in Paris by Mansart begun	1679
First national theater company formed in France	1680
Halley discovers the Great Comet	1680
William Penn founds Philadelphia	1682
Edict of Nantes revoked by Louis XIV	1685
Newton publishes work on gravity	1687
Jean Papillon invents blocks used in wallpaper	1688
Purcell's opera *Dido and Aeneas* performed in London	1689
William and Mary become England's rulers	1689
Sexuality of plants discovered	1694
Wren's Greenwich Hospital, completed in London	1694
Williamsburg becomes Virginia state capital	1699
Congreve's *The Way of the World* produced in London	1700
Detroit, U.S., founded by Antoine de Cadillac	1701
Slave trade with Africa begins	1701
First daily newspaper begun in England	1702
Handel's first opera *Almira* produced in Germany	1703
Duke of Marlborough defeats French at Blenheim	1704
Ironworks established in England	1705
Steamboat invented	1707
First mass immigration of Germans to U.S.	1709
First Meissen factory opens in Prussia	1710
Peter the Great makes St. Petersburg Russian capitol	1712
Smallpox vaccine invented	1717

EUROPE after the PEACE OF WESTPHALIA 1648

20. European Baroque

1590s–1750

Imaginative, surprising, and gay, richly covered with colored marbles, carvings, paintings, and gilding, the Baroque sought to attract attention by [a] striking and picturesque appearance.

Helen Gardner, *Art Through the Ages*

The Baroque style dominates Europe and a few American colonies throughout the 17th and early 18th centuries. An ornate, sumptuous style closely tied to religious, political, and economic developments, the Baroque style integrates exteriors and interiors more fully than did the Renaissance style, particularly in churches. A plastic, exuberant style dominates the Catholic countries of Italy, Spain, Portugal, Austria, Flanders, and Germany where Baroque serves to glorify the church and inspire piety. In Catholic France, the style, which is the taste of the king, demonstrates the power and majesty of the absolute monarchy of Louis XIV. Protestant countries such as England, Holland, and northern Germany lean toward a less monumental, more restrained style that is not closely tied to religion or politics.

20-1. Baroque era costumes.

HISTORICAL AND SOCIAL

The age of the Baroque is a time of contrasts in Europe. Absolute monarchies coincide with the rising nationalistic movements. The great wealth and power of monarchs and nobles contrasts with the abject poverty of the lower classes. The spread of knowledge and scientific advances continues, yet wars, famines, and plagues devastate millions. Manners grow more refined in this age of great theater, music, and opera. Royalty enjoy extravagant entertainment, masques, balls, and receptions. Commerce and trade flourish as major European powers establish colonies in the Americas. Scientists and researchers make great strides in astronomy, physics, calculus, chemistry, and medicine and invent or perfect precision instruments for observation and measurement.

CONCEPTS

The term *Baroque*, which may be from the Portuguese *barocco* or Spanish *barueco*, describes an irregularly shaped pearl. Originally derogatory, it signifies a decline from Renaissance classicism. Associated with the Counter-Reformation of the late 16th century, the style develops out of Late Renaissance tendencies toward emotionalism and deliberate manipulation and/or misuse of classical forms and details.

Baroque energy and tension mirror that of the age. It seeks to awe and inspire, whether to greater worship of God and His church or to stronger allegiance to a nation, monarch, or noble. The style also reflects an ever-expanding understanding of the universe and mind of man through various time–space devices, such as buildings that extend into surrounding spaces and require the viewer to move around and through them or vast cavernous interiors with undulating walls and highly illusionistic ceiling paintings that imply limitless space. Light may be developed as a mystical element or for its dramatic impact. Richness of material, color, and surface decoration complete the splendor and magnificence of the period. Italian churches integrate exterior and interior promoting the idea of unity in interior design, which will in time develop into a common design vocabulary throughout much of Europe.

DESIGN CHARACTERISTICS

Monumental scale, movement, seemingly limitless space, center emphasis, and complex forms and plans characterize Baroque architecture. Classical language, symmetry, unity, and harmony now reflect a more expansive world and church or the goal of self-promotion. Buildings no longer

sit in self-contained isolation, but expand into surrounding space. Often, they are part of large urban projects of which the main longitudinal axis continues into and often through the interior into a large formal garden. The monumental scale of many structures requires movement by

20-2. Bronze door knocker and escutcheons, 17th century; Italy.

20-3. Dome, San Carlo alle Quattro Fontane, Rome, Italy.

20-4. Trevi Fountain, 1732–1737; Rome, Italy; by Noccolo Salvi.

the viewer to fully experience them. Facades and interior walls may curve or undulate. Layers of elements, curves and countercurves, and advancing and receding planes create movement, energy, and dynamism especially toward centers on facades and interiors. Contrasts, such as light and dark, colossal orders (spanning two or more stories; Fig. 20-4, 20-8) and normal orders (mainly on one story), are common design principles.

Articulation using classical elements is more three dimensional and forceful in Baroque designs than Renaissance designs. Forms and motifs may break, twist, and curve. Multiplication of geometric units replaces earlier mathematical modules in the work of some architects. Space, which features multiple vistas, is dynamic and vast. Designers strive for greater spatial unity and more openness. Architecture, sculpture, and painting unite to create drama, inspire, or even overwhelm. More complex and dynamic shapes in plans (such as ovals or triangles) replace the more static ones of the Renaissance. Similarly, large scale, movement, sculpturesque form, classical details, exuberant carving, and sumptuous materials characterize furnishings.

■ *Motifs.* Classical elements, such as pilasters and pediments (Fig. 20-4, 20-5, 20-7, 20-8, 20-14, 20-20, 20-37), are common but are used more dynamically, even capriciously. Other motifs (Fig. 20-2, 20-3, 20-24, 20-40) include colossal columns, **C** and **S** scrolls, shells, swags, flowers, figures, sculpture niches, and cartouches. Some Mannerist characteristics, such as pilasters that taper to the base, continue, particularly in Spain and in the north.

ARCHITECTURE

The Baroque period begins in Rome under the leadership of Pope Sixtus V (1585–1590), whose major rebuilding campaign intends to celebrate Catholic victories over Protestantism and to win back and attract new worshippers. Sixtus initiates the completion of the dome and facade of S. Peter's Basilica and the addition of the piazza in front. Numerous churches spring up or are refurbished. Wide avenues and streets replace narrow medieval ones, and large piazzas and fountains punctuate and highlight vistas. Italian sculptors and painters create a corresponding interior style that contributes to the impact of architecture and urban planning. The building boom in Rome calls forth talented and well-known architects to design great and influential palaces and interiors. From Italy, the Baroque style soon influences all of Europe.

■ *Italy.* In Italy, two architects introduce the forms and language of the Baroque style. The more classical, theatrical work of Gianlorenzo Bernini (Fig. 20-9, 20-12) dominates Rome and, subsequently, France. A sculptor and

20-5. Early Baroque portals; Vienna, Austria.

Design Practitioners

- *Italian architects* continue the Renaissance tradition of excelling in several arts. Thus, well-known architects and artists provide architectural frameworks and even decorate interiors in churches and noble houses. Italians travel to France and northern Europe, spreading the Baroque aesthetic. In addition, pattern books, which usually include planning advice and interior details, spread the style and promote a common language of design.

- *Gianlorenzo Bernini* is a sculptor, painter, poet, stage designer, and architect working in Rome and the Vatican in the early 17th century. By combining architecture, painting, and sculpture, Bernini sets precedents for Baroque high drama. Within a classical framework, he creates expansive and dynamic designs. His first project is the *baldacchino* (canopy) over the high altar in S. Peter's Basilica. Through numerous other projects and works, he establishes an international reputation: Louis XIV calls Bernini to Paris to submit designs for the east front of the Louvre.

- *Francesco Borromini* creates a more plastic, inventive Baroque expression in Rome. He adopts Michelangelo's artistic license and models unusual classical sources, such as Hadrian's Villa. Borromini experiments with complex geometric shapes for plans and facades. His facades undulate or feature curves and countercurves. He places columns on diagonals and designs unusually shaped domes and window surrounds.

- *The Churriguera brothers*, José Benito, Joáquin, and Alberto, are conservative makers of altarpieces and architects in Madrid, Barcelona, and Segovia. They revive Plateresque surface decoration, hence the name Churrigueresque for Spanish Baroque.

- *Pietro da Cortona*, a painter and architect, creates some of the best and most illusionistic Baroque paintings in various palaces in Florence and Rome. His work, characterized by strong columnar accents and contrasts of light and shade, is inventive and eclectic. He borrows elements and details from Michelangelo and antiquity.

- *Johann Bernard Fischer von Erlach* is an Austrian architect and painter who studies in Italy. On his return to Austria, Fischer von Erlach creates eclectic and inventive designs that combine illusionistic painting with architecture. His best-known work, the Karlskirche in Vienna, combines classical and Christian elements.

- *Filippo Juvarra* is a prolific designer who transforms Turin into a royal capital by designing palaces, town houses, churches, and streets. His use of light is especially daring. Juvarra, like Bernini, is internationally known.

- *Balthasar Neumann* is a German Late Baroque/Rococo architect. He is known for his ceremonial staircases that combine architecture, sculpture, and painting into unique expressions.

and material. In comparison, the work of Francesco Borromini (Fig. 20-14) is more revolutionary than Bernini's. Highly plastic, undulating facades and interior walls, complex plans, and unusual motifs characterize his buildings. He is a master of geometric complexity. Papal and noble families continue to build large, impressive palaces and villas as in the Renaissance. Dwellings reflect Baroque planning concepts and decoration in greater expansiveness, monumental staircases, and sumptuous interiors, but they rarely achieve the plasticity, dynamism, and movement that characterize churches.

■ *Spain.* The work of Bernini and Borromini directly influences some Spanish floor plans and facades in shape and complexity. Spanish buildings rarely are as plastic as those in Italy, nor do they expand into surrounding space. Much of Baroque architecture in Spain features surface ornamentation, beginning with the work of the Churriguera family. Uniquely Spanish, Churrigueresque differs from other European manifestations in its profuse surface ornamentation reminiscent of the Renaissance Plateresque. In contrast to the earlier Plateresque (1504–1556), Churrigueresque is more three dimensional and features Mannerist motifs; the decoration may spread to the entire facade instead of restricting itself to doorways and windows.

■ *Germany and Austria.* Occupied with the Thirty Years War (1618–1648) and its effects, Germany and Austria don't adopt Baroque styles until the 18th century (Fig. 20-18, 20-20, Color Plate 47, 20-23); it becomes a style of Catholicism. German Baroque combines the medieval *westwerk* (tall facade with two towers) with movement, center emphasis, layers of elements, and elaborately decorated interiors that are often more Rococo (asymmetrical, naturalistic, curvilinear decoration) than Baroque. The

20-6. Il Gesù, 1571; Rome, Italy; by Giacomo della Porta.

architect, he unites architecture, painting, and sculpture for magnificent theatrical effects. His dynamic style features complex plans; classical elements; monumental scale; movement; and dramatic contrasts in light and dark, color,

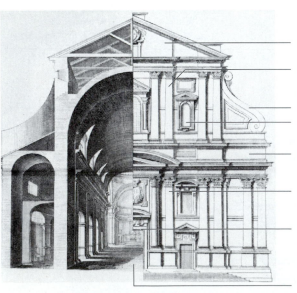

Pediment

Pilaster and engaged columns articulate the upper facade

Large scaled curves

Niche

Entablature

Pilaster and engaged columns articulate the lower facade

Entry and center defined by layering of architectural features and large, monumental scale

Symmetrical emphasis

20-7. Elevation and perspective, Il Gesù.

20-8. Bird's eye view, S. Peter's Basilica, 1506–1626; Rome, Italy; facade completed by Carlo Maderno.

Germans excel in their use of dramatic light and the integration of architecture, painting, and sculpture.

■ *Holland.* Protestant Holland adopts a simpler, more classical style derived from Palladio and his follower Vincenzo Scamozzi. Scale is modest; symmetry and repose are characteristic. Facades (Fig. 20-10) feature temple fronts with clearly defined units and restrained classical ornament, such as swags.

Design Spotlight

Architecture: *S. Peter's Basilica.* Carlo Maderno creates a Latin cross plan for this church (Fig. 20-8, 20-9) out of the original Greek cross of Bramante and Michelangelo by adding several bays to the nave. S. Peter's facade progresses outward in planes from the corners to the center, which is marked by a pediment that provides a vertical element. Planned twin towers, which would have balanced the great width of the facade, are not completed. The monumentality of the facade obscures the vision of the dome intended by Michelangelo. Bernini designs the *piazza*, which reaches into and encloses a vast space, a dynamic composition of oval and trapezoid that represents the welcoming arms of the church. He also plans, but never completes, a smaller colonnade in the opening of the oval so that visitors will suddenly enter the huge open space of the *piazza* and be overwhelmed with the vision of the facade. The *piazza's* size complements the building and accommodates huge crowds of pilgrims and worshippers.

20-9. Plan, Piazza, S. Peter's Basilica, 1656; Rome, Italy; by Gianlorenzo Bernini.

Public and Private Buildings

■ *Types.* Building types include churches, palaces and palace complexes, town and country residences, and public buildings. Unlike other countries, Germans construct monasteries as well as churches and palaces.

■ *Site Orientation.* Churches, public buildings, and some palaces are no longer self-contained and isolated as in the Renaissance. They project into and enclose spaces around them. Important buildings may be focal points of *piazzas* or squares with impressive and monumental approaches (Fig. 20-8, 20-9, 20-26). Often the axis of approach continues into the interior and out to the garden. Expansive city planning is an important Baroque development.

20-10. Mauritshuis, c. 1633; The Hague, Netherlands; by Jacob van Campen.

20-12. S. Andrea al Quirinale, 1658–1670; Rome, Italy; Gianlorenzo Bernini.

20-11. Rosenkranz Basilika, S. Maria Rotunda, 1631–1634; Vienna, Austria.

20-13. Santa Maria de Monte Santo and Santa Maria dei Miracoli, 1662–1679; Piazza del Popolo, Rome, Italy; Carlo Rainaldi.

■ *Floor Plans.* Large churches have basilica or Latin cross plans (Fig. 20-9) to accommodate crowds and ceremonial processions. In addition, these plans are more liturgically functional. Smaller churches and shrines feature central-ized plans symbolizing universal concepts. Architects experiment with combining function and universality in various ways. These include basilica plans with a strong centralized emphasis on majestically domed spaces or oval or elliptical plans. Dynamic Baroque church plans consist of complex combinations of equilateral triangles, ovals, circles, and lozenges (Fig. 20-15) instead of the simple rectangles, squares, and circles of the Renaissance.

Domestic plans may be **U** shaped, a more expansive design, or continue the block surrounding a courtyard of

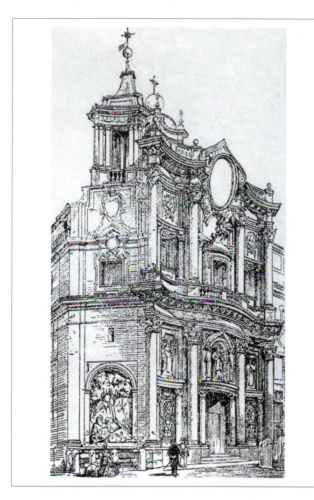

20-14. S. Carlo alle Quattro Fontane, 1634–1682; Rome, Italy; by Francesco Borromini.

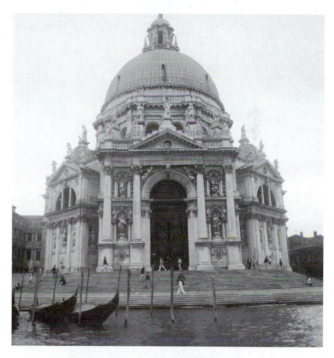

20-16. S. Maria della Salute, 1631–1691; Venice, Italy; by Baldassare Longhena.

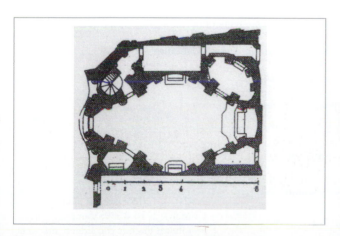

20-15. Floor plan, S. Carlo alle Quattro Fontane.

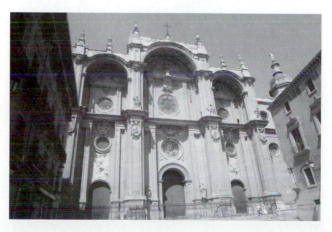

20-17. Granada Cathedral, 1667–1703; Diego de Siloe.

the Renaissance. The majority of rooms remain rectangular, although staircases are often oval or curvilinear. Regardless of the form, plans feature grand staircases, large reception rooms, and suites of state and private apartments. In the palaces and homes of royalty (Fig. 20-24, 20-26, 20-27), architects adopt French planning concepts

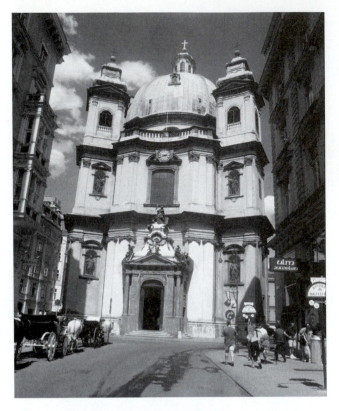

20-18. S. Peter's Church, 1702–1733; Vienna, Austria; by Gabriele Montani and Lukas von Hildebrandt.

20-19. Church of S. Nicholas, 1735; Prague, Czechoslovakia.

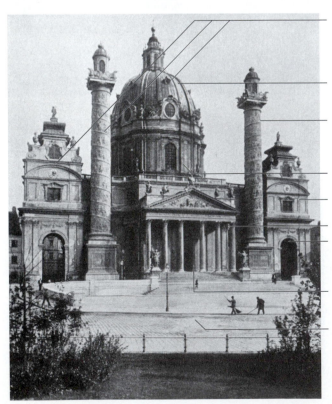

Layers of architectural features create advancing and receding planes

Massive dome to portico

Columns imitate Trajan's column in Rome; decorated with designs in relief; frame and emphasize dome

Pilasters articulate base of dome

Flanking tower with classical features

Temple portico

Round arch repeats from Italian and French influences

Symmetrical emphasis

Church is focus of city square

20-20. Karlskirche (S. Charles' Church), 1716–1739; Vienna, Austria; by Johann Fischer von Erlach and son. (Color Plate 47)

20-21. Palazzo Pisaro, 1652–1710; Venice, Italy.

in which rooms are carefully distributed to demonstrate status and to impress the visitor. Doors align on the same side of sequential rooms to create *enfilade* (vistas) with fireplaces opposite the entrance or the windows. These processional rooms are generally sited on the garden side of the home.

Design Spotlight

Architecture: *Karlskirche (S. Charles' Church).* Designed by Johann Fischer von Erlach and his son for Emperor Joseph I, this distinctive church (Fig. 20-20, Color Plate 47, 20-36) is one of the finest Baroque buildings in Europe. The massive classical facade develops with a temple portico, flanking towers, and huge dome. Two large columns, imitating Trajan's column in Rome, define each side of the entry. They feature spiraling reliefs conveying messages of the virtures of S. Charles Borromeo, who helped the Viennese people during the 1576 Milan plague. Heavily scaled ornamentation is elaborate outside and inside. The nave continues the exterior design with marble columns, large arches, an ornate apse, classical motifs, and gold decoration. The massive domed ceiling dominates the center aisle and highlights the Greek cross plan.

20-22. Palazzo Carignano, 1679; Turin, Italy; by Guarino Guarini and Palazzo Madama, 1718–1721; Turin, Italy; by Filippo Juvarra.

■ *Materials*. Designers typically use local stone or brick. Contrasts in color and/or material accent and emphasize parts and elements. Some Spanish examples feature polychrome decoration or glazed tiles. In Holland, red brick with contrasting white stone details is common.

■ *Facades*. Classical elements, movement, and center emphasis characterize facades (Fig. 20-6, 20-10, 20-11, 20-12, 20-13, 20-14, 20-16, 20-17, 20-18, 20-19, 20-20, 20-21, 20-22, 20-23, 20-24, 20-25, 20-26, 20-27), which are no longer in a single plane as in the Renaissance. Layers of elements; combinations of curved and straight lines; advancing and receding planes; and pilasters, engaged

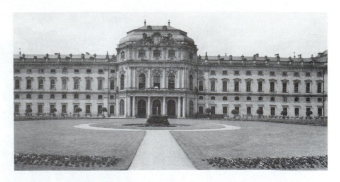

20-23. Residenz, 1719; Würzburg, Germany; by Balthasar Neumann and others.

Important Buildings and Interiors

■ **Amsterdam, Netherlands:** Town Hall, b. 1648, Jacob van Campin.

■ **Dresden, Germany:** Zwinger, 1716–1722, Matthäus Daniel Pöppelmann.

■ **Granada, Spain:**
—Granada Cathedral, 1667–1703, Diego de Siloe.
—Sacristy of La Cartuja, 1713–1747, begun by Francisco Hurtado.

■ **Madrid, Spain:**
—Royal Palace, 1738–1764, Filippo Juvarra.
—S. Fernando Hospital, 1722, Pedro Ribera.

■ **Melk, Germany:** Benedictine Monastery, 1702–1714, Jakob Prandtauer.

■ **Ottobeuren, Germany:** Benedictine Abbey, 1744, Johann Michael Fischer.

■ **Paris, France:** Church of the Invalides, 1670–1708, L. Bruant and J. H. Mansart.

■ **Prague, Czechoslovakia:**
—Church of S. Nicholas, 1735.
—Clam-Gallas Palace, early 18th century, Johann Fischer von Erlach.
—S. Nicholas on the Lesser Side, 1703–1711; Christoph Dientzenhofer.

■ **Rome, Italy:**
—Cornaro Chapel, Santa Maria della Vittora, 1645–1652; Gianlorenzo Bernini.
—Piazza del Popolo, S. Maria di Monte, S. Maria dei Miracoli, 1662–1670, Carlo Rainaldi.
—Palazzo Barberini, 1628–1663, Carlo Maderno, Gianlorenzo Bernini, and Francesco Borromini.
—S. Andrea al Quirinale, 1658–1670, Gianlorenzo Bernini.
—S. Carlo alle Quattro Fontane, 1634–1682, Francesco Borromini.
—S. Maria della Pace, 1656–1657, facade, dome, and piazza by Pietro da Cortona.

—S. Peter's Basilica, 1506–1626, Carlo Maderno and others, piazza, 1656, Gianlorenzo Bernini. (Color Plates 48 and 49)

■ **Salamanca, Spain:** Plaza Mayor, Salamanca, 1729–1733, Alberto de Churriguera.

■ **The Hague, Netherlands:** Mauritshuis, c. 1633, Jacob van Campen.

■ **Turin, Italy:**
—Cappella della S. Sindone, Turin Cathedral, 1667–1690, Guarino Guarini.
—Palazzo Carignano, 1679, Guarino Guarini.
—S. Lorenzo, 1666–1679, Guarino Guarini.
—Stupinigi Palace, 1729–1733, Filippo Juvarra.

■ **Toledo, Spain:** The Transparente, Toledo Cathedral, 1721–1732, Narciso Tomé.

■ **Valladolid, Spain:** University facade, 1715, Narciso Tomé.

■ **Venice, Italy:** S. Maria della Salute, b. 1631, Baldassare Longhena.

■ **Vienna, Austria:**
—Grand Hall, Hofbibliothek Prunksaal.
—Hofsburg (Imperial Palace), 13th–18th centuries.
—Karlskirche (S. Charles' Church), 1716, Johann Fischer von Erlach and son. (Color Plate 47)
—Lower Belvedere, 1715.
—S. Peter's Church, 1702–1733, Gabriele Montani and Lukas von Hildebrandt.
—Schönbrunn Palace, 1696–1713.
—Upper Belvedere, 1721–1722, Johann Lukas von Hildebrandt.

■ **Würzburg, Germany:**
—Residenz, b. 1719, Balthasar Neumann and others.
—Staircase, 1737–1742, Balthasar Neumann.

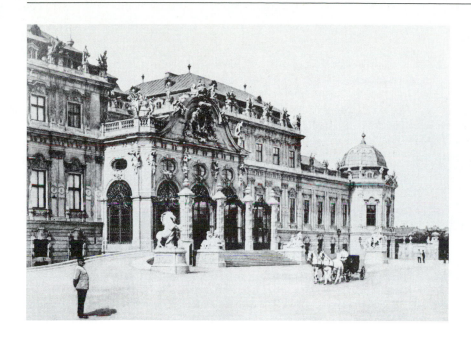

20-24. Upper Belvedere, 1721–1723; Vienna, Austria; by Johann Lukas von Hildebrandt.

20-25. Winter Riding School, Hofburg Palace Complex, 1729–1735; Vienna, Austria; by Johann Bernard Fischer von Erlach.

columns, and columns that increase in projection toward the center create movement and three-dimensionality (Fig. 20-8, 20-20). Facades may undulate and/or project into space. Articulating elements, such as cornices and pilasters, curve or break in response to projections and curves on the facade. Sculpture niches, pediments, and volutes highlight, define, and create contrasts of light and dark. Spanish facades (Fig. 20-17) often have rich surface decoration concentrated around doors and windows and spreading across the facade.

Center emphasis also characterizes palaces and dwellings (Fig. 20-24, 20-26, 20-27). Framing elements, such as pilasters, organize facades into bays. Fronts sometimes feature Renaissance forms of articulation, such as rustication that lightens on each successive story or superimposed orders.

■ *Windows.* Rectangular or curvilinear windows have circular or triangular pediments or complex, curvilinear surrounds. In churches, light is an important design element and a visual metaphor for divine illumination. Light sources often are concealed in walls, roofs, or domes to increase the dramatic impact and/or emphasize mystery (Fig. 20-8, 20-12, 20-16, 20-19, 20-20). Windows on dwellings generally are larger than before.

■ *Doors.* Center emphasis defines entrance doorways (Fig. 20-5, 20-7, 20-14, 20-18), which are impressive in scale and ornament. Arches, columns, and pediments that increase in layers and project often mark these doorways. Doors are of paneled wood or heavily carved.

■ *Roofs.* Roofs (Fig. 20-8, 20-19, 20-20, Color Plate 47, 20-24) are usually gabled with domed crossings and chapels.

20-26. Schönbrunn Palace, 1695–1744; Vienna, Austria; by Johann Fischer von Erlach and son and 1744–1749 by Nikolaus Pacassi.

20-27. Royal Palace, 1738–1764; Madrid, Spain; by Filippo Juvarra.

Oval domes are preferred over circular domes as more dynamic. Gables or flat roofs cover dwellings and palaces. They may be capped by balustrades and sculpture.

■ *Later Interpretations.* Designers adopt the scale and a few key elements, such as center emphasis, in later buildings, but literal copies of Baroque buildings are rare. A Neo-Baroque style develops in France in the 1860s, most notably in the work of architect Jean-Louis-Charles Garnier. Baroque planning concepts, scale, and surface richness continue in various forms through the 19th century.

20-28. Later Interpretation: L'Exposition, 1902; Turin, Italy; by Raimondo d'Aronco; Art Nouveau.

20-29. Later Interpretation: Berlin Cathedral, 1905; Berlin, Germany; by Julius Raschdorff.

Baroque's undulating walls and complex plans influence Art Nouveau in the late 19th and early 20th centuries (Fig. 20-28). Interpretations of Baroque churches continue through the early decades of the 20th century (Fig. 20-29).

INTERIORS

Interiors, like exteriors, are magnificent and designed to impress, persuade, and transport. To do so, they repeat the monumental scale, dynamism, contrasts, and complexity of exteriors. Integration and expansion, even to infinity, are important design principles, particularly in churches where designers experiment with traditional elements and forms to achieve these goals. Rich materials and colors, numerous classical details and embellishments, painted and gilded woodwork, illusionistic paintings, sculpture, elaborate stuccowork, and fine furnishings create dramatic settings for the ecclesiastical and social events that characterize Baroque life.

Design Spotlight

Interior: *S. Peter's Basilica.* Bernini decorates the interiors at S. Peter's (Fig. 20-30, 20-31, 20-32, Color Plates 48 and 49) with costly colored marbles, gilding, and rich coffering on the barrel vaults. The huge scale, architectural details, and glittering surfaces unite to overwhelm the viewer who is required to move around and through the space to experience it. Monumental architectural details articulate walls and ceilings. At the crossing, Bernini's *baldacchino* (canopy) attempts to bring the monumental scale to a more human size. Supported by four twisting or Solomonic columns with Composite capitals, the bronze and gilded canopy rises 100′ or about nine stories. The upper portion features a valance with tassels similar to the ones used in processions. Four massive volutes curve upward to an orb surmounted with a cross. Gilding highlights elements and contrasts with the dark bronze. Light pours in from the dome, accentuating the *baldacchino* and creating a vertical axis in contrast to the longitudinal axis of the Latin cross plan.

Massive dome defines transcept crossing

Religious figures decorate dome

Clerestory windows filter light to interior

Large scale arch and medallions highlight nave

Barrel vault ceiling with coffering

Entablature

Composite capital

Columns articulate and define interior spacing and composition

Layering of architectural features creates emphasis for smaller altar areas

Vertical axis emphasized

20-30. Section, S. Peter's Basilica, 1624–1633; Rome, Italy.

European churches follow Italy's lead in creating splendid settings framed by architectural elements and exuberant wall and ceiling paintings. German church interiors unite architecture, painting, and sculpture especially well. Many feature rococo-style decoration. Typically characteristic of New and Old World Spanish churches are the ornate carved and painted *reredos* that highlight the altars. Dutch church interiors are more sober and austere than others.

European royalty imitate the domestic magnificence of Italians and, later, Louis XIV at Versailles. They vie with one another to create the most opulent dwellings. Prominent architects, painters, and sculptors design interiors for noble families. Wealthy Dutch merchants adopt simplified versions of the Baroque style in their homes.

Public and Private Buildings

■ *Types.* As before, several anterooms, each more magnificent than the last, precede the lavish state and private apartments in the homes of nobility. A visitor's status determines how closely he or she may approach the state bedchamber. Although there is evidence of rooms set aside specifically for dining, most people take meals in entertaining rooms or wherever it is convenient.

■ *Relationships.* Interiors continue Baroque themes of glorification, exuberance, dynamism, drama, and/or emotionalism. Large spaces often have diagonal focal points and vistas in contrast to the more static Renaissance spaces. Walls may undulate like facades. In churches (Fig. 20-30, 20-31, 20-32, 20-34, 20-35, 20-36, 20-37, 20-38), decora-

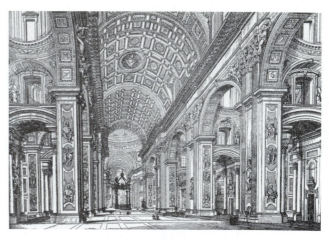

20-32. Nave, S. Peter's Basilica. (Color Plate 48)

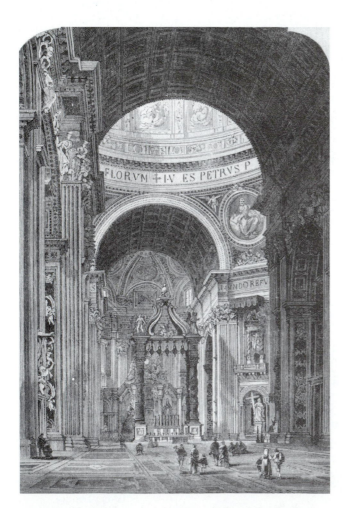

20-31. Crossing showing *baldacchino*, S. Peter's Basilica; interior and *baldacchino* by Gianlorenzo Bernini.

20-33. Nave, Rosenkranz Basilika, S. Maria Rotunda, 1631–1634; Vienna, Austria.

tion intends to inspire worship or greater piety and to glorify God and the church. Themes of paintings vary from highly realistic martyrdoms to miracles. Architecture, sculpture, and paintings, enhanced by strong contrasts of light and shadow, contribute to the drama. In palaces, plans and decorations, which emphasize the power and authority of a particular individual such as the owner, also mean to astonish or overwhelm.

■ *Materials*. Rich materials and strong color contrasts create, support, and enhance the goals of inspiration and awe. Churches (Fig. 20-35, 20-36, 20-38) and dwellings alike often feature such combinations as white walls articulated with real or painted colored marble architectural elements, carved and gilded woodwork, and stuccowork. Architectural details articulate and define spaces, but they are no longer in a single plane as in the Renaissance. Like exteriors, elements layer, curve, and break to create energy or movement or in response to undulating walls.

■ *Color*. Colors, which are from finish materials and textiles, are rich and highly saturated. Reds, greens, blues, and purples are typical. Contrasts of color and material are common. Gilding highlights numerous surfaces.

■ *Lighting*. Artificial lighting is minimal except during social events. Only the wealthy can afford numerous candles, candlesticks, *candelabra*, sconces, and chandeliers in gold and silver. Design and scale compliment interiors and furnishings.

■ *Floors*. Materials include marble, brick, lead-glazed tiles, or stone. Masonry floors may be plain or patterned.

Wealthy Dutch houses have black and white marble floors. Palaces and important residences use parquet, particularly on upper floors and/or in important rooms. People begin putting Oriental and European-made carpets on floors as well as tables. Plain, patterned, or colored rush matting sometimes covers floors, particularly in summer.

■ *Walls*. Architectural elements delineating church interiors (Fig. 20-30, 20-31, 20-32, Color Plates 48 and 49, 20-34, 20-35, 20-36, 20-37, 20-38) and important spaces in palaces may be painted and/or gilded or a contrasting material to the wall. Marble typically covers church walls, but is less common in dwellings, except palaces, because of its cost. A prevalent and less expensive treatment is painting wooden or plaster walls to imitate marble. Residential walls (Fig. 20-39) usually divide into dado, fill, and cornice, like a column. Dadoes are painted, paneled, or left plain. The area above may be painted decoratively; paneled; or covered with costly fabrics, leather, or tapestries (limited to the wealthy). Mirrors in elaborately carved frames become very important during the period. Dutch interiors feature numerous oil paintings.

■ *Frescoes*. Wall and ceiling frescoes are common in both palaces and churches (Fig. 20-36) in most countries. Italian artists fully develop the realistic techniques of the Renaissance to create highly illusionistic frescoes with an impression of limitless space. Movement and strong diagonals unite with twisting forms, sculpturesque figures, and billowing drapery. Real and *trompe l'oeil* architectural elements, stuccowork, and paintings combine in complex compositions with religious, mythological, or allegorical

20-34. Nave, Granada Cathedral, 1667–1703; Diego de Siloe.

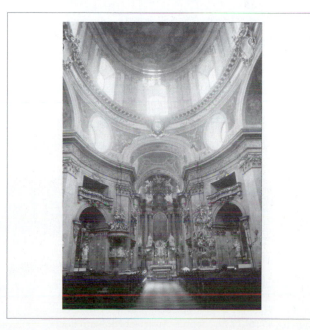

20-35. Nave, S. Peter's Church, 1702–1733; Vienna, Austria; by Gabriele Montani and Lukas von Hildebrandt.

themes. Similar designs appear in royal palaces all over Europe as Italian artists travel to France, Germany, Austria, and England or as European artists study in Italy. Germans also produce excellent frescoes, many of which are in the Rococo style.

■ *Fireplaces.* Mantels with classical details replace fireplace hoods except in Holland. The Dutch frequently hang a valance from the bottom of the hood to capture smoke. Pattern books feature designs for chimneypieces.

■ *Windows and Doors.* Windows are important interior elements in churches and dwellings as they admit the light so important to Baroque design concepts (Fig. 20-30, 20-33, 20-34, 20-37). The sash or double-hung window (two sliding sashes or panels hold the glass), which develops in the 1640s, soon replaces the casement window in

residences. Most windows have interior shutters to block light or give privacy. Curtains, which remain rare except in palaces, consist of two fabric panels hung on wire rods. As important design elements in the *enfilade*, doors are carved and paneled with gilding. Double doors are preferred to enhance impact.

■ *Ceilings.* Architects create vast interior spaces and vistas with barrel or groin vaults, domes, and arches in both public and private buildings (Fig. 20-31, Color Plates 48 and 49, 20-33). Unlike Renaissance architects, they intend to dwarf the viewer, thereby creating more drama and heightening impact. Round and ovoid domes create a vertical

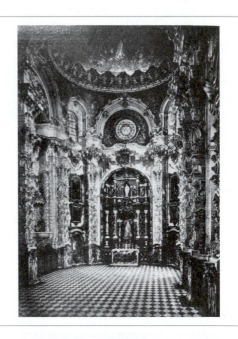

20-37. Sacristy of La Cartuja, 1713–1747; Granada, Spain; by Francisco Hurtado.

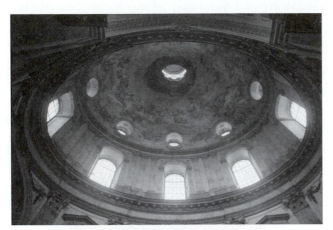

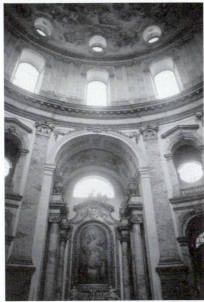

20-36. Wall and ceiling details, Karlskirche (S. Charles' Church), 1716–1739; Vienna, Austria; by Johann Fischer von Erlach and son.

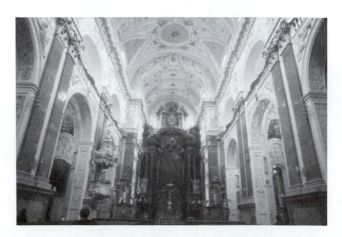

20-38. Nave, Church of S. Ignatius of Loyola, early 18th century; Prague, Czechoslovakia.

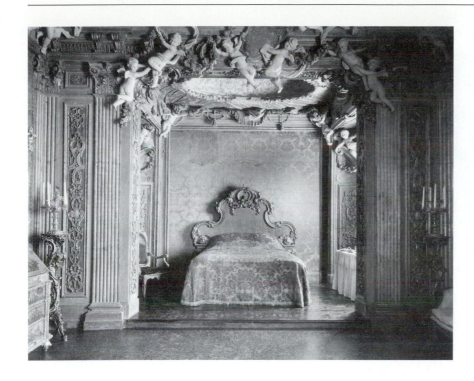

20-39. Bedroom, Palazzo Sagredo, 1718; Venice, Italy. [Attributed to Abbondio Statio (1675–1757) and Carpofaro Mazzetti (c. 1684–1748). Photographed March, 1926. The Metropolitan Museum of Art, Rogers Fund, 1906. (06.1335.1)]

axis and a stronger centralized feeling. In churches and palaces, important ceilings are frescoed, entirely or partly. In dwellings, flat, vaulted, and plasterwork ceilings may be left white or painted and/or gilded. Carving and painting decorate beams and coffers.

■ *Later Interpretations.* As in architecture, key elements of Baroque interiors, such as paintings or architectural elements, often appear later. Their opulence is commonly replicated in 19th-century palaces and wealthy dwellings in scale, exuberant architectural details, gilding, and illusionistic paintings.

FURNISHING AND DECORATIVE ARTS

Furnishings, used to enhance status, become increasingly important and are often designed for specific interiors. Designs reflect Baroque massive scale and dynamism. Comfort, although important, is subordinate to opulence. Furniture is rectilinear with curvilinear ornamentation, which can be excessive. Sculpture and architecture influence furnishings in bold, sculpturesque carving and architectural details.

By the end of the 17th century, most European countries emulate the Baroque furniture of Italy and France, but retain some regional character. Dutch furniture, particularly late in the period, features curving silhouettes, cornices, and bases. In Spain, the *vargueño* is no longer limited to the wealthy, and iron mounts still highlight the undersides of tables. Both Germany and Holland retain the large

two-door cupboards of the earlier period, but with more exuberant carving and decoration.

Public and Private Buildings

■ *Types.* Types include seating, tables, storage pieces, and beds.

■ *Distinctive Features.* Large scale, strong contrasts of color, and sculptural effects distinguish Baroque furniture. Boldly carved figures combined with leaves, scrolls, shells, and other details often form the legs of cabinet stands and tables. Veneers of exotic woods and complex marquetry compositions in multiple colors highlight doors and facades. Prominent cornices, bases, and architectural details distinguish large case pieces. Bun feet (round and slightly flattened form) are common in Holland and Germany.

■ *Relationships.* Furnishings elaborate on Baroque themes. Scale complements interiors. Compositions are bold and exuberant. Also characteristic are dynamism; motifs referring to an individual; and contrasts in scale, material, and color. Sculpturesque forms are common as sculptors sometimes design furniture. Furniture is intended to be placed against the wall; backs of chairs frequently are not upholstered for economy. Back legs on chairs and tables may be plain also.

■ *Materials.* Local and imported hardwoods dominate furniture design, and chief decorations are carving, gilding, lacquer, inlay (pattern laid into wood), veneer (very thin wood applied to other woods), or marquetry (veneer

20-40. Armchair; Venice, Italy.

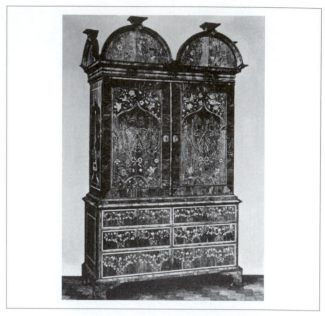

20-41. Cabinet with marquetry.

pattern laid into wood). The Flemish and Dutch are known for their excellent marquetry during the period. Cabinetmakers combine wood with other materials, such as silver or mother-of-pearl, which are often imported by their merchant ships. Exotic woods and/or marble embell-ish many examples. Lacquer imitates that on imported Ori-ental pieces.

■ *Seating.* With increased emphasis on comfort, suites of furniture, daybeds, and easy chairs are more common. Armchairs (Fig. 20-40) begin to appear even in less wealthy homes. Chairs with upholstered frames and lavish trims continue to mark wealth and status.

■ *Tables.* Consoles and tables with rectangular, usually marble tops feature exuberant carving and gilding. There are no tables specifically for dining. Dressing tables with drawers and mirrors on or above them become more com-mon in bedrooms as more refined manners and ways of dressing take hold.

■ *Storage.* Cabinets (Fig. 20-41) are important storage pieces, as reflected in their embellishment. Chests of draw-ers and wardrobes supersede chests in use. Cupboards and buffets remain important display pieces in spaces used for dining.

■ *Beds.* Beds in state apartments are raised on a dais or placed behind a balustrade. In Holland, beds may center against or be built into walls. Most beds are rectangular in form with hangings completely covering them. Valances depict complex curvilinear forms highlighted with gold braid or fringe. Beds of state often have vases of ostrich plumes atop the tester. Bed hangings, upholstery, and other

20-42. Textile, 17th century; Italy.

textiles often match (*en suite*) to create unity (Fig. 20-42). Rich trims enhance both hangings and upholstery.

■ *Decorative Arts.* Trade with the Orient fosters a desire for porcelains and lacquerwork. Some collectors have rooms specially constructed to display porcelains. Others display their assemblages on shelves, in niches, and on mantels. Gold or silver frameworks often surround precious porcelain objects. Other items from the East include lac-quered furniture, screens, and some Chinese wallpaper. Baroque accessories are lavish and large in scale to suit interiors. Curvilinear forms and classical or naturalistic carved and molded decorations and gilding are typical.

21. *Louis XIV*

1643–1715, France

"L'état c'est moi." (*I am the state.*)

Louis XIV

Not only does France become the leading world power in the 17th century, but she also replaces Italy as artistic leader of Europe. Versailles, the grandest French Baroque expression, dazzles all of Europe and sets new standards for luxury and extravagance in architecture, interiors, and furnishings. The palace exemplifies French Baroque planning concepts, design language, and intent. New factories arise to satisfy the demand for beautiful and expensive luxuries in court interiors.

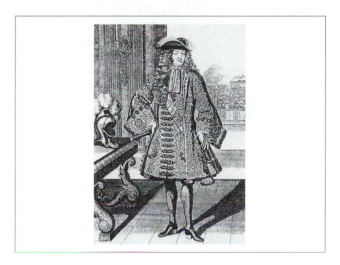

21-1. *Louis XIV*, 1701; by Hyacinthe Rigaud.

HISTORICAL AND SOCIAL

When Louis XIV ascends the throne in 1643 at the age of five, France has established her position as a great European power with a tradition of art patronage. During Louis's early years, the country is governed by Anne of Austria, his mother who is of Spanish nobility, and Cardinal Mazarin, his godfather who is a protegé of the powerful Cardinal Richelieu. Louis marries Marie Thérèse, the daughter of Philip IV of Spain and his first cousin. This connection enhances relationships between France and Spain and contributes to Louis's power. His second wife is Madame de Maintenon, who previously served as a court governess. After Mazarin dies in 1661, Louis rules France alone with the assistance of his economic minister, Jean-Baptiste Colbert. With Colbert's aid, Louis more firmly establishes the divine right of the monarchy begun previously under Richelieu and Mazarin. Louis regards himself as the greatest ruler in Europe and desires to impress others with the magnificence of court life.

To educate people to his greatness, Louis promotes festivals, fireworks, statues, fountains, books, and palaces. To visually support his claims, he demands surroundings that embody the power and grandeur of the Sun King, his court, and court life. He reinstitutes a rigid etiquette system promoting formal rules to govern court relationships and further glorify himself as king. The court overflows with an entourage of nobles and Louis's relatives, descendants, and their attendants, so appropriate housing is needed. This leads to the building of the Palais de Versailles, numerous royal *châteaux* nearby, and the establishment of the surrounding city. Through this building activity, architecture, painting, sculpture, furniture, and the decorative arts unite to create drama and to inspire awe. Court policy, as established under Henri IV, supports the use of art and architecture as tools of the state, thereby ensuring a suitable climate for Louis to accomplish his goals. Italian artists imported into France aid in this endeavor by contributing their skills and expertise. The result produces a unified national art expression, numerous cabinetmaking workshops, and expanded decorative arts factories. Although this has little impact outside of royalty because of its lavishness and expense, it does establish France as a world leader in artistic taste.

CONCEPTS

French Baroque seeks to awe and inspire, not to the glory of the church as in Italy, but to the absolutism of the Sun King, Louis XIV. As the first indigenous example of French decoration, French Baroque projects grandeur and luxury embedded within an overall unity of composition— a standard of beauty totally integrating the landscape,

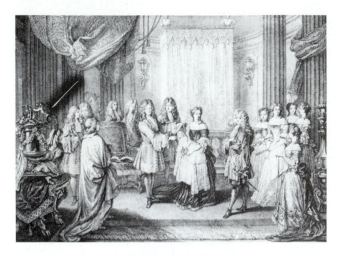

21-2. *Louis XIV, mettant le cordon bleu à Monfieur de Bourgogne père de Louis XV, Roi de France*, 1684–1721; engraving by Antoine Watteau.

architecture, interiors, furniture, and decorative arts into an elaborate statement of court taste. Developed by artists and architects influenced by the Baroque style of Rome, French Baroque rejects Italian exuberance and excesses and embraces the principles of reason, restraint, order, and formality. At times dramatic and exciting, French Baroque exhibits dignity and masculinity. Its ornament, though vigorous, is restrained. The French build on the notion of interiors composed of unified elements that begins in Italian churches, extending this idea more fully to secular interiors. This Baroque style marks France as the new artistic leader of Europe.

DESIGN CHARACTERISTICS

Like Italian examples, French buildings reflect an expansive universe by integrating city, dwelling, and landscape. Versailles is the supreme example of this comprehensive planning. French structures are as extravagantly planned inside and out as Italian ones. Exteriors and interiors display classical design principles and language, symmetrical compositions, monumental scale, bold ornamentation, rich surface details, and costly materials. Facades, which do not undulate in the Italian manner, remain relatively flat, although projecting units, especially toward the center, are common. A classical vocabulary organizes, restrains, and defines compositional elements. Distinctive French features from earlier include end *pavilion*, a projecting frontispiece with a pediment or a separate roof and sculptural ornament, and the tall hipped or mansard roof (two pitches on all four sides). Inside, architecture, sculpture, and painting unite to transport and overwhelm. Defined by classical ordering and motifs, the overall interior image complements the exterior design even though interiors are far more sumptuous than the more restrained exteriors. Pattern books and engravings spread the French aesthetic to the rest of Europe.

■ *Motifs*. Exterior facades display classical architectural features (Fig. 21-6, 21-7, 21-8, 21-10, Color Plate 50, 21-15, 21-16) such as columns, pediments, arches, balustrades, draped figures, niches, quoins, swags, and cartouches. Motifs at Versailles include intertwined *L*s (Fig. 21-4), sun face (Fig. 21-3, 21-4), musical instruments (Fig. 21-4), military symbols, *fleur de lis*, and crowns. Other details (Fig. 21-3, 21-4, 21-5) are acanthus leaves, cherubs, classical

21-3. Motifs with sun face.

21-4. Panel designs with sun face, musical instruments, intertwining **L** motif.

21-5. Panel design showing Baroque scale and geometry with acanthus leaves, swags, and cartouche.

statues, cartouches, dolphins, *Chinoiserie* (pseudo-Chinese), *singerie* (monkeys in human activities), pagodas, and landscapes.

ARCHITECTURE

Baroque Classicism defines the architectural image in France—symmetry, classical ordering, monumental scale, and center focus. The image borrows selectively from the more conservative Italian Baroque of Bernini instead of the more plastic, expressionist style of Borromini. Compositions made of clearly defined and repeated units feature a horizontal emphasis delineated through string courses, cornices, or balustrades. Bays defined by pilasters create a regular rhythm and may increase in projection or be replaced by engaged columns toward the center. A series of stepped or curving walls and a concentration of ornament also emphasize centers and entrances. Urban and rural buildings are integrated with the environment and/or landscape.

The early 17th century is a period of great building activity in France with numerous *châteaux* and *hôtels* (town houses) built for the nobility. While the power of the nobility declines during this period, the middle class increases its wealth and importance and requires appropriate housing. The architectural design of *hôtels* exerts much influence on domestic buildings throughout Europe.

21-6. East front, Louvre, 1667–1670; Paris, France; by Claude Perrault, Louis Le Vau, and Charles Le Brun.

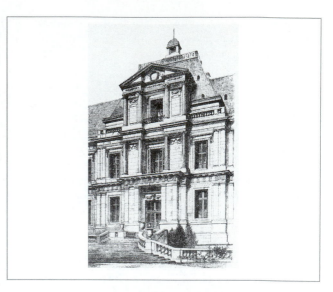

21-8. Frontispiece, Château de Maisons (Maisons-Lafitte).

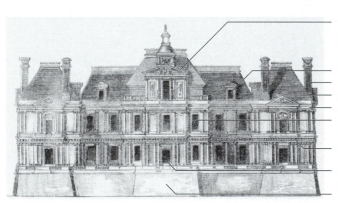

Center emphasis defined by projecting frontispiece with separate roof, pediments, medallions, and swags
Dormer windows
Tall chimney
Steep roof pitch
Cornice
Rectangular bays articulated by pilasters
String course emphasizes horizontal
Symmetrically balanced entry
Typical plan with central court and wings or pavilions

21-7. Château de Maisons (Maisons-Lafitte), 1642–1646; near Paris; by François Mansart.

Public and Private Buildings

■ *Types.* The main building types are *hôtels*, *chateaux*, and the Palais de Versailles. Only a few churches are constructed, as dwellings are more important.

■ *Site Orientation.* Heavily influenced by Italian urban planning concepts, buildings are integrated with the urban and natural environment and are situated along a longitudinal axis that directs progression toward a series of goals or focal points (Fig. 21-12, 21-13). The path typically begins in an urban context, the city, and continues through a forecourt to the building's entrance. Once inside, the path proceeds through an important interior, usually a grand staircase or salon, to the rear gardens and park. Gardens are also organized along a main longitudinal axis with smaller transverse axes and radiating patterns. French urban palaces are more expansive than Italian palaces; this is most exemplified by the *cour d'honneur* (open forecourt).

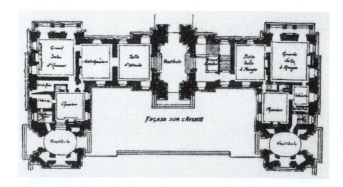

21-9. Floor plan, Château de Maisons (Maisons-Lafitte).

■ *Floor Plans.* Plans (Fig. 21-9, 21-11, 21-14) strive for symmetry along at least one axis, if not two. Rooms generally are rectangular, although a few have oval *salons* or stair halls. There are no interior hallways. Within this context, French architects carefully plan the distribution of rooms

to support formality, rank, ceremony, and the attributes of an aristocratic life. Plans are organized around public and private *appartements* (suites of rooms). Doorways to rooms in state apartments are on the same side of the wall to create an *enfilade* (vista), and each is magnificently decorated. A visitor's status determines how far he or she may go. State *appartements* are usually located on the garden side of the house, and husbands and wives have their own. More intimate and less formal spaces occur near or behind state *appartements*, sometimes alongside them in a double row. Toward the end of the period, rooms with specialized functions become more common. This change reflects the importance of gaming and conversation, as well as the benefit of heating smaller spaces.

■ *Materials.* Typical building materials are stone, with brick used for lesser structures, and wood and plaster incorporated in vernacular examples.

■ *Facades.* Superimposed pilasters divide walls into bays and define the overall ordering as well as the edge of a unit (Fig. 21-6, 21-7, 21-8, 21-10, Color Plate 50, 21-15, 21-16, 21-17). Traditional elements, such as rustication, string courses, and quoins, organize and unify facades. A series of stepped planes that define interior spaces leads to the center of the composition and the entrance. Planes may connect at right angles or, less often, in curves. A frontispiece composed of superimposed orders and a pediment marks the entrance as well as the most important reception room, the *salon*. Pavilions mark the ends of exterior compositions, as well as indicating the placement inside the state bedchamber in the *appartement*.

■ *Windows and Doors.* The proportion of window to wall (Fig. 21-8, 21-17) is greater than in Italy as windows are larger to admit more light. French windows (Fig. 21-16, 21-17), a French invention, extend to the floor and open

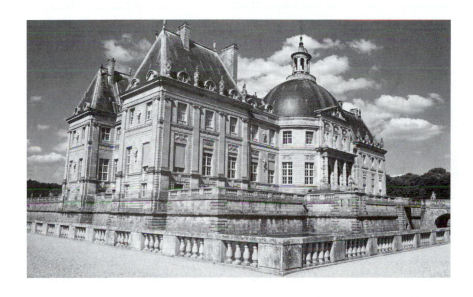

21-10. Château Vaux-le-Vicomte, 1657–1661, near Paris; by Louis Le Vau, André Le Nôtre, and Charles Le Brun. (Color Plate 50)

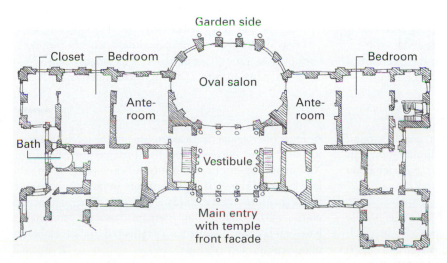

21-11. Ground floor plan, Château Vaux-le-Vicomte, 1657–1661, near Paris.

Design Practitioners

■ Crown patronage elevates the status of French architects during the period. The Royal Academy of Architecture opens in 1671 and trains architects in the rules of classicism based on mathematical relationships and design principles as taught by Vitruvious, Vignola, and Palladio.

■ Although architects often design interior details, such as chimneypieces, they typically do not coordinate interiors. Instead, upholsterers supply textiles and some furniture and generally coordinate decoration. Charles Le Brun sets the precedent for one person who controls all interior design.

■ Furniture may be designed by a *menuisier*, a craftsman who works in solid wood with carving, or by an *ébéniste* (cabinetmaker), who produces furniture with veneers.

■ *Jean Bérain*, architect and engraver, designs furniture combining motifs of antiquity with decorative designs, in the workshop of André Charles Boulle. His style of Renaissance arabesques and grotesques evolves into the more delicate, lighthearted Rococo in the early 18th century.

■ *André Charles Boulle*, chief *ébéniste* to the king, becomes recognized for his intricate tables with marquetry decoration. He develops a special marquetry in tortoise shell and brass known as "Boullework" that is much copied. Only two documented pieces by him exist, although his workshops in the Louvre produce many excellent pieces in this period and the next.

■ *Charles Le Brun*, chief decorator for Vaux-le-Vicomte, is hired as the primary coordinator at Versailles and principal painter to the king. His studies in Rome familiarize him with Italian planning and design concepts. During the years 1671 through 1681, Le Brun decorates the grand *appartements* at Versailles. The concept derives from Italy and features a series of rooms named for planets and mythological figures. The rooms culminate in the Salon of Apollo. Trained as a painter, Le Brun recognizes no difference between the fine and decorative arts. Endeavoring to unite them, he believes in designing every detail to create a harmonious scheme. Le Brun is a founding member of the Academy of Painting and Sculpture.

■ *André Le Nôtre*, who succeeds his father as landscape gardener at the Tuileries in Paris, designs the garden plans at Vaux-le-Vicomte and Versailles. Following Baroque concepts of integration, expansion, and dynamism, Le Nôtre plans the magnificent settings at Vaux and Versailles. He sets new standards for gardens and the integration of structure and landscape, which are much copied in Europe.

■ *Jean Le Pautre*, Le Brun's greatest disciple, designs magnificent tables, *consoles*, *torchères*, and other furnishings for the nobility. A highly prolific designer and engraver of ornament, Le Pautre popularizes Le Brun's designs.

■ *Louis Le Vau* is one of the most successful architects of the 17th century and heads a large workshop of designers and painters. Although he designs many impressive public and private structures, he is best known for his design of Vaux le Vicomte and the first extension to Versailles.

■ *François Mansart*, a young protegé of Colbert and architect to the king and bourgeoisie, is the leading advocate of Italian classicism during the 17th century, although he never visits Italy. Pediments, superimposed orders, and the mansard roof (double pitch on all four sides) characterize his work. A designer of *hôtels*, *châteaux*, and churches, his masterpiece is Château de Maisons.

■ *Jules Hardouin-Mansart* greatly enlarges Versailles beginning in 1678. Additions include north and south wings, the chapel, and enclosing Le Vau's terrace on the rear, which creates the Galerie des Glaces. Nephew of François, Jules's work is among the most Baroque in France. His huge workshop trains many architects of the next generation.

as doors onto porches or balconies. Their use on ground and important floors creates spectacular illumination that adds to the magnificence of interior spaces. Sash windows with heavy, simple moldings are also common.

■ *Roofs*. Roofs include mansard, hipped, and flat, usually covered in slate with cresting at the apex. Roofs pitch steeply as before. Each unit may have its own roof.

■ *Later Interpretations*. Besides some imitation by the English and other Europeans in the 17th century, the Louis XIV image for exteriors and interiors reappears during the late 19th and the early 20th centuries in France and America (Fig. 21-18, 21-19, 21-20). Wealthy American aristocrats seek to establish an identity of social prominence based on European opulence, as reflected in their elaborate mansions and furnishings.

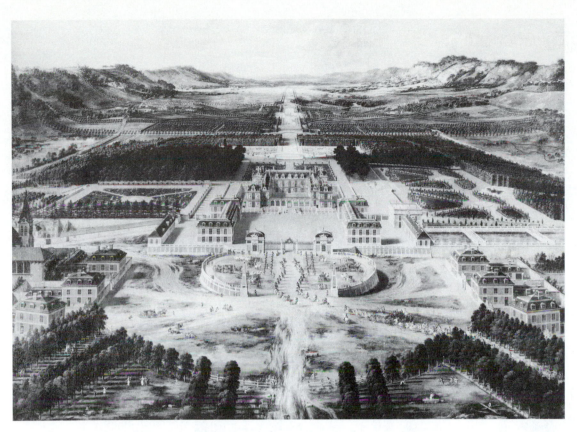

21-12. Aerial view, Palais de Versailles, 1678–1699, near Paris.

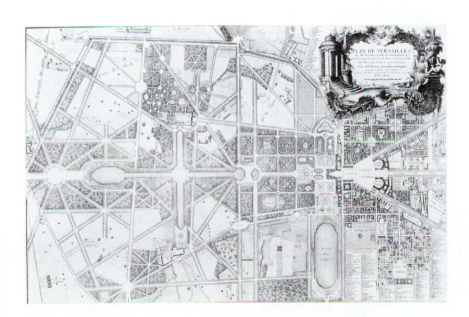

21-13. Landscape plan, Palais de Versailles, late 17th century; engraving by Pierre Le Pautre; designed by André Le Nôtre.

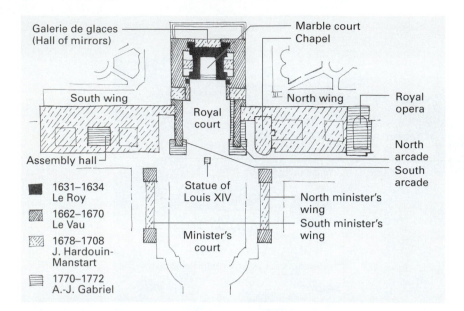

21-14. Floor plan, Palais de Versailles, 1678–1699, near Paris.

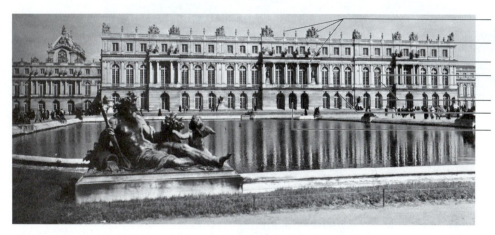

Classical details

Balustrade at roof line

Heavy cornice

Walls divided into bays by pilasters

French doors

Repetitive arches

Entry symmetrically on center and defined by projection out

21-15. Palais de Versailles; by Jules Hardouin-Mansart.

Design Spotlight

Architecture: *Palais de Versailles.* Designed by chief architect Louis Le Vau, landscape designer André Le Nôtre, and architect Jules Houdoin-Mansart, with interiors by Charles Le Brun, this building (Fig. 21-12, Color Plate 51, 21-13, 21-14, 21-15, 21-16, 21-22, Color Plate 52, 21-24, 21-25, 21-26, 21-27, 21-28) is the most important architectural statement of the period. It is a completely planned building complex integrating landscape, architecture, interiors, furnishings, and decorative arts into a unified composition. Built on the site of Louis XIII's hunting lodge not far from Paris, it gradually expands to house about 10,000 people and becomes the center of the Western art world. A satellite city develops around it. The three main avenues of the city terminate in the center of the palace in the king's state chamber. André Le Nôtre's

landscape plan unites *château* and landscape while providing for every activity in which the king might wish to engage. A principal axial vista extends from the entry court through the building into rear gardens that progress from the formal parterres to less formal surrounding gardens to the natural forests beyond. Louis Le Vau's exterior shows Italian Baroque influence with symmetry, classical ordering, monumental scale, and center focus. The composition features a horizontal emphasis delineated through string courses and cornices; bays defined by pilasters create a regular rhythm. Typically French are the frontispiece and stepped walls leading to the center of the courtyard facade. Beginning in 1678, Jules Hardouin-Mansart encloses the rear terrace, adds rooms to each end, and designs the chapel.

21-16. Facade elevation with French doors, Palais de Versailles. (Color Plate 51)

21-18. Later Interpretation: Opera House, 1861–1874; Paris, France; by J. L. C. Garnier; Beaux Arts.

21-19. Later Interpretation: Court of Honor, World's Columbian Exposition, 1893; Chicago, Illinois; Beaux Arts.

21-17. Grand Trianon, 1687; Versailles; by Jules Hardouin-Mansart.

21-20. Later Interpretation: Rosecliff, 1901–1902; Newport, Rhode Island; by McKim, Mead, and White; Beaux Arts.

Important Buildings and Interiors

- **Paris:**
 - —Château de Maisons, 1642–1646, Fançois Mansart.
 - —Church of the Sorbonne, 1635–1642, Jacques Lemercier.
 - —Church of the Val-de-Grâce, 1645–1667, François Mansart, Jacques Lemercier.
 - —Hôtel Lambert, 1640, Louis Le Vau.
 - —Hôtel de Soubise, 1705–1709, Germain Boffrand.
 - —Palais du Louvre, east facade, 1667, Louis Le Vau, Claude Perrault, and Charles Le Brun.
 - —S. Gervais, 1616–1621, Salomon de Brosse.
 - —Place Vendome, 1698, Jules Hardouin-Mansart.
 - —Saint Louis-des-Invalides, 1708, Libéral Bruant and Jules-Hardouin Mansart.

- **Seine-et-Marne:** Château de Vaux-le-Vicomte, 1645–1661, Louis Le Vau, André Le Nôtre, and Charles Le Brun. (Color Plate 50)

- **Versailles:**
 - —Grand Trianon, 1687, Jules Hardouin-Mansart.
 - —Palais de Versailles, 1661–1715, Louis Le Vau, Jules Hardouin-Mansart, André Le Nôtre, and Charles Le Brun (interiors). (Color Plates 51 and 52)

21-21. Oval salon, Château Vaux-le-Vicomte, 1657–1661, near Paris; by Louis Le Vau.

INTERIORS

Baroque interiors illustrate symmetry, formality, grandeur, large scale, rich decoration, vivid color, and luxurious materials appropriate to the rituals of court life. With the development of the French Royal Academy of Painting and Sculpture in 1648, many talented artists are available to embellish interior spaces. Interiors at Versailles present the supreme example of sumptuous embellishment. Their grandeur and magnificence form the setting for the dazzling ceremonies glorifying the king and enhancing his absolute power. Expanding on principles of unity from Italy, Charles Le Brun plans and coordinates the interior design. Furniture, statues, tapestries, and decorative arts are executed by others under his direction. Le Brun, who possesses great power and influence, virtually creates the Louis XIV style.

Public and Private Buildings

- *Types.* Ceremonial interiors (Fig. 21-21, 21-22, 21-24, 21-25, 21-27) are the most lavishly appointed and the most formal. However, most dwellings, even Versailles, have less formal, private spaces that will proliferate in the next period. *Appartements* may include an *antichambre* for eating and waiting; a *chambre de parade* for receiving and entertaining; a *chambre à coucher* for receiving and sleeping; a *cabinet* for conducting business; and a *garderobe* for dressing, storage, and housing servants. No room is set aside primarily for dining yet, although spaces identified as *salle à manger* appear during the period. Several rooms typically hold dining furniture so that people can eat where they please.

- *Relationships.* Rectilinear spaces arranged symmetrically reflect the organization of facades so there is a strong relationship between the exterior and interior—something new in France with this style. Important spaces align with the main, usually longitudinal, axis in the Italian manner. The frontispieces and end *pavilions* denote important interior spaces.

- *Materials.* Rich and costly materials delineated in classical details dominate interiors. Interior architectural details (Fig. 21-21, 21-22, Color Plate 52, 21-27, 21-28) include

niches with classical figures and pilasters dividing walls into bays, which repeat the exterior design. Balustrades and daises subdivide and separate spaces to support etiquette and ritual.

■ *Color.* The typical palette includes white, gold, crimson, cobalt, purple, and deep green. Paintings, materials, and particularly, textiles, supply rich, saturated colors.

■ *Lighting.* Candles serve as the primary source of illumination with the quality enhanced through prisms and mirrors. Important lighting fixtures (Fig. 21-36) of the period include an *appliqué* (wall sconce), *flambeau* (candlestick), *candelabra* (branching candlestick), *torchère* (floor candlestick), and *lustre à cristeaux* (crystal chandelier). They are made of gilded and carved wood, *ormolu* (gilded bronze), and silver. Designs repeat the character of the interior ornamentation. Elaborate *guéridons* (candle stands) may hold either a *candelabra* or large *flambeau*.

■ *Floors.* Floors are of wood, marble (Fig. 21-21), or other masonry, often in complicated patterns. Use of parquet increases throughout the period. The French favor lozenge

Design Spotlight

Interiors: *Galerie des Glaces (Hall of Mirrors), Palais de Versailles.* Begun 1678, the concept for the grand space (Fig. 21-22, Color Plate 52) is by Jules Hardouin-Mansart and the decoration is by Charles Le Brun. Here, classical vocabulary supports Baroque intent as architecture, light, sculpture, and painting unite to astound, awe, and glorify Louis XIV. Light pours into and illuminates the vast space (240′ long, 33′ wide, 40′ high) from 17 arched windows separated by red marble pilasters. Mirrors on the opposite wall reflect and multiply the light in a manner previously unimagined. Numerous gilded surfaces throughout the space also reflect light and create glittering effects that heighten the dramatic impact. A tripartite rhythm of three arched and mirrored bays separated by red marble pilasters defines the walls. Bronze trophies delineate the end bays, while niches of classical sculpture highlight the center ones. The bases and capitals of the pilasters are gilded; the capitals are Corinthian combined with *fleur-de-lis*. A gilded, modillioned cornice supports gilded trophies carried by cherubs. The barrel-vaulted ceiling features painted scenes glorifying the reign of Louis XIV. The wood floor is parquet de Versailles. Tall, arched doors flanked by columns lead to the salons of Peace and War on either end. Originally, the space had solid silver furniture, three rows of crystal chandeliers, numerous *guéridons* (candle stands), upholstered stools, Savonnerie rugs, and various marble and alabaster vases.

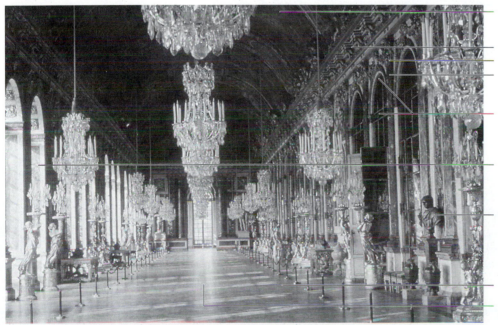

Barrel vault and compartmented ceiling with painted decoration
Heavy entablature
Corinthian capital
Red marble pilasters divide wall into bays

Round arch with mirror reflects light from French doors/windows

French door

Bronze trophies, military symbols

Parquet de Versailles flooring
Large scale: 240′0″ L × 33′0″ W × 40′0″ H

21-22. Galerie des Glaces (Hall of Mirrors), Palais de Versailles, near Paris, 1678–1687; begun by Charles Le Brun and completed by Jules Hardouin-Mansart. (Color Plate 52)

21-23. Detail of carving.

21-24. Salon de la Paix (Drawing Room of Peace), Palais de Versailles.

21-25. Salon de l'Oeil de Boeuf (Bulls-eye Room), Palais de Versailles.

shapes in oak. Parquet de Versailles (Fig. 21-22, Color Plate 52) is a special design composed of a diamond pattern with centers of interwoven planks. Oriental, Savonnerie, and Aubusson rugs in harmonious designs add to the interior richness. Plain or patterned straw matting covers many floors, especially in summer. Piled rugs may lie on top of matting, although some are still used to cover tables and cabinet tops.

■ *Walls.* Walls retain classical proportions and details with an emphasis on the chimneypiece (Fig. 21-25, 21-32) placed on the wall opposite the entrance or the windows and ornately accented above. Marble and wood mantels consist of either a bolection molding or pilasters and a cornice. A *trumeau* (the area above a mantel or door; Fig. 21-26, 21-28, 21-29) usually includes an elaborately framed mirror or a painting. The French use *boiserie*

21-26. Doorways, Palais de Versailles; by Jules-Hardouin Mansart.

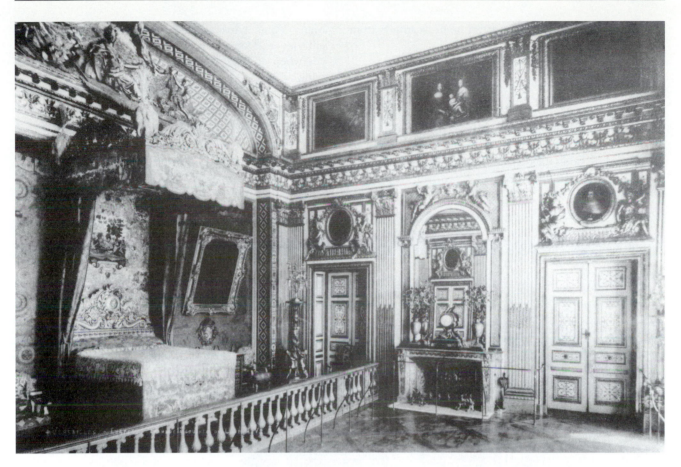

21-27. Louis XIV's Bedchamber, Palais de Versailles, 1701; by Louis Le Vau.

(carved wood paneling; Fig. 21-23) in important rooms as well as lesser ones, unlike the Italians. *Boiserie* typically is painted (21-25, 21-26, 21-27, 21-28); white with gold accents dominates, especially late in the period. Symmetrically arranged wall paneling (Fig. 21-30, 21-34, 21-35) consists of a dado, shaft (or fill), and an elaborate entablature with a decorative frieze and modillioned cornice. The horizontal portion may have regularly sized and spaced rectangular panels and three-dimensional moldings around doors and windows. Walls in some rooms in Versailles are covered in polychrome marble (Fig. 21-24) in rectilinear patterns. A few rooms in aristocratic houses feature painted polychrome grotesques and arabesques or landscapes (Fig. 21-31) in panels. Designers will exploit these forms in the subsequent Rococo style. Textile wall coverings include damasks, plain and patterned velvets, and embossed leather. Combinations of fabrics, trims, fringe, and occasionally valances add richness and variety. Tapestries, the most valuable wall coverings, usually hang only in important rooms. Pictures, which hang over fireplaces, doors, and inside panels, create symmetrical arrangements of form and color instead of being organized by style or subject. Mirrors become important accessories during the

21-28. Wall detail, Louis XIV's Bedchamber, Palais de Versailles, 1701.

period. They hang over fireplaces, on piers opposite windows, or on opposite ends of the room with a table beneath them. Some people place pictures or mirrors on top of expensive tapestries. Mirrors and pictures have carved

and gilded frames and hang at an angle (canted) from cords and tassels.

■ *Windows and Doors.* Windows in ceremonial rooms, bedchambers, and dining parlors feature draperies in velvet or silk in panels or festoons that draw up with tapes (like today's balloon shades), a style newly introduced in the 1670s. Most rooms have interior wood shutters (Fig. 21-28) to block light. *Jalousies à la persienne* (Venetian blinds with wooden slats) appear in the early 18th century.

Many rooms, particularly important ones, have double-entry doors. Doors (Fig. 21-26, 21-34, 21-35) match *boiserie* when present, but otherwise are paneled. Paintings hang above doors, and grand rooms often have *portières* (door curtains) that help prevent drafts and add to interior opulence. *Portières* sometimes have their own curtains to protect them.

■ *Ceilings.* Ceilings (Fig. 21-22, 21-33) are rectangular, heavy in scale, and very elaborate. They may be flat,

21-29. Doorways, 17th century; by Jean le Pautre.

21-30. Wall elevations, 17th century; by Jean le Pautre.

21-31. Panel designs, 17th century; by Daniel Marot.

21-32. Chimneypieces, 17th century; by Jean le Pautre.

21-33. Ceilings, 17th century; by Jean le Pautre.

21-34. Wall elevation, Hôtel de Sully, Paris.

21-35. Wall elevation, Palais de Justice de Rennes.

21-36. Lighting fixtures: *Guéridons* (candle stands) and *candelabra*.

21-37. Later Interpretation: Grand staircase, Opera House, 1861–1874; Paris, France; by J. L. C. Garnier; Beaux Arts.

21-38. Later Interpretation: Mrs. Bradley Martin's Drawing-Room; from *Artistic Houses*, attributed to G. W. Sheldon, New York: D. Appleton, 1883–1884; Beaux Arts.

compartmented (divided by three-dimensional moldings into rectangular sections), coffered, coved (rounded at the juncture of the wall and ceiling), or vaulted with gilded or painted plasterwork. Paintings featuring illusionistic architecture and complex iconography are common in important rooms, as in Italy. French paintings are less exuberant than Italian paintings, however.

21-39. Later Interpretation: Dining room, Marble House, 1892; Newport, Rhode Island; by Richard Morris Hunt.

■ *Later Interpretations.* The Beaux Arts style of the late 19th and early 20th centuries in France, England, and America revives the ornate and lavish interiors of Versailles and other French dwellings (Fig. 21-37, 21-38, 21-39). The wealthy in these countries do this as a way to establish European elegance and status. Some import French rooms to install in their own homes, a practice evident in the Newport "cottages" of Rhode Island as well as in the exuberant estates of Palm Beach, Florida, and Detroit, Michigan.

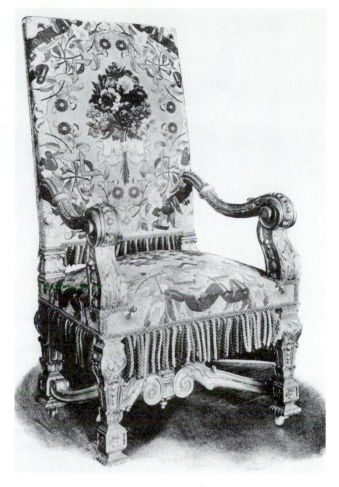

21-40. Gilt *fauteuil*, late 17th century.

FURNISHINGS AND DECORATIVE ARTS

Furniture of the Louis XIV period harmonizes with the interiors, and through the influence of Charles Le Brun, becomes an integral part of the room decoration, especially at Versailles. Furniture supports ceremony, rank, and status, so appearance is more important than comfort. At court, people often stand, so there is an absence of seating and an abundance of cabinets, tables, and storage pieces.

Numerous factories are built to produce goods for the court, the nobility, and the middle class. In 1663, Charles Le Brun helps establish and then directs the *Manufacture Royale de Meubles de la Couronne at Gobelins*, which produces tapestries, paintings, sculpture, silverwork, and furniture. In 1668, vast requirements of glass for Versailles initiate the creation of a royal glass factory nearby. In 1685, Louis XIV forbids public worship of all religions except the Roman Catholic faith, which stifles religious freedom and results in the revocation of the Edict of

Nantes. Consequently, Huguenot (Protestant) craftsmen leave the country causing a setback in decorative arts production in France.

Public and Private Buildings

■ *Types.* Furnishing types, numbers, and design reflect the formality of life. Cabinets, tables, and storage pieces are more common than other types.

■ *Distinctive Features.* Baroque furniture is symmetrical, rectangular, and often accented with large curves (Fig. 21-42). Proportions are massive, and the decoration lavish. Carving, marquetry (veneer patterns), and gilding are more important than in previous periods. Legs vary (Fig. 21-43), but generally are in the form of a scrolled bracket, tapered square pedestal (Fig. 21-40), or round pedestal. Feet are bun, paw, carved, or turned. Many pieces incorporate heavy, ornate H or X (saltire) stretchers, and seating may have curved arms with heavily carved volutes.

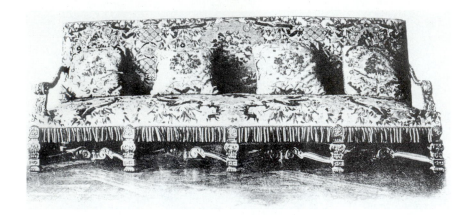

21-41. Gilt *canapé* at Fontainebleau, late 17th century.

■ *Relationships.* Most furniture pieces, designed to be placed against the wall, exhibit a direct relationship to the wall paneling in overall rectilinear shape and the use of moldings and/or columns.

■ *Materials.* Principal woods for construction are beech, oak, walnut, and ebony. Many pieces are gilded and feature marquetry or parquetry (geometric decoration of the same woods with different grains). André-Charles Boulle develops a special marquetry in tortoise shell and brass known as *Boullework* that is much copied. *Ormolu* decoration accents all cabinet pieces, especially on points of strain (Fig. 21-46, 21-48, 21-49). Some Oriental influence is evident in lacquered furniture with *Chinoiserie* motifs rendered on a black background (Fig. 21-47). Tables have richly grained marble tops.

■ *Seating.* Sets of upholstered chairs and sofas are very fashionable. Typical pieces, rectangular with high backs, include a *chaise* (side chair), *fauteuil* (upholstered open armchair; Fig. 21-40), *bergère* (upholstered closed armchair), and *canapé* (sofa; Fig. 21-41). Upholstered seats feature fancy trims and gilded nails. Seating has a special etiquette at court. Only the king and queen may sit in armchairs. A royal child may sit in a chair with a back and no arms. Others of high rank may be honored by being permitted to sit on stools.

■ *Tables.* Tables (Fig. 21-45, 21-47) support a variety of activities including gaming, conversation, and entertainment. The most common are *console* tables (attached to the wall; Fig. 21-42), the *bureau plat* (table desk; Fig. 21-44), occasional tables, and gaming tables.

■ *Storage.* Rooms are built without closets so clothes and other items usually are stored in *armoires* (large cupboards with doors; Fig. 21-48, 21-49) or newly introduced *commodes* (low chests with drawers or doors; Fig. 21-46).

■ *Beds.* Beds (Fig. 21-27, 21-50) are monumental, rectilinear, and completely surrounded with costly fabrics. Hangings, which may match or contrast with other textiles

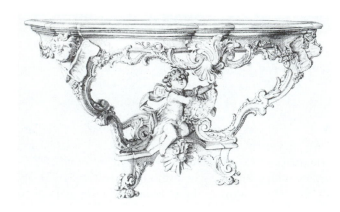

21-42. *Console.*

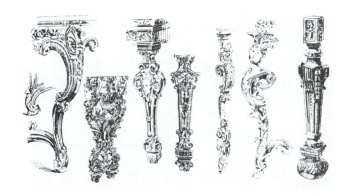

21-43. Legs of *console* tables, late 17th century.

in the room, are embellished with fringes and trims adding to the richness of effect. Most beds have four to six main curtains that may be tied up, drawn up by rings and tapes on the back, or pulled open or closed. Grand beds usually have additional *cantonnières* and *bonnegrâces* (smaller curtains to close gaps around posts). The French prefer rectangular valances and testers, unlike the English and

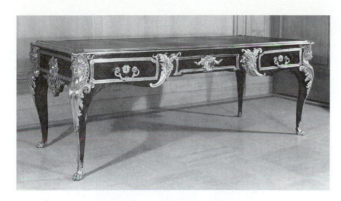

21-44. *Bureau plat*, late 17th or early 18th century; by Charles Cressent.

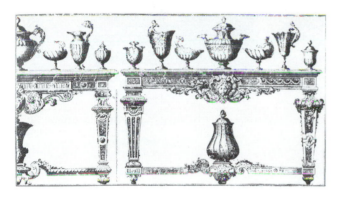

21-45. Table, late 17th century.

Dutch who use shaped ones. Testers vary in size from the half-tester used by children and others of secondary importance to full-size ones called *lit à duchesse* (supported by posts) or *lit d'ange* (suspended by chains from the ceiling). Finials or vases filled with ostrich feathers may top the tester. The canopy bed has an oval or round dome suspended from the ceiling from which hangings fall. To protect their valuable hangings, grand beds may have additional curtains hanging from iron rods outside the bed. Other bed types include portable field beds and trundle beds. In state bedchambers, a balustrade separates the bed from the rest of the room. Some chambers, even important ones, have niches in which to place a bed.

■ *Textiles.* The more important the room, the more textiles it has. French textiles (Fig. 21-53), produced mainly in Lyons, develop from Italian Renaissance influences with a predominance of brocades, velvets, and silks. Plain and patterned velvets typically come from Italy. Stylized flowers in urns surrounded by scrolls and garlands of fruits and flowers with large repeats are common patterns. Toward the end of the century, imported chintzes and muslins begin replacing heavier fabrics. Most chairs have slipcovers or furniture covers to protect their upholstery. Textiles also cover cushions and tabletops or shelves. People of high rank often sit beneath cloths of estate that resemble bed hangings in form and embellishment.

■ *Decorative Arts.* Types of decorative arts include clocks, lighting, tapestries, rugs, ceramics, fireplace furniture, fire screens, paintings, mirrors, and vases. This is France's golden age in decorative arts because of the scope, diversity, and

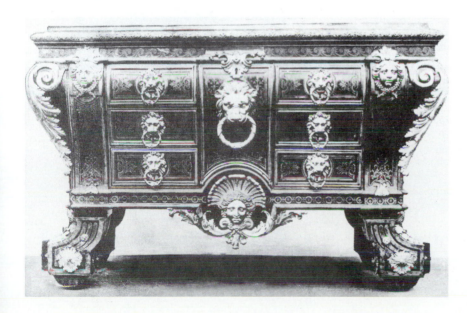

21-46. *Commode*, late 17th century; by André-Charles Boulle.

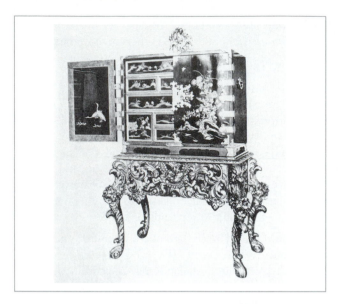

21-47. *Chinoiserie cabinet* on Baroque table, Chinese import, 17th century.

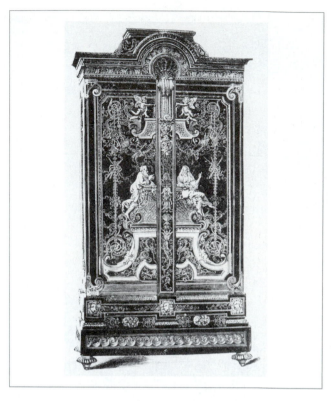

21-49. *Armoire*, late 17th century; by Charles Le Brun.

Design Spotlight

Furnishings: *Armoires.* Massive in scale, designs interpret the important characteristics of the style through symmetry, rectangular panels, classical motifs, marquetry gilding, and *ormolu* decoration. Armoires used as storage are a particular focus for lavish embellishment (Fig. 21-48, 21-49).

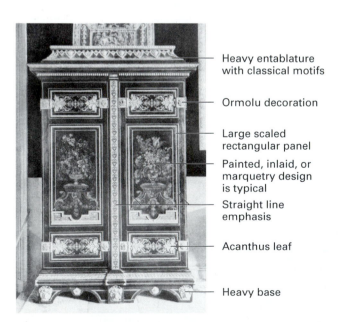

Heavy entablature with classical motifs

Ormolu decoration

Large scaled rectangular panel

Painted, inlaid, or marquetry design is typical

Straight line emphasis

Acanthus leaf

Heavy base

21-48. *Armoire*, late 17th century; attributed to André-Charles Boulle.

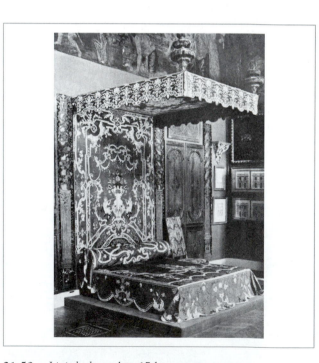

21-50. *Lit à duchesse*, late 17th century.

21-51. Tapestry commemorating the visit of Louis XIV to the Gobelins factory in 1667.

21-52. Tapestry, Gobelins factory; by Charles Le Brun.

detail of the overall designs. Accessories become more numerous and contribute to the dazzling display in rooms. Objects are often in pairs or symmetrical arrangements and conform in design to the overall opulence of the interiors to complement the unified composition. Continuing trade with the Orient provides prized pieces and stimulates new concepts in decoration, such as lacquerwork.

■ *Tapestries.* In 1662, the Gobelins tapestry works (Fig. 21-51, 21-52) are developed under the influence of Le Brun and produce exclusively for the French government. Le Brun designs three series of tapestries called "The His-

tory of the King" illustrating the life of Louis XIV. In 1664, Colbert starts the Beauvais factory as a private enterprise under the control of the government to supply items for the public.

■ *Rugs.* In 1618, the Savonnerie rug factory near Paris begins producing hand-tufted rugs with dark, rich colors and a velvet-smooth piled surface. Designs, which feature a central oval, flowers and foliage, and complex borders, complement Baroque interiors (Color Plate 53). Savonnerie competes with the Aubusson factory—a company begun in the Middle Ages that manufactures carpets in

21-53. Textiles.

21-54. Later Interpretation: Savonnerie rug, 1990s.

lighter colors with a coarse tapestry weave. Open slits where colors meet distinguish Aubusson carpets, which are flat woven.

■ *Ceramics. Faience* (French ceramics of tin-glazed earthenware) is especially admired because its white body resembles porcelain. The Crown's support of the industry increases its importance. Chinese porcelain imports, particularly blue and white designs, continue to be vastly popular. Delftware from Holland competes with French and Chinese wares.

■ *Later Interpretations.* Because of the elaborate richness and production expense of Louis XIV furniture, it is not interpreted much in later periods. Boullework revives in the Louis XVI (neoclassical) period. In the late 19th century, some Louis XIV furniture and rugs (Fig. 21-54) are copied for wealthy interiors.

22. English Restoration

1660–1702

Si monumentum requiris circumspice. (If you would see this monument, look around.)

Inscription to Sir Christopher Wren
(1675–1710), St. Paul's Cathedral, London

Following the return of Charles II from France and the restoration of the monarchy, foreign influences sweep away the Elizabethan and Jacobean styles in architecture, interiors, and furniture. English Restoration architecture wholeheartedly adopts classicism, whether influenced by the Italian Renaissance, French or Italian Baroque, Dutch Palladianism, or Inigo Jones. Interiors may be exuberantly Baroque or pursue a more subdued classicism, often highlighted with rich, three-dimensional carving or plasterwork. Furniture features Baroque design principles and elements tempered by French elegance or Dutch curving silhouettes.

22-1. Charles I.

HISTORICAL AND SOCIAL

A settled government could not be established by Oliver Cromwell. After his death in 1660, Charles II, son of the former king, returns from exile and reclaims the throne. Interested in art and architecture like his father, he encourages foreign craftsmen to come to England to refurbish his royal palaces and the homes of the nobility. His return also sparks a reaction to Puritanism in behavior, art, literature, and drama among the nobility resulting in fewer restrictions and greater freedom. However, Charles clashes with the nobility over his Catholic faith and his belief, like his father's, in the divine right of kings to rule unaided and unassisted. Following Charles's death in 1685, his nephew, James II, tries to continue his predecessor's unpopular policies, and greater severity marks his reign.

In 1688, the exasperated nobility invite the Dutch William of Orange to invade England, ostensibly to protect the interests of his wife, Mary, who is James's eldest daughter. In reality, they fear James II will succeed in his quests. Following the bloodless and successful Glorious Revolution, the notion of an absolute monarchy is crushed, and a Protestant, William III, sits on the throne. Patrons of the arts, William and Mary encourage building and decoration. When William dies in 1702, Anne, his sister-in-law, who is the last of the Stuarts, succeeds him.

Despite internal conflicts, England grows in power and prestige during the second half of the 17th century. England's victory over the French at Blenheim in 1704 establishes her as a leading military power. The work of such men as Isaac Newton and John Locke give her a commanding place in science and thought. Her colonies grow and prosper, and her wealth increases.

CONCEPTS

England develops her own eclectic expression in this period in which foreign influences dominate. Conditions are not conducive to a national Baroque style in architecture as in France, since most Englishmen do not want an absolute monarch to glorify or inspire great allegiance. Baroque elements appear in English buildings, but the image is most often subdued and conservative reflecting the Dutch character, from trade, commerce, and the craftsmen who accompany William and Mary. It coexists and intertwines with the more empirical classicism established by Sir Christopher Wren.

French ideas and styles arrive with Charles II and his nobles who are in exile at the court of Louis XIV and with the Huguenot craftsmen who flee France to escape religious persecution. These French influences stimulate a

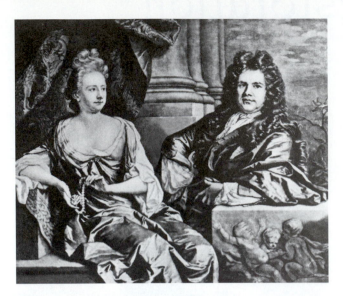

more elaborate and showy character, which appears in several important projects. A few English architects and designers visit Italy, and Italian artisans execute commissions in England, spreading Baroque ideas. Combinations of Italian, French, and Dutch characteristics replace earlier English (Elizabethan and Jacobean) traditions. In furniture, two styles develop: Charles II and William and Mary.

DESIGN CHARACTERISTICS

In English Restoration architecture, a rational classicism defines form and provides details, although Baroque influences are evident. Characteristics include classical elements, large scale, symmetry, center emphasis, some advancing and receding planes, and some curves. English design rarely achieves the plasticity of Italy or the monu-

22-2. Grinling Gibbons and his wife.

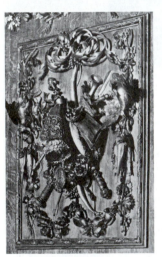
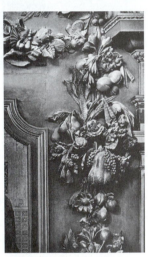
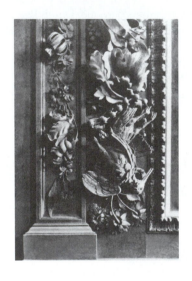

22-3. Wood carvings by Grinling Gibbons.

22-4. Carved panel detail, c. 1670.

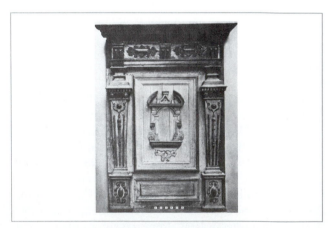

22-5. Paneling detail with pilasters, c. 1630.

22-6. Door hardware, Belton House, 1684–1686; Lincolnshire; by William Stanton.

mental magnificence of France. Many dwellings continue the style of classicism inspired by Inigo Jones.

Both conservative and extravagant interiors characterize this Baroque period. The majority of English interiors are conservative, demonstrating a somber and unostentatious classicism in which human scale, restraint, and repose dominate. Ornate interiors express power and wealth. They typically depict large scale, conspicuous extravagance, illusionistic paintings, complexity, and classical details to create drama or overwhelm. Interpreting this effect, the Carolean or Charles II furniture retains a rectilinear form with curves appearing in details and with French influences creating exuberant forms and decoration. In contrast, more conservative William and Mary furniture features Dutch influences with curvilinear forms and an extensive use of veneers and marquetry. Oriental motifs and lacquerwork are common in both expressions.

■ *Motifs.* Motifs (Fig. 22-3, 22-4, 22-35, 22-42) include pediments, columns (Fig. 22-33), pilasters (Fig. 22-5, 22-7), arches (Fig. 22-7, 22-22, 22-30, 22-31), C and S scrolls (Fig. 22-44), fruits, flowers (Fig. 22-37, 22-39), shells, garlands (Fig. 22-41), leaves, swags, acanthus, and urns.

ARCHITECTURE

Following the restoration of the monarchy, architecture returns to the Palladian classicism of Inigo Jones. However, the Great Fire of London in September of 1666 brings to the forefront Sir Christopher Wren, whose influence determines a different course for building. Wren, who has visited France, introduces Baroque motifs and concepts that move English architecture away from the restrained style of Inigo Jones. Despite monumental scale, center emphasis, and some complexity in form and plan, Wren's work rarely achieves the dynamism, forcefulness, and movement of Italy. Rather, it comes closer to the restrained

classicism of France. A rationalist and mathematician, Wren uses classical elements to control and disguise the mass and form of a building while frequently borrowing from Continental examples. Wren's most Baroque designs are those for the royal family where glorifying the monarchy and/or imitating Versailles are design goals. His most creative works are the city churches in London. These projects follow the passing of the Act for Building Fifty New Churches in 1711, the intention of which is to replace outdated and very small churches.

Sir John Vanbrugh and Nicholas Hawksmoor create the most obvious English versions of Baroque architecture in several country houses and city churches during the early 18th century. Integration of structure and landscape, monumental scale, center emphasis, advancing and receding planes, and classical details characterize their work. Vanbrugh, in particular, is a master of dramatic planning, inside and out. The designs of both men display concern for mass, rhythm, and proportion over the managing of form with classical vocabulary that characterizes Wren's work. Both Vanbrugh and Wren also execute commissions in the Gothic mode, Wren in several churches and Vanbrugh for his own castle.

Before the Restoration, Sir Roger Pratt introduces the symmetrical, rectangular block house with sash windows, hipped roof, classical details, and double-pile plan that will become standard for smaller Georgian houses in England and America.

22-7. Temple Bar, 1670; London; Sir Christopher Wren.

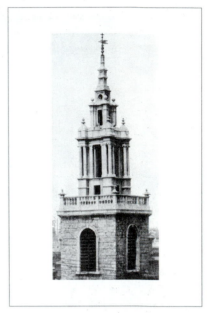

22-8. S. Mary-le-Bow, Cheapside, 1670–1677; London; by Sir Christopher Wren.

22-9. Floor plan, S. Mary-le-Bow.

22-10. Steeple, S. Stephen, Walbrook, 1672–1687; London; by Sir Christopher Wren.

Public Buildings

■ *Types.* Building types include churches, public complexes such as Greenwich Hospital, and collegiate buildings.

■ *Site Orientation.* Wren develops several large complexes, such as Greenwich Hospital, which display the Baroque integration of building and landscape, axial organization, and sequencing of spaces.

■ *Floor Plans.* Wren's plan for S. Paul's Church (Fig. 22-13, 22-14) in London is a Latin cross with domed crossing and apsidal ends of nave and transept. The dome with its considerable height creates a more centralized focus, similar to Continental examples. Plans of his London city churches (Fig. 22-9, 22-11) vary because of irregular sites;

some are square, others are rectangular; one is roughly oval. Most depict basilica plans with or without aisles, vaulting, and/or domes. Wren strives for centralized designs that focus on the pulpit, a visible sign of the primacy of preaching in England's Protestant churches. Church plans by other designers are similar to those by Wren.

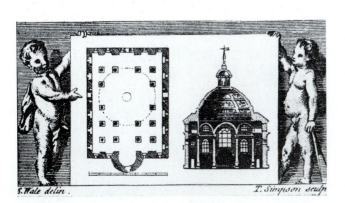

22-11. Floor plan, S. Stephen, Walbrook.

Design Spotlight

Architecture: *S. Paul's Cathedral.* Wren's design for S. Paul's Cathedral (Fig. 22-12, 22-13, 22-14, 22-31, 22-32, 22-33) progresses through several concepts beginning with a domed Greek cross plan to the final Latin cross plan with oval dome. The broad facade has a pedimented center supported on twin columns reminiscent of the east facade of the Louvre. The perspective windows on the lower facade resemble those at the Palazzo Barberinini. The tops of the towers derive from Borromini; the dome's form and shape are reminiscent of Bramante's design for S. Peter's; and the apsial ends of the crossing resemble S. Maria della Pace in Rome. The unusual three-part dome is a design and engineering accomplishment unique to Wren. The entire effect is one of logical planning and monumental form articulated and held in check by classical ordering.

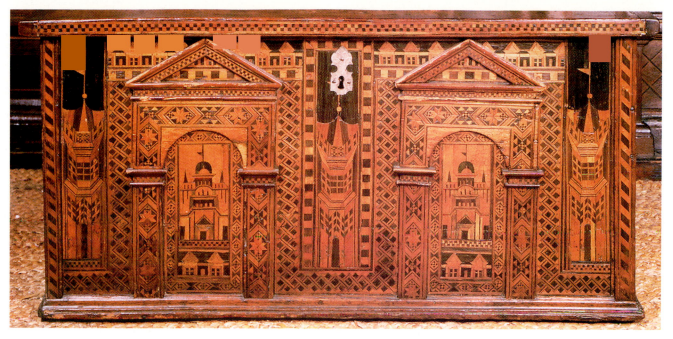

Color Plate 38. Nonesuch Chest, late 16th century; England.

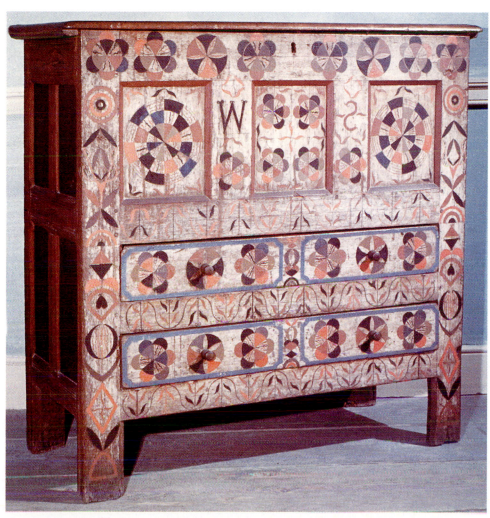

Color Plate 39. Hadley Chest, 1690–1710; Massachusetts.

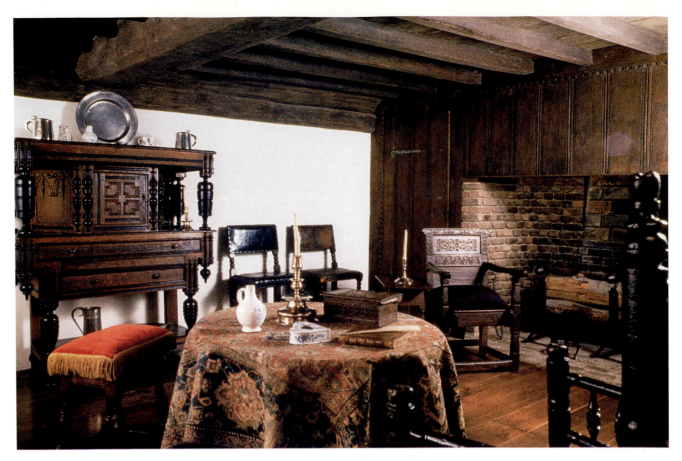

Color Plate 40. Hall and Chamber, Hart House, before 1674; Ipswich, Massachusetts.

Color Plate 41. San Jose y
Miguel de Aguayo, 1768–1777;
San Antonio, Texas.

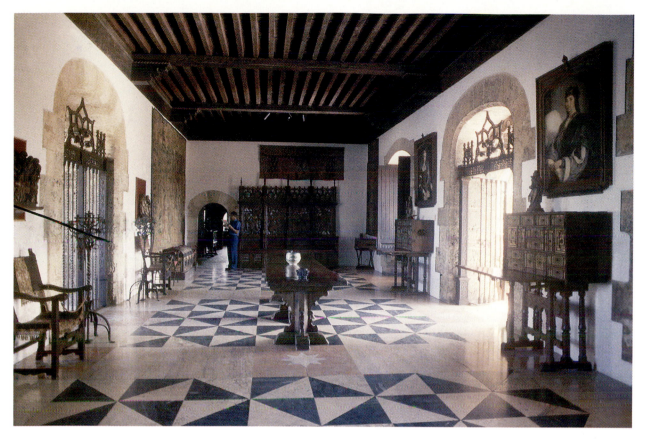

Color Plate 42. Entry, Columbus House, 16th–17th centuries; Santo Domingo, Dominican Republic.

Color Plate 43. Defosse House, 1790, rebuilt 1850, Mansura, Louisiana.

Color Plate 44. Dog Trot Log House with lean-to, c. mid-19th century; Henkel Square, Round Top, Texas.

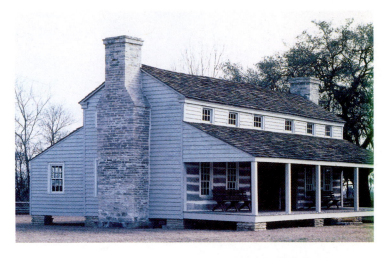

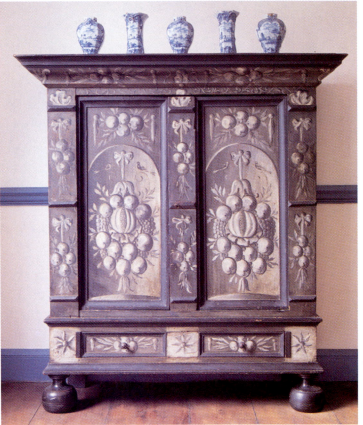

Color Plate 45. Kas, 1690–1730; New York.

Copyright Dorling Kindersley. Van Cortlandt House Museum. Dave King, Photographer

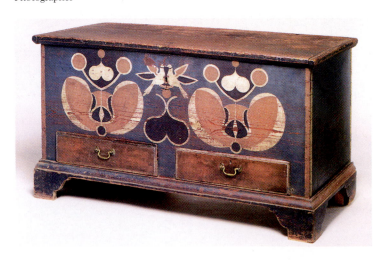

Color Plate 46. Painted Chest, 1795–1810; Shenandoah Valley; by Johannes Spitler.

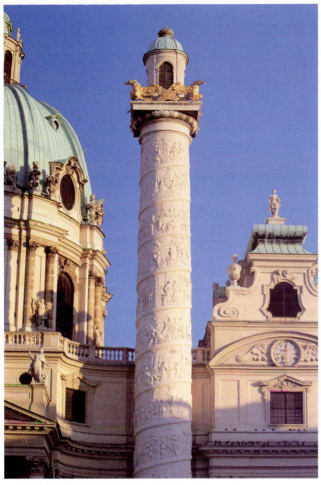

Color Plate 47. Karleskirche (S. Charles' Church), 1702–1739; Vienna, Austria; by Gabriele Montani and Lukas von Hildebrandt.

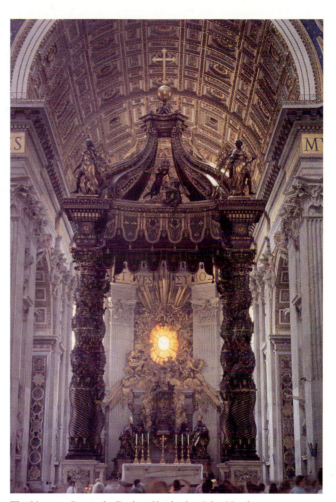

Color Plate 48. S. Peter's Basilica, 1624–1633; Rome, Italy; interior and *baldacchino* by Gianlorenzo Bernini.

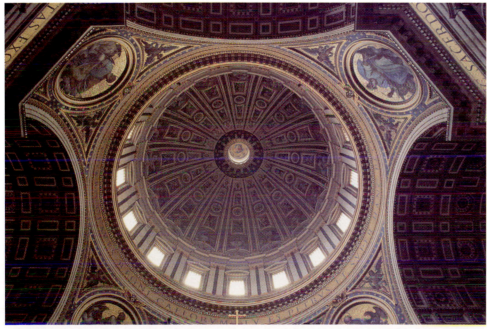

Color Plate 49. S. Peter's Basilica, 1624–1633; Rome, Italy; dome by Michaelangelo.

Color Plate 50. Chateau Vaux-le-Vicomte, 1657–1661; near Paris, France; by Louis Le Vau, Andre Le Notre, and Charles Le Brun.

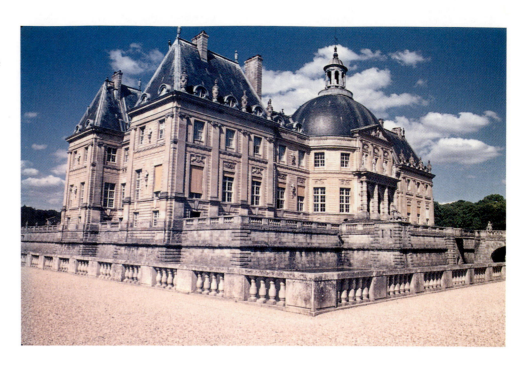

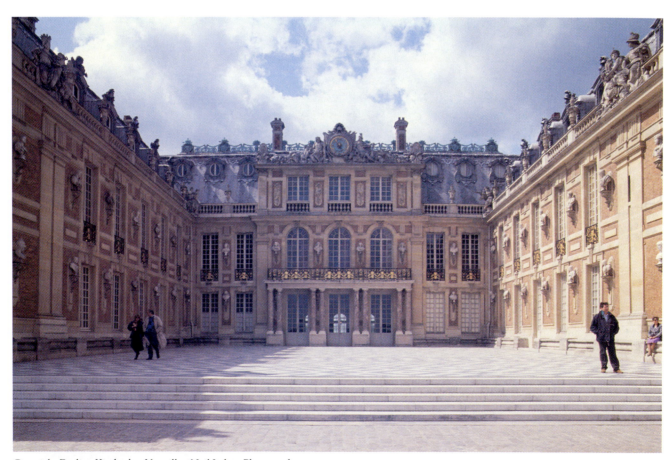

Color Plate 51. Marble Courtyard, Palais de Versailles, 1678–1699; near Paris, France.

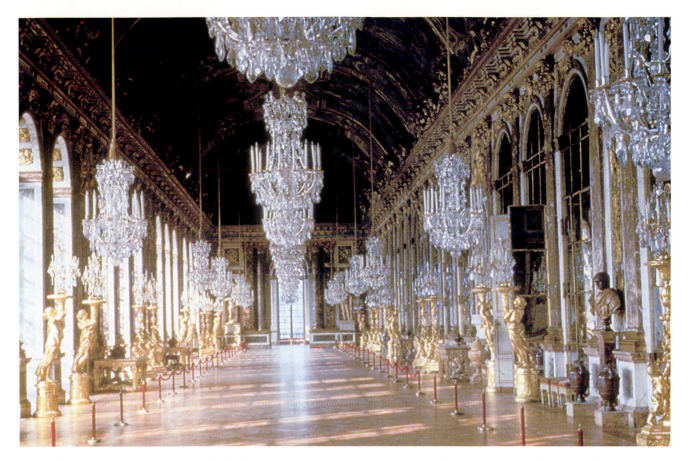

Color Plate 52. Galerie des Glaces (Hall of Mirrors), Palais de Versailles, 1678–1687; near Paris, France; begun by Charles Le Brun and completed by Jules Hardoun-Mansart.

Color Plate 53. Savonnerie Carpet, 1680; Paris, France.

Color Plate 54. Saloon, Sudbury Hall, c. 1676; Derbyshire, England.

Color Plate 55. Cabinet on stand with turned legs and marquetry, William and Mary, c. 17th century; England.

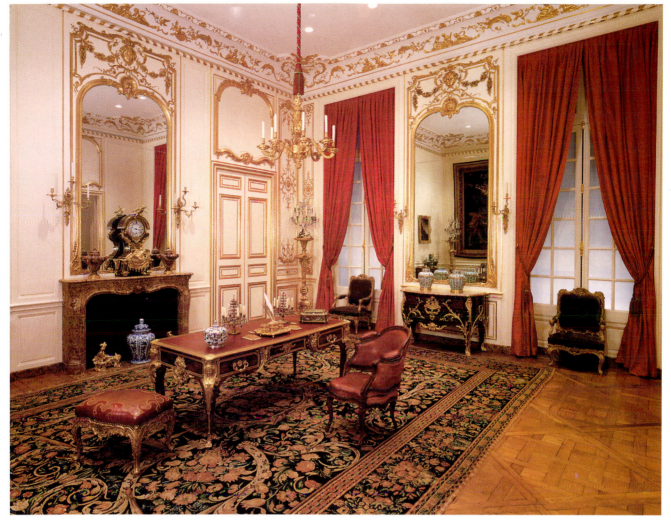

Color Plate 56. Paneled Room, c. 1710–1730; Paris, France; by Jacques Gaultier.

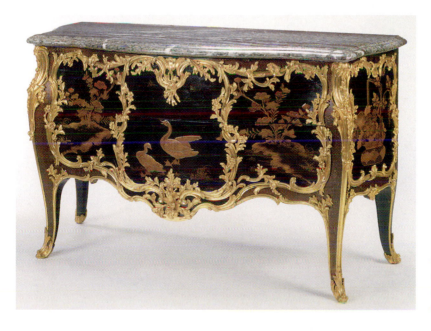

Color Plate 57. Commode with Chinoiserie lacquer work, c. 1750; Paris, France; attributed to Joseph Morris.

Color Plate 58. Marble Hill House, c.1724–1729; Twickenham, England; by Lord Pembroke and Roger Morris.

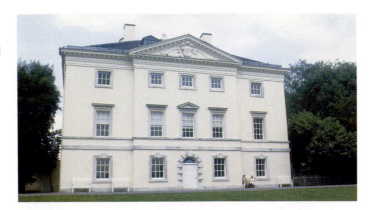

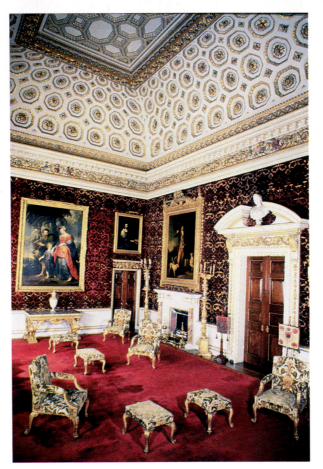

Color Plate 59. Saloon, Holkam Hall, begun 1734; Norfolk, England; by William Kent.

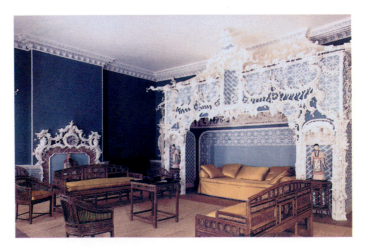

Color Plate 60. Chinese Room, Claydon House, 1757–1768; Buckinghamshire, England.

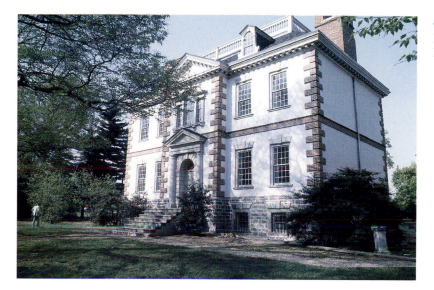

Color Plate 61. Mount Pleasant, 1761–1762; Philadelphia, Pennsylvania.

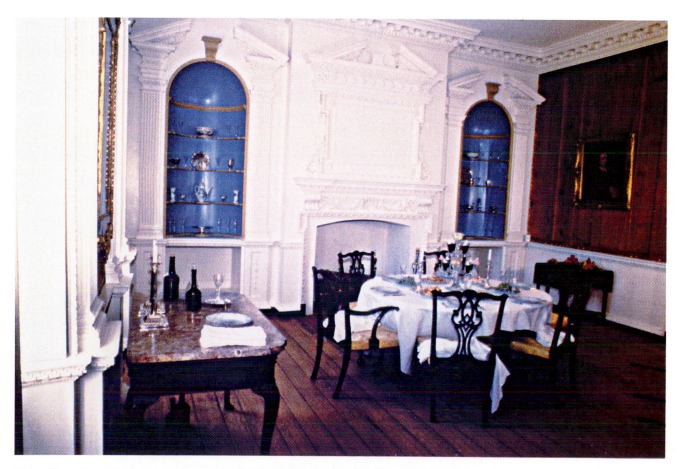

Color Plate 62. Dining Room, Gunston Hall, 1755–1787; Fairfax County, Virginia.

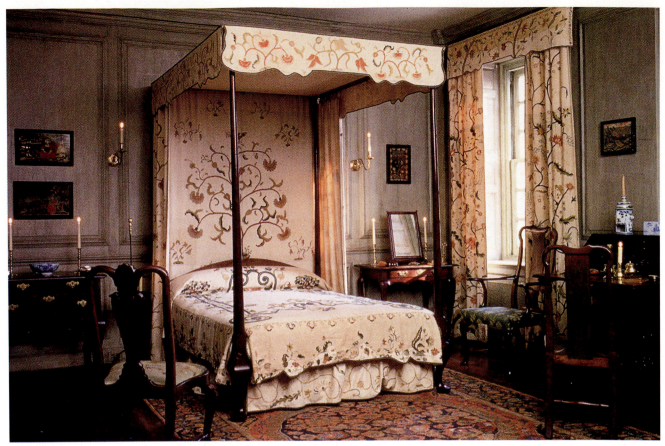

Color Plate 63. Bed with embroidered hangings, early 18th century; Cecil County, Maryland.

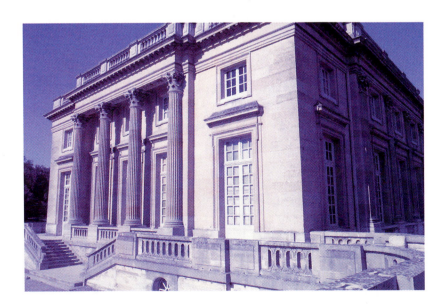

Color Plate 64. Petit Trianon, 1761–1764; Versailles, France; by Ange-Jacques Gabriel.

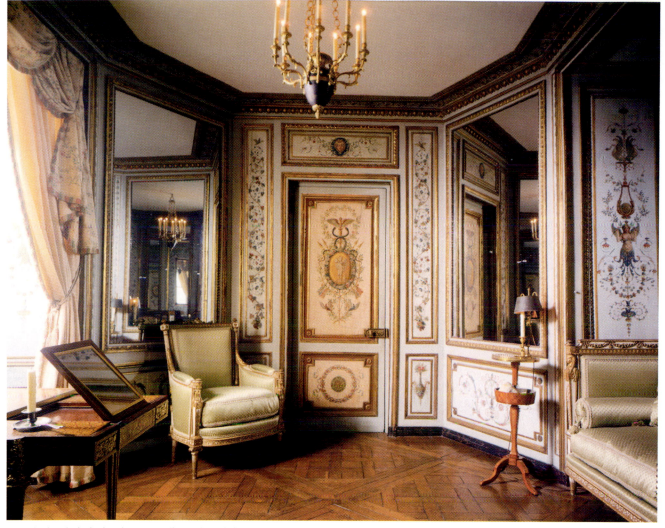

Furnished with daybed and armchair (*bergere*) made by Jean Baptiste Claude Sene (1745–1803) in 1788. Decoration by Pierre Adrien Paris (1745–1819) for Louis Marie Augustin, duc d'Aumont (1709–1782). Painted and gilded oak. H. 9′ 3½″ (283.2 cm); L. 14′ 3½″ (435.6 cm); W. 15′ 5½″ (471.1 cm). The Metropolitan Museum of Art, Gift of Susan Dwight Bliss, 1944. (44.128)

Color Plate 65. Boudoir from the Hotel de Crillon, c. 1770s–1780s; Paris, France.

Color Plate 66. Kedelston Hall, 1759–1770; Derbyshire, England; by James Paine and completed by Robert and James Adam.

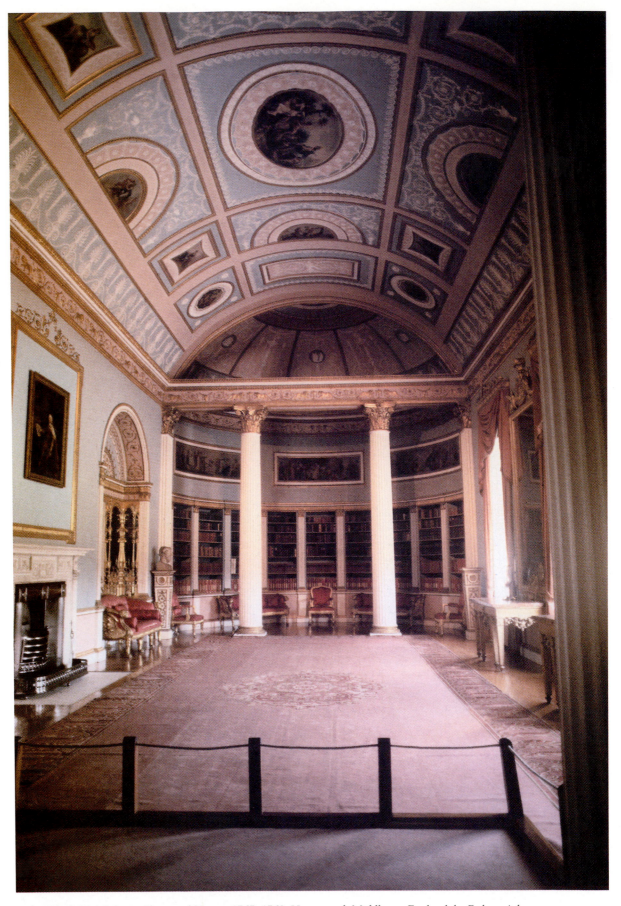

Color Plate 67. Library, Kenwood House, 1767–1769; Hampstead, Middlesex, England; by Robert Adam.

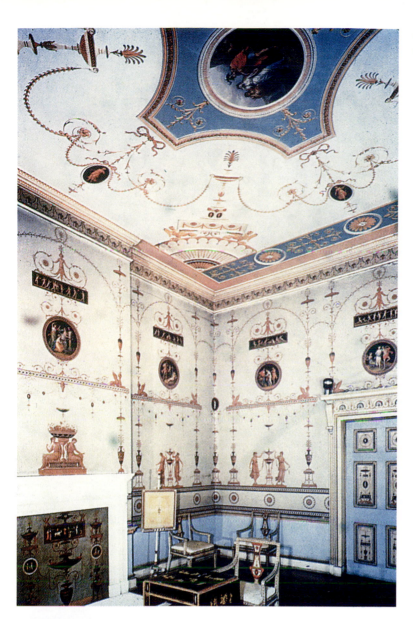

Color Plate 68. Etruscan Dressing Room, Osterly Park, 1775–1777; London, England; by Robert Adam.

Color Plate 69. Monticello, begun 1777; remodeled 1793–1809; Charlottesville, Virginia; by Thomas Jefferson.

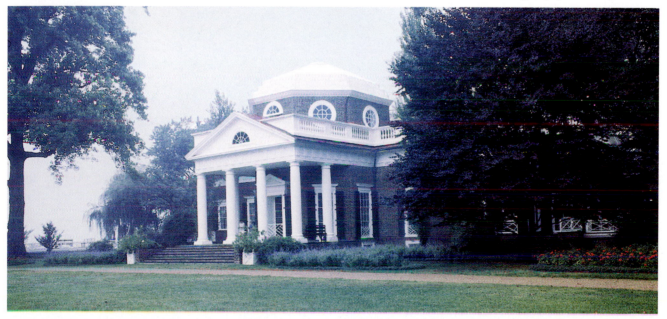

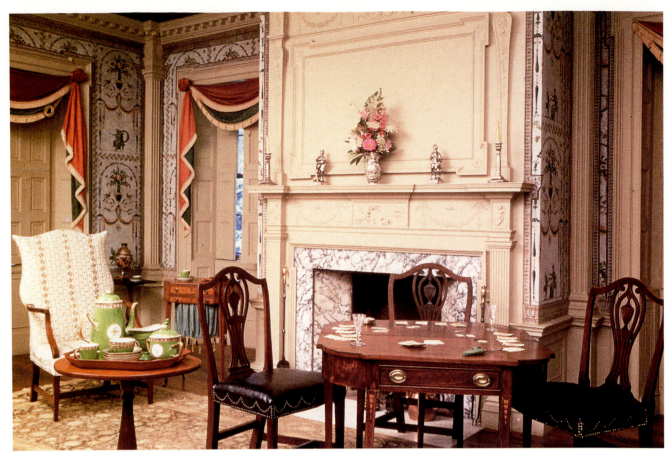

Courtesy, Winterthur Museum

Color Plate 70. Parlor, Phelps-Hatheway House, 1761, added onto 1794; Suffield, Connecticut.

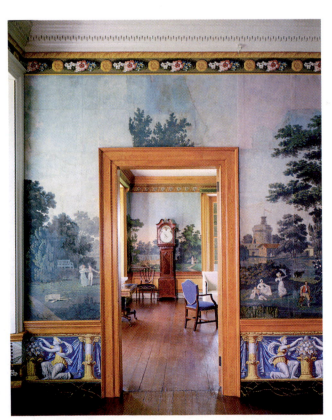

Color Plate 71. Interior, Prestwould, 1794–95; Clarksville, Virginia.

Photograph © Richard Cheek for the Prestwould Plantation

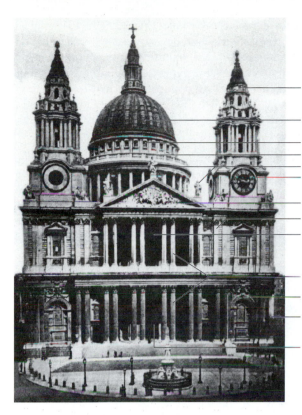

Steeple with classical details

Large dome

Clerestory windows
Balustrade
Classical figure
Medallion shape typical of Wren
Pediment
Pilasters define bays
Classical portico with temple front emphasizes center

Columns span two stories

Classical arch

Large scaled building

Symmetrical composition with layering of architectural features to achieve depth

22-12. S. Paul's Cathedral, 1675–1710; London; by Sir Christopher Wren.

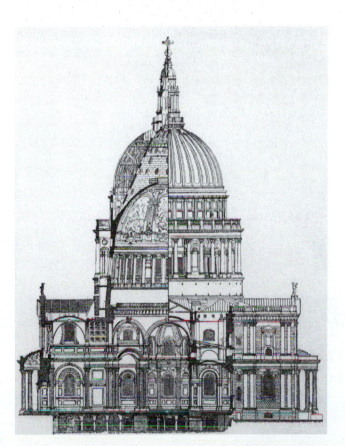

22-13. Section and elevation, S. Paul's Cathedral.

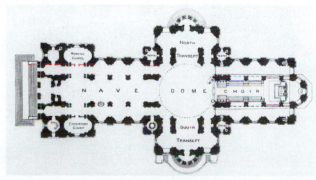

22-14. Floor plan, S. Paul's Cathedral.

■ *Materials.* Stone and brick (Fig. 22-15), often combined, replace wood in London as a result of the Great Fire and increasing timber shortages. Varieties of stone include Portland stone, red and gray granite, and slates. Construction is mostly post and lintel, but churches are typically vaulted and domed.

■ *Facades.* While no common or defining public exterior exists during this period, most feature classical columns, pilasters, pediments, quoins, and arches. Churches typically have towers or steeples (Fig. 22-8, 22-10). Temple fronts (Fig. 22-12, 22-13) define porches or form porticoes and emphasize centers. Pilasters, engaged columns, or

colossal orders (spanning two stories) define bays. String courses delineate stories on buildings without colossal orders. There is some layering of elements, but without the forcefulness and three-dimensionality of Italy. Most compositions build toward the center with projecting architectural details, planes, or walls. Hawksmoor's churches (Fig. 22-15) feature bolder, heavier, and more three-dimensional forms and details.

■ *Steeples.* The classical steeples (Fig. 22-8, 22-10) designed by Wren for the city churches vary greatly in design and have much impact in 18th-century England and America. Most feature tiers that diminish in size. Common details include arched openings, string courses, pilasters, bell towers, lanterns, and tall spires. A few have Gothic details. Hawksmoor's later steeples (Fig. 22-15) show strong influence from Wren.

■ *Windows.* Windows (Fig. 22-12, 22-13) continue to be large in size. Rectangular or arched windows typically have classical surrounds, pediments, and/or lintels. Wren often

22-15. S. Mary Woolnoth, 1716–1727; London; by Nicholas Hawksmoor.

Design Spotlight

Architecture: *Coleshill.* Sir Roger Pratt introduces at Coleshill (Fig. 22-16) the rectangular block, classically detailed manor house with a double-pile floor plan that will dominate smaller Georgian houses in America and Great Britain throughout the 18th century. The design features English, Dutch, and French elements. The facade has two stories nearly equal in size separated by a string course. The much lower ground story is rusticated. Quoins mark the corners, and a modillioned cornice highlights the roofline. Large sash windows capped by lintels are distributed symmetrically across the facade. A pedimented entrance and greater spacing between windows mark the center of the composition. The hipped roof has dormers and is capped by a balustrade and cupola.

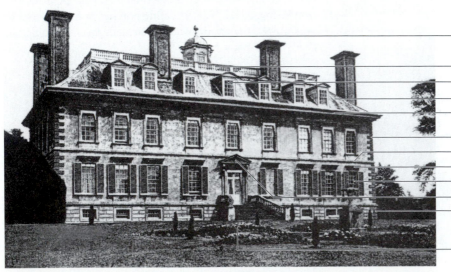

Cupola marks center

Balustrade at roof
Dormer windows
Hipped roof
Modillioned cornice

Quoins
String course
Flat lintel above sash window
Large windows
Classical emphasis at entry
Box shape

Symmetrical composition

22-16. Coleshill, c. 1650 (destroyed 1952); Oxfordshire; by Sir Roger Pratt.

Design Practitioners

■ *Thomas Archer*, an architect, works in the early 18th century. Direct influences from Italians Gianlorenzo Bernini and Francesco Borromini, of whom he had first-hand knowledge, characterize his work. He is best known for his churches.

■ *Grinling Gibbons* is a master wood-carver working from the 1670s to the 1720s. Born in Rotterdam to English parents, he comes to England at age 15 and by 25 he is highly successful. He institutes a new style of carving characterized by minutely detailed open carving of fruit, flowers, leaves, and foliage. Among his most important carvings are those at S. Paul's Cathedral, Trinity College, and Belton House.

■ *Nicholas Hawksmoor* works with Wren and Vanbrugh. A designer of churches and country houses, his work displays interest in mass, restraint in detail, and abstracted geometric forms. S. Mary Woolnoth, London, is his most unusual design.

■ *Gerrit Jensen* (Garrett Johnson) is a cabinetmaker who works for the Crown from Charles II to Queen Anne. He may be the first in England to use Boullework.

■ *Daniel Marot* is a Huguenot who emigrates with William and Mary and becomes a prominent designer of interiors. Following Charles Le Brun at Versailles, he designs all elements in interiors from paneling to bed hangings. Engravings publicize his work, which features unified decoration; brackets for display; paneling with strapwork; garlands; grotesques; and rich, varied textiles.

■ *Sir Roger Pratt*, wealthy and educated, travels in Italy, France, and the Netherlands. Upon his return to England during the Commonwealth, he designs five important houses. The most famous is Coleshill, a double-pile house combining French, Italian, and Dutch characteristics. It serves as the model for numerous Georgian houses in England and America during the 18th century. Also influential is Clarendon House, London.

■ *Sir Christopher Wren* is the dominant name in architecture of the second half of the 17th century. A professor of astronomy at Oxford with an interest in architecture, his earliest building is the Sheldonian Theater in Oxford. Apparently, his only architectural education comes from a visit to France where he meets Bernini as well as French architects and collects prints and pattern books. Following the Great Fire of London in 1666, Wren rebuilds 51 of the 87 parish churches destroyed by the fire and redesigns and constructs S. Paul's on a monumental scale. He executes numerous commissions for the Crown including Hampton Court Palace. His designs remain rational and dominated by classical vocabulary that organizes and controls form and mass.

■ *Sir John Vanbrugh* comes closest to the European Baroque style in his designs for country houses that demonstrate wealth and power for English nobles. Following an army career, he turns to architecture. His most famous work is Blenheim Palace, one of the most monumental buildings in England. Vanbrugh's work is massive and weighty with an emphasis on grand scale and dramatic impact.

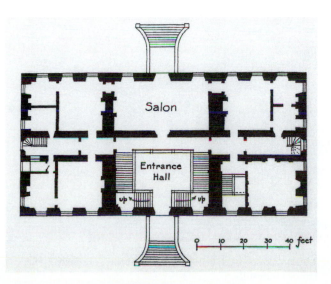

22-17. Floor plan, Coleshill.

incorporates medallion windows placed above rectangular ones (Fig. 22-21, 22-22). At S. Paul's, he adapts the perspective windows used by Maderno at the Palazzo Barberini. In his city churches, he strives for numerous large windows to flood the interiors with light.

■ *Doors*. Entrances often feature classical details and bold surrounds to emphasize their importance and/or to culminate a composition. Porticoes or archways are common in large buildings. Door surrounds (Fig. 22-8, 22-15) consist of triangular, or segmental, closed or broken pediments; lintels carried on columns or pilasters; and interpretations of the Roman arch form. Doors are either of paneled wood, left plain, or painted.

■ *Roofs*. Roofs may be flat with balustrades and sculpture, gabled, hipped, or domed. Churches without domes have gabled roofs. Balustrades at the roofline cap several of the early-18th-century churches.

■ *Later Interpretations.* Restoration church forms, facades, and steeples become standard for later classical churches during the English Neo-Palladian and Georgian period, such as S. Martin-in-the-Fields (Fig. 22-26) in London, and during the American Georgian style.

Private Buildings

■ *Types.* Common types are town houses, country houses, palaces, and palace complexes.

■ *Site Orientation.* Vanbrugh's plans for Castle Howard (Fig. 22-24) and Blenheim Palace (Fig. 22-25) follow a three-sided form with a center courtyard for the main house, which is flanked by service buildings. The axis of approach continues into the vestibule, the grand salon, and the landscape beyond in the French Baroque manner. These are exceptions, as most houses sit in a relatively self-contained manner within the landscape.

■ *Floor Plans.* Most plans are linear or **U**-shaped (Fig. 22-24), although a few examples have **H** or **E** shapes. Great houses, whether new or remodeled, adopt French and Italian *enfilade* planning, and are organized around private and state apartments. Smaller houses adopt a rectangular block and double-pile plan (Fig. 22-17) with a

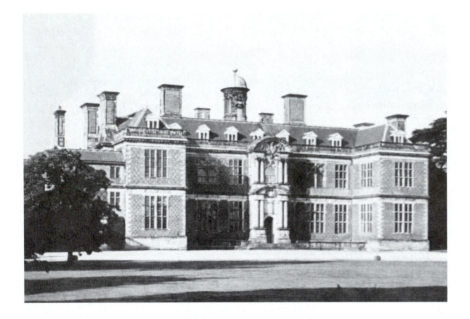

22-18. Sudbury Hall, c. 1676; Derbyshire.

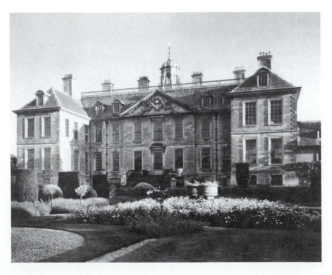

22-19. Belton House, 1684–1686; Lincolnshire; by William Stanton.

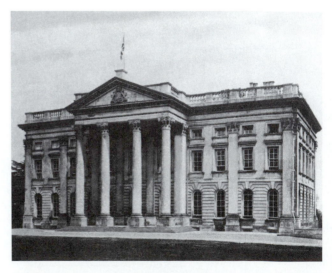

22-20. Moor Park, c. 1690s; Hertfordshire; probably by Sir James Thornhill.

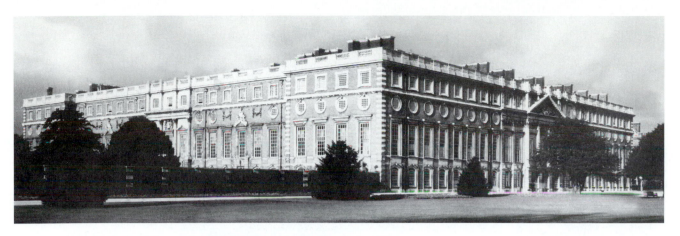

22-21. Hampton Court Palace, 1690–1696; London; by Sir Christopher Wren.

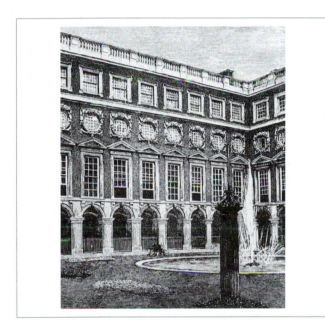

22-22. Fountain Court, Hampton Court Palace.

central passage down its length and rooms on either side. Town house plans become standardized: they are one or more rooms wide and at least two rooms deep, and have two or more stories.

■ *Materials.* Stone and brick (Fig. 22-20, 22-21, 22-22) are typical for dwellings. Brick remains the most common building material. English bond (alternating rows of headers and stretchers) dominates until the 1630s, when Flemish bond (alternating headers and stretchers) replaces it. Red brick with white stone details characterizes examples influenced by Holland.

■ *Facades.* Palaces and great houses often derive facades (Fig. 22-16, 22-18, 22-19, 22-20, 22-21, 22-23, 22-25)

from Versailles or feature Palladian devices such as temple fronts. Symmetrical compositions with large windows and classical details that build toward and/or emphasize centers are typical. Colossal pilasters may divide facades into bays. Grand houses with both linear and U-shaped plans typically have frontispieces (entrance pavilions) and/or end pavilions that often project. As in France, these units mark important interior spaces such as the *salon* in the center, and state bedchambers on each end. Contrasts of light and dark accentuate depth and scale.

Smaller houses depict restrained compositions of stories separated by string courses, quoins, and modillioned cornices. Town houses follow country house design. Typical facades have equal-sized windows on the first two floors. String courses and a heavy cornice at the roofline emphasize the horizontal. Larger examples have projecting centers with pediments and columns.

■ *Windows.* Windows (Fig. 22-16, 22-18, 22-19, 22-20, 22-21, 22-22) remain large as before. The most common type is rectangular with a shaped surround or surmounted with a flat lintel, triangular or segmental pediment, or a mixture of pediment shapes. Palaces or grand houses may have combinations of arched and rectangular windows separated by pilasters or by floor. They may also have round or square windows integrated with rectangular ones. Some buildings have smaller windows on the ground floor, larger windows on the important second floor, and square windows in the attic above. Sliding sash windows appear after the 1670s.

■ *Doors.* Designers of private homes emphasize the importance of entrances (Fig. 22-16, 22-18, 22-19, 22-20, 22-21, 22-25) in similar fashion to designers of public buildings. The most common devices are columns or pilasters carrying a triangular or segmental pediment and/or an arched window. Single- and double-paneled doors may be painted or left plain.

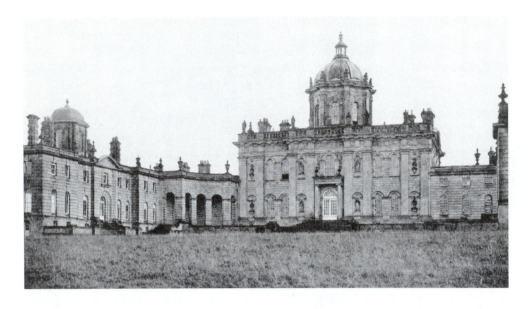

22-23. Castle Howard, 1699–1712; Yorkshire; by Sir John Vanbrugh and Nicholas Hawksmoor.

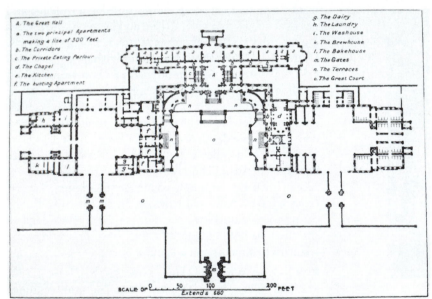

22-24. Floor plan, Castle Howard.

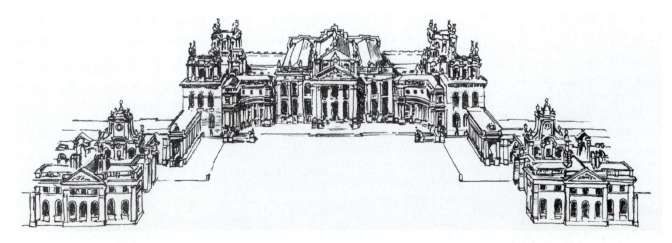

22-25. Blenheim Palace, 1705–1724; Oxfordshire; by Sir John Vanbrugh and Nicholas Hawksmoor.

■ *Roof.* Roofs (Fig. 22-16, 22-18, 22-19, 22-20) on smaller houses are gabled or hipped, while palace and grand houses have flat roofs with balustrades and occasionally sculptures. Some retain the earlier parapets (low retaining walls). Hipped roofs often have dormers. A cupola or dome may mark the center.

■ *Later Interpretations.* The style of large Baroque houses rarely is adopted later, although some elements reappear, as evident in the English Neo-Palladian and Georgian period (Fig. 22-27). However, Pratt's rectangular-block, classical houses become one of the standard house types during the American Georgian style (Fig. 22-28) and later in the Colonial Revival of the early 20th century.

INTERIORS

Interiors are either conservative and more classical or showy and more Baroque. The majority of English interiors during the period are conservative, evidencing more restrained classicism and more somber appearances than Elizabethan and Jacobean interiors. Classical elements, paneling, plasterwork ceilings, and wooden floors are typical. Staircases, balustrades, chimneypieces, paneling, and over doors and windows feature wood carving, the most common decoration during the period. Following Dutch influence, carving becomes lighter, more open, and naturalistic. Compartmentalized plasterwork ceilings featuring naturalistic or classical motifs are also typical.

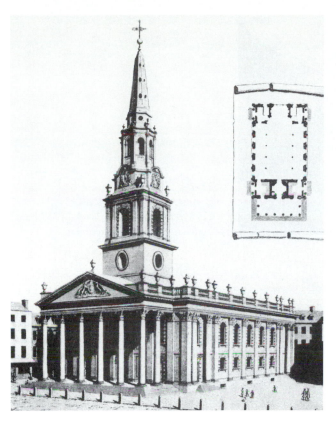

22-26. Later Interpretation: S. Martin-in-the-Fields, 1721–1726; London; by James Gibbs; English Neo-Palladian and Georgian.

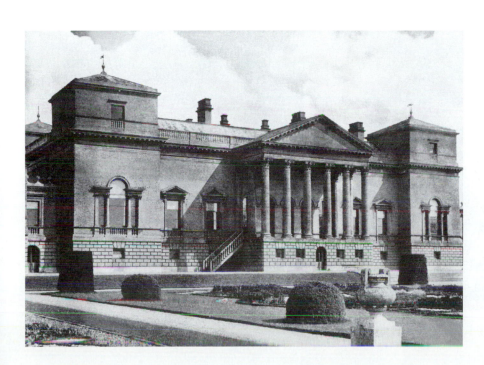

22-27. Later Interpretation: Holkam Hall, begun 1734; Norfolk; by William Kent; English Neo-Palladian and Georgian.

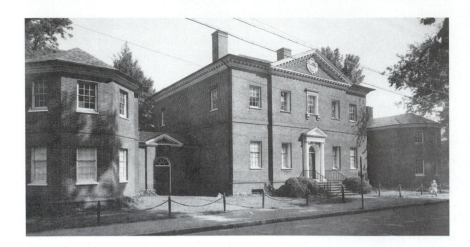

22-28. Later Interpretation: Hammond-Harwood House, 1773–1774; Annapolis, Maryland; by William Buckland; American Georgian.

Illusion, extravagance, ornamentation, and complexity characterize showy interiors. Found only in palatial homes, these interiors exhibit wall and ceiling paintings in vivid colors and exuberant plasterwork and/or wood carving highlighted with gilding. Images often interpret the French Baroque. Foreign craftsmen execute many of these details.

Public Buildings

■ *Types.* The most important interiors in churches are the nave, choir, and altar areas (Fig. 22-29, 22-30, 22-31, 22-32).

■ *Relationships.* Church interiors relate strongly to exteriors through the articulation of dominant architectural fea-

tures such as columns, pilasters, arches, windows, and ceilings. Scale is an important element in delineating the relationship of spaces and circulation paths. Vestibules are often small, preceding entry into a large, imposing nave (Fig. 22-31). A main aisle in the nave is common, but the use of side aisles depends on the size of the church; usually, only large churches have them. Altars typically orient to the east, so the morning sunlight streams in the surrounding windows.

■ *Walls.* Classical forms commonly articulate church interiors. Walls are usually painted white and/or have natural wood paneling. S. Paul's Cathedral (Fig. 22-31, 22-32, 22-33) has columns, pilasters, arches, heavy entablatures, and clerestory windows to articulate and define the interior

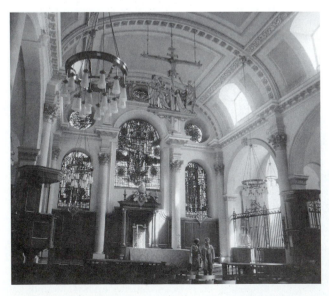

22-29. Nave, S. Mary-le-Bow, Cheapside, 1670–1677; London; by Sir Christopher Wren.

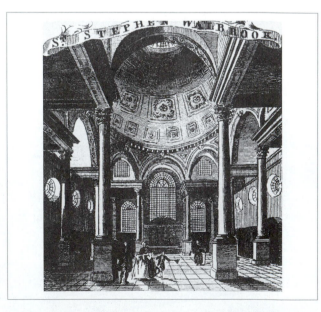

22-30. Nave, S. Stephen, Walbrook, 1672–1687; London; by Sir Christopher Wren.

Important Buildings and Interiors

- **Birmingham:** S. Philip, 1709–1715, Thomas Archer.

- **Cambridge:** Emanuel College, 1667–1673, Sir Christopher Wren.

- **Cambridgeshire:** Thorpe Hall, 1653–1656, Peter Mills.

- **Derbyshire:**

 —Chatsworth House, 1686–1694, William Talman and later Louis Laguerre.

 —Sudbury Hall, c. 1676, carving by Edward Pierce, plasterwork by Robert Bradbury and James Pettifer, painting by Laguerre. (Color Plate 54)

- **Greenwich:** Greenwich Hospital, 1704 and onward, Sir Christopher Wren, Nicholas Hawksmoor, and Sir James Thornhill.

- **Hertfordshire:** Moor Park, c. 1690s, probably by Sir James Thornhill.

- **Lincolnshire:** Belton House, 1684–1686, William Stanton.

- **London:**

 —Christ Church, Spitalfields, 1714–1729, Nicholas Hawksmoor.

 —Eltham Lodge, 1663–1664, Sir Hugh May.

 —Hampton Court Palace, 1689–1694, Sir Christopher Wren.

 —Royal Hospital, Chelsea, 1682–1689, Sir Christopher Wren.

 —S. Bride's, Fleet Street, 1671–1678, Sir Christopher Wren.

 —S. Mary-le-Bow, Cheapside, 1670–1677, Sir Christopher Wren.

 —S. Mary Woolnoth, 1716–1727, Nicholas Hawksmoor.

 —S. Paul's Cathedral, 1675–1710, Sir Christopher Wren, choir stalls, 1696–1698 by Grinling Gibbons.

 —S. Stephen, Walbrook, London, 1672–1687, Sir Christopher Wren.

 —Temple Bar, 1670; London, Sir Christopher Wren.

- **Nothhamptonshire:** Easton Neston, 1696–1702, Nicholas Hawksmoor.

- **Oxfordshire:**

 —Blenheim Palace, 1705–1724, Sir John Vanbrugh and Nicholas Hawksmoor.

 —Coleshill, c. 1650 (destroyed 1952), Sir Roger Pratt.

 —Sheldonian Theater, 1662–1663, Sir Christopher Wren.

- **Surrey:** Blue Drawing Room, Ham House, c. 1675.

- **Yorkshire:** Castle Howard, 1699–1712, Sir John Vanbrugh and Nicholas Hawksmoor.

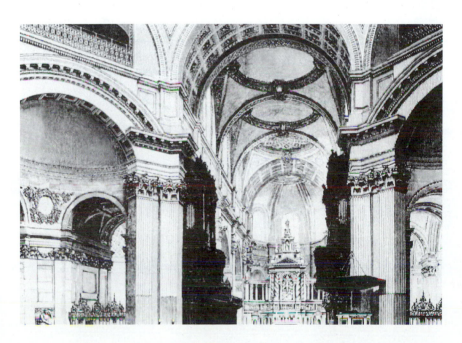

22-31. Nave, S. Paul's Cathedral, 1675–1710; London; Sir Christopher Wren.

walls and the open spaces. Paneling appears within clusters of pilasters. The choirstall (Fig. 22-32) is elaborately embellished with pilasters, paneling, and heavy carving representing the skill of Grinling Gibbons. S. Mary-le-Bow in Cheapside (Fig. 22-29) and Wren's other city churches follow this same pattern, but on a much smaller, more intimate scale. Other leading church architects emulate Wren's designs.

■ *Ceilings.* Ceilings (Fig. 22-29, 22-30, 22-31) feature vaulting, arches, and domes. Circles, squares, and rectangles order the compositions. Compartmented, coffered, and other geometrically designed ceilings may emphasize important areas, such as the altar, the crossing of the transept, and primary circulation paths. Heavy moldings provide rich surface decoration.

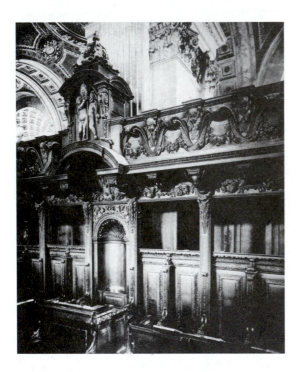

22-32. Section and perspective showing choir, S. Paul's Cathedral; carving work by Grinling Gibbons.

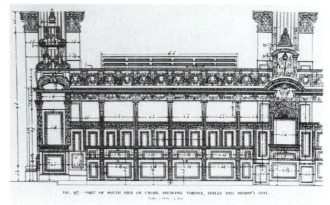

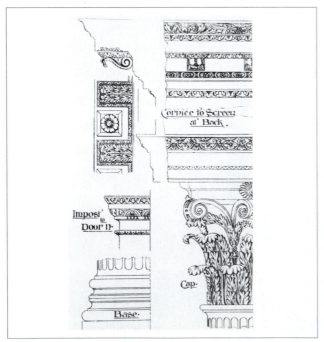

22-33. Column and cornice details, S. Paul's Cathedral.

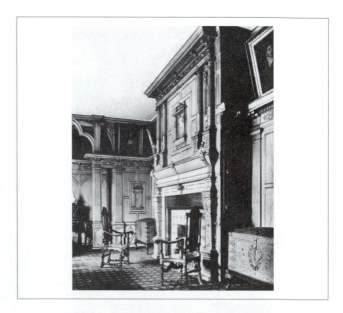

22-34. White Parlor, Holland House, c. 1625.

Private Buildings

■ *Floor Plans.* Stair halls (Fig. 22-37, 22-39) or vestibules replace great halls. They receive greater design emphasis and serve as central circulation spaces. Room names and functions change under French influence. The main reception/entertaining space is now called the *salon* or saloon (Fig. 22-38, Color Plate 54) and retains a central position on the plan. Closets become cabinets, and their lavish decoration signals a new importance. Withdrawing rooms (Fig. 22-40) become general reception rooms and may precede an important sleeping area. Bedchambers are more public, although less so than in France. Lodgings are now called apartments.

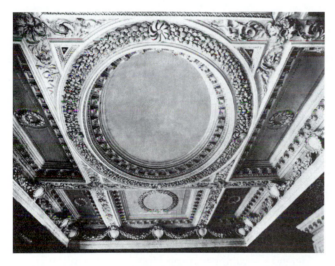

22-35. Saloon ceiling, Coleshill, c. 1650; Oxfordshire; by Sir Roger Pratt.

■ *Color.* Wall colors in conservative state rooms tend to be dull, in browns, grays, blue grays, and olive greens. Those in showy interiors are often lighter, in off-whites or possibly in browns. Gilding may enhance the paneling or important decoration. Brighter colors may appear in more intimate spaces. Sequences of rooms generally feature the same wall colors.

Colors are carefully chosen by architects, homeowners, or upholsterers to enhance the building design, sequence of rooms, and the objects within them. Sometimes colors relate to associations, which often arise from medieval heraldry (green represents fidelity, for example). Expensive colors, such as blues or greens, generally appear in the most important rooms. Color may also relate to a particular material; for example, wainscoting is often various shades of brown, emulating wood. Colors may also serve to enhance paintings, upholstery, or hangings.

■ *Lighting.* As wax candles are expensive and tallow or rush lights are malodorous and burn quickly, minimal lighting is used except during evening social functions or special occasions. Candleholders include candlesticks, sconces, chandeliers, and lanterns. Most candlesticks are of wood, brass, or pewter. By the second half of the century, wealthy homes commonly have silver candlesticks and candelabra or branches in Baroque designs. Sconces have one or more branches and a reflecting back. Chandeliers are rarer in England than in other countries, although lanterns commonly light passages. As candles must be continually snuffed or trimmed, lighting devices are placed on candle stands at heights to facilitate this task. Since the only sources of light are fireplaces and candles, room decorations strive to enhance light with gilding, shiny surfaces, and mirrors.

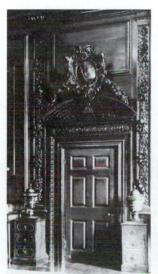

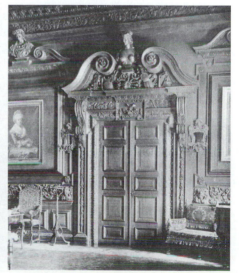

22-36. Door details, Compton Park and Thorpe Hall.

■ *Chimneypiece.* The fireplace (Fig. 22-34, 22-40, 22-41, 22-43) is a focal point and consists of mantel and overmantel in elaborate designs with bolection moldings or columns, pilasters, pediments, brackets, scrolls, and garlands. Oil paintings or mirrors hang above the mantel following French interiors. Naturalistic carvings in high relief

sometimes flank and surmount mantels. Grinling Gibbons is the foremost wood-carver of the period. His designs feature fruits, flowers, and fowl rendered in a three-dimensional manner (Fig. 22-3).

■ *Floors.* Floors are usually wide, unpolished boards of oak or deal. Polished parquet becomes common after its introduction from France in the 1650s. Other floor coverings include stone or marble in black and white or designs derived from pattern books. Rush matting continues, but finer, patterned mats are imported from North Africa or the Far East. Oriental rugs may cover tables or floors.

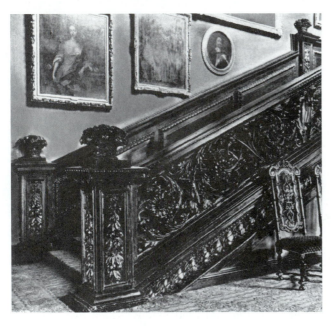

22-37. Staircase, Sudbury Hall, c. 1676; Derbyshire; carving by Edward Pierce; plasterwork by Robert Bradbury and James Pettifer, 1691; painting by Louis Laguerre.

Design Spotlight

Interior: *Drawing Room, Belton House.* Designed for the Brownlow family, this country house (Fig. 22-19, 22-40, 22-41, 22-42) interprets the elegant, classical facades typical of the period. Characteristic of conservative interiors, the drawing room (Fig. 22-40) serves as an important social area and contains some of England's finest examples of the carving work of Grinling Gibbons. The symmetrical space features a dominant chimneypiece composed of a mantel with bolection molding and an overmantel. Surmounting and flanking this are Gibbons's three-dimensional carvings of fruits, flowers, and fowl. Additional carvings and walnut paneling with gilding highlight the other walls. The white compartmented ceiling evidences the richness of the Baroque style with ovals, rectangles, and heavy moldings. Furnishings are more ornate than in most conservative interiors.

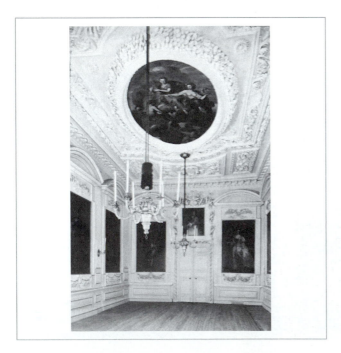

22-38. Saloon, Sudbury Hall, c. 1676; Derbyshire. (Color Plate 54)

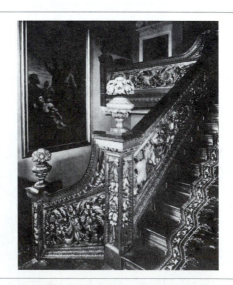

22-39. Staircase, Dunster Castle, c. 1680s; Somerset.

■ *Walls*. Rooms without hangings have paneling (Fig. 22-34, 22-38, Color Plate 54, 22-40, 22-43), which becomes more architectural and divides into three parts like a column. The dado (standardized at 3'-0") stands for the base, the wall surface represents the shaft, and the cornice symbolizes the capital. Panels become larger with prominent moldings and carvings during the period. Classical moldings, such as bead, fillet, dentil, and cyma recta, are common. Important rooms may feature applied naturalistic plasterwork or wood carvings in the manner of Grinling Gibbons around the fireplace (Fig. 22-41) or in paneling. Paneling may be painted, usually in browns, or left natural. Architectural details and the stiles and rails of paneling commonly contrast in color or material. Typical treatments include marbleizing, graining, and Japanning (an imitation of Oriental lacquerwork). Panel centers may feature imported or domestic lacquered panels, oil paintings, or painted designs or scenes. Gilding or silvering may highlight moldings, capitals, and other details in grand rooms. Some spaces have painted *trompe l'oeil* architectural details. Illusionistic, often exuberant, wall paintings in the Baroque manner embellish important rooms and stair halls in great houses.

■ *Staircases*. Staircases (Fig. 22-37, 22-39), often one of the most important features in the house, become a focus for the elaborate carving characteristic of the period. Some

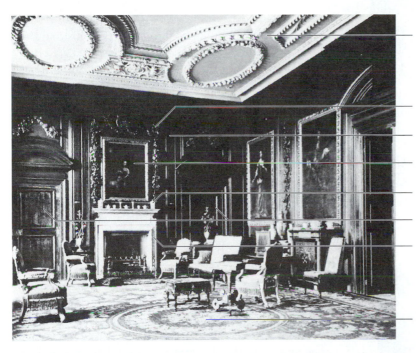

Compartmented ceiling with heavy moldings

Wood carving by Grinling Gibbons

Walnut paneling with beveled edges

Portrait over mantel

Display of oriental porcelain

Symmetrical door placement

Bolection molding surrounds fireplace opening to create mantel; major emphasis in room is chimneypiece

Heavy scaled rug pattern

22-40. Drawing Room, Belton House, 1684–1686; Lincolnshire; by William Stanton.

22-41. Chimneypiece and detail, Saloon, Belton House.

retain the columnar banisters, but they are now enriched with detailed carvings. Others have panels with open and lacy, curvilinear, naturalistic carving.

■ *Windows.* Windows are typically sliding sashes surrounded by architectural details. Most have interior shutters. Curtains in panels or the newer festoons from France adorn windows in important rooms. (Festoon curtains draw up in puffy scallops similar to today's balloon curtains.) Upholsterers use flat, shaped valances trimmed with tapes

22-42. Ceiling in Stair Hall, Belton House.

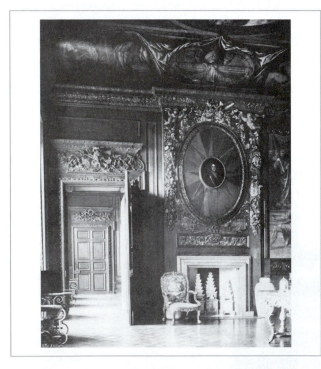

22-43. State Drawing Room, Chatsworth House, 1686–1694; Derbyshire; by William Talman and later Louis Laguerre.

and fringe for added embellishment and/or to hide the nails attaching curtains to window frames.

■ *Doors.* Doors and windows are arranged symmetrically. Typical doors (Fig. 22-36, 22-40, 22-43) are paneled in dark wood, often walnut. Paintings may surmount them. At the end of the period, doors commonly feature an architrave, frieze, cornice, and broken pediment above them. When painted, doors match paneling. Doors in grand rooms have *portières* to prevent drafts.

■ *Textiles.* Interiors of the wealthy feature numerous colorful and opulent textiles whether as hangings, curtains, *portières*, cushions, or upholstery. Fabrics include plain and patterned velvets, damasks, satins, mohairs, India cottons, and woolens. Crimson is a favored color, but others include green, blue, black, white, and yellow. Appliqué; colored, gold, or silver embroidery; and trims embellish and add variety to curtains, wall and bed hangings, and upholstery. Textile or leather hangings often adorn walls in state and reception rooms and may match other fabrics in the room.

■ *Ceilings.* Molded plaster becomes the most common form of ceiling decoration because of a new, harder plaster that dries faster and can be mounted on wire or wood. Following Inigo Jones's earlier compartmented examples, ceiling compositions (Fig. 22-35, 22-38, Color Plate 54, 22-40, 22-42) feature squares, ovals, or circles with centers left bare or filled with paintings. By the 1670s, naturalistic decorations of garlands composed of shells, leaves, and flowers replace compartmentalized designs. Plaster carvings resemble wood carvings. Late in the period, painted panels gain favor over plaster.

■ *Later Interpretations.* Only a few interiors in wealthy homes or grand public buildings imitate the Baroque style in the late 19th and early 20th centuries. However, the paneled room with classical details is repeatedly revived beginning in the late-19th-century England and the American Colonial Revival and continuing today.

FURNISHINGS AND DECORATIVE ARTS

The nobles' desire for luxury and refinement and demands for new forms and finer cabinetwork transform English furniture during the period. They reject traditional prototypes, preferring examples from abroad. Walnut replaces oak as the primary furniture wood; carving, veneer, and lacquer become common. French, Dutch, and Oriental influences affect furniture design. The middle and lower classes adopt plainer versions of high styles or oak furniture in the Elizabethan tradition. Besides Louis XIV variations, two major furniture developments make up the Restoration period.

■ *Charles II, Carolean, or Stuart (1660–1689)*. This furniture style (Fig. 22-44) features rectilinear forms, **S** and **C** curves, scrolls, and turning. Exuberant carving is the main decoration, but the use of veneers increases. Caning, carving, scrolls, and ball and bun feet distinguish Charles II furniture. The expression is extravagant and Baroque.

■ *William and Mary (1689–1702)*. This furniture style (Fig. 22-46, 22-47, 22-48) exhibits curving silhouettes, cabriole and trumpet legs, spoon backs (that curve inward like a spoon bowl) and splats (flat, vertical members in a chair back), and Spanish (resembles a weak scroll) and *pied-de-biche* (cloven-hoof) feet. Richly figured veneers and marquetry and turned, baluster, or trumpet legs are typical.

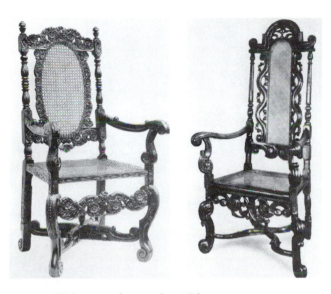

22-44. Walnut armchairs, c. late 17th century.

Also typical are flat stretchers that repeat the shapes of aprons. French and Dutch influences abound in this more conservative expression of Baroque.

Private Buildings

■ *Types*. New forms include easie (wing) chairs and completely upholstered daybeds found only in bedchambers, doorless chests of drawers, settees or sofas, cabinets on stands, and dressing or toilet tables.

■ *Relationships*. Furniture commonly lines the walls when not in use following the French manner. Most arrangements are symmetrical. A common grouping between windows features a table flanked by candle stands and a looking glass on the pier above.

■ *Materials*. Walnut is the most common wood for both conservative and showy furniture. Typical designs feature veneers such as burl (mottled in appearance, cut from irregular growths), oyster veneers (oval shapes resembling oyster shells, cut transversely through a small tree branch or trunk), crossbanding (border bands for tops or doors, cut across the grain), parquetry (geometric forms), and arabesque or seaweed marquetry (pattern of allover scrolls; Fig. 22-48). Gilding and lacquer grow in favor. Imported or locally made lacquered furniture surpasses painted examples in popularity. Many pieces have black backgrounds with incongruous designs of foliage and pseudo-Chinese (*Chinoiserie*) motifs.

■ *Seating*. The principal Carolean chair has a high back and caned panel framed with carving (Fig. 22-37, 22-41, 22-44). The seat also is caned and has an elaborately carved stretcher beneath that matches the cresting. Scroll

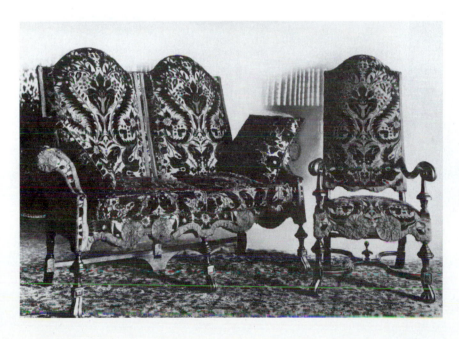

22-45. Charles II upholstered chair and settee, covered in velvet.

legs terminate in ball, bun, or Spanish feet. About 1700, the spoon back with splat is introduced, and legs become baluster turned, columnar, spiral, or trumpet shaped. Cabriole legs (double-curved) with *pied-de-biche* or cloven-hoof feet and upholstered chairs with matching settees (Fig. 22-45) gain in popularity. The backs of settees resemble two chairs put together. Easie chairs, introduced from the Continent about 1680, have tall, upholstered backs with wings to protect the sitter from drafts. Sleeping chairs have ratchets to lower the backs.

■ *Tables.* Oval or round tables supersede trestles during the period. There are infinite varieties of tables for dining,

tea drinking, card playing, and dressing. Dressing or toilet tables (Fig. 22-46), introduced in the late 17th century, have two or three drawers. Mirrors hang above them, or small toilet mirrors sit on top.

■ *Storage.* Cabinets on stands (Fig. 22-47, 22-48, Color Plate 55) may have Japanned, lacquered, or veneered

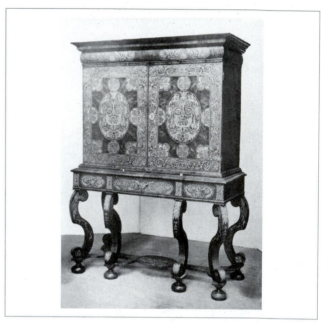

22-47. William and Mary cabinet on stand with scrolled legs, c. 1700.

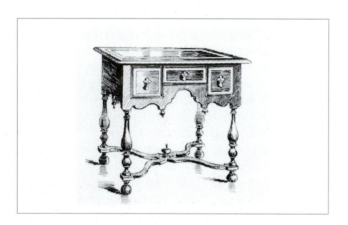

22-46. William and Mary dressing table.

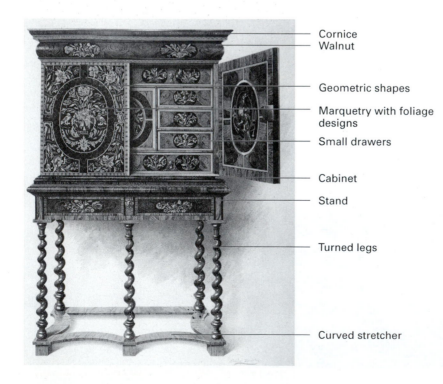

Cornice
Walnut

Geometric shapes

Marquetry with foliage designs

Small drawers

Cabinet

Stand

Turned legs

Curved stretcher

Design Spotlight

Furniture: *Cabinet on Stand.* Cabinets on stands (Fig. 22-47, 22-48, Color Plate 55), fashionable pieces throughout the Restoration period, are a focus for the skills of the marqueter and cabinetmaker. The stand features spiral legs characteristic of France and a flat stretcher. The cabinet has marquetry in oval patterns on both sides of the doors, and the drawers have crossbanding. As is typical, the drawers and doors inside are as decorated as the exterior of the case.

22-48. William and Mary cabinet on stand with turned legs and marquetry. (Color Plate 55)

22-49. Cabinet drawer pulls.

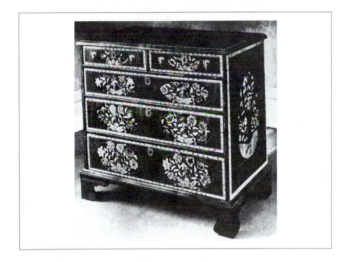

22-50. William and Mary chest of drawers.

facades with many small drawers and secret compartments behind doors. Stands have four or six turned, scrolled, or straight legs. Chests of drawers sometimes sit on stands. After 1680, typical chests of drawers (Fig. 22-50) have four graduated drawers resting on straight bracket (corner) feet. Tops of cabinets, desks, and bookcases (Fig. 22-51) usually are curved or hooded during the William and Mary era and often feature small brackets or shelves to display Chinese porcelain or other small objects. Cabinet pulls (Fig. 22-49) are usually brass, small, and may feature decorative drops.

■ *Beds.* Lighter-scale beds with wood frames entirely covered with fabric replace heavy, carved Elizabethan beds. New designs usually exhibit tall proportions, low headboards, and heavy, complex testers. The *lit d'ange,* new from France, features a tester hanging from the ceiling instead of supported by posts. Sometimes the tester corners hold vases of ostrich feathers. Hangings remain opulent to demonstrate wealth and rank. Curtains still completely enclose the bed. Headboards, testers, and valances often

have complex shapes that are outlined with flat tape, embroidery, and appliqué and trimmed with fringe. Hangings are usually *en suite* with other fabrics in the room.

■ *Textiles.* Usually all fabrics in the room match. Upholstery fabrics include velvet (Fig. 22-45), silk, wool, linen, Turkeywork (knotted fabric that imitates Oriental rugs), and crewel. Rich trims and fringe embellish pieces and enhance their opulent look. Trims and flat tape may outline seats, backs, and wings on chairs and settees. Gilded nails secure fabric to frames. Furniture cases (slipcovers) protect expensive fabrics.

■ *Decorative Arts.* Decorative arts are similar in design to furniture with complex shapes and decoration. Particularly fashionable is Chinese porcelain (Fig. 22-41). Many people, including Queen Mary, enthusiastically collect and display it. Some devote entire rooms to their collections. European ceramic makers imitate porcelain design in tin-glazed earthenware or delft. Particularly popular are blue and white compositions imitating Oriental examples.

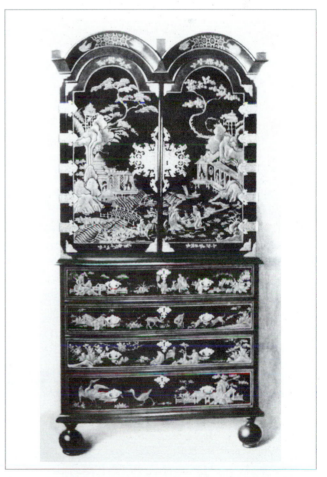

22-51. William and Mary desk and bookcase with double hood.

People particularly prize looking glasses, which become more common during the period. Most are small with heavy wood frames.

■ *Glass.* The perfecting of a lead glass formula by Englishman George Ravenscroft from 1674 to 1676 affects both commercial and domestic glassmaking. This development marks the greatest improvement in glassmaking since the 13th century. Lead glass has unsurpassed clarity and ability to capture light. Its excellence in reflecting and refracting light, especially when cut, is important to chandeliers and other forms of lighting at a time when houses are dark and candles taxed. Lead glass fosters a new style that emphasizes form over shape or applied decoration.

■ *Later Interpretations.* Carolean and William and Mary furnishings are briefly imitated wholly or in part in the early 20th century, but other styles supersede them in popularity.

G. Rococo

1715–1760

Great changes occur in the Western world during the 18th century. At its beginning, aristocrats and nobles rule politically, culturally, and socially with little influence from the middle and lower classes. Europe is largely agrarian. By the end of the century, the rising middle class expands its influence, and Europe begins to industrialize. Throughout the century, exploration of new lands continues. Trade increases with the Far East and the Americas. Scientists make great advances in botany, biology, and the physical sciences. Women occupy positions of influence in several countries: Madame de Pompadour in France, Maria Theresa in Austria, and Catherine the Great in Russia.

The 18th century is known as the Age of Enlightenment or the Age of Reason. The term refers to trends in thought and letters advocating the application of reason to philosophy and life. Thinkers and writers of the period promote the scientific method; empiricism; and disciplined, rational thought over religion and myth. They believe that reason, judiciously applied, can solve human problems and generate progress. They see themselves as emerging from centuries of darkness into a newly enlightened world. Enlightenment ideas derive from the writings of John Locke of England. From them, Voltaire and others in France develop new ideologies and theories of humankind and society. These theories are only marginally accepted until the middle of the 18th century. The Enlightenment gradually becomes an international movement and greatly influences the French and American Revolutions.

Rococo dominates the first half of the century on the Continent. Originating in France from late Baroque, Rococo affects all aspects of interiors and furnishings. The light, asymmetrical style exhibits unity and continuity of parts as forms and motifs flow in an uninterrupted manner. Complex, curvilinear silhouettes and organic ornament define the visual image. Attenuated, graceful curves suggest feminine influence. Rococo largely abandons Classical language in favor of naturalism and themes and motifs alluding to love and romance, pastoral life, exoticism, pleasure, and gaiety.

EUROPE IN THE MIDDLE OF THE EIGHTEENTH CENTURY (1740)

23. Le Régence and Louis XV (Rococo)

1701–1760

We have nothing to do in this world other than to procure for ourselves agreeable sensations and feelings.

Madame de Chatelet, *Discours sur le bonheur*, 1740

Rococo is the symbolic style of the French aristocracy in the first half of the 18th century. The name comes from *rocaille* (meaning "small rockeries often found in grottoes") and *coquille* (cockleshell), itself a common motif. The French call the style *rocaille, goût pittoresque,* or *style moderne.* A reaction to the stiff formality of the Baroque, the style is asymmetrical, light in scale, and defined by curvilinear, naturalistic ornament. Themes and motifs include romance, pastoral life, the exotic, fantasy, and gaiety. The style's finest and most complete expression is in interiors where a total unity of decoration and furniture is common. As a transition between the massive, rectilinear, classical French Baroque and the smaller, curvilinear, naturalistic Rococo, Le Régence features characteristics of both styles. Like Rococo, Le Régence primarily develops in interiors and furniture and has a minimal effect on architecture.

HISTORICAL AND SOCIAL

When Louis XIV dies in 1715, his grandson, who is next in line, is only five years old. The Duc d'Orleans becomes regent until Louis reaches the age of 13. As Louis XIV leaves France heavily in debt from various wars and the royal building campaigns, the Duc d'Orleans attempts to restore financial and social order. Since he lives in Paris rather than at Versailles, the court follows him there, making Paris the artistic, social, and intellectual center of Europe. Louis XV obtains his legal majority and the throne in 1723. His reign fails to halt the political and economic decline begun in the last decades of his grandfather's regime. Because he has little interest in government, Louis XV, along with his nobles and courtiers, pursues pleasure. His mistresses often influence him. His policies at home and abroad are inconsistent. High taxes, wars, loss of the New World colonies, corruption, and mismanagement cripple France and increase dissatisfaction and unrest

among the middle and lower classes. In the last years of his reign, Louis attempts some reforms with the help of his ministers, but the new policies are reversed after his death in 1774. In less than two decades, the monarchy will be overthrown by the Revolution.

CONCEPTS

During his reign, Louis XIV imposes his taste for formal, monumental, and classical architecture, interiors, and furniture on everyone. The Rococo of Louis XV, in contrast, reflects the taste of the nobility. Upon Louis XIV's death, the centralization of life and government at Versailles ceases as the nobility leave for Paris where they build or redecorate *hôtels* (private town houses). They react to the rigidity and formality of court life by seeking comfort and enjoyment. Rococo suits this polished, but hedonistic society that devotes itself to pleasure, fantasy, and gaiety. Women have more influence, with many holding *salons* in their homes where conversation, repartee, and wit form the entertainment. The tastes of Madame du Pompadour, the king's mistress, dictate fashions, and the feminine

23-1. *Amusement du beau sexe.*

23-2. Pastoral scene, mid-18th century; by F. Boucher.

23-4. Molding detail, Palais de Versailles.

shape is reflected in the prevalent curvilinear forms. In social and private spaces, interiors and furniture emphasize human scale, lightness, and naturalism. Novelty, fantasy, and individuality become important design goals. For the first time since the Renaissance, a style does not model itself on classical antiquity. Although associated with the reign of Louis XV, the Rococo style does not confine itself to those years. Characteristics appear before he takes the throne in 1723, and a reaction to its unclassical principles begins in the 1740s.

DESIGN CHARACTERISTICS

Attributes of Rococo begin to manifest in the late 17th century in the published designs and ornament of Jean Bérain and others and in the early-18th-century rooms at Versailles (see Chapter 21, Louis XIV). The first three

decades of the 18th century are a transitional period between late Baroque and Rococo called Le Régence (French Regency). During this time Rococo characteristics begin to appear on and modify Baroque forms and details. Le Régence characteristics include a general lightening in

23-3. Panel detail with shell motif.

23-5. Design for decorative panel; by A. Watteau.

the size of rooms and scale of finishes and decoration; asymmetry; and the appearance of naturalistic, curvilinear ornamentation. Similarly, furniture combines Baroque and Rococo elements, such as high rectangular backs and cabriole legs (double curve).

By 1730, the Rococo style dominates in the smaller, more intimate spaces designed for special purposes, such as music rooms or libraries, that begin to proliferate in the Parisian *hôtels* of the nobility. In these rooms, naturalistic, asymmetrical ornamentation composed of numerous small components, curving tendrils and vines, and continuity of parts replaces the orders and other classical details. Curves dominate form and decoration, and colors lighten and brighten. Themes and motifs reflect gallantry, romance, gaiety, and the exotic. Furniture follows a similar development. To a greater degree than previously, Rococo achieves a complete synthesis of interior design, furniture, and decorative arts.

■ *Motifs.* On exteriors (Fig. 23-9), engaged columns, pilasters, pediments, quoins, string courses, brackets, and corbels appear sparingly and discretely. Interior and furniture motifs include *Chinoiserie* (pseudo-Chinese details; Fig. 23-8, 23-32), *singerie* (monkeys in human activities; Fig. 23-20), Italian comedy figures, musical instruments, hunting and fishing symbols (Fig. 23-18), shells (Fig. 23-3), flowers (Fig. 23-7, 23-35), bouquets tied with ribbon, baskets of flowers, garlands (Fig. 23-36), cupids (Fig. 23-6, 23-19), bows and arrows (Fig. 23-4), torches, romantic landscapes (Fig. 23-2, 23-5, 23-17, 23-36), shepherds and shepherdesses, Turkish arabesques and figures, pastoral emblems such as shepherd crooks, and an allover trellis pattern with flowers in the center of intersecting lines.

23-7. Textile detail with asymmetrical curves and flowers.

23-6. Detail of decorative panel and *trumeau* with cupids.

23-8. Textile detail with *Chinoiserie* influence.

ARCHITECTURE

Le Régence and Louis XV architecture continue the classicism of the Baroque era, but with an increased elegance and lightness in scale and appearance. Plain walls with surface decoration concentrated around doors and windows are characteristic. Larger windows reduce wall space and help to integrate inside and outside. Classical elements, such as the orders, are less common but still articulate noble houses to demonstrate rank and wealth. Simpler exteriors contrast with extravagant decoration inside. The planning of private spaces reflects a desire for comfort and convenience, whereas state apartments remain as large and ornate as before.

Private Buildings

- *Types.* *Hôtels* (town houses) built in Paris for the aristocracy are the chief Rococo building type.

- *Relationships.* Most *hôtels* are sited at the rear of large plots of land in the city to create gracious *cours d'honneur*

Important Treatises and Design Practitioners

- Sets of engravings and treatises spread the Rococo aesthetic beginning in the late 17th century. Engravings feature *rocaille* ornament and objects. Treatises depict selected rooms, not entire suites of rooms, in elevation and section. They rarely discuss decoration. Illustrations include examples of walls, doors, chimneypieces, and paneling that often incorporate mirrors, beds, *canapés*, and consoles. Often, treatises advertise products, designers, and/or services.

- *Cinquième livre d'ornements,* 1734; Juste-Aurèle Meissonier.

- *De la distribution des maisons de plaisance et de la décoration des edificies en general,* 2 vols., 1737–1738; Jacques-François Blondel.

- *Livre d'architecture,* 1745; Germain Boffrand.

- Many people create Rococo interiors. Architects who design the space may design architectural and decorative elements and perhaps coordinate the activities of the craftsmen who execute the design. In addition, architects may provide designs (their own or those of others) for other elements, such as furniture or lighting. Upholsterers continue to provide textiles and furniture. Particularly affecting fashion are *marchands-merciers* (merchandise dealers), who have shops of furniture and accessories. They do not design, but often commission furniture from others on the behalf of clients. Wealthier nobles have their own design staffs.

- *Jean Bérain,* architect and engraver, designs furniture combining motifs of antiquity with decorative designs in the workshop of André Charles Boulle. His style of Renaissance grotesques evolves into the more delicate, lighthearted asymmetrical interlacing arabesques combined with foliage, shells, and flowers that characterize Rococo in the early 18th century.

- *Jacques-François Blondel* teaches architecture and interior decoration and trains many future architects of the later 18th century. However, most of his influence comes from his numerous treatises. In these works, he emphasizes the importance of space planning or the distribution of spaces over interior decoration, in which he includes paneling, doors, windows, chimneypieces, floors, and important pieces of furniture.

- *Germain Boffrand's hôtels* feature sculptural facades and unusual room shapes. His interiors, which later influence Germany, depict lavish Rococo decorations. Boffrand creates some of the most magnificent and influential Rococo interiors in the Hôtel de Soubise in Paris.

- *André Charles Boulle* continues to work as a royal *ébéniste* with workshops in the Louvre. Boullework (a tortoiseshell and brass marquetry) becomes less common during the Rococo period. He supposedly introduces *commodes* around 1700.

- *Charles Cressent,* a sculptor and *ébéniste,* is known for his exquisite gilt-bronze furniture mounts. In addition to furniture, Cressent designs clocks, sconces, and andirons.

- *Juste Aurèle Meissonier* is a designer who produces lavish Rococo designs, many of which are engraved and published. In 1726, he becomes painter, sculptor, architect, and interior designer to the king. His designs feature asymmetry and curving foliage, flowers, and shells.

- *Jean-François Oben* is a German immigrant who becomes *ébéniste* to Louis XV. His most famous piece is the *bureau du roi* (a rolltop desk for Louis XV). Known for his excellent marquetry, Oben also produces furniture for Madame de Pompadour's houses and her rooms at Versailles.

(forecourts) with majestic gates of entry. Architects experiment with courtyard shapes that relate to the site's shape.

■ *Floor Plans.* Plans are generally symmetrical with rectangular rooms. A few plans depict oval spaces. Designers carefully plan the distribution of rooms to give the appropriate dignity and grandeur required for the nobility while still providing comfort and privacy. As earlier, organization centers on *appartements* (suites of rooms). Each has a variety of spaces within it. In the *appartements de parade* (ceremonial rooms arranged *enfilade* on the garden side), nobles receive important people and deal with important matters. People of similar status eat, play cards, converse, and socialize in *appartements de société* (smaller spaces with less formal décor). Ceremonial and social spaces may be separated by floor or by axis with ceremonial spaces on the longer one. Ceremonial spaces are more easily accessible from the entrance than social spaces. *Appartements de commodité* (private spaces) have bedchambers, *boudoirs* (dressing rooms or private siting rooms for women), and *appartement des bains* (bathing rooms).

■ *Materials.* Most *hôtels* are of local stone and trabeated construction. Some lower stories are arched.

■ *Facades. Hôtels* exhibit a scale suitable for the nobility. Buildings are symmetrical and horizontal with more continuity and refinement than Baroque buildings. As before, architects emphasize centers and/or ends (and important interiors) by projecting them forward or with defining architectural elements. Articulation and details are subordinate to the whole to create a unified volume. To further achieve unity, fronts feature less movement and fewer contrasts of light and dark as in the Baroque style. Smooth upper-story walls have larger windows usually separated by plain wall surfaces. Subtle rustication sometimes highlights lower stories and surrounds openings. Pediments, columns, or rustication accentuate entrances, and string courses mark stories.

■ *Windows.* Rectangular or arched windows (Fig. 23-9) have simple lintels above them. Curvilinear ironwork (Fig. 23-10), such as on balconies, may distinguish lower portions. Decorative surrounds highlight dormer windows.

23-9. Window detail; Paris.

23-10. Ironwork.

- *Doors.* For emphasis, designers locate doorways as centerpieces in compositions and surround them with columns, pediments, coats of arms, and other ornamentation.

- *Roofs.* Mansard, hipped, or low-pitched or flat roofs with balustrades are typical.

- *Later Interpretations.* Rococo architecture is rarely revived as such. Elements and principles of the style may appear in later buildings.

INTERIORS

Interiors and furnishings are the primary expressions of Le Régence and Louis XV (Rococo) style. As a transition style, Le Régence exhibits characteristics of the waning Baroque period and the ascending Louis XV period. During the 1670s and 1680s, rooms become less formal with lighter, even playful, decoration. Wood paneling replaces heavy marble walls, columns and pilasters disappear, and cornices diminish in size. Corners and tops of paneling, doors, and windows begin to curve. Naturalistic, exotic, or fanciful ornamentation replaces classical. Decoration often is asymmetrical.

Rocaille decoration with its asymmetrical profusion of curving tendrils, foliage, flowers combined with shells, and minute details defines the character of the Louis XV interior. Themes depict gaiety, pleasure, romance, youth, and the exotic. In all but the grandest and most formal rooms, classical elements are rare. Most rooms maintain a rectangular form, but curving lines, continuity of parts, and asymmetrical arrangements of naturalistic decorations characterize wall panels and finishes, ceilings, textiles, furniture, and decorative arts. Oval rooms are uncommon in

Design Spotlight

Interior: Salle du Conseil, *Palais de Fontainebleau.* This small-scaled room (Fig. 23-11) articulates the Rococo emphasis on symmetrical balance in the distribution of architectural elements as highlighted by the centered chimneypiece, arches, and double doors. The chimneypiece is smaller and projects less than before. The mantel shelf is slightly higher than the dado. Panels, which vary in width, display an abundance of curves, figures, flowers, and decorative embellishment. This effect repeats in the *trumeau* over the doors. The matched set of furniture includes a *canapé* and several *fauteuils*. Its overall lightness and portability responds to the feminine quality characteristic throughout the period. Because the room functions as a public space, furniture lines the walls when not in use. *Appliqués* flank the mirror to enhance the quality of light. The parquet de Versailles floor continues in popularity.

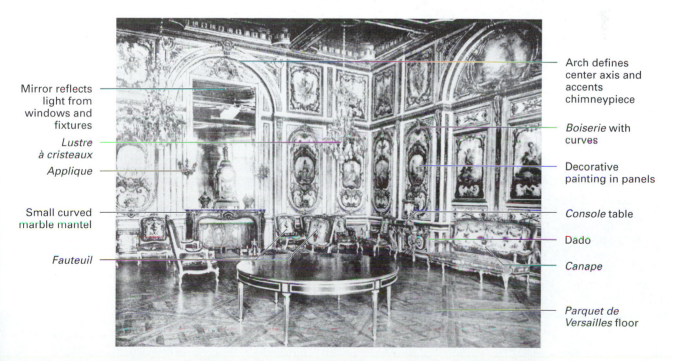

23-11. Salle du Conseil, Palais de Fontainebleau, mid-18th century.

France. Paneling may be designed to incorporate sofas, consoles, tables, beds, and/or mirrors.

Room decoration remains hierarchical as earlier; the more important the space, the larger its size and more lavish its decoration. As the main reception for important persons, the *chambre de parade* is the most formal and lavish room in the house and least likely to exhibit Rococo characteristics. The room depicts rich colors, costly materials, the orders, portraits, tapestries, antiques, and formal furniture that demonstrate and reinforce the owner's social position. Similarly, the state bedchamber and its antechamber retain their formal and opulent decor. Social

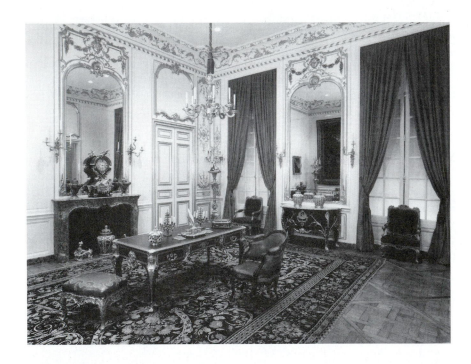

23-12. Paneled room, Jacques Gaultier, 1725–1726; Paris. (Color Plate 56)

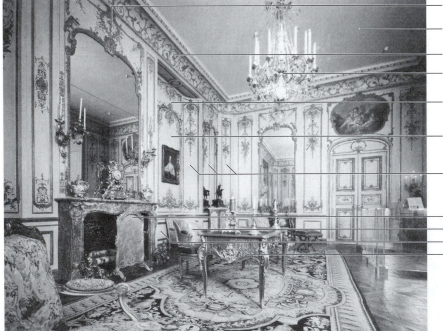

Chimneypiece is main focal area, and is on center axis

Lower ceiling height than in Louis XIV period

Decorative, curved frieze

Lustre à cristeaux

Decoration mainly on top and bottom of panel

White paneling with gilded details

Three different panel widths, wide flanked by narrow

Firescreen
Fauteuil with caned back
Dado
Bureau plat

23-13. Varengeville Room, Hôtel de Varengeville, 1736–1752; Paris. [Woodwork French XVIII century. Boiserie: from the Hotel Pillet-Will, Paris. Photograph: 1996. The Metropolitan Museum of Art, The Charles B. Wrightsman Foundation Fund, 1963. (63.228.1)]

Important Buildings and Interiors

- **Fontainebleau:** Palais de Fontainebleau, Salle du Conseil, mid-18th century.
- **Paris:**
 —Church of S. Roche, 1719–1736; Robert de Cotte.
 —Chateâu de Champs-dur-Marne, c. 1700, Pierre Bullet.
 —Hôtel Amelot de Gournay, 1710–1713, Germain Boffrand.
 —Hôtel Crozat, 1700–1702, Pierre Bullet.
 —Hôtel de Matignon, 1721–1724, Jean Courtonne.
 —Hôtel de Roquelaure, 1722, Pierre Lassurance.
 —Hôtel de Soubise, 1704–1709, Pierre Alexis Delamair, Salon de la Princesse, 1737–1740, Germain Boffrand.
 —Hôtel de Toulouse, Galerie Dorée, c. 1720, Robert de Cotte.
- **Strasbourg:** Palais de Rohan, 1728–1742, Robert de Cotte.
- **Versailles:** Palais de Versailles, redesign of various rooms, mid-18th century.

Private Buildings

- *Relationships.* The ornate interiors contrast with refined, plainer exteriors. Important spaces retain their grand scale, although some are one story instead of two. Private rooms become smaller and more intimate.

- *Color.* During Le Régence, most paneling is painted white with gilded details (Fig. 23-12, 23-13). By the 1730s, a pastel yellow, blue, or green palette replaces white. Single hues and contrasting values of the same hue decorate paneling.

- *Lighting.* Large windows, light-colored walls, shiny surfaces, and numerous mirrors fill rooms with light along with ornate lighting fixtures (Fig. 23-11, 23-12, 23-13, 23-22). Lanterns are more common than the *lustre à cristeaux* in *salons* and stair halls. Small and large *appliqués*, *flambeaus*, and *candelabra* on mantels and tables, and *torchères* also provide light. Elaborate *guéridons* may hold either a *candelabra* or large *flambeau*. To multiply light, the fixtures often sit in front of mirrors. They typically are made of *ormolu* (gilded bronze), porcelain, or silver in asymmetrical, naturalistic shapes. Some have crystal or lead glass drops.

rooms, such as the *salon* and *salle à manger* (dining room), usually feature Rococo themes and less formal decorations. Specialized rooms for various activities, such as music or gaming, develop during the period.

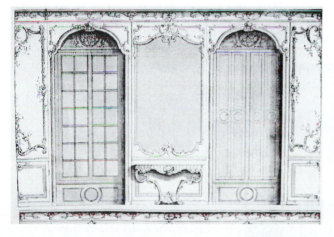

23-14. Elevations, design for sides of rooms, early to mid-18th century.

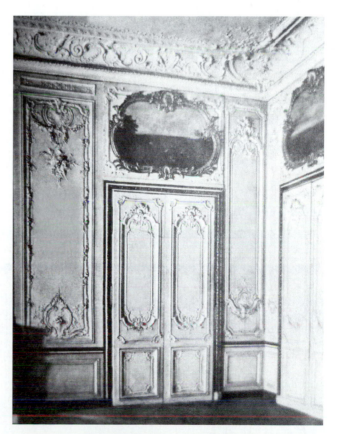

23-15. *Boiserie* in the Salle de Porcelaines, Palais de Versailles.

■ *Floors.* The most common flooring is wood blocks or parquet (Fig. 23-11). Entries, halls, landings, and grand *salons* may feature marble or stone in blocks or squares. Rugs include Oriental, Savonnerie, and Aubusson. The latter two are made in Rococo colors and motifs.

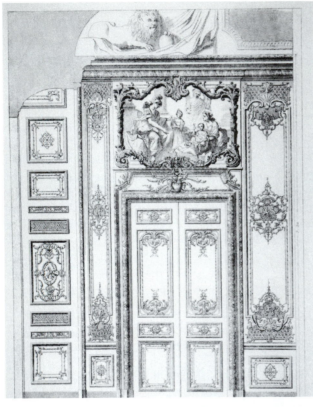

23-16. Elevation with doorway, Palais de Versailles, mid-18th century.

■ *Walls. Boiserie* (carved wood paneling) with alternating wide and narrow panels is the most common wall treatment (Fig. 23-11, 23-12, 23-13, 23-14, 23-15, 23-16, 23-17, 23-18, 23-21). In contrast to the ornament, paneling remains symmetrical even to the point of a false door to balance a real one, and it retains the tripartite divisions of earlier. Asymmetrical curves, foliage, and shells soften the corners, bottoms, and tops of panels. Decoration, which at times obscures form, extends beyond moldings and borders. Curves may be free form or resemble a woman's upper lip; complex compositions feature multiple C, reverse C, and S scrolls. *Boiserie* may be left natural, painted, or lacquered. Panels and moldings may contrast in color or be two shades of the same hue. Panel centers may have fabrics or colorful painted arabesques with or without figures and naturalistic motifs or landscapes (Fig. 23-5, 23-6, 23-8, 23-11, 23-17, 23-20, 23-21).

Tapestries (Fig. 23-36), usually limited to grand rooms, depict Rococo themes in numerous colors and subtle shadings similar to paintings. Wallpapers gain favor but are not used in rooms of state. Types include hand-painted Chinese papers, flocked English papers, and patterns imitating textiles. English papers dominate the French market until the late 1750s when war between the two countries halts their importation. Larger and more numerous mirrors with complex curvilinear frames are located on walls, over fireplaces (Fig. 23-18, 23-19), on ceilings, inside fireplaces in summer, and on window shutters.

■ *Chimneypiece.* As the focal point, the fireplace sets proportions for paneling. The chimneypiece (Fig. 23-11, 23-12, 23-13, 23-17, 23-18, 23-19) is smaller and projects less than before. The mantel shelf is slightly higher than the dado. The panel above the fireplace is the same size as larger ones in the room and features a *trumeau* (over-mantel or over-door treatment typically with a painting or

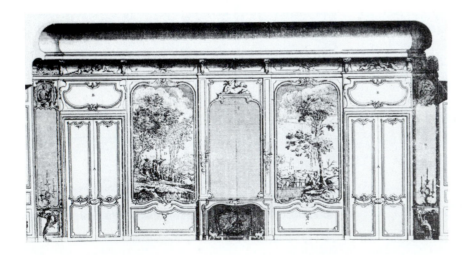

23-17. Elevation, side of a *grande salon*, mid-18th century.

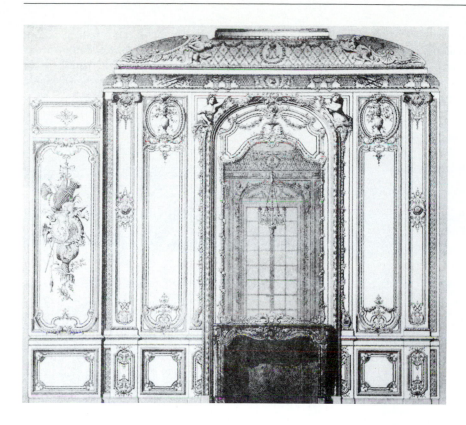

23-18. Elevation, Salon de Medailles, Palais de Versailles, mid-18th century.

mirror in a curving, gilded frame; Fig. 23-6, 23-19). The marble mantel itself is curvilinear, and its color may match tabletops in the room. Red is the most desired color, followed by yellow, gray, and violet.

■ *Windows.* Windows (Fig. 23-14) are larger than before and feature curving tops. Most have interior shutters that match the paneling. Divided panels and festoons appear in important rooms. Pelmets (fabric valances) come into general use after 1720.

■ *Doors.* Door panels (Fig. 23-13, 23-15, 23-16, 23-17) match those of walls. Over each door is a *trumeau* with paintings of pastoral, mythological, or romantic scenes in asymmetrical curvilinear frames. Important rooms have *portières* that help prevent drafts and add to the interior opulence.

■ *Ceilings.* Coved ceilings, curving corners, and *rocaille* decoration extending onto the ceiling itself are the most common treatments (Fig. 23-13, 23-15, 23-16, 23-17, 23-18). Some ceilings are plain with a central plaster rosette.

■ *Later Interpretations.* Beginning in the 1840s, Victorian Rococo Revival interiors (Fig. 23-23) repeat the curves and naturalistic ornament of the 18th-century Rococo style, primarily in details such as mantels, wallpaper, textiles,

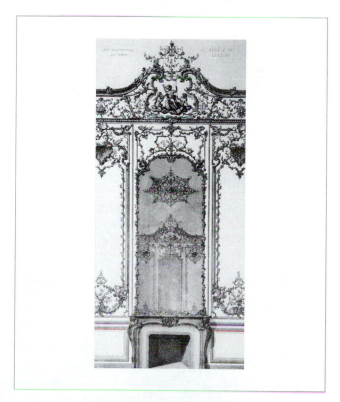

23-19. Elevation with mantel and overmantel.

furniture, and color. The goal is to evoke images of the style, not to recreate it. Rococo Revival interiors often have numerous curvilinear patterns on walls, floors, and, ceilings. A more accurate rendition of Rococo occurs in the late 19th century as paneling and furnishings copy original scale, curves, and ornament. The wealthy sometimes import and install entire 18th-century rooms from France. Neo-Rococo becomes a fashionable interior style as critics and designers recommend it in place of heavy Victorian styles in the early 20th century (Fig. 23-25).

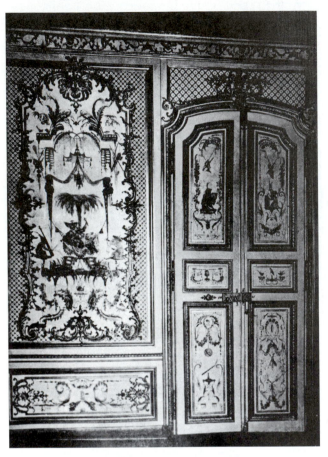

23-20. Panel and door of the Grande Singerie, Château de Chantilly; by Christophe Huet.

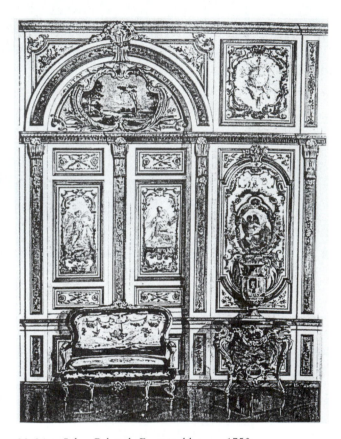

23-21. *Salon*, Palais de Fontainebleau, c. 1750.

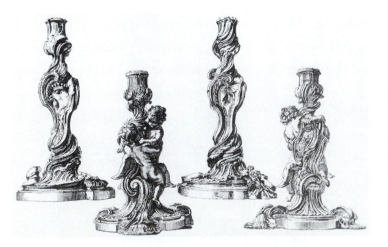

23-22. Lighting fixtures: *Flambeaus, candelabra,* and *appliqués.*

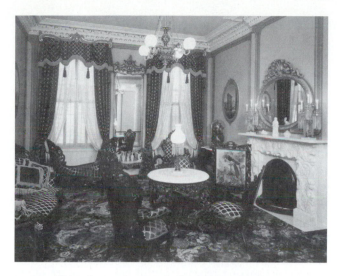

23-23. Later Interpretation: Parlor, Whittemore House, c. 1852; Astoria, Queens, New York; Victorian Rococo Revival. [The Richard and Gloria Manney, John Henry Belter Rococo Revival Parlor. Astoria, NY, built about 1852. Rosewood parlor suite attributed to John Henry Belter (1804–1863), New York City. Photographed 1996. The Metropolitan Museum of Art, Gift of Sirio D. Molenti and Rita M. Pooler, 1965. (65.4)]

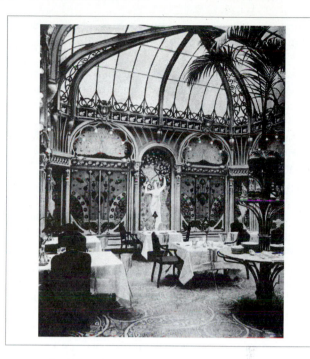

23-24. Later Interpretation: Salle de Restaurant, published in *Art et Décoration*, 1899; Art Nouveau.

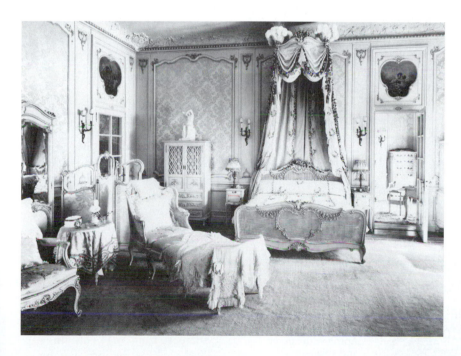

23-25. Later Interpretation: Bedroom; New York; 1905; Neo-Rococo.

Edith Wharton and Ogden Codman (in *The Decoration of Houses*) and Elsie de Wolfe promote French taste. The asymmetry, naturalistic ornament, and sensuous curves of Rococo also influence the fin-de-siècle style, Art Nouveau (Fig. 23-24), of the late 19th and early 20th centuries. Human scale and curvilinear appeal ensure Rococo's continued use today.

FURNISHINGS AND DECORATIVE ARTS

As in interiors, Le Régence is a transition period in which furniture combines the elements and ornament of Louis XIV (Baroque) and Louis XV (Rococo). Pieces are scaled down in size and become less formal and more curvilinear.

Naturalistic, asymmetrical ornament highlights legs, backs, and seats. The most characteristic pieces are chairs, tables, and commodes.

Louis XV furniture is characterized by asymmetrical *rocaille* decoration and an absence of straight lines. Emphasis on comfort results in smaller pieces and an increased use of upholstery. Any part that can curve does, including legs, backs, sides, and facades. Curves are slender, graceful, and drawn out. Other important features of the style include *ormolu* and a continuity of parts especially evident in moldings and mounts. Furnishings exhibit the highest standards of construction and craftsmanship. Matched sets of furniture may include one or more of a *canapé* (sofa), *fauteuil* (upholstered open armchair), *bergère* (upholstered closed armchair), stool, *lit* (bed), *console*, mirror, fire screen, and screen. Pursuit of novelty gives rise to multipurpose pieces after 1750.

Private Buildings

■ *Types.* New pieces, such as lounging furniture, that support comfort and convenience appear. Gaming pieces, small tables, and ladies' writing furniture are especially fashionable.

■ *Distinctive Features.* During Le Régence, size decreases. Chair backs become lower and begin to curve. Cabriole legs (Fig. 23-26, 23-28) replace straight ones, and stretchers begin to disappear. Most seating has a wood frame around seats and/or backs. Arms curve and are set back from the seat corner. In the Rococo style, typical seating has cabriole legs with a whorl foot and a curved wooden frame around the seat and back that flows into the legs and arms, creating continuity of parts. Low, upholstered backs and scrolled arms with *manchettes* (arm pads) also are common. Curving silhouettes, marquetry, and *ormolu* with naturalistic forms characterize case pieces. *Ormolu's* curving forms flow uninterrupted across drawers and doors.

■ *Relationships.* Louis XV furniture perfectly suits interiors in size, silhouette, and decoration. Curves and *rocaille* decoration of paneling repeat in furniture. Pieces are often colored and decorated for specific rooms (Fig. 23-11, 23-21). When not in use, furniture is arranged around the perimeter of the space as before. Grand rooms are sparsely furnished, but private ones are often cluttered. Beds sit in alcoves or behind a balustrade in staterooms.

■ *Materials.* Cabinetmakers use more than 100 types of local and exotic woods to create colorful veneers and mar-

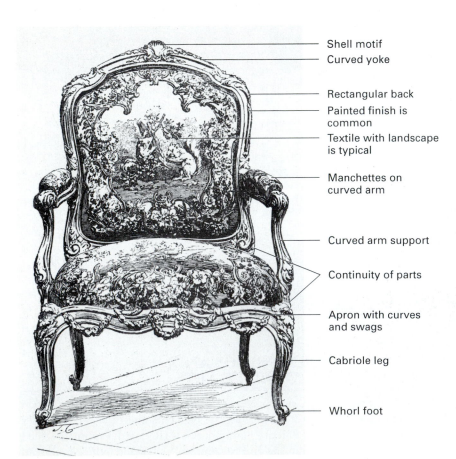

Shell motif
Curved yoke
Rectangular back
Painted finish is common
Textile with landscape is typical
Manchettes on curved arm
Curved arm support
Continuity of parts
Apron with curves and swags
Cabriole leg
Whorl foot

23-26. *Fauteuil.*

Design Spotlight

Furniture: *Fauteuil.* Scaled down from Louis XIV, parts of the curving frame of this chair flow into one another in typical Rococo fashion. The shield-shaped back composed of small curves; cabriole legs with whorl feet; horizontal arms with *manchettes* (pads) resting on curving supports and set back from the edge of seat; and asymmetrical, naturalistic carving on the frame are typical characteristics. The Beauvais tapestry upholstery features a subject from La Fontaine's *Fables* and is set in a curving and asymmetrical frame.

quetry (Fig. 23-31). Mahogany, first imported during Le Régence, comes into vogue after 1760. Makers also incorporate lacquered panels from the Orient into *commodes*, *armoires*, and screens. They favor Chinese (red on black with some gold and silver), Japanese (gold and silver on black), and Coromandel (polychrome on black) lacquers, but soon develop their own methods and colors to match

interiors. The most famous is *Vernis Martin*, a shiny lacquer developed by Etienne-Simon and Guillaume Martin in 1730. Used on both walls and furniture, the most common color is a rich green. Furniture colors often match those in the room, and white or natural with painted decoration is most common. Caning is very fashionable for seats and backs; cushions add softness and comfort. Finely crafted

23-27. *Duchesse brisée.*

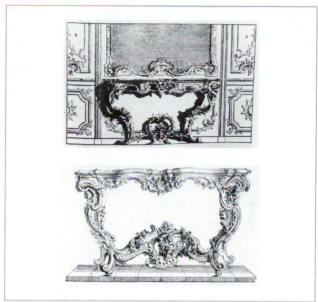

23-29. *Consoles.*

23-28. *Canapés.*

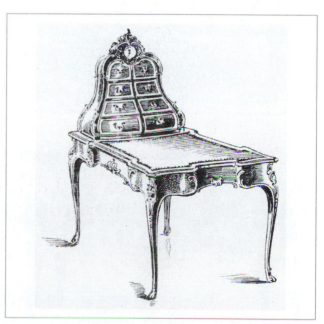

23-30. *Bureau plat.*

curvilinear gilded bronze mounts (Fig. 23-31) are used for decoration, as hinges or handles, and on corners and points of strain.

■ *Seating.* Seating comes in many sizes and forms for maximum comfort. *Fauteuils* (Fig. 23-11, 23-12, 23-13, 23-26) and *chaises* have either a flat (*à la Reine*) or concave (*en cabriolet*) upholstered back. The *bergère* has a wider seat; a loose cushion; and closed, upholstered arms. An arched horseshoe back forms the arms of the *bergère en gondole*. The *bergère confessional* has a higher back and wings. The *voyeuse* (conversation chair) has a flat rail on its back, on which to lean. The most common form of *canapé* (Fig. 23-11, 23-21, 23-28) has a back resembling three *fauteuils* or *bergères* put together. Lounging furniture becomes more important and includes the *chaise longue* (armchair with a seat long enough for the sitter's legs) and a *duchesse brisée* (a deep *bergère* with stool; Fig. 23-27).

■ *Tables.* The many types of tables include game, card, work (Fig. 23-11), and toilette tables. Rooms typically have varieties of *ambulantes* (small tables) in many shapes that fulfill many functions. None is exclusively for eating. *Consoles* (tables fixed to the wall and supported only in front by legs; Fig. 23-14, 23-21, 23-29) are an integral part of room decoration. Usually placed between two windows or opposite the fireplace, they are exquisitely carved and gilded with marble tops. Mirrors in carved and gilded frames hang above them.

■ *Storage. Commodes* (Fig. 23-12, 23-31, Color Plate 57) appear during Le Régence. They are the most fashionable and lavishly decorated piece of Louis XV furniture, requiring the greatest skills of cabinetmaker and metalworker.

Design Spotlight

Furniture: *Commode.* Curving forms and decoration and asymmetrical ornament characterize *commodes* (Fig. 23-31, Color Plate 57), one of the most fashionable Rococo pieces. *Bombé* sides and a serpentine front feature complex marquetry and extravagant *ormolu.* The naturalistic, asymmetrical *ormolu* flows uninterrupted over the two drawers and inconspicuously incorporates the drawer pulls, illustrating the continuity of parts typical of Rococo style. Typical also are the marble top and cabriole legs. Pairs of *commodes,* often with matching candle stands, placed under mirrors on opposite sides of the room are typical in *salons.*

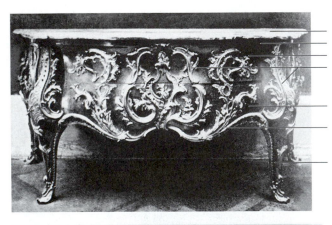

Marble top
Wood veneer
Upper drawer
Gilded bronze decoration emphasizes curves and hides construction
Lower drawer

Serpentine front

Cabriole leg

23-31. *Commodes;* by Jacques Caffieri and Joseph Baumhauer.

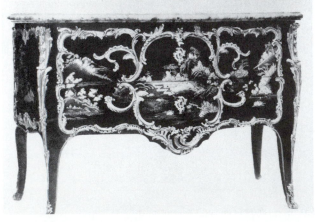

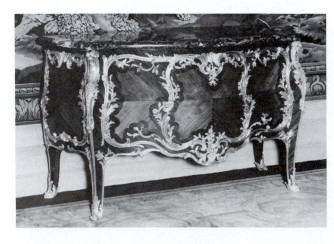

Many have undulating horizontal (serpentine or reverse serpentine) and vertical (*bombé*) shapes that are a challenge to veneer. Some are lacquered; others have porcelain plaques. Their magnificent gilded bronze mounts often obscure divisions between drawers. Writing furniture includes the *bureau plat* (flat table desk; Fig. 23-12, 23-13, 23-30), *secrétaire à abattant* (drop-front desk; Fig. 23-32), and *bureau à cylindre* (rolltop desk). *Armoires* (Fig. 23-33) continue as important storage pieces, but are lighter in scale overall than earlier. Especially fashionable for drawing rooms is a pair of *encoignures* (low corner cupboards). *Tables de nuit* (nightstands) provide convenient storage for chamber pots and washbasins.

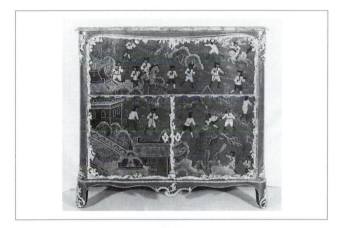

23-32. *Secrétaire à abattant*; by Jacques Dubois.

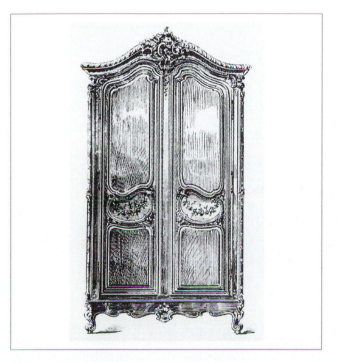

23-33. *Armoire.*

■ *Beds.* The most fashionable beds are the *lit à la duchesse* with an oblong tester or canopy as long as the bed and the *lit d'ange*, which has a smaller canopy. Both have a low headboard and footboard but no posts. The *lit à la polonaise* has four iron rods that curve up to support a dome-shaped canopy. The *lit à la française* (Fig. 23-34) has a headboard and footboard of equal height; the long side sits against the wall and a canopy above supports hangings. The *lit à la turque* resembles a sofa, but has wider proportions.

■ *Textiles.* Heavy brocades and damasks are no longer in vogue. Silks (especially painted), linens, chintzes, and other printed cottons are popular in summer, while plain or patterned velvets or damasks appear in winter (Fig. 23-35). Sets of furniture often have covers with matching tapestries (Fig. 23-11). In 1760, Christophe-Philippe Oberkampf opens a textile factory in Jouy-en-Josas near Versailles that quickly becomes known for *toile de Jouy*, (a cotten, linen, or silk fabric with engraved decorations in a single color, such as red, on a white or cream background). Bedrooms and *boudoirs* frequently feature toiles or cottons. Silk and lightweight brocade or damask draperies comprise window treatments and bed hangings. Textile colors are strong and brilliant. Crimson, a symbol of royalty, is most favored, followed by blue, yellow, green, gold, and silver. Patterns depict Rococo themes and motifs and frequently are asymmetrical.

■ *Decorative Arts.* Decorative arts follow the curvilinear, asymmetrical shapes and naturalistic and exotic ornament of Louis XV. Accessories include mirrors, porcelains, andirons, and fire screens (Fig. 23-13). Many rooms have a lacquered, upholstered, or mirrored folding screen with

23-34. *Lit à la française*; Chambord.

23-35. Textiles: Flowers and Indian palampore, c. mid-19th century.

23-36. Tapestry: Beauvais after Vernansal, c. 1750.

23-38. Vase, Sèvres.

23-37. *Faience* plate; Rouen.

three or four panels. André-Charles Boulle introduces the gilt bronze mantel clock about 1700. Mantel clocks with complex curvilinear shapes and ornament often have matching candlesticks. Tall case clocks with extravagant marquetry and *ormolu* are important pieces in Rococo interiors.

23-39. Later Interpretation: Parlor chair, mid-19th century; Victorian Rococo Revival.

23-40. Later Interpretation: *Canapé*, published in *Art et Decoration*, 1901; Art Nouveau.

23-41. Later Interpretation: Armchair, late 20th century; adaptation with Rococo influence.

■ *Porcelain*. Since the first importation of porcelain from the Orient, Europeans seek to make their own. The Italians and others create soft-paste porcelain (artificial porcelain lacking an ingredient of true porcelain) beginning in the 16th century. Finally, in the 18th century, the Germans succeed in making hard-paste or true porcelain and open the first factory at Messien in 1710. It dominates European porcelain until the mid-18th century when it is superseded by French products. In the 18th century, French porcelain factories (Fig. 23-37, 23-38) open at S. Cloud, Chantilly, and Sèvres. Crown patronage ensures that France becomes the center for porcelain. For the luxury market, Sèvres, the premier factory, produces table and tea services, trays, bowls and covers, clock cases, vases, potpourri, and *candelabra*. It creates exquisite biscuit figures (unglazed) as part of dinner sets. The Sèvres factory uses rich ground colors, such as *rose Pompadour* (pink), *bleu de roi* (royal blue), and *vert pré* (green) with painted scenes and flowers and gilding. The factory makes hard-paste porcelain after 1768.

■ *Later Interpretations*. Rococo Revival (Fig. 23-39), originating in the 1830s, features cabriole and reverse cabriole legs and naturalistic carving. Pieces are heavier in scale and more complicated in silhouette than the originals. Furniture incorporates new manufacturing processes such as lamination. Toward the end of the 19th century, Art Nouveau (Fig. 23-40) borrows curves, light scale, and feminine qualities from Rococo. Also during this time, more accurate imitations of Louis XV furniture begin appearing. Reproduction and adaptations of Louis XV furniture continue today (Fig. 23-41).

24. English Neo-Palladian and Georgian

1702–1770

In studying a design of Palladio's, which we recommend to the young architect as his frequent practice, let him think as well as measure. Let him consider the general design and purpose of the building, and then consider how far, according to his own judgment, the purpose will be answered by that structure. He will thus establish in himself a custom of judging by the whole as well as the parts; and he will find new beauties in the structure considered in this light.

Isaac Ware, *Complete Body of Architecture*, 1756

24-1. Costume.

With the accession of George I to the English throne in 1714, members of the Whig party appoint themselves arbiters of taste for the nation. Believing that rational, correct, and polite should define English architecture, they promote Neo-Palladian as the only proper style. The style also becomes a visual metaphor for the owner's culture and education. Inside homes, classical architectural elements adorn rooms, display the owner's refinement, and highlight the collections acquired on grand tours. By mid-century, classicism coexists with Rococo, Chinese, and Gothic influences in interiors and furniture.

HISTORICAL AND SOCIAL

During the 18th century, Britain acquires most of its vast empire. Her navy rules the seas, and she establishes industrial supremacy, yet the period is relatively stable and prosperous. Queen Anne, the last of the Stuarts, rules from 1702 to 1714. She has little interest in government, art, literature, or the theater, and governs through advisors. At her death she leaves no heirs. Although others are closer in line, the Act of Settlement, passed in 1701, requires that the throne go to Anne's nearest Protestant relative, either Electress Sophia of Hanover, Germany, or Sophia's son, George Lewis. The act, designed to prevent the return of the Catholic, pro-French Stuarts, results in George Lewis ascending the throne.

The Georgian period encompasses the reigns of George I (1714–1727), George II (1727–1760), and the first years of George III (1760–1820). George I speaks little English and has no interest in either governing or artistic patronage. Unpopular largely because of a dissolute private life, he often returns to Hanover for long periods.

George II, as boorish as his father was, can at least speak English. Like others of his family, he is not interested in art and prefers Hanover to England. However, he shrewdly chooses ministers who bring prosperity to the country. George III succeeds to the throne in 1760. Unlike his two predecessors, he develops an interest in ruling the country where he was both born and educated. In the first years of his reign, he regains many of the powers that the Whigs had taken. In 1770, George III appoints as prime minister Frederick North, Second Earl of Guilford, whose policies provoke the American Revolution.

England's American colonies increase in number and wealth, and she gains power, prestige, and territory in a series of wars. The treaty ending the War of the Spanish Succession gives England French territories north of Hudson Bay, Nova Scotia, and Newfoundland. It also expands limited trade with Spain's American colonies. At the end of the French and Indian War in 1763, England owns Canada, French holdings east of the Mississippi, and Spanish Florida in America, as well as India in the Far East.

404

With the accession of George I, the Whig party comes into and remains in power for nearly 50 years. Merchants, industrialists, landed but untitled gentry, and Protestant dissenters back the party, which shifts power to the landed nobility. Among Whig concerns is a national architectural style that exhibits no qualities associated with the Stuarts, Catholicism, and almost anything foreign.

The importance of education and culture increases during the period. Grand tours are fashionable for young English gentlemen. These extended visits to the Continent enable them to complete their educations and further develop gentlemanly qualities. As they travel and study, they also collect art, manuscripts, coins, and the like. Collecting, which requires leisure, knowledge, and money, is part of the 18th-century image of the educated and cultured man. An important component of this education is a knowledge of architecture and design. Gentlemen frequently are as learned as the trained architects they hire to build their homes. Thus, the grand Neo-Palladian country house becomes a visual metaphor for the culture and education of the owner and a symbol of his wealth and power.

on antiquity, and has nationalistic associations. Two books published in 1715 help promote the style, *Vitruvius Britannicus* by Colen Campbell, a record of classical buildings in England, and an English version of Palladio's *I quattro libri dell'architettura*. The great Neo-Palladian patron, Sir Richard Boyle, Earl of Burlington and Earl of Cork, and his protégé, William Kent, also help define its form. Architectural treatises that increase in number after 1720s emphasize honesty of design, primacy of proportion, and harmony of the whole. Neo-Palladian classicism defines grand and lesser interiors until mid-century when Rococo, Chinese, and Gothic elements appear. As no interiors actually designed by Palladio are known, stylistic elements derive from Vitruvius, Inigo Jones, and the Baroque style.

In the 1730s, artists, writers, and dilettantes rediscover England's medieval past and deem it worthy of emulation, although many others regard it as inferior to Classicism. A few structures are built or remodeled in a style that becomes known as Gothic Revival, most notably Strawberry Hill, home of Sir Horace Walpole. In landscapes, newly created Gothic ruins coexist with classical ones to create picturesque views.

CONCEPTS

According to members of the Whig party, correct architecture is one of common sense and good taste. Consequently, they encourage not the Baroque classicism of Sir Christopher Wren, Nicholas Hawksmoor, and John Vanbrugh, but the Renaissance classicism of Andrea Palladio and, more important, the Englishman, Inigo Jones. Neo-Palladianism, which dominates residential buildings of the period, appeals because it is rational yet flexible, is based

24-2. *Marriage a la Mode II*, 1743; painting by William Hogarth.

DESIGN CHARACTERISTICS

Forms and elements of Neo-Palladian architecture derive from, but do not copy, Vitruvius, Palladio, or Inigo Jones. Elements and ornamentation are classical, and compositions are symmetrical, horizontal, and feature classical repose. Each decorative element serves a constructional or aesthetic purpose. Gothic details, such as pointed arches, battlements, and tracery, on contemporary buildings characterize the early Gothic Revival period. Elements often follow a classical arrangement, but with an honesty and flexibility in design.

The somber classicism of the late 17th century continues in interior design until Neo-Palladianism overcomes it about 1715. Characterized by classical architectural details, monumental proportions, and rich finishes and materials, Neo-Palladian interiors are some of the finest created in England. Readily adaptable, the style soon appears in smaller houses and interiors. About mid-century, French Rococo, Chinese, and Gothic Revival details begin to mix with classicism.

Similarly, furniture follows several styles and influences during the period. Queen Anne, the earliest style, continues Anglo-Dutch traditions in simplicity and curvilinear forms. Early Georgian style, which features several substyles based on ornamentation, transitions from the attenuated, plain Queen Anne style to the low, broad, carved Chippendale style. The furniture of William Kent, an important Early Georgian designer, mixes Baroque and classical elements. As in interiors after mid-century, the

furniture of Chippendale features classical, Rococo, Chinese, and Gothic elements.

■ *Motifs.* Classical architectural details (Fig. 24-2, 24-4, 24-5, 24-7, 24-8, 24-16), such as columns, pilasters, balusters, dentil moldings, and quoins, appear in architecture, interiors (Fig. 24-27, 24-30, 24-31, 24-32, 24-38), and furniture throughout the period. In Queen Anne furniture, motifs include shells and acanthus leaves (Fig. 24-50). Early Georgian furniture may feature swags, urns, eagles, cabochons (a gem shape or bead cut in convex form and highly polished), lion masks, satyr masks, and/or foliage. Motifs in furniture and interiors after mid-century (Fig. 24-35, 24-36, 24-52) include ribbons, leaves, shells, foliage, birds, pointed arches, quatrefoils, and tracery. *Chinoiserie* becomes popular and includes faux bamboo, Oriental figures, and pagodas (Fig. 24-39, 24-40, 24-53, 24-58, 24-60).

24-3. Mantel detail, Claydon House, 1757–1768; carving by Luke Lightfoot.

24-4. Venetian or Palladian window, from *The Designs of Inigo Jones* by William Kent.

ARCHITECTURE

Neo-Palladian becomes a national style in the first half of the 18th century. Almost exclusively domestic, the style defines numerous country houses and affects smaller dwellings and town houses. Symmetrical, geometric, and relatively plain, forms are simple; outlines are uncomplicated. Rules are closely observed, particularly for proportions, which derive from nature, antiquity, or the Renaissance. Distinctive and different from Italian examples are the undecorated walls or spaces around windows and the decorative elements that emphasize them. Other definitive characteristics include cube shapes, porticoes, temple fronts, Venetian or Palladian windows (tripartite windows composed of two rectangular lower sections flanking a taller arched center; Fig. 24-4), Diocletian or thermae windows (semicircular windows with two vertical mullions dividing them into three lights), and blocky quoins (corner blocks) surrounding windows and doors.

The number of Gothic-style buildings increases beginning in the 1730s. Early examples display Gothic details arranged in a classical manner with symmetry, careful articulation of parts, and classical proportions. A new phase of the Gothic style, somewhat more archaeologically correct,

24-5. S. Martin-in-the-Fields, 1721–1726; London; by James Gibbs. This church had great influence in America.

24-6. Christ Church, 1714–1729; Spitalfields, London.

begins in the late 1740s. Still Gothic only in details, elements are less rigidly arranged, and the style becomes infused with sentiment and nostalgia (Fig. 24-19). It remains outside the mainstream of architecture for residences during the period.

Private Buildings

- *Types.* Chief building types are country and town houses. Monumental country houses may be composed of several parts, while smaller ones, called villas, are simple rectangular blocks. Some public structures, such as banks, hospitals, and churches (Fig. 24-5, 24-6, 24-25), adopt Neo-Palladianism.

- *Site Orientation.* Gardens of the 18th century continue the formality and geometry of earlier years. William Kent introduces less formal designs that lead to picturesque compositions of winding paths, streams, and irregular plantings. By mid-century, in contrast with their orderly exteriors, country houses typically are sited within irregular and wild gardens with temples, pavilions, and Gothic "ruins" (Fig. 24-14, 24-18).

- *Floor Plans.* The typical rectangular block main house still dominates the site. Imitating the tripartite compositions of Palladio (Fig. 24-9), some larger examples may have wings with smaller dependencies (Fig. 24-11, 24-17). Large and small houses have either double-pile plans with halls running lengthwise or adapted Palladian plans. The integration of rectangular, square, oval, elliptical, and hexagonal spaces or rooms with apsial ends appears. Symmetry, the sequences of spaces, and the alignment of doors and windows are important planning considerations.

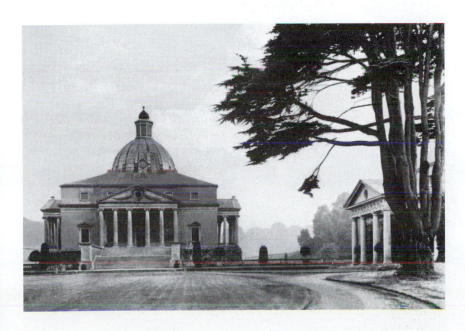

24-7. Mereworth Castle, 1723; Kent; by Colein Campbell.

Design Practitioners

■ *Richard Boyle*, Third Earl of Burlington, Fourth Earl of Cork, is the great promoter of Neo-Palladianism in England. A Whig leader, Burlington develops a passion for architecture and returns to Italy in 1719 with the intention of studying and gathering as much information as possible about Palladio. He purchases numerous drawings by Palladio and publishes them in 1739. While in Italy, he meets William Kent. Upon their return to England, Kent and Burlington strive to bring about a Renaissance in the arts and architecture. Burlington's own home, Chiswick, designed by him, is one of the most influential Neo-Palladian buildings.

■ *Colin Campbell* is a Scottish lawyer-turned-architect. Under the patronage of Scottish nobility, Campbell publishes *Vitruvius Britannicus*, a three-volume record of classical buildings in England that includes some of Campbell's own work. It becomes the standard for Neo-Palladian design.

■ *Thomas Chippendale* is a prominent cabinetmaker who markets his work in a trade publication entitled *The Gentleman's and Cabinet-Maker's Director*, first published in 1754. The book, which is the first to be completely devoted to furniture and lavishly illustrated, is enormously popular and influential, with a reprint published in 1775 and an enlarged version in 1762. Designs for all household furnishings illustrate Rococo, Chinese, and Gothic elements, and the book gives instructions for making items. Chippendale does not invent the styles depicted in his book, and it is unclear how many designs he created, but he capitalizes on current trends. There seems to be no documentation that he made or carved furniture.

■ *James Gibbs* is an architect who studies in Italy with Carlo Fontana, so he probably is better trained than many of his contemporaries. However, his Catholic faith limits official patronage. His work is more Baroque than that of others. Gibbs's church, S. Martin-in-the-Fields, has great influence in America as do his publications, *Book of Architecture* (1728) and *Rules for Drawing Several Parts of Architecture* (1732).

■ *John Baptist Jackson* is a prominent wallpaper designer and manufacturer. His work sets new standards for quality in design and product. He is known for his "*chiaro oscuro*" papers, which depict engraved landscapes or antique sculpture within curving Rococo borders in monochromatic grays.

■ *William Kent* is a prolific Neo-Palladian architect, interior designer, furniture designer, painter, and landscape architect. Kent studies in Italy and meets the Earl of Burlington. They form a lifelong partnership. Kent designs large Neo-Palladian mansions, interiors, furniture, and gardens for the wealthy with an emphasis on total unity. His designs exhibit great variety from chaste Neo-Palladian to Venetian Baroque to neo-antique designs adapted from Vitruvius or Inigo Jones.

■ *Matthias Lock*, a carver and designer of ornament, is one of the first to design and work in the Rococo style. Lock, along with Henry Copland, publishes several works of Rococo ornament before *The Director* appears. He also works for Chippendale and may be responsible for some designs in *The Director*. Lock is an early advocate of *Chinoiserie*.

Other Important Treatises

■ *Complete Body of Architecture*, 1756; Isaac Ware.

■ *Designs of Chinese Buildings*, 1757; Sir William Chambers.

■ *Designs of Inigo Jones*, 1727; edited by William Kent.

■ *Designs of Inigo Jones*, 1735; Isaac Ware.

■ *Designs of Inigo Jones and William Kent*, 1744; John Vardy.

■ *Gothic Architecture improved by Rules and Proportions, in many Grand Designs of Columns, Doors, Windows, Chimney-pieces, Arcades, Colonnades, Porticos, Umbrellos, Temples, and Pavillions etc.*, 1742; Batty Langley.

■ *Palladio Londinensis*, 1734; William Salmon.

■ *The Builder's Compleat Assistant*, 1738; Batty Langley.

■ *The Gentleman's or Builder's Companion containing Variety of Usefull Designs for Doors, Gateways, Peers, Pavilions, Temples, Chimney-Pieces, etc.*, 1739; William Jones.

■ *The Universal System of Household Furniture*, 1759–1762; John Mayhew and William Ince.

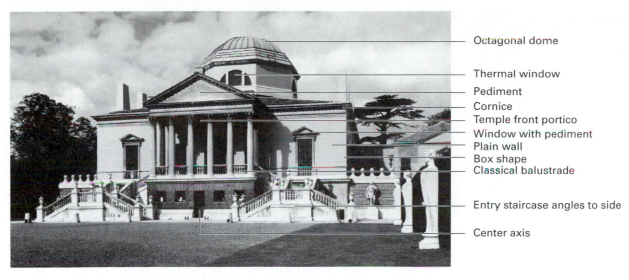

Octagonal dome

Thermal window

Pediment

Cornice

Temple front portico

Window with pediment

Plain wall

Box shape

Classical balustrade

Entry staircase angles to side

Center axis

24-8. Chiswick House, begun 1725; Chiswick; by Lord Burlington and William Kent.

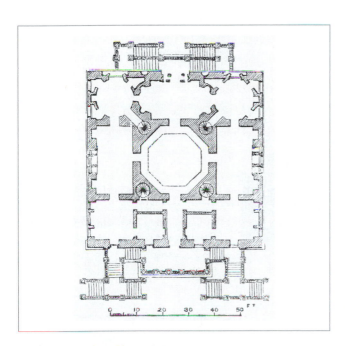

24-9. Floor plan, Chiswick House.

As before, plans are organized around the grand salon, hall (Fig. 24-31, 24-33), and suites of apartments. The stair hall (Fig. 24-30, 24-35) and saloon (Fig. 24-27, 24-34, 24-38) are usually on the main axis, flanked by other public rooms including a lavishly decorated dining room. In mid-century, a more circular arrangement of rooms and doorways around a stair hall replaces this arrangement. Larger and more numerous social gatherings dictate these more flexible plans in which stair halls become the main circulation space. Subsequently, top-lit oval or circular stairs become more important and replace other forms. The most important rooms are typically on the ground and first floors, which are emphasized by size and treatment on the exterior.

From the 1720s onward, designers treat urban row houses as one large Palladian-style structure. Town houses (Fig. 24-20, 24-22) are typically three stories high, one or more rooms wide, and two rooms deep. Kitchens, offices, and servants' quarters may occupy the basement or be in separate buildings. Drawing and dining rooms are usually on the first floor, as are bedrooms of important family members and the parlor or family room. Lesser family members' bedrooms are on the second floor. Servants sleep in the attic.

■ *Materials.* Structures are of brick, local stone, or stucco (Fig. 24-7, 24-8, 24-10, 24-15, 24-16). Early in the century, brick usually is red, but as higher firing temperatures become possible, its color varies from brown to gray, white, or cream. Lighter-colored bricks resemble stone. In the 1720s, facades begin to be stuccoed. Wood and metal portions, including sashes, sash frames, shutters, doors, and door cases, are painted in bold colors whose variety and hue depend on the owner's wealth. Less affluent homeowners primarily use greens, while the wealthy can choose off-whites, browns, grays, yellows, blues, and greens. Doors are a dark color, such as green, black, or red-brown, with a light-colored door case of wood or stone. Shutters, and sometimes sashes, are painted a dark color.

■ *Facades.* Facades (Fig. 24-7, 24-8, 24-10, 24-12, Color Plate 58, 24-13, 24-16, 24-21) are distinctive, having a temple front or pedimented portico at the center, Venetian or Palladian windows, and plain walls. Designers generally group windows, elements within porticoes, and other details in threes. They borrow or adapt facades and features from

Vitruvius, Palladio, Inigo Jones, and Colen Campbell. Entry staircases often angle to the side of the portico instead of leading directly up in the Roman/Palladian manner. Floors vary in size depending on their importance with first floors being the largest. Most openings are rectangular, rather than arched. String courses mark stories, and quoins delineate corners. A modillioned cornice generally separates roof and wall. Pediments and pilasters mark centrally placed doorways. In the 1720s, groups of row houses, treated as one composition emphasize their centers by a temple front. Gothic Revival structures (Fig. 24-19) feature towers, pointed arches, trefoils, stained glass, battlements, and other Gothic details symmetrically or asymmetrically arranged.

■ *Windows.* Most windows have uncomplicated surrounds, but some exhibit pediments, quoins, or arched tops (Fig. 24-7, 24-8, 24-10, 24-16, 24-21). Designers use Venetian or Palladian windows (tripartite windows with arched centers flanked by two lower rectangular lights; Fig. 24-4, 24-16) singly or in sequences after 1760. Some are within relieving arches (arches that are roughly constructed to ease excess weight). Diocletian or thermae windows usually highlight domes. Other windows are double hung. There are no standard sizes or dimensions for panes, but six-over-six or eight-over-eight panes are most common. Clearer, more expensive glass fills lower-story windows while thicker, less translucent glass is reserved for upper story windows. Most town house windows are plainly treated, but grander ones have pediments or lintels. Shutters accentuate many double-hung windows.

■ *Doors.* Neo-Palladian compositions (Fig. 24-13) of pilasters or columns and round or triangular pediments

24-10. West side, Houghton Hall, 1722–1726; Norfolk; by Colen Campbell or James Gibbs with various interiors by William Kent.

24-11. Floor plan, first floor, Houghton Hall, from *Vitruvius Britannicus*; Colen Campbell.

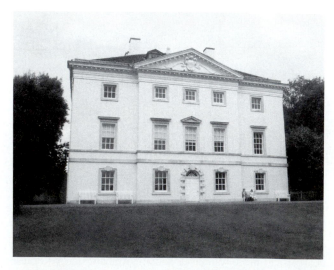

24-12. Marble Hill House, c. 1724–1729; Twickenham; by Lord Pembroke and Roger Morris. (Color Plate 58)

Important Buildings and Interiors

- **Bath:**
 - —The Circus, begun 1754, John Wood I.
 - —Queen Square, 1729–1736, John Wood I.
- **Buckinghamshire:**
 - —Claydon House, 1757–1768, carving by Luke Lightfoot.
 - —Stowe, gardens, 1732, William Kent.
- **Cambridge:** King's College, Fellows' Building, 1724–1730, James Gibbs.
- **Chiswick:** Chiswick House, begun 1725, Lord Burlington; Gallery, begun 1725, William Kent and Lord Burlington.
- **Hertfordshire:** Wrotham Park, 1754, Isaac Ware.
- **Kent:** Mereworth Castle, 1723, Colen Campbell.
- **London:**
 - —Christ Church, Spitalfields, 1714–1729.
 - —S. Martin-in-the-Fields, 1721–1726, James Gibbs.
 - —Spenser House, 1756–1765, John Vardy.
 - —Staircase, 44 Berkeley Square, London, begun 1742, William Kent.
 - —Wanstead House, 1713–1720, demolished 1822, Colen Campbell.
- **Norfolk:**
 - —Houghton Hall, begun 1722–1726, Colen Campbell or James Gibbs, Marble Parlour, 1733, William Kent, Saloon, c. 1730, William Kent, Stone Hall, 1722–1731, Colen Campbell or James Gibbs and William Kent.
 - —Holkham Hall, begun 1734, William Kent.
- **Oxford:** Radcliffe Camera, 1739–1749, James Gibbs.
- **Oxfordshire:**
 - —Ditchley, 1720–1722, James Gibbs.
 - —Kirtlington Park, 1741–1748, by James Gibbs and William Smith, interiors by John Sanderson.
 - —Rousham, gardens, c. 1730s, William Kent.
- **Surrey:** Clandon Park, 1715, Giacomo Leoni.
- **Twickenham:**
 - —Marble Hill House, c. 1724–1729, Lord Pembroke and Roger Morris. (Color Plate 58)
 - —Strawberry Hill, 1747, for Sir Horace Walpole.
- **Wiltshire:**
 - —Lacock Abbey, 1753–1755, Sanderson Miller.
 - —Stourhead, 1724, Colen Campbell.
 - —Wilton, Palladian Bridge, 1736, Lord Pembroke and Roger Morris.
- **York:**
 - —State Bedchamber, Nostell Priory, 1769–1770, redecorated by Thomas Chippendale.
 - —Assembly Rooms, 1731, Lord Burlington and William Kent.
- **West Yorkshire:** Harewood House, 1758, John Carr.

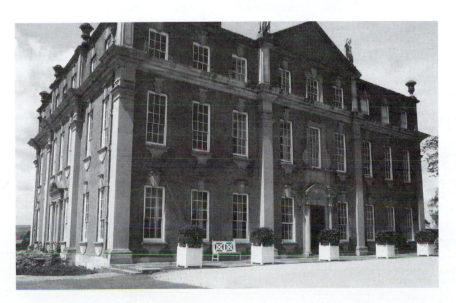

24-13. Mawley Hall, 1730; Shropshire; design ascribed to Francis Smith.

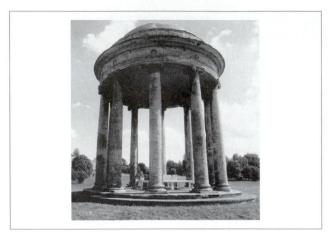

24-14. Temple in garden, Stowe, 1732; Buckinghamshire; by William Kent.

24-15. Entry Gate House, Holkam Hall, begun 1734; Norfolk; by William Kent.

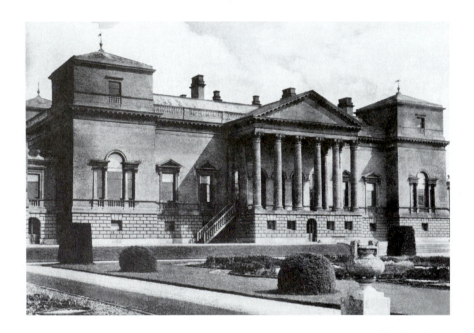

24-16. Holkam Hall, begun 1734; Norfolk; by William Kent.

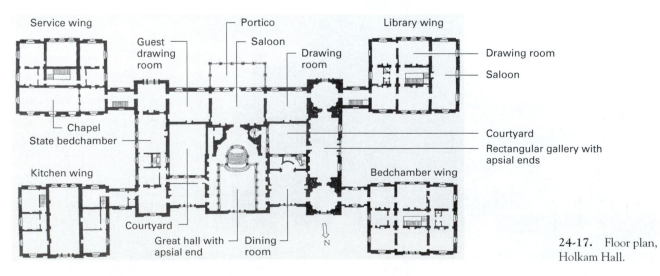

24-17. Floor plan, Holkam Hall.

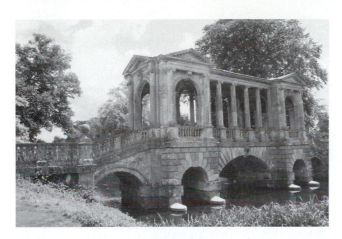

24-18. Wilton, Palladian Bridge, 1736; Wiltshire; by Lord Pembroke and Roger Morris.

replace more massive and ornament Baroque treatments. Fanlights (semicircular windows with radiating mullions), which allow light into the hall, appear in the 1720s. Doors themselves have raised or recessed panels; six is a typical number for panels. Pattern-book authors give complicated proportional systems for door paneling. Door fittings and knobs are of cast iron.

■ *Roofs.* Neo-Palladian roofs are low-pitched hipped or flat with balustrades (Fig. 24-16, 24-21). Centers or ends of compositions sometimes are domed (Fig. 24-7, 24-8). Gothic style roofs (Fig. 24-19) pitch steeply and may have battlemented parapets and towers with conical roofs.

■ *Later Interpretations.* Neo-Palladian examples are popular in 18th-century America (Fig. 24-23), but are rare in the 19th century. Palladian elements, such as temple

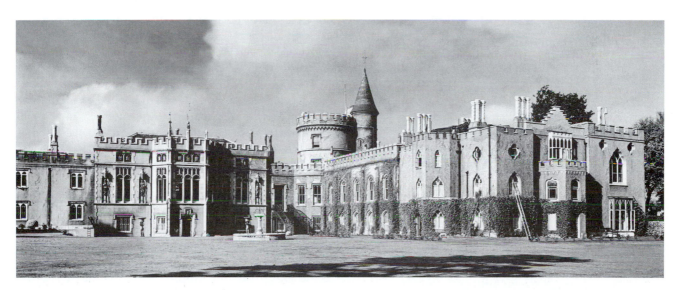

24-19. Strawberry Hill, 1747; Twickenham; for Sir Horace Walpole.

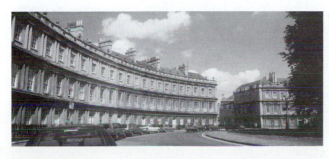

24-20. The Circus, begun 1754; Bath; by John Wood I.

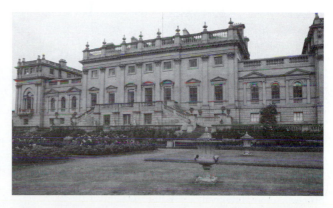

24-21. Harewood House, 1758; West Yorkshire; by John Carr.

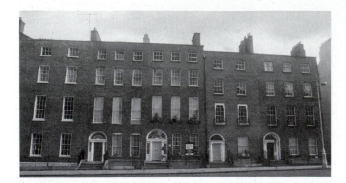

24-22. Town houses, mid-18th century; Dublin, Ireland.

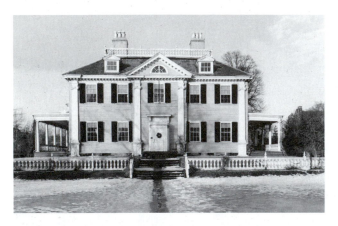

24-23. Later Interpretation: Vassall-Longfellow House, 1759; Cambridge, Massachusetts; American Georgian.

24-24. Later Interpretation: West Virginia State Building, World's Columbian Exposition, 1893; Chicago, Illinois; by J. S. Silsbee; Colonial Revival.

fronts, are common in American Colonial Revival (Fig. 24-24) or English Victorian Queen Anne. An occasional house, particularly in the country, may model Neo-Palladian ideals. A number of English and American architects during the mid- to late 20th century design in the Palladian manner.

INTERIORS

Interiors continue 17th-century traditions until the advent of Neo-Palladianism about 1715. In contrast to the chaste exteriors, Neo-Palladian interiors are elaborately decorated with classical and Baroque elements. Proportions are monumental, materials rich and costly, colors bold, and furniture massive. Classical details abound, placed over and around doors and windows, on ceilings or walls, and at the chimneypiece. Designers borrow elements and ornamentation from antique models, Palladio, Inigo Jones, and Venetian Baroque. They sometimes attempt to create an antique look using assemblages derived from ancient or Renaissance sources. William Kent is the leading designer of interiors and furniture for Neo-Palladian houses.

Large or elaborate Palladian elements are easily simplified for smaller homes, and pattern books contain illustrations of staircases, chimneypieces, paneling, doors, and windows. Consequently, numerous middle-class houses and interiors in Britain and America adopt classically derived elements throughout the period. By mid-century, French Rococo, Chinese, and Gothic forms and motifs appear on walls, ceilings, chimneypieces, textiles, wallpapers, and furniture. English Rococo, more conservative than the French, appears mainly as ornamentation instead of form in both interiors and furniture. Similarly, a Chinese influenced ornament often appears in rooms in which tea is taken. Unlike the Rococo and Chinese styles, the Gothic style begins as an architectural style before appearing in interior details and furniture. Applying Gothic elements to the latest rooms and furniture, designers do not attempt to revive medieval models and construction methods. Rococo ornamentation mixes freely with Chinese and Gothic ornamentation, and some houses feature each public room in a different style.

Designers carefully calculate proportions of rooms, chimneypieces, door and window surrounds, and other details with complex formulas given by the masters or derived from antique models. Spaces often take the form of a single or double cube or a cube and a half. Rooms are decorated according to their significance; the more important the room, the larger the scale and the more extravagant its decoration. The most lavish spaces are state apartments, reception rooms, and saloons, which reflect a formal way of life.

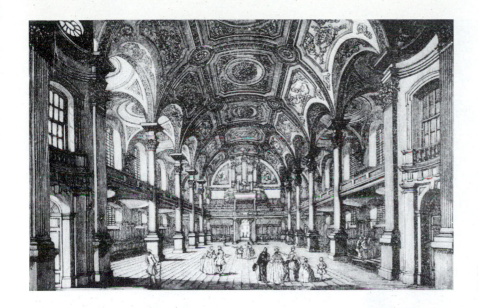

24-25. Nave, S. Martin-in-the-Fields, 1721–1726; London; by James Gibbs.

24-26. Staircase detail; Chichester.

Private Buildings

■ *Types.* With more emphasis on culture and learning, collectors display their assemblages in galleries or the traditional closet, and libraries become more common. By mid-century, stair halls (Fig. 24-30, 24-35) and staircases (Fig. 24-26) are important design elements, and dining rooms are becoming prevalent.

■ *Relationships.* In contrast to plainer exteriors, interiors are sumptuous with particular attention given to circulation areas, reception rooms, saloons, chimneypieces, ceilings, and furnishings.

■ *Color.* In the early 18th century, color unifies rooms. Moldings and other details match walls, except in great houses where they are sometimes gilded. By the 1720s, lighter hues, particularly white, replace earlier dark colors. A Neo-Palladian ideal is classic simplicity. Inside, this translates into light- or stone-colored walls (Fig. 24-31)

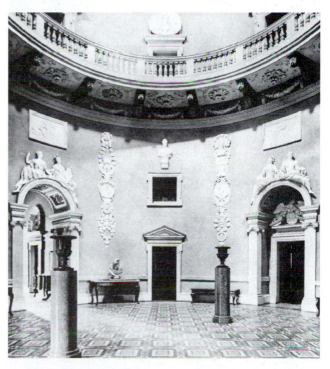

24-27. Saloon, Mereworth Castle, 1723; Kent; by Colen Campbell.

that clearly reveal proportions and architectural details in the manner of Inigo Jones. Most houses have at least one important room treated in this way.

As the period progresses, numerous colors in various intensities and values become available. Typical colors include pea green, olive green, gray green, gray, sky blue, straw yellow, and a variety of gray or brown stone colors.

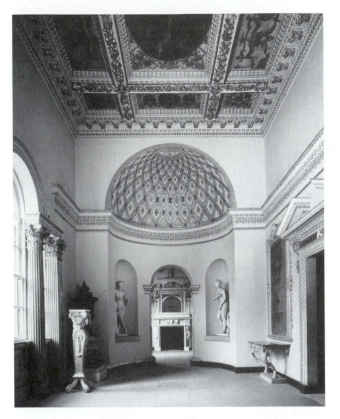

24-28. Gallery, Chiswick House, begun 1725; Chiswick; William Kent and Lord Burlington.

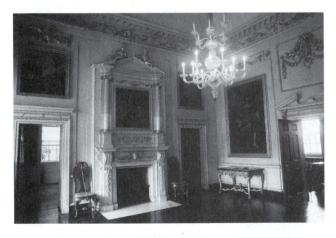

24-29. Drawing Room, Marble Hill House, 1724–1729; Twickenham; Lord Pembroke and Roger Morris.

People consider stone colors most appropriate for halls and stronger colors appropriate for other rooms. Reds and greens commonly distinguish libraries and dining rooms. Sometimes the color selection relates to the particular stylistic influence, such as brown for Gothic (Fig. 24-36) and rose for Rococo. Graining and marbling diminish as the

Design Spotlight

Architecture: *Chiswick House.* Designed by Lord Burlington and William Kent, this country villa (Fig. 24-8, 24-9, 24-28) outside of London imitates and adopts the image, proportions, and axial alignment of the Villa Rotunda by Palladio. A temple-fronted Corinthian portico, and symmetrically angled staircases to either side of it, define the main entry. Blank walls emphasize the pedimented windows. Unlike the Villa Rotunda, the portico does not repeat so all four sides are different in design. On the rear, Burlington copies Palladio's drawings of Venetian windows set within relieving arches to enliven the plain facade. Unlike Italian examples, tall chimneys shaped like obelisks highlight the roofline. The square plan develops around a central octagon topped by a dome with thermae windows (derived from those in Roman baths). Square, rectangular, and circular rooms are symmetrically grouped around the central space. Door and window openings evidence a formal alignment; there are only a few hallways. The interiors copy the designs of Inigo Jones, most notably in the architectural features. The gallery, facing the rear garden, is a long room with apsidal ends, a concept that appears later in the work of British architect Robert Adam.

Design Spotlight

Interiors: *Stone Hall, Houghton Hall.* This country house (Fig. 24-10, 24-11), designed by Colen Campbell or James Gibbs and embellished by William Kent, establishes the wealth of the owner Sir Robert Walpole and is one of the most important houses of its time. The Stone Hall (Fig. 24-31), a grand entry space, imitates the classical character of the hall in the Queen's House in Greenwich by Inigo Jones. Developed as a 40-foot cube, it features symmetrical alignment of the chimneypiece, large doors, and niches. Important architectural features include the elaborate *aedicula* surrounding the doors and niches, the second floor classical balustrade with supporting brackets, and the Baroque-style ceiling. The cream colored walls, mahogany doors, and black and white marble tile floor are all characteristic of the period.

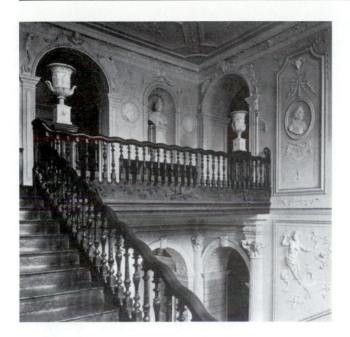

24-30. Stair Hall, Mawley Hall, 1730; Shropshire; design ascribed to Francis Smith.

period progresses. Doors and baseboards are painted brown or black to hide wear.

■ *Lighting.* Artificial lighting, generally minimal, comes primarily from fireplaces, rushlights, or candles; oil lamps are rare before the 1780s. Interiors are dark at night compared to those of today. Candles are difficult to make at home and those purchased of beeswax are expensive. Since wicks must be trimmed constantly, most people use only a few tapers except when entertaining. Lighting fixtures (Fig. 24-43, 24-46) include candlesticks, candelabra on

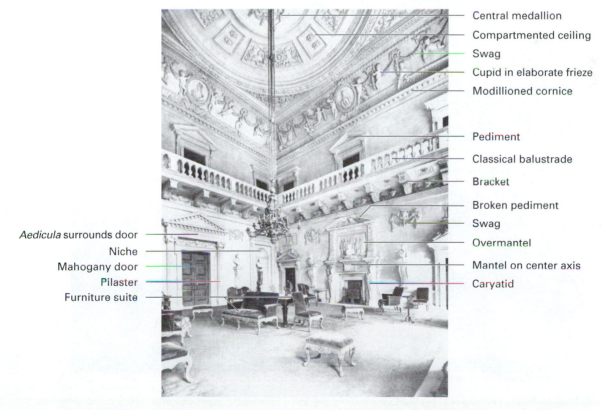

Central medallion
Compartmented ceiling
Swag
Cupid in elaborate frieze
Modillioned cornice

Pediment
Classical balustrade
Bracket
Broken pediment
Swag
Overmantel
Mantel on center axis
Caryatid

Aedicula surrounds door
Niche
Mahogany door
Pilaster
Furniture suite

24-31. Stone Hall, Houghton Hall, begun 1722–1731; Norfolk; by Colin Campbell or James Gibbs and William Kent.

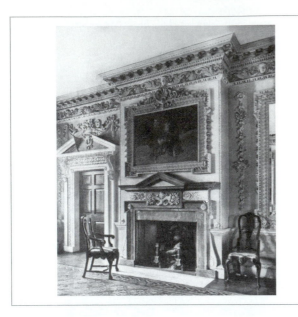

24-32. Chimneypiece, Drawing Room, Godmersham Park, c. 1732; Kent.

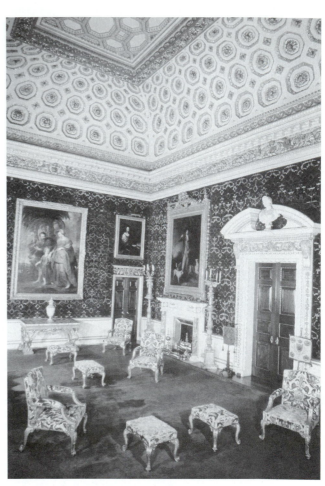

24-34. Saloon, Holkam Hall. (Color Plate 59)

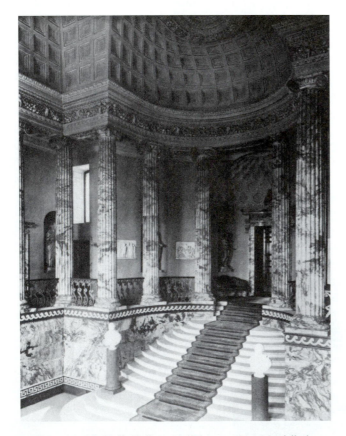

24-33. Marble Hall, Holkam Hall, begun 1734; Norfolk; by William Kent.

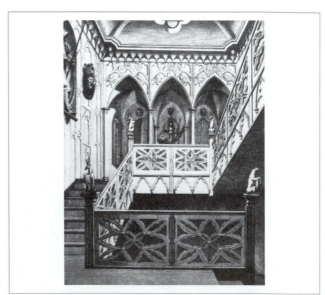

24-35. Stair Hall, Strawberry Hill, 1747; Twickenham; for Sir Horace Walpole.

side tables, and/or branches (wall sconces). To multiply light, candles sit in front of mirrors, and sconces have mirrored backs. Shiny textures and glossy finishes also reflect and increase light. After 1730, chandeliers of glass, wood, or metal are available, but remain rare in most homes. Those of glass are preferred for their reflecting qualities. Servants wrap these items of conspicuous consumption in fabric when not in use to protect them.

■ *Floors.* Typical floor materials are wood or masonry. Oak, pine, or fir board floors have random dimensions. Wood floors are not varnished, but scrubbing them with sand or limewash produces a silvery sheen. Parquet enhances the grandest rooms. Paint, in solids or patterns, disguises cheaper woods. Stone and marble floors (Fig. 24-27) are limited to entrances and ground-floor rooms because of their weight. They follow a variety of geometric patterns and colors, but black and white or grays are especially favored.

Painted floor cloths gain importance during the period; black and white marble patterns are preferred. Carpet becomes more common during the 18th century. Brussels carpet (loop-pile carpet) is first woven in 1735 at Kidderminster and Wilton in 1740. Kidderminster also introduces ingrains and list carpet (carpet with strips of cloth, ingrain,

or selvages of fabric forming weft threads). Piled carpet appears in most rooms and on stairs. Ingrains (an American term for flat-woven carpet with a reversible pattern), considered utilitarian, are reserved for halls and servants' quarters. Drugget (a wool or partly wool fabric) of baize, serge, or haircloth protects carpets in wealthy homes or serves as floor coverings in humble ones. Other floor coverings include Oriental rugs (Fig. 24-43) and reed, cane, or rush matting.

■ *Wall Paneling.* Paneling (Fig. 24-29, 24-37, 24-43), which is generally painted, remains a favorite wall treatment. Most panels are rectangular and recessed, but those in wealthy homes are often raised. Narrow panels flank wider ones, and paintings and pictures hang in the centers. Important rooms have elaborate moldings that are often gilded. Egg and dart is characteristic for dadoes and cornices although the dado molding may feature the *guilloche* (overlapping circular forms) or Vitruvian scroll (wave pattern). Grand rooms (Fig. 24-34, Color Plate 59) have deep and elaborate cornices with dentils or modillions. Occasionally, paneling incorporates shelves, semicircular cupboards with shell-shaped tops or niches, which reflect the passion for antique collectibles.

■ *Other Wall Treatments.* By mid-century, completely paneled walls are no longer fashionable. Instead, the wall over the paneled dado is painted, papered, or hung with fabric glued to the wall (Fig. 24-34, Color Plate 59, 24-38). Wall fabrics include damask, velvet, painted or patterned silk, tapestry, and needlework. As an alternative to paneling, walls may have elaborate plasterwork details (Fig. 24-27,

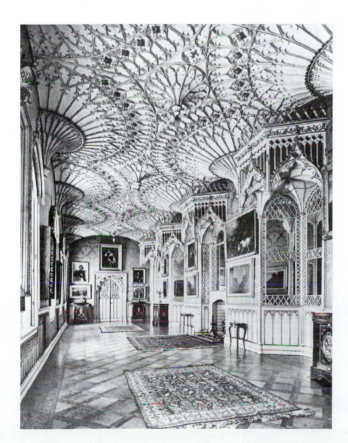

24-36. Long Gallery, Strawberry Hill.

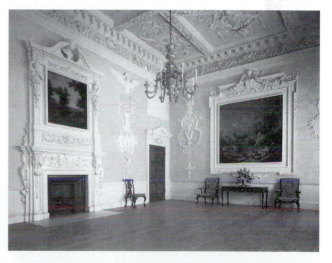

24-37. Dining Room, Kirtlington Park, 1741–1748; Oxfordshire; by James Gibbs and William Smith, interiors by John Sanderson. [Wood, plaster, marble. L. 36'; W. 23' 11"; H. 20' 3". The Metropolitan Museum of Art, Fletcher Fund, 1931. (32.53.1). Photograph © 1996 The Metropolitan Museum of Art]

24-30, 24-32, 24-36, 24-41) that may be classical, Rococo, Chinese, Gothic, or a combination.

Wallpaper begins to appear in public and reception rooms during the period. Made of shredded rags, the thick and heavy paper comes in squares, which are matched and glued on the wall. Eventually, rolls, which are easier to hang and allow larger repeats, replace squares. Backgrounds are color-washed by hand, and patterns hand blocked. Types include flocked papers imitating cut-piled fabrics, architectural papers, papers incorporating prints or antique statues, and simple repetitive patterns. Although expensive, hand-painted Chinese or "India" papers also are popular, so English manufacturers soon produce imitations of them. English wallpapers are exported to America and France.

■ *Chimneypieces.* The chimneypiece (Fig. 24-29, 24-31, 24-32, 24-37, 24-38, 24-43, 24-45) is the focal point of the interior; following Inigo Jones and others, it usually has two tiers. The lower mantel boldly projects into the room and incorporates a variety of classical motifs including caryatids, columns, and consoles as well as the ear motif (Fig. 24-32). Chimneypieces are of plaster, wood, and marble or scagliola (imitation marble) in white, black, gray, and sometimes other colors. In the 1740s, Rococo, Chinese, and Gothic motifs ornament chimneypieces. Above the mantel is a solid or broken pediment with carved or plaster details, such as masks, rosettes, or swags. A painting or chimney glass (horizontal mirror usually in three parts) may hang over the mantel.

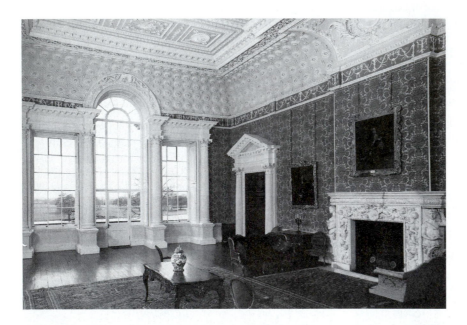

24-38. Saloon, Claydon House, 1757–1768; Buckinghamshire; carving by Luke Lightfoot.

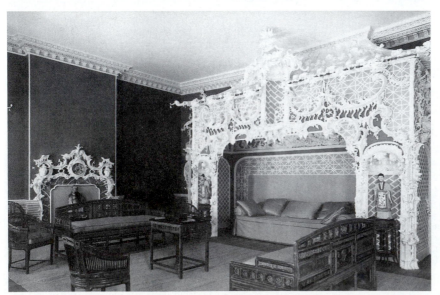

24-39. Chinese Room, Claydon House. (Color Plate 60)

■ *Staircases.* Staircases (Fig. 24-26, 24-30, 24-33, 24-35) are impressive architectural features. Those on important floors are wider with more elaborate ornamentation. Imported mahogany is stained, while lesser woods are painted. Steps have three slender, columnar balusters per tread and feature carving on tread ends. Chinese fretwork and Rococo and Gothic details appear at mid-century. As stairs ascend to upper floors, balusters become plainer, and steps narrower.

■ *Windows.* Double-hung windows are typical. Venetian or Palladian windows, pediments, and other architectural details highlight windows (Fig. 24-28, 24-38) in important rooms; others are plain. Sashes are painted white. Most windows have internal shutters in two or three sections that match the paneling. Some recess into shutter boxes inside the jamb. Roller and venetian blinds help block light, but work poorly. Grand houses have curtains of luxurious materials, while others use white or undyed cotton, wool, or linen. Festoons and side panels are the most common window treatments. Festoons, made of light fabrics, hang high above the window to let in as much light as possible when raised. Tassels adorn operating cords. In grand rooms, windows may be topped with wood that is carved and elaborately painted.

Design Spotlight

Interiors: *Chinese Room, Claydon House.* Home to the Verney family, this house boasts a series of rooms designed in different historic influences including Neo-Palladian (Fig. 24-38), Rococo, Gothic, and Chinese. This extraordinary room (Fig. 24-39, 24-40, Color Plate 60) is the work of master carver and decorator Luke Lightfoot, who was most likely inspired by books on Chinese designs. The alcove is richly ornamented with carved *Chinoiserie* decoration that features a pagoda image, niches with Oriental statues, and elaborate latticework. The latticework repeats around the room as a dado. Door surrounds are equally ornate with Chinese heads and intricate carving, and door panels feature fretwork. The blue-green walls are a popular Chinese color. The bamboo furniture from Canton is sympathetic to the space, but dates to about 1800.

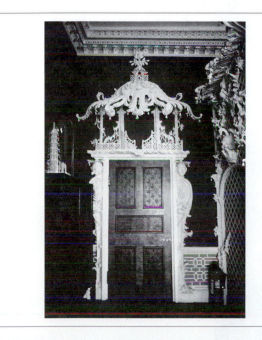

24-40. Detail of carved woodwork, Chinese Room, Claydon House.

24-41. Stuccowork, Russborough House, c. 1730; Ireland. (Copyright Dorling Kindersley. Photographer Joe Cornish)

■ *Doors.* Doorways to important rooms often have *aedicula* (frame composed of columns or pilasters carrying an entablature and pediment) and are symmetrically situated (Fig. 24-28, 24-31, 24-32, 24-38). Most doors have six or eight mahogany panels with carved and gilded moldings. Surrounds typically incorporate classical details, often feature the ear motif, and may be painted white. Open doorways (Fig. 24-27, 24-30) may have pilasters flanking the opening and an arch above. William Kent's designs often display a bust in a broken pediment above the door (Fig. 24-34). After mid-century, Gothic, Rococo, or *Chinoiserie* motifs (Fig. 24-36, 24-40, 24-44) may embellish the door as well as the overdoor treatment.

■ *Textiles.* Textiles increase in use during the period as new inventions, such as the flying shuttle and spinning jenny, increase the speed of production, produce a better product, and lower costs. Despite ongoing battles between English cotton manufacturers and importers of India cot-tons, printed cottons (calicoes or chintz) become more fashionable during the period. *Toiles* (which feature engraved decorations in blue, red, purple, or sepia on a light background) are first manufactured in Drumcondra, Ireland, in 1752, using copper plates. This type of printing allows larger and more defined repeats.

■ *Ceilings.* The cove and compartmentalized plasterwork ceilings of Inigo Jones return to fashion in grand homes (Fig. 24-28, 24-30, 24-31). Alternative treatments are coffers and paintings, often called mosaic ceilings (Fig. 24-28, 24-33, 24-34). Others feature Rococo, Chinese and/or Gothic motifs (Fig. 24-36, 24-42, 24-43). Ceilings in lesser rooms and lesser houses typically are flat and painted white or cream.

■ *Later Interpretations.* Neo-Palladian details, such as pediments or overmantels, often appear together in later interiors. This is particularly evident in 18th-century

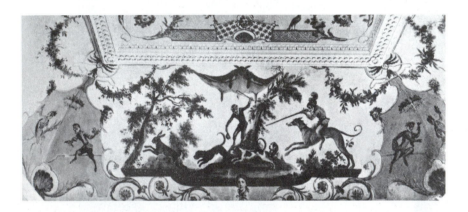

24-42. Typical *singerie* motif.

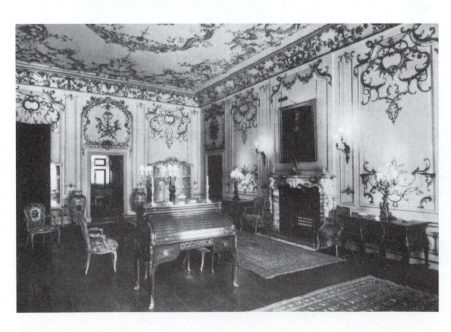

24-43. Drawing Room, Chesterfield House.

American Georgian interiors (Fig. 24-47) and those of the early-20th-century Colonial Revival period (Fig. 24-48) that copies 18th-century American houses. A few architects continue through the 20th century to design based on the concepts of Palladio.

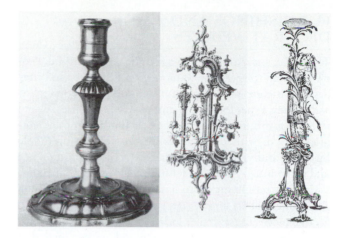

24-46. Lighting fixtures: Candlestick, *girandole*, lamp stand.

24-44. Doorway detail, Rococo influence.

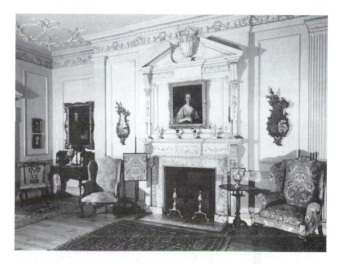

24-47. Later Interpretation: Drawing Room, Powel House, 1767; Philadelphia, Pennsylvania; American Georgian.

24-45. Chimneypiece, Rococo influence.

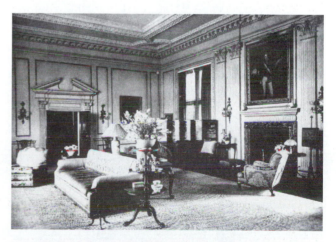

24-48. Later Interpretation: Living Room, Charles H. Sabin House, early 20th century; Long Island, New York; by Cross and Cross Architects; Georgian Revival.

FURNISHINGS AND DECORATIVE ARTS

The 18th century is a golden age in English furniture. People are able to spend more money on furniture, and they demand higher standards in craftsmanship and comfort, as well as new types for special purposes. In response, several styles of furniture rapidly succeed each other in the Georgian period, with cabinetmaking becoming a profitable business. Individual cabinetmakers achieve prominence and move into a higher social status. Thomas Chippendale is the first cabinetmaker to have a style named after him. As cabinetmakers do not sign their pieces, it is difficult to ascribe pieces to particular individuals or firms. Authenticated pieces have a well-documented provenance that includes written records such as bills of sale.

Private Buildings

■ *Types.* Typical furniture pieces include chairs, sofas, tables, secretaries, high chests of drawers (tallboys), dressing tables, tall case clocks, fire screens, and beds. Card tables are introduced during Queen Anne's reign, and their numbers increase with the popularity of card playing. Additional new pieces include more forms for tea tables, extension dining tables, and commodes.

■ *Queen Anne (1702–1714).* Continuing the Dutch traditions of the William and Mary style, the Queen Anne style relies on silhouette and wood grain for beauty rather than applied decoration. English examples are relatively plain,

but comfortable and human in scale. Curves dominate forms, and proportions are slender and elongated. Chairs (Fig. 24-49), which are the definitive piece, feature a plain crest with curving details and an open spoon-shaped (inward curve) back to fit the body. They have a solid splat (vertical member of a chair back that can be an indicator of style) in vase, fiddle, or parrot profiles. The seat may be trapezoidal or curving. The slender and graceful cabriole legs may have stretchers and a shell sometimes combined with acanthus on the knee. Legs terminate in pad, club, or hairy paw feet.

■ *Baroque and William Kent (1710–1750).* Following the lead of flamboyant architect and designer William Kent, designers turn to English and Venetian Baroque prototypes; Neo-Palladian influences begin appearing in architectural details. Since neither Palladio nor Inigo Jones designed furniture, designers have no precedents to follow. Kent's massive, elaborate designs (Fig. 24-54, 24-57) are limited to large, wealthy houses. He designs a full range of

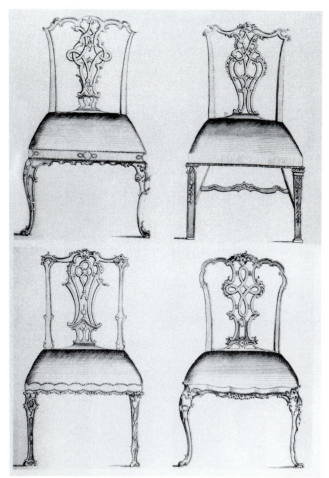

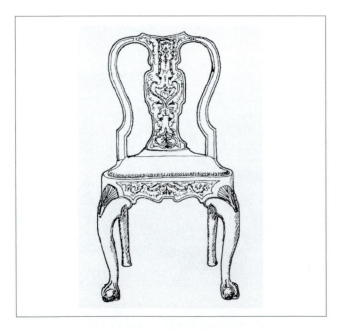

24-49. Queen Anne side chair in walnut, c. 1700.

24-50. Parlor side chairs.

furnishings, but prefers side and pier tables with marble tops and scrolled legs or single supports in a classical shape. His favorite motifs are the shell, double shell, Vitruvian scroll, masks, swags, lions, dolphins, and brackets. Grand pieces are gilded. Kent furnishings dominate their interiors and show architectural emphasis.

■ *Early Georgian (1714–1750).* This style marks a transition from the Queen Anne to the Chippendale style. Queen Anne forms continue but with more embellishment early in the period. Under Neo-Palladian influence, furniture becomes more massive, and case pieces (bookcases, desks) incorporate architectural details such as columns and pediments. Early Georgian chairs feature a more embellished Queen Anne form with marquetry; gilding; lacquer; and more carving on splats, knees, and seat rails.

Design Spotlight

Furniture: *Chippendale Chair.* Perhaps one of the most popular pieces of furniture ever made, this chair (Fig. 24-51) derives from Chippendale's *Director.* It has a rectangular back with cupid's bow crest ending with ears, a ribboned splat, cabriole legs with ball and claw feet, and elaborate carving. The intricate detailing is characteristic of English furniture. Typically made in mahogany, the chair is an elegant example of mid-18th-century fashion evident in large country houses. It was widely copied, subsequently appearing in the developments of the American Georgian and Colonial Revival periods, as well as being widely reproduced today.

Proportions become lower and broader than in the Queen Anne period, and splats begin to feature open or pierced carving. Cabriole legs are wider and less elongated. Common details include lion masks, satyr masks, eagle head, dolphins, and late in the period, Rococo influences. The Windsor chair with its splayed legs, saddle seat, and hooped back with slender spindles appears during this period.

■ *Chippendale (1750–1770).* Continuing the Early Georgian form, this furniture style (Fig. 24-50, 24-51, 24-52, 24-53) features Rococo, Chinese, and Gothic influences. Rococo influence mainly appears in carved decoration such as flowers, shells, and ribbons. Chinese influence appears in motifs such as pagodas, bamboo, and bells. Gothic influence manifests in motifs such as cluster column legs, pointed arches, and tracery. Thomas Chippendale's book *The Gentleman's and Cabinet-Maker's Director* of 1754 illustrates, but does not originate, the style that bears his name.

Chippendale chairs have serpentine crests (a concave, convex, concave form that curves down to meet back uprights) or cupid's bow crests (a double ogee curve whose ends turn up into ears). Crests and splats display Rococo, Gothic, and/or Chinese motifs. Some Chinese Chippendale chair backs feature fretwork with no splat. Stretchers, legs, arms, seat rails, and tabletops may have open or solid fretwork (interlaced ornamentation usually geometric) in Chinese examples. Arms and legs sometimes imitate bamboo (Chinese) or cluster columns (Gothic). Feet include pad, club, ball and claw, French whorl, and block. Legs may be straight or cabriole. *The Director* does not illustrate ball and claw feet.

■ *Relationships.* Furniture arrangements support room function, with an emphasis on formality, customs, harmony, and integration. Symmetry is important in the placement of major pieces of furniture. The finest furniture occupies

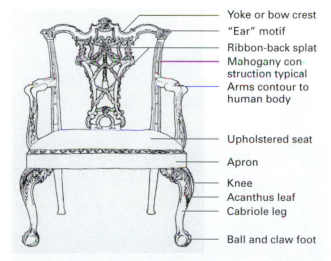

Yoke or bow crest
"Ear" motif
Ribbon-back splat
Mahogany construction typical
Arms contour to human body

Upholstered seat

Apron

Knee
Acanthus leaf
Cabriole leg

Ball and claw foot

24-51. Armchair with ribbon-back, Chippendale-style, c. 1755.

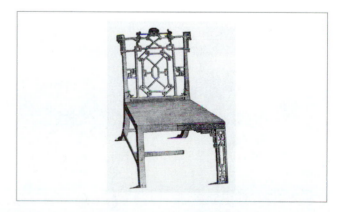

24-52. Side chair, Chinese-style, published in Chippendale's *The Gentleman's and Cabinet-Maker's Director,* 1754.

the best drawing room, and is arranged around the perimeter of the room when not in use. Side chairs and armchairs are more common than sofas and wing chairs.

- *Materials.* Walnut dominates Queen Anne furniture. Imported mahogany supersedes it in the 1730s and becomes the chief wood for Early Georgian and Chippendale furniture. Because mahogany has a fine grain and is easy to carve, carving becomes the main form of ornamentation with minimal marquetry and inlay. Unlike French Rococo, Chippendale rarely features *ormolu*. Lacquering or Japanning, usually in black or red, adds color to some pieces, particularly bedroom furniture. Crossbanding and herringbone are favored veneer patterns.

- *Seating.* Seating includes side chairs and armchairs (Fig. 24-32, 24-49, 24-50, 24-51, 24-52, 24-53, 24-54), settees, *easie* chairs (Fig. 24-55), and many forms of armchairs and armless chairs with upholstered seats and backs. Settees resemble large chairs for two people. The large, upholstered sofa (sopha; Fig. 24-56) is rare before mid-century. The third edition of *The Director* illustrates sofas with Rococo influence. Chippendale designates chairs with upholstered armchairs as French or "elboe" chairs. Sets of matching upholstered furniture dominate important rooms in grand houses (Fig. 24-34).

- *Tables.* Georgian drawing rooms have numerous small tables, reflecting society's interest in inviting friends for

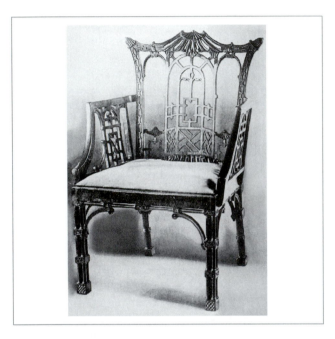

24-53. Armchair, Chinese-style.

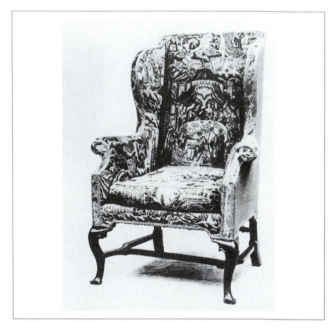

24-55. *Easie* (wing) chair, c.1700

24-54. Armchairs; by William Kent.

24-56. Camel-back sofa.

tea, cards, and/or conversation. Card or game tables have folding tops that rest on a hinged leg. When closed, they sit against the wall. Tops have baize or needlework covers, wells for counters, and places for candles. Tops of tea tables may be round, oblong, rectangular, piecrust (top edge carved in series of small curve resembling a pie crust), or polygonal. They may be mounted on legs or a carved or fluted shaft terminating in a carved tripod called a claw. Dining tables have three parts: a center with drop leaves and two semicircular ends. The ends are placed against the wall when not in use. Other types include breakfast tables, sideboard tables with marble tops for dining rooms, decorative side tables (Fig. 24-57), pier tables, night tables, and toilet tables.

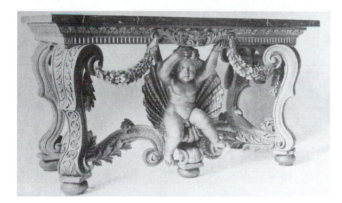

24-57. Side table; by William Kent.

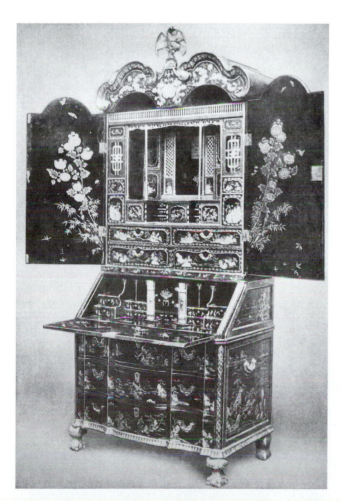

24-58. Desk and bookcase with *Chinoiserie* decoration, c. 1710.

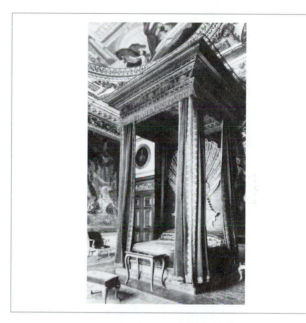

24-59. Bed, Green Velvet Bed Chamber, Houghton Hall, begun 1722–1731; Norfolk; by William Kent.

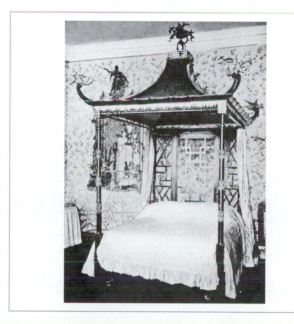

24-60. Bed, Chinese-style, c. 1750s.

■ *Storage.* Every fashionable Georgian drawing room has a commode. It features straight, bombé, and/or serpentine-shaped fronts and sides. Carving is the main decoration, but some display marquetry and gilt bronze in the French manner. Large case pieces, such as desks and bookcases (Fig. 24-58), often have architectural details, such as columns or broken pediments for displaying sculpture or porcelain. Alternative decorations include Gothic pointed arches or a Chinese pagoda outline. Glass mullions may feature Rococo leaves, curving tendrils, and other details.

■ *Beds.* Four-poster beds are most fashionable. Queen Anne types follow earlier forms, but Chippendale head-boards are elaborately carved with Rococo, Chinese, or Gothic details. Canopies and testers may be pagoda shaped in Chinese examples (Fig. 24-60). Bedroom furnishings are sometimes Japanned. As before, beds feature elaborate hangings with trims and tassels (Fig. 24-59).

■ *Textiles.* Typical textiles include velvets, silks, wools, linens, cottons, and leather. Crewel embroideries based on Indian *palampore* motifs (Fig. 24-61) are also popular for upholstery and bed hangings. Wood block and copperplate print fabrics are common. Textiles provide much of the color in rooms. Furniture cases (slipcovers) of lightweight cottons or woven checks protect upholstery fabrics. Chair backs are sometimes not upholstered to save money.

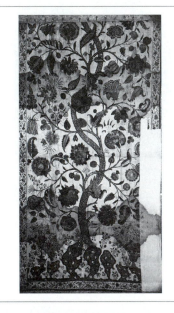

24-61. Textiles: English *palampore*. (Sample of English Calico—18th century. Victoria & Albert Museum, Crown Copyright)

24-63. Looking glass.

24-62. Ceramics: Spode and Worcester.

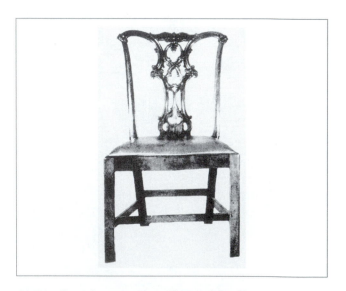

24-64. Later Interpretation: Chippendale ribbon-back chair; copied from Chippendale's *Director*, mid-18th century; American Georgian.

■ *Decorative Arts*. Most grand interiors feature oil paintings collected on grand tours. They hang flat and symmetrically inside panels. Specially designed niches or cabinets display ancient sculptures or collections. Other accessories include painted and gilded wall brackets, folding screens, and fire screens following the forms and decoration of furniture. Factories in Chelsea, Worcester, Caughley, and Spode manufacture porcelain beginning in the 1740s. Adopting Chinese and European styles, the factories produce table sets; tea, coffee, and chocolate sets; figurines; and sets of figures with Rococo and *Chinoiserie* decoration (Fig. 24-62).

■ *Glass*. The period also witnesses the development of Anglo-Irish glass. After Parliament establishes free trade with Ireland in 1780, English businessmen open glasshouses there, the most famous of which is Waterford, which opened in 1783. Glass made between 1780 and 1835 is called Anglo-Irish because close ties between the two countries result in similar characteristics. Anglo-Irish glass has exceptional clarity, and cutting methods effectively reflect and refract light. After the government levies an excise tax by weight on glass, designs become thinner,

lighter, and more Rococo. Chandeliers and other lighting devices are entirely of lead glass.

■ *Mirrors*. Queen Anne pier glasses feature simple and curvilinear outlines that resemble chair backs. The glass must be in two pieces to fit the tall shape. Wood frames may be left plain, painted, or gilded. New in the period is the chimney glass, which is horizontal in form with three parts to hang over the mantel. Architectural looking glasses with columns and pediments framing the glass are developed in the Early Georgian period (Fig. 24-63). Chippendale examples feature complicated outlines; gilding; and Chinese, Rococo, and/or Gothic motifs.

■ *Later Interpretations*. Interest in the Chippendale style continues through the American Georgian period (Fig. 24-64). It is rekindled in the 1860s, with reproductions and adaptations of Chippendale, Queen Anne, and Early Georgian furniture appearing in rooms in Britain, Canada, and America. The renewed admiration for 18th-century furnishings embraces antiques, and by the 1880s, collecting becomes a popular pastime, leading to a demand for 18th-century textiles, wallpapers, carpets, and decorative arts. These trends continue through the 20th century.

25. *American Georgian*

1700s–1780s

The houses in general make a good Appearance and also as well furnished as in Most places you will see with, many of the rooms being hung with printed canvas and paper & which looks very neat. Others are well wainscoted and painted as in other places.

> James Birket, *Some Cursory Remarks made by James Birket in his Voyage to North America 1750–1751*

The American Georgian style reflects a complex community of people who share similar standards, values, and ideals related to democracy and independence. Colonists with diverse social backgrounds along the eastern Atlantic coast from Canada to South Carolina maintain strong connections to their English heritage and tradition. They copy English precedents in education, art, and architecture. Traditional, vernacular buildings, interiors, and furnishings with strong regional differences of the 17th century yield to a learned, tasteful, refined image based on classicism that is similar throughout the colonies.

25-1. Minuteman.

HISTORICAL AND SOCIAL

England loses control of her colonies along the Atlantic coast in the second half of the 18th century because of harsh government policies brought on primarily by the French and Indian War. Unified by ideas, language, and heritage, settlers band together to break the bonds of English political connections. Colonists seek to govern themselves, more or less, because they dislike Britain's attempts at control. They eventually develop government centers and focus on the value of democracy, separate rights, and the common man. Leaders of this spiritual and political revolution include Benjamin Franklin, George Washington, Thomas Jefferson, George Mason, and James Monroe—men who will mold a new nation. These men, influenced by the Enlightenment, articulate a voice for the country, one that questions connections to Britain. Increased attempts of British domination lead to the beginning of the American Revolution in 1775 and the Declaration of Independence in 1776.

Financial independence for colonists evolves through farming and exports of tobacco, rice, indigo, lumber, and iron. Trade between America and Britain continues, and trade between America and the West Indies increases. This brings economic prosperity, further immigration, and an increase in building activity. People can rise socially and economically based on their own abilities, unlike in Europe where the wealthy control opportunities. By 1753, the country has approximately 1.5 million people, 20 percent of whom are Negro slaves owned by the wealthy gentry.

Testament to this growth and prosperity are new government facilities, religious buildings, and larger domestic structures appearing in Canada, New England, the mid-Atlantic, and the South. Generally sited in seaport towns and along navigable rivers, major developments occur in Toronto, Ottawa, Boston, Newport, Philadelphia, Annapolis, Williamsburg, New Bern, and Charleston. Large, grand houses built for wealthy gentleman farmers, aspiring politicians, and prospering merchants provide some of the best illustrations of America's taste and talent. Like their English counterparts, these gentlemen consider the knowledge of architecture essential to their education and a mark of refinement. Working with local carpenters and inspired by English publications and design developments, the colonists adopt classical principles in buildings and interiors. Typically, these structures support formal lifestyles and refinement in social and behavioral customs

430

emphasizing conversation, gaming, dancing, musical recitals, and drinking tea. Vernacular interpretations imitate these models.

CONCEPTS

Design influences in America come from the English nobility, whose elaborate houses depict cultured tastes refined by the French court of Louis XV, trade with the Orient, and travel to Italy. Rococo, *Chinoiserie*, and Palladian designs contribute to an image based on reason and refinement. With prosperity and more settled times, colonists follow the English gentry in seeking gentility, culture, manners, and civility. Formal, classical houses and furnishings support this polite society and its activities. Knowledge about the appropriate 18th-century design language comes through many English pattern books including *Palladio Londinensis: The London Art of Building* (1734) by William Salmon, *Workman's Treasury of Designs* (1740) by Batty Langley, *British Architect* (1745) by Abraham Swan, and *The Gentleman's and Cabinet-Maker's Director* (1754) by Thomas Chippendale.

25-2. Ear motif.

DESIGN CHARACTERISTICS

Colonial buildings reveal increasing formality, sophistication, and familiarity with developments in England. Architecture is symmetrical, ordered, and balanced. Classical details and Neo-Palladian design influences increase throughout the period. Regional manifestations decline as a common design vocabulary develops. Public and private structures are similar in form and ornament, yet both usually maintain a smaller scale and simpler treatments than in England. As in architecture, interiors become increasingly formal, classical, and refined. Treatments and finishes reflect English preferences. Similarly, furniture reflects English Queen Anne and Chippendale styles. Examples typically emphasize curving forms, symmetrical compositions, and proportions in harmony with the scale of the interiors.

■ *Motifs*. Classical motifs (Fig. 25-5, 25-14, 25-17, 25-23, 25-42, 25-48), defining the architectural overall image, include pilasters, pediments, dentil moldings, balustrades, round arches with keystones, and quoins. Common motifs in interiors include the ear (right-angled projection; Fig. 25-2), shell (Fig. 25-3), acanthus leaf, rosette

25-3. Detail from chest of drawers showing shell motif, hardware, and bracket feet.

25-4. Rosette.

25-5. Door detail, Westover, 1730s–1750s; Charles City County, Virginia. This doorway derives from the builder's handbook *Palladio Londinensis: The London Art of Building* (1734) by William Salmon.

(Fig. 25-4), and pineapple or pine cone, as well as renditions of naturalistic flowers.

ARCHITECTURE

During this period, Americans look to English prototypes for architectural design inspiration. Reflecting an ordered visual unit, the buildings increasingly derive from classical traditions inspired by Andrea Palladio, Inigo Jones, James Gibbs, architectural pattern books, and carpenter's building manuals. Representative compositions incorporate unity, symmetry, classical ordering, and fashionable motifs, but with smaller scale and less ornateness than the English prototypes. No longer expressing the irregular, additive, and utilitarian approach of the earlier 17th century, examples show discipline, detailing, and preplanning. High-style and vernacular interpretations dot the landscape.

Domestic buildings appear near transportation routes within an urban neighborhood or develop farther away as agricultural estates, often along rivers. The rectangular block main house dominates the site. Typically housing the wealthy upper class, urban examples are more common in the north and rural ones dominate in the mid-Atlantic and South. Today, surviving homes represent only a small portion of housing as most colonists live in small, one- or two-room wooden dwellings.

Design Practitioners

- Professional *architects* are unknown in the colonies. Gentlemen and master masons armed with pattern books or firsthand knowledge of English prototypes design public and private buildings. Colonists become aware of English fashions through immigrants who bring examples or knowledge, colonial governors, and trade with the mother country.

- Numerous *artisans* produce furniture: cabinet-makers, chair makers, turners, and carvers. Various merchants import needed materials such as paint, gilding, brass, hardware, and veneers. The colonial furniture industry develops freely with no formal guild system, although youngsters serve apprenticeships to learn their crafts.

- As in England, *upholsterers* supply up-to-date beds, hangings, bed furniture, textiles, upholstery, and other dry goods. Because their clients are among the wealthiest of colonists, upholsterers are the most prosperous craftsmen.

- *William Buckland*, a noted wood-carver in Maryland and Virginia, works on the construction of Gunston Hall and the Hammond-Harwood House. His robust carvings showing Rococo influence exhibit excellent craftsmanship. He is known to have used as a resource, *British Architect* by Adam Swan.

- *John Goddard* and *John Townsend*, founders of a Quaker family of cabinetmakers from Rhode Island, provide a distinctive American signature by incorporating block fronts with carved shells on case pieces. Distinctive corkscrew finials, fluted urns, and ogee bracket feet with small volutes also are typical characteristics.

- *Peter Harrison*, born in York, settles in Newport in 1748 and supplies designs for many buildings in Newport and elsewhere. He learns architecture from his large collection of architectural books. His Redwood Library in Newport follows a masterful Palladian design.

- *Paul Revere*, noted Boston silversmith, produces a variety of silverware characterized by refined design and skilled craftsmanship.

Public Buildings

- *Types.* Public buildings include government structures, churches, educational structures, and taverns. After mid-century, new types, such as hospitals and markets, increase.

25-6. Exchange building and customs house, 1767–1772; Charleston, South Carolina.

■ *Public Structures.* Whether governmental or educational, public structures (Fig. 25-6, 25-7, 25-10, 25-11, 25-13, 25-16, 25-17) are formal, two stories tall, and symmetrically balanced, but larger in scale than domestic structures. Later examples have three or four stories. They share with dwellings such attributes as double-pile plans, rectangular block forms, sash windows, dormers, and modillioned cornices defining the roofline. In both public and private buildings, Palladian influence is apparent in temple fronts, the orders, quoins, arches, and Palladian windows. This influence increases after mid-century. Dutch cupolas are common, particularly on statehouses. The first domed structure in America is the Maryland State House, begun in 1772.

■ *Churches.* These religious buildings (Fig. 25-8, 25-9, 25-12, 25-14, 25-15) develop a common form and design vocabulary during the period, which is visible first in urban examples throughout the colonies. Country churches retain more regional variations. The influence of Sir Christopher Wren's city churches appears in steeples and balconied, vaulted interiors beginning in the 1720s. In the Wren manner, steeples atop rectangular towers define facades rather than highlighting a traditional crossing. Rectangular towers usually have string courses and varieties of window shapes. Later examples have pediments, quoins, and pilasters. Upper portions typically are octagonal with arches, pilasters, and clocks. Following Wren and Gibbs,

25-8. Christ Church, 1732–1735; Lancaster County, Virginia. Based on a cruciform plan, this old Virginia church building incorporates the formula for the golden section with the Fibonacci number sequence.

25-7. Raleigh Tavern (reconstruction), established 1717; Williamsburg, Virginia.

porticoes and temple fronts precede tower entrances after mid-century.

■ *Site Orientation.* Government centers and churches are sited along major transportation arteries for visual recognition. Other public structures spring up along dominant thoroughfares for accessibility to urban centers.

■ *Floor Plans.* Churches follow the British tradition, with a Latin cross plan in the South and a more centralized plan in New England. After mid-century, New England Congregational churches begin to abandon the traditional central meetinghouse plan in favor of the Latin cross in the Wren and Gibbs tradition. In Latin cross plans, the entry door is on a center axis leading through the nave to the altar. Crossings are usually absent. Governmental and educational buildings often have a double-pile plan or a variation.

■ *Materials.* Common building materials (Fig. 25-7, 25-12, 25-16, 25-17) are wood, brick, and stone. Selection varies due to geographic location and the availability of resources. Brick is the most common material, although some wood-frame construction with clapboard siding predominates in New England areas. Mid-Atlantic and southern regions frequently choose handmade red brick or sometimes quarried stone. Stone contrasts in color to brick, which may alternate in color, pattern, and selection. Some public structures are of wood treated to imitate stone.

■ *Facades.* Public facades indicate an increasing application of classical details throughout the period (Fig. 25-10, 25-14, 25-17). Sash windows, dormers, and modillioned cornices are common with the exception of churches, which do not have dormers. Designers emphasize center entrances with aedicula (frames composed of columns or

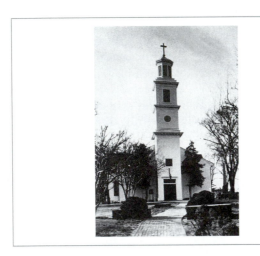

25-9. S. John's Church, 1741; Richmond, Virginia.

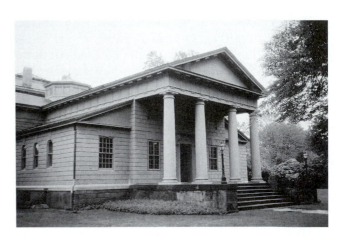

25-11. Redwood Library, 1749–1750; Newport, Rhode Island; by Peter Harrison.

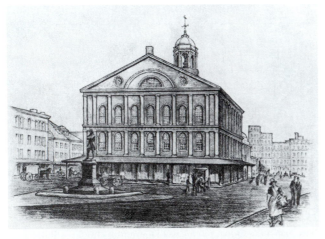

25-10. Faneuil Hall, 1740–1742; Boston, Massachusetts; by John Smibert; enlarged and rebuilt in 1805 by Charles Bulfinch.

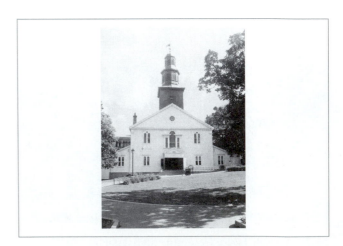

25-12. S. Paul's Church, 1750; Halifax, Nova Scotia.

pilasters carrying an entablature and pediment; Fig. 25-20, 25-21, 25-28), temple fronts, porticoes, and/or cupolas. Lower stories may be arched, and upper ones are divided into bays with pilasters in the Palladian manner (Fig. 25-16). The tower and steeple mark the entrance front of churches (Fig. 25-9, 25-14). The door may be in the tower

or immediately behind a portico. Sides divide into bays with pilasters and/or windows.

■ *Windows.* Sash windows are typical. Some churches have round-arched or round windows. Windows are often large to admit as much light as possible. Stained glass is rare, as plain glass is preferred to make nature, God's creation, visible.

■ *Doors.* Classical details define doorways. Surrounds vary from simple pilasters and a pediment to Doric porticoes. Doors themselves are of paneled wood and are usually painted a dark color.

■ *Roofs.* Hipped or gable roofs are the most common. Domes are very rare.

■ *Later Interpretations.* Traditional forms for churches continue as the Georgian rectangular block with tower and steeple. A few public buildings and/or collegiate ones maintain Georgian forms and details. However, they are more likely to adopt a more monumental form and feature more robust classical details that are better suited to public structures.

Private Buildings

■ *Site Orientation.* The typical rectangular block main house dominates the site. Imitating the tripartite compositions of Palladio, it may be flanked by two smaller buildings called dependencies (Fig. 25-27, 25-30, 25-31). These smaller structures have a similar design and may be offices or guest rooms. Established on a center axis, the circulation

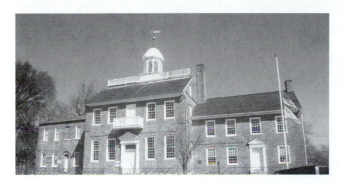

25-13. Courthouse, 1750s; New Castle, Delaware.

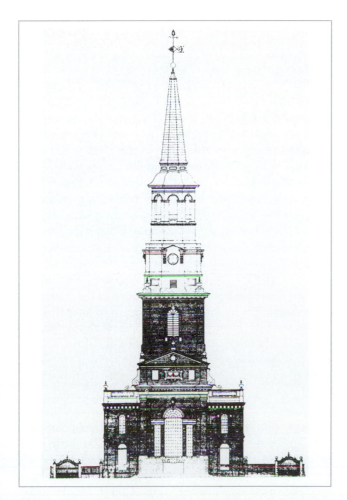

25-14. Christ Church, 1727–1754; Philadelphia, Pennsylvania.

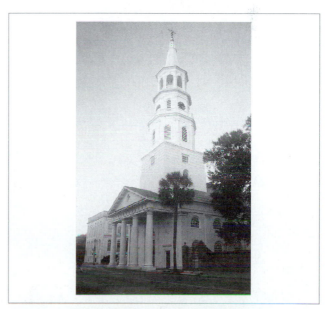

25-15. S. Michael's Church, 1752–1761; Charleston, South Carolina; supposedly designed by Samuel Cardy somewhat resembling the London model of S. Martin-in-the-Fields by James Gibbs.

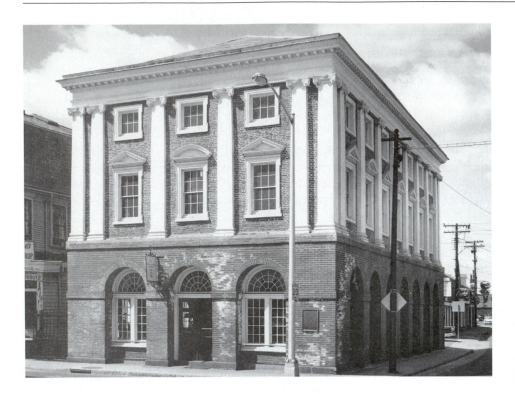

25-16. Brick Market, 1761–1772; Newport, Rhode Island; by Peter Harrison and adapted from the published Palladian designs of Inigo Jones and his pupil John Webb.

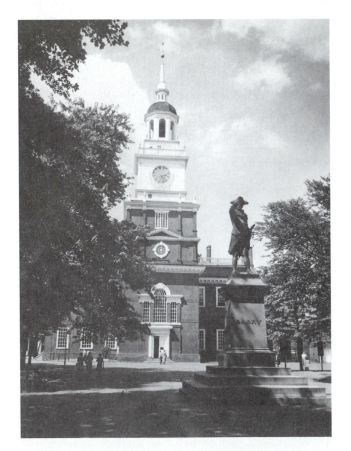

25-17. Independence Hall, 1731–1791; Philadelphia, Pennsylvania.

Design Spotlight

Architecture: *Drayton Hall.* Probably developed from pattern books by a master joiner, this impressive house (Fig. 25-18, 25-19, 25-40) was the first Anglo-Palladian house in America. As the country seat of Royal Judge John Drayton, a wealthy rice grower, its overall symmetrical design and floor plan follow that of an English manor house. The main facade features a classical projecting two-story portico with steps ascending to it in the Palladian manner, which creates a strong sense of procession. This differs from England where two-story porticoes are rare because of the climate. In the portico, imported Portland stone Ionic columns surmount Tuscan in the Roman tradition. The double stairs are modeled after those in Coleshill. The interiors harmonize with the exterior to repeat the architectural features.

paths provide an ordered arrangement of house, outbuildings, and gardens (Fig. 25-30). In a plantation setting, the house has egress in two directions, to the river or to a roadway. The outbuildings, more vernacular in character, have specific functions—kitchen (Fig. 25-43), smokehouse, storage, stables, and servants' quarters.

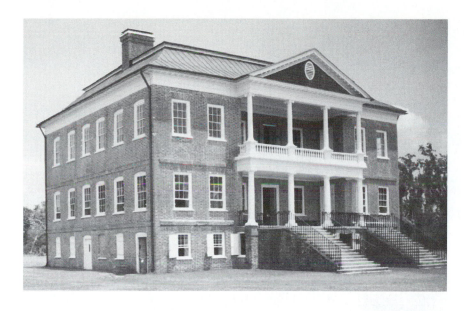

25-18. Drayton Hall, 1738–1742; Charleston, South Carolina.

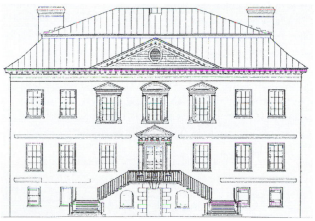

25-19. Northeast elevation, Drayton Hall.

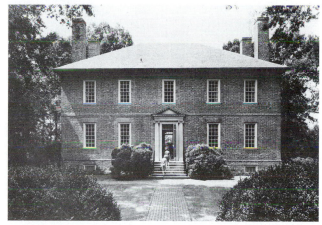

25-21. Wilton, 1754; Richmond, Virginia.

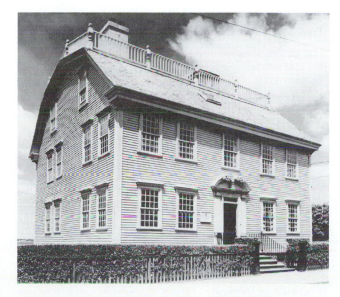

25-20. Hunter House, 1748; Newport, Rhode Island.

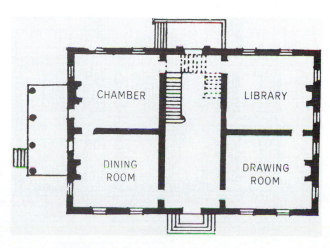

25-22. Floor plan, Wilton.

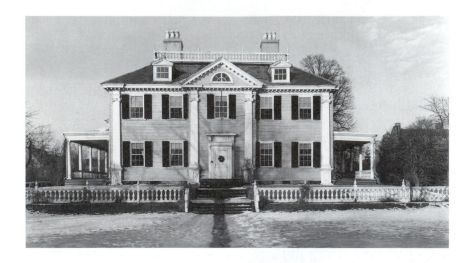

25-23. Vassall-Longfellow House, 1759; Cambridge, Massachusetts.

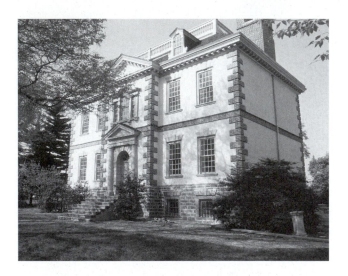

25-24. Mount Pleasant, 1761–1762; Philadelphia, Pennsylvania. (Color Plate 61)

■ *Floor Plans.* Most large houses (Fig. 25-22, 25-27, 25-32) have a center passage (Fig. 25-45, 25-50, 25-52) flanked symmetrically by two rooms on either side, with a repetitive footprint for both floors. The long passage, a circulation and living area, has entry doors at each end to catch cooling breezes and a stairway to the second floor. The adjoining rooms (Fig. 25-48, 25-51, 25-53) for socializing, dining, and sometimes sleeping are often rectangular or square with fireplaces located on interior center walls or exterior walls. Town houses usually have side passages with

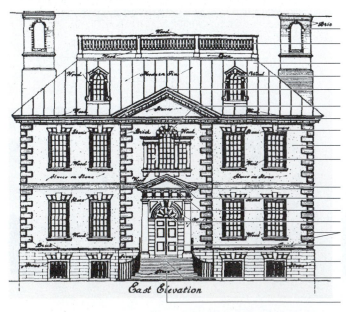

Chimney on exterior wall
Classical balustrade on top of roof

Hipped roof
Dormer window
Pediment

Palladian window
Cornice
Keystone

Stucco on stone

Double hung window,
9 over 9 glass panes

String course
Pediment
Aedicula
Fan light
Quoins
Main entry on center axis

Stone base

Stairs create procession

Emphasis on classical entry design

East Elevation

25-25. East elevation, Mount Pleasant.

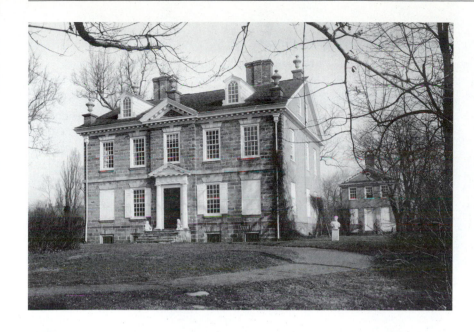

25-26. Cliveden, 1763–1764; Germantown, Pennsylvania.

two to three rooms on one side (Fig. 25-28). Private spaces, such as bedchambers, may be separated from the public spaces through placement and circulation paths.

■ *Materials.* Domestic buildings imitate public ones in the application and general use of materials (Fig. 25-21, 25-23).

■ *Facades.* Facades with classically delineated entries are common (Fig. 25-18, 25-19, 25-20, 25-21, 25-23, 25-24, Color Plate 61, 25-25, 25-26, 25-28, 25-29, 25-30, 25-31). In brick homes, a belt or string course composed of a wide, flat band marks floors. Early examples tend to be plain with ornamentation limited primarily to the doorway and roofline (Fig. 25-20). After mid-century, alterations or additions to the facade include porticoes, pilasters, pediments, arches, keystones, and quoins to enhance the three-dimensional character (Fig. 25-23, 25-25).

■ *Windows.* Repetitively sized and spaced double-hung windows with six-over-six (Fig. 25-19, 25-23) or nine-over-nine (Fig. 25-25) glass panes dominate, an obvious change from the previous use of small casement windows. Many have exterior shutters, especially after mid-century.

■ *Roofs.* Roofs for domestic buildings are often hipped (Fig. 25-21, 25-23, 25-31). Some are accentuated with a classical white balustrade. Gable and gambrel roofs

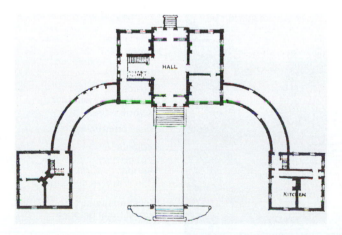

25-27. Floor plan, Mount Airy, 1754–1764; Richmond County, Virginia.

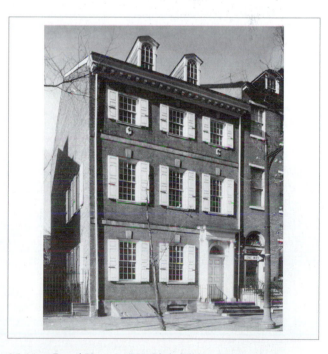

25-28. Powel House, 1767; Philadelphia, Pennsylvania.

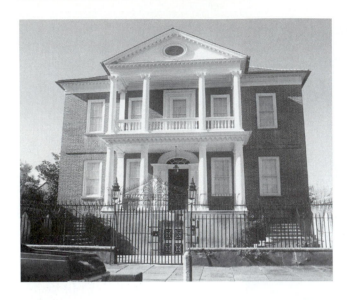

(Fig. 25-20, 25-26) are also common. Dormer windows add variety to the roof design. Chimney locations at the roofline identify the planned arrangement of spaces.

■ *Later Interpretations.* Colonial Revival (Fig. 25-33, 25-34, 25-35), beginning in the late 19th and early 20th centuries, provides the best later illustrations of the residential Georgian image. Suburban homes of the late 20th century continue to reflect America's love for the 18th-century prototype.

25-29. Miles Brewton House, 1765–1769; Charleston, South Carolina; by the London architect Ezra Waite.

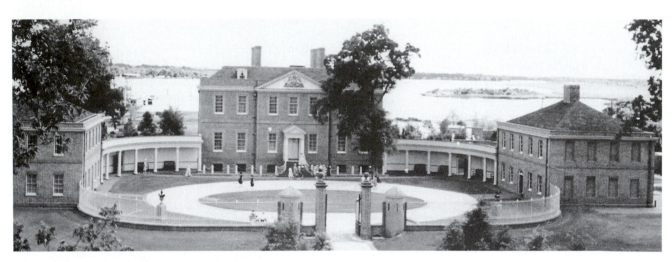

25-30. Tryon Palace, 1770; New Bern, North Carolina.

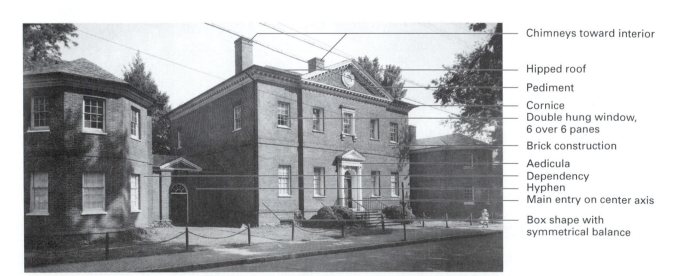

Chimneys toward interior

Hipped roof

Pediment

Cornice
Double hung window, 6 over 6 panes

Brick construction

Aedicula
Dependency
Hyphen
Main entry on center axis

Box shape with symmetrical balance

25-31. Hammond-Harwood House, 1773–1774; Annapolis, Maryland; by William Buckland.

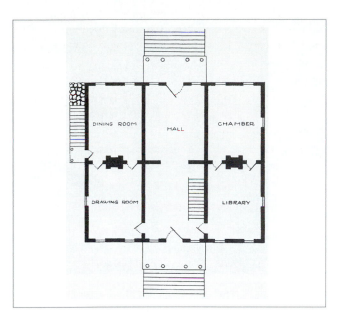

25-32. Floor plan, Prestwould, 1794–1795; Clarksville, Virginia.

Design Spotlight

Architecture: *Floor Plan, Prestwould.* The plan (Fig. 25-32) shows the centered arrangement of the rectangular block main house with a double-pile plan of a center passage and staircase. The passage serves as a cool living space in summer and allows access to adjoining rooms. Two rooms on either side flank it symmetrically on both floors. These rooms for socializing, dining, working, and sleeping are rectangular, with fireplaces located on the interior center walls. This plan type continues in the Federal Period.

Design Spotlight

Architecture: *Hammond-Harwood House.* Designed by William Buckland, English carpenter and joiner, this is a country house (Fig. 25-31, 25-51) in town. The rectangular block main house dominates the site. Imitating the tripartite compositions of Palladio and others, it is flanked by two dependencies (smaller buildings with half-octagon fronts). Hyphens or small connecting units join the main house and dependencies. A pediment tops the projecting three center bays of the main house. Pediments carried by engaged columns or pilasters repeat over the main doorway and smaller doors in the hyphens. Typical Georgian characteristics are the modillioned cornices, hipped roof, and sash windows.

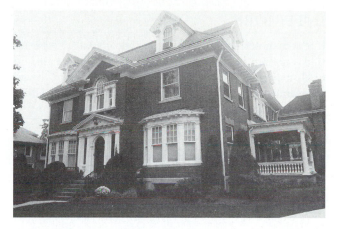

25-33. Later Interpretation: House, c. 1900–1910; Buffalo, New York.

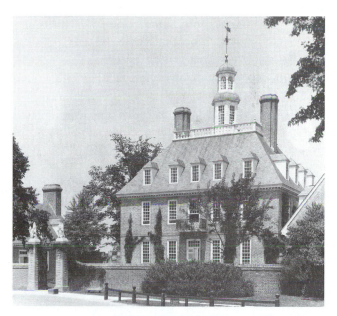

25-34. Later Interpretation: Governor's Palace, 1705–1749, reconstruction in 1930s; Williamsburg, Virginia.

25-35. Later Interpretation: House on Monument Avenue, 1930s; Richmond, Virginia.

INTERIORS

Interiors directly reflect the symmetrically balanced exteriors, creating a classically ordered, unified image based on English prototypes. Commercial interiors vary in design according to use. Churches, defined by architectural detailing and simplicity, often feature balconies and seating in compartments. Residential interiors depict a dominant fireplace treatment on the main wall with a door or two windows located on the opposite wall on the center axis. The articulation of borders and outlines is important in creating unity, outside and inside, and even incorporates the furniture details of fringe, piping, and decorative edges.

Public Buildings

- *Relationships.* Interiors reflect exterior design with particular attention given to circulation areas, such as doors and stairs. Classical elements repeat in interiors.

- *Floors.* Floors in religious and government structures display variety through the selection of wood, stone, and brick in regular, geometric patterns.

- *Walls.* Classic wall divisions are common in religious and government structures (Fig. 25-36, 25-37, 25-38).

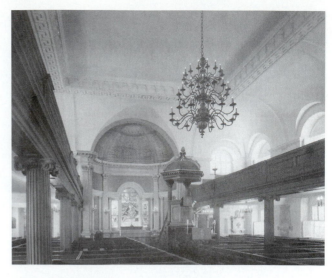

25-37. Nave, S. Michael's Church, 1752–1761; Charleston, South Carolina; by Samuel Crady (?).

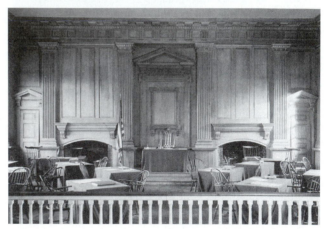

25-38. Interior, Independence Hall, 1731–1791; Philadelphia, Pennsylvania.

25-36. Nave, Trinity Church, 1725; Newport, Rhode Island; by Richard Mundoy, who was inspired by Christopher Wren.

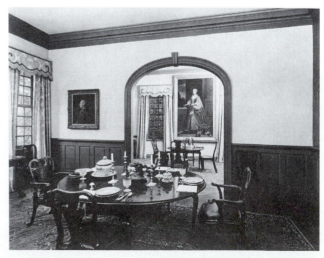

25-39. Dining Room, Stratford Hall, 1725–1730; Westmoreland County, Virginia.

Important Buildings and Interiors

- **Alexandria, Virginia:** Gatsby's Tavern, 1750s.
- **Annapolis, Maryland:** Hammond-Harwood House, 1773–1774.
- **Boston, Massachusetts:**
 —Christ Church (Old North Church), 1723, spire 1741, William Price.
 —Faneuil Hall, 1740–1742, John Smibert, enlarged and rebuilt in 1805 by Charles Bulfinch.
 —King's Chapel, 1749–1750, Peter Harrison.
 —Old Brick Meeting House, 1713.
 —Old State House, 1748.
- **Cambridge, Massachusetts:** Vassall-Longfellow House, 1759.
- **Charles City County, Virginia:**
 —Berkeley, 1727.
 —Shirley Plantation, 1769.
 —Westover, 1730–1735.
- **Charleston, South Carolina:**
 —Drayton Hall, 1738–1742.
 —Miles Brewton House, 1765–1769, Ezra Waite.
 —S. Michael's Church, 1752–1761; Samuel Cardy (?).
- **Fairfax County, Virginia:**
 —Gunston Hall, 1755–1787. (Color Plate 62)
 —Mount Vernon, 1726–1787.
- **Fredericksburg, Virginia:** Kenmore, 1751.
- **Germantown, Pennsylvania:** Cliveden, 1763–1764.
- **Halifax, Nova Scotia:** S. Paul's Church, 1750.
- **James County, Virginia:** Carter's Grove, 1750–1753.

- **Lancaster County, Virginia:** Christ Church, 1732–1735.
- **New Bern, North Carolina:** Tryon Palace, 1770.
- **New Castle, Delaware:** Courthouse, 1750s.
- **Newport, Rhode Island:**
 —Brick Market, 1761–1772, Peter Harrison.
 —Hunter House, 1748.
 —Redwood Library, 1749–1750, Peter Harrison.
 —Touro Synagogue, 1759–1763, Peter Harrison.
 —Trinity Church, 1725.
- **Philadelphia, Pennsylvania:**
 —Christ Church, 1727–1754.
 —Independence Hall, 1731–1791.
 —Mount Pleasant, 1761–1762. (Color Plate 61)
 —Powel House, 1767.
- **Providence, Rhode Island:** First Baptist Meeting House, 1774–1775, Joseph Brown.
- **Richmond, Virginia:**
 —S. John's Church, 1741.
 —Wilton, 1754.
- **Richmond County, Virginia:** Mount Airy, 1754–1764.
- **Williamsburg, Virginia:**
 —The Capitol, 1701–1705.
 —George Wythe House, 1750s.
 —Public Hospital, 1770–1773.
 —Raleigh Tavern, established 1717.
 —Wren Building, College of William and Mary, 1695–1702, probably Sir Christopher Wren.

25-40. Section, Drayton Hall, 1738–1742; Charleston, South Carolina.

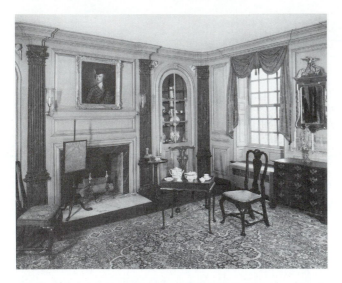

25-41. Drawing Room, Hunter House, 1748; Newport, Rhode Island.

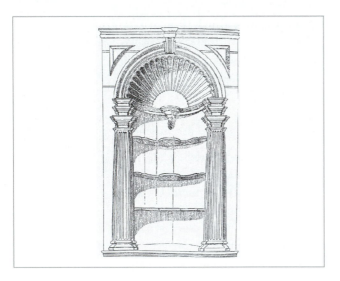

25-42. Shell-top corner cupboard.

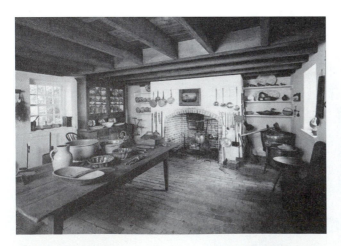

25-43. Kitchen, Mt. Harmon Plantation at World's End, late 18th century; Cecil County, Maryland.

Features typical in residences are similar to those found in various commercial environments.

■ *Ceilings.* Church ceilings are often vaulted. Classical piers or columns carry the vaults similar to Wren's city churches. Ceilings in other structures usually are flat or coved. Churches and public structures are most likely to have chandeliers.

Private Buildings

■ *Types.* Public spaces in domestic homes, such as passages (Fig. 25-45, 25-50, 25-52), drawing rooms (Fig. 25-41, 25-48), and dining areas (Fig. 25-39, 25-51, 25-53), are multifunctional and have a formal character emphasizing refinement and wealth. Grouped in proximity to one

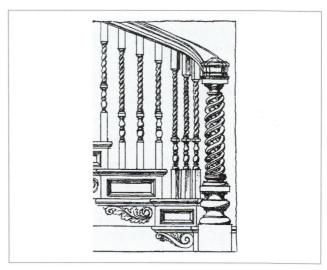

25-44. Stairway detail, Lee House, 1768; Marblehead, Massachusetts.

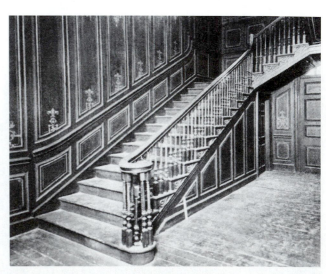

25-45. Stair Hall, Wilton House, 1754; Richmond, Virginia.

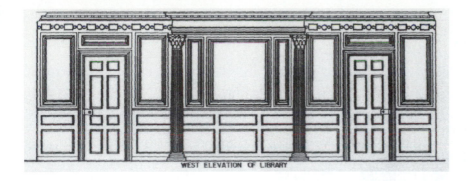

WEST ELEVATION OF LIBRARY

25-46. Elevation, Vassall-Longfellow House, 1759; Cambridge, Massachusetts.

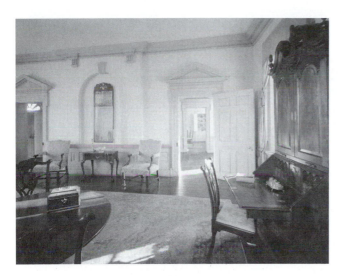 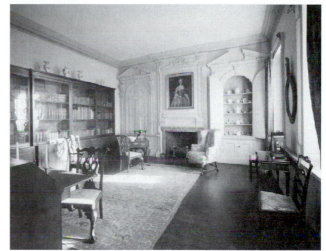

25-47. Parlor, second-floor grand parlor, Mount Pleasant, 1761–1762; Philadelphia, Pennsylvania.

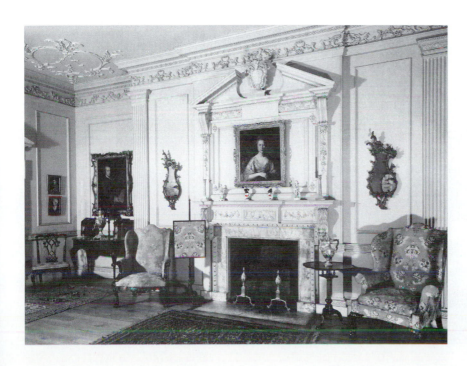

25-48. Drawing Room, Powel House, 1767; Philadelphia, Pennsylvania.

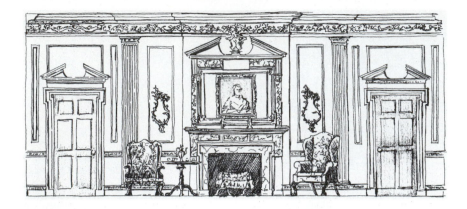

25-49. Elevation, Drawing Room, Powel House; doors removed in museum installation.

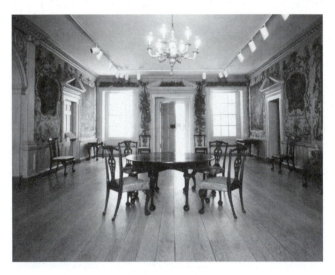

25-50. Entrance Hall, Van Rensselaer House, 1765–1769; Albany, New York. [The Metropolitan Museum of Art, Gift of Mrs. William Bayard Van Rensselaer in memory of her husband, William Bayard Van Rensselaer, 1928. (28.143)]

Design Spotlight

Interiors: *Dining Room, Gunston Hall.* Home to George Mason, author of the United States Bill of Rights, Gunston Hall has a dining room (Fig. 25-53, Color Plate 62) that is architecturally the most important room in the house. Its elaborate architectural details highlight the woodworking talents of William Buckland. Walls depict the classic divisions of a cornice, fill, and paneled dado. The typical Georgian fireplace has a broken pediment above the mantel. Flanking the fireplace are two beaufats for displaying silver and porcelains. Pilasters and a broken pediment frame each beaufat. Along with the ornamentation, other details signal the room's importance, including the carefully matched blind doweled floors and the black walnut doors. Rituals of dining assume greater importance during the 18th century, and dining rooms become the stage for the master's hospitality.

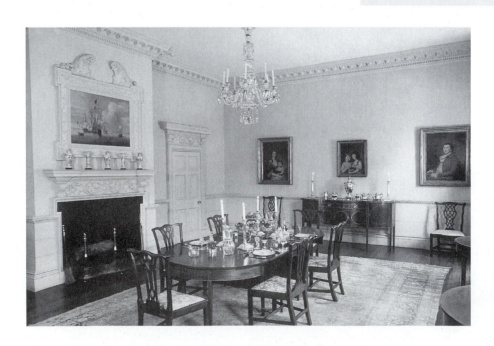

25-51. Dining Room, Hammond-Harwood House, 1773–1774; Annapolis, Maryland; by William Buckland.

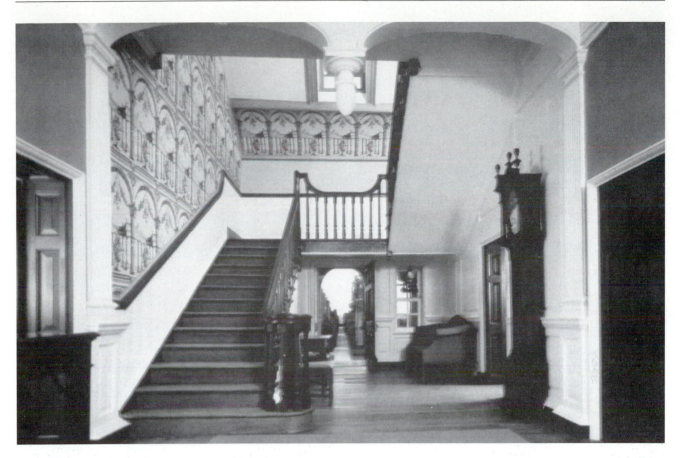

25-52. Stair Hall, Gunston Hall, 1755–1787; Fairfax County, Virginia.

another, they support socializing, gaming, and dining. The best room, parlor, or drawing room supports only entertaining and formal family functions. Dining occurs where convenient and seasonally comfortable. Immediate circulation to a detached kitchen (Fig. 25-43), a working and gathering place for servants, also is important. The best bedchamber, which houses the finest furnishings, may occupy a first- or second-floor position.

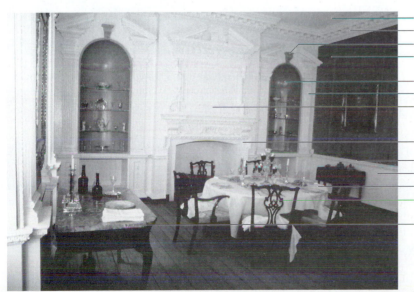

Plain ceiling
Cornice
Broken pediment with keystone at arch
Overmantel with broken pediment and "ear" motif
Beaufat for display
Pilaster
Chimneypiece on center axis

"Ear" motif frames mantel

Dado or chair rail
Dado
Covered dining table
Chippendale-style chair with ribbon-back splat
Sideboard table for serving

25-53. Dining Room, Gunston Hall. (Color Plate 62)

25-54. Lighting fixtures: Brass candlesticks.

■ *Relationships.* Intimate scaled spaces prevail, emulating the character of the Rococo development in Europe, but with less ornateness. Most colonists prefer greater simplicity. Each room is usually treated as an individually designed unit with little relation to the adjoining space.

■ *Color.* Scholarship indicates that interiors used more intense colors than originally believed (Fig. 25-53). Color choices available in England are also available in the colonies, although colonists are less likely to use color to depict wealth. The color palette has medium values of russet-rose, Prussian blue, sky blue, blue gray, pea green, olive green, gray green, deep green, and charcoal gray accented with white or off-white. Walls may appear in one of these colors, including cream, with details, textiles, and/or accessories conveyed in another color. Colors for entertaining rooms, used principally in the evening, are chosen with their appearance by candlelight and firelight in mind.

■ *Lighting.* Expensive light fixtures (Fig. 25-39, 25-41, 25-48, 25-54) of brass, porcelain, silver, and glass come from England, while cheaper ones of wood and pewter originate locally. Houses are well lit for entertainment, but the amount of light is limited compared to current standards. Strategically placed looking glasses (mirrors; Fig. 25-41, 25-68) help enhance the light quality. Families often gather around one or two candlesticks, a practice that continues until the introduction of portable lamps in the 19th century. Candlesticks enhance the light quality on game tables; wall sconces accentuate the room perime-

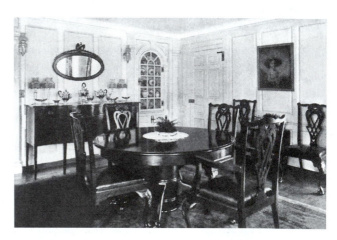

25-55. Later Interpretation: Dining Room, Little Residence, 1916; Concord, Massachusetts; Colonial Revival.

ter; and chandeliers, which are more common in public buildings, hang at the center from ceilings.

■ *Floors.* Residential flooring usually features wide boards cleaned with water and sand. Some floors are painted in solids, patterns, or to resemble rugs, and floor cloths are common, even in the best rooms. Oriental rugs are rare until the end of the 18th century, and most often appear on tables because they are too expensive to walk on. Very wealthy homes may have carpet. During the summer, rush matting replaces rugs.

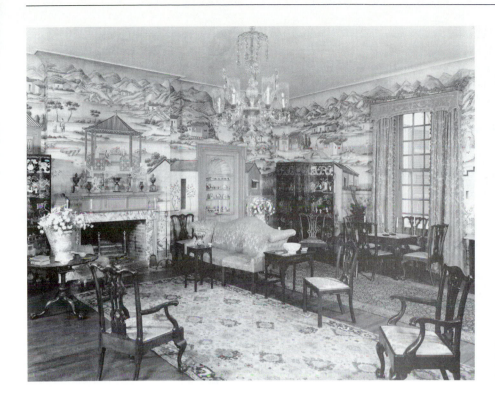

25-56. Later Interpretation: Chinese Parlor, Winterthur Museum, c. 1930s; wallpaper c. 1770; Colonial Revival.

■ *Walls*. Classic wall divisions often incorporate a cornice, frieze, small architrave, shaft, dado rail, paneled dado, and baseboard (Fig. 25-39, 25-40, 25-46, 25-47, 25-49, 25-53, Color Plate 62). Wall treatments include paneling, wallpaper, fabric, or paint. Wood paneling may be left natural, stained, or painted, and it may only highlight a fireplace wall. Wallpaper or fabric, usually imported from England in a variety of patterns and solid colors, appears above the dado and covers the walls of passages, drawing rooms, and other spaces (Fig. 25-52). Typical patterns include framed paintings or prints, architectural papers, small prints, naturalistic designs resembling Oriental papers, and imitations of textiles. A typical fireplace wall (Fig. 25-48, 25-49, 25-53) accents a vertically integrated mantel and overmantel design articulated with a broken pediment, pilasters, classic details, and the distinctive ear (Fig. 25-2) motif. The center section projects into the room. Walls on either side might have beaufats (niches or cupboards usually with doors originally for serving drinks, but later for display; Fig. 25-41, 25-42, 25-53, Color Plate 62) for the display of decorative porcelain, a unique feature of the period. The niche itself might be framed with pilasters and a broken pediment. Other interior walls could complement this design or be simpler in appearance.

■ *Windows*. Windows usually include recessed wooden shutters on either side with no drapery treatment allowing natural light to filter in (Fig. 25-41, 25-47). Curtains are rare even among the wealthy and appear only in the best rooms. Early examples typically include paired panels and festoons that resemble swags and cascades.

■ *Doors*. Doorways (Fig. 25-46, 25-49) express the classic image through broken pediments, round arches, and pilasters, and may repeat the ear motif. Wood doors with panels are common and either painted white or, if walnut or mahogany, left natural.

■ *Ceilings*. Often left undecorated, ceilings depict an American preference for simplicity in contrast to English precursors.

■ *Later Interpretations*. Excellent examples of Georgian design appear as popular expressions during the Colonial Revival (Fig. 25-55, 25-56), when American history becomes a popular design theme in the late 19th century and again in the late 20th century. Reproductions and adaptations of Georgian woodwork, wallpapers, paint colors, and mantels remain popular today.

FURNISHINGS AND DECORATIVE ARTS

Furniture design complements the building, imitates English prototypes, and offers high style as well as vernacular interpretations. Elaborate and simpler examples produced in walnut and mahogany illustrate the Queen Anne style (beginning about 1720 and lasting until 1790), and the Chippendale style (1750–1790), with Chinoiserie, Gothic,

and Rococo designs copied from pattern books such as Thomas Chippendale's *Director*. Queen Anne lasts longer in America as there is no subsequent Georgian development. Therefore, examples may combine both Queen Anne and Chippendale elements. (Some American museums refer to Queen Anne as Late Baroque and Chippendale as Rococo, believing these terms to be more descriptive of the character of all decorative arts.) Articulated with great attention to form, proportion, and detail, furniture designs respond to the tastes of wealthy, sophisticated clients. American examples may be less ornate, particularly in the use of marquetry and materials, than the English models. Vernacular interpretations from rural locales mirror this fashion, but the results are of local woods with awkward proportions, cruder craftsmanship, less ornamentation, and painted finishes. Comfort is important, so arms curve and seats contour slightly to fit the body.

Local cabinetmakers compete with English makers and contribute to a thriving colonial furniture-making industry. Within the vocabulary of English prototypes, regional preferences in design, construction, and ornament appear in the various cabinetmaking centers in the Colonies. Apprenticeships and immigrants from various regions in England contribute to these differences. Major furniture centers develop in Boston, Rhode Island, New York, Philadelphia, and Charleston. Smaller cabinetmaking centers spring up in other areas, such as Long Island, Maryland, and Williamsburg.

■ *Types*. Typical furniture pieces include chairs, sofas, tables, secretaries, high chests of drawers (highboys), dress-

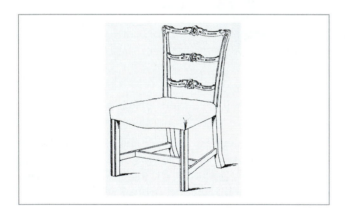

25-57. Chippendale ladder-back chair.

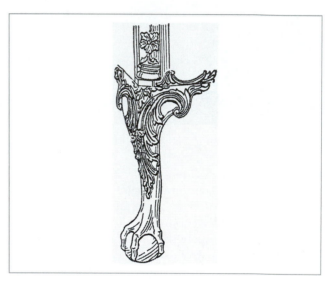

25-59. Cabriole leg with ball and claw foot.

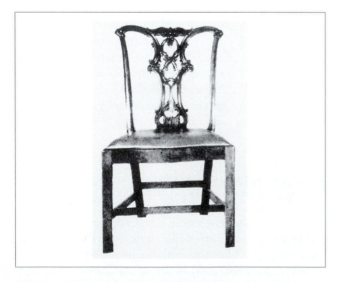

25-58. Chippendale ribbon-back chair; copied from Chippendale's *Director*.

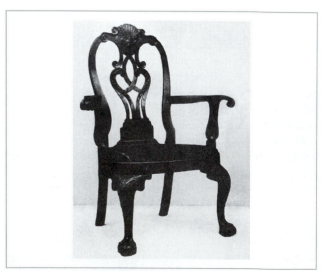

25-60. Queen Anne armchair.

ing tables (lowboys), tall case (grandfather or hall) clocks, firescreens, and beds.

■ *Distinctive Features.* Forms and ornament reflect English Queen Anne, Early Georgian, and Chippendale modes. Highlighting Rococo and English influences, cabriole legs (Fig. 25-59) appear on various examples, frequently in combination with the ball and claw, pad, or spoon foot. Large cabinets usually have straight or ogee bracket feet or a plinth base. A few examples have short cabriole legs. Broken pediments and finials commonly surmount large casepieces.

■ *Relationships.* As in English homes, furniture arrangements in American homes support room function, with an emphasis on formality, customs, harmony, and integration. Symmetry is important in the placement of tables and/or pier tables and looking glasses (mirrors; Fig. 25-68). The

finest furniture occupies the best drawing room and is arranged around the perimeter of the room when not in use. In this space, many side chairs and armchairs are common with few sofas and no wing chairs. Wing chairs regarded as seats for the old or infirm, typically are found in bedchambers.

■ *Materials.* Walnut and imported mahogany are the principal woods for all cabinetmaking, but regional woods such as maple, cherry, and pine provide good substitutes. Often, the regional woods are stained or painted in imitation of the more valuable walnut or mahogany to enhance their appearance. Japanning and *Chinoiserie* lacquer is fashionable in the early part of the century. Designs featuring raised and gilded flowers, trees, and/or people usually against a black background decorate dressing tables, high chests, chairs, and tall case clocks. Boston becomes a

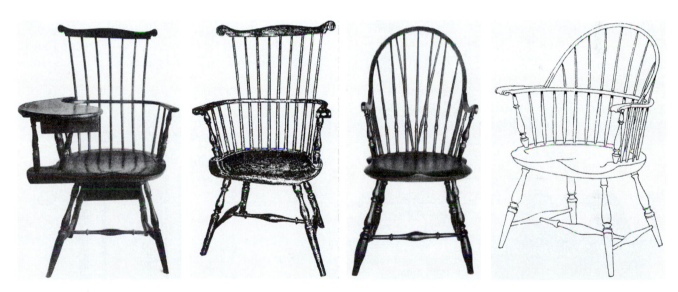

25-61. Windsor chairs.

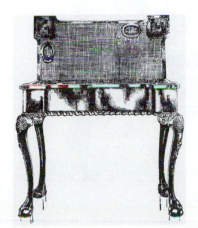
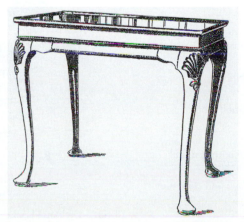

25-62. Tables.

center for Japanned furniture in the first half of the century, producing some of the finest examples.

■ *Seating.* Furnishings distinctive to the period are Chippendale chairs (Fig. 25-50, 25-57, 25-58), Queen Anne chairs (Fig. 25-39, 25-60), Windsor chairs (Fig. 25-61),

easy or wing chairs (Fig. 25-48), and camel-back sofas. Queen Anne chairs follow English prototypes in a curving silhouette, solid splat, and cabriole legs. Chippendale-style chairs feature rectangular outlines, pierced spats, trapezoid seats, and cabriole legs. Chinese, Gothic, and Rococo ornament are common. Philadelphia cabinetmakers create the most high style chairs featuring rich Rococo carving. Sofas have curvilinear backs and six cabriole or straight legs. Backs and seats may be lightly tufted to hold stuffing in place. Numerous loose pillows add comfort. Easy chairs, which have tall backs, wings, and straight or cabriole legs, commonly appear in bedrooms. Some conceal chamber pots in their seats. Chamber pots also fit into some corner chairs. The first Windsor chairs are imported from England in the 1720s; they are made in America by the 1740s. Often found in public buildings, Windsor's have low or high backs with spindles, saddle seats, and splayed legs.

■ *Tables.* Public rooms have numerous card and tea tables (Fig. 25-62), which line the walls when not in use. Card tables have a folding top like English examples. Tea tables have rectangular or round tops, often with pie-crust edges. Sideboard tables with marble tops define eating areas. Dining tables, made in several pieces, are plain since they

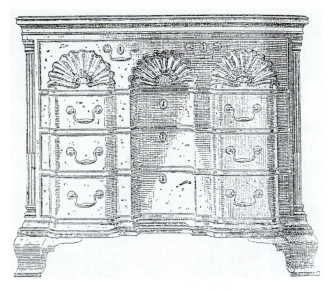

25-63. Chest of drawers, mid-18th century; Newport, Rhode Island; by John Townsend and John Goddard.

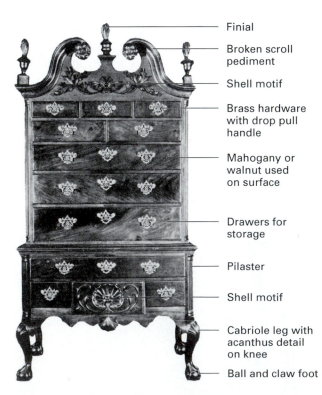

25-64. High chest of drawers (highboy).

- Finial
- Broken scroll pediment
- Shell motif
- Brass hardware with drop pull handle
- Mahogany or walnut used on surface
- Drawers for storage
- Pilaster
- Shell motif
- Cabriole leg with acanthus detail on knee
- Ball and claw foot

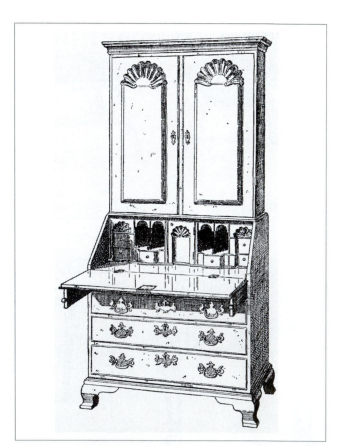

25-65. Desk and bookcase, mid-18th century.

are covered with a cloth when in use. Dressing tables, which frequently match high chests of drawers, are bedroom pieces.

■ *Storage.* Desks with drop lids for writing and bookcases (Fig. 25-65) often display pilasters, broken scroll pediments, and block fronts or they may be painted with Chinese landscapes. Newport is known for its blockfront furniture. Examples feature three panels that are convex, concave, convex, respectively. Atop each panel is a convex or concave shell carving. During the 1750s and 1760s, Boston cabinetmakers build excellent bombé (vertical out-

ward curving silhouette) chests of drawers, chest-on-chests, desks, and desks and bookcases. Low (Fig. 25-63) and high (highboys; Fig. 25-64) chests of drawers provide drawer storage in best bedchambers and may match beds and other pieces. Philadelphia is known for its matching high chests and dressing tables that are the most ornate in the Colonies. Carved ornament and designs often derive from Chippendale's *Director.* Chests-on-chests are common for storage of clothes in bedchambers. As clients order pieces individually, they determine the amount of embellishment. Brass hardware with curved details is common on

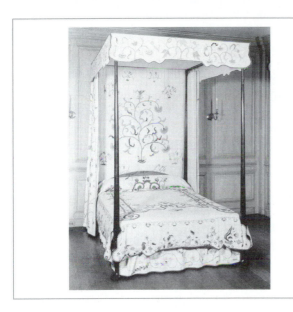

25-66. Bed with embroidered hangings, early 18th century; Cecil County, Maryland. (Courtesy, Winterthur Museum) (Color Plate 63)

25-67. Wallpaper, c. 1770; China, used in Powel House, dining room, Philadelphia.

Design Spotlight

Furniture: *Bed with Embroidered Hangings.* This bed (Fig. 25-66, Color Plate 63) with thin posts has elaborate embroidered bed hangings including the valance, curtains, head cloth, tester cloth, base, and counterpane. Originally the bed would have had curtains at the foot end. Textiles "en suite" such as these provide essential design and color in rooms. Embroidery may be done by the ladies of the house or imported from London where it is the work of professionals. The fabric may be natural linen or cotton with embroidery imitating Indian palampores in colors of rust, olive, gold, indigo blue, brown, and black.

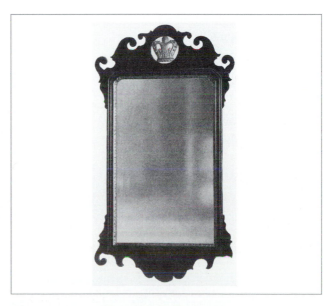

25-68. Looking glass.

25-69. Salt glaze plate, c. 1780.

flat surfaces. Typical forms include a shied back that may be pierced and a ring or bail handle.

- *Beds.* Poster beds (Fig. 25-66, Color Plate 63) with thin pencil posts are common in the best bedrooms and are usually embellished with elaborate bed hangings. Other beds include low posts, field beds with arched canopies, and press beds that fold for storage. Bedchambers often have several beds and pallets may cover floors at night to accommodate family members, guests, and servants. Beds often display elaborate textile valances, curtains, head cloths, tester cloths, bases (dust ruffle), and counterpane (coverlets). Shaped valances with flat tape trim are common. Tester cornices are commonly covered with fabric to match hangings. In the South, mosquito netting surrounds the bed for protection from insects. Wool is the most common fabric for bed hangings; muslin or dimity hangings replace heavier ones in summer.

- *Textiles.* Distinctive textile designs for upholstery, bed hangings (Fig. 25-67), window treatments, and wall appli-

cations (Fig. 25-67) copy European influences. English fabrics predominate as the colonies are forbidden to produce their own textiles. Typical fabrics include wools, linens, cottons, damasks, moires, chintzes, and some silks. Louis XV flowers, Indian palampore motifs, crewel embroidery (Fig. 25-66), *toile de Jouy* prints, and *Chinoiserie* patterns may embellish the surface. Wood-block and copperplate print fabrics are common. Textiles provide much of the design and color in rooms, and rooms done "en suite" (with all of the textiles matching) are typical. Furniture cases (slipcovers) of light fabrics to protect the upholstery are common.

- *Ceramics.* Foreign and domestic ceramics (Fig. 25-53, 25-69) may decorate American interiors, particularly niches, mantels, and tables. However, rooms are far less accessorized than today. English wares dominate the market, including those from Chelsea, Worcester, Bow, and Derby. Other ceramics imported into the colonies are delftware from Holland, Meissen from Germany, Cantonware from the Orient, and some Sèvres from France. Items include figures, vases, dinner services, and other serving pieces.

- *Silver.* Silver is both imported and made in the colonies and usually appears in the homes of the wealthy. Several American craftsmen become very well known, particularly Paul Revere. Items in production include flatware, candleholders, tea- and coffeepots, tea caddies, porringers, and serving pieces. Most Americans, however, eat and drink from pewter or wood vessels such as plates, cups, chargers, tankards, and spoons, which are relatively cheap and recyclable.

- *Later Interpretations.* Colonial Revival features various interpretations of 18th-century furniture design that may or may not be true to the original model. The precursor period also spawned historical reproductions offered by Kendall and Baker, Knapp, and Tubbs, and through stores such as Ethan Allen. Reproductions and adaptations of Georgian furniture and accessories remain fashionable today.

H. Early Neoclassical

The Neoclassical Movement, beginning in Rome and France in the 1740s, evidences a renewed interest in classical antiquity that encompasses Europe, Russia, England, and the United States. An outgrowth of scholarship, archaeology, and a reaction to the Rococo, this eclectic style seeks to imitate or evoke images of ancient Greece and Rome in art, architecture, interiors, furniture, decorative arts, landscapes, literature, dress, and behavior. Drawing on models from Egypt, Greece, Rome, and the Etruscans, the Early Neoclassical style can be plain, severe, and monumental or express the lightness, grace, and refinement of Rococo with classical forms and motifs.

A continuation of Renaissance and Baroque classicism, the Neoclassical Movement regards antiquity differently from these previous movements. Earlier designers saw themselves as inheriting antiquity and continuing its traditions. They believed that they designed in the manner of the ancients. In contrast, Neoclassical designers divide antiquity into different periods and styles with differing visual characteristics. They design by removing individual traits from their historical context and using them to solve present design problems.

Systematic scientific investigations by scholars, architects, and artists form a strong theoretical base for Neoclassicism. After studying ancient structures, many publish their analyses, theories, and drawings in architectural and art historical treatises. Designers now can more fully understand and choose from a broad spectrum of classical models. An important outgrowth of these investigations is the knowledge that Grecian art inspired the Romans. Admiration for Greece leads to the preference for Grecian models and, ultimately, to the Greek Revival in the 19th century when the ideal of Grecian simplicity supersedes Roman complexity and ornament. Archaeology also gives great impetus to the movement by providing models to study. The discovery and excavations at Herculaneum (begun in 1738) and Pompeii (begun in 1748), two Greco-Roman towns near Naples that were buried by an eruption of Mount Vesuvius in 79 B.C.E., inspire numerous architects, artists, and designers.

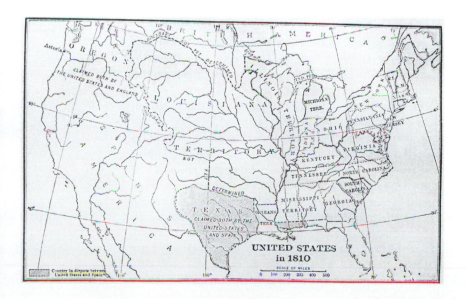

UNITED STATES
in 1810

26. Louis XVI and French Provincial

1774–1789

Amorous alcoves lost their painted Loves and took on gray and white decorations. The casinos of little comediennes did not glitter any more. English sentiment began to bedim Gallic eyes, and so what we know as the Louis XVI style was born.

Elsie de Wolfe, *The House in Good Taste*, 1914

Rejecting the unclassical Rococo and responding to the renewed interest in antiquity, Louis XVI style is a return to classicism. In architecture, images can be severe and monumental or graceful and elegant. Interiors, furniture, and decorative arts maintain the scale, elegance, and charm of Rococo, but lines straighten, curves become geometric instead of free-form, and ornament derives from antiquity.

LOUIS XVI

HISTORICAL AND SOCIAL

When Louis XVI takes the throne in 1774, he inherits an extremely troubled nation burdened by debts, inflation, and growing discontent among the people. The huge governmental bureaucracy, wars, and supporting the monarchy require great sums of money, and because the nobles and the church are not taxed, the burden falls on the *bourgeoisie* (middle class) and peasants. As the financial crisis worsens, the government bureaucracy works less and less effectively. When the population's needs exceed agricultural output, food shortages and famines fuel more discontentment. Louis XVI attempts reforms with the help of his ministers, but the nobility blocks most of their efforts. Further resistance comes from the writers and philosophers influenced in their thinking by the Enlightenment. They maintain that using reason and logic will help solve human ills, and that all people possess the right to property, life, and freedom, which governments should exist to maintain. These ideas appeal to the *bourgeoisie* and eventually filter down to the lower classes. Like the nobility, the middle and lower classes want a voice in government.

26-1.　Louis XVI.

26-2.　Marie Antoinette at Le Petit Trianon.

Though kind and genuinely concerned about his people, Louis is weak, ineffective, and often vacillates in making decisions. He prefers to spend time at his hobbies instead of governing. The French particularly dislike and distrust his wife, Marie Antoinette, whom they believe is

Important Treatises

- *Antiquities of Athens*, 1762; James Stuart and Nicholas Revett.
- *Observations sur l'architecture*, 1765; Abbé Marc-Antoine Laugier.
- *Thoughts on the Imitation of Greek Art in Painting and Sculpture*, 1755; Johann Winckelmann.
- *Treatise on Architecture*, 1759; William Chambers.
- *The Works in Architecture of Robert and James Adam*, 1773; Robert and James Adam.

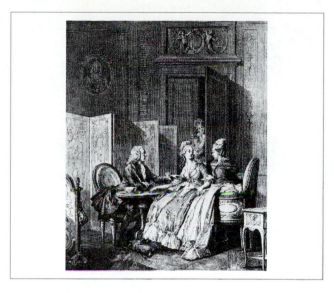

26-3. *Déclaration de la Grossesse*, engraving by Jean-Michell Moreau le Jeune.

more devoted to Austria, her homeland, than to France. Her extravagances and the poor reputations of her friends increase their suspicions and add to their antagonism.

In 1789, a land tax intended to avoid bankruptcy of the government brings immense opposition and forces Louis to call a meeting of the Estates General. For the first time in nearly two centuries, this representative body composed of the nobility, clergy, and commoners meets at Versailles. The Estates General assumes governing powers, a first step toward revolution. Commoners separate from the group and, declaring themselves a national assembly, vow to write a new constitution. Royal troops attempt to disperse the assembly, while an indecisive Louis XVI delays action. After Parisians take the Bastille, a royal fortress, on July 14, 1789, Louis must give in to their demands. The king and his family soon are imprisoned at the Tuileries in Paris. In 1791, a new constitution forms a parliamentary government and limits the powers of the monarchy. The constitution lasts only a year. Although Louis swears obedience to it, he continues to work against the revolution. To help restore the king's power, Austria and Prussia declare war on France. Nevertheless, on August 10, 1792, the monarchy is overthrown. In September, a National Convention declares France a republic. The king is convicted as a traitor, sentenced to death, and guillotined in early 1793. The violent Reign of Terror ensues, and the queen, numerous aristocrats, priests, and even commoners are executed.

CONCEPTS

France never completely rejects classical influence despite the dominance of the Rococo style in the first half of the 18th century. As early as 1730, critics begin attacking the artificiality and lack of classical order in Rococo as symptomatic of a depraved modern society. They call for a new classicism, one that is rational, truthful, and natural or derived from nature. As previously, the Academy of Architecture continues to emphasize classicism. French designers and architects, visiting the French Academy in Rome,

observe the work of their colleagues, who adopt a severe, structurally honest style. They collect the engravings of Piranesi, read the newest architectural theories, and visit ancient ruins. French Neoclassicism therefore draws on French 17th-century (Baroque) and Italian 16th-century classical traditions (Renaissance), the rationalist thought of the Enlightenment, as well as archaeological discoveries at Pompeii and Herculaneum. Influenced by designers' and architects' studies of antiquity, the Neoclassical style is more archaeologically correct than that of previous classical developments.

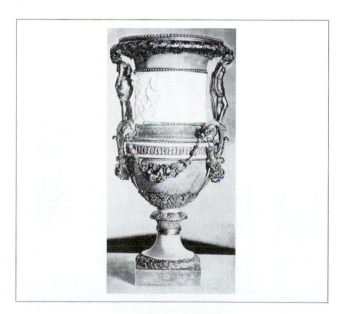

26-4. Vase in *porcelaine dure de Sèvres*; decorated by Boizot and Thomire.

26-5. Designs for marquetry panel vignettes, late 18th century; by Pierre-Gabriel Berthault.

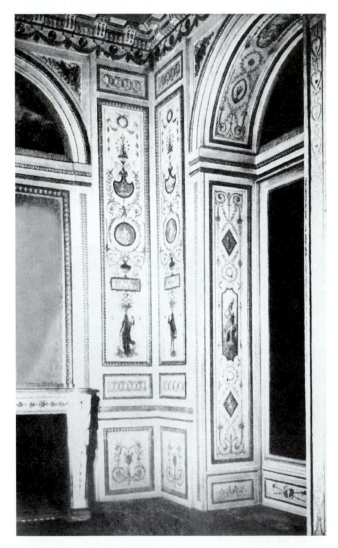

26-6. Wall detail, Boudoir de la Marquise de Sérilly; decoration by Rousseau de la Rottière, late 18th century.

DESIGN CHARACTERISTICS

General characteristics include light scale, rational planning, mathematical proportions, and an emphasis on straight lines and/or geometric forms. Classical forms and details dominate architecture, interiors, and furniture. Interiors and furniture maintain the scale and grace of the Rococo style but with straight lines, geometric curves, and greater simplicity. Designers employ classical attributes, such as symmetry and repose, as well as classical forms and motifs. Although designs often are assemblages of ancient motifs, the result is a modern manifestation. The French call the style *goût grec* or *goût arabesque*.

■ *Motifs.* Motifs (Fig. 26-4, 26-5, 26-6, 26-7, 26-14, 26-15, 26-16, 26-21, 26-25, 26-27, Color Plate 65) come from Greek, Roman, Etruscan, and Egyptian sources. They included garlands, swags, frets, *guilloches*, palmettes, classical figures, sphinxes, masks, flower, bouquets, baskets of flowers, shepherds, shepherdesses, farm tools, and bal-

26-7. Detail, balcony railing.

loons after the first successful balloon flight in 1783. Although classical motifs dominate, some Rococo themes continue, including flowers, shepherds, shepherdesses, bows, *Chinoiserie*, and *singerie*.

ARCHITECTURE

Architecture reflects the rationalist views of its designers, who strive for geometric volumes, structural honesty, and simplicity. Structures are blocklike with plain facades and minimal ornamentation. Designers, using antique models that supply form and details, often exactly reproduce individual parts, such as columns, but rarely copy entire buildings. Through their own or others' investigations and the numerous pattern books and treatises, architects are well acquainted with antique concepts. Late in the century, some begin designing visionary examples or structures with fanciful details, an influence of the English Picturesque.

The scale of buildings varies from monumental to elegant and refined. Proportions are broad and often derive from antique sources. Designers emphasize horizontality, clarity, stability, and repose, classical attributes that give feelings of dignity and grandeur. There is less emphasis on scale and specific design details to proclaim status and rank.

Public and Private Buildings

■ *Types.* Older building types, such as churches (Fig. 26-9), palaces, and *hôtels* continue. New types include markets, hospitals, theaters, and auditoriums. A unique example is Le Hameau (Fig. 26-11), Marie Antoinette's country farm and village on the grounds of Versailles. Reflecting a desire for simplicity and a return to nature, it serves as a place for her to escape court life and play country maiden. Motifs identified with her borrow from this rustic influence.

■ *Site Orientation.* Most structures face streets or squares (Fig. 26-8). Some residences are set in gardens that are carefully planned to look unplanned. They often feature classical and/or Gothic "ruins."

■ *Floor Plans.* Architects sometimes attempt to adapt antique plans to modern needs while striving to apply logic and reason to the planning of space. Distribution of rooms in residences remains generally the same as previously, but designers pay more attention to function. Plans are generally rectangular or centralized.

■ *Materials.* Brick, stone, and marble are the chief building materials (Fig. 26-9, 26-10). Some buildings have cast-iron details. Designers use trabeated and arcuated construction. A few reach back to Gothic construction techniques, which they consider honest.

■ *Facades.* Exteriors (Fig. 26-9, 26-10, Color Plate 64) are often composed of large geometric blocks and plain walls. Parts are clearly articulated, but ornamentation is minimal. Smooth, low-relief rustication highlights lower stories and some entrances. Pediments, columns, and porticoes mark entrances and ends. Columns are structural not decorative, while pilasters and engaged columns articulate facades and mark bays. Civic facades are usually tripartite.

26-8. Place de la Concord, 1753–1775; Paris; by Ange-Jacques Gabriel.

26-9. S. Geneviève (Panthéon), 1757–1790; Paris; by Jacques-Germain Soufflot.

Design Spotlight: Louis XVI

Architecture: *Petit Trianon*. Originally built for Louis XV as a place to escape with his mistress, this elegant small house (Fig. 26-10, Color Plate 64) on the grounds of Versailles was finished after her death. Marie Antoinette later transforms the surrounding gardens, enhancing the visual setting, and adds nearby Le Hameau. Consequently, this retreat environment boasts a beautifully proportioned classical building in close proximity to a rustic farm complex—both clear statements of the queen's desire for simplicity and nat-

uralness. Designed by architect Ange-Jacques Gabriel, the symmetrically balanced stone house epitomizes the architectural concepts of Neoclassicism. Corinthian columns define the garden entrance, large French doors and windows surround the facade, and classical balustrades highlight the terrace and roof. Intimate in scale, the exterior is generally plain and austere. The four facades are different in design but are related by various elements.

Small scaled, box-shaped house

Classical balustrade at roof

Corinthian columns
Plain, stone facade
French doors
Classical balustrade surrounds terrace

Planned garden
Symmetrical balance

26-10. Petit Trianon, 1761–1764; Versailles; by Ange-Jacques Gabriel. (Color Plate 64)

26-11. Le Hameau, c. 1774–1783; Versailles; by architect Richard Mique, gardener Antoine Richard, and painter Hubert Robert.

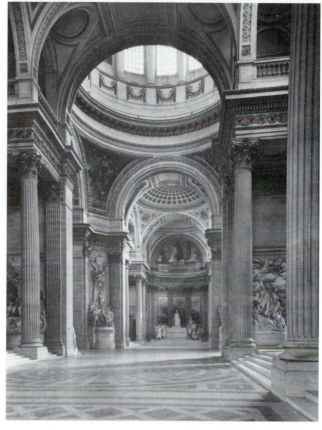

26-12. Central crossing with dome, S. Geneviève (Panthéon), 1757–1790; Paris; by Jacques-Germain Soufflot.

■ *Walls*. Walls are smooth and flat to emphasize volume. String courses rarely delineate stories, but most structures have a prominent cornice between wall and roof.

■ *Windows*. Windows (Fig. 26-10) are large and rectangular with plain and relatively flat surrounds. Some have straight lintels or triangular pediments above them.

■ *Doors*. Designers emphasize doorways with columns, pilasters, pediments, and rustication and through central placement.

■ *Roofs*. Most roofs are flat with balustrades (Fig. 26-10).

■ *Later Interpretations*. Following the French and American Revolutions and new, more democratic forms of government, Neoclassicism becomes the preferred style for government buildings. This influence continues today.

INTERIORS

As in architecture, Louis XVI interiors return to classicism in attributes and decoration instead of changes in layout and modes of living. Interiors retain the human scale, light proportions, and charm of the Rococo. Designers now emphasize classical motifs, symmetry, and straight lines. As before, unity is important. Aristocratic society has not changed; members still seek luxury, comfort, and gaiety. However, some occasionally advocate the (perceived) simplicity of the ancient world as long as it does not intrude on their quest for pleasure.

Because there were previously few known examples of Greek and Roman domestic architecture, classical interiors and furniture had been speculative at best. By this period, however, designers are able to visit archaeological discoveries to see the actual homes in which the ancients lived. A few "Etruscan" rooms (*goût étrusque*) with decoration derived from Pompeiian examples appear in the 1760s.

26-13. *Cabinet doré*, Royal Apartments, Palais de Versailles, c. 1770s–1780s; by Richard Mique.

Late in the period, designers and cabinetmakers begin to copy more closely ancient decoration and furniture.

Public and Private Buildings

■ *Floor Plans*. Distribution of rooms does not change during the period, but the trend toward smaller, more inti-mate spaces continues. The *salon* and *salle à manger* (dining room) become separate spaces. Dining rooms and *boudoirs* are more common.

■ *Color*. Colors become lighter and cooler, dominated by pale green, white, gray blue, and pearl gray. Black and red dominate Etruscan rooms.

26-14. *Le Salon de Musique* of Marie Antoinette, Royal Apartments, Palais de Fontainebleau, c. 1770s–1780s.

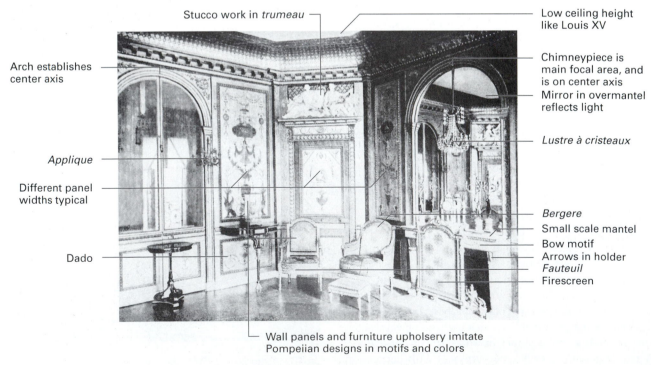

Stucco work in *trumeau*

Low ceiling height like Louis XV

Arch establishes center axis

Chimneypiece is main focal area, and is on center axis

Mirror in overmantel reflects light

Applique

Lustre à cristeaux

Different panel widths typical

Bergere

Small scale mantel

Bow motif

Arrows in holder

Dado

Fauteuil

Firescreen

Wall panels and furniture upholsery imitate Pompeiian designs in motifs and colors

26-15. *Boudoir* of Marie Antoinette, Royal Apartments, Palais de Fontainebleau, c. 1770s–1780s.

■ *Lighting.* As before, rooms are bright during the day from large windows but dark at night by today's standards. The use of oil lamps increases during the period, but they do not replace candles as the main artificial light source. The designs of ceiling lanterns, *lustres à cristeaux, flambeaus,*

Design Spotlight: Louis XVI

Interiors: *Boudoir of Marie Antoinette, Palais de Fontainebleau.* Certainly one of the most ornately embellished interiors of the period, this intimate space (Fig. 26-15) strongly emphasizes Neoclassical principles. Walls are symmetrically aligned and proportioned with major focal points in arches, classical figures accent the *trumeaus,* and imitations of Pompeiian wall paintings adorn the panels. Furnishings contribute to the theme. Brighter colors, gilding, and a painted aurora cloud ceiling enliven the interior. The chimneypiece, however, provides an unexpected rustic surprise—the mantel has a bow mounted horizontally and the supports have arrows as capitals with rounded arrow holders below. Bouquets of flowers decorate the dado panels. This blend of classicism and farm/hunting motifs is an important characteristic of the style.

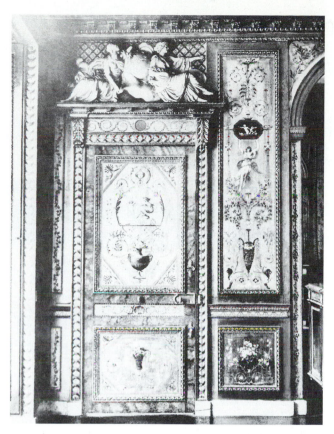

26-16. Door detail, *Boudoir* of Marie Antoinette, Royal Apartments, Palais de Fontainebleau.

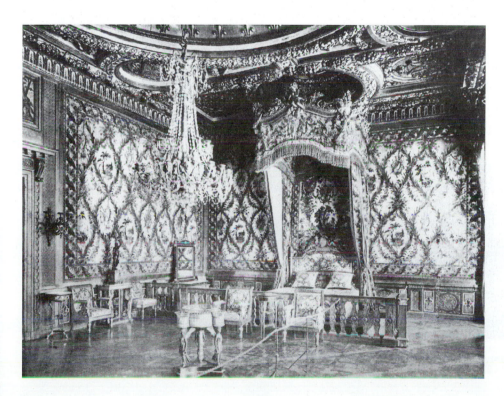

26-17. Bedroom of Marie Antoinette, Royal Apartments, Palais de Fontainebleau.

candelabra, appliqués, and *guéridons* reflect the new taste by displaying classical elements, such as columns, urns, and lyres (Fig. 26-28). *Girandoles* often feature classical figures. Ceiling fixtures hang from silk cords with tassels.

■ *Floors.* Parquet remains in vogue for most residential spaces (Fig. 26-13, 26-14, 26-19). Black and white marble also is fashionable, especially in churches (Fig. 26-12) and for residential vestibules, stair halls, and *salons.* The facto-

ries of Savonnerie, Aubusson, and Beauvais produce rugs in neoclassical patterns (Fig. 26-18). Matting replaces carpet in summer.

■ *Walls.* Symmetry continues to define wall paneling (Fig. 26-13, 26-14, 26-18, 26-19, 26-20, 26-21, 26-23) even to the point of a false door to balance a real one. As before, the common form is a large panel flanked by two smaller panels; opposite walls are similarly treated. A low dado with a field above capped by a cornice emulates the column. Panel moldings, smaller than previously, are gilded or painted in a color contrasting with the center. Decorative painting, wallpaper, or fabric adorns panel centers (Fig. 26-15, 26-16, 26-17, Color Plate 65). Similar to Pompeiian and Italian Renaissance walls, designs frequently display arabesques, grotesques, and classical figures. Wall paintings usually have large areas of flat color articulated with borders and unobtrusive repeating patterns and/or figures inside them. *Grisaille,* which imitates relief sculpture in monochromatic grays, is especially fashionable.

Carved stucco becomes an alternative to wood paneling in the 1750s, often imitating marble or stone or forming panels. Wallpaper increases in popularity. Common patterns include architectural papers, colorful arabesques in the Pompeiian manner, replications of textiles, and Chinese patterns. Matching or contrasting borders highlight cornices and other architectural details. Framed tapestries feature classical themes. Mirrors with classical shapes and

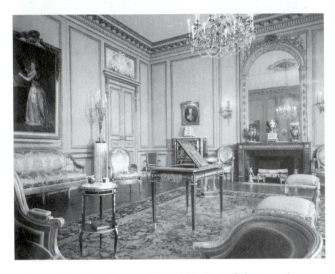

26-18. The *Tessé* Room, 1768–1772; Paris. [Photograph: 1996. The Metropolitan Museum of Art. Gift of Mrs. Herbert N. Straus, 1942. (42.203.1)]

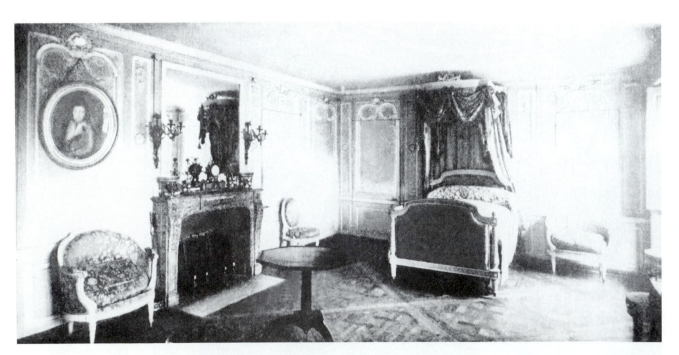

26-19. *Boudoir* of Marie Antoinette, Petit Trianon, 1787; Richard Mique.

decoration adorn fireplaces, furniture, walls, and/or piers between windows.

■ *Chimneypieces.* Protruding less into the room than before, chimneypieces (Fig. 26-13, 26-15, 26-19, 26-20, 26-21, 26-22) feature a vertically integrated mantel and overmantel. Mantels again become rectangular with a straight shelf usually supported by columns or brackets. Classical motifs, such as swags, urns, or masks, are carved on supports and beneath the shelf. Sometimes motifs representing country life appear, such as a bow and arrow embellishing a mantel shelf and support columns (Fig. 26-15). Although some mantels have contrasting colors of marble, most are plain white.

■ *Windows.* French doors/windows maintain universality. Most have complete entablatures above them. Windows in important rooms (Fig. 26-21, 26-23, 26-24) have curtains, with festoons being the most common form. Draperies and curtains typically have elaborate trims. Upholstery and drapery textiles that match in color are still popular.

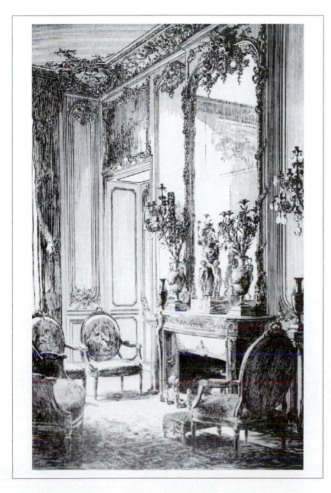

26-20. *Salon*, home of M. L. Double, late 18th century.

Design Practitioners: Louis XVI

■ *Martin Carlin* is an *ébéniste*, who mainly works in rosewood and decorates pieces with porcelain plaques. Carlin produces many pieces for Parisian *marchands-merciers* (dealers). Distinctive in his work are *ormolu* drapery swags.

■ *Ange-Jacques Gabriel* succeeds his father, Jacques, as *Premier Architecte du Roi*. His early work is Rococo, but about 1750 he abandons its for a severe, pure French classicism with roots in Louis XIV. His major works include small *appartements* at Versailles and the Petit Trianon. He also designs elegant, refined Neoclassical interiors.

■ *Georges Jacob* is an outstanding *ébéniste* who works in the Louis XVI, Directoire, and Empire periods. He is among the first to adopt mahogany for chairs, introducing the English tradition to France. He also introduces carved and pierced splats to chairs. Jacob founds a successful family cabinetmaking business that continues into the 19th century.

■ *Abbé Marc Laugier* supplies a theoretical base for Neoclassicism in *Essai sur l'architecture* (1753), in which he emphasizes the structural logic of classicism.

■ *Claude-Nicolas Ledoux* trains under J.-F. Blondel and becomes a leading designer of *hôtels*. His work becomes increasingly simplified and extreme, characterized by blocklike shapes and the Doric order. Also a visionary, he designs Chaux, an ideal city with fantastic structures, and creates interiors in the Neoclassical mode.

■ *Jean-Baptist Réveillion* produces the finest hand-blocked wallpapers in France in the late 18th century. No others rival his papers in design and printing. Designs feature refined classical arabesques in the Pompeiian manner printed in clear and bright colors in many shadings and variations of hues. With his work, French wallpapers begin to dominate the market.

■ *Jean-Henri Riesener*, a German, succeeds Oben as *Ébéniste du Roi*. He becomes the leading Neoclassical *ébéniste*, designing pieces that range from highly luxurious (early) to plain and simple (1780s). His works feature excellent marquetry and mother-of-pearl inlay. He designs many pieces for Marie Antoinette, often with marquetry roses. Riesener loses royal patronage when his prices become too high, and he quits working soon after the Revolution.

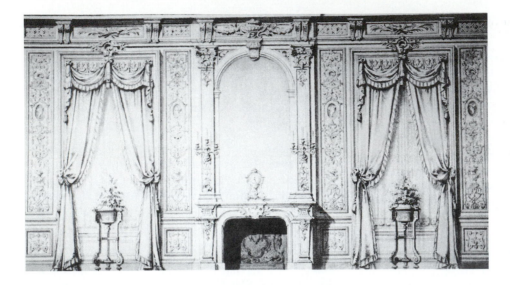

26-21. Wall elevation with chimneypiece and window, 1770s–1780s.

Important Buildings and Interiors: Louis XVI

- **Arc-et-Senans:** Royal Saltworks, 1774–1779, Claude-Nicolas Ledoux.

- **Fontainebleau:** Royal Apartments, Palais de Fontainebleau, c. 1770s–1780s.

- **Paris:**

 —The Barrière de la Villette, 1784–1787, Claude-Nicolas Ledoux.

 —Hôtel de Montmorency, 1769–1779, Claude-Nicolas Ledoux.

 —The Mint, 1768–1775, Jacques-Denis Antoine.

 —Place de la Concord, 1753–1775, Ange-Jacques Gabriel.

 —S. Geneviève (Panthéon), 1757–1790, Jacques-Germain Soufflot.

- **Versailles:**

 —Cabinet de la Méridienne, Versailles, 1781, Richard Mique.

 —Le Hameau, c. 1774–1783, architect Richard Mique, gardener Antoine Richard, and painter Hubert Robert.

 —Petit Trianon, 1761–1764, Ange-Jacques Gabriel, Marie Antoinette's Boudoir, 1787, Richard Mique. (Color Plate 64)

 —Royal Apartments, Palais de Versailles, c. 1770s–1780s, Ange-Jacques Gabriel, Richard Mique, and others.

26-22. Chimneypieces; by LaLonde.

■ *Doors.* Doorways in public spaces serve as important paths of circulation and therefore display elaborate classical moldings. Often, heights are greater than in residential buildings. Palaces and *hôtels* have door panels (Fig. 26-15, 26-16, 26-18, 26-25, 26-26) similar to wall paneling. They may be painted or stained wood. Panel moldings may be gilded, and panel centers may feature painted arabesque decorations. As in the Rococo period, *trumeau* paintings are still in vogue, but subjects become classical or feature landscapes.

■ *Ceilings.* Public spaces (Fig. 26-12) feature vaulted and coffered ceilings enhanced with classical moldings. Domes may highlight center crossings or define an important area.

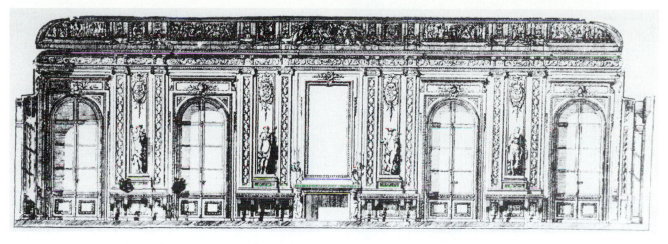

26-23. Wall elevation showing French doors and chimneypiece; c. 1770s–1780s; by Desprez.

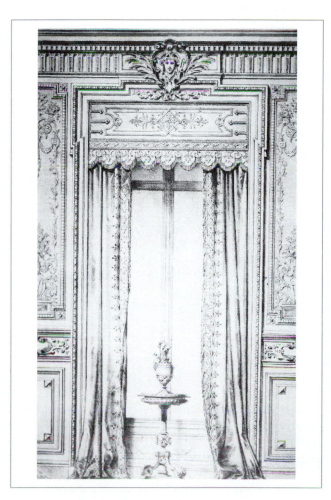

26-24. Window detail.

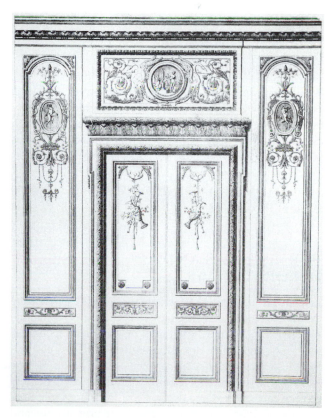

26-25. Door detail.

26-26. Wall elevation showing *boiserie*, *Salle à Manger*, Hôtel de la Perfecture à Lille.

Residential designs for ceilings (Fig. 26-17, 26-19, 26-20, 26-27) vary from plain to ornate. Most are flat and simply painted, unlike those in England. Important rooms may have ceilings with combinations of geometric shapes symmetrically arranged and accented with classical motifs and flowers. Other spaces feature decorative borders with elaborate corner motifs.

■ *Later Interpretations.* In the late 19th century, designers begin to revive Louis XVI interiors and furniture. Society decorator Elsie de Wolfe reestablishes a taste for French designs, starting with the renovation of her own home (Fig. 26-29). Her book, *The House in Good Taste*, and various consumer magazines popularize her ideas (Fig. 26-30). Louis XVI designs are still widely imitated today, but less so than Rococo designs.

26-27. Ceiling designs.

FURNISHINGS AND DECORATIVE ARTS

Like interiors, Louis XVI furniture depicts Neoclassical motifs in the form and scale of Rococo. Pieces are simple rectangles with outlines softened by ornament. Columns, moldings, and other details carefully articulate parts in the classical manner. Circles, ovals, and ellipses replace Rococo's asymmetrical, complex curves. Straight legs replace cabriole legs. As the acme of French cabinetmaking, the style's construction, excellent proportions, and harmonious ornament are never surpassed. Although named for him, the style appears before Louis XVI takes the throne and continues after his death. Classical influence first appears as ornamentation between 1760 and

1770, a transitional period. By 1775, the style has fully taken hold.

Private Buildings

■ *Types.* All types of Louis XV furniture continue. Some new table forms based on Pompeiian designs appear, especially late in the period. Dining tables are more common.

■ *Relationships.* The Baroque and Rococo practice of designing furniture to suit the design and colors of the room

26-28. Lighting fixtures: *Flambeaus*, *candelabra*, and *appliques*.

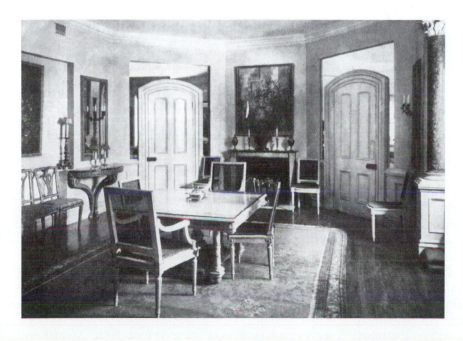

26-29. Later Interpretation: Dining Room, Irving House (home of Elsie de Wolfe), c. 1898; New York City; by Elsie de Wolfe.

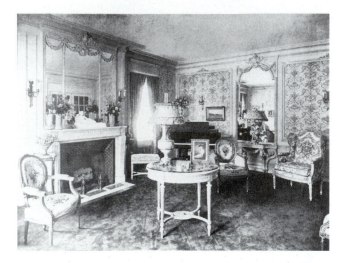

26-30. Later Interpretation: *Salon* in the Louis XVI style, as published in *Room Beautiful*, 1915.

Design Spotlight: Louis XVI

Furniture: *Fauteuils.* Similar in scale to Louis XV versions, *fauteuils* (Fig. 26-31) appear formally or informally grouped within interiors. Rectangular and oval chair backs are common. Legs are straight, tapered, and/or fluted; some are spiral cut. Gilding and/or painting accent the frame. Horizontal arms have *manchettes* (arm pads) resting on curving supports. Upholstery may be of silk, cotton, linen, or tapestry. Typical pattern motifs include swags, vases, flowers, rinceaus, urns, acanthus leaves, classical figures, and stripes; some examples feature farm motifs such as straw hats, shovels, and corn. Popular colors include dull shades of gray, green, yellow, and pink on cream backgrounds.

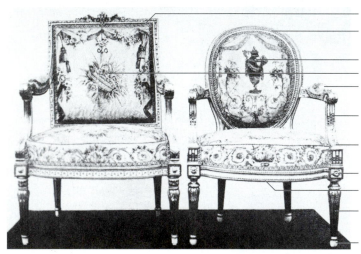

Rectangular back
Oval back

Classical motif
Country motif
Manchettes
on curved arm
Curved arm
support
Gilded or painted
finish common
Rosette in square
Apron curved
Tapered
and fluted leg
Toe cap

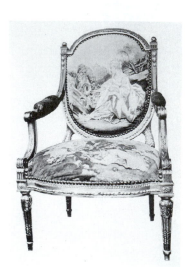

26-31. *Fauteuils* showing various tapestry designs.

continues. Form and proportions often determine the placement of a piece. Seating, beds, or storage pieces often sit in specially designed niches. Furniture continues to be arranged around the perimeter of the room when not in use.

■ *Distinctive Features.* Rococo's light proportions, slender forms, and human scale continue as do some motifs, such as flowers, symbols of love, hunting, and music. Straight lines, geometric curves, and classical motifs distinguish Louis XVI furniture from Rococo. Legs become straight, tapered, and/or fluted (Fig. 26-33). The quiver leg, shaped like a quiver of arrows, is new. Spirals, which are extremely difficult to carve, are reserved for the legs on the finest pieces. A characteristic feature is a reentrant corner formed by part of a square or circle with a rosette in the center

(Fig. 26-35, 26-36); it is usually found on *commodes* and on chair frames and leg. Oval backs are new (Fig. 26-31). Late in the period, pieces often have large areas of plain mahogany, a reflection of a new emphasis on simplicity.

■ *Materials.* Mahogany and ebony are the most popular furniture woods. Wood frames of seating may be left natural, partially or entirely painted, or gilded. Marquetry and gilding retain their popularity. Especially fashionable are two-tone gilding composed of shiny and flat areas and marquetry landscapes and/or classical scenes (Fig. 26-35). Geometric marquetry in lozenges and trellis patterns becomes more common. Boullework is revived. Both Oriental and French lacquerwork remain in vogue. People now prefer Japanese lacquer in gold and black. Dominant colors for

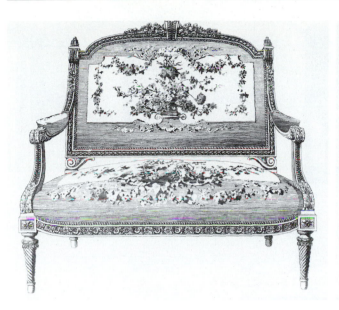

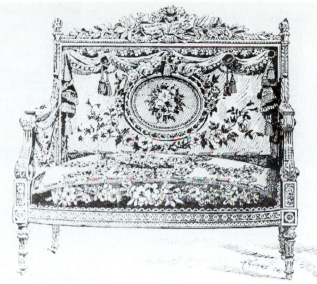

26-32. *Canapés* with tapestry designs.

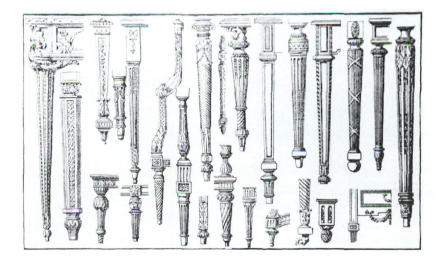

26-33. Designs for furniture legs.

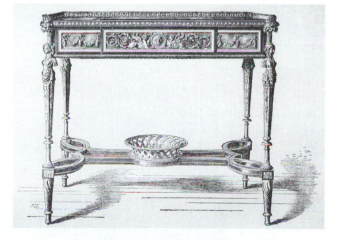

26-34. Table in bronze given by Marie Antoinette to Madame de Polignac.

vernis martin (French lacquer) are red, bright blue, and green. Gilt bronze mounts are unsurpassed in their excellence. Also common are metal inlays, toecaps, and castors. Porcelain plaques often decorate pieces (Fig. 26-35), particularly writing furniture for women. Louis XVI's love of mechanical devices assures their incorporation into many pieces of furniture. At the end of the period, plain and undecorated mahogany surfaces and metal furniture, especially for tables, become fashionable.

■ *Seating.* All Louis XV types of *chaises*, *fauteuils*, and *canapés* continue, but reflect Neoclassical design principles (Fig. 26-13, 26-14, 26-15, 26-17, 26-18, 26-19, 26-20, 26-31, 26-32, 26-33). Pieces retain the outlining wooden frames of the Rococo style, but their straight lines now are

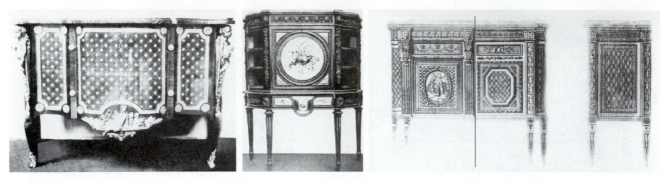

26-35. *Commodes* with marquetry and porcelain decoration.

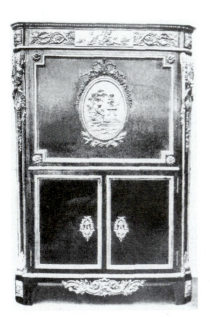

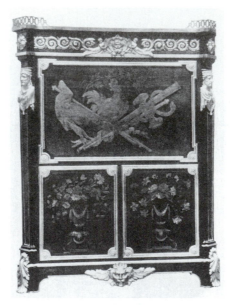

26-36. *Secrétaire à abattant.*

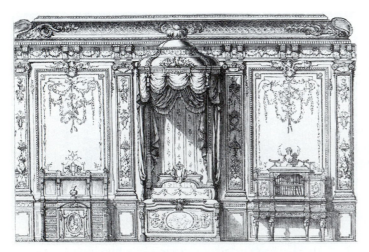

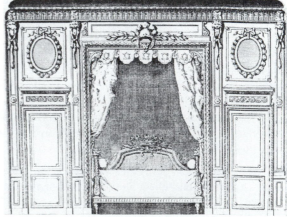

26-37. Wall elevations with *lit* (bed).

26-38. Textile: Brocade.

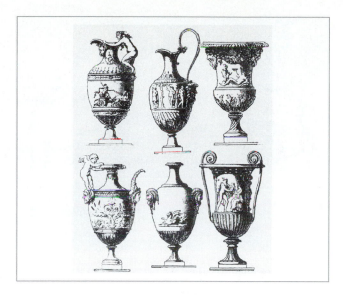

26-39. Vases; by Charles Normand.

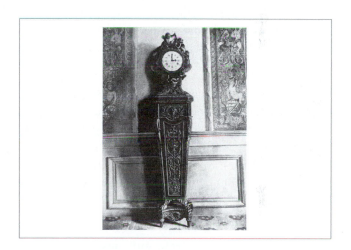

26-40. Tall clock; by Martin Carlin.

carved with classical running patterns, such as the bead. Continuity of parts disappears in response to classicism's demand that points of junction be delineated. Chair backs may be rectangular or oval (Fig. 26-31); some feature balloon shapes and splats after the first balloon flight in 1783. About 1785, the sabre leg (quadrangular, outward curving leg) replaces straight back legs, and arms begin to curve back from the front of the seat.

■ *Tables.* Tables (Fig. 26-18, 26-34), small and large, remain numerous as before. Small, movable ones with serpentine tops and elongated cabriole legs, similar to Louis XV tables, continue. A new form based on a Pompeiian tripod table appears (Fig. 26-17). Dining tables, made in parts, usually divide in the center. Each portion has drop leaves. Some have castors and/or extra leaves. Dining tables stand against the wall when not in use. *Consoles* (Fig. 26-23) with Neoclassical designs are in vogue for drawing rooms and *salons*.

■ *Storage.* Commodes (Fig. 26-18, 26-35) remain fashionable, and their shapes and decoration reflect the new style as do other case pieces. Rectangles, circles (bow front), or semicircles (*demi-lune*) replace the undulating surfaces of Rococo pieces. The straight legs are tapered and fluted or

vase-shaped. Small classical moldings, key patterns, Vitruvian scrolls, palmettes, *guilloches*, and garlands highlight facades. Marquetry of flowers, trophies, landscapes, architecture, or classical figures embellishes doors or drawers (Fig. 26-35). Tops are of marble. Later pieces feature columns or caryatids on corners. New is the *commode-desserte*, an oblong piece with rounded ends. Doors and/or drawers fill the center, and shelves with brass galleries fill the quarter-circle ends. The *secrétaire à abattant* (Fig. 26-36) becomes more architectural with columns, pilasters, and pediments. Some have matching bookcases.

■ *Beds.* All types of Louis XV *lits* remain (Fig. 26-17, 26-19, 26-37). As before, they are draped or have canopies. Hangings match other fabrics in the room. Beds in alcoves are common.

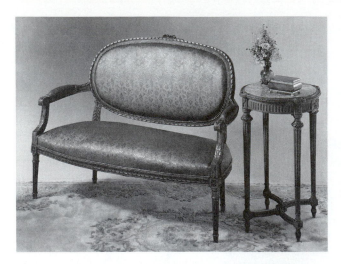

26-41. Later Interpretation: Settee covered in Naugahyde brocade, c. 1950s.

■ *Textiles.* Textiles are basically the same as in the Louis XV period, but motifs now are classical—urns, acanthus leaves, classical figures (Fig. 26-31, 26-32, 26-38). Cottons and linens become more common. Painted silks feature classical motifs. Tapestries adorn sets of furniture, and stripes are more fashionable than before. Textiles in a room often match. Colors are lighter and often duller than before, such as gray or lilac, with white and gold becoming the most fashionable.

■ *Decorative Arts.* Accessories and decorative arts reflect the classical in form and designs, particularly vases and clocks (Fig. 26-39, 26-40). Figures in classical dress are common motifs. Design and workmanship are unsurpassed. Although shapes for porcelains become severe and lines simple, decoration is sumptuous with classical landscapes

and/or figures and heavy gilding. Straight sides and rectangular handles distinguish Neoclassical porcelains. Pieces are heavier and more solemn in feeling than Rococo pieces. In the 1780s, Sèvres introduces jeweling (drops of colored enamel).

■ *Later Interpretations.* As in interiors, Louis XVI style is revived in the late 19th century. Edith Wharton and Elsie de Wolfe promote it as a timeless, enduring style. Variations of Louis XVI furnishings continue in popularity through the 1950s (Fig. 26-41, illustrating the use of the new vinyl fabric naugahyde) and are still produced today, often dramatically painted and/or upholstered (Fig. 26-42).

FRENCH PROVINCIAL

Provincial, *rustique,* or *régional* refers to houses, interiors, and furniture of the peasants and *bourgeoisie* in the rural areas of France from the reigns of Louis XIII through French Empire. Although inspired and influenced by court or high styles, provincial is simpler in design, construction, and decoration. Unlike high styles, provincial examples maintain traditional elements and exhibit regional varieties based on climate, geography, economy, and materials. Provincial types continue in France's New World colonies.

HISTORICAL AND SOCIAL

By the beginning of the 17th century, relative peace and prosperity in France spread to the peasants and the *bourgeoisie.* Although most of them continue to live simply with only a few possessions, their interest in fashionable court styles of furnishing increases. Regional cabinetmak-

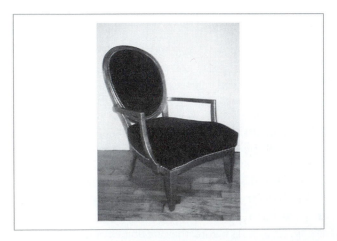

26-42. Later Interpretation: Armchair in Louis XVI style, c. 2000.

26-43. Etching of woman; by Gerard Dow.

ers look to Paris for inspiration; those closer to Paris show more high-style influence; and those farther away demonstrate far less. Some areas, such as Alsace, exhibit influences from bordering countries.

CONCEPTS

Increased wealth fosters the adoption of more and fashionable furniture by the middle and lower classes. Provincial or *régional* styles are subject to local tastes and traditions, the wealth of clients, local climate, nearby influences, and available materials. Houses, interiors, furniture, and decorative arts reflect a simpler lifestyle less dependent on wealth, rank, and status.

DESIGN CHARACTERISTICS

Provincial styles derive from high or court styles, but are simpler, less refined, and/or more naive than high styles. Examples exhibit strong, identifiable regional character. Necessity and practicality are important in the types of pieces chosen, materials, and decoration. Provincial furniture is well made, often well designed, and possesses a certain charm. Nevertheless, it is a vernacular interpretation of court styles. Local traditions and preferences more strongly define the image than national styles.

■ *Motifs.* Typical motifs (Fig. 26-47, 26-49, 26-53, 26-54) borrow and adapt from high styles and include lozenges, stars, circles, fruit, flowers, foliage, shells, C and S scrolls, columns, colonnettes, fluting, urns, and lyres.

ARCHITECTURE

Homes of the *bourgeoisie* and peasants range from medium-sized mansions to simple, plain one-room cottages (Fig. 26-44). Function and tradition are more important than style or design principles such as symmetry. Dwellings are built of local stone, brick, or wood and plaster. Roofs may be of thatch, tile, or shingles. Grander homes may be more likely to follow prevailing architectural styles and planning than peasant dwellings.

INTERIORS

Wealthier *bourgeoisie* can more readily follow prevailing decorating trends. Nevertheless, most interiors are simply

26-44. Farmhouse; Normandy.

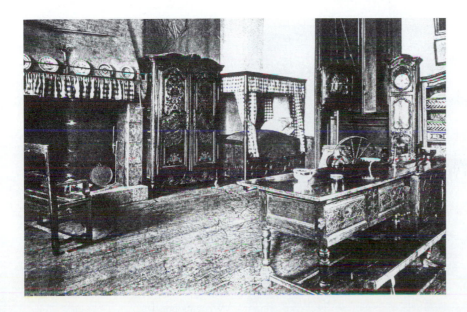

26-45. *Salle de Ferme;* d'Ille-et-Vilaine.

treated (Fig. 26-45, 26-46, 26-47, 26-48). Common treatments include paneling on at least one wall, textile hangings, wallpaper, and painted decorations. Rugs and curtains are rare.

FURNITURE

Provincial furniture adapts the forms, contours, and some of the ornamentation of court styles to local needs and preferences. Local cabinetmakers are able to follow high styles, particularly in the 18th century with help from numerous pattern books. However, clients generally regard comfort, convenience, and economy as more important than fashion. Scale relates to human proportions and suits smaller rooms in smaller houses. Ornamentation is less profuse and often naive. Carving is the main form of decoration.

Regional character is stronger in provincial furniture than in high style. Although furniture types are similar throughout France, supporting the similar lifestyles of provincial peoples, some regions prefer and/or more highly develop certain types. Some pieces are unique to a particular region. An example is the *panetière* (bread cupboard; Fig. 26-56) of Provence and Normandy. Woods and deco-

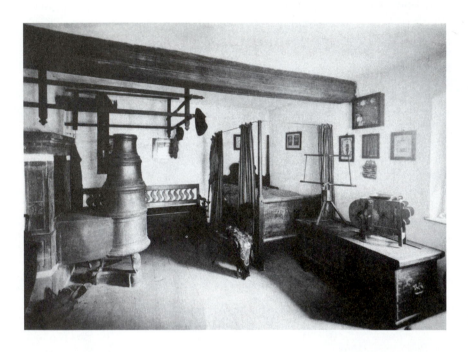

26-46. *Salle de la Maison Alsacienne;* Nancy.

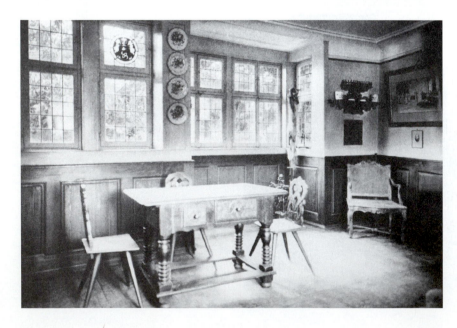

26-47. *Salle de la Westercamp;* Wissenbourg.

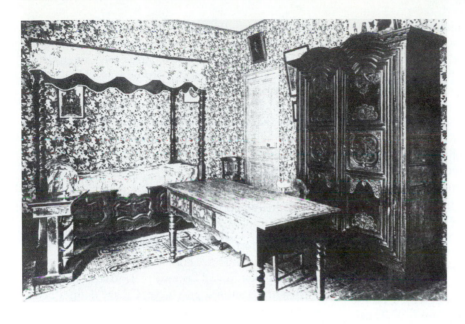

26-48. *Chambre à Coucher.*

26-49. Panel detail.

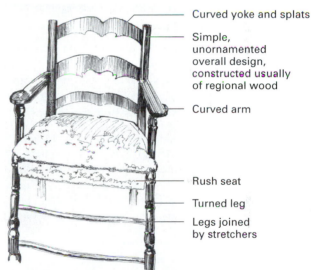

Curved yoke and splats

Simple, unornamented overall design, constructed usually of regional wood

Curved arm

Rush seat

Turned leg

Legs joined by stretchers

26-50. *Chaise à capucine.*

Design Spotlight: French Provincial

Furniture: *Chaise à capucine.* The majority of *régional* furniture follows the 18th-century Rococo style in curvilinear form and ornament. Comfort, convenience, and economy are more important than fashion. Scale relates to human proportions and suits smaller rooms in smaller houses. This *chaise* (Fig. 26-50), a popular chair type, typically features a rush seat, curved back splats, and turned legs with stretchers. Outlines usually are simple and uncomplicated. Variations of this form appear in Canada and the United States with the emigration of French settlers from the provinces.

26-51. Table.

ration also vary with the region. Styles often last longer in the provinces and/or may mix characteristics of several high styles.

Louis XIII (reigned 1610–1643) is first of the court styles to exhibit regional or provincial character in the early 1700s; it lasts about a century in most areas. People in Gascogne prefer its spiral turning and geometric ornamentation much longer. Although the Louis XIV style (reigned 1643–1715) generally is too grand and opulent for provincial tastes, its influence appears most often in the panels of *armoires* and other case pieces. The majority of *régional* furniture follows the 18th-century Rococo style in curvilinear form and ornamentation. Rococo or Louis XV (reigned 1715–1774) style easily adapts to the needs of all. Because its scale, charm, grace, and comfort have universal appeal, the style dominates provincial furnishings even throughout the periods of Louis XVI (1774–1789), Directoire (1789–1804), and Empire (1804–1814). Louis XVI style appears most often in classical ornamentation and mixes in shape and ornament with Rococo. Directoire and Empire have little effect in the provinces.

■ *Types.* Because of their simpler lifestyles, provincial people require fewer types of furnishings. Typical early pieces include chairs, beds, chests, and tables. During the prosperous 18th century, tall case clocks, writing furniture, *canapés*, and wall shelves add to furnishings.

■ *Distinctive Features.* All regions share a preference for turning. Legs may be turned or cabriole; stretchers are characteristic. Seats in all periods are wood or rush. Backs may have spindles, slats, lattice, or splats. Back shapes depend on style; Rococo slats curve, while Louis XVI types are straight. Outlines usually are uncomplicated, but some

pieces are *bombé* and/or serpentine in form. Similarly, paneling on case pieces follows style in shape and decoration although asymmetrical, Rococo curves most often define panels. Aprons (horizontal supports under tabletops or the bottoms of case pieces), cornices, and stiles (vertical members in a panel) often feature carved or applied decoration. Metal hinges in brass or steel often run the entire length of panels. Escutcheons (metal plates surrounding a key hole) are prominent.

■ *Relationships.* More practical and utilitarian, provincial furniture rarely demonstrates rank or precedence. However, people do highly prize certain pieces, such as the *armoire*, and proudly display them in public rooms of their homes.

■ *Materials.* Most pieces are of solid wood (Fig. 26-53, 26-54). Wood varies by region, but oak and fruitwoods are common. Normandy and Brittany prefer oak, while walnut dominates the southern provinces. Cherry defines better pieces. Imported mahogany is limited to very fine pieces for the *bourgeoisie* after the mid-18th century. Construction, usually simple, varies with the skill of the cabinetmaker and the region. Areas closer to style centers often see more finely constructed and ornamented examples. Veneer, marquetry, *ormolu*, and gilding are less common than in high styles, but may define pieces from Lorraine. Examples from Alsace often feature painted decoration, often with colors in blue, white, or gray.

■ *Seating.* Seating (Fig. 26-45, 26-46, 26-47) includes turned and ladder-back *chaises*, *fauteuils*, stools, benches, and *canapés*. Upholstery is rare; cushions are used for comfort. Common in all regions is the *chaise à capucine* (Fig. 26-50), a turned arm- or armless chair with rush seat and legs joined by stretchers. Contours and back slats may

26-52. Table, late 18th Century.

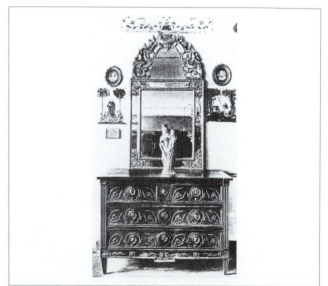

26-53. *Commode.*

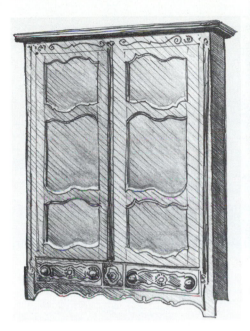

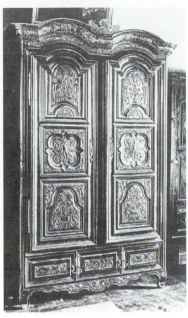

26-54. *Armoires.*

curve in response to Rococo style or be straight under Louis XVI influences. The *chaise à bec corbin* follows Louis XIV shape, but turning replaces its molded and carved arms and legs.

■ *Tables.* Provincial homes typically do not have the card, tea, and toilet tables of grand ones. However, dining tables, small occasional tables, and work tables are common (Fig. 26-45, 26-47, 26-48, 26-51, 26-52). Shapes and ornament follow prevailing styles.

■ *Storage.* Typical case pieces are *commodes* (Fig. 26-53), *buffets*, wall and standing cupboards, *armoires*, and chests. Chests (Fig. 26-46) are common storage pieces throughout the periods. *Buffets* also are characteristic in provincial dining rooms or kitchens. Variations and names differ by region. The *buffet bas*, a long, low cupboard, is most common in all regions. Typical in Normandy and Provence is the *buffet à deux corps*, a two-part cupboard with paneled doors and drawers. As in high-style interiors, *commodes*, typically with three drawers and brass bail handles, become common in provincial public rooms in the 18th century. Rococo contours may be *bombé* or serpentine, while semicircular contours define Louis XVI examples. *Armoires* (Fig. 26-45, 26-48, 26-54) are highly prized pieces. Most have two long paneled doors and a straight or arched cornice. Those influenced by Rococo designs stand on short cabriole legs and feature curvilinear panels and tops and naturalistic decoration.

■ *Beds.* Four-poster beds (Fig. 26-45, 26-46, 26-48, 26-55) are common, but some are built into wall alcoves, particularly in colder regions. Poster beds have hangings for warmth and privacy. The *lit clos*, typical of Brittany and

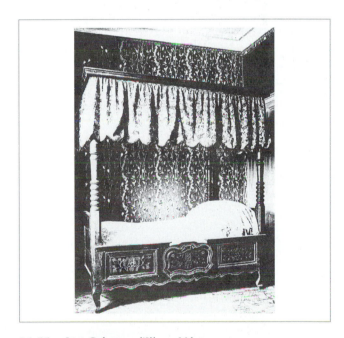

26-55. *Lit à Colonnes*; d'Ille-et-Vilaine.

colder regions, resembles a cupboard with its paneled sides and doors or curtains. In the 18th century, wealthier homes sometimes possess a *lit d'ange* (with a canopy not as long as the bed attached to the wall) or a *lit à la duchesse* (with a canopy as long as the bed attached to the wall).

■ *Textiles.* Textiles range from silks, cottons, woolens, linens, and homespun. In the second half of the 18th century, rooms become more colorful with toiles and painted

26-56. *Panetière.*

26-57. Later Interpretation: Bedroom suite, c. 1990s–2000.

or printed chintzes. The housewife sometimes embroiders seat covers. Few pieces are completely upholstered, but people use cushions for comfort. Window curtains remain rare.

■ *Decorative Arts.* Wall and *buffet* shelves often display local pottery, brass, or pewter. Dining rooms often feature *lavabos* or wall fountains. Tall case clocks become popular in the 18th century.

■ *Later Interpretations.* Provincial, an American term, appears in the early 20th century in response to demands

for French furnishings. Simpler *régional* furniture is easier and cheaper to manufacture than court styles. French Provincial remains a fashionable residential style today (Fig. 26-57).

27. Late English Georgian

1760–1810

The present reign is indeed rendered remarkable by the multitude of magnificent buildings, fine streets, and spacious squares, that have been added, and still are adding to this metropolis.

Anonymous, *London and Its Environs Described,* 1761

The Late English Georgian period wholeheartedly adopts Neoclassicism for architecture, interiors, and furniture. Although a continuation of the classicism of Neo-Palladian architecture, the new style exhibits slenderer proportions, flatter details, and more ornamentation. Designers freely adapt elements and motifs from ancient civilizations. Robert Adam is the leading Late Georgian designer of architecture, interiors, and furniture. Following the example set by Chippendale, books by George Hepplewhite and Thomas Sheraton illustrate prevailing Neoclassical modes in furniture.

27-1. Costume.

HISTORICAL AND SOCIAL

George III assumes the throne in 1760 and determines to regain the powers of the monarchy taken by the Whigs. His lack of statesmanship and the fact that his reforms resemble absolute monarchism prevent his effecting any lasting changes. Following the loss of the American colonies, Britain attempts reforms under the leadership of Prime Minister William Pitt, the Younger. Pitt helps reestablish the country's credibility and promotes social changes, such as the abolition of slavery. These and other moderate reforms end with the French declaration of war in 1793.

The effects of the Industrial Revolution begin to make themselves known during the period. Agricultural and textile production increase, and new materials, such as cast iron, appear. Pritchard and Darby erect the first cast-iron bridge at Coalbrookdale, Shropshire, in 1779. James Watt's steam engine provides power for numerous factories after 1775. London and other cities experience unprecedented growth and development. Cities soon feature wider, paved streets, more lighting, and new housing. Industrialization enables the larger and wealthier middle class to adopt fashionable trends in housing, clothing, and furnishings.

Despite technical innovations, the period witnesses much violence and repression. Riots are common, and people can be executed or imprisoned for seemingly minor infractions of the law. Although the nobility lives long and well, the lower classes do not benefit equally. Many die of disease and starvation. The practice of medicine is primitive at best, and principles of cleanliness and good nutrition are rare. Even among the wealthy, beauty aids, such as white lead, can be lethal.

Although George III takes more interest in government than his predecessors, like them, he is not interested in music, the arts, or architecture. He is neither a collector nor an arbiter of taste. Therefore, his court is not as splendid as those of Louis XV and Louis XVI of France. Nor do design innovations arise from royal patronage. Instead, they come from the nobility and middle classes. Nevertheless, British society is refined with polished manners, and grand tours of Europe remain important for young gentlemen. Members of all classes increasingly study and admire antiquity.

CONCEPTS

Neoclassicism becomes fashionable during the 1760s, eclipsing a brief enthusiasm for Rococo, Chinese, and Gothic Revival. The previous half-century of Neo-Palladianism prepares the British to join the rest of Europe and again be

inspired by antiquity. Artists, architects, and others continue their grand tours to Italy and Greece, as well as other ancient sites. As on the Continent, sources of inspiration expand, and designers increasingly rely on archaeology and the many authoritative studies of Greek and Roman art and architecture.

Robert Adam, architect, interior designer, and furniture designer, dominates the period. Adam's work draws from Greece, Rome, Italian Renaissance and Baroque, and the French Renaissance. As he adapts, expands, and abstracts forms and ornamentation, Adam freely breaks the rules and varies proportions according to the situation in contrast to the more rigid Neo-Palladianism. He strives for movement, which he sees as advancing or receding planes, flexibility, and the picturesque. Like others before him, Adam exercises complete design control by designing everything, including furniture and accessories, to create a harmonious decorative scheme.

DESIGN CHARACTERISTICS

Neoclassical designers continue the Neo-Palladian principles of symmetry, unity, formality, and classical elements. However, they adapt a broader range of elements from many sources, and their use of elements becomes more archaeologically correct. They strive for elegance and lightness, but scale ranges from monumental to small and elegant. Plans often consist of rooms in contrasting shapes and sizes, as derived from prototypes such as Roman baths and Imperial palaces.

In England, interiors are the prime expression of Neoclassicism. As defined by the work of Robert Adam, rooms are light in scale, formal, and refined with classical motifs and elements in low relief plaster against brightly colored walls and ceilings. Rugs typically reflect ceiling designs. Curved walls and niches add movement. Similarly, furniture is light in scale and dominated by classical motifs, although not necessarily classical in form. Contrasting geometric and curvilinear shapes in form and ornamentation repeat the contrasting shapes of plans.

■ *Motifs.* Architectural and interior details (Fig. 27-2, 27-3, 27-4, 27-5, 27-20, 27-21, 27-27, 27-28, 27-30, 27-31, 27-32, 27-33, 27-35, 27-36, 27-37) include swags, urns, pediments, paterae (oval or circular forms with radiating lines), anthemions or honeysuckles, classical figures, lyres, laurel wreaths, columns, pediments, and other classical elements. Furniture motifs (Fig. 27-44, 27-47, 27-52) include swags, urns, paterae, Prince of Wales feathers, lyres, vases, wheat, ribbons, honeysuckles, drapery, classical figures, architectural details, and repeating patterns.

27-2. Door hardware; by Robert Adam.

27-3. Wall ornament; by Robert Adam.

27-4. Entablature detail.

27-5. Jasperware, Wedgwood Factory; by Josiah Wedgwood.

ARCHITECTURE

English Neoclassical architecture favors simple geometric shapes and elegant classical decoration. Varying from severe to graceful, the style incorporates some principles and forms of Palladianism. However, it relies on a broader range of antique (Egypt, Greece, and Rome) and later models (Renaissance and Baroque) and often uses classical elements in a different way than before. Unlike French buildings, English buildings sometimes have picturesque qualities, such as complicated silhouettes or in-and-out movement. Following Robert Adam, some English architects change classical proportions and ornament, freely adapting it to their own or their patron's style and taste. Others, such as William Chambers, continue to follow the classical rules.

27-6. Pulteney Bridge, 1769–1774; Bath, England; by Robert Adam.

27-7. Somerset House, 1776–1786; London; by William Chambers.

Design Practitioners

■ *Robert Adam* is the leading Neoclassical designer in England. One of four brothers and the second son of Scottish architect William Adam, Robert travels to France and Italy where he acquaints himself with the leaders of Neoclassicism. He also studies and measures ancient buildings, most notably Diocletian's palace in Spalato. A champion of Roman architecture, Adam's work is also greatly influenced by Piranesi, Raphael, and Michelangelo. In contrast to architects who follow earlier Neo-Palladianism, Adam follows no set rules, adjusting proportions and elements according to individual requirements. Because he designs and builds few houses, he is best known for his interiors.

■ *Sir William Chambers* is the other great Neoclassical designer in England along with Adam. Born in Sweden, Chambers travels to China, India, and Italy and studies architecture in France. Upon his return to England, he soon becomes a successful architect, serving as architectural tutor to the Prince of Wales. Upon his ascent to the throne, George III appoints Chambers as Architect to the King. Chambers' work is more formal and robust than Adam's as he relies more on correct proportions and the use of the elements in the Palladian manner. His sources of inspiration include ancient Rome, Italian Renaissance and Baroque, and French Baroque. His treatise *Design of Chinese Buildings* (1757) becomes an important resource for British architects, but better known and more influential is *A Treatise on Civil Architecture* (1791).

■ *Thomas Chippendale* turns to Neoclassical design in the 1760s and executes commissions for Robert Adam. As previously, his furniture exhibits excellent quality although in a style unlike that which bears his name.

■ *Angelica Kauffmann* is a painter and decorator who completes wall and ceiling paintings and furniture decorations for the Adam brothers. Although known for her excellent painting, which impacts Neoclassical furniture, British society appreciates her great beauty and charm. As a leading history painter, Kauffmann is one of two women-artist founders of the Royal Academy in London in 1768. No other women are admitted until the early 20th century.

Public and Private Buildings

■ *Types.* Town and country houses are the main building types, although banks, churches, and other public structures (Fig. 27-6) also exhibit the style. Middle-class businessmen and professionals build numerous small to medium villas in a plainer Neoclassical mode.

■ *Site Orientation.* Architects more carefully consider the relationship between house and landscape. Houses may be sited in irregular gardens complete with newly built ancient or Gothic ruins.

■ *Floor Plans.* Plans (Fig. 27-9, 27-11, 27-17) generally follow French prototypes in the disposition of rooms. Exceptions are those in which rooms are organized in circular fashion around the staircase to facilitate entertaining. Most plans feature spaces in different sizes and shapes, often based on antique Roman models, which follow one another in a carefully planned sequence. Rooms may be round, oval, apsidal, square, or rectangular. Architects sometimes plan spaces as a series of picturesque views. Toward the end of the period, plans grow less formal and are more loosely arranged. In town houses, important

27-8. Kenwood House, 1767–1769; Hampstead, London; by Robert Adam.

rooms begin to move to the ground floor instead of the first floor as before.

■ *Materials.* Industrialization yields new materials or improves older ones. Higher firing temperatures give a wider range of brick colors (Fig. 27-8, 27-12, 27-14, 27-15, 27-16) including yellow, gray, brown, white, and cream. No longer is red the most common brick color; white or cream brick is chosen to resemble the stone used in grander houses. Alternative materials include stucco and ceramic tiles that imitate brick. Improved casting techniques produce ironwork in delicate Neoclassical motifs for balconies and window frames. By the end of the period

the use of structural ironwork, such as on staircases (Fig. 27-20), increases, and iron plates help create fireproof structures.

■ *Facades.* Exteriors vary from severely plain to overly decorated with classical elements. Triumphal arches, niches, and other Roman elements on facades join the temple fronts and other Neo-Palladian details (Fig. 27-7, 27-8, 27-13). As before, most feature columns and pediments, which usually mark entrances and ends, but the scale is lighter (Fig. 27-10, Color Plate 66, 27-15, 27-16). The Corinthian order dominates early in the period, while Doric is more common later. Rustication emphasizes the

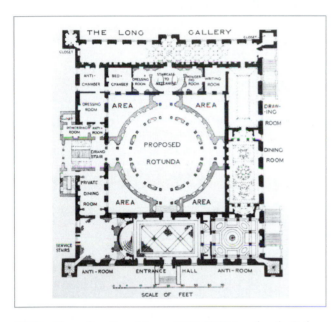

27-9. Floor plan, Syon House, 1762–1769; London; by Robert Adam.

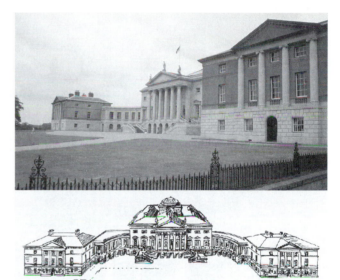

27-10. Kedleston Hall, 1759–1770; Derbyshire, England; by James Paine and completed by Robert and James Adam. (Color Plate 66)

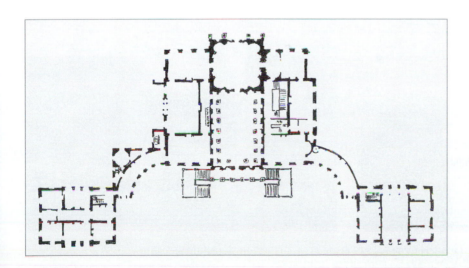

27-11. Floor plan, Kedleston Hall.

27-12. South front, Stowe, 1771; Buckinghamshire, England; by Robert Adam.

lower portion of some walls. Classically derived decoration concentrates around windows and doors. Smooth, blank walls separate fenestration. Exterior architectural features continue to indicate important interiors as before. Town houses and smaller villas often are severely plain with little or no ornamentation.

■ *Windows.* Pediments often surmount windows. Rectangular sashes prevail, but others may be arched or Palladian. Improved manufacturing techniques yield larger glass panes, so window sizes increase and mullions become thinner. There are no standard sizes or numbers of panes during the period. Mullions and sashes generally are painted dark colors, such as gray, brown, or green, instead of white. Some are grained to imitate mahogany. By the 1770s, taller windows give access to balconies.

27-13. The Adelphi, 1768–1772; London; by Robert Adam.

27-14. Overview and facade detail, Royal Crescent, 1767–1775; Bath, England; by John Wood II.

Design Spotlight

Architecture: *Osterley Park.* Completed in 1576, this grand building (Fig. 27-15) was originally the home of Sir Thomas Gresham, a prosperous merchant and founder of the Royal Exchange. Originally, Elizabethan in style, it was later remodeled in the 1750s, possibly by Sir William Chambers, and then again in 1763–1780 by Robert Adam for Sir Hugh Smithson, later Duke of Northumberland. Based on a U-shaped plan, the build-ing features a double portico defining the main axis and the processional entry through the courtyard. The white temple front is inspired by Roman models. The portico and roof balustrade accent the red brick com-position and offer contrast in color. Original towers flank the corners and establish the facade perimeters. As was typical of Adam's designs, the portico is lightly scaled.

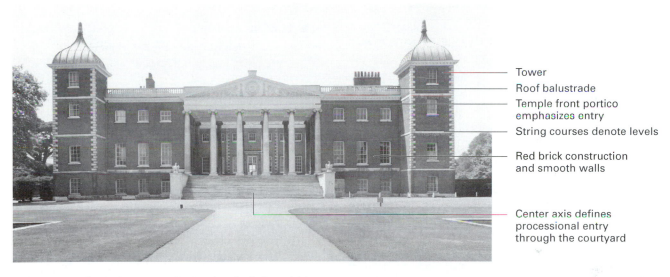

Tower

Roof balustrade

Temple front portico emphasizes entry

String courses denote levels

Red brick construction and smooth walls

Center axis defines processional entry through the courtyard

27-15. Osterley Park, 1763–1780; London; by Robert Adam.

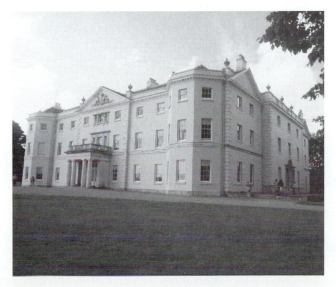

27-16. Saltram House, remodeled 1768–1781; Plymouth, England; by Robert Adam.

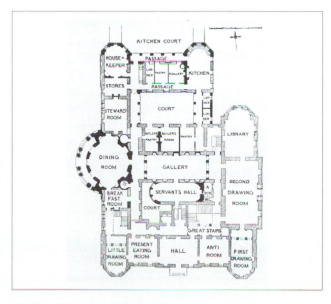

27-17. Floor plan, Saltram House.

27-18. Later Interpretation: Nathaniel Russell House, before 1809; Charleston, South Carolina.

27-19. Later Interpretation: The Podium Shopping Arcade, 1990s; Bath, England.

■ *Doors.* Columns or pilasters and pediments frame doors as earlier, but they are more attenuated; cases are painted light or stone colors. Fanlights (semicircular or elliptical windows often with radiating mullions) become larger and feature delicate radiating mullions and Neoclassical motifs. Doors commonly have six panels, although some have three, five, or eight. Most are painted dark brown or green. Hardware is simple and of brass or cast iron, and often incorporates classical motifs.

■ *Roofs.* Roofs (Fig. 27-10, 27-13, 27-15, 27-16) are flat or low-pitched. Slate replaces clay tiles for coverings. A balustrade often hides the roof.

■ *Later Interpretations.* British architects never completely abandon classicism throughout the remaining 19th century. Traditional building types displaying the style include banks and clubs. However, beginning in the 1890s and continuing through the Edwardian period, a revival of

Important Buildings and Interiors

■ **Bath, England:**
—Pulteney Bridge, 1769–1774, Robert Adam.
—Royal Crescent, 1767–1775, John Wood II.

■ **Buckinghamshire, England:** South Front, Stowe, 1771, Robert Adam.

■ **Derbyshire, England:** Kedleston Hall, 1759–1770, James Paine, completed by Robert and James Adam; Marble Hall, c. 1761–1770, Robert Adam. (Color Plate 66)

■ **Edinburgh, Scotland:** Charlotte Square, 1791–1807, Robert Adam.

■ **London, England:**
—The Adelphi, 1768–1772, Robert Adam.
—Carleton House, 1783–1795, demolished 1826, Henry Holland.
—Home House, No. 20, Portman Square, 1773–1776, Robert Adam.
—Kenwood House, 1767–1769, Hampstead, Robert Adam. (Color Plate 67)
—Osterley Park, London, 1763–1780, Robert Adam. (Color Plate 68)
—Pantheon, 1769–1772, demolished 1937, James Wyatt.
—Somerset House, 1776–1780, William Chambers.
—Syon House, 1762–1769, Robert Adam.

■ **Plymouth, England:** Saltram House, remodeled 1768–1781, Robert Adam.

■ **West Yorkshire, England:** Interiors, Harewood House, 1760s–1780s, Robert Adam.

■ **Worcestershire, England:** Interiors, Croome Court, c. 1761–1771, Robert Adam.

Neoclassicism appears. Buildings are larger in scale than before and feature classical forms and decoration drawn from Inigo Jones, Wren, Palladio, and Adam. Numerous residential, commercial, and government buildings still exhibit the style today (Fig. 27-19).

INTERIORS

Late English Georgian interiors feature delicate colors, classical ornamentation in low relief, and refined proportions. Rooms are formal, elegant, and unified. Often they are simple geometric shapes with curving ends or sculpture niches for movement. Columns sometimes delineate apses.

Some designs follow antique prototypes, and occasionally designers reuse ancient artifacts and integrate them into new settings. Regardless of size, the scale of elements within interiors is small and refined. Columns and similar forms are slender and elongated. Designers adapt classical rules of proportion to the situation. Decoration derives from the discoveries of Pompeii and the Italian Renaissance, most notably the work of Raphael.

Robert Adam is the most influential designer of Neoclassical interiors. Harmonious and sophisticated, his interiors feature elegant proportions and classical ornament that he abstracts and adapts to suit the particular interior.

27-20. Staircase detail, Kenwood House, 1767–1769; Hampstead, London; by Robert Adam.

Design Spotlight

Interiors: *Library, Kenwood House.* One of the most spectacular rooms in England, this library (Fig. 27-21, Color Plate 67) displays all of the characteristic features of Robert Adam's style. He was commissioned to rebuild the house and design the interiors in 1767–1769 by owner William Murray, who was the attorney general of England. The rectangular plan features apsidal ends divided by a Corinthian colonnade. The barrel-vaulted and compartmented ceiling displays rectangles, ovals, squares, circles, and semicircles with painted classical ceiling decorations by Antonio Zucchi, assisted by Angelica Kaufman. Colors are primarily pale shades of blue, pink, white, and gold. A frieze with anthemions borders the perimeter. Pale blue walls and delicate furnishings integrate with the overall composition.

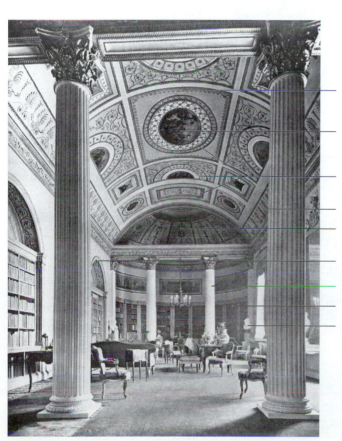

Barrel vault, compartmented ceiling with classical decoration inspired by Pompeii

Paterae

Geometric shapes

Athemion border in low relief

Half-domed ceiling

Delicate arch

Corinthian columns

Apsidal end

Bust on pedestal

27-21. Library, Kenwood House, 1767–1769; by Robert Adam. (Color Plate 67)

He designs all elements, from walls and ceilings to furniture and accessories, to achieve unity.

Private Buildings

■ *Types.* Unlike the French, Adam emphasizes the dining room in plan and ornament. He regards it as the place where gentlemen make political decisions and public policies after dinner once the ladies have withdrawn to the *salon.*

■ *Color.* The period adopts a vibrant palette thought to be derived from antiquity. Colors (Fig. 27-21, Color Plate 67, 27-27) include lilac; terra-cotta; Pompeiian red; and bright pinks, blues, and greens. Red and black compose Etruscan color schemes (Fig. 27-28, Color Plate 68) reminiscent of Grecian vases. The middle class continues using earlier colors such as stone, gray, olive green, brown, straw, sky blue, and pea green. Soft white remains fashionable, particularly for ceilings. *Grisaille* (decoration in shades of gray intended to imitate relief carving), marbling, and graining

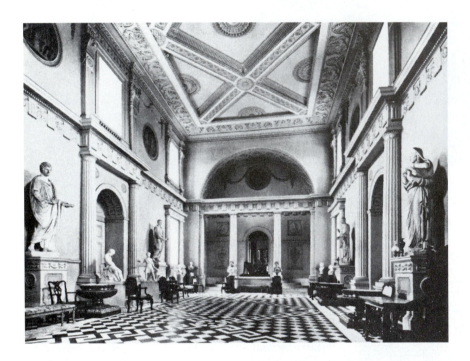

27-22. Hall, Syon House, 1762–1769; London; by Robert Adam.

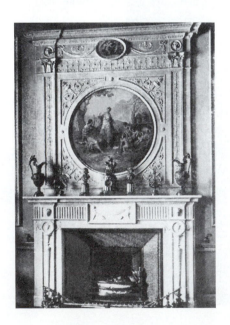

27-23. Fireplaces, Nostell Priory and 20 Portman Square; England; Robert Adam.

return to fashion. Gilding highlights plaster decoration, and moldings replace the complete gilding of earlier. Plasterwork may be white or colored.

■ *Lighting.* During the day, shutters, blinds, and slipcovers protect expensive textiles and furniture from fading. At night, most homes are dark. Candles, especially those of beeswax, are expensive, so most people use them sparingly. Those who can afford candles use them in *candelabra*; candlesticks; wall sconces; and chandeliers made of metal, ceramics, or glass (Fig. 27-38). In 1783, François-Pierre Ami Argand invents a tublar wick lamp whose light is adjustable. Soon, Argand lamps (Fig. 27-38), called colza-

oil lamps in England, highlight mantels, tables, and wall shelves. The shapes and decoration of all lighting devices follow classical models. In 1799, the first factory to produce gas for lighting opens in London, and gas is distributed in parts of the city.

■ *Floors.* The grandest rooms have stone, marble, or scagolia (an imitation marble) floors (Fig. 27-22, 27-35). Random-width stained and polished oak, pine, or deal boards are most common. Plain, uncovered wood floors may be stained, polished, painted in marble patterns, or stenciled. The wealthy continue to use parquet in important rooms, but less often, as carpet (Fig. 27-26, 27-30,

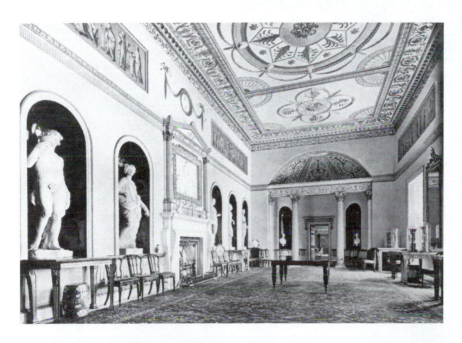

27-24. Great Dining Room, Syon House, 1761–1769; by Robert Adam.

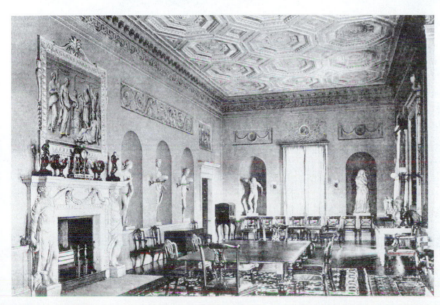

27-25. Banqueting Room, Croome Court, c. 1761–1766; Worcestershire, England; by Robert Adam.

27-32, 27-33) grows more fashionable and less expensive. Axminster, Moorlands, or Kidderminster manufacture knotted pile carpets in Turkish, Persian, or Neoclassical patterns. Less expensive alternatives include woven loop pile (called Brussels or Wilton) or ingrains. Most carpet is made in 27-inch or 36-inch widths, sometimes with bor-

ders, so it can easily be cut to fit any room shape. Carpet and rugs often repeat ceiling designs. Plain or patterned matting replaces carpet in the summer.

■ *Walls.* Walls (Fig. 27-21, 27-22, 27-24, 27-27, 27-29, 27-33, 27-37) depict a variety of treatments. Completely

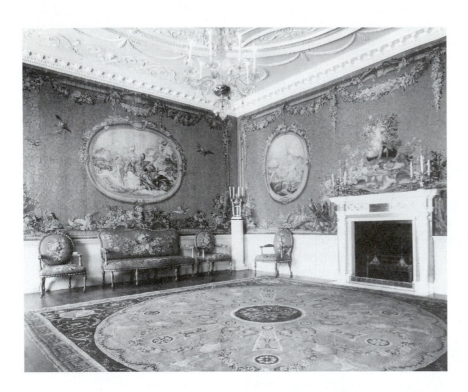

27-26. Tapestry Room, Croome Court, c. 1763–1771; by Robert Adam. [Tapestries: designed 1758–67 by Francois Boucher (1703–1770); woven 1764–71 in the workshop of Jacque Neilson (1714–88) at Royal Gobelins Manufactory in Paris, for George William (1721–1809), sixth earl of Coventry. Wool and silk. Ceiling: designed by Robert Adam; executed by Joseph Rose. Photographed about 1995. The Metropolitan Museum of Art, Gift of Samuel H. Kress Foundation, 1958. (58.75.1–.23)]

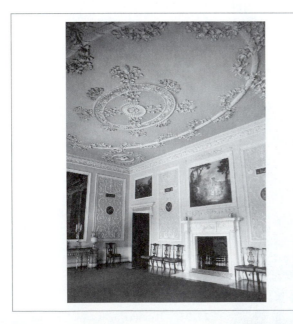

27-27. Dining Room, Osterley Park, 1766–1768; by Robert Adam.

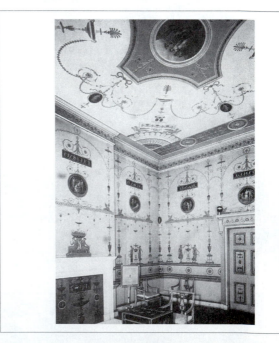

27-28. Etruscan Dressing Room, Osterley Park, 1775–1777; by Robert Adam. (Color Plate 68)

paneled walls are out of fashion. Instead, the wall above the dado is painted or papered or features Neoclassical plasterwork. These treatments sometimes imitate Pompeian wall paintings (Fig. 27-28, Color Plate 68). Others have compartments of low-relief classical ornamentation in white or the same color as the wall. Small painted scenes are often interspersed among the ornamentation.

Alternative treatments include fabrics and wallpaper, the use of which increases during the period. English, Chinese, and French papers replace hand-painted decoration and fabric in numerous fashionable homes. Patterns include architectural forms, such as columns or moldings; florals; stripes; classical scenes; or landscapes. Flocked papers emulating fabrics are almost as expensive as the fabrics themselves. Tapestries may also adorn walls, particularly in rooms designed by Robert Adam (Fig. 27-26).

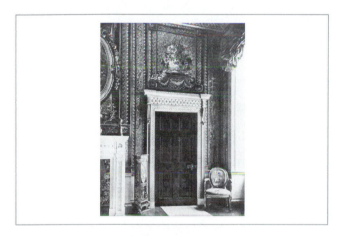

27-29. Door detail, Tapestry Room, Osterley Park; by Robert Adam.

■ *Window Treatments*. Window treatments become increasingly elaborate during the period. Simple panels nailed to the window remain common; many now have valances to hide the tacks. Single and double festoons (pull-up curtains resembling today's balloon shades) are the most fashionable window treatments. Made in light fabrics, they resemble classical swags. In the 1780s, the French introduce draw rods (also called French rods). Panel curtains hanging on rings soon replace festoons. By the turn of the century, elaborately swagged top treatments called drapery are fashionable. Both drapery (top treatment) and curtains (underneath treatment) are of light fabrics and trimmed with fringe and tassels. Curtains are tied back during the day. Shutters, cloth blinds, and Venetian blinds, with or without curtains, also help block light.

■ *Doors*. Doors (Fig. 27-29, 27-33) are usually paneled mahogany with brass hardware. Gilding may highlight panels. Narrow molding frames the door with a cornice and frieze above.

■ *Textiles*. The Industrial Revolution makes more textiles available so most people can now afford them for upholstery, curtains, bed hangings, and furniture cases. In 1774, England eases restrictions on the use of domestic cotton, while imports remain illegal. Consequently, by 1785, cotton prevails for household use. English chintzes and calicoes replace damasks, silks, and velvets, even among the wealthy. Various-scaled multicolored English prints rival those previously imported from India. Linen use also increases. Most cottons and linens are block printed, but copperplate printing is firmly established by 1760. Copperplate prints in a single color (red, blue, purple, black, yellow) on a light ground, known as *toiles*, gain popularity. Especially fashionable for curtains is tabby, a silk of alternating moiré and satin stripes.

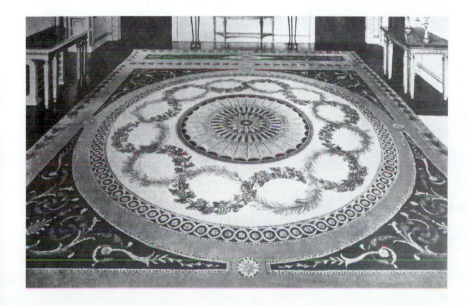

27-30. Rug; Adam style.

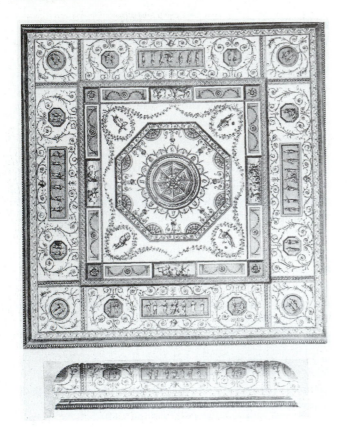

27-31. Ceiling designs; by Robert Adam.

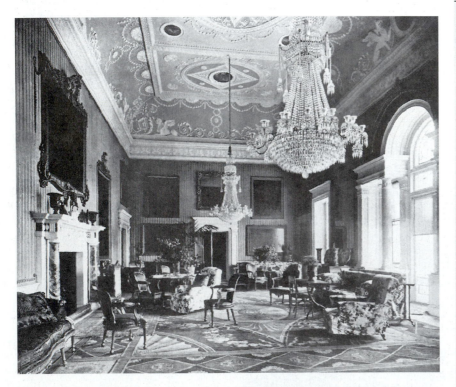

27-32. Saloon, Saltram House, remodeled 1768–1781; Plymouth, England; by Robert Adam.

Design Spotlight

Interiors: *Dining Room, Saltram House.* In 1768–1770 this room was originally designed by Robert Adam as a library for John Parker II, Lord Boringdon. Ten years later, it was remodeled as a dining room (Fig. 27-33), reflecting one of the best preserved examples of Adam's talents in England. Developed from a rectangular plan with an apsidal end, it articulates his classical language through the chimneypiece, niches (originally windows), and geometric ceiling composition. The rug interprets the overall ceiling design. With the remodeling, pedestals with urns flank the bow-shaped sideboard, and side chairs with oval backs provide seating. White plaster decoration by Joseph Rose accents the Wedgwood green walls and ceiling.

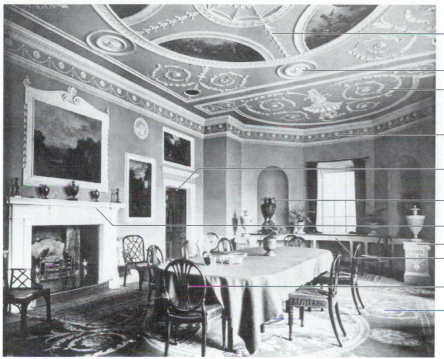

Honeysuckle motif

Rosette in circle

Compartmented ceiling with classical motifs similar to Roman stuccowork

Frieze with classical swag and rosette

Mahogany door with frieze above

Niche with vase (originally side window)

Mantel with classical features

Pedestal with vase

Curved sideboard

Oval back on chairs

Rug integrates with ceiling design

27-33. Dining Room, Saltram House; by Robert Adam.

27-34. Vestibule, Somerset House, 1776–1786; London; by William Chambers.

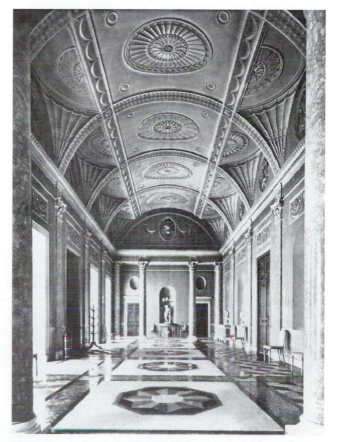

27-35. Hall, Heavingham Hall, late 18th century; Suffolk, England; by James Wyatt.

27-36. Chimneypieces; by Robert Adam.

■ *Chimneypieces.* Chimneypieces (Fig. 27-25, 27-26, 27-32, 27-33, 27-36, 27-37) are usually of white, black, or gray marble or scagolia with classical motifs, such as pilasters or columns. Proportions are slender. The design of coal grates complements interior decoration. Chimneyboards featuring Neoclassical motifs, flowers, or mirrors fill fireplace openings in summer.

■ *Staircases.* Staircases remain focal points and adopt classical decoration. Many stairs curve, and skylights often illuminate them. Cast-iron banisters (Fig. 27-20) become more common and feature urns, honeysuckle, and other motifs.

■ *Ceilings.* Ceilings (Fig. 27-21, 27-22, 27-24, 27-25, 27-26, 27-27, 27-28, 27-31, 27-32, 27-33, 27-34, 27-37) are focal points especially in important rooms in grand houses. Most are flat; some are coved or vaulted. Designs develop from geometric shapes or compartments and repeated patterns separated by color. Decoration consists of classical motifs in low plaster relief similar to Roman stuccowork. Small paintings with classical themes and figures may be interspersed among the compartments. Paintings contrast with the white or colored reliefs and clear, bright ceiling colors. The design centers on an oval or circle with plasterwork or a painting. Sometimes details are picked out

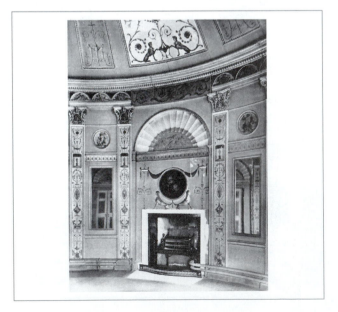

27-37. Chimneypiece, Cupola Room, Heaton Park, late 18th century; Lancashire, England.

27-38. Lighting fixtures: Hanging lamp and Argand lamp.

by gilding. Carpet reflects or repeats ceiling patterns. Ceilings in lesser houses are flat and painted white.

■ *Later Interpretations.* Late in the 19th century, a renewed admiration for Adam's work follows several international exhibitions. Soon Late English Georgian interiors reappear in English and American homes and public buildings. They become especially popular in the first two decades of the 20th century after a reprint of the Adam brothers' book. Few interiors are exactly reproduced today, but individual elements and colors may appear.

FURNISHINGS AND DECORATIVE ARTS

Late English Georgian furniture is light in scale and rectilinear in form and features carved, painted, and inlaid classical motifs. Influences include French Neoclassical and furniture designed by Robert Adam for particular rooms. George Hepplewhite's *The Cabinet-Maker and Upholsterer's Guide* (1788) and Thomas Sheraton's *The Cabinet-Maker and Upholsterer's Drawing Book* (1794) illustrate fashionable Late Georgian furnishings. Neither author likely invents the styles illustrated in his publication. Although their names are associated with particular characteristics and styles, the books feature some common qualities. Today, the term *Hepplewhite* typically refers to curving backs and tapered rectangular legs, while *Sheraton* means square backs and cylindrical legs. In reality, both books show designs with these characteristics.

■ Two other important books are *The Works in Architecture by Robert and James Adam* (1777) and *The Cabinet-Maker's London Book of Prices, and Designs of Cabinet Work* (1788) by Thomas Shearer. Despite the interest in antiquity, antiques are not fashionable during the period.

Public and Private Buildings

■ *Types.* For dining rooms, Robert Adam introduces the sideboard table flanked by urns and pedestals, which evolves into sideboards with drawers and doors. Also new are the Pembroke table, quartetto and trio tables, Carleton house writing table, and pedestal dining tables.

■ *Relationships.* Because furniture still lines the walls in formal, symmetrical arrangements when not in use, designers regard it as architectonic and integral to the room. Toward the end of the period, furniture arrangements become less formal, grouping around the fireplace instead of lining the walls. Brass toe caps and castors facilitate moving.

■ *Materials.* Most cabinet furniture is made of satinwood, but rosewood or other exotic woods are also popular (Fig. 27-47, 27-50, 27-52). Adam prefers mahogany (Fig. 27-53) for dining room and library furniture. Many pieces feature contrasting veneer bands and inlay. *Ormolu* mounts adorn designs in the French taste. Marquetry using a variety of colored woods creates classical images. Especially fashionable are Japanning in polychrome, painted black or matching walls, and *grisaille*. Some pieces have gilding or porcelain plaques. Door and drawer pulls are round or oval and made of brass.

■ *Seating.* Chairs are most typical of the style. Backs may be shield, heart, oval, wheel, camel, square, or rectangular. Hepplewhite backs are shield, heart, and oval (Fig. 27-33,

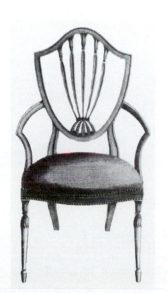
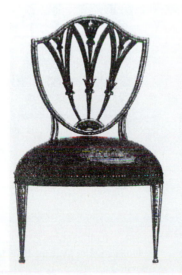
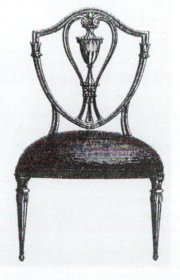

27-39. Chairs with shield back, published in *The Cabinet-Maker and Upholsterer's Guide*, 1788; by George Hepplewhite.

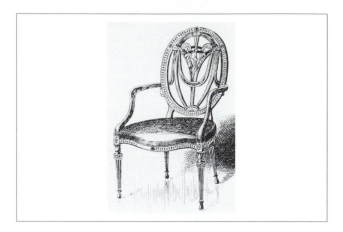

27-40. Armchair with oval back, c. 1780s; by George Hepplewhite.

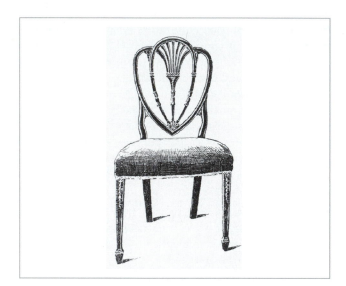

27-41. Heart-back chair, c. 1780s; by George Hepplewhite.

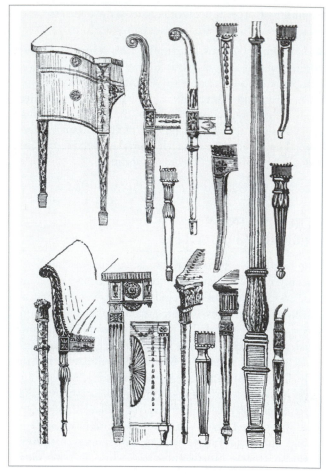

27-42. Furniture legs; by George Hepplewhite.

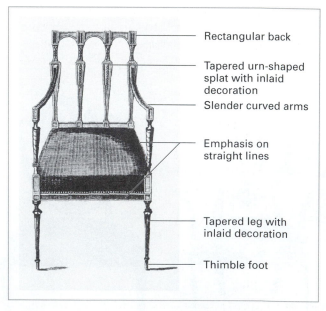

Rectangular back

Tapered urn-shaped splat with inlaid decoration

Slender curved arms

Emphasis on straight lines

Tapered leg with inlaid decoration

Thimble foot

27-43. Parlour chair, c. 1792, published in *The Cabinet-Maker and Upholsterer's Drawing Book in Four Parts*, c. 1802; by Thomas Sheraton.

27-39, 27-40, 27-41), while those of Sheraton are typically rectangular (Fig. 27-43, 27-44). Backs and splats display endless variety in carved, painted (Fig. 27-45), or inlaid ornament. Quadrangular or cylindrical legs are plain, fluted, or reeded (convex ridges adjoining each other and covering a vertical surface) and terminate in spade or thimble feet (Fig. 27-42). Other seating includes sofas in several forms and chair-back settees (Fig. 27-46).

■ *Tables.* Many types of small tables support an increasing variety of activities. Card and tea tabletops exhibit rectangular, semicircular, stepped shapes (Fig. 27-47). The *demilune* (semicircular) is especially fashionable at the end of the century. Folding tops are still popular so tables can stand against the wall. Pembroke tables (drop-leaf with

27-44. Chair backs, c. 1794, published in *The Cabinet-Maker and Upholsterer's Drawing Book in Four Parts,* c. 1802; by Thomas Sheraton.

Design Spotlight

Furniture: *Parlor Chair.* Designed by Thomas Sheraton, this parlor chair (Fig. 27-43) appears in his book *The Cabinet-Maker and Upholsterer's Drawing Book in Four Parts.* Rectangular backs with various center motifs (Fig. 27-44) illustrate his design diversity and range of compositions. Quadrangular or cylindrical legs are plain, fluted, or reeded and terminate in spade or thimble feet. Lightly scaled chairs such as this one may appear in areas for entertaining, dining, or sleeping.

27-45. Painted Sheraton Fancy Chair, late 18th century; by Thomas Sheraton.

slender tapering legs and a drawer in the apron; Fig. 27-49) serve as breakfast tables in bedrooms or as card or game tables in drawing rooms. Quartetto or trio tables have four or three, respectively, tables that diminish in size so they can slide into one another. In the drawing room, each guest has his or her own. Table legs are slender and tapered (Fig. 27-48). Pedestal or pillar and claw dining tables appear. Pedestals have four outward curving legs with brass toe caps and castors. Because each pedestal is a separate unit, dining tables can be any size and are taken apart when not in use.

■ *Storage. Commodes,* featuring painted or veneer classical decoration, remain fashionable (Fig. 27-51, 27-52). Semicircular or bow fronts are in vogue in the 1770s. The sideboard (Fig. 27-50) with drawers and doors may be bow or

kidney shaped with six tapering legs. Classical motifs, stringing (narrow inlay bands usually outlining legs or drawers), and crossbanding (border bands laid transversely to the surface) delineate its parts in the classical manner. Tallboys (Fig. 27-53) continue in popularity. Breakfront secretary bookcases (Fig. 27-54) appear in libraries; the center portion, which projects forward, has a drop leaf for

writing. Inside, curtains, typically in green silk, cover the glass and protect books from light and dust. New to the period and designed to be free-standing, the Carleton House writing table has a low storage unit with drawers

27-46. Settee, upholstered in painted silk.

27-47. Tops for card tables, published in *The Cabinet-Maker and Upholsterer's Guide*, 1788; by George Hepplewhite.

and doors resting on its top and extending along the sides and back.

■ *Beds.* Richly draped four-poster beds continue in fashion (Fig. 27-55). Posts (Fig. 27-56) and testers are slender and carved with classical ornament. Some testers curve or have pediments or urns. French beds with canopies and draperies mounted on the wall also are fashionable. Hangings are as rich as before, but feature more classical swags. Hangings

27-48. Legs for pier and card tables, published in *The Cabinet-Maker and Upholsterer's Drawing Book in Four Parts*, c. 1802; by Thomas Sheraton.

27-49. Harlequin Pembroke table; by Thomas Sheraton.

27-50. Sideboard, mahogany with inlay of satinwood; by Robert Adam.

may be of dimity, plain or patterned silk or satin, velvet, cotton, or linen. As time passes, lighter fabrics become dominant. Rich trims continue to embellish hangings.

■ *Textiles.* Furnishing fabrics continue to be coordinated in color and commonly exhibit classical motifs in concert with the room's other materials and finishes. Neoclassical upholstery (Fig. 27-57) itself is thinner and more square in shape than previously. Tufting helps maintain shape and hold the horsehair and down stuffing in place. Shiny brass nails also hold fabrics in place and often arrange in geometric patterns. Furniture cases are of chintz or calico. As before, textiles and wallpaper often match in color and pattern. Scarves, precursors of Victorian antimacassars, drape the backs of sofas and chairs to prevent damage from wig powder and hair grease.

27-51. Decorated cabinet, satinwood with painted oval panels in the manner of Angelica Kauffmann.

27-52. *Commodes*; typical of Adam, Hepplewhite, and Sheraton.

■ *Decorative Arts.* Silver production increases with innovations of the Industrial Revolution. Sheffield plate (silver over copper) is introduced in the 1770s. Soon, even middle-class homes have numerous silver objects, such as candlesticks, sconces, tea urns, teapots, and tableware. Silver designs feature classical shapes, such as urns or columns, and relatively flat decoration that does not interfere with profiles. By the 1790s, designs stray from classical models.

27-55. State bed, Osterley Park, c. 1776; by Robert Adam.

27-53. Tallboy, mahogany with serpentine front.

27-54. Desk and bookcase, published in *The Cabinet-Maker and Upholsterer's Drawing Book in Four Parts*, c. 1802; by Thomas Sheraton.

27-56. Bed posts, late 18th century; by Thomas Sheraton.

27-57. Textiles: fabrics; Adam style.

27-58. *Girandoles* (mirrors); by Robert Adam and George Hepplewhite.

■ *Mirrors.* Late Georgian *girandoles* (mirrors; Fig. 27-58) become slender rectangles or ovals often surmounted with delicate metal filigree. Some rectangular ones have upper panels with engravings or *verre églomisé* (reverse painting on glass). Convex mirrors with heavy circular frames also are typical.

■ *Ceramics.* A high tariff on imported porcelain passed in 1772 forces the English to make more of their own. Although they began producing hard-paste porcelain in the late 1760s, factories now produce large quantities of bone china. Josiah Spode II standardizes the recipe for bone china about 1800. Straight lines, rectangular handles, classical motifs, and Greek and Roman shapes define Neoclassical porcelain. Decoration may be sumptuous, even to the point of obscuring form. Many pieces copy or are influenced by Chinese and Japanese porcelain in addition to Neoclassical porcelain.

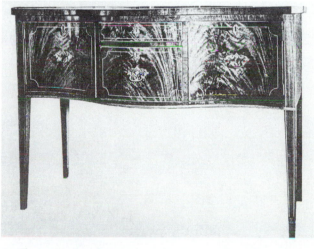

27-59. Later Interpretation: Sideboard, 1790–1800; in the style of George Hepplewhite; American Federal.

■ *Wedgwood.* Josiah Wedgwood is a craftsman, entrepreneur, and well-known ceramist who helps introduce Neoclassical design into stoneware and earthenware. Black basalt ware, the first ornamental stoneware developed by him, resembles Greek vases. Jasperware (Fig. 27-5), Wedgwood's most famous invention, first appears in 1774. The new stoneware follows Neoclassical shapes and motifs and is made in cobalt blue, lilac, sage green, yellow, and black with white relief decoration.

■ *Later Interpretations.* Designers reproduce and adapt Adam, Sheraton, and Hepplewhite furnishings, along with Chippendale furnishings, in the American Federal period (Fig. 27-59) and again in the 1870s and 1880s. Collectors also pursue Late Georgian antiques to complement Adam style interiors. People still choose reproductions or adaptations of Neoclassical furniture today.

28. American Federal

1776–1820

In (the) early years of nationhood, the sense of American identity demanded an American architecture for the common man as well as the privileged. Though closely derived from contemporary English hand books, Asher Benjamin's influential guide . . . published in Boston in 1806, declared American cultural independence and social egalitarianism. Architecture in America must be different from architecture in Europe, the author asserted. Americans had different materials to work with, less use for decoration, and a need to ecomomize on labor and materials.

Carole Rifkind, *A Field Guide to American Architecture*

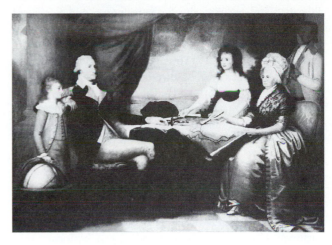

28-1. *The Washington Family*, c. 1790s; painting by George W. Parke Custis.

The Federal style is the first phase of Neoclassicism in America. Derived primarily from English models, the style takes its name from the time of its inception, which coincides with the establishment of the federal government in America. As in Europe, the style features classical details and ornament, slender proportions, and contrasting circular and rectangular shapes. However, the American Federal style typically is simpler and smaller in scale than the European Neoclassical style.

HISTORICAL AND SOCIAL

The Articles of Confederation, approved by Congress in 1777 and subsequently ratified by the states, retain the sovereignty of the 13 individual states. Under the Articles, Congress represents the states, not the people, with very limited powers. Thus, it cannot unite the country into a single political entity. Rivalries and conflicts among the states increase, threatening the stability of the young nation. Nationalists, such as George Washington and James Madison, realize the Articles are ineffective, and the more ardent want to discard them. The Treaty of Paris ends the war of independence, and leaders from the 13 states begin developing a government that will unite them as a nation.

In 1787, delegates meet in Philadelphia with the intention of amending the Articles. Instead, they draw up the Constitution, which gives power to the people instead of the states. The Constitution also creates a three-branch government—executive, judicial, and legislative. Follow-

ing many conflicts and compromises, the convention of delegates adopts the Constitution, and in 1788, it becomes the law of the land. George Washington is unanimously elected as the first president; he is inaugurated in April 1789.

Conflicts soon reappear between the first two important political parties. The Federalists advocate a strong central government headed by the wealthy and educated. Merchants and traders of the Northeast support this party. The Republicans, believing in the abilities of the common people, support limiting federal powers and sympathize with the French Revolution. Farmers and workers, especially in the South, follow this ideology. Despite differences, the young nation prospers and America remains neutral in the hostilities between England and France. Although the Revolution severs political connections with England, many Americans, as former Englishmen, wish to maintain economic, cultural, and social ties with Great Britain.

Commerce with England and France increases, and America initiates trade with the Orient in 1785. New state capitol buildings spring up in every state, while the new federal city of Washington incorporates in 1799. Frenchman Pierre L'Enfant develops a formal plan for the city with wide streets, circles, and stars punctuated by important and symbolic buildings. Georgia and North Carolina establish state-chartered universities in 1785 and 1789, respectively.

505

The population grows and spreads westward, although the country remains predominantly rural. Households are large with parents; numerous children; and sometimes grandparents or other relatives, boarders, servants, and/or slaves living together. The Direct Tax of 1798, levied by Congress to meet the financial needs for national defense, describes and assesses the land, property, and houses of each citizen. An important source for information on house types and sizes as well as interior furnishings, the Direct Tax indicates that the majority of Americans live in small, one- or two-room dwellings. Mansions and row houses are the exception. By the end of the period, the Industrial Revolution begins to make its appearance. Inventions help industrialize the textile industry and farming. Samuel Slater opens the first spinning mill in Rhode Island in 1791, while Eli Whitney invents the cotton gin in 1793.

In 1803, President Jefferson negotiates and signs the Louisiana Purchase. The acquisition of land from the upper Missouri to the Gulf of Mexico doubles the size of the nation and increases her power and wealth. Unfortunately, neither he nor his successor James Madison can keep the United States out of war with Great Britain. Britain's continued outrage against the United States, its merchants, and its ships forces Congress to declare war in June 1812. Although the war really does not settle critical issues, it ends European dominance in American affairs and engenders strong feelings of nationalism in the young nation.

CONCEPTS

After the Revolution, America follows Europe in wholeheartedly adopting Neoclassical forms and motifs in architecture, interiors, furniture, and decorative arts. (Some examples appear as early as 1760.) As a new nation, the country needs an official architectural style to legitimize its emancipation and to personify its cultural identity. Leaders acquainted with trends in Europe, such as Thomas Jefferson, advocate Neoclassicism, which offers models from Greece and Rome, two ancient republics. A national architecture adopting these models becomes a visual metaphor linking these old republics with the new one.

Americans learn about Neoclassicism from pattern books and fashion periodicals; immigrant craftsmen, cabinetmakers, and upholsterers; imported furnishings; and travel. Important government leaders, such as George Washington, Benjamin Franklin, and John Adams, admire its beauty and import furnishings in the style from France and England. Continuing cultural ties with England assures that many Americans follow English models of Neoclassicism—Robert Adam in interiors and Hepplewhite and Sheraton in furniture.

DESIGN CHARACTERISTICS

Based largely on English prototypes, the Federal style reflects slender proportions, classical decoration, contrasts of color, and geometric forms. Emphasis is on straight lines and geometric curves, such as circles or ellipses. American designs typically are simpler than European ones. National

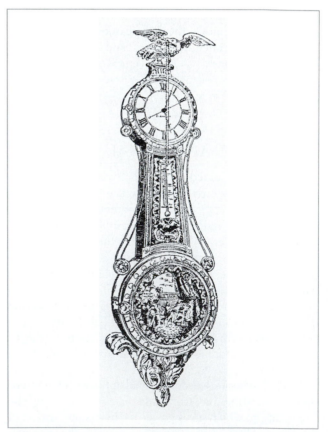

28-3. Wall clock.

28-2. Eagle.

symbols, such as the eagle, serve as important icons in establishing the cultural identity.

■ *Motifs.* Motifs include eagles (Fig. 28-2, 28-3, 28-5, 28-52), paterae (oval), swags, egg and dart, palmettes, honeysuckle, classical figures, baskets, urns, and stripes (Fig. 28-29, 28-30, 28-31, 28-32, 28-33, 28-49). The image of George Washington (Fig. 28-53, 28-54) appears often, particularly in decorative arts.

ARCHITECTURE

American Neoclassic architecture differs from England's in scale, construction methods, and building materials. Scale remains domestic instead of monumental. Wood-frame construction and brick prevail instead of stone. Gentleman amateurs or master craftsmen, rather than trained architects, design and build most structures. Therefore, American Neoclassicism does not have a strong theoretical base, as in Europe. Nor do Americans emphasize design dependence on classical models. Consequently, the Federal style is largely imitative, not necessarily innovative. A few immigrant builders and architects do introduce some innovations.

The style is largely urban and concentrates along the eastern seaboard, although examples dot the entire nation. With Jefferson's urging, most government buildings adopt the Neoclassical image. He promotes this image as a symbol of the new nation, with the intellectual idea that buildings are to be read as models of the new republic. Federal buildings generally retain Georgian forms, but are taller with slenderer proportions. Circular or elliptical forms usually highlight facades. Classical details, moldings, and ornamentation become shallower in relief and more delicate in scale. Urban structures tend to follow the Neoclassical style more closely than rural ones.

Public Buildings

■ *Types.* Building types include statehouses, churches, meetinghouses, banks, theaters, and warehouses.

■ *Statehouses (Capitols).* In Virginia, Thomas Jefferson designs the state capitol in Richmond (Fig. 28-4, 28-25) in

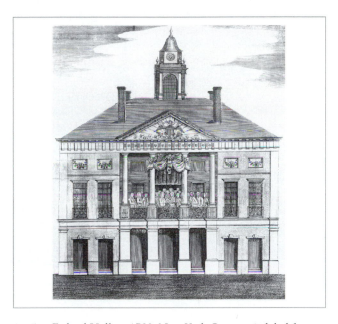

28-5. Federal Hall, c. 1789; New York City; remodeled from the New York City Hall by Pierre Charles L'Enfant.

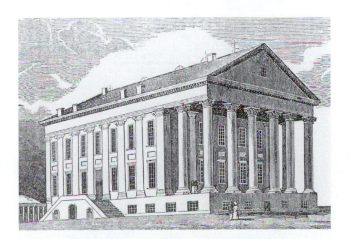

28-4. Virginia State Capitol, 1785–1789; Richmond, Virginia; by Thomas Jefferson. This structure was the first Neoclassical building in the United States and consequently influenced many others.

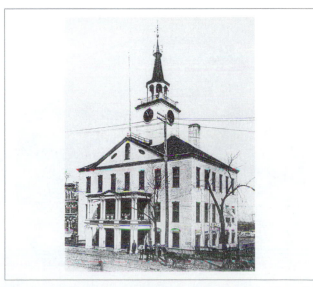

28-6. Old City Exchange, 1797; Savannah, Georgia.

1785–1788 as the first temple-form public building since antiquity. Its design emulates Roman models, specifically the Maison Carrée in Nîmes, France. By contrast, in the Connecticut and Massachusetts statehouses (Fig. 28-7), Charles Bulfinch introduces what becomes the typical form for capitols—a symmetrical facade with a portico or temple front and, inside, a domed rotunda flanked by two chambers. The United States Capitol (Fig. 28-12) follows this form on a grander scale.

■ *Churches.* Churches and meetinghouses (Fig. 28-9) continue earlier forms derived from the early 18th century, such as James Gibbs's S. Martin-in-the-Fields in London. However, slenderer proportions, curving forms (especially windows), and refined classical ornamentation proclaim Neoclassical influence. Differences between the New England meetinghouse and the Anglican church diminish during the period. The meetinghouse plan becomes less square and more rectangular, like the church. Its entrance and

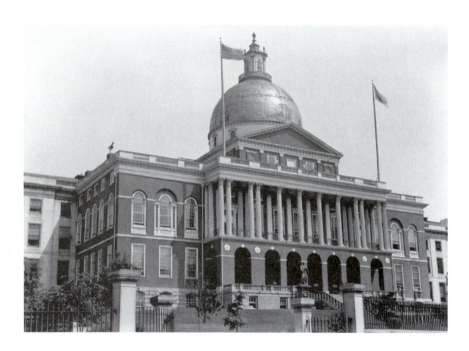

28-7. Massachusetts State House, 1795–1798; Boston, Massachusetts; by Charles Bulfinch.

28-8. The White House, 1792–1799; Washington, DC; by James Hoban; porticoes c. 1808 by Benjamin Henry Latrobe.

28-9. Meetinghouse, 1816; Lancaster, Massachusetts; by Charles Bulfinch.

pulpit moves from the longer side of the plan to the shorter, creating the axial symmetry desired in Neoclassicism. Interiors remain largely the same as before with a large open center space flanked by balconies and a choir loft opposite the pulpit.

■ *Site Orientation.* Urban structures are sited on streets. Lawns often surround churches. A unique development is Jefferson's plan for the University of Virginia (Fig. 28-11), which features two rows of five pavilions linked by colonnades facing each other across a lawn. At the head of the rectangle is the library, called the Rotunda, which emulates the Pantheon in Rome.

28-10. S. Mary's Roman Catholic Cathedral, 1814–1818; Baltimore, Maryland; by Benjamin Henry Latrobe. This building is Latrobe's most important project and was the first significant Roman Catholic church in the United States.

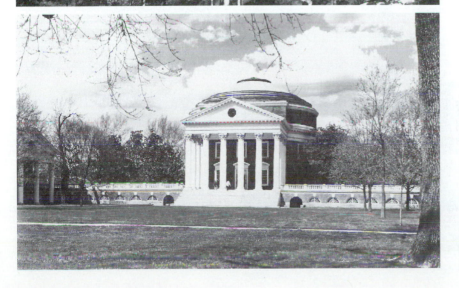

28-11. University of Virginia, 1817–1826; Charlottesville, Virginia; by Thomas Jefferson. This complex represents Jefferson's view of an "academical village" with classical pavilions flanking a lawn.

Design Practitioners

As before, master builders and gentlemen amateurs conduct most building in America. There are few native trained architects, as there is no one to train them. French and English immigrant architects and professionally trained designers set standards for professionalism and add distinctiveness to the Federal style. Underscoring the importance of pattern books, Asher Benjamin publishes the first American builder's manual, *The Country Builder's Assistant*, in 1797.

■ *Charles Bulfinch* is generally considered America's first native-born architect. Born into a wealthy, prominent family, he receives a good education that includes a grand tour in which he visits both England and France. Upon his return, he works in Boston, where his ideas and buildings help transform the city from a provincial town to an elegant Federal city. He constructs many different building types and succeeds Latrobe as chief architect of the U.S. capitol; the dome, colonnade, and west terrace are Bulfinch's designs. What separates him from the traditional gentleman architect is his use of drawings to develop ideas and his full involvement in design and construction. He also collects fees for his work.

■ *Duncan Phyfe* is a Scottish immigrant cabinetmaker who opens a cabinetmaking shop in New York City. A commission for John Jacob Aster assures his fame, and he receives commissions from many parts of the United States. Phyfe works in the prevailing styles of Sheraton, Hepplewhite, Regency, Directoire, and Empire. He favors solid mahogany with carving over veneer and is among the first to adopt reeding (convex channels in a leg, upright, or seat)

over fluting on arms, uprights, and legs. Phyfe also adopts the curule form and saber legs of the Regency and Empire styles.

■ *Benjamin Henry Latrobe* is a professionally trained English architect who immigrates to America in 1796. His first American commission is the Virginia Penitentiary in Richmond, Virginia, which is the first modern prison. Other distinctions include Sedgely, the first Gothic Revival house, built in 1799 (now destroyed); the first use of Greek orders in America in the Bank of the United States, built in Philadelphia in 1798–1800 (now destroyed); and the first attempts to collect fees based on a percentage of building costs. President Jefferson appoints Latrobe surveyor of public buildings, and he works on the U.S. Capitol building. Highly inventive, Latrobe's works exhibit great variety in design and form and set new standards for American architecture.

■ *Samuel McIntire* is a leading architect, woodcarver, and cabinetmaker in Salem, Massachusetts. Trained by his father as a wood-carver, he is largely self-taught in architecture. Best known for the mansions he executes for prosperous Salem merchants, his interiors and furniture feature exquisite classical detailing derived from many sources.

■ *John and Thomas Seymour* are father and son cabinetmakers who emigrate from England in 1785. After arriving in Maine, they move to Boston in 1794 where they become prominent cabinetmakers. Contrasting veneers and inlay, half-circle inlay, and painted interiors of case pieces characterize their work.

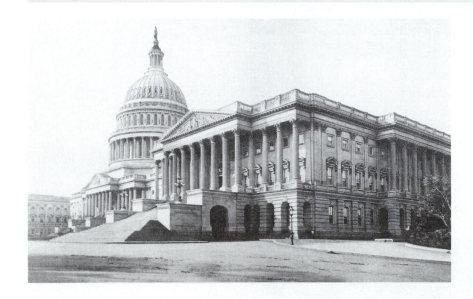

28-12. U.S. Capitol, 1793–1830; Washington, DC; by William Thornton, Charles Bulfinch, and Benjamin Henry Latrobe.

■ *Floor Plans.* Plans are symmetrical or nearly so. Many combine contrasting circular or elliptical spaces with rectangular ones in the English manner. Staircases are often circular in form.

■ *Materials.* Brick, alone and in combination with wood, dominates public structures. Brick and/or wood may be painted to imitate stone, which is rarely used. Typical colors are white, off-white, light gray, or blue. Wood framing is the more common form of construction, although more arches and vaulting appear during the period.

■ *Facades.* Facades (Fig. 28-5, 28-6, 28-7, 28-8) are symmetrical and typically combine circular and rectangular forms. Walls may be plain or articulated with slender pilasters and other elements. Columns are widely spaced and attenuated. String courses may separate stories, and pediments or projecting porticoes mark entrances. Windows, porches, and projections introduce curves and movement. Church facades (Fig. 28-9, 28-10) typically feature a columned portico, behind which is a tall, multilevel steeple, which features columns, arched openings, and classical ornamentation. Ornamentation, which is usually low in relief, reveals refined proportions and delicate scale.

■ *Windows.* Sash windows (Fig. 28-5, 28-6) are taller with thinner mullions. Some have lintels or are framed with

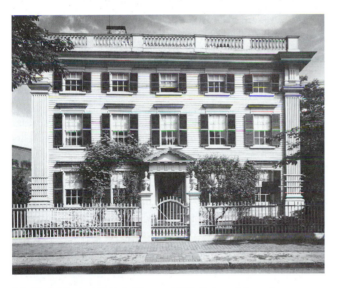

28-13. Pierce-Nichols House, 1782; Salem, Massachusetts. (Courtesy Peabody Essex Museum)

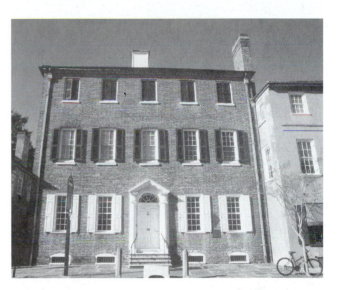

28-15. Heyward-Washington House, c. 1790; Charleston, South Carolina.

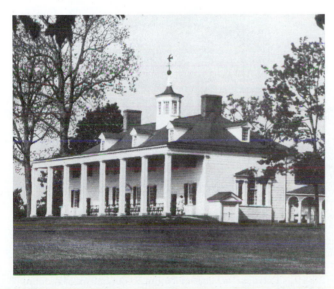

28-14. Mount Vernon, 1776–1785; Mount Vernon, Virginia.

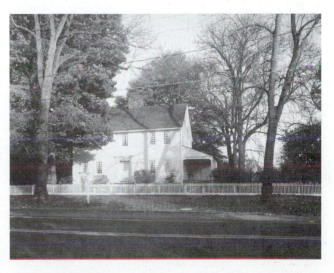

28-16. Phelps-Hatheway House, 1761, added onto 1794; Suffield, Connecticut.

classical details. Others are set within relieving arches (segmental arches over lintels to alleviate excess weight; also called blind arches). Fan and Palladian windows contrast with rectangular openings.

■ *Doors.* Door surrounds feature pediments and columns or fanlights and sidelights. Doors, which may be single or double, are paneled and painted a dark color or white.

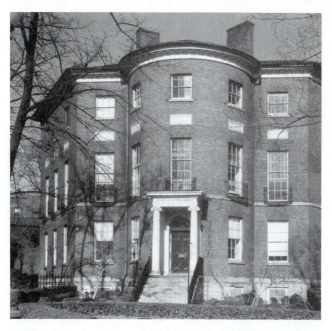

28-17. The Octagon, 1799–1800; Washington, DC; by William Thornton.

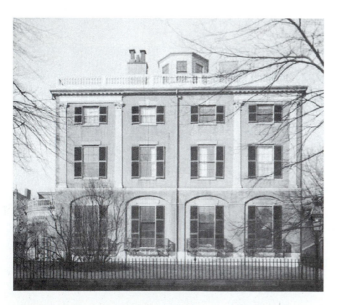

28-18. Second Harrison Gray Otis House, 1800; Boston, Massachusetts; by Charles Bulfinch.

■ *Roofs.* Roofs may be low-pitched gables or flat and hidden by a balustrade. Statehouses, churches, and steeples often have domes and cupolas (Fig. 28-5, 28-7).

■ *Later Interpretations.* Rarely revived as a separate style, Federal elements, such as fanlights, appear in public structures beginning in the late 19th century and continuing to the present.

Private Buildings

■ *Types.* Dwellings include detached structures and row houses. Urban houses are the main carriers of the Federal style. Often, rural dwellings exhibit little change, other than slender proportions and low-relief ornamentation.

■ *Site Orientation.* Urban structures are sited on streets (Fig. 28-13, 28-17, 28-18), but may be surrounded by lawns or have front and/or rear gardens. Rural houses (Fig. 28-14, 28-21) are generally oriented toward the main road.

■ *Floor Plans.* Plans (Fig. 28-22) develop from symmetry and may continue the rectangular block and double-pile plan. Many have three stories. Plans often feature apsidal or circular rooms combined with rectangular ones, repeating the contrasting forms of exteriors. Some rooms project, breaking up the rectangular block. Occasionally, symmetrical facades conceal asymmetrical plans. Circular staircases (Fig. 28-38, 28-39) often appear instead of straight ones adding movement to interiors. They also distinguish Federal houses from Georgian houses. Row houses follow standard London plans of front and back rooms with side

28-19. Portico, Tucker-Rice House, 1800; Salem, Massachusetts; by Samuel McIntire.

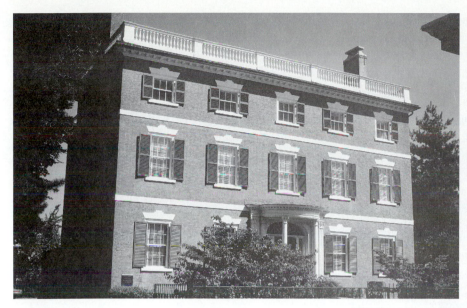

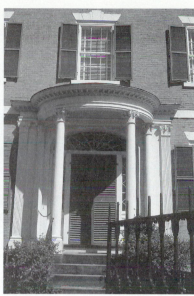

28-20. Facade and portico, Gardner-Pingree House, 1804–1805; Salem, Massachusetts; by Samuel McIntire.

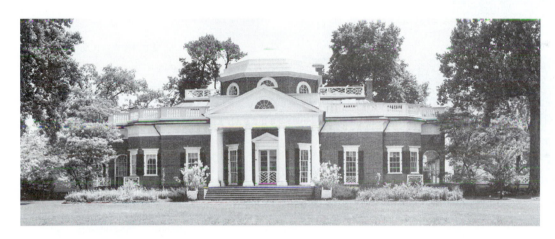

28-21. Monticello, begun 1777, remodeled 1793–1809; Charlottesville, Virginia; by Thomas Jefferson. (Color Plate 69)

passages for entries and stairs. Some regional forms appear, such as the single Charleston house featuring a room fronting on the street and others extending to the rear with a side porch or piazza and entrance.

■ *Materials.* More houses are of brick (Fig. 28-15, 28-17, 28-20, 28-21, 28-23), but wood remains a common choice. Trim typically is of wood. Wood or brick may be painted to imitate stone. Colors include white, cream, buff, stone or light gray, and light blue. Shutters (or blinds) are usually painted dark green.

■ *Facades.* Like public buildings, dwelling facades (Fig. 28-13, 28-14, 28-15, 28-16, 28-17, 28-18, 28-19, 28-20, 28-21, Color Plate 69, 28-23) feature contrasting curving and rectangular forms. Projecting bow centers, semicircular projecting porches, and/or rounded windows introduce curves and movement. Walls typically are plain, but may be

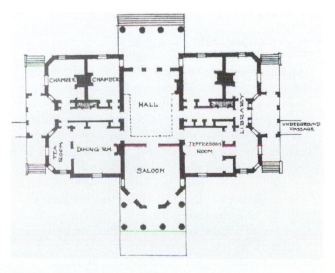

28-22. Floor plan, Monticello.

articulated with slender pilasters and other elements. String courses may separate stories. Columns are widely spaced and attenuated, and delicate classical ornamentation is low in relief.

■ *Windows.* As on public buildings, sash windows (Fig. 28-17, 28-23) on domestic structures are tall with thin mullions. Some have lintels, entablatures, or pediments above them. Fan or Palladian windows (Fig. 28-28) also create contrasting curves. Occasionally, windows may be set within relieving arches.

■ *Doors.* Fanlights (semicircular or semielliptical windows with radiating mullions) above front doors distinguish Federal houses (Fig. 28-19, 28-21, 28-23). Fanlights may combine with sidelights (two tall, narrow windows flanking a door), a pediment supported by pilasters, or engaged columns. Doors are paneled and painted a dark color or white.

■ *Roofs.* Roofs may be low-pitched gables or flat and hidden by a balustrade (Fig. 28-14, 28-21, 28-23). A few houses feature hipped roofs. A decorative cornice, usually with dentils, accentuates the wall beneath the roof.

■ *Later Interpretations.* Beginning in the late 19th century, Colonial Revival houses (Fig. 28-24) often feature fan- and sidelights, curving porches, and/or the slender proportions of Federal houses. These elements often are combined with Georgian or Greek Revival characteristics.

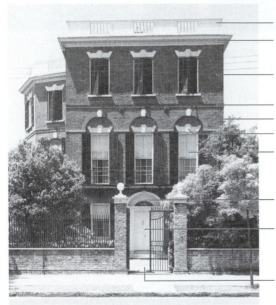

Balustrade hides low-pitched roof

Cornice

Brick construction

String course
Relieving arch
Lintel with keystone

Tall double hung window with thin mullions

Fan light window over entry door

Double doors with panels

House sites on street

28-23. Nathaniel Russell House, before 1809; Charleston, South Carolina.

Design Spotlight

Architecture: *Nathaniel Russell House.* Designed by local architect Russell Warren, this sophisticated brick house (Fig. 28-23) illustrates typical attributes of Federal dwellings in the South. Generally taller and slenderer than local Georgian examples, the building fronts the street, has three stories with string courses separating the levels, displays relieving arches over window lintels, and has a low-pitched roof hidden by a balustrade. The entryway features a delicate fanlight, white pilasters and moldings, and a dark paneled door. The plan is rectangular with an oval drawing room, eliptical flying staircase, and a Palladian window positioned at the cross axis.

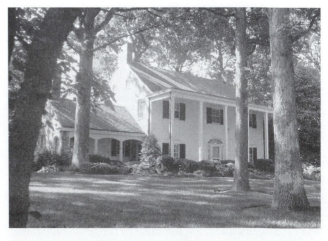

28-24. Later Interpretation: House on Mansion Drive, c. 1930s; Alexandria, Virginia; Colonial Revival.

Important Buildings and Interiors

- **Baltimore, Maryland:** S. Mary's Roman Catholic Cathedral, 1814–1818, Benjamin Henry Latrobe.

- **Boston, Massachusetts:**
 —First Harrison Gray Otis House, 1795, Charles Bulfinch.
 —Massachusetts State House, 1795–1798, Charles Bulfinch.
 —New South Church, 1814, Charles Bulfinch.
 —Second Harrison Gray Otis House, 1800, Charles Bulfinch.
 —Tontine Crescent, c. 1793, Charles Bulfinch.

- **Charleston, South Carolina:**
 —Heyward-Washington House, c. 1790.
 —Joseph Manigault House, 1801, Gabriel Manigault.
 —Nathaniel Russell House, before 1809, Russell Warren.

- **Charlottesville, Virginia:**
 —Monticello, begun 1777, remodeled 1793–1809, Thomas Jefferson. (Color Plate 69)
 —University of Virginia, 1817–1826, Thomas Jefferson.

- **Mount Vernon, Virginia:** Banquet Hall, Mount Vernon, c. 1776–1785.

- **New Haven, Connecticut:** Center Church, 1812–1814, Asher Benjamin and Ithiel Town.

- **New York City, New York:** Federal Hall, c. 1789, remodeled from the New York City Hall by Pierre Charles L'Enfant.

- **Philadelphia, Pennsylvania:** Bank of Pennsylvania, 1798–1800, Benjamin Henry Latrobe.

- **Richmond, Virginia:** Virginia State Capitol, 1785–1789, Thomas Jefferson.

- **Salem, Massachusetts:**
 —Gardner-Pingree House, 1804–1805, Samuel McIntire.
 —Pierce-Nichols House, 1782.

- **Suffield, Connecticut:** Phelps-Hatheway House, 1761, added onto in 1794.

- **Washington, DC:**
 —The Octagon, 1799–1800, William Thornton.
 —United States Capitol, 1793–1830, William Thornton, Charles Bulfinch, and Benjamin Henry Latrobe.
 —The White House, 1792–1829, James Hoban, porticoes c. 1808 by Benjamin Henry Latrobe.

INTERIORS

Federal interiors follow those of Robert Adam, but are more simply decorated with fewer colors. Lavish gilding, elaborate classical reliefs, and paintings are rare. Like Adam's, Federal rooms are elegant, refined, and formal. American rooms are generally smaller than British ones, but retain refined proportions. Classical motifs and architectural details dominate. Hierarchy of room decoration continues.

Public and Private Buildings

- *Types.* Important public spaces, such as those in statehouses and churches (Fig. 28-25, 28-26, 28-27), serve as places for gathering, meeting, and sometimes entertaining. Domestic structures follow earlier Georgian examples for room use and living patterns with one exception. During the period, more people set aside a room specifically for dining (Fig. 28-37). Patterns of entertaining change, and lavishly appointed dinners followed by card playing become popular.

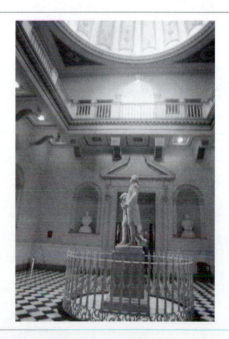

28-25. Rotunda, Virginia State Capitol, 1785–1789; Richmond, Virginia; by Thomas Jefferson.

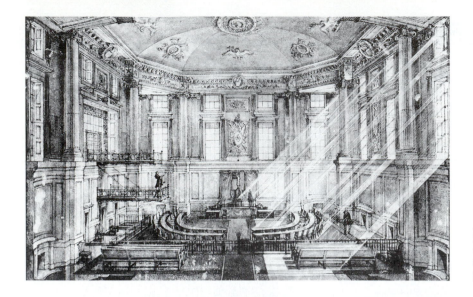

28-26. House of Representatives, Federal Hall, c. 1789; New York City; remodeled from the New York City Hall by Pierre Charles L'Enfant.

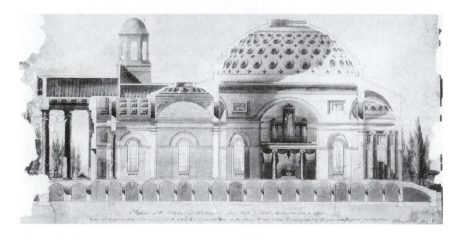

28-27. Section view, S. Mary's Roman Catholic Cathedral, 1814–1818; Baltimore, Maryland; by Benjamin Henry Latrobe.

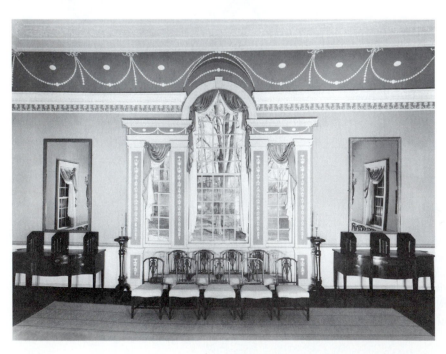

28-28. Banquet Hall, Mount Vernon, 1776–1785; Mount Vernon, Virginia.

■ *Relationships*. In houses, exterior design often reflects room placement. Wider spaces between windows outside denote more important spaces inside.

■ *Materials*. Plain plaster replaces paneling for walls. Most rooms have a baseboard, dado, and cornice (Fig. 28-28, 28-29, 28-31, 28-34, 28-37). Some have plasterwork ceilings. The most important rooms feature pilasters and columns. Classical moldings form cornices and chair rails. Wooden and white, gray, or pink marble mantels depict classical elements.

■ *Color*. Delicate but strong, clear colors are typical. White, off-white, buff, gray, and many shades of blue and green are typical colors (Fig. 28-28, 28-29, 28-35, Color Plates 70 and 71). Marbling and graining are fashionable.

■ *Lighting*. Forms and decoration of lighting fixtures (Fig. 28-30, 28-34, 28-35, 28-37, 28-40) are Neoclassical. Candlesticks and candelabra in both silver and brass adopt classical shapes, particularly columns. Whale oil and Argand lamps (Fig. 28-37, 28-40) become more common in the last two decades of the century. Sets of Argand

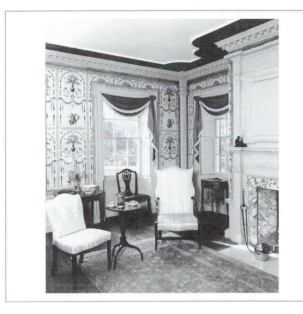

28-29. Parlor, Phelps-Hatheway House, 1761, added onto 1794; Suffield, Connecticut; now in Winterthur Museum, Wilmington, Delaware. (Courtesy, Winterthur Museum) (Color Plate 70)

28-31. Door detail, Entrance Hall, The Octagon, 1799–1800; Washington, DC; by William Thornton.

28-30. Door detail, Entrance Hall, Oatlands, c. 1800; Leesburg, Virginia.

28-32. Mantel, The Octagon.

lamps may decorate or flank a mantel, and are also available as brackets or chandeliers. Shiny surfaces and strategically placed mirrors maximize light, but many rooms are dark even during the day. Closed curtains and shutters protect valuable fabrics from sunlight. Due to expense, only a few candles are lit at night.

■ *Floors.* Softwood floors are typical. They are sometimes painted in solid, usually dark, colors or in patterns that imitate marble or other materials. Masonry floors are rare in America. Floor coverings include floor cloths, matting, and commercial and homemade carpets. Painted floor cloths in geometric patterns are popular, particularly in entrance halls. Brussels and Wilton carpets are too expensive for most Americans, so they more often purchase less costly ingrain (flat woven, reversible carpet), Venetian (flat-woven, multicolored, striped carpet), and list (carpet made of cloth strips or selvages) carpets. Especially favored are patterns of geometric shapes with classical motifs. Car-

28-33. Mantel, Judge Lynch House, c. 1790; Lynchburg, Virginia.

Design Spotlight

Interiors: *Parlor, Gardner-Pingree House.* Designed in 1804–1805 by Samuel McIntire, this parlor (Fig. 28-35) provides a glimpse of the Federal taste. Elegant and formal, it retains refined classical proportions. The white mantel and door surrounds display delicate Adamesque characteristics including Corinthian columns, swags, and paterae. A gold striped wallpaper covers the upper portion of the wall, above a paneled dado. Delicately embroidered window curtains hang to one side and flank the mantel. Furnishings are light in scale and follow the designs of Hepplewhite and Sheraton, with straight, tapering legs.

28-34. Parlor, Oliver House, c. 1800; Salem, Massachusetts.

pet is taken up in summer, and replaced with matting. People commonly place a drugget or baize crumb cloth beneath the dining table and a small hearth rug in front of the fireplace.

■ *Walls.* Classical wall divisions are typical (Fig. 28-25, 28-28, 28-29, 28-31, 28-35, 28-36) and include a baseboard, dado, dado rail, shaft or upper wall, and entablature.

The dado is usually paneled, and distemper (water-based) paint or wallpaper covers the upper portion of the wall. Wallpaper, increasingly fashionable, comes from England, France, and China, but is also made in America. Designs (Fig. 28-29, 28-34, 28-35, Color Plate 71) include architectural details, scenic or landscape papers, drapery patterns, rainbow papers, textile imitations, small repeating

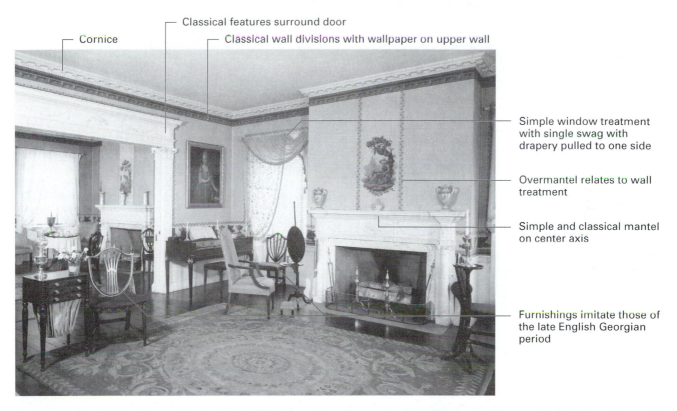

Cornice

Classical features surround door

Classical wall divisions with wallpaper on upper wall

Simple window treatment with single swag with drapery pulled to one side

Overmantel relates to wall treatment

Simple and classical mantel on center axis

Furnishings imitate those of the late English Georgian period

28-35. Parlor, Gardner-Pingree House, 1804–1805; Salem, Massachusetts; by Samuel McIntire. (Courtesy Peabody Essex Museum)

28-36. Section, Monticello, begun 1777, remodeled 1793–1809; Charlottesville, Virginia; by Thomas Jefferson.

patterns, and Neoclassical patterns. Borders, essential on painted and papered walls, come in many patterns, including some that match wallpapers. Typically, borders outline all architectural features.

■ *Mantels.* Mantels are simple and classical (Fig. 28-29, 28-32, 28-33, 28-34, 28-35, 28-37), featuring motifs common to the period. Some fireplaces are rebuilt to accommodate coal grates. Overmantel treatments are integrated with the wall design and may feature a decorative looking glass (Fig. 28-52).

■ *Windows.* Windows may be left plain, have interior shutters, or display simple window treatments (Fig. 28-28, 28-29, 28-35), which become more common as the period progresses. Typical treatments may consist of a single swag with festoon or sheer white cotton next to the window topped with floor-length curtains and shaped valances in solid colors. Trims and contrasting linings often enhance single and double festoons. Blinds in several forms also appear at windows. Slat types (Venetian) blinds are fashionable but expensive. Roller blinds, which usually do not

28-37. Dining Room; Baltimore, Maryland.

28-38. Stair Hall, Wickam-Valentine House, 1811; Richmond, Virginia; by Alexander Parris.

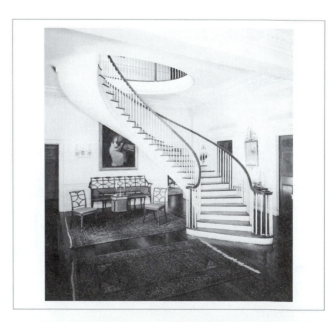

28-39. Stair Hall, Montmorenci, 1822; Winterthur Museum, Wilmington, Delaware. (Courtesy, Winterthur Museum)

28-40. Lighting fixtures: Candlestick and Argand lamp.

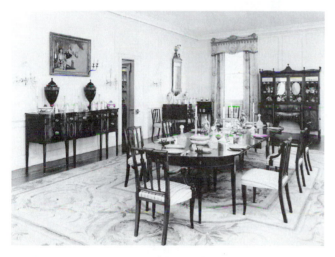

28-41. Later Interpretation: Dining Room, DuPont House, Winterthur Museum, c. 1930s; Wilmington, Delaware; Colonial Revival. (Courtesy, Winterthur Museum)

work well, are available at a reasonable price. Other shades are made of plain or pleated silk or cotton. Roller blinds or shades may display decorative painting.

■ *Doors.* Important doors are paneled and either painted or of polished mahogany. Those in major rooms have classical surrounds (Fig. 28-30, 28-31).

■ *Ceilings.* Most ceilings are plain, flat, and light in color. Those in affluent homes may have carved or cast plaster decorations in the center and near the cornice imitating the work of Robert Adam. A few ceilings feature painted or stenciled designs.

■ *Later Interpretations.* Interiors of Colonial Revival buildings adopt features of the Federal style mainly in the early 20th century (Fig. 28-41). Particularly evident are classical details in cornices, paneling, and mantels. Wallpapers from the Federal period are reproduced, and decorating books and periodicals illustrate Adam-style rooms. Elements of Federal interiors continue to highlight public and private interiors to the present.

FURNISHINGS AND DECORATIVE ARTS

Federal furniture adopts the light scale, geometric contrasts, veneers, straight legs, and classical ornament of European Neoclassical models such as Adam, Hepplewhite, and Sheraton from England and the Louis XVI style in France. Regional differences in construction and appearance decline during the period. Because makers often consult pattern books, similar designs and motifs appear in all areas.

Cabinetmaking centers change. Some, such as Newport and Boston, decline in importance, while others, such as Philadelphia and New York, retain their significance. A few, particularly ports such as Salem and Baltimore, become more prominent. Rural cabinetmakers often follow Neoclassical models with some idiosyncrasies.

Cabinetmaking becomes more specialized than before to meet increased demands for furniture. Many different artisans work on a piece including the turner, inlay maker, gilder, cabinetmaker, and upholsterer. By the end of the period, industrialization begins to affect the furniture industry. New sawing techniques produce thinner veneers, and makers increasingly use machines. Large furniture warehouses with stock pieces increase in number, although smaller firms specializing in custom furnishings also remain.

Private Buildings

■ *Types.* New kinds of specialized furniture include work and sewing tables, night tables, cellarettes, and knife boxes. Large dining tables that seat 20 or more increase in use. Card tables are more common than tea tables. Sofas and suites of furniture are more popular.

■ *Distinctive Features.* Light scale, slender and refined proportions, straight usually tapering legs, reeding, fluting, spade feet, thimble feet, and contrasts of circular and rectangular forms distinguish Federal furniture. Veneers, inlay, marquetry, and classical motifs dominate. Designs and motifs typically derive from fashionable pattern books, such as *The Cabinet-Maker and Upholsterer's Drawing Book* by Thomas Sheraton. Brass toe caps or castors appear on chairs, sofas, and tables.

■ *Relationships.* As before, furniture lines the perimeter of the room when not in use (Fig. 28-28). The finest pieces adorn the most important spaces.

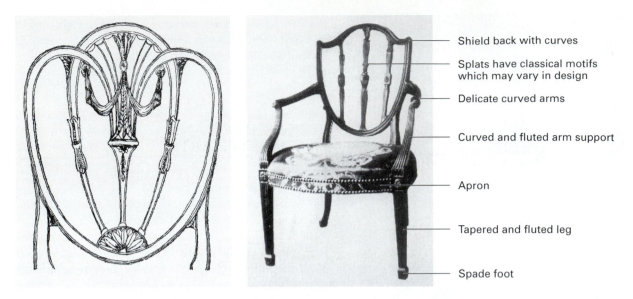

Shield back with curves

Splats have classical motifs which may vary in design

Delicate curved arms

Curved and fluted arm support

Apron

Tapered and fluted leg

Spade foot

28-42. Heart-back side chair and shield-back armchair, in the style of George Hepplewhite.

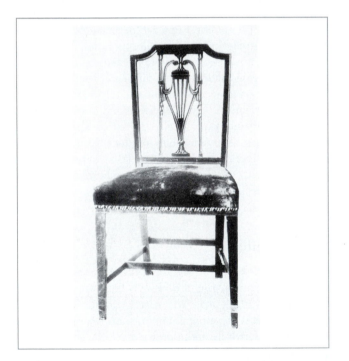

28-43. Side chair, in the style of Thomas Sheraton.

Design Spotlight

Furniture: *Shield-Back Armchair.* Designed in the style of cabinetmaker George Hepplewhite, this chair (Fig. 28-42b) reflects the Late English Georgian style popular in the late 18th century. Emphasizing straight lines and delicate scale, it develops with soft curves on the back and arms. Shield, heart, and oval backs are characteristic of Hepplewhite's designs. The legs are tapered and fluted with spade feet. Often used in drawing rooms and dining areas, the chair is available in matched sets.

cabinets, and doors. Marquetry classical figures, urns, swags, and other classical motifs embellish facades. Metal pulls for drawers and doors typically are imported. Round and oval shapes are most common, but a few lion masks appear. Gilded nails, sometimes in swag patterns, secure upholstery to frames. Pedestals typically have brass toe caps and castors.

■ *Color.* Woods contrasting in color characterize much Federal furniture, but painted furniture also is fashionable. Baltimore is known for its painted furniture. Pieces may be painted completely or have painted details mixed with other decoration. Colors include black, white, yellow, blue, and red. Decoration consists of flowers, fruit, and classical motifs. Gilding highlights some decoration.

■ *Seating.* Chairs and sofas generally follow Hepplewhite and Sheraton prototypes (Fig. 28-35, 28-42, 28-43, 28-45,

■ *Materials.* Woods include the native cherry, birch, and maple and the imported mahogany, ebony, satinwood, and rosewood. Veneers create contrasts of circles, ovals, squares, and rectangles in different colors and grains on facades and tops (Fig. 28-47, 28-48, 28-49). Light and dark contrasts are common, especially in New England, Philadelphia, and Baltimore. New Yorkers prefer solid mahogany. Crossbanding and stringing outline drawers,

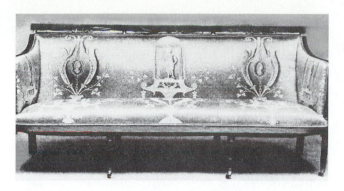

28-44. Sofa, in the style of Thomas Sheraton; by Duncan Phyfe.

28-50). A few emulate Louis XVI examples. Typical chair and settee back shapes are camel, shield, oval, and rectangular. Lolling chairs (called Martha Washingtons; Fig. 28-29, 28-46) have tall, upholstered backs and slender legs and arms. Common in America, particularly New England, they are largely out of fashion in Europe. Easy chairs, usually found in bedchambers, become lighter in scale with straight legs. New forms include the *bergère* with a low rounded upholstered back and the *fauteuil* with a square upholstered back. Chairs remain more common than sofas or settees. Sofas (Fig. 28-44) have square or curving backs

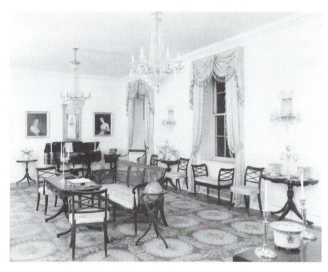

28-45. Baltimore Drawing Room, Winterthur Museum; Wilmington, Delaware; furniture in the Federal style. (Courtesy, Winterthur Museum)

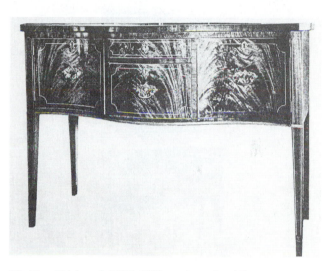

28-47. Sideboard, 1790–1800, in the style of George Hepplewhite.

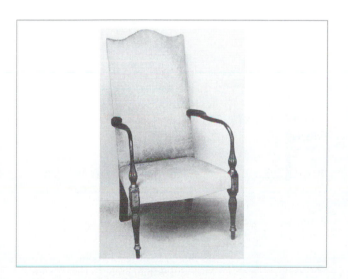

28-46. Lolling (Martha Washington) chair, in the style of Thomas Sheraton.

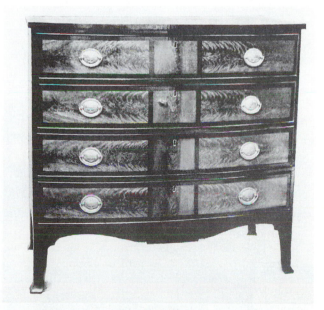

28-48. Chest of drawers, 1790–1800.

and slender, tapering quadrangular or circular legs. The curve of camel-back sofas becomes more elongated, and its arms form scrolls. Upholstery is stuffed with horsehair, straw, and other materials, with no springs, resulting in a silhouette that is clear with sharp edges.

■ *Tables.* Americans use a variety of tables including game and card tables, tea tables, breakfast tables, and dining tables (Fig. 28-34, 28-35, 28-37). Work tables with a bag

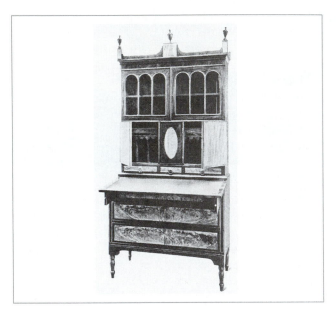

28-49. Writing desk with bookcase, c. 1800.

for sewing, a drawer for writing, a game board, or a mirror for dressing may have four turned or tapered legs or a pedestal. Pembroke tables are common in bedchambers. Sofa tables sometimes appear in front of sofas. Dining tables, made in several sections, may have pedestals (pillar and claw) or slender, tapered legs and are often semicircular with drop leaves. Sections sit against the wall when not in use. Card tables, which become more common than tea tables, exhibit the greatest variety of forms. Shapes for tops include round, semicircular, oblong, serpentine, ovolo, or canted corners. The more complex the shape, the more costly the table. Bands, paterae, or husks may highlight the apron. Card tables may have slender, tapered legs with stringing or marquetry or pedestals in the form of lyres, columns, eagles, or dolphins.

■ *Storage.* Chest of drawers, commodes, bureaus, and desks and bookcases reflect Neoclassical influence in scale, form, and ornamentation (Fig. 28-48, 28-49). Ladies' desks are new forms. Most have four tapered legs and small drawers and openings sometimes hidden by tambour doors (panels composed of strips of wood glued to a strong fabric backing). Sideboards (Fig. 28-47), which display prized decorative items, usually have three or four sections of doors and drawers adorned with veneer patterns and stringing. Shapes include bow, kidney, and serpentine. Legs are slender and tapered. Unlike Europeans, Americans place cellarettes or wine coolers beneath sideboards.

■ *Beds.* The typical bed has four slender turned, carved, reeded, or fluted posts and a flat or serpentine tester (Fig.

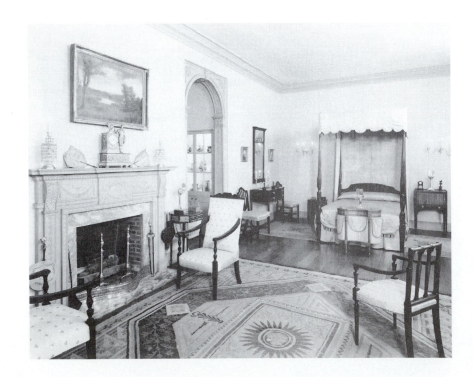

28-50. McIntire Bedroom, Winterthur Museum; Wilmington, Delaware; furniture of the Federal period. (Courtesy, Winterthur Museum)

28-50, 28-51). Charleston bedposts often feature rice carving. Beds remain expensive pieces because of the elaborate hangings.

■ *Textiles.* Federal is the last period in which all textiles in a room match. Throughout the period, more and a greater variety of textiles (Fig. 28-54) appear. Many have shiny surfaces to enhance light. Horsehair is common for chair seats. Printed or white cottons are used at windows or for slipcovers, bed hangings, and dressing tables. Chairs and sofas sometimes have fabric festoons beneath the seats. Following drapery, bed hangings are more complicated in design (Fig. 28-50). Valances are no longer flat and shaped, but feature trimmed swags and festoons. Most people remove window treatments and bed hangings entirely in summer or replace them with lighter weight cottons.

■ *Clocks.* Americans both make and import accessories from Europe and China. Tall case clocks often are the most expensive piece in the house, but less expensive wall and shelf clocks (Fig. 28-3) gradually supersede them. In 1805, Eli Terry begins to successfully mass-produce wall and shelf clocks with wooden works, interchangeable parts, and assembly-line construction. His rectangular shelf clock features a swan's neck broken pediment, brass finials, and short legs. A landscape or other American scene highlights the space below the face. Simon Willard develops the banjo clock with a round face and long, flaring shaft.

■ *Looking Glasses. Girandoles* (Fig. 28-52), mirrors with round, gilded, heavy frames and convex glass, become fashionable during the period. They may feature candleholders and often are topped with an eagle. Tabernacle glasses (mirrors) have gilded side columns supporting a bold cornice, with a landscape, naval battle, or scene of Mount Vernon beneath the cornice. Also fashionable are looking

28-51. Bedpost detail.

28-52. *Girandole* (mirror), c. 1800.

28-53. Vase with image of George Washington; produced in France.

28-54. Textiles: *Toile de Jouy* prints with symbols of the new American republic.

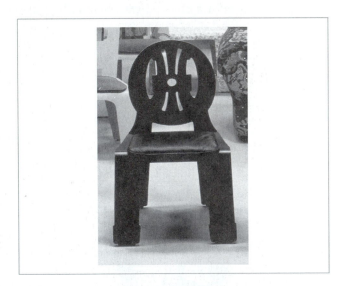

28-55. Later Interpretation: Chair, Knoll International, New York, 1984; Robert Venturi.

glasses with delicate, gilded moldings and crestings of urns, arabesques, or flowers.

■ *Ceramics.* In 1785, America initiates trade with China, and soon Chinese porcelain, silver, and furniture embellish American homes. Porcelain designs consist of monograms instead of coats of arms and American motifs such as eagles, portraits of Washington (Fig. 28-53), and the United States seal. Americans also import great numbers of English ceramics made for the American market. They favor blue and pink Staffordshire with transfer-printed American scenes. In addition, English porcelains, creamware, lustreware, and Wedgwood adorn American tables and mantels.

■ *Later Interpretations.* Reproductions and adaptations of Federal furniture and decorative arts appear at the end of the 19th century and continue to the present. Chairs (Fig. 28-55), dining tables, beds, wallpapers, and some textiles are most common.

Glossary

à la Reine (Fr.) A flat upholstered chair back.

abacus The block between the capital and the architrave; typically rectangular except in the Corinthian and Composite orders, in which it is concave with cut-off corners.

acanthus A Mediterranean plant with thick, scalloped leaves; stylized forms highlight Greek, Roman, and later architecture, details, and furniture.

acropolis The main part of a Greek city, usually on the summit of a hill, housing the main temples and treasuries.

acroteria (*acroterion*, s.) An ornament placed on the lower parts and apex of a pediment.

adobe Sun-dried clay brick in varying sizes used to build many Spanish missions and dwellings in the southwestern United States.

aedicule (*aedicula*, pl.) A small motif composed of columns or pilasters supporting a pediment; typically surrounds a niche or window.

aisles Areas flanking the nave and separated from it by the arcade in a basilica or Latin cross church.

ambulantes (Fr.) Small or occasional tables.

antae (*anta*, s.) Pilasters with columns between them on the corners of exterior walls in temples.

antechamber (Fr.) First room of a suite; typically used for eating and waiting.

antefix Ornament blocks placed at the ends of roof tiles; upright ornament placed on the corners of pediment tops of case pieces in Neoclassical furniture.

anthemion Motif consisting of a radiating cluster of stylized leaves and flowers of the honeysuckle.

apartment (*appartement*, Fr.) A series of rooms associated with a single person; appearing in the late 15th century, rooms arrange in a linear sequence and progress from most public to most private spaces.

appartements des bains (Fr.) Rooms for bathing.

appartements de commodité (Fr.) Suites of private spaces with bedchambers, *boudoirs*, and *appartement des bains* (bathing rooms).

appartements de parade (Fr.) Suites of ceremonial rooms arranged *enfilade* on the garden side; used to receive important people and deal with important matters.

appartements de société (Fr.) Suites of smaller spaces with less formal décor where people of similar status eat, play cards, converse, and socialize.

appliqué (Fr.) A wall sconce; a shaped and worked decoration that is applied to a piece of furniture or textile.

apron A horizontal support under a chair seat, table top, bottom frame of a case piece, or window sill; often carved, pierced, or otherwise decorated.

apse A semicircular or polygonal space on the eastern or altar end of a church.

arabesque or **seaweed marquetry** Veneer in a pattern of small, allover scrolls characteristic of English case pieces in the 17th and early 18th centuries.

arabesque A decoration composed of flat, geometric patterns and flowing, curving lines and tendrils. Developing in Hellenic Greece and used in Rome, it becomes a pronounced feature of Islamic art and architecture; plant forms are less realistic and become formal patterns in Muslim forms.

arcade A row of arches carried on columns or piers; may be open, as in a nave, or closed, as on the facade of a building.

arch In architecture, a structure of wedge-shaped blocks that spans an opening; supported on the sides by columns or piers.

arch order A motif composed of arches framed by engaged columns carrying a lintel.

architectonic Relating to or resembling aspects of architecture, such as space or structure.

architrave A horizontal member (or lintel) immediately above a column.

archivolts Moldings on the face of an arch that define it and follow its shape.

arcuated Construction using arches.

armoire (Fr.) (*armario*, Sp.) French term for a wardrobe; a tall, upright cupboard, with or without interior shelves, having a door or doors on its facade.

armoire à deux corps (Fr.) A case piece made in two sections developing in the French Renaissance; the broader lower section has two paneled doors, while the upper section is narrower and is often topped with a pediment.

artesonades (Sp.) A ceiling of geometric carved wooden panels.

atrio (Sp.) An enclosed courtyard of a Spanish Colonial mission complex that includes burial grounds and space for outdoor services.

atrium A space in the Roman house forming an entrance hall or court; the roof is open to the sky. In Early Christian and later architecture, a forecourt.

Aubusson A carpet with a coarse tapestry weave, woven at the Aubusson factory in France established in the Middle Ages; open slits where colors meet distinguish these flat woven types.

axial plan A plan that is longitudinal or arranged along an axis.

azulejos (Sp.) Spanish and Portuguese ceramic tiles, typically in blue and white.

bailey A courtyard or open area of a castle.

baluster A turned or carved upright, sometimes in the form of a column; it may appear in a chair back or with others in a balustrade.

balustrade A parapet or railing composed of a handrail, balusters, and a base.

baptistery A separate building used for baptismal rites.

barrel vault A semicircular continuous vault used from Roman times to the present.

basilica Roman halls of justice typically composed of aisles, galleries, and an apse opposite the entrance; a church with a nave and two or more aisles, with or without galleries. Basilica churches evolved from Roman examples.

battered Slanted wall for stability; usually battered on one side.

battlements A parapet consisting of raised rectangular shapes (*merlons*) and openings (*crenellations*); part of early fortification techniques.

bay A vertical division of an exterior or interior marked by an order, pilasters, fenestration, vaulting unit (as in a nave), or roof component.

bay window An angular window that projects outward at ground level.

bed hangings Draperies intended to surround a bed for privacy, protection from drafts, and as an indication of wealth. A set of hangings includes the **head cloth** that hangs behind the headboard at the head; the **ceiler,** the cloth inside the tester or cornice; the **valances,** the shaped or plain fabrics hanging from the tester or cornice; **bases** that are similar to today's dust ruffle; **curtains** on all four sides that completely enclose the bed; and the **counterpoint** or **counterpane** (coverlet).

bergère (Fr.) An upholstered chair with closed arms.

bergère confessional (Fr.) An upholstered chair with a higher back and wings.

bergère en gondole (Fr.) An upholstered chair with an arched horseshoe back that continues to form the arms.

besso (Jp.) A country house.

billet Romanesque molding composed of regularly spaced short cylinders or square pieces; derives from Norman architecture.

boiserie (Fr.) Carved wood paneling.

bombé (Fr.) Vertical swelling shapes on furniture.

boss An applied circular or oval furniture ornament that develops from crossing points of ceiling ribs in Gothic architecture.

boudoir (Fr.) A dressing room or private sitting room for a woman.

Boullework Marquetry composed of tortoise shell and brass perfected by French *ébéniste* Andre-Charles Boulle in the 17th century. A thin layer of tortoise shell and brass are glued together and shaped into complicated designs with a jigsaw; when separated, they produce identical images of brass with a tortoise shell ground and vice versa.

bow front A case piece with a convex front shaped like a bow or a semicircle; common in the 18th century.

braccio (Sp.) Lantern mounted on iron brackets in Spanish houses.

Brewster chair A 17th century turned chair with rush or wooden seat and spindles in the back, below each arm, and under the seat; a 19th-century name for William Brewster, an Elder in Plymouth Colony, America, who owned one.

briqueté entre poteaux (Fr.) Half-timber construction with a brick infill covered with plaster.

brocade Woven textile with a raised pattern that is emphasized by color or contrasting surface; typically, a plain, twill, or satin ground with twill or satin pattern. The back is distinguished by additional weft threads used in the design but not carried from selvage to selvage. Originally woven in China with gold or silver threads.

Brussels carpet A loop pile wool carpet in the 18th and 19th centuries with a linen warp first woven in Brussels about 1710 and in England about 1740. Manufacture of Brussels carpets ended in 1930. Today woven loop pile carpets are made on Wilton looms.

buffet Serving tables or cupboard used for serving meals. In medieval times, a buffet was a set of shelves for display and an important piece to demonstrate rank or status, since the number of shelves depended upon the rank of the owner.

bun foot A type of furniture foot that is round and slightly flattened on top and bottom, resembling a bun.

bureau à cylindre (Fr.) A rolltop desk or a cylinder-front desk.

bureau plat (Fr.) A table desk oblong in shape with three drawers in the frieze; introduced in the 17th century.

burl Veneer with a mottled appearance deriving from irregular growths on the tree.

buttress Mass of masonry built against a wall to strengthen it against the pressure of an arch or vault.

byôbu (Jp.) Decorative Japanese screen of two, three, or six panels that adds color and pattern and provides privacy and protection from drafts.

cabinet (Fr.) A small, private room within a suite used for conducting business.

cabochon An oval ornament with no facets resembling a polished stone or gem.

cabriole leg A curving form imitating an animal's leg; it curves out to a knee, down and into an ankle, and swells out again to a foot.

calico Plain or printed cotton cloth imported from India.

calligraphy The art of highly ornamental script.

camera (It.) In residences, the owner's bedroom; often includes a studio (*studiolo*), a small private space in which the owner keeps his most treasured possessions.

canapé (Fr.) A sofa or settee.

candelabrum (candelabra, pl.) (Fr.) A multiarm candleholder usually placed on a table or stand.

capital The uppermost member of a column or pilaster.

caquetoire (Fr.) A French Renaissance chair with a trapezoid seat and a tall, narrow back with carving, outward-curving arms.

Derived from the French term *caqueter*, meaning to cackle or to gossip, it was designed to accommodate the wide skirts of the 16th century.

cartouche A tablet or panel, usually oval with an ornamented frame or scrolled edges; usually contains an inscription, coat-of-arms, or monogram.

Carver chair A 19th-century term for a 17th-century turned chair with wood or rush seat and spindles only in its back; John Carver, first governor of Plymouth Colony, owned one, hence the name.

caryatid A female figure used as a column.

casement window A metal or timber window hung vertically and opening outward.

cassapanca (It.) A chest with an added back used as a seat; serves as a seat of honor when raised on a dais.

cassone (It.) A chest or coffer with a hinged lid, in Italy; large ones for clothing typically were part of a bride's dowry and featured elaborate decoration.

cathedral The main or mother church of a diocese.

celadon Chinese glaze derived from iron that varies from delicate green to gray-blue. In Europe the term refers to Chinese and other porcelain wares with a greenish glaze; origin of the term is uncertain.

cella The main room of a temple, which usually houses the cult statue; also called the *naos*.

centralized plan A plan that radiates from or around a center point.

certosina (It.) Inlay of ivory, bone, metal, or mother-of-pearl in complex geometric patterns on dark wood; found in Italy and Spain. The name derives from a Carthusian order of monks.

châines (Fr.) In French architecture, vertical bands of rusticated masonry dividing facades into panels or bays.

chaise longue (Fr.) Means literally *long chair*; variation of a daybed consisting of an armchair with a seat long enough for the legs.

chamber à coucher (Fr.) A room within a suite used for receiving and sleeping.

chamber de parade (Fr.) The main reception room for important persons and, consequently, the most formal and lavishly decorated room in the French aristocratic house.

chamfer A flat surface made by smoothing off the angle of a corner where two sides meet; surface can be hollow or concave or have a molding in place of the angle.

chateau (*chateaux*, pl.) (Fr.) A monumental, luxurious country house or castle of a French aristocrat.

chimera A Greek mythological creature with the head of a lion, body of a goat, and tail of a snake.

china clay See *kaolin*.

china stone See *pai-tun-tzu*.

Chinese lacquer Composed of red ornament on a black background with some gold and silver.

Chinoiserie (Fr.) Chinese and pseudo-Chinese motifs that reflect European fanciful, naïve, and/or Romantic notions about China.

chintz Originally, painted or printed cotton from India, not like today's glazed and printed cottons. In Hindi, *chint* means spotted cloth; its plural, *chintes*, becomes *chintz*; used for clothing and furnishings in 17th and 18th centuries.

chochin (Jp.) An outdoor paper lantern; a portable spiral of thin bamboo covered with rice paper that folds flat when not in use.

choirstall chair Evolves from seating in choirs of churches; a box shape with a tall back and solid paneled arms and bases.

cinquefoil Five-lobed form; see also *foils*.

clapboard American and Canadian term for overlapping, horizontal wedge-shaped boards covering a timber-framed structure; the upper portion of the board is thinner; called *weatherboarding* in England.

clerestory Windows placed high in a wall, especially above a roof; also *clere-story*, *clearstory*, or *clear-story*.

cloister A covered passage around an open space; in monasteries, connects the church to the chapter house and refectory.

cluster column A column with several attached or detached shafts; also called *compound column*.

coffer A sunken decorative panel in a ceiling; or a medieval chest intended for transporting goods, with an arched top and no feet.

coffered ceiling A suspended grid of three-dimensional geometric panels developing in the Italian Renaissance.

colossal order or **colossal column** An order or column that spans two or more stories.

commode (Fr.) A low chest with drawers or doors introduced in the late 17th century; term derives from *convenient* or *accommodation*.

commode-desserte (Fr.) An oblong commode with quarter-circle rounded ends with shelves and brass galleries and doors and/or drawers in the center; introduced in Louis XVI period.

common bond A brick pattern consisting of five rows of stretchers (lengths) and one row of headers (ends).

compartmented ceiling A ceiling of rectangular panel grids defined and divided by three-dimensional moldings.

compluvium A rectangular opening in the atrium roof in a Roman house; roof slopes down to allow rain to fall into a shallow opening in the floor (*impluvium*).

Composite A type of column developed in late Roman times. Its capital is composed of the two pairs of Ionic volutes and the double row of acanthus leaves of the Corinthian; the shaft, which rises from a base, may be fluted or plain.

compound column See *cluster column*.

Connecticut or **Wethersfield chest** A 17th-century American oak or pine chest on four short legs with one or more drawers; often painted, its decoration consists of split spindles, applied moldings, and three panels of which the center features stylized Tudor roses (sometimes called *sunflowers*).

console (Fr.) A table fixed to the wall and supported only in front by legs or a pedestal; introduced in Louis XIV.

convento (Sp.) Spanish term for monastery that commonly adjoins a church.

coquina In Spanish Colonial Florida, a more permanent building material of shell stone.

corbel A bracket usually supporting a beam of a roof, floor, or other feature.

corbel table A wall projection composed of brackets connected by round arches; characteristic of Romanesque and Romanesque Revival architecture.

corbel vault A vault composed of large masonry slabs that are piled on top of one another and gradually overlapping the ones below.

Corinthian An order developed by the Greeks; rising from a base is the slenderest of fluted shafts, capped by an inverted bell-shaped capital. Two rows of eight acanthus leaves highlight the lower portions, and rising from them are stalks terminating in small volutes that support the abacus. The abacus curves outward to the corners, ending in a point or chamfer. A carved rosette decorates the center; the entablature resembles that of the Ionic.

cornice The uppermost or crowning portion of the entablature; also any ornamental projection molding along a wall or arch.

Coromandel lacquer Lacquerwork composed of polychrome designs on a black background with incising around motifs.

cortile (It.) A central courtyard surrounded by an arcade in a palace or other building.

cours d'honneur (Fr.) Forecourt of a building.

court cupboard Consists of open shelves with elaborate carving and is no more than 4′-0″ tall. Introduced from France at the end of the 16th century, it displays plates in the great hall or great chamber of English Renaissance houses; commonly called a *credence* in the period.

cove A ceiling that is rounded instead of rectangular where it joins the wall.

credenza (It.) A small domestic cupboard; an oblong chest with drawers in the frieze and two or three doors beneath separated by narrow panels or pilasters. During the 15th century, it becomes a common Renaissance piece.

crewel work Designs embroidered on linen in worsted wool thread in a chain stitch; patterns include trees, flowers, foliage rising from mounds combined with animals. Used in the 17th and 18th centuries primarily for bed hangings.

crockets Blocks of stone carved with foliage that decorate the raking angles of spires or canopies; typical of Gothic architecture.

Cromwellian chair Mid-19th-century term for an English and American armless rectilinear chair with turned legs and upholstered or leather seat and back; its name derives from its austerity characteristic during the rule of Oliver Cromwell in England.

cross banding A narrow border strip of veneer or inlay running across the grain of the main portion and contrasting in color and grain.

cross vault Two barrel vaults intersecting at right angles; also may be called a *groin vault*.

crossing A square or nearly square area where the nave, chancel, and transept intersect; four arches corresponding to the four arms of the church define it.

cubiculum In Roman houses, a bedroom; sometimes refers to other less defined spaces.

cupid's bow crest A top rail composed of a double ogee curve whose ends turn up into ears; name derives from its supposed resemblance to Cupid's bow.

cusp A projecting point formed by the intersections of curving Gothic tracery.

dado Part of a pedestal between the base and cornice in classical architecture; later, the lower portion of a wall when decorated separately.

dais A raised platform.

damask Fabric with woven designs in contrasting shiny and dull surfaces; reversible; originally woven in China; imported into Europe through Damascus, hence its name.

Dante A 19th-century term for an Italian **X**-form chair with four legs curving up to the arms and a leather or fabric seat; sometimes a seat of honor. Author Dante Alighieri owned a chair of this form.

Delft or **delft** Tin-glazed earthenware made in the Netherlands.

demi-lune A semicircular case piece.

dentil Molding composed of rectangular (toothlike) blocks.

dependency A smaller, minor building flanking a larger, major one; typical of American Georgian interpretations of Palladian *villas*.

Diocletian window *See* **thermae** window.

divan A 19th-century couch without arms or back; evolves from the *tazar*, with its pile cushions for sitting or reclining in Turkey.

dome A hemispherical or semi-elliptical convex covering over a circular, square, or polygonal space.

domus In Roman architecture, a single-family dwelling for the well-to-do.

donjon (Fr.) A tall, inner tower of a castle; also called *keep*.

Doric An order developed by the Greeks characterized by a heavy column with fluted shaft and no base; an echinus and abacus comprise the capital; triglyphs and metopoes with relief sculpture define the frieze. Roman Doric columns are more slender than Grecian ones and have a base.

double-hung or **sash window** Two sliding sashes or panels hold the glass and slide up and down; invented in Holland in the 1640s. Pegs are used to hold sashes up until they are replaced by cords and counterweights.

dovetail A joint composed of wedge-shaped projections (like a bird's tail) that connect two perpendicular boards together.

drawtop or **draw table** An extension table with two leaves; the two end leaves slide under the center one when closed and pull out when open.

dressing table Any table designed to be used when dressing or applying makeup. During the 17th century, the term refers to a small table with two or three drawers. During the 18th century, dressing tables become more elaborate with drawers, cupboards, and superstructures, and are used by both men and women.

dressoir (Fr.) A display piece with open shelves arranged in tiers or steps like a buffet. It develops in the Middle Ages and

eventually becomes a table with shelves used to dress or prepare food for cooking.

drugget Wool or partly wool fabric used to protect carpets.

duchesse brisée (Fr.) A deep *bergère* with stool.

Dutch cross bond Alternating rows of headers and stretchers with colored mortar that creates diamond patterns.

ear A decorative element consisting of a right-angled projection in a doorway, fireplace, or other feature; or extensions on both sides of the crest rail of a chair beyond the back upright.

earthenware Pottery of common clays that does not become impervious to liquids upon firing; must be glazed or will remain porous.

easie chair Period name for an upholstered wing chair introduced in the late 17th century.

ébéniste (Fr.) A cabinetmaker who produces furniture with veneers; term derives from the use of ebony as the primary wood used for veneer.

echinus A rounded cushion or projection that is part of the Doric capital.

egg and dart (egg and tongue or **ovolo)** Molding composed of alternating oval and pointed forms.

en cabriolet (Fr.) A concave upholstered chair back.

encoignure (Fr.) Low corner cupboard with a bow or flat front that stands on three or four legs; a series of shelves, graduated in size, may fit on top.

enfilade (Fr.) French system of aligning interior doors in a series of rooms so that when they are opened, they create a vista; doors are near windows with fireplaces centered on the same wall as doors. Introduced about 1650, *enfilade* is typical of Baroque palace planning.

engaged column A column attached to a wall, circular in section.

English bond A brick pattern of alternating rows of headers and stretchers.

entablature Part of the building above the columns; composed of architrave, frieze, and cornice.

entasis A slight swelling or outward curve of a column shaft; Greek optical refinement designed to counter any inward curve; also gives column the appearance of responding to the load it carries.

equipal (Sp.) A chair with a circular seat supported by a cylindrical base of cedar splits that was popular in Mexico, particularly for *patios*.

espadaña (Sp.) A parapet.

estipite A pilaster that tapers to the base and is composed of baluster blocks; an invention of Northern Mannerism, *estipite* distinguish Spanish Baroque or Churrigueresque.

faience Tin-glazed earthenware made in France after 1600. Wares follow fashionable European styles and copy Chinese ceramics in underglaze blue. Porcelain supersedes faience in popularity; it becomes a peasant art by 1800.

fan vaulting Vaulting that resembles a fan in shape; characteristic of the Perpendicular (Gothic) style in England.

fanlight A semicircular or semi-elliptical window with radiating mullions, often above a door.

farthingale chair or **back stool** A rectangular side chair common in the English Renaissance with four legs joined by stretchers close to the floor, an upholstered seat, and a slightly raked upholstered back. *Farthingale* is a 19th-century term suggesting that the form developed to accommodate wide hoop skirts; commonly called a *back stool* during the period because of its resemblance to a stool with a back.

fascia Vertical face, each projecting beyond the other; typical of Ionic and Corinthian orders.

fauteuil (Fr.) An upholstered chair with open arms.

feng shui Chinese system of orientation that uses the earth's natural forces to balance yin and yang to achieve harmony.

festoon An ornament depicting a garland of fruit or flowers tied with ribbons and hanging from a rosette or other form; also, a curtain that draws up by tapes on the back, forming a swag, introduced in the 18th century.

flambeau (Fr.) A candlestick.

Flemish bond A brick pattern of alternating headers (ends) and stretchers (length) on the long side.

fleur-de-lis (Fr.) A motif consisting of three stylized flowers or petals; the center is erect while the two flanking petals curve out and down. Although widely used as a heraldic device in the Middle Ages, it becomes associated with French royalty through French designers' use of it for them.

Florentine arch A rounded arch accented with moldings and a center keystone and ending at capitals supported by columns or pilasters.

fluted Displaying concave shallow channels or grooves in a column, pilaster, chair leg, or other vertical surface.

flying buttress On an exterior, an arch form extending from the nave wall between clerestories to a separate pier a short distance away; like a regular buttress, it helps strengthen against pressure from vaults.

foils Small arc openings or lobes separated by cusps in Gothic tracery; trefoils have three lobes; quatrefoils have four; cinquefoils have five.

frailero (Sp.) A rectangular arm or side chair resembling the Italian *sedia*.

fresquera (Fr.) A ventilated food cupboard decorated with spindles and lattice; typically hangs on the wall.

fret A Greek ornament composed of intersecting lines at right angles; also called *Greek key*.

fretwork Carved ornament composed of straight lines in geometric patterns; it may be open or in relief; seen on aprons, legs, stretchers, and arms of furniture with Rococo or Chinese influence.

frieze The middle portion of the entablature between the architrave and cornice; may be decorated or plain; also, a decorated band on an interior wall beneath the cornice.

fulcrum A headrest on a Roman couch; a structure on which the sitter leans, which is often lavishly decorated with animals, busts, and satyrs.

furniture cases Period term for slipcovers that protect upholstery.

fusuma (Jp.) A Japanese opaque interior sliding screen.

futon (Jp.) A thick, rolled comforter that serves as bed and bed covering.

gable roof A roof composed of two sloping sides.

gadrooning Repeating carved decoration consisting of concave flutes or convex reeding on the edges of tables and feet; typical decoration on the cups and covers of Elizabethan and Jacobean furniture.

gambrel A roof with a double pitch on either side of a ridge.

garderobe (Fr.) A room within a suite used for dressing and storage, as well as sleeping quarters for servants.

gate leg table A 19th-century term for a table with drop leaves supported by hinged gates or frames when up; introduced in the early 17th century, its contemporary name was *falling table*.

Ghiordes **knot** See *Turkish knot*.

great hall A communal living space of the Middle Ages; room for eating, entertaining, dancing, and, sometimes, sleeping; core of the medieval house.

Greek cross A cross with four arms of equal length.

griffin A mythological creature with the head and wings of an eagle and the body of a lion.

grisaille A *trompe l'oeil* painting that imitates relief sculpture in monochromatic grays.

groin vault Two barrel vaults intersecting at right angles; groins are the lines of intersection; also called *cross vault*.

grotesque A fanciful ornament in paint and stucco used as decoration on walls by the Romans and resembling an arabesque; composed of medallions, sphinxes, foliage, and other forms.

guéridon (Fr.) A candle stand.

guilloche Twisted circular bands or overlapping circular forms of ornament.

gul A repeating octagonal motif originating in Turkoman rugs; derived from the Persian term for flower, it may be a very stylized floral motif or a heraldic device or tribal symbol, since each tribe had its own distinctive *gul*.

Hadley chest A 17th-century oak or pine chest made in an area between Hartford, Connecticut, and Deerfield, Massachusetts. It stands on four short legs and has two or three drawers; the upper portion has three recessed panels decorated with shallow carving, usually stylized tulip or Tudor rose designs.

half-timber construction (*columbage*, Fr.; *fackwerk*, Gr.) Consists of a structural wooden frame with an infill of brick, wattle and daub (clay, mud, and sticks), plaster, or other materials.

hard-paste An alternate term for *true porcelain*.

haremlik In the Middle East, private or women's areas of the home where women, children, and servants dwell; male access is limited to the head of the house and relatives.

hieroglyphics A form of Egyptian picture writing.

highboy American term for a high chest of drawers supported on legs.

hipped roof A roof composed of a single slope on all four sides; hips are the lines of intersection.

horseshoe arch A rounded or pointed arch that is narrower at the bottom like a horseshoe; often found in Islamic buildings.

hosho (Jp.) The crowning element or finial of a *pagoda* roof in Japanese architecture.

hôtel (Fr.) Town house.

hypostyle hall In Egyptian temples, a covered area filled with tightly clustered columns.

ikebana (Jp.) A formal flower arrangement typically found in the Japanese *tokonoma*; also refers to Japanese art of flower arranging.

Imari (Jp.) Porcelain with crowded, elaborate patterns in strong reds, blues, and golds; patterns derive from native Japanese textiles and brocades. It is shipped from the port of Imari; its forms, decoration, and palette are copied in Europe.

impluvium A shallow cistern in the floor of the atrium used to catch rainwater from the *compluvium* in a Roman house.

incised Carved in low relief.

ingrain American term for flat woven carpet with a reversible pattern resembling a coverlet. In England it was called *Kidderminster* or *Scotch carpet*.

inlay Decoration created by embedding pieces of one material into another to create a flat surface.

insula An apartment house for the middle class in Roman cities.

Ionic A Greek order with slender fluted shaft and capital composed of two pairs of volutes or spirals, one pair on the front of the column and one pair on the back. The volutes rest on a circular echinus carved with egg and dart and bead moldings; the shallow abacus also is carved. The shaft is more slender than Doric and has a base. Architrave may be plain or composed of fascia and may be capped by a dentil or egg and dart moldings. Ionic temples do not have antefixes, but may have lion heads to carry rain from the roof.

iwan (*liwan*) In Islamic dwellings, a summer main room, typically located on the south side of the principal courtyard and closed on three sides; the open side provides a cool space for entertaining in warm weather.

jalousies à la persienne (Fr.) Venetian blinds with wooden slats, introduced in the early 18th century.

Japanese lacquer Gold and silver motifs on a black background.

Japanning English and European imitations of Oriental lacquer done on white, blue, yellow, and green backgrounds in addition to red and black. Not really a lacquer, it consists of many coats of varnish. Decorations in gold and silver are raised and depict Chinese and pseudo-Chinese scenes and motifs in gold or silver.

Japonisme A style evolving from Japanese prints, decorative arts, and architecture that develops in late 19th and early 20th centuries in Europe and America.

jerga A flat woven woolen rug in a twill weave of two colors.

jetty The upper story that extends beyond the lower in a timber framed structure; building can be jettied on one or more sides. Common in European, English, and American medieval buildings and their later interpretations.

joined stool An English Renaissance stool with oblong seat, turned or fluted columnar legs, and a continuous stretcher near the floor.

kairo (Jp.) A roofed corridor surrounding the sacred area of a Japanese Buddhist temple complex.

Kakiemon (Jp.) A type of Japanese porcelain with asymmetrical designs in red, yellow, green, and blue with occasional gilding; colors and patterns exploit the white body and adapt to octagonal, hexagonal, and square shapes. *Kakiemon* is the name of the family who develops it in the late 17th century; imported into Europe, it is often copied.

k'ang (Ch.) A built-in or free-standing platform for sitting or reclining in Chinese homes; often has a canopy supported by columns and embellished with carving.

kaolin China clay; a white clay used in porcelain.

katagami (Jp.) Fabric dyed by means of a hand-cut stencil.

keep A tall, inner tower of a castle; also called *donjon*.

Ken (Jp.) In Japanese architecture, a system of modules for house plans derived from the arrangement of structural pillars; a unit of measurement equal to 5.96'.

klismos A light, simple chair developed by the Greeks; depends upon its silhouette and proportions for beauty. Four outward curving legs support a seat of plaited leather or rushes; the back uprights continue the curve of the back legs and support a horizontal concave board at shoulder height.

kodo (Jp.) A lecture hall within a Japanese Buddhist temple complex.

kokera-buki Wooden shingles in multiple layers in traditional Japanese architecture.

kondo (Jp.) The main hall of a Japanese Buddhist temple complex in which the images of Buddha are housed.

Kufic Earliest calligraphy of Islamic art; vertical and angular in form, it is particularly suitable for inscriptions on stone or metalware and textiles.

lacquer An opaque finish made from the sap of trees. Lacquering originates in China but is also used in Japan. Following the importation of lacquered wares into Europe, the Europeans soon learn how to imitate or make it.

lancet A slender, pointed window usually with two lights.

laterna (Sp.) A lantern with a metal frame.

latias (Sp.) Smaller beams or branches laid over *vigas* in the roofs of Spanish and Spanish Colonial buildings; *latias* support the final mud covering for the flat roof.

Latin cross A cross with three short arms and one long arm.

lattice An open-work grille; in Chinese architecture, a large-scale geometric pattern used on doors.

lavabo A wall fountain consisting of a wash basin with flaring sides and an upper portion to hold and distribute water.

lettiera (It.) A bed with a high headboard; rests on a platform composed of three chests for storage, sitting, etc; develops in the Italian Renaissance.

linenfold Carving in wood that resembles vertical folds of cloth; probably introduced in the 15th century by Flemish carvers, it has no architectural prototype. *Linenfold* is probably a 19th-century term; it was originally called *wavy work*.

list carpet Carpet with strips of cloth, ingrain, or selvages of fabric forming weft threads; rag rugs in 19th century.

lit (Fr.) Bed.

lit d'ange (Fr.) A bed that has a smaller canopy attached to the wall.

lit à la duchess (Fr.) A bed with an oblong tester or canopy as long as the bed attached to the wall or posts.

lit à la française (Fr.) A bed that has a headboard and footboard of equal height; the long side sits against the wall and a canopy above supports hangings.

lit à la polonaise (Fr.) A bed with four iron rods that curve up to support a dome-shaped canopy.

lit à la turque (Fr.) A bed that resembles a sofa with sides and back, but has different proportions.

loggia A porch or gallery open on one or more sides.

long gallery A long narrow space that connects wings of an Elizabethan house and used for socializing, entertaining, and exercising.

lowboy American term for a small dressing table with drawers, intended for ladies and to match and accompany a high chest of drawers (highboy).

lozenge A diamond-shaped motif or ornament.

lustre à cristeaux (Fr.) A crystal chandelier.

madresah A religious school attached to a mosque; a collegiate mosque or theological college.

majolica Italian tin-glazed earthenware developing in the 14th century from Valencia; opaque white body with painted decorations.

manchettes (Fr.) Arm pads.

mansard roof A roof with two slopes on all four sides; the lower is more steeply pitched.

maqsurea A wooden screen or grill near the *mihrab* in a *mosque*, serving to protect dignitaries from crowds.

marquetry Veneer pattern applied to furniture.

mausoleum A magnificent tomb usually intended as a monument.

melon support or **cup and cover** A heavy, elaborately carved, bulbous support typical of Elizabethan and Jacobean furniture; shape resembles a melon or a chalice with a domed lid.

menuisier (Fr.) In France, a craftsman who works in solid wood with carving.

meri-boteh Derived from the Persian term meaning cluster of leaves, this rug motif is shaped like a pear or pine cone; it becomes the principal motif in European paisley.

metope Flat slabs recessed between triglyphs in a Doric frieze; usually decorated with painting or relief sculpture.

mihrab In Islamic architecture, a niche usually in the center of the *qibla* serving to distinguish it; may be the focus of prayer.

millefleurs (Fr.) Literally, a thousand flowers; group of French tapestries made between c. 1480 and c. 1520 with hundreds of scattered flowers, often forming backgrounds for pastoral or courtly scenes.

minaret A tall, slender tower or turret attached to a *mosque*; it has one or more projecting balconies from which the faithful are called to prayer.

minbar A pulpit in a *mosque* from which the *imam* (leader) declares the *khutba* (sermon) and affirmation of allegiance by the community; may be to the right of the *mihrab*.

modillion A small bracket, usually with carved decoration, that, in a series, supports a Corinthian or Composite cornice.

module A unit of measurement that determines the size and/or proportions of a building, interior spaces, or individual elements.

monopodium (*monopodia*, pl.) Head and chest of lion attached to a paw.

mortise and tenon A type of joint composed of a rectangular projection (tenon) that is inserted into a rectangular cavity with a corresponding shape (mortise).

mosque In Islamic architecture, a religious building for common prayer, also used for other purposes.

motte A conical, raised mound of a castle, usually within a bailey.

mudéjar A decoration combining Islamic and Spanish characteristics.

muhaqqaq A form of Islamic calligraphy that is a horizontal script; it is one of six basic styles for calligraphy codified at the end of the 13th century.

muqarnas Small, interlocking, ornamental corbelled brackets and niches decorating the undersides of arches or vaults in Islamic architecture; these concave segments resemble stalactites.

narthex An arcaded entrance porch of a basilica church.

nave The center portion of a basilica or Latin cross church.

newel The main post or support for a stair rail.

niche-pilaster In Spanish and Spanish Colonial architecture, a pilaster whose shaft features a niche with a figure and/or other elements.

norens (Jp.) Split curtains used for privacy.

obelisk A monolithic pillar tapering to a pyramid-shaped point; carved with *hieroglyphics*.

oculus (*oculi*, pl.) A circular opening, usually in the apex of a dome.

ogee arch A pointed arch composed of two curves, one convex, one concave; introduced in the early 14th century and used throughout the Middle Ages.

ogival arch A pointed arch created by S-curves, found in Islamic architecture.

open-well staircase Stairs rise on the walls of a square, leaving the center open.

order In Classical architecture, base, shaft, capital, and entablature treated according to an accepted mode comprise an order. Greeks develop three orders: Doric, Ionic, and Corinthian; Romans add Tuscan and Composite.

oriel window A window that projects outward above ground level.

ormolu (Fr.) A gilded bronze ornament applied to furniture or standing alone, as in a clock.

ottoman A small overstuffed seat without back or arms for one or more people; introduced from Turkey into England in the 18th century. By the 19th century the form becomes circular or octagonal with deep tufting.

oyster veneer A veneer of oval shapes resembling oyster shells that are cut transversely through a small tree branch or trunk.

pagoda (Ch.) A Buddhist temple in the form of a tower; usually polygonal in shape with highly ornamental roofs projecting from its many stories.

pai-tun-tzu (*petuntse*) (Ch.) China stone; a feldspathic rock used in porcelain.

palampore A mordant-printed, resist-dyed cotton with foliage and flowers (or tree of life motif) from India; composed of a single panel and occasionally used for coverlets.

palazzo (palazzi, pl.) (It.) Italian urban palace.

Palladian or **Venetian window** A tripartite window composed of two rectangular lower sections flanking a taller, arched center light; derived from arch, column, space, pier combinations seen in the work of Sebastiano Serlio and Andrea Palladio.

palmette A stylized palm leaf in a fan shape; originates in ancient Egypt and is used by the Greeks and Romans.

panetière (Fr.) A bread cupboard; common in Provence and Normandy.

papelera (Sp.) An elaborate cabinet similar to a *vargueño*, but without a drop front or a permanent base.

parapet A low retaining wall for support or protection at the edge of a roof or other structure; sometimes battlemented.

pargework Plastering in patterns over beams; typical of ceilings during the Elizabethan and Jacobean periods.

parquetry Marquetry or inlay in geometric forms.

paterae An oval or circular form, often with radiating lines.

patio An open or inner courtyard in Spanish or Spanish-influenced buildings.

pavilion A distinctive, prominent structure marking the ends and center of the facade of a building; typical of French architecture.

pedestal A base supporting a column.

pediment In classical architecture, the triangular area formed by the cornice and sloping sides of the roof; also, a similar form over a door, window, mantel, or surmounting a case piece. Shapes include triangular, segmental (rounded), broken (open at the apex), or swan's neck (double curve).

pelmet A flat fabric valance.

Pembroke table A small table with two drop leaves, a drawer in its apron, and slender tapering legs, usually with castors; often used as a breakfast table. The name derives from the Countess of Pembroke, who supposedly ordered the first table of this type.

pendentive A triangular curving form that allows construction of a circular dome over a square or rectangular space; originates in Byzantine architecture.

pent roof A roof composed of a single sloping plane, may be between stories; also called a *shed roof*.

peripteral A temple or building surrounded by a single row of columns.

peristyle A row of columns surrounding a temple, other building, or courtyard.

Persian (*Senneh*) **knot** An asymmetrical knot in which a wool strand encircles one warp and winds loosely around the other;

one end pulls through the two warps while the other emerges outside the paired warps. A more difficult knot to tie than the Turkish, it gives a more clearly defined pattern and tightly woven rug.

phoenix A mythological bird, which after living 500+ years, burned itself on a funeral pyre and rose again as a young bird from its own ashes; common in the Far East and also known in classical antiquity and Early Christian times.

piano nobile (It.) The main floor or first floor above ground level in a residence; typically the most important rooms locate there, including the owner's state apartments and main entertaining rooms; literally means "floor of the nobles."

piazza (It.) (*plaza*, Sp.) An open space that varies in shape and purpose; typically public and surrounded by buildings.

piecrust table Modern term for an 18th-century small table with the top edge carved or molded in a series of small curves resembling a pie crust.

pied-de-biche (Fr.) A cloven-hoof foot.

pierrotage (Fr.) In France and her colonies, a type of half-timber construction with stones and clay between framing.

pietra dura (*pietre dure*, pl.) (It.) Decorative inlay composed of marble, hard minerals, semi-precious stones inlaid in wood; used on tabletops and in panels during the Italian Renaissance; because of expense, production limited to Milan and Florence.

pilaster A vertical member with the general form and proportions of a column, but rectangular in section.

pinnacle The terminating element, usually tapering to a point or knob.

podium A continuous base or pedestal supporting columns.

porcelain Ceramic with a white body that is translucent and made of china clay and a feldspathic rock; **true** or **hard-paste porcelain** has china clay and china stone, while **artificial** or **soft-paste porcelain** lacks one of these ingredients. True porcelain originates in China; although true porcelain is made in Germany in the early 18th century, artificial porcelains dominate European production until the middle of the century.

portcullis A heavy wood and iron grating in the portal of a castle or other defended building.

portico A roofed space forming the entrance or center of a facade; may be open or closed and typically has columns.

portiere A curtain hanging at a door to protect from drafts and to embellish.

pseudo-peripteral A building or temple with surrounding engaged columns creating the impression of a peristyle.

pylon Greek word for gateway; in Ancient Egypt, a monumental gateway shaped like a truncated pyramid.

qibla A prayer wall in a mosque oriented toward Mecca, the direction in which Muslims must face when praying.

quadruped A deer-shaped leg with hoof.

quartetto tables Four small tables that diminish in size so they fit beneath one another; 18th century term for nesting tables; three tables are called *trio tables*.

quatrefoil A four-lobed form; see also *foils*.

quoin The cornerstone on the angles of a building; marks the corner by its difference in rustication, color, size, or material from the wall.

rail A horizontal member framing a panel chest, window sash, or door.

raku (Jp.) Pottery made by hand, featuring a thick, dark lead glaze, and fired at low heat; colors range from dark brown to light red, yellow, green, cream. Its irregular shape and glaze give it a primitive appearance, but in reality it is highly sophisticated. Wares are used in the tea ceremony.

ramma (Jp.) The transom area above a sliding panel that may be perforated or elaborately carved for air flow and light filtration.

redodo (Sp.) A decorated wall situated behind the altar.

reeded Displaying convex ridges next to each other and covering a surface.

reja (Sp.) An ornate iron grille or screen common in Spanish churches and civic buildings.

relieving arch A segmental arch over the lintel serving to alleviate excess weight; also called a *blind arch*.

respond A half-pillar rising from nave arcade columns to the springing (beginning) of the ribs of the vault in Gothic architecture.

retable (*retablos*, Sp.) A screen behind an altar commonly in Spanish and Spanish-influenced churches; large in scale, the *retable* has many painted or carved panels arranged in successive stories and is a form of altarpiece.

ribbed vault A vault with structural or decorative projecting bands defining the lines of intersection.

rinceau A linear pattern of scrolling vines, leaves, and foliage.

rocaille (Fr.) Asymmetrical decoration with a profusion of curving tendrils, foliage, flowers combined with shells, and minute details that defines the character of the Rococo or Louis XV; originally referred to small rockeries in the artificial grottoes at Versailles, but soon was applied to furniture ornament that resembled small irregular rocks and shells.

Romayne work Motif consisting of a profile of a head within a roundel.

rose window A circular window with tracery that converges in the center like the spokes of a wheel; typical of Gothic and Gothic Revival architecture.

rosette A circular stylized floral motif.

runner A horizontal brace for furniture legs at the floor.

rustication Smooth or rough-cut blocks of stone with deeply cut joints; gives a rich textural appearance.

sala The main reception room with the most lavish decoration in an Italian or Spanish residence.

salle á manger (Fr.) Dining room.

salon (Fr.) An elegant apartment or living space.

saltire **stretcher** A flat or raised stretcher in an **X** shape.

sash or **double-hung window** A window composed of two sliding sashes (sashes are the frames that hold the glass); introduced from Holland to England (and America) in the late 17th century.

Savonarola A 19th-century term for an Italian **X**-form chair with many interlacing slats and a wooden back; often used by

scholars; name derives from Girolamo Savonarola, a Tuscan monk and reformer, executed during the Renaissance.

Savonnerie Hand-knotted cut-pile carpet made at the Savonnerie factory in France, established in 1626.

scagliola Imitation marble composed of plaster or cement and marble chips.

secretaire à abattant (Fr.) An upright desk with a drop-front writing surface and drawers or doors below; when open the drop front reveals small drawers, doors, and compartments. Chains or pulls support the drop front when open. Introduced in the 17th century but very fashionable in the 18th century.

sedia (It.) A box-shaped arm chair with runners.

selamlik A public or men's area of the Middle Eastern home where guests, male friends, and business associates are received and entertained.

sella curulis X-shaped folding stool, sometimes with a back, used by Roman *curules* or city magistrates; *curule* chairs have a back and become the X-form folding chairs of the Middle Ages and the Renaissance.

Senneh **knot** See *Persian knot.*

serpentine crest The top rail in concave, convex, concave shape that curves down to meet back uprights.

settee An armchair extended to seat two or more; introduced during the 17th century as a more comfortable form of settle.

settle A wooden bench with a back and arms developing during the Gothic period; less portable than a bench, its development indicates more stable times.

sgabello (It.) A stool chair; octagonal seat resting on a box with solid supports or trestles for legs and a fan-shaped back; light in weight but uncomfortable; typically used for dining.

sgraffito Decoration made by scratching or incising a design in the slip covering of the piece so that the color of the body shows through; technique is done before glazing.

shaft The vertical part of the column.

shed roof See *pent roof.*

shibi (Jp.) An ornament of a stylized dolphin tail that accents ends of roof ridges in Japanese architecture.

Shibui (Jp.) The highest aesthetic level of traditional Japanese design, reflected in simplicity, implicitness or inner meaning, humility, silence, and use of natural materials; it affects all visual arrangements and daily activities.

Shinden **style** (Jp.) Arrangement for aristocratic dwellings in the Heian period (794–1192) in Japan; *shinden* is the main dwelling in the center; covered walkways connect it to one-story rectangular pavilions on each side.

shin-kabe (Jp.) A plaster wall with exposed structure; typical of traditional Japanese architecture.

shoin **style** (Jp.) An aristocratic Japanese style of building that takes its name from the *shoin*, a decorative alcove with window and desk. It features a *tokonoma* and *tana.*

shoji (Jp.) A Japanese sliding screen composed of a wooden lattice grid covered with translucent rice paper; a *shoji* subdivides an interior and/or serves as a door or window.

sidelights Two tall, narrow windows flanking a door.

singerie (Fr.) A motif of monkeys dressed in clothing and engaged in human activities.

soft-paste Artificial porcelain that lacks one or more of the ingredients of true porcelain; common in Europe and England until the mid-18th century.

solar A withdrawing room located around the great hall in a medieval house; a private bed-sitting room for the owner and family. *Solar* derives from French *sol* (floor) and *solive* (beam).

solomonic column A twisted column; name derives from its supposed use on Solomon's temple in Jerusalem.

spade foot A rectangular tapering foot resembling a spade or shovel.

Spanish foot A tapering rectangular ribbed foot terminating in an inward-turned scroll. Originates in Spanish and Portuguese Baroque furniture in 17th century; common in England and America during the late 17th and early 18th centuries; also known as a *Portuguese foot* or a *paintbrush foot.*

sphinx A mythological creature with the head of a man and the body of a lion; common in Egyptian architecture.

spire A tall, tapered structure that terminates in a point and rises from a tower, turret, or roof (usually that of a church); it may be pyramidal, polygonal, or conical in shape.

splat A flat, vertical member in a chair back. An important ornamental element and determinant of style, splats may be shaped, carved, pierced, or otherwise decorated.

split baluster turning A small turned element with curving side out and flat side applied as decoration to furniture.

spoon back American term for a chair back in which the uprights curve in to fit the human body; term derives from its resemblance to a spoon bowl. Common on some William and Mary chairs, but characteristic of Queen Anne. Often found on Chinese chairs.

squinch A small arch or bracket or many projecting arches across the angles of a square or polygonal structure that form a base for a dome.

stile A vertical member framing a panel, chest, window, sash, or door.

stoneware Pottery of clay and fusible stone, it vitrifies upon firing so it becomes impervious to liquids. Glazes are applied for decoration; unlike porcelain, it is not translucent.

straight bracket foot Two brackets with straight sides joining at a right angle under the corner or case piece.

strapwork An ornament of flat, curving bands resembling leather thongs often interlaced with arabesques or grotesques; a common Northern European Mannerist motif popularized by pattern books.

stretcher A horizontal brace connecting furniture legs for additional support.

string course A projecting molding that may be plain or carved, running horizontally on a building; typically, it separates stories.

stringing A narrow band of inlay or contrasting veneer outlining a leg, drawer, or other element.

strings The open side of a stair beneath the steps.

stumpwork Needlework, much of which is in relief, raised on a foundation of wadding or wool; may be embellished with sequins; used on objects that receive little wear and tear.

stylization Simplification; reducing an object to it simplest form or reproducing the essence of its character.

stylobate The upper step on which the columns sit; common in Classical architecture.

summer beam In timber frame structure in England and America, the main supporting beam that crosses the ceiling and supports the joists of the floor above.

swastika A religious symbol dating to the Bronze Age; a cross with arms of equal length terminated by right-angle extensions lying in the same direction.

tabby Lime mortar with oyster shells, used for buildings in Spanish Florida.

table l'italienne (Fr.) During the French Renaissance, a table with a rectangular top and supports of figures, eagles, or griffins joined by a complex stretcher.

table de nuit (Fr.) A nightstand intended to hold a chamber pot, pitcher, and wash basin.

tablinum (It.) A room in the atrium, usually on the main axis, used as an office or master bedroom in Roman houses.

tambour A flexible door or shutter composed of strips of wood glued to a cotton or linen backing; front side may be reeded.

tana (Jp.) A series of shelves originally used for Buddhist scrolls that characterizes the *shoin* style in Japanese houses.

tansu (Jp.) Any of a wide variety of chests of drawers in Japan; introduced in early times, *tansu* become more common and specialized forms develop during the Edo period with the rise of a large merchant class.

tatami (Jp.) Woven straw mats with edges of black cloth used in Japanese houses; *tatami*, which are 3'-0" × 6'-0" × 3", form modules for room dimensions.

tazar The main reception area within a winter or summer hall in an Islamic residence; a step or two up and an imposing arch separate it from the rest of the space.

temple front Composed of columns and a pediment, it replicates the main facade of a temple; may be used decoratively or to form a porch or portico.

terra-cotta Baked clay used in construction and decoration; unglazed tile.

terrazzo Mosaic floor composed of small pieces of marble or granite in a concrete mixture.

tesserae Small components of mosaics; may be glass, bone, concrete, marble, etc.

thermae window An arched window divided into three lights by two mullions; typical in Roman baths and adapted by Palladio and the Neo-Palladians in England; also called a *Diocletian window.*

thimble foot A cylindrical tapering foot typical of Hepplewhite or Sheraton furniture.

tholos (*tholoi*, pl.) A circular building with columns.

tie rods or **tie bars** Horizontal metal (or wooden) connectors that give additional support to arches and the outward thrust of vaults.

toile de Jouy (Fr.) White or cream cotton, linen, or silk fabric with monochromatic engraved decoration in red, blue, green, black, or purple.

tokonoma (Jp.) A built-in alcove evolving from private altars that defines the *shoin* style in Japanese houses.

torchiera (It.) (*torchere*, Sp.; *torchière*, Fr.) In Italy, a floor candle stand.

torii (Jp.) Characteristic main entrance gate to a Japanese shrine or Shinto complex; composed of two posts topped with horizontal beams.

trabeated Post and lintel or post and beam construction; consists of two uprights (posts) supporting a horizontal member (beam or lintel).

tracery Curving, ornamental stone or wooden subdivisions in an architectural opening. Typical of Gothic stained glass windows, tracery appears on wood paneling, in plasterwork, and on furniture in Gothic and Gothic Revival.

transept A space(s) at a right angle to and crossing the nave of a church.

transverse arch An arch or rib formed from pilasters or engaged columns that rises from a pier and crosses the ceiling to the opposite pier in a church or cathedral.

trefoil A three-lobed form; see also *foils.*

trestle A support composed of legs joined by a horizontal beam; legs may be plain, turned, or columnar.

trestle table A table composed of a board top supported by trestles, originally developed in the Middle Ages. Some tops were left unattached to facilitate taking the table apart and moving it.

triclinium In Roman dwellings, a dining room with three couches on three sides.

triforium Arches or a gallery above the nave arcade; it may have three arches, which gives it its name.

triglyph A block with three vertical divisions in a Doric frieze.

trompe l'oeil (Fr.) Literally, fool the eye; a photographically realistic depiction.

trumeau (Fr.) Over-mantel or over-door treatment typically with a painting in a curving, gilded frame.

trumpet leg A turned leg that tapers from wide to narrow, resembling an upturned trumpet; typical of William and Mary style furniture in England and America.

tsuitate (Jp.) A single-panel screen with legs; although small, it may screen views, partition space, or control drafts in a Japanese interior.

Turkey work or **Norwich work** English Renaissance textile that imitates Oriental rugs; woolen thread is pulled through a loosely woven cotton base and hand knotted.

Turkish (*Ghiordes*) **knot** A symmetrical hand-tied knot in which a strand of wool encircles two warp threads; the loose ends emerge between the two warps; easier to tie than a Persian knot, but yields a coarser rug.

Tuscan A Roman column with a base and unfluted shaft; an echinus and abacus comprise the capital; architraves are simply treated, usually with moldings.

tympanum A triangular space formed by the sides of the roof and the cornice in a pediment; typically has relief sculpture. Also,

in churches in the Middle Ages, the space between the lintel and the arch in a doorway.

type A domed roof element that lights an interior staircase; common in English Renaissance houses.

ukiyo-e (Jp.) Popular colored woodblock prints developing in the 16th century that depict common people, landscapes, and myths; term means "pictures of the floating world" and derives from the images themselves and the asymmetrical arrangements.

vargueño (Sp.) A furniture piece consisting of a drop-front cabinet on a base; the only decorations on the front are wrought-iron mounts and locks, in contrast to the interior, in which the small drawers and doors feature elaborate inlay. The typical base has splayed legs and iron braces; rings or loops on the sides permit mobility.

vault An arched covering of brick or stone; see also *barrel vault*, *groin vault*, and *cross vault*.

veneer A thin layer of wood or other material attached to another surface, usually to create a decorative effect.

Venetian carpet Flat-woven, multicolored, striped carpet.

Venetian window See *Palladian window*.

vernis Martin (Fr.) A shiny lacquer developed in France by the Martin brothers in 1730. Application of many coats of varnish produces a thick surface capable of being carved in low relief; available in many colors, green was favored.

verre églomisé (Fr.) A decorative painting done mainly in gold, white, and blue on the reverse side of a glass panel to be used in a door, case piece, picture frame, or mirror; fashionable during the Neoclassical period, although the technique is developed by ancient Romans.

vigas (Sp.) Large beams or logs supporting the flat roof in Spanish and Spanish Colonial architecture; *vigas* may protrude through walls.

villa In Roman architecture, a country farmhouse or mansion; from the Renaissance onward, a country house.

volute A spiral scroll reminiscent of a ram's horn or shell, forming the capital of the Ionic order and also part of the capital in Corinthian and Composite orders.

voussoirs Wedge-shaped blocks forming an arch.

voyeuse (Fr.) A conversation chair with a flat rail on its back on which a person can lean.

wainscot chair English, American, and French rectilinear armchair with carved panels, evolving from a seat incorporated into a paneled wall during the Gothic period. It may have panels under the arm and all four sides to the floor or only a paneled back.

wainscoting Wooden paneling for walls; derives from a Dutch term for a grade of oak used in fine interior work.

westwerk A tall facade with two towers or turrets on the west end of a church; inside are multistoried galleries. Characteristic of Carolingian or Romanesque churches and revived in German Baroque.

yeseria (Sp.) Elaborately carved stucco work.

zabutons (Jp.) Square floor cushions used for seating in Japan.

zapata (Sp.) A bracket capital in Spanish and Spanish Colonial architecture.

Bibliography

Architecture, Art History

Adams, Laura Schneider. *A History of Western Art*. New York: Harry N. Abrams, Inc., 1994.

Arrigo, Joseph. *The Grace and Grandeur of Natchez Homes*. Stillwater, MN: Voyageur Press, Inc., 1994.

Baedecker, Karl. *Handbook for Travelers to Paris and Its Environs*. Leipzig: K. Baedeker Publishers, 1891.

Ball, Victoria Kloss. *Architecture and Interior Design: A Basic History through the Seventeenth Century*. New York: John Wiley and Sons, 1980.

———. *Architecture and Interior Design: Europe and America from the Colonial Era to Today*. New York: John Wiley and Sons, 1980.

Brownell, Charles; Loth, Calder; Rasmussen, William M. S.; and Wilson, Richard Guy. *The Making of Virginia Architecture*. Richmond: Virginia Museum of Fine Arts, 1992.

Ching, Francis D.K. *Building Construction Illustrated*. New York: J. Wiley & Sons, 1991.

A Chronology of Western Architecture. New York: Facts on File Publications, 1987.

A Dictionary of Terms Used in Architecture and Building. New York: Industrial Publication Co., 1909.

Fleming, John; Honour, Hugh; and Pevsner, Nikolaus. *The Penguin Dictionary of Architecture*. New York: Penguin Books, 1980.

Foley, Mary Mix. *The American House*. New York: Harper and Row Publishers, 1980.

Girouard, Mark. *Life in the English Country House: A Social and Architectural History*. New York: Penguin Books, 1978.

Glancey, Jonathan. *The Story of Architecture*. New York: Dorling Kindersley Publishing, Inc., 2000.

Gowans, Alan. *Images of American Living, Four Centuries of Architecture and Furniture as Cultural Expression*. Philadelphia: J. B. Lippincott Company, 1964; Harper & Row, 1976.

———. *Styles and Types of North American Architecture: Social Function and Cultural Expression*. New York: Harper Collins Publishers, 1992.

Harris, Cyril. M., ed. *Illustrated Dictionary of Historic Architecture*. New York: Dover Publications, Inc., 1983.

Hepburn, Andrew H. *Great Houses of American History*. New York: Bramhall House Books, 1972.

Jones, Inigo. *The Designs of Inigo Jones, consisting of plans and elevations for publick and private buildings*. London: William Kent, 1727.

Kalman, Harold. *A History of Canadian Architecture*, Volume 1. Toronto: Oxford University Press, 1994.

Kelly, J. Frederic. *The Early Domestic Architecture of Connecticut*. New York: Dover Publications, Inc., 1952.

McAlester, Virginia, and McAlester, Lee. *A Field Guide to American Houses*. New York: Alfred A Knopf, 1984.

Musgrove, John, ed. *Sir Banister Fletcher's A History of Architecture*, 19th ed. London: Butterworths, 1987.

Nicolson, Nigel. *The National Trust Book of Great Houses of Britain*. Norwich, England: Jarrold & Sons Ltd., 1979.

Norwich, John Julius, ed. *Great Architecture of the World*. London: Michael Beazley Publishers Limited, 1991.

Norwich, John J., ed. *The World Atlas of Architecture*. New York: Portland House, 1988.

Perring, Dominic, and Perrin, Stefania. *Then and Now*. New York: MacMillan Publishing, Co., 1990.

Poesch, Jessie. *The Art of the Old South: Painting, Sculpture, Architecture and the Products of Craftsmen, 1560–1860*. New York: Alfred A Knopf, 1983.

Ricciuti, Italo William. *New Orleans and Its Environs, The Domestic Architecture 1727–1870*. New York: Bonanza Books, 1938.

Rifkind, Carole. *A Field Guide to American Architecture*. New York: The New American Library, Inc., 1980.

Saylor, Henry H. *Dictionary of Architecture*. New York: John Wiley & Sons, 1952.

Shapiro, Harry L. *Homes Around the World*. New York, NY: The American Museum of Natural History, 1945.

Shipway, Verna Cook, and Shipway, Warren. *The Mexican House*. New York: Architectural Book Publishing, Inc., 1960.

Smith, G. E. Kidder. *Source Book of American Architecture*. New York: Princeton Architectural Press, 1996.

Spong, Dennis J. *The Creative Impulse: An Introduction to the Arts*. New York: Prentice Hall, 1990.

Stevenson, Neil. *Architecture: The World's Greatest Buildings Explored and Explained*. New York: Dorling Kindersley Publishing, Inc., 1997.

Stockstad, Marilyn. *Art History*, Volume I. New York: Harry N. Abrams, Inc., 1995.

Summerson, John. *Architecture of the Eighteenth Century*. New York: Thames and Hudson, 1986.

———. *Architecture in Britain, 1530–1830*, 9th ed. New Haven, CN: Yale University Press, 1993.

———. *The Classical Language of Architecture*. Cambridge: MIT Press, 1966.

———. *Georgian London*. London: Barrie and Jenkins, 1988.

Traquair, Ramsay. *The Old Architecture of Quebec*. Totonto: The Macmillan Company of Canada Limited, 1947.

Wallis, Frank E. *How to Know Architecture*. New York: Harper and Brothers, 1910.

Watkin, David. *A History of Western Architecture*, 2d ed. New York: Barnes and Noble, Inc., 1996.

Whiffen, Marcus, and Koeper, Frederick. *American Architecture, Volume One: 1607–1860*. Cambridge: MIT Press, 1984.

———. *American Architecture, Volume Two: 1860–1976*. Cambridge: MIT Press, 1992.

Yarwood, Doreen. *The Architecture of England from Prehistoric Times to the Present Day*. London: B. T. Batsford, Ltd., 1963.

Interiors, Finishes, and Textiles

Beard, Geoffrey W. *Craftsmen and Interior Decoration In England, 1660–1820*. New York: Holmes & Meier, 1981.

———. *The National Trust Book of the English House Interior*. London: Viking, 1990.

———. *Stucco and Decorative Plasterwork in Europe*. New York: Harper and Row, 1983.

———. *Upholsterers and Interior Furnishing in England 1530–1840*. New Haven: Yale University Press, 1997.

Blakemore, Robbie G. *History of Interior Design and Furniture from Ancient Egypt to Nineteenth-Century Europe*. New York: Van Nostrand Reinhold, 1997.

Bossert, Helmuth. *An Encyclopaedia of Colour Decoration from the Earliest Times to the Middle of the XIXth Century*. London: Victor Gollancz, Ltd., 1928.

Bristow, Ian, C. *Architectural Colour in British Interiors 1615–1840*. New Haven: Yale University Press, 1996.

Byron, Joseph. *Photographs of New York Interiors at the Turn of the Century*. New York: Dover, 1976.

Clabburn, Pamela. *The National Trust Book of Furnishing Textiles*. London: Viking, 1988.

Dutton, Ralph. *The English Interior, 1500 to 1900*. New York, B. T. Batsford, 1948.

Garrett, Elisabeth Donaghy. *At Home: The American Family, 1750–1870*. New York: Harry N. Abrams, Inc., 1990.

Gore, Alan, and Gore, Ann. *The History of English Interiors*. London: Phaidon, 1991.

Jourdain, Margaret. *English Interiors In Smaller Houses, From the Restoration to the Regency, 1660–1830*. London, B. T. Batsford, Ltd., 1923.

Lynn, Catherine. *Wallpaper in America from the Seventeenth Century to World War I*. New York: W. W. Norton and Company, 1980.

Mayhew, Edgar de N., and Myers, Minor, Jr. *A Documentary History of American Interiors from the Colonial Era to 1915*. New York: Charles Scribner's Sons, 1980.

McCorquodale, Charles. *History of the Interior*. New York: Vendome Press, 1983.

Montgomery, Florence M. *Printed Textiles: English and American Cottons and Linens, 1700–1850*. New York: The Viking Press, 1970.

———. *Textiles in America, 1650–1870*. New York: W. W. Norton and Company, 1984.

Moss, Roger W., ed. *Paint in America: The Colors of Historic Buildings*. Washington DC: National Trust for Historic Preservation, 1994.

Peck, Amelia, et. al. *Period Rooms in the Metropolitan Museum of Art*. New York: Harry N. Abrams, Inc., 1996.

Sweeney, John A. H. *The Treasure House of Early American Rooms*. New York: Viking Press, 1963.

Yarwood, Doreen. *English Interiors: A Pictorial Guide and Glossary*. Guildford, Surrey: Butterworth Press, 1983.

Furniture and Decorative Arts

Aronson, Joseph. *The Encyclopedia of Furniture*, 3d ed. New York: Crown Publishers, 1965.

Beard, Geoffrey W. *The National Trust Book of English Furniture*. London: Viking, 1985.

———, and Goodison, Judith. *English Furniture, 1500–1840*. Oxford: Phaidon-Christie's, 1987.

———. *Georgian Craftsmen and Their Work*. London: Country Life, 1966.

Boger, Louise Ade. *The Complete Guide to Furniture Styles, Enlarged Edition*. New York: Charles Scribner's Sons, 1969.

———, and Boger, H. Batterson. *The Dictionary of Antiques and the Decorative Arts, Enlarged Edition*. New York: Charles Scribner's Sons, 1967.

Cooke, Edward S., ed. *Upholstery in America and Europe from the Seventeenth Century to World War I*. New York: W. W. Norton and Co., 1987.

Fales, Dean A., Jr. *American Painted Furniture, 1660–1880*. New York: E. P. Dutton, 1979.

Fitzgerald, Oscar P. *Four Centuries of American Furniture*. Radnor, PA: Wallace-Homestead Book Company, 1995.

Forman, Benno M. *American Seating Furniture, 1630–1730*. New York: W. W. Norton and Company, 1988.

Gloag, John. *A Complete Dictionary of Furniture*. Revised and expanded by Clive Edwards. Woodstock, NY: The Overlook Press, 1991.

Gruber, Alain. *The History of Decorative Arts: The Renaissance and Mannerism in Europe*. New York: Abbeville Press, 1993.

Hayward, Helena, ed. *World Furniture*. New York: McGraw-Hill Book Company, 1965.

Hurst, Ronald L., and Prown, Jonathan. *Southern Furniture, 1680–1830—The Colonial Williamsburg Collection*. New York: Harry N. Abrams, Inc., 1997.

Jacobson, Dawn. *Chinoiserie*. London: Phaidon Press, Ltd., 1999.

Newman, Harold. *An Illustrated History of Glass*. London: Thames and Hudson, 1977.

Osburne, Harold, ed. *The Oxford Companion to the Decorative Arts*. Oxford: Oxford University Press, 1985.

Savage, George, and Newman, Harold. *An Illustrated Dictionary of Ceramics*. New York: Van Nostrand Reinhold Co., 1974.

Shea, John. *Antique and Country Furniture of North America*. New York: Van Nostrand Reinhold Co., 1975.

Strange, Thomas Arthur. *English Furniture, Decoration, Woodwork, and Allied Arts from the Last Half of the Seventeenth Century to the Early Part of the Nineteenth Century*. London: B. T. Batsford, 1950.

Thornton, Peter. *Authentic Decor: The Domestic Interior, 1620–1920*. New York: Crescent Books, 1985.

———. *Form and Decoration: Innovation in the Decorative Arts, 1470–1870*. New York: Harry N. Abrams, 1998.

Wanscher, Ole. *The Art of Furniture: 5000 Years of Furniture and Interiors*. New York: Reinhold Publishing Corp., 1966.

Watson, Sir Francis. *The History of Furniture*. New York: William Morrow and Company, Inc., 1976.

Timelines

Andrea, Alfred J., & Overfield, James H. *The Human Record*. Boston: Houghton Mifflin, 1994.

Bunch, Bryan, and Hellemans, Alexander, eds. *The Timetables of Technology*. New York: Touchstone, 1994.

Fry, Plantagenet Somerset. *History of the World*. London: Dorling Kindersley, 1994.

Hodges, Henry. *Technology in the Ancient World*. New York: Barnes & Noble. 1992

James, Peter, and Thrope, Nick. *Ancient Inventions*. New York: Ballentine Books, 1994.

McKinney, Howard D., and Anderson, W. R. *Music in History*. New York: American Book Company. 1949.

Panati, Charles. *Panati's Browser's Book of Beginnings*. Boston: Houghton Mifflin Co., 1984.

Paxton, John, and Fairfield, Sheila. *Calendar of Creative Man*. New York: Facts on File, Inc., 1980.

Scarre, Chris. *Smithsonian Timelines of the Ancient World*. New York: Dorling Kindersley, Inc. 1993.

Wilson, Mitchell. *American Science and Invention*. New York: Bonanza Books, 1996.

Oriental

Kates, George N. *Chinese Household Furniture*. New York: Dover, 1962.

Morse, Edward S. *Japanese Homes and Their Surroundings*. Rutland, VT: Charles E. Tuttle Company, Inc., 1972.

Ningyo: *The Art of the Human Figurine*. New York: The Japan Society, 1995.

Stierlin, Henri, ed. *China*. Germany: Benedikt Taschen, n.d.

———. *Japan*. Germany: Benedikt Taschen, n.d.

Antiquity

Baker, Hollis S. *Furniture in the Ancient World: Origins and Evolution, 3100–475 BC*. New York: Macmillan, 1966.

Boëthius, Axel. *Etruscan and Early Roman Architecture*. New York: Penguin Books, 1978.

Desroches-Noblecourt, Christiane. *Tutankhamen*. New York: New York Graphic Society, 1963.

Lawrence. A. W. *Greek Architecture*, 4th ed. rev. New York: Penguin Books, 1983.

Linley, David. *Classical Furniture*. New York: Harry N. Abrams, 1993.

Richter, G. M. A. *The Furniture of the Greeks, Etruscans, and Romans*. London: Phaidon, 1989.

Robsjohn-Gibbings, T. H., and Pullin, Carlton W. *Furniture of Classical Greece*. New York: Knopf, 1963.

Roman, James F. *Daily Life of the Ancient Egyptians*. Pittsburgh, PA: Carnegie Museum of Natural History, 1990.

Smith, W. Stevenson. *The Art and Architecture of Ancient Egypt*, 3d ed. New Haven, CT: Yale University Press, 1998.

Ward-Perkins, J. B. *Roman Imperial Architecture*. New York: Penguin Books, 1985.

Middle Ages

Branner, Robert. *Gothic Architecture*. New York: G. Braziller, 1961.

Conant, Kenneth, John. *Carolingian and Romanesque Architecture, 800 to 1200*, 2d ed. New York: Penguin, 1979.

Geck, Francis, J. *French Interiors and Furniture: The Gothic Period*. Boulder, CO: Stureck Educational Services, 1988.

Jackson, Thomas Graham, Sir. *Byzantine and Romanesque Architecture*. New York: Hacker Art Books, 1975.

Krautheimer, Richard. *Early Christian and Byzantine Architecture*, 4th ed. New Haven, CT: Yale University Press, 1986.

Kubach, Hans Erich. *Romanesque Architecture*. New York, Abrams 1975.

Martindale, Andrew. *Gothic Art*. New York: Praeger Publishers, 1967.

Milburn, R. L. *Early Christian Art and Architecture*. Berkeley, CA: University of California Press, 1988.

Radding, Charles M., and Clark, William W. *Medieval Architecture and Medieval Learning: Builders and Masters in the Age of Romanesque and Gothic*. New Haven, CT: Yale University Press, 1992.

Sanderson, Warren. *Early Christian Buildings: A Graphic Introduction*. Champlain, NY: Astrion Publishers, 1993.

Scarce, Jennifer M. *Domestic Culture in the Middle East: An Exploration of the Household Interior*. Richmond, Surrey: Curzon Press, 1996.

Tracy, Charles. *English Medieval Furniture and Woodwork*. London: Victoria and Albert Museum, 1988.

von Simson, Otton Georg. *The Gothic Cathedral: Origins of Gothic Architecture and the Medieval Concept of Order*. 2d ed. New York: Harper & Row 1964.

Wilson, Christopher. *The Gothic Cathedral: The Architecture of the Great Church*. New York: Thames and Hudson, 1990.

Wood, Margaret. *The English Medieval House*. London: Ferndale Editions, 1981.

Renaissance

Akerman, James S. *Palladio*. Baltimore, MD: Penguin Books, 1972.

Fleming, John A. *The Painted Furniture of French Canada, 1700–1840*. Camden East, Ontario: Camden House, 1994.

Geck, Francis, J. *French Interiors and Furniture: The Period of Francis I*. Boulder, CO: Stureck Educational Services, 1982.

———. *French Interiors and Furniture: The Period of Henry II*. Boulder, CO: Stureck Educational Services, 1985.

———. *French Interiors and Furniture: The Period of Henry IV*. Boulder, CO: Stureck Educational Services, 1986.

———. *French Interiors and Furniture: The Period of Louis XIII*. Boulder, CO: Stureck Educational Services, 1989.

Girouard, Mark. *Robert Smythson and the Elizabethan Country House*. New Haven, CT: Yale University Press, 1983.

Hutchins, Catherine E. *Arts of the Pennsylvania Germans*. New York: W. W. Norton and Company, 1983.

Kennedy, Roger G. *Mission: The History and Architecture of the Missions of North America*. Boston: Houghton Mifflin, 1993.

Kubler, George, and Soria, Martin. *Art and Architecture in Spain and Portugal and Their American Dominions: 1500–1800*. Baltimore: Penguin Books, 1959.

Melor, Michel; Guillaume, Jean; d'Anthenaise, Claude; Barthélémy; Salé, Marie-Pierre; and Dubois, Caroline. *Chateaux of the Loire*. Paris: Beaux Arts Magazine, 1991.

Mowl, Timothy. *Elizabethan and Jacobean Style*. London: Phaidon, 1993.

Odom, William Macdougal. *A History of Italian Furniture from the Fourteenth to the Early Nineteenth Century*, 2d ed. New York: Archive Press, 1966.

Palardy, Jean. *The Early Furniture of French Canada*. 2d ed. Translated by Eric McLean. New York: St. Martin's Press, 1965.

Pedrini, Augusto. *Italian Furniture, Interiors, and Decoration of the Fifteenth and Sixteenth Centuries*, new rev. ed. London: A. Tiranti, 1949.

Summerson, John. *Inigo Jones*. Harmondsworth, England: Penguin, 1966.

Thornton, Peter. *The Italian Renaissance Interior, 1400–1600*. New York: Harry N. Abrams, Inc., 1991.

Treib, Marc. *Sanctuaries of Spanish New Mexico*. Berkeley: University of California Press, 1993.

Baroque

Beard, Geoffrey W. *The Work of Christopher Wren*. London: Bloomsbury Books, 1987.

———. *The Work of Grinling Gibbons*. Chicago: University of Chicago Press, 1990.

———. *The Work of John Vanbrugh*. London: Batsford, 1986.

Blitzer, Charles. *Age of Kings*. New York: Time, Inc., 1967.

Blunt, Anthony, ed. *Baroque and Rococo Architecture and Decoration*. Hertfordshire: Wordsworth Editions, Ltd., 1988.

Geck, Francis, J. *Art and Architecture in France: 1500–1700*. Baltimore: Penguin Books, 1953.

———. *French Interiors and Furniture: The Period of Louis XIV*. Boulder, CO: Stureck Educational Services, 1990.

Hatton, Ragnhild. *Europe in the Age of Louis XIV*. Great Britain: Harcourt, Brace & World, Inc., 1969.

Lees-Milne, James. *Baroque in Spain and Portugal and Its Antecedents*. London: B. T. Batsford, Ltd., 1960.

Mitford, Nancy. *The Sun King: Louis XIV at Versailles*. New York: Harper & Row, Publishers, Inc., 1966.

Norberg-Schultz, Christian. *Baroque Architecture*. New York: Harry N. Abrams, 1971.

Thornton, Peter. *Baroque and Rococo Silks*. London: Faber and Faber, 1965.

———. *Seventeenth-Century Interior Decoration in England, France and Holland*. New Haven, CT: Yale University Press, 1978.

Van der Kemp, Gérald. *Versailles*. New York: Park Lane, 1981.

Wittkower, Rudolf. *Art and Architecture in Italy: 1600–1750*. Baltimore: Penguin Books, 1973.

Rococo

Downs, Joseph. *American Furniture: Queen Anne and Chippendale Periods in the Henry Francis du Pont Winterthur Museum*. New York: Macmillan Company, 1952.

Fowler, John, and Cornforth, John. *English Decoration in the Eighteenth Century*, 2d ed. London: Barrie and Jenkins, 1983.

Geck, Francis, J. *French Interiors and Furniture: The Period of Louis XV*. Roseville, MI: Stureck Educational Services, 1993.

———. *French Interiors and Furniture: The Regency Period*. Roseville, MI: Stureck Educational Services, 1992.

Harris, John. *The Palladian Revival: Lord Burlington, His Villa and Garden at Chiswick*. New Haven, CT: Yale University Press, 1994.

Norberg-Schultz, Christian. *Late Baroque and Rococo Architecture*. New York: Rizzoli, 1985.

Nylander, Jane C. *Our Own Snug Fireside: Images of the New England Home, 1760–1860*. New Haven CT: Yale University Press, 1994.

Parissen, Steven. *Palladian Style*. London: Phaidon Press, Ltd., 1994.

———. *The Georgian House in Britain and America*. New York: Rizzoli, 1995.

Scott, Katie. *The Rococo Interior: Decoration and Social Spaces in Early Eighteenth-Century Paris*. New Haven, CT: Yale University Press, 1995.

Smith, Charles Saumarez. *Eighteenth-Century Decoration: Design and the Domestic Interior in England*. New York: Harry N. Abrams, 1993.

Whitehead, John. *The French Interior in the Eighteenth Century*. New York: Dutton Studio Books, 1993.

Early Neoclassic

Beard, Geoffrey W. *The Work of Robert Adam*. London: Bloomsbury Books, 1987.

Groër, Léon. *Decorative Arts in Europe 1790–1850*. New York: Rizzoli, 1986.

Irwin, David. *Neoclassicism*. New York: Phaidon Press, Ltd., 1997.

Kelly, Alison. *Decorative Wedgwood in Architecture and Furniture*. New York: Born-Hawes Publishers, 1965.

Linley, David. *Classical Furniture*. New York: Harry N. Abrams, 1993.

Middleton, Robin, and Watkin, David. *Neoclassical and 19th Century Architecture/1*. New York: Rizzoli, 1987.

Montgomery, Charles F. *American Furniture: The Federal Period in the Henry Francis du Pont Winterthur Museum*. New York: Bonanza Books, 1978.

Oglesby, Catharine. *French Provincial Decorative Art*. New York: Scribner, 1951.

Parissien, Steven. *Adam Style*. Washington, DC: The Preservation Press, 1992.

Yarwood, Doreen. *Robert Adam*. London: Dent, 1970.

Index

Credits for Text Illustrations

Ackerman, Phyllis, *Wallpaper Its History, Design and Use*, New York, Frederick A. Stokes Co., 1923: Fig. 15-71a, b.

Alinari/Art Resource, New York: Fig. 8-16, 11-41.

Alpine Log Homes, Victor, Montana: Fig. 19-21 (Dann Coffey, Photographer).

Courtesy of the American Museum of Natural History: Fig. 1-11, 1-18.

Andrews, Wayne: Fig. 14-24.

Appelton's American Standard Geographies, *Physical Geography*, New York, D. Appelton and Company, 1887: Section B Opener.

Architectural Interiors, International Correspondence Schools Staff, Scranton, PA, International Textbook Company, 1909: Fig. 9-29, 10-25, 12-35.

Architectural Record, Vol. XV #2, New York, 1904: Fig. 28-6.

The Architectural Reprint, Vol. III. Nos. 1, 2, 3, and 4, Washington, DC: The Reprint Co., February 1903: Fig. 12-29, 14-5, 14-8, 14-11, 14-22, 21-16, 23-9, 23-10.

Archives of the Archdiocese of Baltimore: Fig. 28-27.

Arizona Development Board, Travel Promotion Department: Fig. 13-25, 17-12.

The Art of Aubrey Beardsley, New York, Boni & Liveright, Inc., 1918: Fig. 3-8.

The Art Journal Illustrated: The Industry of All Nations, London, Published for the Proprietors, by George Virtue, 1851: Fig. 5-41.

Artistic Furniture and Architectural Interiors, Decorations, Etc., Boston & New York, Geo. H. Polley & Co., 1892: Fig. 21-28.

Artistic Houses, New York, Benjamin Blom, Inc., 1883, Republished, 1971: Fig. 3-41, 9-27, 21-39.

Asukaen, Nara, Japan: Fig. 3-9.

Ayervais, Michael, The Ayervais Collection: Fig. 3-1, 3-46, 3-48.

Baedeker, Karl (Ed.), *Baedeker's Egypt*, Leipsec, Karl Baedecker, Publisher, 1902: Fig. 4-8.

Bajot, M. Edouard, *Encyclopedie du Meuble, The Encyclopedia of Furniture*, France: prior to 1900: Fig. 21-43, 23-27, 23-28b, 26-32a.

Baker, Hollis, *Furniture in the Ancient World*, New York, Macmillan Co., A Giniger Book, 1966: Fig. 4-14, 4-26, 4-29, 4-32, 4-33.

Baneat, Paul, *Le Mobilier Breton*, Paris, Leon Marotte, n.d.: Fig. 26-45, 26-48, 26-53, 26-54b, 26-55.

Bartlett, George B., *Concord—Historic, Literary and Picturesque*, Boston, Lothrop Pub. Co., 1885: Fig. 25-1.

Benn, H. P. and H. P. Shapland, *The Nation's Treasures*, London, Simpkin, Marshall, Hamilton, Kent, and Co. Ltd. and Benn Brothers, Ltd., 1910: Fig. 12-60b, 27-40, 27-45.

Benn, R. Davis, *Style in Furniture*, New York, Longmans, Green, & Co., 1920: Fig. 2-49, 27-49, 27-56.

Biltmore Estate Collection, Used with permission from Biltmore Estate, Ashville, North Carolina: Fig. 14-39.

Bolto, Camillo, *Arte Italiana Decorativa e Industriale*. Milano, Ulrico Hoepli, 1894: Fig. 12-36b, 12-62b, 14-50a.

Bossert, Helmuth, *Encyclopedia of Colour Decoration: From the Earliest Times to the Middle of the XIXth Century*, n.d.: Fig. 4-18, 4-20, 5-29, 6-35, 23-21.

British Department of the Environment, Sussex, England: Fig. 12-31, 24-8.

British Information Bureau/Services: Fig. 11-36, 11-37, 15-10, 22-21, 24-36.

British Museum, London: Fig. 6-48.

British Tourist Authority: Fig. 10-22.

Brooks, Alfred M., *Architecture and the Allied Arts*, Indianapolis, The Bobb-Merrill Co., 1914/1926: Fig. 6-40, 7-6, 10-9, 11-15.

Buel, J.W., *The Story of Man*, Philadelphia, Historical Publishing Co., 1889: Fig. 1-29.

Bullock, Albert E., *Grinling Gibbons and His Compeers*, London, J. Tiranti & Company, 1914: Fig. 22-32a.

Burmeister, Alice, private collection: Fig. 1-36a, b, 1-39a, 1-41.

Butterworth, Hezekiah, *Zigzag Journeys Around the World*, Boston, Dana Estes & Co., 1895: Fig. 3-47.

Byrne, Arthur and Mildred Stapley, *Spanish Interiors and Furniture, Vols. I, II, and III*, New York, William Helburn, Inc., 1922: Fig. 13-3, 13-7, 13-9, 13-21, 13-22, 13-27, 13-31, 13-33, 13-34, 13-35, 13-36, 13-37, 13-38, 13-39, 13-40, 13-42, 13-43, 13-44, 13-45, 13-46, 13-47, 13-48a, 13-49b, c, 13-52a, b, 13-53, 13-55, 13-56, 13-57a, b, 13-58b, 13-59, 13-60, 13-61a, b, 13-62a.

Carolina Art Association, Carl Julian: Fig. 28-23.

Courtesy of Century Furniture, Copyright © 1998–2000 [Century Furniture Industries], All rights reserved: Fig. 23-41.

Cescinsky, Herbert, *Chinese Furniture*, London, Benn Brothers, Ltd., 1922: Fig. 2-34, 2-35, 2-37, 2-39.

———, *English Furniture of the 18th Century*, New York, Funk & Wagnalls Co., 1922: Fig. 21-48.

The Charles Hosmer Morse Museum of American Art, Winter Park, Florida, © The Charles Hosmer Morse Foundation, Inc.: Fig. 8-17.

Photograph by Richard Cheek, for the Preservation Society of Newport County: Fig. 21-20, 21-40.

Chicago Architectural Photographing Company: Fig. 3-27.

Clerisseau, M., *Antiquities de le France*, Paris, Philippe-Denys-Pierres, 1778: Fig. 5-21b.

Clifford, Chandler R., *Artistic Furniture & Architectural Int.*, New York, Clifford and Lawton, 1892: Fig. 9-37, 26-35c.

———, *The Decorative Periods*, New York, Clifford and Lawton, 1906: Fig. 4-28a, 6-43a, 11-48, 12-2d.

———, *Period Furnishings: An Encyclopedia of Historic Furniture, Decorations, and Furnishings*, New York, Clifford and Lawton, 1911/1914: Fig. 2-4, 2-5, 3-3, 9-5c, e, 10-3a, c, 10-27, 11-10, 11-44, 11-59, 15-71c, 21-3a, 21-54b, 25-61b, 26-27c, 26-33, 27-23a, 27-31a, 27-42.

Clute, Eugene, *The Treatment of Interiors*, New York, The Pencil Point Press, 1926: Fig. 16-25, 16-36, 17-45, 23-40, 24-48.

CMA Mexicana de Aviacion: Fig. 17-3.

Convention and Visitors Bureau, Mitchell, South Dakota: Fig. 8-12.

The Convention and Visitors Bureau of Chamber of Commerce of Greater Philadelphia: Fig. 25-17.

Cooper-Hewitt, National Design Museum, Smithsonian Institution, NY/Art Resource, NY, Gift of Grace Lincoln Temple: Fig. 3-50.

Cousins, Frank, *Colonial Architecture*, New York, Doubleday, Page & Co., 1912: Fig. 28-19.

The Craftsman: An Illustrated Monthly Magazine for the Simplification of Life, Gustav Stickley (Ed.), Syracuse, New York, Volume 5, October 1903–March 1904: Fig. 1-9, 1-10; Volume 6, April 1904–September 1904: Fig. 1-17; Volume 7, October 1904–March 1905: Fig. 1-42, 15-73, Section A Opener.

Crane, Walter, *The Basis of Design*, London, G. Bell & Sons Ltd., 1925: Fig. 7-18, 11-13.

Daniels, Fred H., *The Teaching of Ornament*, New York, The J. C. Witter Co., 1900: Fig. 5-4b, 5-7, 6-3b, 6-5, 9-5a, b, 9-14, 11-28.

Daughters of the Republic of Texas Library at the Alamo, San Antonio, Texas: Fig. 17-10.

De Forest, Julia, *A Short History of Art*, New York, Dodd, Mead, and Co., 1881: Fig. 5-16, 6-12, 7-2, 9-12.

de Lozuya, Marques, *Muebles de Estilo Espanol*, Barcelona, Editorial Gustavo Gili, S.A.: Fig. 13-62b.

de Wolfe, Elsie, *The House in Good Taste*, New York, The Century Co., 1913: Fig. 26-29.

Dilke, Lady, *French Furniture and Decoration in the XVIII Century*, London, George Bell and Sons, 1902: Fig. 23-20, 23-31a, 26-4, 26-6, 26-31a, 26-35b, 26-36a.

© Disney Enterprises, Inc.: Fig. 11-40.

Dolmetsch, H., *Der Ornamenten Schatz*, Stuttgart, Verlag Von Julius Hoffman, 1886: Fig. 12-2a, 12-36a, 14-4a.

© Copyright Dorling Kindersley: Fig. 11-61, 24-41a, b (Joe Cornish, Photographer), 14-33 (John Parker, Photographer).

Dow, Arthur W., *Composition*, New York, Doubleday, Page & Co., 1925: Fig. 3-5a, b.

Dunlap, Deborah Rushan: Fig. 4-31, 5-39, 9-30.

Eberlin, Harold D., *Spanish Interiors, Furniture, and Details*, New York, Architectural Book Publishing, Inc., 1925: Fig. 13-4, 13-8, 13-30, 13-41, 13-48b, 13-49a, 13-58a, 13-62c.

————, Abott McClure, and Edward Stratton Holloway, *The Practical Book of Interior Decoration*, Philadelphia, Lippincott, 1919: Fig. 21-29, 27-23b, 27-25.

Edgell, George H., *The American Architecture Today*, New York, Charles Scribners Sons, 1928: Fig. 12-32.

Ellwood, G. M., *English Furniture and Decoration 1680-1800*, Stuttgart, Julius Hoffman, n.d.: Fig. 27-58a.

Elwell, Newton W., *Architecture, Furniture, and Interiors of Maryland and Virginia During the Eighteenth Century*, Boston, George H. Polley and Company, 1897: Fig. 28-31, 28-33, 28-34, 28-42.

Endeman, Judith L.: Fig. 1-16.

By permission of English Heritage Photo Library: Fig. 12-50, 15-58, 24-28 (Photo by Paul Highnam), 24-29.

Erman, Adolf, *Life in Ancient Egypt*, New York, Benjamin Blom, Inc., 1894/1969 Fig. 4-1, 4-10, 4-15, 4-27.

Essex Institute, Massachusetts: Fig. 16-14, 28-13, 28-35.

© ESTO, Mamaroneck, NY, Ezra Stoller, Photographer: Fig. 3-32.

Fergusson, James, *A History of Architecture in all Countries from the Earliest Times to the Present Day*, London, John Murray, 1874: Fig. 5-1, 6-18b, 6-20, 7-4, 7-8, 7-12a, 11-21.

Fergusson, James, *History of Modern Styles of Architecture*, New York, Dodd, Mean, 1899: Fig. 10-19, 15-27, 24-9.

Fotographia De Arts Moreno, Madrid: Fig. 13-19.

Courtesy of Freer Gallery of Art, Smithsonian Institution, Washington, DC: Fig. 3-2, 3-34 (Accession # F1903.54).

French Government Tourist Office: Fig. I-1, 10-11, 11-22, 12-49, 14-15, 21-17, 21-22, 26-10, 26-44.

Fuentes, Maria: Fig. 17-8.

Gardiner, Samuel, R., *A Student's History of England*, New York, Longmans, Green and Co., 1908: Fig. 10-2, 10-5, 10-17, 10-23, 10-24, 15-1, 15-2, 15-19, 22-7, 22-15, 22-22, 24-25.

Gardner, Helen, *Art Through the Ages*, New York, Harcourt, Brace and Co., 1926: Fig. 1-20, 4-3, 6-3a, 9-34, 15-15.

Garnier, C., *Le Nouvel Opéra de Paris*, Paris, 1880: Fig. 21-38.

Gelis, Paul, *Le Mobilier Alsacien*, Paris, C. Massin et Cie, 1926: Fig. 26-46, 26-47, 26-51.

Courtesy of The Getty Conservation Institute, Los Angeles, Photograph by Guillermo Aldana, © The J. Paul Getty Trust, All rights reserved: Fig. 4-21.

The J. Paul Getty Museum, Los Angeles: Fig. 21-45, 23-12, 23-31c, 23-32.

Gendreau, Philip D.: Fig. 2-17.

Gidal, Tim: Fig. 1-26.

Gillon, Edmond V. Jr., *Pictorial Archives of Early Illustrations and Views of American Architecture*, New York, Dover Publications, Inc., 1971: Fig. 6-25, 28-8.

Gloag, John, *British Furniture Makers*, New York, Hastings House, n.d.: Fig. 11-55a, 15-67, 20-41, 24-55, 27-39b.

Godfrey, Walter H., *A History of Architecture in London*, New York, Charles Scribners Sons, 1911: Fig. 15-24, 22-10, 22-11, 22-13, 22-14, 22-26, 22-30, 24-5.

Good, Chris: Fig. 1-6, 1-21, 1-23, 1-24, 1-27, 1-33, 1-35, 1-38, 1-40, 1-46, 2-10, 2-15b, 2-23, 2-36, 2-40, 2-41, 3-10, 3-11, 3-24, 3-36, 4-6, 4-19b, 4-22, 5-31, 6-22, 7-3, 11-60, 12-9, 12-19, 12-47, 12-61, 14-7, 14-34, 14-51, 15-16, 15-21, 15-22, 15-25, 15-29, 15-33, 15-52a, b, c, 15-57, 16-2a, b, 16-9, 16-10, 16-15, 16-22, 16-26, 16-28, 16-30, 16-33, 16-35a, b, c, 17-2a, b, 17-22, 17-26a, b, c, 17-27, 17-39, 17-42, 17-44, 17-47a, b, 17-48, 18-27, 18-33a, b, 18-34a, 18-35, 18-36, 18-37b, 18-38, 18-39a, 18-40, 19-6, 19-30, 19-51, 19-54, 20-40, 20-42, 21-11, 21-14, 22-8, 22-9, 22-25, 23-38, 24-62a, 25-49, 26-50, 26-54a, 27-11, 27-38b.

Goodyear, William Henry, *History of Art for Classes, Art Students, and Tourists in Europe*, New York, A. S. Barnes and Co., 1889: Fig. 5-9, 5-11, 5-19b, 5-25, 5-28, 6-6, 6-13, 7-17, 8-10a, 10-16a, 11-8, 11-17b, 12-4, 20-32.

Gordon, Eugene, Photographer, 1984: Fig. 9-4.

Gotch, J. Alfred, *Old English Houses*, London, Methuen and Co., Ltd., 1925: Fig. 15-8, 15-26, 15-28, 15-35, 22-16, 22-17, 22-23, 22-24.

Grant, Bonnie: Fig. 4-25, 5-32, 5-36, 10-29, 11-56.

Guérinet, Armand, *Materials et Documents d'Art Décoratif*, Paris, Libraire d'Architecture et d'Art Décoratif, n.d.: Fig. 23-7, 23-8, 23-35c.

Courtesy of the Board of Regents, Gunston Hall Plantation, Mason Neck, VA: Fig. I-l2, 25-52, 25-53.

Guy Chaddock & Company, Bakersfield, CA: Fig. 26-57.

Halsey, R.T.H. and Elizabeth Tower, *The Home of Our Ancestors*, Garden City, Doubleday & Co. Inc., 1925: Fig. 2-33, 25-54c, 25-60, 25-67, 28-1, 28-37, 28-43, 28-44, 28-46, 28-52, 28-53, 28-54a.

Hamlin, Alfred D. F., *A History of Ornament, Renaissance and Modern*, New York, The Century Company, 1923: Fig. 6-45, 24-26, 25-44, 26-7.

15-50, 15-54, 15-55, 15-69, 22-35, 22-39, 22-40, 22-41, 22-42, 22-45, 27-32, 27-33.

Leixner, Othmar, *Einfuhrung in Die Architektur*, Vienna, Franz Deuticke, 1919: Fig. 4-9, 5-10, 5-16, 6-28, 7-10, 7-11, 8-10b, 9-2, 9-3, 9-7, 10-13, 10-15, 11-5, 11-14, 11-16, 11-17a, 11-23, 11-33, 12-2b, c, 12-5, 12-18, 13-5, 13-23, 14-4b, 14-17, 14-50b, 20-5, 20-6, 20-10, 20-14, 20-22, 20-25, 21-8b, 21-9, 27-34.

Lenygon, Francis, *English Decoration and Furniture of the XVIth–XIXth Centuries*, London, B.T. Batsford, 1924: Fig. 2-48, 24-52, 24-53, 24-58, 24-60.

Lévy, Emile (Ed.), *Art et Décoration*, Paris, Librairie Centrale des Beaux—Arts, Volumes 1897–1906: Fig. 3-7, 20-28, 21-51, 23-24.

Courtesy of Rolande L'Heureux and Archives Nationales du Québec: Fig. 18-3.

Courtesy of The Library of Congress, Prints and Photographs Division, Historic American Building Survey: Fig. 5-27, 9-24, 10-18, 11-52, 12-52, 14-23, 15-59, 16-5, 16-11, 16-12, 16-13, 16-23, 17-5, 17-13, 17-23, 17-25, 17-28, 17-52, 18-1a, b, 18-2, 18-7, 18-9, 18-10, 18-12, 18-13, 18-16, 18-17, 18-28, 18-32, 19-1, 19-2, 19-20, 19-37, 19-38, 19-39, 19-42, 19-43, 19-44, 19-45, 19-46a, b, 19-46b, 19-47, 19-52a, b, 19-53, 19-55a, b, 21-13, 22-28, 24-23, 25-2, 25-6, 25-10 (drawing by Rafele), 25-23, 25-25, 25-26 (Philip B. Wallace, photographer), 25-31, 25-34, 25-36, 25-37, 25-38, 25-40, 25-43, 25-46, 25-47a, b, 28-7, 28-9, 28-17, 28-18, 28-26, 28-36, 28-38 (F. D. Nichols, photographer).

Litchfield, F., *Illustrated History of Furniture*, Boston, The Medici Society of America, 1922: Fig. 4-28b, 5-34, 5-38, 9-32, 11-49, 11-53b, 11-54, 12-37, 12-57, 13-54, 14-48a, 15-60c, 15-63, 15-70, 21-50, 24-46b, c, 26-32b, 27-31b, 27-50, 27-58b.

Lockwood, Luke Vincent, *Colonial Furniture in America*, new and enlarged edition, New York, Charles Scribners Sons, 1913: Fig. 16-42, 16-43b, 16-44, 16-46, 16-48, 16-49, 25-68, 28-48, 28-49.

Long, John, *Early Settlements in America*, New York, Row, Peterson & Co. 1925: Fig. 16-1b, 17-1, 17-51c.

Lubke, Wilhelm, *Geschichte der Architekture*, Leipzeg, Verlag Von E.A. Seemann, 1865: Fig. 9-23, 10-3b, 10-4a, 10-10, 10-14, 10-16b, c, 12-11, 12-45, 21-8a.

Macquoid, Percy, *A History of English Furniture*, Volumes 1 and 2, London, Lawrence and Bullen, Ltd., 1905: Fig. 22-44a, 22-48, 22-51.

Marco, Antonio Salo, *El Estillo Reanacimiento Espanol*, Barcelona, Casa Editorial Feliu y Susanna, ND: Fig. 13-18.

The Maryland Historical Society, Baltimore, Maryland: Fig. 28-10.

Massachusetts Department of Commerce and Development: Fig. 16-3.

May, Bridget: Fig. 12-3, 12-14, 12-23, 20-12a, b, 20-13.

Mayer, August L., *Architecture and Applied Arts in Old Spain*, New York, Brentano's, 1921: Fig. 13-6, 13-10, 13-11, 13-12, 13-13, 13-15, 13-20, 13-63c, 20-27.

McClelland, Nancy, *The Practical Book of Wall Treatments*, Philadelphia, J. B. Lippincott Company, 1926: Fig. 23-15.

Meden, Robert Paul: Fig. 17-20, 19-41.

Medieval Academy of America, Illustration by Kenneth Conant: Fig. 10-12.

Mee, A. and H. Thompson, *The Book of Knowledge*, New York, The Grolier Society, 1912: Fig. 2-2, 4-19a, 20-21.

The Mentor, Volume 1, No. 49, New York, The Mentor Association, 1914: Fig. 19-8.

The Metropolitan Museum of Art, The Cloisters Collection, 1956, Gift of John D. Rockefeller, Jr., 1937, (37.80.6): Fig. 14-49b.

———, The Cloisters Collection, 1956, (56.70): Fig. 11-47.

———, Gift of Josephine M. Fiala, 1968, (68.133.7): Fig. 12-51.

———, Fletcher Fund, 1931, (32.53.1), Photograph © 1996 The Metropolitan Museum of Art: Fig. 24-37.

———, Gift of The Hagtop Kevorkian Fund, 1970, (1970.170), Photograph © 1995: Fig. 9-20.

———, Frederick C. Hewitt Fund, 1911, (JP655): Fig. 3-35.

———, Gift of Samuel H. Kress Foundation, 1958, (58.75.1.23): Fig. 27-26.

———, Gift of Sirio D. Molenti and Rita M. Pooler, 1965, (65.4): Fig. 23-23.

———, Rogers Fund, 1903, (03.14.13), Gift of J. Pierpont Morgan, 1917, (17.190.2076), Anonymous Gift, 1945, (45.16.2): Fig. 6-31, 6-41.

———, Rogers Fund, 1906, (06.1335.1): Fig. 20-39.

———, Rogers Fund, 1918, (Negative #MM83546FF): Fig. 25-48.

———, Rogers Fund, 1939, (39.153): Fig. 12-44.

———, Sage Fund, 1926, (26.290): Fig. 16-34.

———, Gift of Mrs. Herbert N. Straus, 1942, (42.203.1): Fig. 26-18.

———, Gift of Mrs. William Bayard Van Rensselaer in memory of her husband, William Bayard Van Rensselaer, 1928, (28.143): Fig. 25-50.

———, The Charles B. Wrightsman Foundation Fund, 1963, (63.228.1): Fig. 23-13.

Mint Museum of Art, Charlotte, NC, Gift of Dr. and Mrs. Francis Robicsek: Fig. 1-32 (1982.192.2)

Modern World Dictionary of the English Language, New York, P. F. Collier and Sons, 1906: Fig. 11-7.

Morse, Edward S., *Japanese Homes and Their Surroundings*, Boston, Ticknor and Co., 1886: Fig. 3-22, 3-23, 3-30, 3-31, 3-37.

Courtesy of the Mount Vernon Ladies' Association: Fig. 28-28.

Municipality of Vienna (Ed.), *Wien* (*Vienna Through a Camera*), Wien, Verlag von Martin Gerlach & Co., 1907: Fig. 20-20, 20-24.

Musées Nationaux, Paris: Fig. 21-7, 21-12.

Museum of The City of New York, The Byron Collection: Fig. 9-28, 23-25.

Courtesy of the Museum of Early Southern Decorative Arts, Winston-Salem, NC: Fig. 19-26, 19-27, 19-28, 19-31, 19-32, 19-35, 19-36.

Myers, Philip Van Ness, *Ancient History*, Boston, Ginn and Co., 1904: Fig. 4-13, Section C Opener.

———, *A General History*, Boston, Ginn and Co., 1898: Section F Opener.

Nash, John, *The Mansions of England in the Olden Time*, London, William Heinman, 1912: Fig. I-11, 11-35, 11-45, 11-53a, 15-40, 15-44, 15-47.

National Gallery of Art, Washington, DC, Samuel H. Kress Collection: Fig. 6-27.

National Monuments Record, England: Fig. 27-15.

National Tourist Bureau, Guatemala City, C.A.: Fig. I-15, 1-37.

The National Trust Photo Library, National Trust for Places of Historic Interest or Natural Beauty, London, England: Fig. 2-31, 6-38, 22-19 (Photograph by Rupert Truman), 24-38, 24-39, 27-28, 27-55 (Photograph by Bill Batten).

Nelson-Atkins Museum of Art, Kansas City, Missouri, (Purchase: Nelson Trust) 64-4/4: Fig. 2-42.

New Mexico State Tourist Bureau: Fig. 17-32.

The New York Public Library: Fig. 8-11, 20-7, 28-5.

Newport County Chamber of Commerce, RI: Fig. 25-20.

North Carolina News Bureau, Department of Conservation & Development: Fig. 5-26, 25-30.

Northend, Mary H., *American Homes and Their Furnishings in Colonial Times*, London, T. Fisher Unwin, 1912: Fig. 16-27, 25-54a, b, 25-69.

Northrop, Henry D., *The American Educator and Book of Universal Knowledge*, Chicago, I. B. Saunders Co., 1903: Fig. 1-1.

Northwind Picture Archives: Fig. 5-13, 5-18.

Nutting, Wallace, *American Windsor*, Boston, Old America Co., 1917: Fig. 25-61a, c.

———, *Furniture Treasury*, Framingham, MA, Old America Co., 1926: Fig. 16-24, 16-32, 16-37, 16-43a, 16-47, 25-3, 25-4, 25-42, 25-59, 25-62a, b, 25-63, 25-65, 28-2, 28-3, 28-42a, 28-51.

Nye, Alvan C., *A Collection of Scale-Drawings, Details, and Sketches of What Is Commonly Known as Colonial Furniture*, New York, William Helburn, 1895: Fig. 16-39, 16-40a, 16-41, 25-57, 25-61d.

Palladio, Andrea, *The Four Books of Architecture*, London, Isaac Ware, 1738: Fig. I-7, 6-19, 12-13, 12-24, 12-27, 12-46.

Courtesy of Parke, Davis & Co., Used with permission: Fig. 9-19.

Parker, John Henry, *ABCs of Gothic Architecture*, 2nd Ed., Oxford, Parker and Co., 1882: Fig. 10-4b.

Courtesy of Peabody Essex Museum: Fig. 3-39, 16-14, 28-13, 28-35.

Pencil Points Press Inc., 1930: Fig. 11-19 (Etching by John Taylor Arms), 14-20, 15-32, 16-19, 17-11, 17-30.

Pennell, E. R., *The Life of James McNeill Whistler*, Philadelphia, J. B. Lippincott, 1911: Fig. 3-42.

Penor, Rodolphe, *Guide, Artistique & Historique au Palais de Fontainebleau*, Paris, André, Daly Fils & Cie, 1889: Fig. 14-4c.

Percier, Charles and Pierre F. Fontaine, *Recueil de Décorations Intérieures*, Paris, Jules Didot Ainé, 1827: Fig. 6-39, 6-49.

The Philadelphia Society for the Preservation of Landmarks: Fig. 25-28.

Pollack, Pam, *Chairs through the Ages*, edited by Harold H. Hart, Copyright © by Hart Publishing Company, Inc., New York, Dover Publications: Fig. 6-42, 9-36, 15-61, 15-62, 16-38, 27-41.

Portland Art Museum, Portland, Oregon, Axel Rasmussen Collection, purchased with the Indian Collection Subscription Fund: Fig. 1-43.

The Preservation Society of Newport County, RI: Fig. 25-16 (Photograph by John T. Hopf), 25-41 (Photograph by Richard Cheek).

Prignot, Eugène, *L'Architecture, La Décoration, L'Ameublement Soixante Compositions et Dessins Inédit*, Paris, C. H. Claesen, 1873: Fig. 23-22c, 26-21, 26-24, 26-27a, b.

Publishers Photo Service: Fig. I-5, 9-21.

Ramsey, May Francis: Fig. 2-25, 25-11.

Ridpath, John Clark, *Cyclopedia of Universal History, Vol. II*, Cincinnati, The Jones Bros. Publishing Co., 1885: Section E Opener.

Robet, William, Photographer, Neola, Oklahoma: Fig. 1-12.

The Room Beautiful: A Collection of Interior Illustrations Showing Decoration and Furnishing Details of the Important Furnishing Periods, New York, Clifford and Lawton, 1915: Fig. 4-24, 5-37, 21-24, 26-17, 26-30.

Rouyer, Eugène, *French Architecture and Ornament from Francis I to Louis XVI*, Boston, George H. Polley and Company, 1866: Fig. 14-3, 21-35, 21-36, 23-4, 23-6, 23-16, 23-18, 23-19, 26-25, 26-26.

Ruskin, John, *St. Mark's Restoration: The History of Venice*, New York, John Wiley and Sons, 1886: Fig. 11-4.

Sale, Edith Tunis, *Interiors of Virginia Houses of Colonial Times*, Richmond, VA, William Byrd Press, Inc., 1927, by Permission of the Library of Congress: Fig. 25-22, 25-27, 25-32, 25-45, 28-22.

San Antonio Convention and Visitors Bureau: Fig. 17-9.

Sanders, William Bliss, *Half Timbered Houses and Carved Oakwork of the 16th and 17th Centuries*, London, Bernard Quartich, 1894: Fig. 15-9, 15-41, 15-60a, 15-66b.

Schmitz, Herman, *The Encyclopedia of Furniture*, Plymouth, GB, Ernest Benn Ltd., 1926: Fig. 14-40, 14-46.

Serlio, Sebastiano, *D'Architettura*, 1540, On Geometry and Perspective, Book II, Paris, 1545: Fig. 12-38.

Sheraton, Thomas, *The Cabinet-Maker and Upholsterer's Drawing Book*, London, L. T. Bensley, 1802: Fig. 27-43, 27-44, 27-48, 27-54.

Sherman, Curt: Fig. I-6, I-9, 1-3, 1-5, 1-25, 1-30, 1-44, 2-24, 2-43, 3-6, 3-12, 3-13, 3-14, 3-15, 3-16, 3-18, 3-19, 3-20, 3-21, 3-28, 3-29, 3-33, 3-40, 3-44, 3-45, 4-17, 4-23, 5-2, 5-6, 6-23, 6-26, 6-32, 6-33, 7-16, 9-10, 9-11, 9-15, 9-16, 11-38, 11-42, 11-43, 11-51, 12-10, 12-17, 12-39, 15-20, 15-30, 15-43, 15-53, 17-4, 17-6, 17-14, 17-16, 17-24, 17-31, 17-33, 17-35, 17-37, 17-40, 17-41, 17-46, 17-49, 17-50, 17-51b, 17-53, 19-7, 19-11, 19-12, 19-24, 21-10, 21-21a, 21-25, 24-18, 24-21, 24-30b, 25-18, 25-24, 26-11, 27-10a, b.

Singleton, Esther, *The Collecting of Antiques*, New York, The Macmillan Co., 1926: Fig. 13-2, 14-47, 16-40b, 16-45a, b, 23-37, 24-46a, 24-62b, 24-64, 25-58, 25-64, 27-5b, 27-59, 28-47.

Smith, Edwin: Fig. 11-13.

Smith, G. E. Kidder, New York, NY: Fig. 8-6.

The Smithsonian Institution, Office of Anthropology, Bureau of American Ethnology Collection: Fig. 1-28.

Some Account of Domestic Architecture in England (Editor of the Glossary of Architecture), Oxford, John Henry Parker, 1853: Fig. 11-25a, b.

Spanish National Tourist Office: Fig. 6-21.

Speltz, A., *The Colored Ornament of All Historical Styles*, London, B. T. Batsford, Ltd., 1915: Fig. 6-34, 6-36.

Spofford, Harriet Prescott, *Art Decoration Applied to Furniture*, New York, Harper and Row, 1877: Fig. 26-37b.

Statham, H. Heathcote, *A Short Critical History of Architecture*, London, B. T. Batsford, 1912: Fig. 6-7a, b, 6-8, 6-10, 6-15, 6-16, 6-17, 6-29, 7-13, 20-37, 24-6, 27-7.

Photograph courtesy of Steelcase Inc., Grand Rapids, MI: Fig. 3-43.

Stephenson, Nathaniel, *An American History*, Boston, Ginn & Co., 1919: Fig. 22-1, Section H Opener.

Stoddard, John Lawson, *Lectures on Southern California, Grand Canyon, of the Colorado River, Yellowstone National Park*, Chicago, Geo. L. Shuman & Co., 1926: Fig. 1-22.

Stoddard, John Lawson, *A Trip Around the World*, n.p., n.d.: Fig. 1-8, 6-11, 9-6, 14-31, 15-11, 21-18.

Stranahan, C. H., *A History of French Painting*, New York, Charles Scribners Sons, 1888: Fig. 26-1.

Strange, Thomas Arthur, *An Historical Guide to French Interiors, Furniture and Decoration During the Last Half of the Seventeen Century, the Whole of the Eighteenth Century, and the Earlier Part of the Nineteenth*, New York, Charles Scribners Sons, 1903: Fig. 14-35, 14-42, 21-4a, b, 21-5, 21-23, 21-26, 21-27, 21-30, 21-31, 21-32a, b, 21-33, 21-34, 21-37, 21-41, 21-42, 21-44, 21-46, 21-47, 21-53, 21-54a, 23-2, 23-5, 23-11, 23-14, 23-17, 23-22a, 23-28a, 23-29a,b, 26-5, 26-13, 26-14, 26-15, 26-16, 26-19, 26-22, 26-23, 26-28a, b, c, d, 26-31b, 26-35a, 26-36b, 26-37a, 26-39.

Stuart, James and Nicholas Revett, *The Antiquities of Athens*, New York and London, Benjamin Blom, 1968: Fig. 5-19a, 5-20, 5-21a.

Sturgis, Russell, *A Dictionary of Architecture and Building*, New York, The Macmillan Company, 1904: Fig. 5-3, 7-9, 7-12b, 7-15, 10-6, 11-31, 13-14, 23-3.

Tattersall, C. E. C., *Fine Carpets in the Victoria and Albert Museum*, New York, Charles Scribners Sons, 1924: Fig. 2-44c.

The Thomas Jefferson Memorial Foundation: Fig. 28-21.

Timms, W. H. and George Webb, *The Thirty-Five Styles of Furniture*, London, Timms & Webb, 1904: Fig. 4-34, 5-35, 9-26, 12-48a, b, 12-55a, 12-58, 14-26a, 14-43a, 15-65, 22-46, 23-30, 23-33.

Tipping, H. Avray, *English Homes, Period II, Volume 1, Early Tudor*, London, Offices of Country Life, 1921: Fig. 15-13, 15-14, 15-34.

———, *English Homes, Period V, Volume 1*, London, Offices of Country Life, 1924: Fig. 22-20, 22-27, 22-37, 22-50, 24-7, 24-10, 24-11, 24-16, 24-17, 24-27, 24-30a, 24-31, 24-32, 24-33, 24-35, 24-42, 24-43, 24-44, 24-45, 24-54, 24-57, 24-59, 24-63, 27-2, 27-3, 27-5a, 27-9, 27-17, 27-22, 27-24, 27-29, 27-30, 27-35, 27-36a, b, 27-37, 27-38a, 27-46, 27-52a, b, 27-53.

———, *Grinling Gibbons and the Woodwork of His Age (1648-1720)*, London, Country Life, 1914: Fig. 22-2, 22-3a, b, c, d, 22-4, 22-5, 22-32b, 22-33, 22-34, 22-36a, b, c, 22-43, 22-49.

Courtesy of Trans World Airlines (TWA): Fig. I-10, 4-5, 4-7, 11-11, 11-12.

A Treatise on Architecture and Building Construction, Vol. 5, Scranton: The Colliery Engineering Co., 1899: Fig. 4-4, 6-2, 8-3, 8-5, 11-24, 12-21.

Trouvailles, Inc.: Fig. 26-42.

Tuer, Andrew W., *Japanese Stencil Design*, New York, Scribners, 1892/1967: Fig. 3-4.

Turkish Ministry of Culture and Tourism: Fig. 8-4, 8-13, 9-25.

Uniroyal, Public Relations Department: Fig. 26-41.

Courtesy of Architectural Drawings Collection, the University of Texas at Austin; drawing by Catherine Suttle and Barbara Redmon. Published in Harwood, Buie, *Decorating Texas: Decorative Painting in the Lone Star State from the 1850s to the 1950s*, Ft. Worth, TX, TCU Press, 1993: Fig. 19-25.

University of Texas, Institute of Texan Cultures at San Antonio, Courtesy of Florence Collett Ayres: Fig. 13-51.

Van Aerssen, Jakob, *Ecclesiastical History for School and Home*, Durck und Verlag der Missionsdruckerel, 1901: Fig. 8-8, 11-18, 18-20, 20-31.

d. Verleger, Eigenthum, Aus d. Kunstanst d. Bibl. Instit. In Hildbhn, pre-1900: Fig. 4-16.

Victoria & Albert Museum, Crown Copyright, London/Art Resource, NY: Fig. 3-49, 24-61.

Virginia Department of Historic Resources: Fig. 19-4.

Virginia Tourism Corporation: Fig. 16-4, 16-6, 16-7, 16-21, 25-7, 25-8, 25-9, 25-21, 25-39, 28-4, 28-11, 28-14, 28-30.

Von Falke, Otto, *Decorative Silks*, New York, William Helburn, Inc., 1922: Fig. 2-44b, 8-22a, b, 12-62d, 13-63a.

Wallace, B., Fig. 17-51.

Wallis, Frank E., *How to Know Architecture*, New York, Harper and Brothers, 1910: Fig. 14-14, 14-16, 14-18, 22-12.

Ware, William R., *The American Vignola, Part I*, Scranton, PA, International Textbook Co., 1904: Fig. 5-8.

Warren, Garnet and Horace B. Cheney, *The Romance of Design*, New York, Doubleday, Page, and Co., 1926: Fig. 11-58, 12-62a, b, c, 13-63b, d, 14-50c, d, 15-71d, e, 23-35a, b, 23-36, 26-2, 26-38, 27-57a, 28-54b.

West, Willis Mason, *The Modern World*, Boston, Allyn and Bacon, 1915: Section G Opener.

The White City Beautifully Illustrated, n.p. 1893: Fig. 3-26, 21-19, 24-24.

Widdenhager, Von Graft, *History of Art*, 1919: Fig. 5-33, 6-30, 8-19, 9-8, 10-14, 12-22, 12-30, 12-63, 20-30.

Winslow, Carlton and Bertram G. Goodhue, *The Architecture and Gardens of the San Diego Exposition*, San Francisco, Paul Elder & Co., 1916: Fig. 13-26.

Courtesy Winterthur Museum, Winterthur Photographic Services, Winterthur, Delaware: Fig. 16-29, 25-56, 25-66, 28-29, 28-39, 28-41, 28-45, 28-50.

Wytsman, P. (Ed.), *Intérieurs et Mobiliers de Styles Ancien*, Bruxelles, 1900: Fig. 14-27, 14-28, 14-30, 14-36.

Photograph by Yvon: Fig. 21-15.

Credits for Color Plates

Color Plate 2: Endeman, Judith.

Color Plates 4, 12, 15: Speltz, Alexander, *The Coloured Ornament of All Historical Styles. Part 1: Antiquity*. London: B.T. Batsford, Ltd., 1915.

Color Plates 6,18, 27, 30, 36, 37, 50, 61, 64, 66, 69: Sherman, Curt.

Color Plate 8: Ayervais, Michael, The Ayervais Collection.

Color Plate 9: Courtesy of The Getty Conservation Institute, Los Angeles.

Color Plate 10: Baker, Hollis, *Furniture in the Ancient World*, courtesy of The K.S. Giniger Co., 1966.

Color Plates 6, 24, 42, 43, 44, 52, 54, 58: Harwood, Buie.

Color Plate 7: Turkish Tourism and Information Office.

Color Plate 29: Erich Lessing/Art Resource, NY.

Color Plate 38: The Victoria and Albert Museum, London/Art Resource, NY.

Color Plate 40: Historic Deerfield.

Color Plate 41: Library, Daughters of the Republic of Texas at the Alamo (Ernst Schuchard, artist).

Color Plate 46: Museum of Early Southern Decorative Arts.

Color Plate 53: French Government Tourist Office.

Color Plate 55: Macquoid, Percy, *A History of English Furniture, Volumes 1 and 2*. London: Lawrence and Bullen, Ltd., 1905.

Color Plates 56, 57: The J. Paul Getty Museum, Los Angeles.

Color Plate 59: By kind permission of the Earl of Leicester and Trustees of Hokham Estate.

Color Plates 60, 67, 68: National Trust for Places of Historic Interest or Natural Beauty, National Trust Photo Library, London, England.

Color Plate 62: Courtesy of Board of Regents, Gunston Hall Plantation.